Wynn Kapit / Lawrence M. Elson

The ANATOMY COLORING BOOK

FOURTH EDITION

PEARSON

Boston Columbus Indianapolis New York San Francisco Upper Saddle River
Amsterdam Cape Town Dubai London Madrid Milan Munich Paris Montréal Toronto
Delhi Mexico City São Paulo Sydney Hong Kong Seoul Singapore Taipei Tokyo

Editor-in-Chief: Serina Beauparlant
Associate Editor: Nicole McFadden
Director of Development: Barbara Yien
Text Permissions Associate Project Manager: Michael Farmer
Text Permissions Specialist: S4 Carlisle
Senior Managing Editor: Deborah Cogan
Production Project Manager: Caroline Ayres/Michael Penne
Copyeditor: Brooke Graves/Graves Editorial Service
Production Management and Composition: Integra
Design Manager: Marilyn Perry
Interior Designer: Howie Severson
Cover Designer: Wynn Kapit, Riezebos Holzbaur Design Group
Senior Manufacturing Buyer: Stacey Weinberger
Marketing Manager: Derek Perrigo

Library of Congress Cataloging-in-Publication Data

Kapit, Wynn.
 The anatomy coloring book/Wynn Kapit, Lawrence M. Elson.—4th ed.
 p.; cm.
 Includes bibliographical references and index.
 ISBN 978-0-321-83201-6
 I. Elson, Lawrence M., 1935- II. Title.
 [DNLM: 1. Anatomy—Atlases. 2. Anatomy—Terminology—English. QS 15]
 611—dc23
 2012029126

44 2022

www.pearsonhighered.com

ISBN-13: 978-0-321-83201-6
ISBN-10: 0-321-83201-9

DEDICATION

For my wife, Lauren, and sons, Neil and Eliot.

—WYNN KAPIT

This edition is dedicated to the millions of students of anatomy, and their teachers, who have used this book in the pursuit of visualizing and understanding the structure and function of the human body by "hands on" coloring of structure, related nomenclature, and structural and functional relationships. Their diligent and successful acquisition of anatomic knowledge, and its application to their professional and personal lives, gives evidence of the value of kinesthetic (tactile) learning. May their new insights make the world a better place.

—LARRY ELSON

ABOUT THE AUTHORS

WYNN KAPIT

Wynn Kapit, the designer and illustrator of this book, has had careers in law, graphic and advertising design, painting, and teaching.

In 1955, he graduated from law school, with honors, from the University of Miami and was admitted to the Florida Bar. He practiced law both before and after military service. Four years later, he decided to pursue a childhood ambition and enrolled at what is now the Art Center College in Los Angeles, where he studied graphic design. Afterwards, he worked in the New York advertising world for six years as a designer and art director. He "dropped out" in the late 1960s, returned to California, and began painting. His numerous exhibitions included a one-man show at the California Palace of the Legion of Honor in 1968. He returned to school and received a master's degree in painting from the University of California at Berkeley in 1972.

Kapit was teaching figure drawing in Adult Ed in San Francisco in 1975 when he decided he needed to learn more about bones and muscles. He enrolled in Dr. Elson's anatomy class at San Francisco City College. While he was a student, he created the word-and-illustration coloring format that seemed to be a remarkably effective way of learning the subject. He showed some layouts to Dr. Elson and indicated his intention to do a coloring book on bones and muscles for artists. Immediately recognizing the potential of this method, Dr. Elson encouraged Kapit to do a "complete" coloring book on anatomy and offered to collaborate on the project. The first edition of *The Anatomy Coloring Book* was published in 1977, and its immediate success inspired the development of a completely new field of publishing: educational coloring books.

Kapit went on to create *The Physiology Coloring Book* with the assistance of two professors who were teaching at Berkeley: Dr. Robert I. Macey and Dr. Esmail Meisami. That book was published in 1987 and has gone through two editions. In the early 1990s, Kapit wrote and designed *The Geography Coloring Book,* now in its second edition.

LAWRENCE M. ELSON

Lawrence M. Elson, PhD, planned the content and organization, provided sketches, and wrote the text for the book. This is his seventh text, having authored *It's Your Body* and *The Zoology Coloring Book* and co-authored *The Human Brain Coloring Book* and *The Microbiology Coloring Book.* He received his BA in zoology and pre-med at the University of California at Berkeley and continued there to receive his PhD in human anatomy. Dr. Elson was assistant professor of anatomy at Baylor College of Medicine in Houston, participated in the development of the Physician's Assistant Program, lectured and taught dissection anatomy at the University of California School of Medicine in San Francisco, and taught general anatomy, from protozoons to humans, at City College of San Francisco.

In his younger days, Dr. Elson trained to become a naval aviator and went on to fly dive-bombers off aircraft carriers in the Western Pacific. While attending college and graduate school, he remained in the Naval Air Reserve and flew antisubmarine patrol planes and helicopters. His last position in his 20-year Navy career was as commanding officer of a reserve antisubmarine helicopter squadron.

Dr. Elson is a consultant to insurance companies and personal injury and medical malpractice attorneys on causation-of-injury/death issues, a practice that has taken him throughout the United States and Canada. He has testified in hundreds of personal injury trials and arbitrations. His research interests are focused on the anatomic bases of myofascial pain arising from low velocity accidents.

You can contact him at docelson@gmail.com.

TABLE OF CONTENTS

REPRODUCTIVE SYSTEM

PREFACE

"A picture is worth a thousand words," states one Chinese proverb. Another says "…a million words." Indeed it is! And we are proud to present our fourth edition with a new and improved design, primarily reflected in the increased size of the illustrations and the addition of a separate text page adjacent to each related illustration.

This may be your first scientific higher education (college, graduate, and professional level) coloring book. In fact, we assume it is. A look inside—at first glance—may prove daunting! Stick with us, follow our lead, and you will come away from the experience with greater understanding than you can imagine.

You have been here before perhaps: while holding a conversation with your teacher you got lost in her words. The teacher then pulled out a pad of paper, and said, as she began drawing, "Look," and your eyes riveted on the paper before you as the illustrative explanation evolved. And, when your teacher finished her presentation, you saw the light. So, you are a visual learner! You looked at the drawing for a minute, and then said, "Can I draw what I see, and you tell me if I'm on the right track?" You took pencil in hand and illustrated your understanding, and, as you did, the meaning became even clearer. So, you are also a *kinesthetic* (hands-on) learner—you learn by doing! This book is designed for and dedicated to you.

We are offering instruction to a much broader audience than do typical texts, and there may be topics to be colored that are challenging to a first-year college student but not so challenging for a first-year medical or physical therapy student. If a page of illustration(s) confuses you, step back and look at the drawing(s) in the context of its place in the body. Keep going back to larger and more expanded views until you are comfortable with that level; then go one level deeper. Review the numerical order of coloring in the list of names; you may have missed something. Check the glossary or consult your major text or given reference. Also, if you have any suggested corrections, please let me (Elson) know. We really want you to have a positive learning experience, and have a sense of reward in seeing your completed work. After all, it's your body!

We are grateful to the thousands of colorers who have advised and encouraged us, including coaches, trainers, teachers, paramedics, body workers, court reporters, attorneys, insurance claims adjusters, judges, students and practitioners of dentistry and dental hygiene, nursing, medicine/surgery, chiropractic, podiatry, massage therapy, myotherapy, physical therapy, occupational therapy, exercise therapy, dance, and music! More informal seekers of self-realization and those with impairments have also been drawn to *The Anatomy Coloring Book* because of its lighter, more visual approach to understanding. Truly, a picture is worth a thousand words!

Happy Coloring!

REPRODUCTIVE SYSTEM

BIBLIOGRAPHY AND REFERENCES

APPENDIX A: ANSWER KEYS (TO REVIEWS ON PAGES 34, 41, 58, 66, 114, 119)

APPENDIX B: SPINAL INNERVATION OF SKELETAL MUSCLES

GLOSSARY

INDEX

PREFACE

"A picture is worth a thousand words," states one Chinese proverb. Another says "…a million words." Indeed it is! And we are proud to present our fourth edition with a new and improved design, primarily reflected in the increased size of the illustrations and the addition of a separate text page adjacent to each related illustration.

This may be your first scientific higher education (college, graduate, and professional level) coloring book. In fact, we assume it is. A look inside—at first glance—may prove daunting! Stick with us, follow our lead, and you will come away from the experience with greater understanding than you can imagine.

You have been here before perhaps: while holding a conversation with your teacher you got lost in her words. The teacher then pulled out a pad of paper, and said, as she began drawing, "Look," and your eyes riveted on the paper before you as the illustrative explanation evolved. And, when your teacher finished her presentation, you saw the light. So, you are a visual learner! You looked at the drawing for a minute, and then said, "Can I draw what I see, and you tell me if I'm on the right track?" You took pencil in hand and illustrated your understanding, and, as you did, the meaning became even clearer. So, you are also a *kinesthetic* (hands-on) learner—you learn by doing! This book is designed for and dedicated to you.

We are offering instruction to a much broader audience than do typical texts, and there may be topics to be colored that are challenging to a first-year college student but not so challenging for a first-year medical or physical therapy student. If a page of illustration(s) confuses you, step back and look at the drawing(s) in the context of its place in the body. Keep going back to larger and more expanded views until you are comfortable with that level; then go one level deeper. Review the numerical order of coloring in the list of names; you may have missed something. Check the glossary or consult your major text or given reference. Also, if you have any suggested corrections, please let me (Elson) know. We really want you to have a positive learning experience, and have a sense of reward in seeing your completed work. After all, it's your body!

We are grateful to the thousands of colorers who have advised and encouraged us, including coaches, trainers, teachers, paramedics, body workers, court reporters, attorneys, insurance claims adjusters, judges, students and practitioners of dentistry and dental hygiene, nursing, medicine/surgery, chiropractic, podiatry, massage therapy, myotherapy, physical therapy, occupational therapy, exercise therapy, dance, and music! More informal seekers of self-realization and those with impairments have also been drawn to *The Anatomy Coloring Book* because of its lighter, more visual approach to understanding. Truly, a picture is worth a thousand words!

Happy Coloring!

ACKNOWLEDGMENTS

Mary and Jason Luros: Your advice and counsel was much appreciated and for that I thank you.

Lindsey Fairleigh: Thank you for editing the rough script and formatting Microsoft Word so I could develop the typescript in consistent fashion, and for just being a good "ear," competent editor, and friend throughout the project.

Bill Neuman, PE: Thank you for helping me out with keystones and gravitational forces and all matters of engineering related to the human body.

Glen Giesler, PhD: Your contribution to the functional organization of cranial nerves was much appreciated.

Hedley Emsley, PhD, MRCP: Thank you for your kind review of the dermatomal map used in this book.

Eric Ewig, PT: Your insight on musculoskeletal function and dysfunction from the physical therapist's clinical perspective was invaluable. You were most helpful!

And last but not least to my wife, Ellyn, without whose love and understanding this project would have never been completed.

WYNN KAPIT
Santa Barbara, CA

LARRY ELSON
Napa Valley, CA

INTRODUCTION TO COLORING
(Important tips on how to get the most out of this book)

HOW THE BOOK IS ARRANGED

The book is divided by subject matter into sections. Each section contains many topics. Each topic consists of a page of illustrations, and a column of text on the page facing it.

It is not important that you color the sections in order, but for whichever section you select *you should color the pages in order.* You may wish to read through the text before coloring, and reread it more carefully afterward; or you may choose to color first. But *always read the coloring notes (CN) before coloring.* They let you know if certain colors are required, as well as what order to color in and what to look out for.

COLORING TOOLS

Colored pencils are preferred. They won't show through to the other side of the page. With colored pens, test each color on a page in the back of the book to see if it shows through. Lighter colors and water-based pens will be less likely to do so; their transparent qualities also allow details and labels on the illustration to remain visible.

At least 10 colors are necessary. One of them should be a medium gray. A single colored pencil can virtually create many colors, as varying the point pressure produces a range of light and dark values. If you purchase your colors individually, such as at stores selling art supplies, then choose mostly lighter colors. You will need red, blue, purple, yellow, gray, and black. Buying colors individually also enables replacement when a pencil is lost or used-up.

HOW THE COLORING SYSTEM WORKS

Structures (the parts of the illustrations to be colored), are identified by names presented in outlined (colorable) lettering. Each name has a small letter (A–Z) or number (subscript, letter label) following it. This letter label connects the name with its related structure in the illustration. *Name and structure are to receive the same color.* Look at the cover for a colored example.

Boundaries of the structures are defined by dark lines. Color over everything within the boundaries. The label may be found either within the structure or connected to it by a light line. Not every structure to be colored is labeled. When structures similar in size and shape lie adjacent to each other, color them all with the same color even if some are not labeled.

It is important to color the names; they guide you through the order of coloring. Coloring also promotes memorization. You may also find very slight spacing between letters in the names according to syllables. These groupings, along with the glossary in the back, help with learning pronunciation of these unfamiliar words. Indentations in the list of names reflect important relationships among the structures.

A different color is required for each name and its letter label, except where different names are followed by the same letter but have different superscripts (e.g., D^1, D^2, shown on the opposite page). They ($D–D^2$) all receive the "D" color because of a close relationship between the structures to which they refer. Even when restricted to a single color you may distinguish between such related names and structures by creating different values with varying pressure on the pencil. If you run out of colors because of a very long list of names, it will obviously be necessary to repeat a color and use it on more than one name. Except where indicated, you may choose your own colors. Lighter ones are advised for large areas, and dark or bright colors for the smaller structures that are harder to see.

Red is usually associated with arteries, blue with veins, purple with capillaries, yellow with nerves, and green with lymphatics. However, on pages dealing exclusively with any of these structures, you will naturally have to use many colors for the different structures in the same group.

SYMBOLS USED THROUGHOUT THE BOOK

𝓝𝓐𝓜𝓔 𝓞𝓕 𝓢𝓣𝓡𝓤𝓒𝓣𝓤𝓡𝓔 A′ (Subscript or label)

(Color in both name and the two structures labeled A the same color)

Nasal cavity

Hard palate

Laryngopharynx

Epiglottis

Larynx

𝓝𝓔𝓦 𝓝𝓐𝓜𝓔 B (Color in new color)
𝓝𝓔𝓦 𝓝𝓐𝓜𝓔 C (Color in new color)
𝓝𝓔𝓦 𝓝𝓐𝓜𝓔 D (Color in new color)

𝓝𝓔𝓦 𝓝𝓐𝓜𝓔 D′ (Color in both name and structure the same color as D)

𝓝𝓔𝓦 𝓝𝓐𝓜𝓔 D² (Color in both name and structure the same color as D)

𝓝𝓔𝓦 𝓝𝓐𝓜𝓔 E-¦- (Do not color in the name, or any structure with this label)

𝓝𝓔𝓦 𝓝𝓐𝓜𝓔 F✷ (Color in name gray, and any structure with this label gray)

𝓝𝓔𝓦 𝓝𝓐𝓜𝓔 G• (Color the name or structure black)

𝓝𝓔𝓦 𝓝𝓐𝓜𝓔 H— (Color the name, but there is no structure to color)

(Subject matter is microscopic in size)

------ (Boundary line of structure lying beneath or behind overlying structure)

ABBREVIATIONS

In the text, the following abbreviations (in upper or lower case) may precede or follow the names of the structures identified due to space limitations.

e.g., Post. auricular m., Brachial a., Scalenus med. m.

A., As. = Artery(ies)
Ant. = Anterior
Br., Brs. = Branch(es)
Inf. = Inferior
Lat. = Lateral
Lig. = Ligament
M., Ms. = Muscle(s)
Med. (preceding term) = Medial
Med. (after term) = Medius
N., Ns. = Nerve(s)
Post. = Posterior
Sup. = Superior, superficial
Sys. = System
Tr. = Tract
V., Vs. = Vein(s)

Study of the human body requires an organized visualization of its internal parts. Dissection (*dis*, apart; *sect*, cut) is the term given to preparation of the body for general or specific internal inspection. Internal body structure is studied in sections cut along imaginary flat surfaces called *planes*. These planes are applied to the erect, standing body with limbs extended along the sides of the body, palms and toes forward, thumbs outward. See this "anatomical position" in the following page. Views of the internal body in life and after death can be obtained by a number of techniques that produce computer-generated representational images of human structure in series (sections) along one or more planes. These anatomic images may be produced by computerized tomography (CT) and magnetic resonance imaging (MRI).

The **median plane** is the midline longitudinal plane dividing the head and torso into right and left halves. The presence of the sectioned midline of the vertebral column and spinal cord is characteristic of this plane. Planes parallel to the median plane are sagittal. Watch out! "Medial" is not a plane.

The **sagittal plane** is a longitudinal plane dividing the body (head, torso, limbs) or its parts into left and right parts (*not* halves). It is parallel to the median plane.

The **coronal** or **frontal plane** is a longitudinal plane dividing the body or its parts into front and back *halves or parts.* These planes are perpendicular to the median and sagittal planes.

The **transverse** or **cross plane** divides the body into upper and lower halves or parts (cross sections). This plane is perpendicular to the longitudinal planes. Transverse planes are horizontal planes of the body in the anatomical position.

ORIENTATION TO THE BODY
ANATOMIC PLANES & SECTIONS

CN: Use your lightest colors on A–D. (1) Color a body plane in the center diagram; then color its name, related sectional view, and the sectioned body example. (2) Color everything within the dark outlines of the sectional views.

MEDIAN ᴀ
SAGITTAL ʙ
CORONAL, FRONTAL ᴄ
TRANSVERSE, CROSS ᴅ

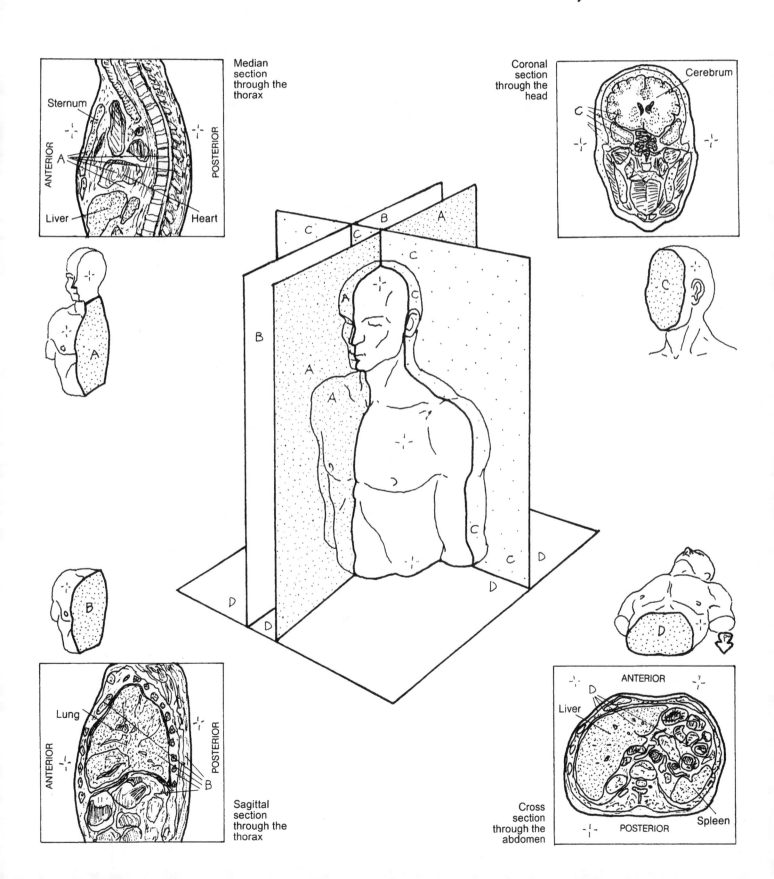

Median section through the thorax

Sternum

ANTERIOR

A

Liver

Heart

POSTERIOR

Coronal section through the head

Cerebrum

C

Lung

ANTERIOR

POSTERIOR

B

Sagittal section through the thorax

ANTERIOR

Liver

D

Spleen

Cross section through the abdomen

POSTERIOR

1

Terms of position and direction describe the relationship of one structure on/in the body to another with reference to the *anatomical position*: body standing erect, limbs extended, palms of the hands forward, thumbs directed outwardly.

Cranial and **superior** refer to a structure being closer to the top of the head than another structure in the head, neck, or torso (excluding limbs).

Anterior refers to a structure being more in front than another structure in the body. **Ventral** refers to the abdominal side; in bipeds, it is synonymous with anterior. **Rostral** refers to a beak-like structure in the front of the head or brain that projects forward.

Posterior and **dorsal** refer to a structure being more in back than another structure in the body. *Dorsal* is synonymous with *posterior* (the preferred term) except in quadrupeds.

Medial refers to a structure that is closer to the median plane than another structure in the body.

Lateral refers to a structure that is farther away from the median plane than another structure in the body.

Employed only with reference to the limbs, **proximal** refers to a structure being closer to the median plane or root of the limb than another structure in the limb.

Employed only with reference to the limbs, **distal** refers to a structure being farther away from the median plane or the root of the limb than another structure in the limb.

Caudal and **inferior** refer to a structure being closer to the feet or the lower part of the body than another structure in the body. These terms are not used with respect to the limbs. In quadrupeds, *caudal* means closer to the tail.

The term **superficial** is synonymous with *external*, the term **deep** with *internal*. Related to the reference point on the chest wall, a structure closer to the surface of the body is superficial; a structure farther away from the surface is deep.

Ipsilateral means "on the same side" (in this case, as the reference point); **contralateral** means "on the opposite side" (of the reference point).

The **quadruped** presents four points of direction: head end (cranial), tail end (caudal), belly side (ventral), and back side (dorsal).

CN: Color the arrows and the names of the positions and illustrations.

CRANIAL, SUPERIOR, A
ANTERIOR, VENTRAL B
ROSTRAL B'
POSTERIOR, DORSAL C
MEDIAL D
LATERAL E
PROXIMAL F
DISTAL G
CAUDAL, INFERIOR H
SUPERFICIAL I
DEEP J
IPSILATERAL K
CONTRALATERAL L

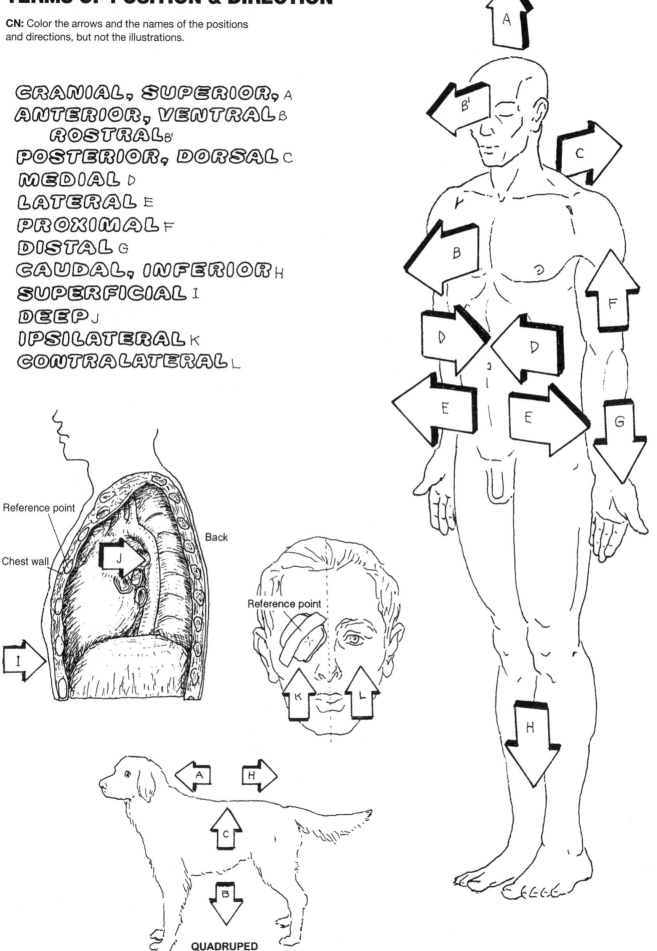

Reference point

Chest wall

Back

Reference point

QUADRUPED

Collections of similar cells constitute *tissues*. The four basic tissues are integrated into body wall and visceral structures/organs. A **system** is a collection of organs and structures sharing a common function. Organs and structures of a single system occupy diverse regions in the body and are not necessarily grouped together.

The **skeletal system** consists of bones and the ligaments that secure the bones at joints.

The **articular system** comprises both fixed and movable joints.

The **muscular system** includes the skeletal muscles that move the skeleton, the face, and other structures, and give form to the body; cardiac muscle pumps blood through the heart; smooth muscle moves the contents of viscera, vessels, and glands, and also moves the hair on skin.

The **cardiovascular system** consists of the four-chambered heart; arteries conducting blood to the tissues; capillaries through which nutrients, gases, and molecular material pass to and from the tissues; and veins returning blood from the tissues to the heart.

The **lymphatic system** is a system of vessels assisting the veins in recovering the body's tissue fluids and returning them to the heart. Lymph nodes filter lymph throughout the body.

The **nervous system** consists of impulse-generating/-conducting tissue organized into a central nervous system (brain and spinal cord) and a peripheral nervous system (nerves). The peripheral nervous system includes the visceral (autonomic) nervous system, which is involved in involuntary "fight or flight" and vegetative functions.

The **endocrine system** consists of glands that secrete chemical agents (hormones) into the tissue fluids and blood, affecting the function of multiple areas of the body—not the least of which is the brain. Hormones help maintain balanced metabolic functions in many of the body's systems.

The **integumentary system** consists of the skin, which is provided with many glands, sensory receptors, vessels, immune cells, antibodies, and layers of cells and keratin that resist environmental factors harmful to the body.

CN: It is important to use very light colors for this page and the next to retain the details of the illustrated body systems. For future reference, try to impress yourself with an overall general image of each system, without specific details. (1) For realism, color the muscular system, B, brown; lymphatic, E, green; nervous, F, yellow; endocrine, G, orange; and integumentary, H, the color of your own skin. (2) The cardiovascular system's name remains uncolored; arteries, C, and veins, D, are to be colored red and blue, respectively. (3) Apply variations of red and blue for the smallest vessels.

SKELETAL A
ARTICULAR A'
MUSCULAR B
CARDIOVASCULAR
ARTERIES C
VEINS D
LYMPHATIC E
NERVOUS F
ENDOCRINE G
INTEGUMENTARY H

Skull

A / A'

Joint capsule

Rib cage

Vertebral column

Pelvis

Ligament

Heart muscle

Heart

Vein

Artery

Smooth B muscle of viscus

Thoracic duct

Lymph node

Lymph vessel

Cisterna chyli

Brain

Nerve

Spinal cord

Cauda equina

Pineal

Hypophysis

Thyroid

Thymus

Adrenal

Islets

Ovary

Testis

The **respiratory system** consists of the upper (nose through larynx) and lower respiratory tract (trachea through the air spaces of the lungs). Most of the tract is airway; only the air spaces (alveoli) and very small bronchioles exchange gases between alveoli and the lung capillaries.

The **digestive system** consists of an alimentary canal and glands. It performs the breakdown, digestion, and assimilation of food as well as excretion of the residua. Glands include the liver, the pancreas, and the biliary system (gallbladder and related ducts).

The **urinary system** is responsible for the conservation of water and maintenance of a neutral acid–base balance in the body fluids. The kidneys are the main functionaries of this system; residual fluid (urine) is excreted through ureters to the urinary bladder for retention and discharged to the outside through the urethra.

The **immune/lymphoid system** consists of multiple organs involved in body defense. This system includes a diffuse arrangement of immune-related cells throughout the body; these cells resist invasive microorganisms and remove damaged or otherwise abnormal cells.

The **female reproductive system** secretes sex hormones, produces and transports germ cells (ova), receives and transports male germ cells to the fertilization site, maintains the developing embryo/fetus, and sustains the fetus until birth.

The **male reproductive system** secretes male sex hormones, forms and maintains germ cells (sperm), and transports germ cells to the female genital tract.

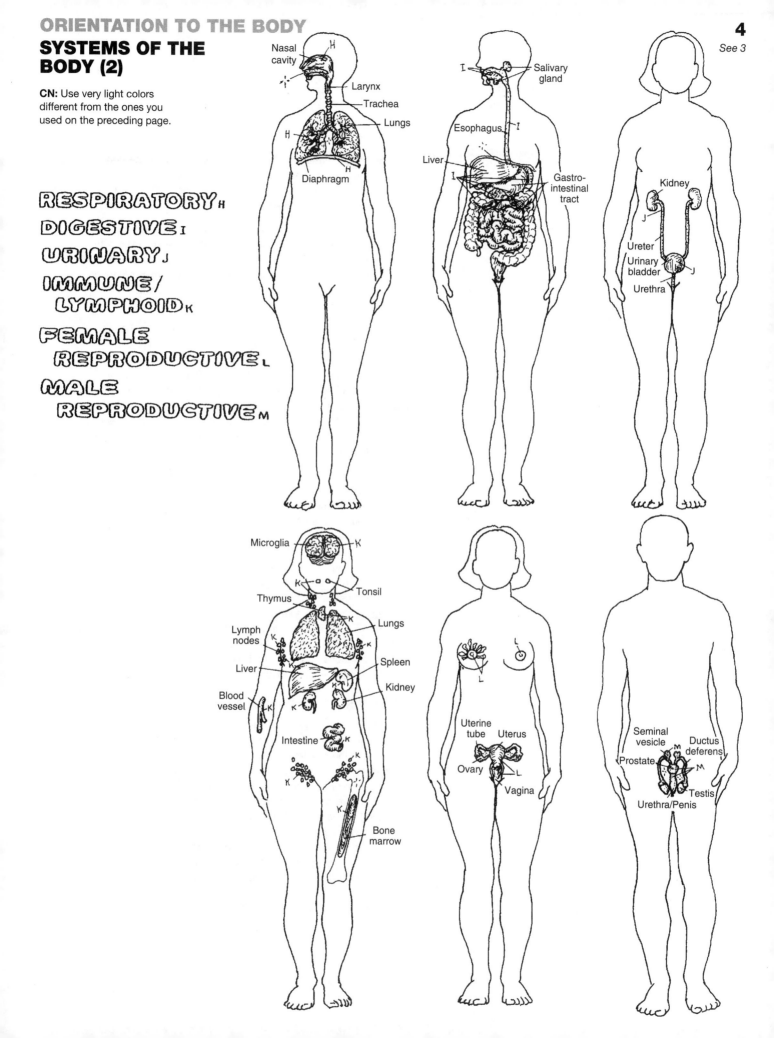

SYSTEMS OF THE BODY (2)

CN: Use very light colors different from the ones you used on the preceding page.

RESPIRATORY H
DIGESTIVE I
URINARY J
IMMUNE / LYMPHOID K
FEMALE REPRODUCTIVE L
MALE REPRODUCTIVE M

CLOSED BODY CAVITIES

Closed body cavities are not open to the outside of the body. Though organs may pass through them or exist in them, their cavities do not open into these closed cavities. Closed body cavities are lined with a membrane.

The **cranial cavity** is occupied by the brain and its coverings, cranial nerves, and blood vessels (page 68). The **vertebral cavity** houses the spinal cord, its coverings, related vessels, and nerve roots (page 77). Both cavities are lined by the **dura mater**, a tough, fibrous membrane. The dura mater of the vertebral cavity is continuous with the cranial dura at the foramen magnum.

The **thoracic cavity** contains the lungs, heart, and neighboring structures in the chest. Its skeletal walls are the thoracic vertebrae and ribs posteriorly, the ribs anterolaterally, and the sternum and costal cartilages anteriorly (page 28). The roof of the cavity is membranous; the floor is the muscular thoracic diaphragm (page 48). The middle of the thoracic cavity, called the *mediastinum* (page 103), is a partition packed with structures (e.g., heart). It separates the thoracic cavity into discrete left and right parts that are lined with **pleura** and contain the lungs.

The **abdominopelvic cavity**, containing the gastrointestinal tract and related glands, the urinary tract, and great numbers of vessels and nerves, has muscular walls anterolaterally (page 49), the lower ribs and muscle laterally, and the lumbar and sacral vertebrae and muscles posteriorly (page 48). The roof of the abdominal cavity is the thoracic diaphragm. The abdominal and pelvic cavities are continuous with one another. The pelvic cavity, containing the urinary bladder, rectum, reproductive organs, and lower gastrointestinal tract, has muscular walls anteriorly, bony walls laterally, and the sacrum posteriorly. The internal surface of the abdominal wall is lined by a serous membrane, the **peritoneum**, that is continuous with the outer membrane of the abdominal viscera (page 138). The serous secretions enable the mobile abdominal viscera to slip and slide frictionlessly during movement.

OPEN VISCERAL CAVITIES

Open visceral cavities are largely tubular passageways (tracts) of visceral organs that open to the outside of the body (page 14), and include the **respiratory tract**, open at the nose and mouth, the **digestive tract** that opens at both the mouth and the anus, and the **urinary tract** that opens in the perineum at the urethral orifices. These cavities are lined with a mucus-secreting layer (**mucosa**) that is the working tissue of open cavities (providing secretion, absorption, and protection). The mucosa is lined with epithelial cells, and supported by a vascular connective tissue layer and a smooth muscle layer. The male genital tract (not shown) opens into the lower urinary tract. The female genital tract (not shown) opens into the perineum by way of the vagina. Both tracts are lined with mucosae. See pages 157 and 158.

ORIENTATION TO THE BODY
CAVITIES & LININGS

CN: Use light colors for the cavities A–D and slightly darker shades of the same color for the linings A¹–D¹. (1) Start with the names and color A in the upper two drawings, and complete both sides before going on to B, C, and D. (2) Color the names and open visceral cavities in the lower part of the page. Note that the inner lining, H, is the same color throughout; pick a bright color for it.

CLOSED BODY CAVITIES

CRANIAL A
 DURA MATER A'
VERTEBRAL B
 DURA MATER B'
THORACIC C
 PLEURA C'
ABDOMINOPELVIC D
 PERITONEUM D'

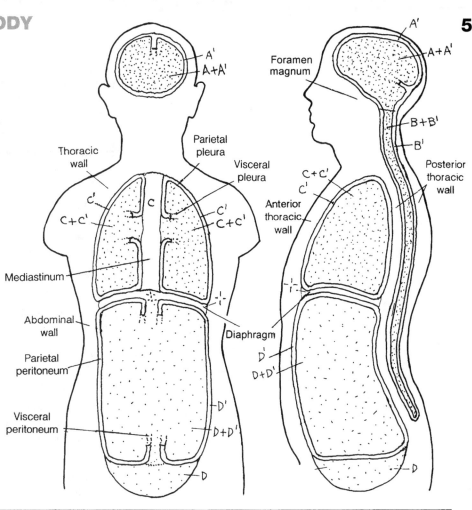

OPEN VISCERAL CAVITIES

RESPIRATORY TRACT E
URINARY TRACT F
DIGESTIVE TRACT G
MUCOSA H

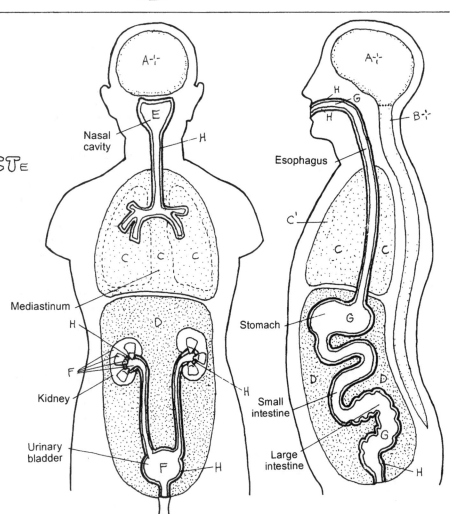

The *cell* is the basic unit of living structure in the human organism. A body structure more complex than a cell is a collection of cells (tissues, organs) and their products. The activities of cells constitute the life process. What basic life processes are you aware of in the 10 trillion cells of your own body?

Cell organelles: "little organs"; the collection of membrane-bound functional structures in the cell, including the nucleus, mitochondria, and so on.

Cell membrane: the limiting lipoprotein membrane of the cell. It retains internal structure and permits exportation and importation of materials by infolding/outfolding, as in the formation of pseudopods by white blood cells.

Nuclear membrane: porous, limiting lipoprotein membrane; regulates passage of molecules into and from the nucleus.

Nucleoplasm: the nuclear substance containing chromatin and RNA.

Nucleolus: a mass of largely RNA; it forms ribosomal RNA (RNAr) that passes into the cytoplasm and becomes the site of protein synthesis.

Cytoplasm: the ground substance of the cell excluding the nucleus. Contains the organelles and inclusions (membrane-free collections of lipids, glycogen, and pigments).

Smooth/rough endoplasmic reticulum (ER): convoluted, membrane-lined tubules to which ribosomes may be attached (rough ER: flattened) or not. Smooth ER is abundant in cells that synthesize steroids (lipids), such as the liver. It stores calcium ions in muscle.

Ribosomes: the site of protein synthesis, where amino acids are strung in sequence as directed by messenger RNA from the nucleus.

Golgi complex: flattened membrane-lined sacs that bud off small vesicles from the edges of the complex; collects secretory products and packages them for use or export.

Mitochondrion: membranous, oblong structure in which the inner membrane is convoluted like a maze and on which a complex series of reactions take place between oxygen and products of digestion, providing energy for cell operations.

Vacuoles: membrane-lined transport vehicles that can merge with one another or other membrane-lined structures (e.g., cell membrane, lysosomes).

Lysosomes: membrane-lined vats of enzymes (proteins) with capacity to digest microorganisms, damaged cell parts, and ingested nutrients.

Centriole: barrel-shaped bundle of microtubules located near the nucleus in the cell center (*centrosome*); usually paired and perpendicular to one another. Centrioles from spindles are used by migrating chromatids during cell division.

Microtubules: part of the cytoskeleton; radiate from the centrosome; provide structural and motive support for organelles.

Microfilaments: actin filaments involved in membrane alteration for endo- and exocytosis and formation of pseudopods.

THE GENERALIZED CELL

CN: Color gray the variety of cell shapes at upper left. Use the lightest colors for A, C, D, F, and G. (1) Small circles representing ribosomes, H, are found throughout the cytoplasm, F, and on the rough endoplasmic reticulum, G^1; color those entire larger areas, including the ribosomes, first, and then color over the ribosomes again with a darker color.

CELL SHAPES

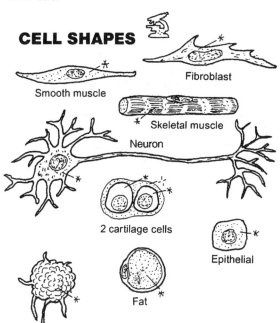

Fibroblast

Smooth muscle

Skeletal muscle

Neuron

2 cartilage cells

Epithelial

Fat

White blood

ORGANELLES

CELL MEMBRANE A
ENDOCYTOSIS B
EXOCYTOSIS B'
NUCLEAR MEMBRANE C
NUCLEOPLASM D
NUCLEOLUS E
CYTOPLASM F
ENDOPLASMIC RETICULUM
SMOOTH G ROUGH G'
RIBOSOME H
GOLGI COMPLEX I
MITOCHONDRION J
VACUOLE K
LYSOSOME L
CENTRIOLE M
MICROTUBULE N
MICROFILAMENT N'

GENERALIZED CELL

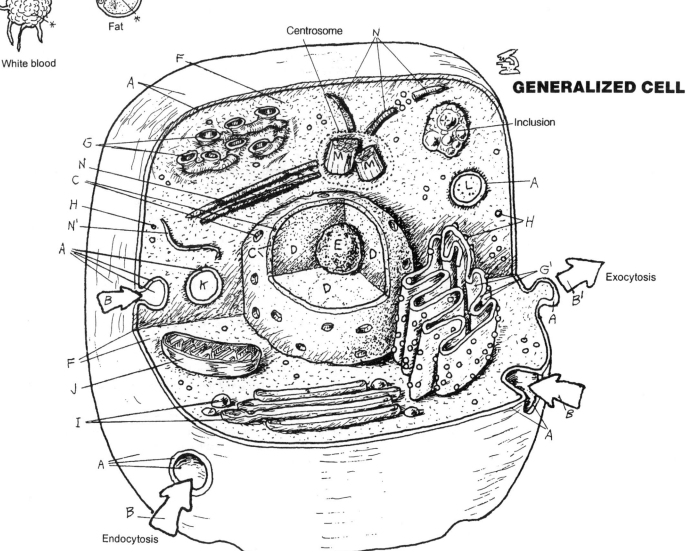

Centrosome

Inclusion

Exocytosis

Endocytosis

The ability to reproduce their kind is a characteristic of living things. Cells reproduce in a process of duplication and division called **mitosis**. In the proverbial nutshell, nuclear **chromatin** (a diffuse network of DNA and related protein), once duplicated, transforms into 46 **chromosomes**, which divide into paired subunits (92 **chromatids**); those chromatids separate and move into opposite ends of the dividing cell, forming the 46 chromosomes of each of the newly formed **daughter cells**. For clarity, we show only four pairs of chromatids and chromosomes.

Interphase: the phase between successive divisions; the longest period of the reproductive cycle. Duplication of DNA (in chromatin) occurs during this phase. The dispersed chromatin (D*) is a network of fine fibrils, not visible as discrete entities in the nucleoplasm. The nucleus and **nucleolus** are intact. The paired centrioles divide in the centrosome.

Prophase: the dispersed chromatin (D*) thickens, shortens, and coils to form condensed chromatin chromosomes (D^{1*}). Each chromosome consists of two chromatids (E and F) connected by a centromere (G). Each chromatid has the equivalent amount of DNA of a chromosome. In prophase, the nuclear membrane and nucleolus break up/dissolve. The centrioles separate and migrate to opposite poles of the cell where they project microtubules (**spindle** fibers) called **asters**. **Kinetochores** (G^1) form on the **centromeres**.

Metaphase: strands of microtubules develop across the cell center from paired centrioles. The chromatids attach to the spindle fibers at the centromere and line up in the center of the cell, half (46 chromatids) on one side, half on the other.

Anaphase: activated daughter centromeres (G^1; kinetochores), each attached to one chromatid, move to the ipsilateral pole of the cell along the spindle fiber, taking their chromatids with them. The separated chromatids constitute chromosomes. Anaphase ends when the daughter chromosomes arrive at their respective poles (46 on each side).

Telophase: the cell pinches off in the center, forming two daughter cells, each identical to the mother cell (assuming no mutations). The cytoplasm and organelles, having duplicated earlier, are segregated into their respective newly forming cells. As the nucleus is reconstituted, and the **nuclear membrane** and nucleolus reappear in each new cell, the chromosomes fade into dispersed chromatin, and the centromere disappears. Complete cleavage of the parent cell into daughter cells, each with identical cellular content, terminates the mitotic process. Each daughter cell enters interphase to start the process anew.

CELL DIVISION / MITOSIS

CN: Use the colors you used on the preceding page for A, B, C, and H for those names on this page. Use contrasting colors for E–E² and F–F²; use gray for D–D¹. (1) Begin with the cell in interphase. (2) Color the name of each stage and its appropriate arrow of progression. Note that the starting chromatin, D* in interphase, is colored differently in the daughter cells, E², F²; nevertheless, it is the same chromatin.

CELL MEMBRANE ᴀ
NUCLEAR MEMBRANE ʙ
NUCLEOLUS ᴄ
CHROMATIN ᴅ*
 CHROMOSOME ᴅ'*
CHROMATID ᴇ
 CHROMOSOME ᴇ'
 CHROMATIN ᴇ²
CHROMATID ꜰ
 CHROMOSOME ꜰ'
 CHROMATIN ꜰ²
CENTROMERE ɢ
 KINETOCHORE ɢ'
CENTRIOLE ʜ
ASTER ɪ
SPINDLE ᴊ

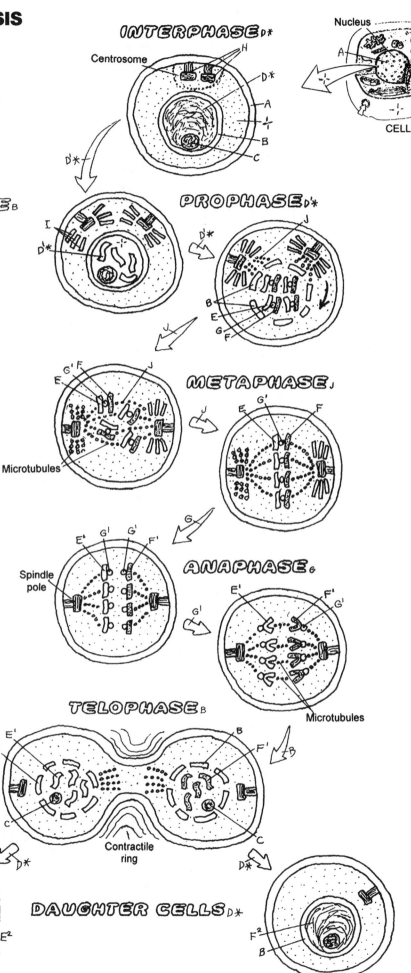

INTERPHASE ᴅ*

Nucleus

CELL

Centrosome

PROPHASE ᴅ*

METAPHASE ᴊ

Microtubules

ANAPHASE ɢ

Spindle pole

Microtubules

TELOPHASE ʙ

Contractile ring

DAUGHTER CELLS ᴅ*

Epithelial tissues, one of four basic tissue types, form the working surface of skin and all body cavities, including glands, ducts, and vessels. They protect, secrete and absorb. They are sensitive; some even contract (myoepithelia). Epithelial cells are connected by one or more cell junctions; the lowest layer of epithelia in a tissue is bound to the underlying connective tissue by a basement membrane.

SIMPLE EPITHELIA

This surface tissue functions in filtration, diffusion, secretion, and absorption. **Simple epithelia** line air cells, blood and lymphatic vessels, glands, body cavity membranes, and viscera.

Simple squamous epithelia are thin, plate-like cells. They function in diffusion. They line the heart, all blood and lymphatic vessels, air cells, body cavities, and glomeruli in the urinary tract.

Simple cuboidal epithelia are generally secretory cells and make up glands throughout the body, tubules of the kidney, and terminal bronchioles of the lungs.

Simple columnar epithelia line the gastrointestinal tract and are concerned with secretion and absorption. Their free (apical) surface may be covered with finger-like projections of cell membrane (microvilli), increasing the cell's surface area for secretion/absorption.

The cells of **pseudostratified columnar epithelia**, bunched together in a single layer, appear stratified but are not; each cell is attached to the basement membrane. These cells line reproductive and respiratory tracts. Cilia on the free surface collectively move surface material by means of undulating power strokes alternating with resting strokes.

STRATIFIED EPITHELIA

Stratified epithelial tissue is characterized by more than one layer of cells.

This tissue of multiple layers is named for the flat (**squamous**) cells on the tissue surface. They may be keratinized (skin) or not (oral cavity, esophagus, etc). Basal cells are generally columnar and germinating. **Stratified** epithelia are resistant to damage from wear and tear due to the ready replacement of cells.

The lining tissue of the excretory passageways of the urinary tract, **transitional stratified epithelia** consist of variable layers of cells that have the capacity to stretch thin or contract in response to changing volumes of urine.

GLANDULAR EPITHELIA

Glandular cells produce and secrete/excrete materials of varying composition, such as hormones, sweat, and sebum.

Exocrine glands (e.g., sweat, sebaceous, pancreatic, mammary) arise as outpocketings of epithelial tissue, retain a duct to the free surface of the cavity or skin, and excrete sweat or sebum.

Endocrine glands arise as epithelial outgrowths but lose their connections to the surface during development. They are intimately associated with a dense capillary network into which they secrete their products (e.g., hormones).

TISSUES: EPITHELIAL

CN: Use your lightest colors. (1) Color over all of the cells of the epithelial tissues, but not the basement membranes or fibrous connective tissues. (2) Color the arrows pointing to the locations of the epithelial tissues in various organs of the body.

Blood vessel
Heart cavity

Free surface

Basement membrane
Supporting connective tissue

SIMPLE EPITHELIA
SQUAMOUS A
CUBOIDAL B
COLUMNAR C
PSEUDOSTRATIFIED COLUMNAR D

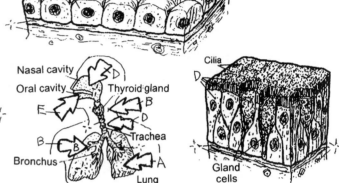

Microvilli

Stomach

Gastrointestinal tract

Nasal cavity
Oral cavity
Thyroid gland
Trachea
Bronchus
Lung

Cilia

Gland cells

STRATIFIED EPITHELIA
STRATIFIED SQUAMOUS E
TRANSITIONAL F

Keratin

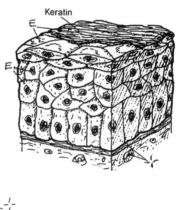

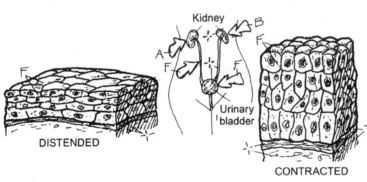

Kidney

Urinary bladder

DISTENDED

CONTRACTED

GLANDULAR EPITHELIA
EXOCRINE G
ENDOCRINE H

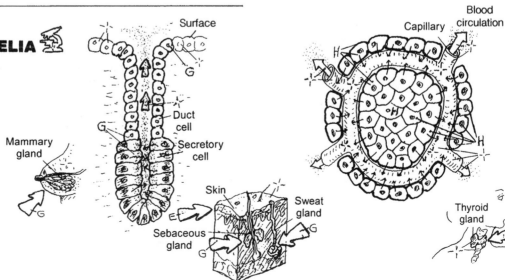

Surface

Duct cell

Secretory cell

Mammary gland

Skin
Sweat gland
Sebaceous gland

Blood circulation
Capillary

Thyroid gland

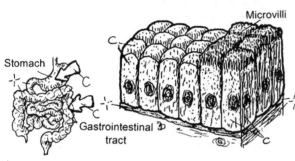

Connective tissue proper consists of variable numbers of cells and fibers, in a viscous matrix, which are collectively concerned with connecting, binding, and supporting body structure. Seen here at about 600x magnification, c.t. proper consists of loose and dense arrangements of fibers. All these fibers are the "packing material" of the body, holding bones together, binding joints and skeletal muscle, and protecting neurovascular structures throughout the body.

Loose, areolar connective tissue is characterized by many cells; a loose, irregular arrangement of fibers; and a moderately viscous fluid matrix. **Fibroblasts** secrete the fibers of this tissue. **Collagen** (linkages of protein exhibiting great tensile strength) and **elastic fibers** (made of the protein elastin) are the main fibrous support elements in this tissue. **Reticular fibers**, a smaller form of collagen, support small cell groups of the blood-forming tissues, the lymphoid tissues, and adipose tissue. Mobile **macrophages** engulf cell debris, foreign matter, and microorganisms in concert with the immune response (page 122). **Fat cells**, which store lipids, may be seen in small or large numbers (adipose tissue). **Plasma cells** secrete antibodies in response to infection (page 121). **Mast cells**, found next to capillaries, are involved in the inflammatory response (page 122) and respond especially in allergic reactions. Other cells may transit the loose fibrous tissues, including white blood cells. The **matrix** is the intercellular **ground substance** in which all of the above cells function. Numerous **capillaries** populate this tissue. Loose connective tissue called *superficial fascia* is also found deep to the epithelial tissues of mucous and serous membranes of hollow organs.

Adipose connective tissue is an aggregation of fat cells supported by reticular and collagenous fibers and closely associated with both blood and lymph capillaries. It serves as a source of fuel, an insulator, and mechanical padding; it also stores fat-soluble vitamins.

Dense regular connective tissue, consisting of parallel-arranged masses of collagenous/elastic fibers, forms ligaments and tendons that are powerfully resistant to axially loaded tension forces, yet permit some stretch. This tissue type contains few cells, largely fibroblasts.

Dense irregular connective tissue consists of irregularly arranged masses of interwoven collagenous (and some elastic) fibers in a viscous matrix. It forms capsules of joints, envelops muscle tissue (deep fasciae), encapsulates certain visceral organs (liver, spleen, and others), and largely makes up the dermis of the skin. This tissue resists impact, contains few cells, and is minimally vascularized.

TISSUES: FIBROUS CONNECTIVE TISSUES

CN: Use yellow for C and C¹ and red for J. We suggest not coloring the matrix, I; however, if you do, use a very light color for it in each of the four drawings, and color I only after the other structures in the frame have been colored. (1) Color the name "Loose, Areolar" above the box at upper left; color the frame and the components within the frame. Repeat with the other three boxes. (2) Color the representative areas where these tissues are found.

CELLS

FIBROBLAST A
MACROPHAGE B
FAT CELL C
PLASMA CELL D
MAST CELL E

FIBERS

COLLAGEN F
ELASTIC G
RETICULAR H

MATRIX, GROUND
SUBSTANCE I

CAPILLARY J

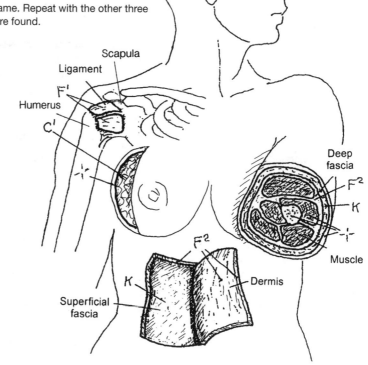

LOOSE, AREOLAR K
CONNECTIVE TISSUE

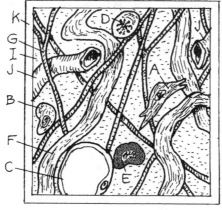

ADIPOSE C¹
CONNECTIVE TISSUE

DENSE REGULAR F¹
CONNECTIVE TISSUE

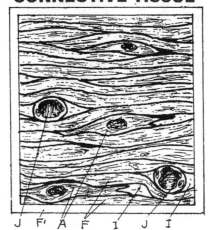

DENSE IRREGULAR F²
CONNECTIVE TISSUE

CARTILAGE

Microscopic sections of **cartilage** tissue reveal cells (**chondrocytes**) in small cavities (**lacunae**) surrounded by a hard but flexible **matrix** of water bound to complex sugar-protein molecules (proteoglycans, glycosaminoglycans or GAG), and **collagen fibers**. This matrix characterizes cartilage. The fibrous component determines the quality of the cartilage: hyaline, elastic, or fibrous. Avascular cartilage receives its nutrition by diffusion from vessels in the perichondrium. Cartilage does not repair well after injury.

Well known as the covering at bone ends (articular cartilage), **hyaline cartilage** is avascular, insensitive, and compressible. Porous, it enhances absorption of nutrients and oxygen. It supports the external nose (feel your nose and compare it with the elastic cartilage of your ear). It is the main structural support of the larynx and much of the lower respiratory tract. It forms the model for most early developing bone (page 18).

Elastic cartilage is essentially hyaline cartilage with **elastic fibers** and some collagen. It supports the external ear and the epiglottis of the larynx. Feel its unique flexibility in your own external ear.

Fibrocartilage consists of dense **fibrous tissue** interspersed with cartilage cells and intercellular matrix. It offers strength with flexibility, resisting both impact and tensile forces. The best example of this tissue is the intervertebral disc.

BONE

Bone is unique for its mineralized matrix (65% mineral. 35% organic by weight). Composed of bone, the skeleton is an anchor for muscles, tendons, and ligaments. It harbors many viscera, assists in the mechanism of respiration, and is a reservoir of calcium. The interior cavity in certain bones is a center of blood cell formation.

Bone has compact and cancellous (spongy) forms (page 17), **Compact bone** is the impact-resistant, weight-bearing shell of bone lined by a sheath of life-supporting fibrous periosteum. Compact bone consists of columns called **haversian systems** or osteons; concentric layers (**lamellae**) of mineralized, collagenous matrix around a central **haversian canal** containing **blood vessels**. **Volkmann's canals** interconnect the haversian canals. Note the interstitial lamellae between columns and the circumferential lamellae enclosing the columns. Between lamellae are small cavities (**lacunae**) interconnected by little canals (**canaliculi**). Bone cells (**osteocytes**) and their multiple extensions fill these spaces, which connect with the haversian canal. In areas of resorbing bone matrix, large, multinucleated, avidly phagocytic **osteoclasts** can be seen with multiple cytoplasmic projections facing the matrix they are destroying. Bone-forming cells (*osteoblasts*; not shown) develop in the periosteum. **Spongy bone** is internal to compact bone and is easily seen at the ends of long bones. It consists of irregularly shaped, interwoven beams (*trabeculae*) of bone, lacking haversian systems.

TISSUES: SUPPORTING CONNECTIVE TISSUES

CN: Use the same colors as you used on the preceding page for collagen, D, elastic fibers, E, and the matrix, C. Use a light tan or yellow for F and red for L. Use light colors for A, B, G, I, and I¹. As before, if you intend to color the matrix, color it last. (1) Complete the section on cartilage before coloring the bone section.

CARTILAGE

CHONDROCYTE A
LACUNA B
MATRIX C
COLLAGEN FIBER D
ELASTIC FIBER E

BONE

BONE F
PERIOSTEUM F'
COMPACT BONE G
HAVERSIAN SYSTEM G'
HAVERSIAN CANAL H
LAMELLAE G'
OSTEOCYTE I
OSTEOCLAST I'
LACUNA B
CANALICULI J
VOLKMAN CANAL K
BLOOD VESSEL L
SPONGY BONE G²

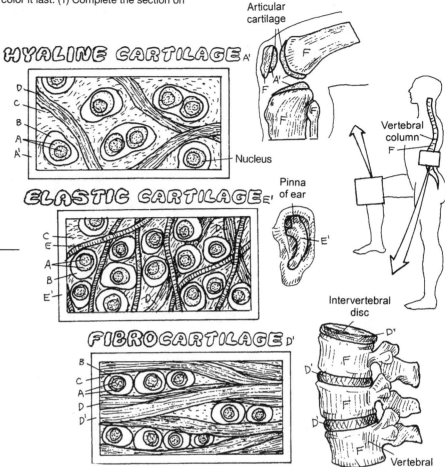

HYALINE CARTILAGE A'

Nucleus

Articular cartilage

Vertebral column F

ELASTIC CARTILAGE E'

Pinna of ear

FIBROCARTILAGE D'

Intervertebral disc

Vertebral body

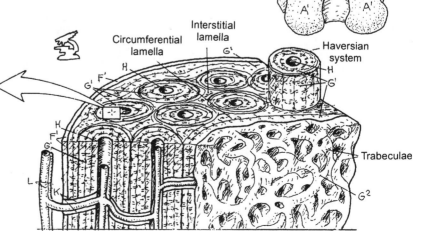

Circumferential lamella

Interstitial lamella

Haversian system

Trabeculae

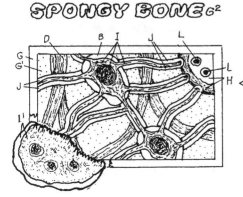

SKELETAL / STRIATED MUSCLE

Skeletal muscle cells are long, striated, and multinucleated, formed of myofibrils, **mitochondria**, and other organelles within the cytoplasm (*sarcoplasm*); each is enveloped in a cell membrane (**sarcolemma**). Collections of muscle cells make up what is called the *belly* (or contractile portion) of a muscle. Skeletal muscles contribute greatly to the shape of the body. Between bony attachments, muscles cross one or more joints, moving them. Muscles always pull; they never push.

Skeletal muscle contractions consist of rapid, brief shortenings, often generating considerable force. Each contracting cell shortens maximally. The contraction of skeletal muscle requires nerves (*innervation*). Without a nerve supply (*denervation*), skeletal muscle cells cease to shorten; without reinnervation (a nerve connection), the cells will die. A denervated portion of muscle loses its tone and becomes flaccid. In time, the entire muscle will atrophy. Muscle contraction is generally under voluntary control, but the brain involuntarily maintains a degree of contraction among the body's skeletal muscles (*muscle tone*). After injury, skeletal muscle cells with moderate functional capabilities can regenerate from myoblasts. Skeletal muscle hypertrophy also occurs in response to training/exercise.

CARDIAC / STRIATED MUSCLE

The **cardiac muscle cells** that make up heart muscle are branched, striated cells with one or two centrally located nuclei and a sarcolemma surrounding the sarcoplasm. They are connected to one another by junctional complexes called **intercalated discs**. Their structure is similar to skeletal muscle cells, but less organized. Cardiac muscle is highly vascularized; its contractions are rhythmic, strong, and well regulated by a special set of impulse-conducting muscle cells rather than nerves. Rates of contraction of cardiac muscle are mediated by the autonomic nervous system.

VISCERAL / SMOOTH MUSCLE

Smooth muscle cells are long, nonstriated, tapered cells with centrally placed nuclei; each cell is surrounded by a cell membrane (**plasmalemma**). The myofilaments intersect with one another in a less organized pattern than skeletal muscle. These muscle cells occupy the walls of visceral organs and serve to propel the contents along the length of those cavities by slow, sustained, often powerful rhythmic contractions (consider menstrual or intestinal cramps). Smooth muscle cells act as gates (*sphincters*) in specific sites, regulating the flow (as in resisting the flow of urine). Well-vascularized smooth muscle fibers contract in response to both autonomic nerves and hormones. They are also capable of spontaneous contraction.

CN: Use red for C and your lightest colors for B, E, G, and I. (1) The sarcolemma, F, which covers each skeletal and cardiac muscle cell, is colored only at the cut ends. The plasmalemma, F¹, which covers each smooth muscle cell, is colored only at the cut ends. (2) The nuclei, A, of cardiac and smooth muscle cells, located deep within the cells, are to be colored only at the cut ends. (3) An intercalated disc, H, of a cardiac cell has been separated to reveal its structure (schematically).

*NUCLEUS*ₐ
*CONNECTIVE TISSUE*ʙ
*CAPILLARY*c
*MITOCHONDRION*ᴅ

SKELETAL / STRIATED MUSCLE

*MUSCLE*ₑ
*CELL*ₑ"
*SARCOLEMMA*_F_

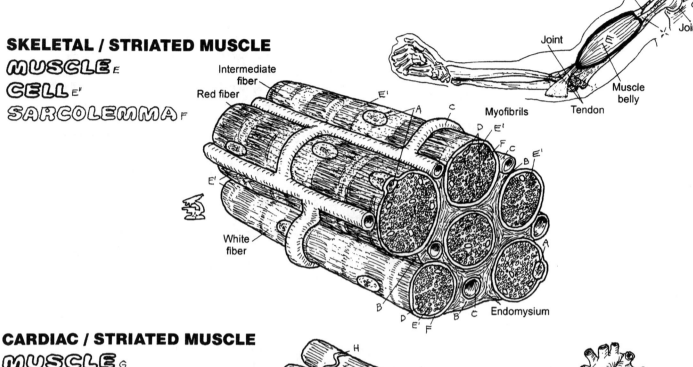

CARDIAC / STRIATED MUSCLE

*MUSCLE*ɢ
*CELL*ɢ'
*INTERCALATED DISC*ₕ

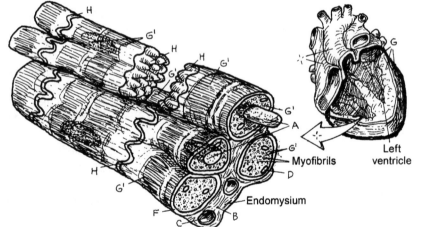

VISCERAL / SMOOTH MUSCLE

*MUSCLE*ᵢ
*CELL*ᵢ'
*PLASMALEMMA*_F¹_

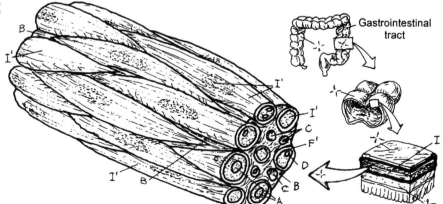

A section of a **skeletal muscle cell** is shown with the **sarcolemma** opened to reveal some cellular contents. The most visible of the contents are the **myofibrils**, the contractile units of the cell. They are enveloped by a flat tubular **sarcoplasmic reticulum** (SR) that, in part, regulates the distribution of calcium ions (Ca++) into the myofibrils. Inward tubular extensions of the sarcolemma, called the **transverse tubule system** (TTS), run transversely across the SR, at the level of the Z lines of the myofibrils. The TTS, containing stores of sodium ions (Na+) and calcium ions (Ca++), conducts electrochemical excitation to the myofibrils from the sarcolemma. **Mitochondria** provide energy for the cell work.

The myofibrils consist of *myofilaments*: **thick filaments** (largely **myosin**) with heads that project outward as *cross bridges* and **thin filaments** (largely **actin**) composed of two interwoven strands. These two filament types are arranged into contractile units, each of which is called a **sarcomere**. Each myofibril consists of several radially arranged sarcomeres. At the end of each sarcomere, the thin filaments are permanently attached to the **Z line**, which separates one sarcomere from the next. The relative arrangement of the thick and thin filaments in the sarcomere creates *light* (I, H) and *dark* (A) *bands/zones* and the **M line**, all of which contribute to the appearance of cross-striations in skeletal and cardiac muscles.

Shortening of a myofibril occurs when the thin filaments slide toward the center (**H zone**), bringing the Z lines closer together in each sarcomere. The filaments do not shorten; the myosin filaments do not move. The close relationship of the TTS to the Z lines suggests that this site is the "trigger area" for induction of the sliding mechanism. This sliding motion is induced by **cross bridges** (heads of the immovable thick filaments) that are connected to the thin filaments. Activated by high-energy bonds from ATP, the paddle-like cross bridges swing in concert toward the H zone, drawing the thin filaments with them. The sarcomere shortens as the opposing thin filaments meet or even overlap at the M line.

Occurring simultaneously in all or most of the myofibrils of a muscle cell, shortening of sarcomeres translates to a variable shortening of the resting length of the muscle cell. Repeated in hundreds of thousands of conditioned muscle cells of a professional athlete, the resultant contractile force can pull a baseball bat through an arc sufficient to send a hardball a hundred meters or more through the air.

CN: Use the same colors used on the preceding page for sarcolemma, A, and mitochondrion, D. Use light colors for G and J, a dark color for H, and very dark colors for F and K. (1) Begin by noting the drawing of the arm, and coloring A in the section of dissected muscle. (2) Color the parts A through H in the muscle cell in the large illustration. (3) Color the parts of the exposed (lowest) myofibril in the large illustration and the color-related letters, bands, lines, and zone. Note that the cut end of this myofibril receives the color E, for identification purposes; it is part of the A band of the sarcomere diagrammed just below. (4) Color the relaxed and contracted sarcomere, the filaments, and the mechanism for contraction, noting the color relationship with the myofibril and its parts.

SKELETAL MUSCLE CELL

SARCOLEMMA A
SARCOPLASMIC RETICULUM B
TRANSVERSE TUBULE SYSTEM C
MITOCHONDRION D

MYOFIBRIL E
 SARCOMERE F
 I BAND G
 THIN FILAMENT (ACTIN) G'
 Z LINE F'
 A BAND H
 THICK FILAMENT (MYOSIN) H'
 CROSS BRIDGE I
 H ZONE J
 M LINE K

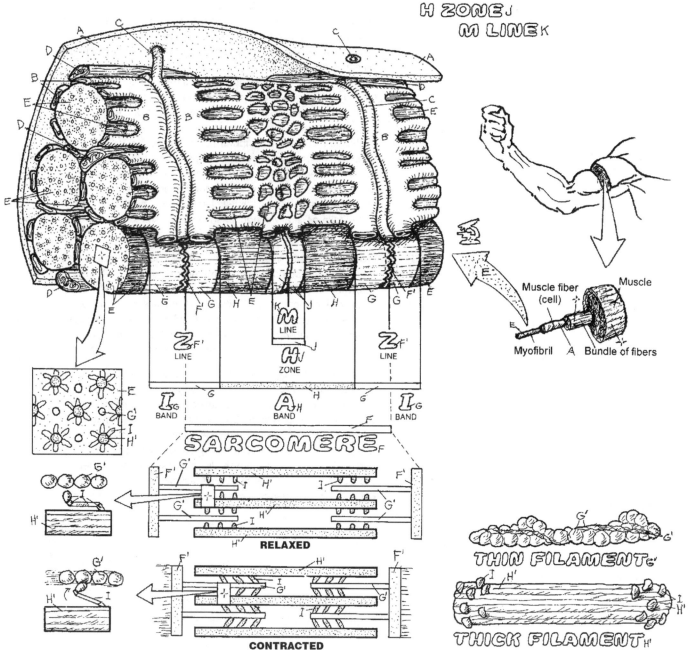

Nervous tissue consists of neurons (nerve cells) and neuroglia. Neurons generate and conduct electrochemical impulses by way of neuronal (cellular) processes. Neuroglia are the supporting, nonimpulse-generating/conducting cells of the nervous system. The main, nucleus-bearing part of the neuron is the **cell body**. Its cytoplasm contains the usual cell organelles. Uniquely, the endoplasmic reticulum occurs in clusters called *Nissl substance*. Neuronal growth consists of migration and arborization of processes. Neurons are the impulse-conducting cells of the brain and spinal cord (**central nervous system, or CNS**) and the spinal and cranial nerves (**peripheral nervous system, or PNS**).

TYPES OF NEURONS

Neurons fall into three structural categories based on numbers of processes (*poles*); unipolar, bipolar, and multipolar. Processes that are highly branched (arborized) and uncovered are called **dendrites**. They bring impulses to the cell body of origin (of which they are a part). Slender, long, minimally branched processes called **axons** conduct impulses away from the cell body of origin. Within each structural category, there is a great variety of shapes and sizes of neurons. **Unipolar** neurons have, or appear to have (pseudounipolar), one branch that splits near its cell body into a central and peripheral process (sensory neuron of the PNS, lower left). Both processes conduct impulses in the same direction, and each is termed an axon. **Bipolar** neurons have two (central and peripheral) processes (also called axons), conducting impulses in the same direction. **Multipolar** neurons have three or more processes, one of which is an axon. Motor neurons send impulses to other neurons or to effectors (skeletal/smooth muscles). Unipolar and bipolar generally conduct sensory impulses.

Most axons are enveloped in one or more (up to 200) layers of an insulating phospholipid (**myelin**) that enhances impulse conduction rates. Myelin is produced by **oligodendrocytes** in the CNS and by **Schwann cells** in the PNS. All axons of the PNS are ensheathed by the cell membranes of Schwann cells (*neurilemma*) but not necessarily myelin. The gaps between Schwann cells are **nodes of Ranvier**, enabling rapid node-to-node impulse conduction. Schwann cells make possible axonal regeneration in the PNS.

Neuroglia exist in both the CNS and PNS (Schwann cells). **Protoplasmic astrocytes** occur primarily in CNS gray matter (dendrites, cell bodies), **fibrous astrocytes** among the myelinated axons of white matter in the CNS. Their processes attach to both neurons and blood vessels and seem to offer metabolic, nutritional, and physical support. They may play a role in the blood–brain barrier. Oligodendrocytes are smaller than astrocytes, have fewer processes, and exist near neurons. **Microglia** are the small scavenger cells (phagocytes) of the brain and spinal cord.

TISSUES: NERVOUS

CN: Use a light color for A. Note the small arrows indicating direction of impulse conduction. The neurons of the peripheral nervous system shown at lower left are illustrated in the orientation of the left upper limb, although highly magnified.

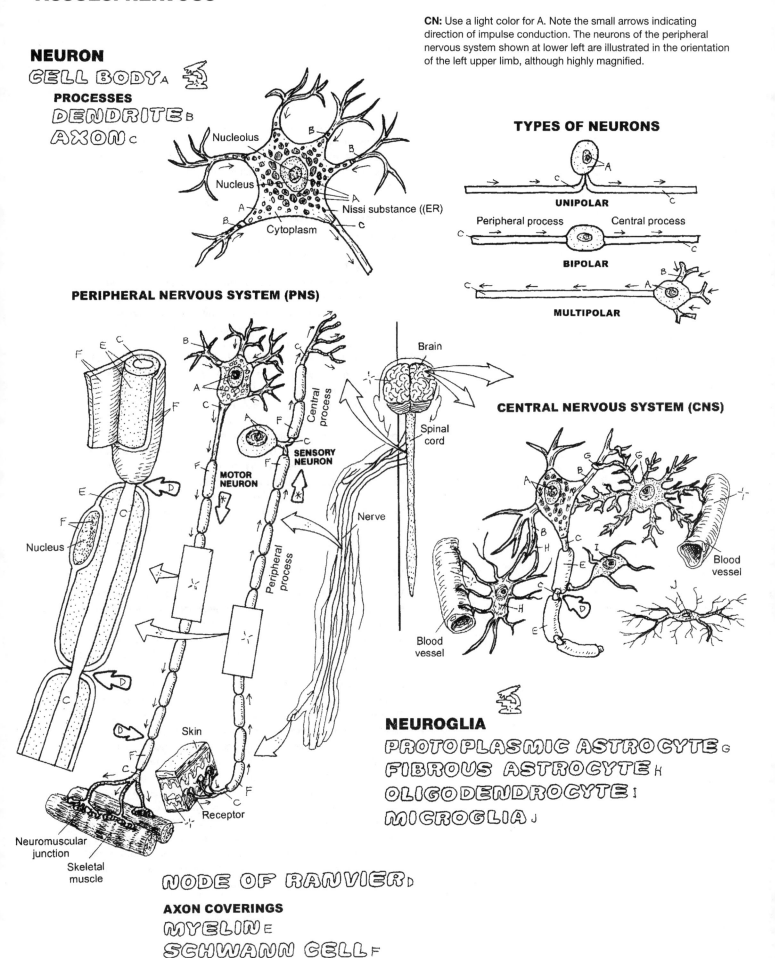

NEURON

CELL BODY A

PROCESSES

DENDRITE B

AXON C

Nucleolus

Nucleus

Nissl substance ((ER)

Cytoplasm

TYPES OF NEURONS

UNIPOLAR

Peripheral process Central process

BIPOLAR

MULTIPOLAR

PERIPHERAL NERVOUS SYSTEM (PNS)

Brain

Spinal cord

Central process

SENSORY NEURON

MOTOR NEURON

Nerve

Nucleus

Peripheral process

CENTRAL NERVOUS SYSTEM (CNS)

Blood vessel

Blood vessel

Skin

Receptor

Neuromuscular junction

Skeletal muscle

NEUROGLIA

PROTOPLASMIC ASTROCYTE G

FIBROUS ASTROCYTE H

OLIGODENDROCYTE I

MICROGLIA J

NODE OF RANVIER D

AXON COVERINGS

MYELIN E

SCHWANN CELL F

There are many variations in the way these four tissues (epithelial, connective, muscle, and nervous) contribute to a discrete construction of the soma (body wall) and the viscera of the body. Here we compare a musculoskeletal structure with the wall of the small intestine.

SOMATIC STRUCTURE

Somatic structure, which refers to the skin-covered musculoskeletal frame of the body, is concerned with stability, movement, and protection. The outermost covering of the body wall is a protective keratinized **stratified squamous epithelial tissue** (epidermis). Other epithelial tissues in somatic structure are the inner layers of blood vessels and the glands (not shown). **Connective tissue** layers of the body wall include the **deep layer of skin** (dermis), consisting of dense, irregular fibrous connective tissue; and the sub-adjacent, variously mobile, subcutaneous **superficial fascia** (loose connective and adipose tissues), containing cutaneous nerves, small vessels, and occasional large veins. **Deep fascia** is a more vascular, sensitive, dense, and irregular fibrous tissue. It ensheathes skeletal muscle (myofascial tissue) as well as the supporting nerves and vessels. **Ligaments** (dense regular connective tissue) bind **bone** to bone by deep insertions into the **periosteum** (vascular, cellular, dense, irregular, fibrous tissue) and the underlying bone (Sharpey's fibers). **Skeletal muscles** and their **nerves** are packaged in groups, separated by slippery septa of deep fascia that also secure neurovascular bundles. The fibrous investments of skeletal muscle converge at the ends of muscles to form tendons that attach and insert into the periosteum much as ligaments do.

VISCERAL STRUCTURE

Visceral structure is generally concerned with absorbing, secreting, trapping, and/or moving food, air, secretions, and/or waste in its cavities. **Epithelial tissue** makes up the surface layer (**mucosal lining**) of the inner visceral wall. Facing the lumen, a single layer of cells may enzymatically break down surface material for absorption; or it may simply provide a mucus-covered surface for transport in conjunction with peristaltic contractions. Secretions from unicellular or multicellular **glands** assist in preparing material for absorption. The **mucosa** includes a subepithelial layer of loose fibrous tissue (**lamina propria**) supporting mobile cells, glands, vessels, and nerves. The deepest layer of the mucosa (when present) is a thin smooth-muscle layer that moves the finger-like projections (villi) of the mucosal surface. Deep to the mucosa is a dense fibrous tissue (**submucosa***)*, replete with large vessels and small nerves/nerve cells supplying the mucosa. Deeper yet, two or three layers of **smooth muscle** (*tunica muscularis*), innervated by local nerve cells, move the intestinal wall in peristaltic contractions. The outermost layer of the gastrointestinal tract is the slippery **serosa**, consisting of an outer secretory simple squamous epithelial layer and an inner supporting layer of light fibrous tissue.

INTEGRATION OF TISSUES

CN: Use light, contrasting colors for A and B, medium brown for C, and yellow for D. Blood and lymph vessels and nerves are not to be colored, as they are composed of multiple tissues. (1) Start with the upper drawing and color it completely before coloring the lower drawing.

SOMATIC STRUCTURE

EPITHELIAL TISSUE

*SKIN (OUTER LAYER)*A

CONNECTIVE TISSUE

*SKIN (DEEP LAYER)*B

*SUPERFICIAL FASCIA*B¹

*DEEP FASCIA*B²

*LIGAMENT*B³

*BONE*B⁴

*PERIOSTEUM*B⁵

MUSCLE TISSUE

*SKELETAL MUSCLE*C

NERVOUS TISSUE

*NERVE*D

VISCERAL STRUCTURE

EPITHELIAL TISSUE

*MUCOSAL LINING*A¹

*GLAND*A²

*SEROSA (OUTER LAYER)*A³

CONNECTIVE TISSUE

*LAMINA PROPRIA*B⁶

*SUBMUCOSA*B⁷

*SEROSA (INNER LAYER)*B⁸

MUSCLE TISSUE

*SMOOTH MUSCLE*C¹

NERVOUS TISSUE

*NERVE CELLS*D¹

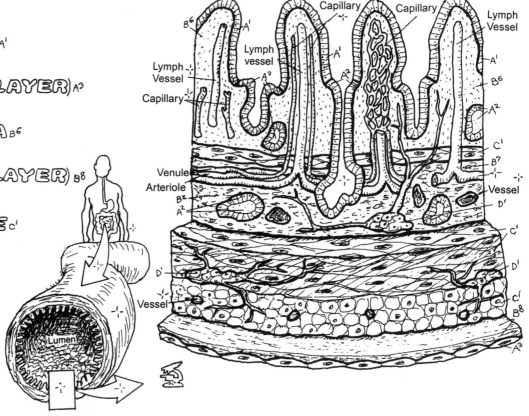

"There is no magician's mantle to compare with the skin in its diverse roles of waterproof, overcoat, sunshade, suit of armor and refrigerator, sensitive to the touch of a feather, to temperature, and to pain, withstanding the wear and tear of three score years and ten, and executing its own running repairs."[1]

The **epidermis** is an avascular, stratified squamous epithelial layer. Because the germinating **stratum basale** is adjacent to the dermis, you will be coloring from the lowest layer up. This single layer of cuboidal-low columnar cells is always mitotically active, being supplied by capillary fluids diffusing through the basement membrane from the subjacent dermis. Their progeny are pushed up into the adjacent **stratum spinosum**, where they appear spiny under the microscopic. As they get further away from the "lunch truck" (capillaries), the cells begin to disintegrate and pick up keratohyalin granules (**keratinocytes**). Moving further away from the basement membrane, these keratinocytes reveal dark-staining granules, thus forming the **stratum granulosum**. Absent capillaries, these outer layers of epithelia receive inadequate nutrition. The outermost **stratum corneum** consists of cells (**corneocytes**) filled with little else but keratin granules and lipids, creating a barrier to hydration below. The outermost layers are sloughed off naturally, assisted by bathing. The **stratum lucidum** is seen in thick, hairless skin and represents another stage of intracellular disintegration.

Melanocytes produce melanin granules that disperse along their cytoplasmic extensions (*dendrites*). These dendrites are woven among the cells of the strata basale and spinosum, and disseminate melanin among the keratinocytes. *Melanin* protects the skin from ultraviolet (UV) radiation. **Merkel cells** are sensors to mechanical deformation (touch) of the surface of the skin, and send related impulses to the accompanying nerve. **Langerhans (dendritic) cells** are seen both in strata basale and spinosum as well as the dermis. These cells are essentially phagocytic and present antigen to T lymphocytes (see page 122).

Nails are plates of compacted, highly keratinized cells of the stratum corneum. They are translucent, revealing a vascular **nail bed** below. The nail bed consists of the strata basale and spinosum only. The proximal part of the nail plate (**nail root**) fits into a groove under the proximal nail fold. The epithelia around the root are the source tissue (A^2) for the nail plate, and they extend from the region of the nail root to the *lunule*. The **nail plate** is lengthened as the epithelia of the **matrix** grow distally.

[1]*Source*: Reprinted by permission from Lockhart, R. D., Hamilton, G. F., and Fyfe, F. W. *Anatomy of the Human Body* (2nd ed.). J.B. Lippincott & Co., Philadelphia, 1959.

CN: Use very light colors throughout. (1) Begin by coloring gray the small block of epidermis at the top of the page. (2) Color the names and strata of epidermis in the larger skin section at upper right. The order of coloring here is unusual; begin coloring with the name of the stratum basale, A, and then color the corresponding layer A. Continue coloring the names and layers B, C, and E in an upward direction, which is also the direction of epidermal growth. (3) The name of the layer stratum lucidum, D, is uncolored because it is seen only in thick, hairless skin. (4) Color the magnified section of epidermis at lower right in the same manner as you did in paragraph 2, using dark gray for the melanocyte and a lighter gray for the Merkel and dendritic cells. Note, but do not color, the vascular dermis below the basement membrane. (5) Color the longitudinal section of the nail plate and its supporting elements at the lower left.

EPIDERMIS

STRATUM CORNEUM E
STRATUM LUCIDUM D ⁛ (Not shown)
STRATUM GRANULOSUM C
STRATUM SPINOSUM B
STRATUM BASALE A

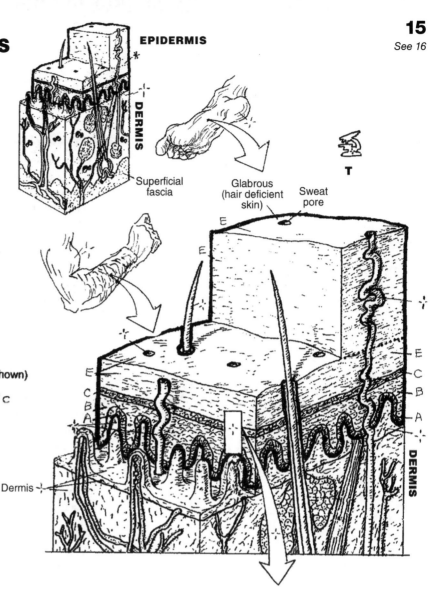

EPIDERMIS

DERMIS

Superficial fascia

Glabrous (hair deficient skin)

Sweat pore

T

Dermis

DERMIS

NAIL

NAIL PLATE F
NAIL ROOT F'
NAIL BED A'
MATRIX A²

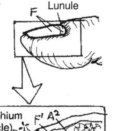

F Lunule

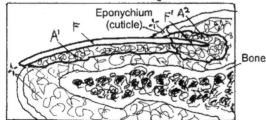

Eponychium (cuticle) F' A²

A' F

Bone

NAIL PLATE & RELATIONS

STRATA OF EPIDERMIS & CONSTITUENTS

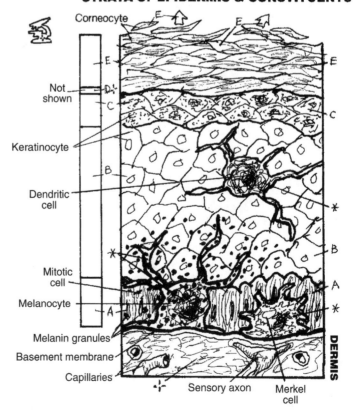

Corneocyte

Not shown

Keratinocyte

Dendritic cell

Mitotic cell

Melanocyte

Melanin granules

Basement membrane

Capillaries

Sensory axon

Merkel cell

DERMIS

The **dermis**, the deeper of the two layers of skin, is characterized by loose connective tissue in the upper 20% (**papillary layer**), with **dermal papillae** protruding into the epidermis without violating the basement membrane (*epidermal-dermal junction*), and a denser irregular reticulated fibrous network in the lower 80%. During development, a number of epidermal derivatives (skin appendages) push into the dermis (hair shafts and hair follicles, sebaceous glands, sweat glands). **Arteries** and **veins** form capillaries that reach into the papillae, along with lymphatic capillaries, **nerves**, and sensory **receptors**. On its deep side, the dermis is bordered by *superficial fascia* (hypodermis, subcutaneous tissue), a loose connective tissue layer with variable amounts of adipose tissue.

Hair shafts rise from epidermal **follicles** pushed down into the dermis/hypodermis of relatively thin skin during development. They are *not* found in thick skin, lips, urogenital orifices, and parts of the hands and feet. The follicle begins where the hair leaves the epidermis and terminates at its base in the form of a bulb. The bulb's base is turned inward (*invaginated*) to accommodate a vascular dermal papilla. Germinating (matrix) cells here contribute to the formation of a hair shaft. The root of the hair begins in the bulb and extends to the point where the hair shaft leaves the skin. Hair shafts are composed of layers of keratin surrounded by layers of follicular cells. An obliquely placed bundle of smooth muscle attaches the outer membrane of the follicle to a dermal papillary peg. This is the **arrector pili muscle**; when it is contracted, the attached hair erects. In many mammals, hair "standing on end" is a sign of increased vigilance.

Sebaceous glands are grape-shaped collections (*acini*) of cells with a common duct that surround hair follicles. The base of each gland is mitotically active; the daughter cells move into the gland center and become filled with lipid. The secretory product and the cell debris constitute *sebum*. The gland duct transports the sebum to the epidermal surface or into the upper hair follicle. Sebum is odorless, coats the skin and hairs, and provides a degree of waterproofing.

Sweat glands are coiled tubular glands in the deep dermis. The ducts of these glands traverse the epidermis by spiraling around the keratinocytes and open onto the surface. Gland cells produce **sweat**, which consists largely of salt water with a dash of urea and other molecules. Sweating provides a degree of cooling by evaporation.

CN: Use red for I, blue for J, green for K, yellow for L, and light colors for the rest.
(1) In the skin section, color the hair shafts, C, and sweat pores, G, in the otherwise uncolored epidermis. (2) Follow the text carefully as you color the enlarged views of the sebaceous glands, E, and sweat glands, G.

DERMIS

PAPILLARY LAYER A (Loose connective tissue)
 DERMAL PAPILLA A'
RETICULAR LAYER B (Dense connective tissue)
 HAIR SHAFT C
 FOLLICLE C'
 ARRECTOR PILI MUSCLE D
 SEBACEOUS GLAND E
 EPITHELIAL CELL E'
 SECRETION F
 BURST EPITHELIAL CELL E²
 SEBUM F+E²
 SWEAT GLAND G
 DUCT EPITHELIUM G'
 GLAND EPITHELIUM G²
 SWEAT H

ARTERY I
VEIN J
LYMPHATIC VESSEL K
NERVE L
 RECEPTOR L'

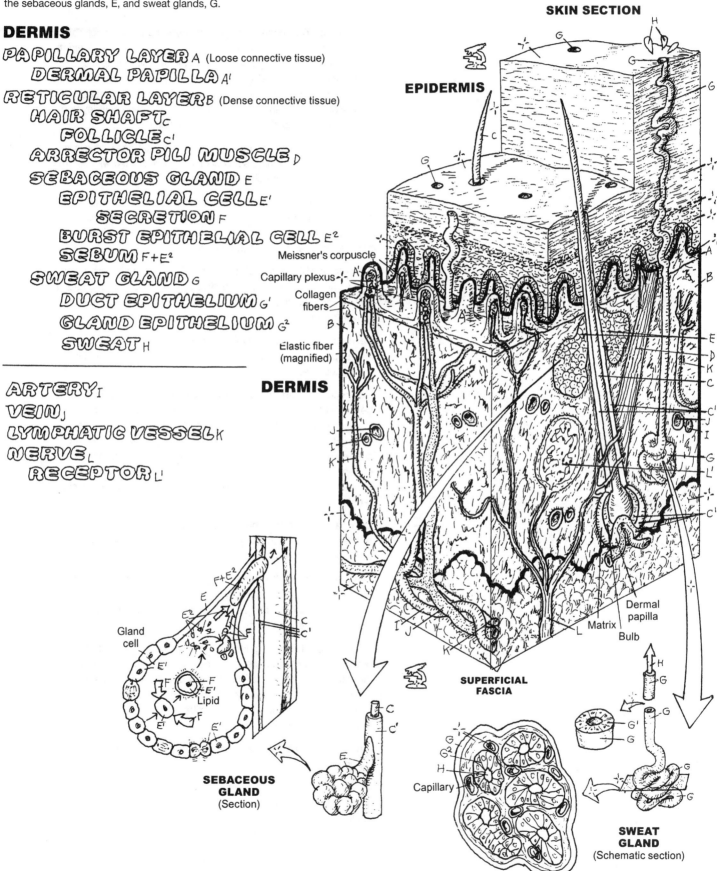

SKIN SECTION

EPIDERMIS

Meissner's corpuscle
Capillary plexus
Collagen fibers
Elastic fiber (magnified)

DERMIS

Dermal papilla
Matrix
Bulb

SUPERFICIAL FASCIA

Gland cell
Lipid

SEBACEOUS GLAND
(Section)

Capillary

SWEAT GLAND
(Schematic section)

Bone is a living, vascular structure, composed of organic tissue and mineral. The organic component (cells, fibers, extracellular matrix, vessels, nerves) makes up about 35% of a bone's weight; 65% of the bone's weight is mineral (calcium hydroxyapatite). Bone functions as (1) a support structure; (2) a site of attachment for skeletal muscle, ligaments, tendons, and joint capsules; (3) a source of calcium; and (4) a significant site of blood cell development. The femur is classified as a **long bone**.

The **epiphysis** is the end of a long bone. The mature epiphysis is largely cancellous bone. Its articulating surface is lined with 3–5 mm of hyaline (articular) cartilage.

The **diaphysis** is the shaft of a long bone. It has a marrow-filled medullary cavity surrounded by compact bone that is lined externally by bone cell-forming periosteum and internally by bone-forming endosteum (not shown).

Articular cartilage is smooth, slippery, porous, malleable, insensitive, and bloodless; it is the only remaining evidence of an adult bone's cartilaginous past. It is the articulating surface in freely movable joints.

Periosteum is a fibrous, cellular, vascular, and highly sensitive life support sheath for bone, providing a source of bone cells throughout life.

Cancellous (spongy) bone consists of interwoven beams (trabeculae) of bone in the epiphyses of long bones, the bodies of the vertebrae, and other bones without cavities. The spaces among the trabeculae are filled with red or yellow marrow (see colorable arrows) and blood vessels. Cancellous bone forms a dynamic latticed truss capable of mechanical alteration in response to the stresses of weight, postural change, and muscle tension.

Compact bone forms the stout walls of the diaphysis and the thinner outer surface of other bones where there is no articular cartilage (e.g., the flat bones of the skull).

The **medullary cavity** is the cavity of the diaphysis. It contains marrow: red in the young, turning to yellow in many long bones in maturity. It is lined by thin connective tissue with many bone-forming cells (*endosteum*).

Red marrow is a red, gelatinous substance composed of red and white blood cells in a variety of developmental forms (*hematopoietic tissue*), and specialized capillaries (*sinusoids*) enmeshed in reticular tissue. In adults, red marrow is generally limited to the sternum, vertebrae, ribs, hip bones, clavicles, long bones, and cranial bones.

Yellow marrow is fatty connective tissue that does not produce blood cells.

The **nutrient artery** is the principal artery and major supplier of oxygen and nutrients to the shaft or body of a bone; its **branches** snake through the labyrinthine canals of the haversian systems and other tubular cavities of bones.

LONG BONE STRUCTURE

CN: Use light blue for C, a tan color for D, very light colors for E and F, yellow for I, and red for J and J[1].
(1) Color the vertical bar to the right, which represents the epiphysis, A, and the diaphysis, B, of the long bone. Then color the parts of the long bone and the small drawing to its left. (2) Leave the medullary cavity, G, uncolored.

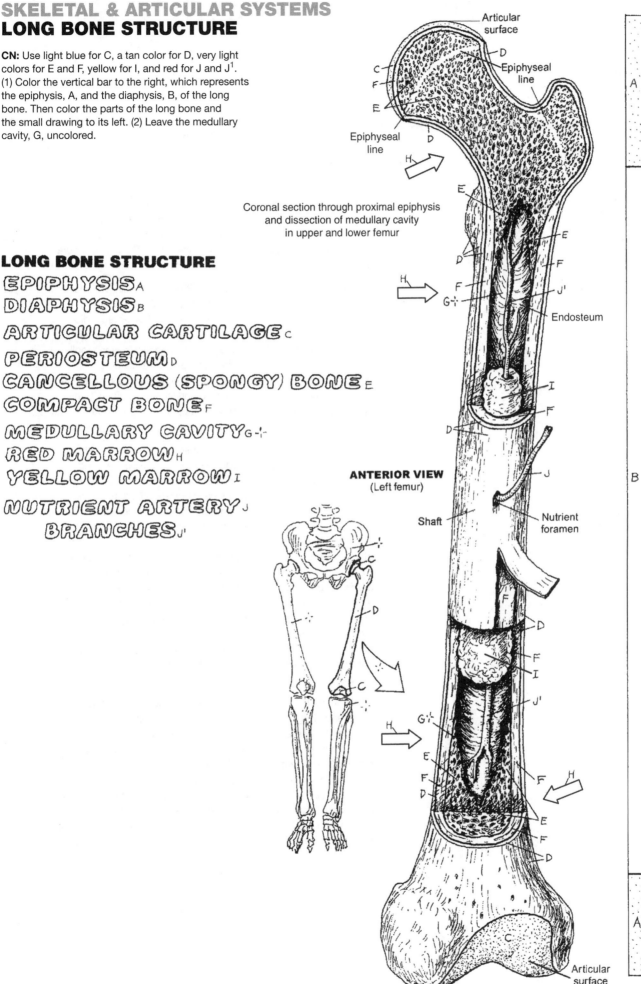

Coronal section through proximal epiphysis and dissection of medullary cavity in upper and lower femur

LONG BONE STRUCTURE

EPIPHYSIS A
DIAPHYSIS B
ARTICULAR CARTILAGE C
PERIOSTEUM D
CANCELLOUS (SPONGY) BONE E
COMPACT BONE F
MEDULLARY CAVITY G
RED MARROW H
YELLOW MARROW I
NUTRIENT ARTERY J
 BRANCHES J[1]

Articular surface

Epiphyseal line

Epiphyseal line

Endosteum

ANTERIOR VIEW
(Left femur)

Shaft

Nutrient foramen

Articular surface

Bone development occurs by intramembranous and/or endochondral ossification. Here we show longitudinal sections of developing long bone, demonstrating both forms of ossification but emphasizing endochondral bone growth.

The endochondral process begins at about 5 weeks after fertilization with formation of cartilage models (bone prototypes) from embryonic connective tissue. Subsequently (over the next 16–25 years), the cartilage is largely replaced by bone (views 2–8). The rate and duration of this process largely determines a person's standing height.

Endochondral ossification begins with a hyaline cartilage model (1). As the cartilage structure grows, its central part dehydrates. The cartilage cells there begin to degenerate: they enlarge, die, and calcify. At the same time, blood vessels bring bone-forming cells (*osteoblasts*) to the waist of the cartilage model, and a collar of bone (2) is formed around the cartilage shaft within the membranous perichondrium. This vascular, cellular, fibrous membrane around the bone collar is now called *periosteum*. The new bone collar (**periosteal bone**) becomes a supporting tubular shaft for the cartilage model with its core of degenerating, calcifying cartilage (3).

Blood vessels from the fibrous periosteum penetrate the bone collar, enter the cartilage model via a *periosteal bud* (4), and proliferate, conducting periosteal osteoblasts into the cartilage model (4). Starting at about 8 weeks post-fertilization, these bone-forming cells line up along peninsulas of calcified cartilage (5) at the extremes of the shaft (**diaphysis**) and secrete new bone (5). The calcified cartilage degenerates and is absorbed into the blood. In this manner, **endochondral bone** replaces calcified cartilage. The two sites of this activity are called *primary centers of ossification*. The direction of growth at these sites is toward the ends of the developing bone. The calcified cartilage and some endochondral bone of the diaphysis are subsequently absorbed, forming the medullary cavity (5). This cavity of the developing tubular bone shaft becomes filled with gelatinous red marrow in the fetus. Productive primary (diaphyseal) centers of ossification are well established at birth.

Beginning in the first few years after birth, *secondary centers of ossification* begin at the epiphyses as blood vessels penetrate the cartilage there (6). The healthy cartilage between the epiphyseal and diaphyseal centers of ossification becomes the **epiphyseal plate** (7). Its growth is responsible for bone lengthening. The gradual replacement of this cartilage by bone cells in the metaphysis (7) thins this plate and ultimately permits fusion of the epiphyseal and diaphyseal ossification centers (8), ending longitudinal bone growth (at 12–20 years of age). Dense areas of bone at the fusion site (**epiphyseal line**) may remain into maturity.

CN: Set aside the colors used for C, F, and E on the preceding page and use them here for hyaline cartilage, A, periosteal bone, B, and endochondral bone, E. Use red for D. (1) Complete each stage before going on to the next. (2) Do not color the periosteum, which appears adjacent to periosteal bone in step 3 and continues to the end. (3) Color the small shapes, E, that appear in the epiphyses and the diaphyses, views 5–8. They represent spongy (cancellous) bone of endochondral origin.

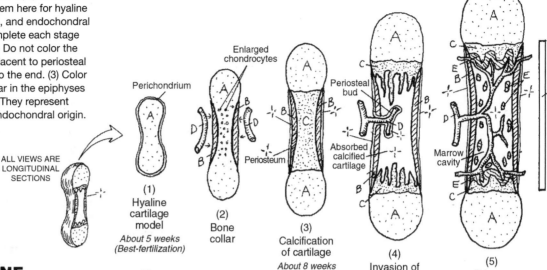

ALL VIEWS ARE LONGITUDINAL SECTIONS

Perichondrium

(1)
Hyaline cartilage model
About 5 weeks (Best-fertilization)

Enlarged chondrocytes

Periosteum

(2)
Bone collar

(3)
Calcification of cartilage
About 8 weeks (Post-fertilization)

Periosteal bud

Absorbed calcified cartilage

(4)
Invasion of periosteal bud

Marrow cavity

(5)
Primary ossification site in diapysis
At birth (38 weeks post-fertilization)

DEVELOPING BONE

HYALINE CARTILAGE A

PERIOSTEAL BONE B

CALCIFIED CARTILAGE C

BLOOD VESSEL D

ENDOCHONDRAL BONE E

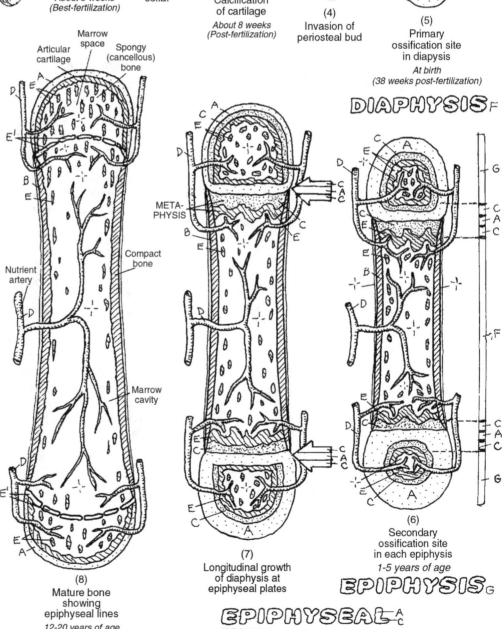

Articular cartilage

Marrow space

Spongy (cancellous) bone

Nutrient artery

Compact bone

Marrow cavity

(8)
Mature bone showing epiphyseal lines
12-20 years of age

EPIPHYSEAL LINE E'

META-PHYSIS

(7)
Longitudinal growth of diaphysis at epiphyseal plates

EPIPHYSEAL (GROWTH) PLATE A/C

DIAPHYSIS F

(6)
Secondary ossification site in each epiphysis
1-5 years of age

EPIPHYSIS G

Redrawn and reproduced, by permission, from Bloom and Fawcett, *A Textbook of Histology* (10th ed.). W.B. Saunders Co., Philadelphia, 1975.

The **axial skeleton**, the principal supportive structure of the body, is oriented along its median longitudinal axis. It includes the skull, vertebrae, sternum, ribs, and hyoid bone. Much of the mobility of the torso is due to the multiple articulations throughout the vertebral column.

The **appendicular skeleton** includes the pectoral and pelvic girdles and the bones of the arms, forearms, wrists, hands, thighs, legs, and feet. The joints of the appendicular skeleton make possible a considerable degree of freedom of movement for the upper and lower limbs. Fractures and dislocations are more common in this part of the skeleton, but often more serious in the axial skeleton.

CLASSIFICATION OF BONES

Bones have a variety of shapes and defy classification by shape; yet such a classification historically exists. **Long bones** are clearly longer in one axis than in another; they are characterized by a medullary cavity, a hollow diaphysis of compact bone, and at least two epiphyses (e.g., femur, phalanx). **Short bones** are roughly cube-shaped; they are predominantly cancellous bone with a thin cortex of compact bone and have no cavity (e.g., carpal and tarsal bones). **Flat bones** (cranial bones, scapulae, ribs) are generally more flat than round. **Irregular bones** (vertebrae) have two or more different shapes. Bones not specifically long or short go into this latter category.

Sesamoid bones are developed in tendons (e.g., patellar tendon); they are mostly bone, often mixed with fibrous tissue and cartilage. They have a cartilaginous articular surface facing an articular surface of an adjacent bone; they may be part of a synovial joint ensheathed within the fibrous joint capsule. The structures are generally pea-sized and are most commonly found in certain tendons/joint capsules in hands and feet, and occasionally in other articular sites of the upper and lower limbs. The largest sesamoid bone is the patella, integrated in the tendon of the quadriceps femoris. Sesamoid bones resist friction and compression, enhance joint movement, and may assist local circulation.

CN: Use light but contrasting colors for A and B. (1) Color the axial skeleton, A, in all three views. Do not color the intercostal spaces between the ribs. (2) Color the darker, outlined appendicular skeleton, B. (3) Color the arrows identifying bone shape/classification.

AXIAL SKELETON A
APPENDICULAR SKELETON B

CLASSIFICATION OF BONES

LONG C
SHORT D
FLAT E
IRREGULAR F
SESAMOID G

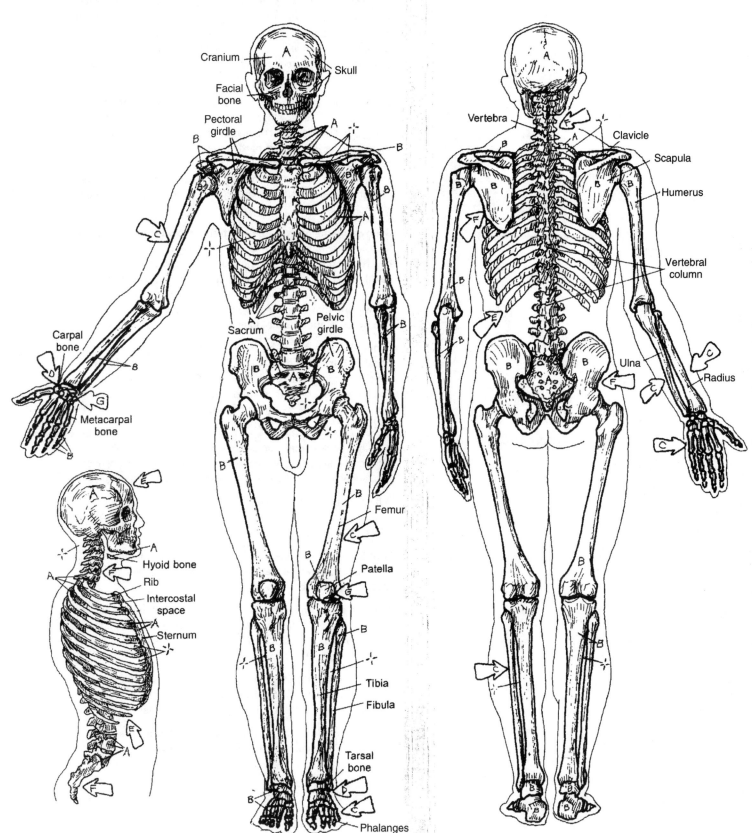

Cranium
Skull
Facial bone
Pectoral girdle
Carpal bone
Metacarpal bone
Sacrum
Pelvic girdle
Hyoid bone
Rib
Intercostal space
Sternum
Femur
Patella
Tibia
Fibula
Tarsal bone
Phalanges
Vertebra
Clavicle
Scapula
Humerus
Vertebral column
Ulna
Radius

Bones are connected at **joints** (*articulations*). All bones move at joints. Joints are functionally classified as immovable (*synarthroses*), partly movable (*amphiarthroses*), or freely movable (*diarthroses*). Structural classification of freely movable joints can be seen below.

Fibrous joints (*synarthroses*) are those in which the articulating bones are connected by fibrous tissue. Sutures of the skull are essentially **immovable** fibrous joints, especially after having ossified with age. Teeth in their sockets are fixed fibrous joints (*gomphoses*). *Syndesmoses* are **partly movable** fibrous joints, such as the interosseous ligaments between bones of the forearm or the bones of the leg.

Cartilaginous joints (*synchondroses*) are essentially **immovable joints** seen during growth, such as growth (epiphyseal) plates, and the joint between the first rib and the sternum. Fibrocartilaginous joints (*amphiarthroses*) are **partly movable** (e.g., the intervertebral disc, and a part of the sacroiliac joint). Symphyses also are partly movable fibrocarlilagious joints, such as between the pubic bones (symphysis pubis) and the manubrium and the body of the sternum (sternal angle).

Synovial joints (*diarthroses*) are **freely movable** within ligamentous limits and the bony architecture. They are characterized by **articulating bones** whose ends are capped with **articular cartilage** and are enclosed in a ligament-reinforced, sensitive, fibrous (**joint**) **capsule** lined internally with a vascular **synovial membrane** that secretes a lubricating fluid within the cavity. The **synovial membrane** does not cover articular cartilage.

Synovial or serous fluid-secreting membranes line fibrous tissue pockets (**bursa(e)** that exist throughout the body wherever there are areas of frictional contact between two adjacent structures). These sacs facilitate irritation-free movement. Often associated with synovial joints, several are associated with the hip, shoulder, and knee joints, to mention but a few.

Ball-and-socket joints are best seen at the hip and shoulder. Movements in all direction are permitted: flexion, extension, adduction, abduction, internal and external rotation, and circumduction.

A **hinge joint** permits movement in only one plane: flexion/extension. The ankle, interphalangeal, and elbow (humeroulnar) joints are hinge joints.

A **saddle** (sellar) **joint** (e.g., carpometacarpal joint at the base of the thumb) has two concave articulating surfaces, permitting all motions but rotation.

The **ellipsoid** (condyloid, condylar) **joint** is a reduced ball-and-socket configuration in which significant rotation is largely excluded (e.g., the bicondylar knee, temporomandibular, and radiocarpal (wrist) joints).

A **pivot joint** has a ring of bone around a peg; for example, the C1 vertebra rotates about the dens of C2, a rounded humeral capitulum on which the radial head pivots (rotates).

Gliding joints (e.g., the facet joints of the vertebrae, the acromioclavicular, intercarpal, and intertarsal joints) generally have flat articulating surfaces.

CN: Use a light blue for D, black for F, and gray for H.
(1) Do not color the bones in the upper half of the page.
(2) Below, color the arrows pointing to the location of
the joints as well as the joint representations.

CARTILAGINOUS JOINT
IMMOVABLE B
PARTLY MOVABLE B'

FIBROUS JOINT
IMMOVABLE A
PARTLY MOVABLE A'

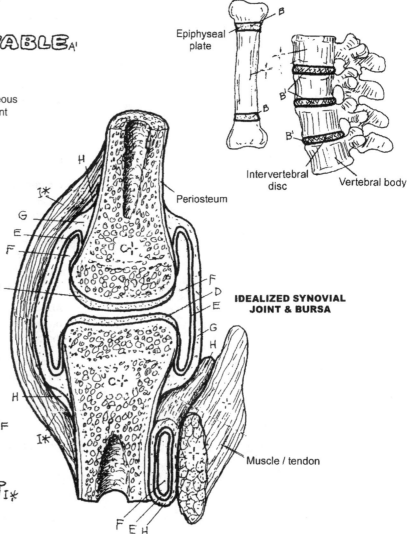

Suture
A

Interosseous
ligament
A'

Epiphyseal
plate

B

B'

B

B'

Intervertebral
disc

Vertebral body

Periosteum

IDEALIZED SYNOVIAL
JOINT & BURSA

Muscle / tendon

SYNOVIAL JOINT
(Freely movable)

ARTICULATING BONES C
ARTICULAR CARTILAGE D
SYNOVIAL MEMBRANE E
SYNOVIAL CAVITY (FLUID) F
JOINT CAPSULE G
BURSA H
COLLATERAL LIGAMENT I*

TYPES OF SYNOVIAL JOINTS

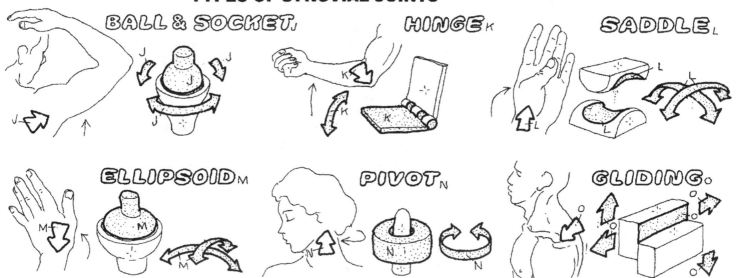

BALL & SOCKET J
HINGE K
SADDLE L
ELLIPSOID M
PIVOT N
GLIDING O

Movements of bones occur at joints. Terms of movement are therefore applicable to joints, not bones (e.g., flexing bones tends to break them!). Ranges of motion are limited by the bony architecture of a joint, related ligaments, and the muscles crossing that joint. Specific directions of movement can be clearly delineated, and ranges of motion measured, by reference to the anatomical position.

Extension of a joint generally means straightening it. In the anatomical position, most joints are in relaxed extension (neutral). In relation to the anatomical position, movements of extension are directed in the sagittal plane. Extreme, even abnormal extension is called *hyperextension*. At the ankle and wrist joints, extension is termed **dorsiflexion**.

Flexion of a joint is to bend it or decrease the angle between the bones of the joint. Movements of flexion are in the sagittal plane. At the ankle joint, flexion is also called **plantar flexion**.

Adduction of a joint moves a bone toward the midline of the body (or, in the case of the fingers or toes, toward the midline of the hand or foot). In relation to the anatomical position, movements of adduction are directed in the coronal plane.

Abduction of a joint moves a bone away from the midline of the body (or hand or foot). Movements of abduction are directed in the coronal plane.

Circumduction is a circular movement, permitted at ball and socket, condylar, and saddle joints. Circumduction is characterized by flexion, abduction, extension, and adduction of the joint done in sequence.

Rotation of a joint is to turn the moving bone about its axis. Rotation of a limb toward the body is *internal* or *medial rotation*; rotation of the limb away from the body is *external* or *lateral rotation*.

Supination is external rotation of the radiohumeral joint in which the hand and wrist are turned palm up. In the foot, supination of the subtalar (talocalcaneal) joint and the transverse tarsal joints (talonavicular and calcaneocuboid joints; see page 40) moves the sole of the foot in a medial direction.

Pronation is internal rotation of the radiohumeral joint in which the hand and wrist are turned palm down. In the foot, pronation of the subtalar and transverse tarsal joints rotates the foot in a lateral direction.

Inversion turns the sole of the foot inward, elevating its medial border, as a result of supination at the subtalar and transverse tarsal joints and adduction of the forefoot. See Glossary.

Eversion turns the sole of the foot outward, elevating its lateral border as a result of subtalar and transverse tarsal joint pronation and forefoot abduction.

CN: Observe the side view anatomical position of the body centered between the figures above with flexed joints C and D and extended joints A and B. (1) Color the listed items of movement and the related arrows pointing to the various joints in each of the figures shown. (2) As you color each arrow, move your own related joint in the same manner.

EXTENSION A
DORSIFLEXION B
FLEXION C
PLANTAR FLEXION D
ADDUCTION E
ABDUCTION F
CIRCUMDUCTION G
ROTATION H
SUPINATION I
PRONATION J
INVERSION K
EVERSION L

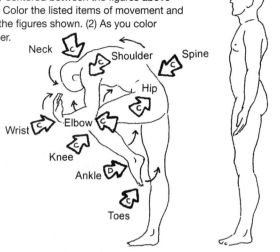

ANATOMICAL POSITION
(Neutral)

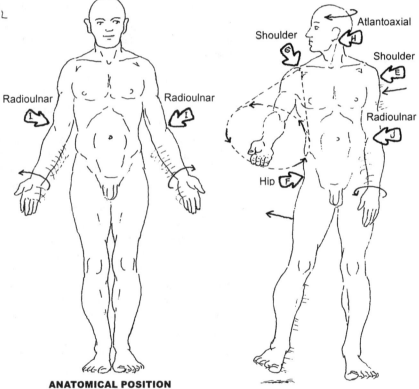

ANATOMICAL POSITION
(Neutral)

The skull is composed of **cranial bones**, forming a vault for the brain, and **facial bones**, giving origin to the muscles of facial expression and providing buttresses to protect the brain. Except for the temporomandibular joint (a synovial joint), all bones are connected by generally immovable fibrous sutures which, over time, tend to ossify into synostoses.

The orbit is composed of seven bones (C, E, F, I, J, K, and L), one of which (K) makes a very small contribution to the floor of the orbit and is not visible in these drawings. The orbit, which has two fissures and one canal, is home to the eye and related muscles, nerves, and vessels. The most delicate of the skull bones is at the medial orbital wall (I). The external nose is largely cartilaginous and is therefore not part of the bony skull except for the **nasal** bones.

At certain sites of the skull, the bone is particularly thickened into pillars (*buttresses*). These maintain a strong resistance to forces imposed on it by transmitting forces away from the vulnerable orbits, nasal cavities, and brain, and therefore resisting fracture. Three of the most obvious are the superior, lateral, and inferior orbital buttresses that you can readily feel on yourself. There are buttresses around the mouth (masticatory), at the point of the chin (mental tubercle), and the back of the skull (**occipital**) as well.

Numerous foramina provide a passageway for cranial nerves and blood vessels into and out of the interior of the cranium and skull. Many of these neurovascular passengers are identified on page 23. Note the three paired foramina in the vertical plane above and below the orbit, and in the **mandible**. These are exit sites for the supraorbital, infraorbital, and mental nerves that supply sensory fibers to the skin of the face. They are all cutaneous branches of the three divisions of the trigeminal nerve (V^1, V^2, and V^3; see page 83).

Place your finger in your ear while making chewing motions and looking at the lateral view of the skull around the external auditory meatus on the adjacent illustration. That is the condyle of the mandible that you feel coming up against the floor of the external auditory meatus (canal). Just above this you can feel the **zygomatic arch**, and deep to that is the temporalis muscle and its strong fascial covering (page 45). This bony-musculo-fascial wall helps protect the middle meningeal artery (which rides in a groove on the internal surface of the **temporal** bone) following an impact to the side of the head.

8 CRANIAL

OCCIPITAL (1)ₐ PARIETAL (2)ʙ FRONTAL (1)ᴄ
TEMPORAL (2)ᴅ ETHMOID (1)ᴇ SPHENOID (1)ꜰ

14 FACIAL

NASAL (2)ɢ VOMER (1)ʜ LACRIMAL (2)ᵢ
ZYGOMATIC (2)ⱼ PALATINE (2)ₖ MAXILLA (2)ₗ
MANDIBLE (1)ₘ INFERIOR NASAL CONCHA (2)ₙ

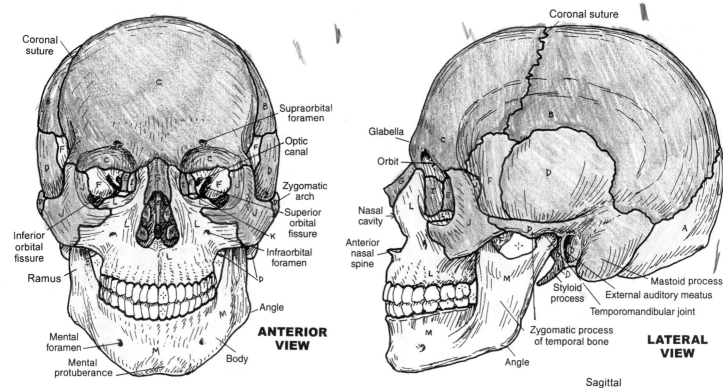

ANTERIOR VIEW

Labels (anterior view): Coronal suture, Supraorbital foramen, Optic canal, Zygomatic arch, Superior orbital fissure, Infraorbital foramen, Inferior orbital fissure, Ramus, Mental foramen, Mental protuberance, Body, Angle

LATERAL VIEW

Labels (lateral view): Coronal suture, Glabella, Orbit, Nasal cavity, Anterior nasal spine, Mastoid process, External auditory meatus, Temporomandibular joint, Zygomatic process of temporal bone, Angle, Styloid process

CN: Save the brightest colors for the smallest bones and the lightest colors for the largest. (1) Color one bone in all the views in which it appears before going on to the next bone. (2) There are some very small bones in the orbits and in the lower part of the posterior view of the skull; look carefully before coloring to determine their color boundaries. (3) Do not color the darkened areas in the orbits and nasal cavity in the anterior view.

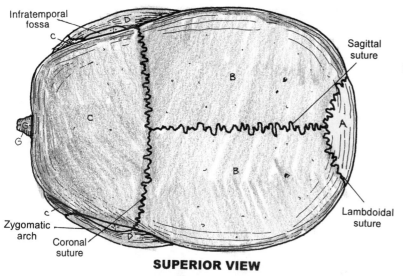

SUPERIOR VIEW

Labels (superior view): Infratemporal fossa, Sagittal suture, Lambdoidal suture, Coronal suture, Zygomatic arch

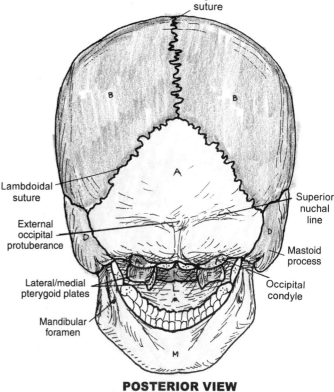

POSTERIOR VIEW

Labels (posterior view): Sagittal suture, Lambdoidal suture, External occipital protuberance, Lateral/medial pterygoid plates, Mandibular foramen, Superior nuchal line, Mastoid process, Occipital condyle

In the upper illustration, you are looking into the interior of the right side of the skull. Start anteriorly, and note the bony septum dividing the **nasal** cavity into left and right cavities. The **vomer** and perpendicular plate of the **ethmoid** contribute significantly to the nasal septum. Traumatic disruption of the nasal septum may result in a "deviated septum," a condition that can make nasal breathing difficult. There are bony cavities (paranasal sinuses) in the skull (page 129) and here the large **sphenoid** sinus can be seen in the sphenoid bone. The pituitary gland fits in a saddle-shaped sella turcica above the sphenoid sinus. On either side of the sella is a large sinus filled with venous blood (cavernous sinus). On occasion, the flow through the sinus may become interrupted by infection-related debris, forming a cavernous sinus thrombosis resulting in raccoon (black) eyes, swelling, and the risk of an occult (hidden) venous hemorrhage.

In the illustration at lower left, looking onto the floor of the cranial cavity (base of the skull, interior view), you see the anterior cranial fossae that support the frontal lobes of the cerebrum (page 73); the olfactory tracts lie over the cribriform plates, through which pass the olfactory nerves (page 99) (sense of smell). The middle cranial fossae embrace the temporal lobes; note the numerous foramina (canals) for cranial nerves and vessels. The posterior cranial fossa retains the cerebellum posteriorly and the brain stem anteriorly (page 76), as well as related cranial nerves and vessels that enter or exit the posterior cranial fossa (page 83). A fall or other blunt force applied to the back of the head will often cause little or no injury to the back of the head, but will cause the base of the frontal lobes to scrape across the *anterior* cranial fossae, resulting in a possible contrecoup contusion of one or both frontal lobes/prefrontal areas.

In the illustration at bottom right, you are looking at an exterior view of the base of the skull. The large external surface of the **occipital** bone is a site of attachment for layers of posterior cervical musculature (page 47). The foramen magnum transmits the lower brain stem/spinal cord. The large occipital condyles articulate with the facets of the atlas or first cervical vertebra. The muscular pharyngeal wall attaches around the posterior nasal apertures.

CRANIAL
OCCIPITAL_A PARIETAL_B FRONTAL_C TEMPORAL_D ETHMOID_E SPHENOID_F

FACIAL
NASAL_G VOMER_H ZYGOMATIC_J PALATINE_K MAXILLA_L INFERIOR NASAL CONCHA_N

CN: Use the same colors for these bones as were used on the previous page. (1) Color the three views simultaneously. (2) In the lower views, pay close attention to the many foramina that are left uncolored. (3) Notice, but don't color, the small drawing below that summarizes the large fossae of the skull interior to its left. Try to visualize those fossae in the larger view.

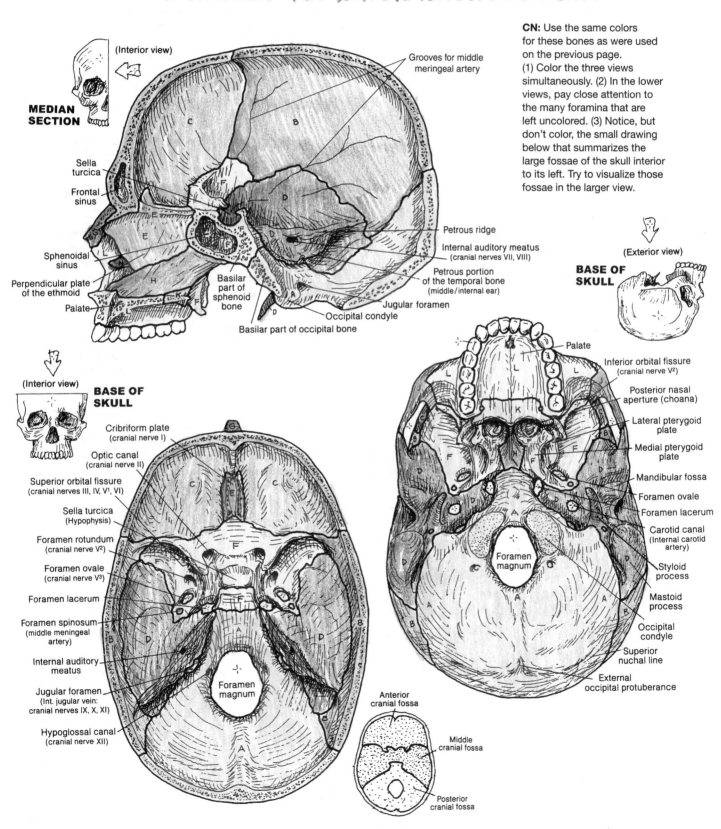

MEDIAN SECTION (Interior view)

Grooves for middle meringeal artery

Sella turcica

Frontal sinus

Sphenoidal sinus

Perpendicular plate of the ethmoid

Palate

Petrous ridge

Internal auditory meatus (cranial nerves VII, VIII)

Petrous portion of the temporal bone (middle/internal ear)

Jugular foramen

Occipital condyle

Basilar part of sphenoid bone

Basilar part of occipital bone

BASE OF SKULL (Exterior view)

BASE OF SKULL (Interior view)

Cribriform plate (cranial nerve I)

Optic canal (cranial nerve II)

Superior orbital fissure (cranial nerves III, IV, V¹, VI)

Sella turcica (Hypophysis)

Foramen rotundum (cranial nerve V²)

Foramen ovale (cranial nerve V³)

Foramen lacerum

Foramen spinosum (middle meningeal artery)

Internal auditory meatus

Jugular foramen (Int. jugular vein: cranial nerves IX, X, XI)

Hypoglossal canal (cranial nerve XII)

Foramen magnum

Palate

Inferior orbital fissure (cranial nerve V²)

Posterior nasal aperture (choana)

Lateral pterygoid plate

Medial pterygoid plate

Mandibular fossa

Foramen ovale

Foramen lacerum

Carotid canal (Internal carotid artery)

Styloid process

Mastoid process

Occipital condyle

Superior nuchal line

External occipital protuberance

Foramen magnum

Anterior cranial fossa

Middle cranial fossa

Posterior cranial fossa

Two **temporomandibular joints** form the craniomandibular joint, which consists of the heads of the left and right **condylar processes** of the **mandible** articulating with paired articular fossae of the **temporal bones**. Movement or trauma to one of these two temporomandibular joints (TMJ) always involves the contralateral joint. The TMJ is a complex synovial joint, gliding, angling, and rotating during what appears to be simple hinge movements of the lower jaw. Movements of the TMJ can be seen on page 45.

The TMJ is encapsulated within a fibrous (joint) capsule, the only true ligament of the joint. The **articular disc** (meniscus) is a fibrocartilaginous, oval plate between the cartilage-lined articular fossa and the articular cartilage of the condylar process. It divides the **synovial cavity** into **superior** and **inferior joint spaces**. The disc incorporates two avascular bands whose long axes lie in the coronal plane. They can be seen in cross section in the views at lower left. An intermediate zone of fibrous tissue connects these bands. The disc is well connected, anteriorly to the lateral pterygoid muscle, posteriorly to the vascular, elastic **retrodiscal pad** in the bilaminar region from which it gets its nutrition, and medially/ laterally to the condylar process. When the mouth is closed, the head of the condylar process abuts the larger, **posterior band**. As the mouth opens, the condylar head rotates forward and downward to abut the **anterior band** at full opening (35–50 mm between upper and lower incisors). During mouth opening, the meniscus itself is stretched as it is pulled forward with the condylar head.

The **articular disc** of the TMJ may fray or become dislocated or detached with aging, abuse (trauma), or misuse (clenching, grinding of teeth). This condition may be associated with bitemporal headaches (temporalis muscle overuse), clicking during jaw movement, and reduced range of motion. The disc may also be structurally incomplete (even perforated) from birth.

TEMPOROMANDIBULAR JOINT
(Craniomandibular)

CN: Use light blue for C, light colors for A and B, and leave E¹–E² uncolored. (1) Begin by coloring the TM joint and the corresponding ligaments at the upper right gray. (2) In the central illustration ("Articular surfaces of TM joint"), use the same color for the articular surface of the condylar process and the articular fossa. (3) Color the mandible at lower right. (4) Color the lateral view of the TM joint, and the two views of the TM joint in the sagittal plane with the mouth closed (left) and the mouth open (right).

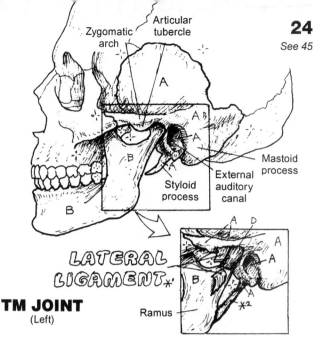

TEMPOROMANDIBULAR JOINT

TEMPORAL BONE ᴀ
MANDIBLE ʙ
 CONDYLAR PROCESS ʙ'

JOINT STRUCTURES

ARTICULAR CARTILAGE ᴄ
JOINT CAPSULE ᴅ
SYNOVIAL CAVITY ᴇ•
 SUPERIOR JOINT SPACE ᴇ'∴
 INFERIOR JOINT SPACE ᴇ²∴
ARTICULAR DISC ꜰ
 ANTERIOR BAND ꜰ'
 POSTERIOR BAND ꜰ²
RETRODISCAL PAD ɢ

TM JOINT
(Left)

LATERAL LIGAMENT *'
STYLOMANDIBULAR LIGAMENT *²

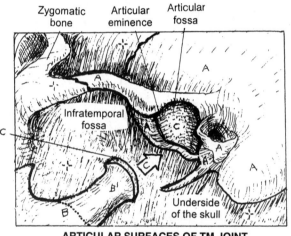

ARTICULAR SURFACES OF TM JOINT
(View of the skull from the side and below)

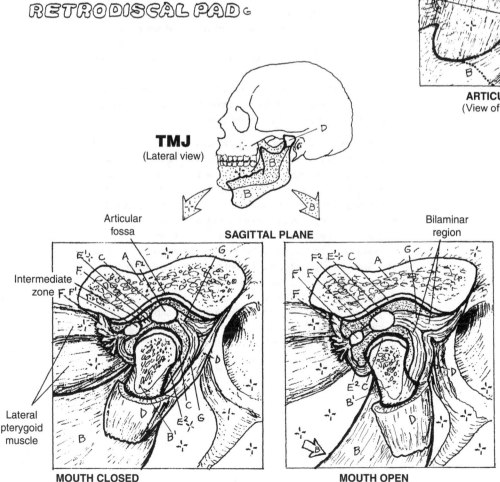

TMJ
(Lateral view)

SAGITTAL PLANE

MOUTH CLOSED

MOUTH OPEN

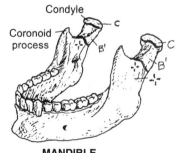

MANDIBLE

The vertebral column (*spine*) has 24 individual **vertebrae** arranged by region: **cervical** (7), **thoracic** (12), and **lumbar** (5). Note that the five **sacral** vertebrae are fused to form the *sacrum*, and that the four **coccygeal** vertebrae form the *coccyx*. Numbers of vertebrae in each region are remarkably constant; rarely, C1 and C2 may be fused to the occipital bone of the skull; L5 may be fused to the sacrum (sacralized lumbar vertebra); or S1 may be free (transitional vertebra). The cervical spine is normally curved (*cervical lordosis*) with the convexity facing anteriorly; the thoracic spine is normally curved with the convexity facing posteriorly, and the lumbar spine's convexity faces anteriorly. All of these curves form secondary to the development of postural reflexes about three months after birth. Examples of excessive vertebral curvatures are shown at lower left. The sacrum is the keystone of a weight-bearing arch involving the hip bones. The sacral/coccygeal curve is congenital.

Each pair of individual, nonfused vertebrae, with intervening intervertebral disc, facet joints, and ligaments, constitute a **motion segment**, the basic movable unit of the vertebral column. Combined movements of motion segments underlie movement of the neck and upper, middle, and low back. Each pair of vertebrae in a motion segment, except C1–C2, is attached by three joints: a partly movable *intervertebral disc* anteriorly, and a pair of gliding synovial *facet* (zygapophyseal) *joints* posteriorly. **Ligaments** secure the bones together and fibrous joint capsules envelop the facet joints. The longitudinal series of **vertebral foramina** form the spinal (or neural or vertebral) canal, transmitting the spinal cord and related coverings, vessels, and nerve roots. Located bilaterally between each pair of vertebral pedicles are passageways leading in and out of the spinal canal (each called an *intervertebral foramen*), which transmit spinal nerves, their coverings/vessels, and vessels to and from the spinal cord.

The **intervertebral disc** is a partly movable fibrocartilaginous joint between two vertebrae consisting of (1) the load-bearing **annulus fibrosus** (layers of concentric, interwoven collagenous fibers integrated with cartilage cells) attached to the vertebral bodies above and below, and (2) the more central **nucleus pulposus** (a mass of thin, degenerated collagen and proteoglycans in water). The water of the nucleus pulposus (like water everywhere) is noncompressible; it transfers the load imposed on it to the annulus. The discs make possible movement between vertebral bodies. With aging, the discs dehydrate and thin, resulting in a loss of height. The cervical and lumbar discs, in particular, are subject to early degeneration. Weakening and/or tearing of the annulus can result in a localized (focal) protrusion of the nucleus and adjacent annulus that can compress a **spinal nerve** in the intervertebral foramen or lateral recess of the spinal canal.

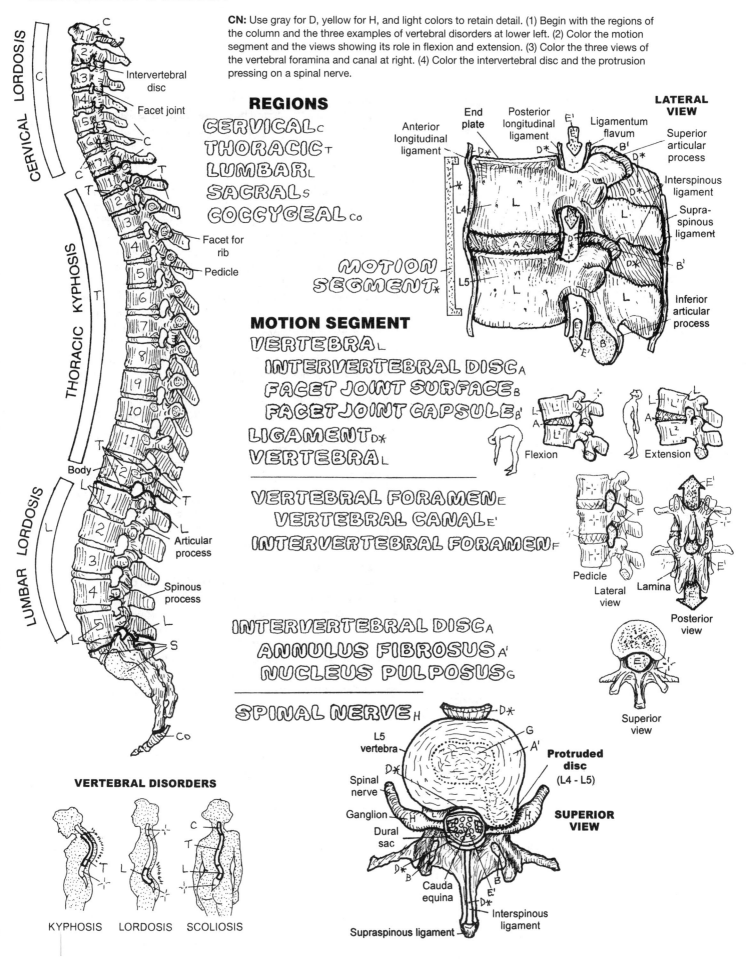

CN: Use gray for D, yellow for H, and light colors to retain detail. (1) Begin with the regions of the column and the three examples of vertebral disorders at lower left. (2) Color the motion segment and the views showing its role in flexion and extension. (3) Color the three views of the vertebral foramina and canal at right. (4) Color the intervertebral disc and the protrusion pressing on a spinal nerve.

CERVICAL LORDOSIS

Intervertebral disc

Facet joint

THORACIC KYPHOSIS

Facet for rib

Pedicle

Body

LUMBAR LORDOSIS

Articular process

Spinous process

REGIONS

CERVICAL c
THORACIC T
LUMBAR L
SACRAL s
COCCYGEAL Co

MOTION SEGMENT

VERTEBRA L
INTERVERTEBRAL DISC A
FACET JOINT SURFACE B
FACET JOINT CAPSULE B'
LIGAMENT D*
VERTEBRA L

VERTEBRAL FORAMEN E
VERTEBRAL CANAL E'
INTERVERTEBRAL FORAMEN F

INTERVERTEBRAL DISC A
ANNULUS FIBROSUS A'
NUCLEUS PULPOSUS G

SPINAL NERVE H

LATERAL VIEW

Anterior longitudinal ligament

End plate

Posterior longitudinal ligament

Ligamentum flavum

Superior articular process

Interspinous ligament

Supra-spinous ligament

MOTION SEGMENT *

Inferior articular process

Flexion

Extension

Pedicle

Lateral view

Lamina

Posterior view

Superior view

L5 vertebra

Spinal nerve

Ganglion

Dural sac

Cauda equina

Supraspinous ligament

Protruded disc (L4 - L5)

SUPERIOR VIEW

Interspinous ligament

VERTEBRAL DISORDERS

KYPHOSIS LORDOSIS SCOLIOSIS

The seven relatively small **cervical vertebrae** support and move the head and neck, supported by intervertebral discs between C2 and T1, ligaments and strap-like paracervical (paraspinal) muscles. The ring-shaped *atlas* (C1) has no body; thus, there are no weight-bearing discs between the occipital bone (occiput) of the skull and C1, and between C1 and C2 (the *axis*). Head weight is transferred to C3 by the large **articular processes** and **facets** of C1 and C2. The atlantooccipital joints, in conjunction with the C3–C7 facet joints, permit a remarkable degree of flexion/extension (nodding "yes" movements). The dens of C2 projects into the anterior part of the C1 ring, forming a pivot joint and enabling the head and C1 to rotate up to 80° (repetitive "no" movements). Such rotational capacity is permitted by the relatively horizontal orientation of the cervical facets. The C3–C6 vertebrae are similar; C7 is remarkable for its prominent **spinous process**, easily palpated (check this on your own body). The anteriorly directed cervical curve (convex anteriorly) and the extensive paracervical musculature generally preclude palpation of the other cervical spinous processes.

The **vertebral arteries** arise from the *subclavian* arteries and reach the brain stem, by way of the *foramina* of the **transverse processes** of the upper six cervical vertebrae, and make an S-turn into the foramen magnum. These vessels are subject to stretching injuries with extreme cervical rotation of the hyperextended neck.

The cervical vertebral canal conducts the cervical spinal cord and its coverings (not shown). The C4–C5 and C5–C6 motion segments are the most mobile of the cervical region and are particularly prone to disc and facet degeneration with aging.

The twelve **thoracic vertebrae**—characterized by long, slender spinous processes, heart-shaped **bodies**, nearly vertically oriented **facets**, and eleven intervertebral discs, support the chest and articulate with **ribs** bilaterally. In general, each rib forms a synovial joint with two **demifacets** on the bodies of adjacent vertebrae and a single facet on the transverse process of the lower vertebra. Variations of these costovertebral joints are seen with T1, T11, and T12. The existence of the ribs in the thoracic region contributes to the relatively reduced range of motion in this part of the vertebral column.

CN: Use the same colors as were used on the previous page for C and T. Use red for M, and dark colors for N, O, and R. (1) Begin with the parts of a cervical vertebra, noting that K and L receive different colors to distinguish them from the typical cervical vertebra C. Color K and L. (2) Color the parts of a thoracic vertebra and the thoracic portion of the vertebral column. Note that three different colors are assigned to the different facet surfaces N, O, and P.

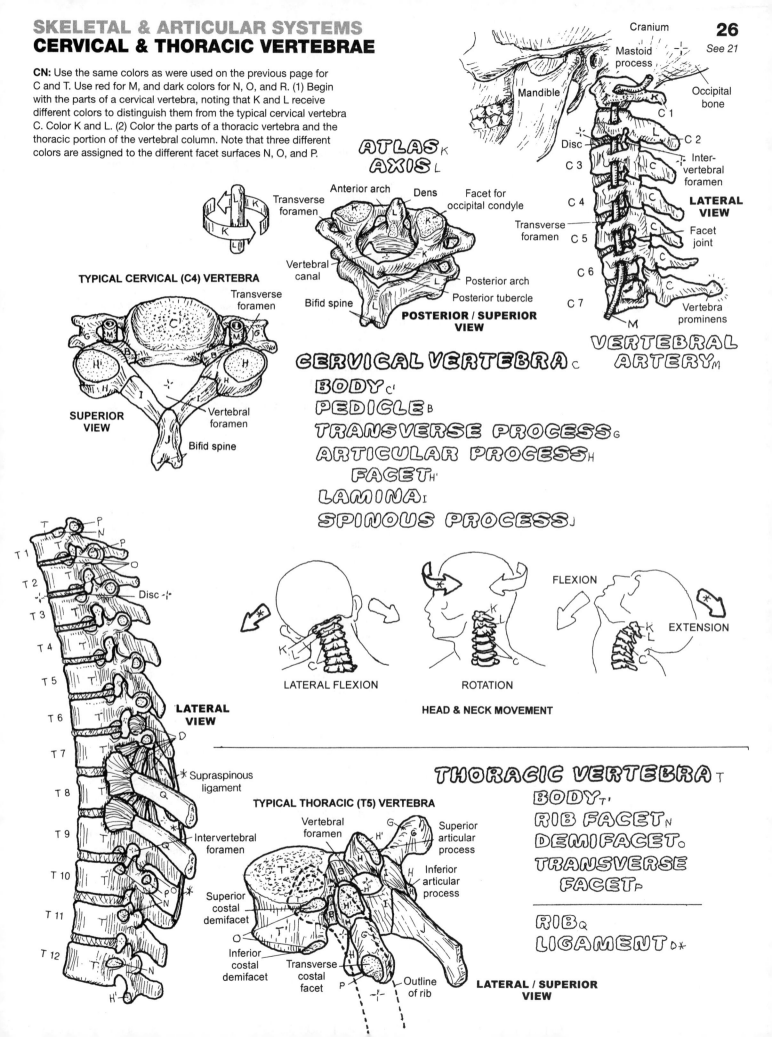

ATLAS K
AXIS L

Anterior arch — **Dens** — **Facet for occipital condyle**
Transverse foramen
Vertebral canal
Bifid spine
Posterior arch
Posterior tubercle

POSTERIOR / SUPERIOR VIEW

Cranium
Mastoid process
Mandible
Occipital bone
C 1
Disc
C 2
Intervertebral foramen
C 3
Transverse foramen
C 4
LATERAL VIEW
Facet joint
C 5
C 6
C 7
Vertebra prominens
M

TYPICAL CERVICAL (C4) VERTEBRA

Transverse foramen
Vertebral foramen
Bifid spine
SUPERIOR VIEW

CERVICAL VERTEBRA C
BODY C'
PEDICLE B
TRANSVERSE PROCESS G
ARTICULAR PROCESS H
FACET H'
LAMINA I
SPINOUS PROCESS J

VERTEBRAL ARTERY M

LATERAL VIEW

T 1
T 2
Disc
T 3
T 4
T 5
T 6
D
T 7
* Supraspinous ligament
T 8
Q
T 9
Intervertebral foramen
T 10
T 11
T 12

LATERAL FLEXION

ROTATION

FLEXION
EXTENSION

HEAD & NECK MOVEMENT

THORACIC VERTEBRA T
BODY T'
RIB FACET N
DEMIFACET O
TRANSVERSE FACET P

RIB Q
LIGAMENT D*

TYPICAL THORACIC (T5) VERTEBRA

Vertebral foramen
Superior articular process
Inferior articular process
Superior costal demifacet
Inferior costal demifacet
Transverse costal facet
Outline of rib

LATERAL / SUPERIOR VIEW

The five **lumbar vertebrae** are the most massive of all the individual vertebrae. Their thick processes secure the attachments of numerous ligaments and muscles/tendons. Significant flexion and extension of the lumbar and lumbosacral motion segments, particularly at L4–L5 and L5–S1, are possible. At about L1 the spinal cord terminates and the cauda equina (bundle of lumbar, sacral, and coccygeal nerve roots; see page 68) begins. The lumbar **intervertebral foramina** are large; transiting nerve roots/sheaths take up only about 50% of the foraminal volume. Disc and facet degeneration, with reduction of foraminal space, is common in the L4–L5 and L5–S1 segments, increasing the risk of nerve root irritation/compression. Occasionally, the L5 vertebra is partially or completely fused to the sacrum (sacralized L5), leaving only four lumbar vertebrae. The S1 vertebra may be partially or wholly fused to L5 (lumbarized S1), resulting in essentially six lumbar vertebrae and a sacrum of four fused vertebrae.

The **planes of the articular facets** strongly influence, but do not completely determine, the direction and degree of motion-segment movement. The plane of the **cervical facets** is angled off the horizontal plane about 30°, giving the neck considerable freedom of motion, especially in rotation. The **thoracic facets** are arranged more vertically in the coronal plane and are virtually non-weight-bearing. The range of motion here is significantly limited in all planes, especially rotation. The plane of the **lumbar facets** is largely sagittal, resisting rotation of the lumbar spine. The L4–L5 facet joints permit the greatest degree of lumbar motion in flexion/extension. These lower lumbar facets, oriented in the sagittal plane as they are, are prone to reorienting toward the coronal plane under continued rotational stress. This change makes it easier for L4–L5 and L5–S1 to experience disc trauma by allowing more rotation than normal when rotating the torso left or right while bearing loads.

The **sacrum** consists of five fused vertebrae; the **intervertebral discs** here are largely replaced by bone. The dura-lined sacral **(vertebral) canal** (recall page 5) contains the terminal (dural or thecal) sac of the dura mater that ends at S2. The sacral (and coccygeal) nerve roots continue inferiorly as the cauda equina, transiting their respective sacral intervertebral foramina. This sac is relatively safe for injection into or withdrawal of cerebrospinal fluid The sacrum joins with the ilium of the hip bone at the auricular surface, forming the sacroiliac joint. The sacrum and the ilia of the hip bones form an arch for the transmission and distribution of weight-bearing forces from the spine to the heads of the femora.

The **coccyx** consists of 2–4 tiny fused, rudimentary vertebrae. On rare occasion, there may be more coccygeal vertebrae. Falls on the coccyx are generally one of the more unpleasant experiences of life.

CN: Use the same colors as were used on the previous two pages for C, T, L, E, F, A, S, and Co. (1) Begin with the three large views of lumbar vertebrae. (2) Color the different planes of articular facets among the three movable vertebral regions. (3) Color the four views of the sacrum and coccyx. Note that the vertebral canal in the median section of the sacrum, S, takes the vertebral canal color, E^1.

PLANES OF ARTICULAR FACETS

LUMBAR VERTEBRA L
VERTEBRAL FORAMEN E
VERTEBRAL CANAL E'
INTERVERTEBRAL FORAMEN F
INTERVERTEBRAL DISC A

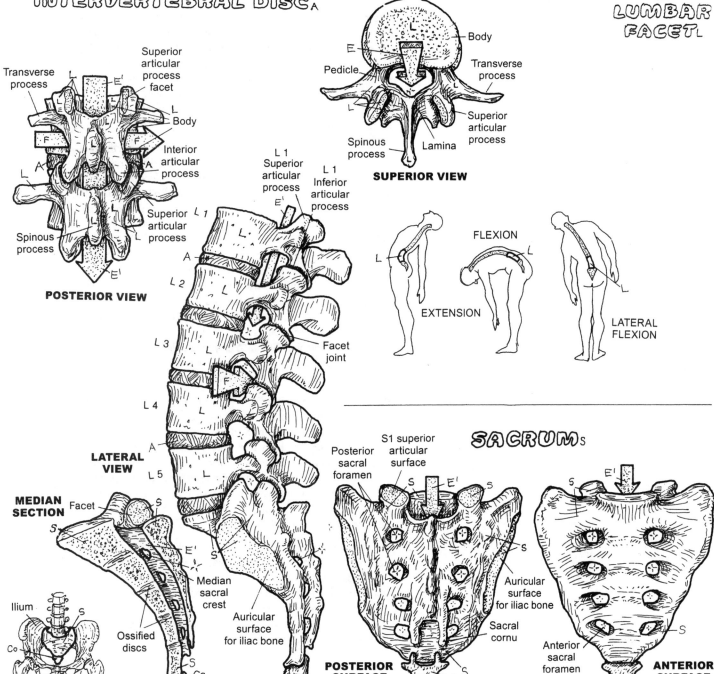

Facet joint

CERVICAL FACET c

THORACIC FACET T

LUMBAR FACET L

SUPERIOR VIEW

Body
Pedicle
Transverse process
Superior articular process
Lamina
Spinous process

POSTERIOR VIEW

Transverse process
Superior articular process facet
Body
Interior articular process
Superior articular process
Spinous process

LATERAL VIEW

L 1 Superior articular process
L 1 Inferior articular process
Facet joint

L 1
L 2
L 3
L 4
L 5

FLEXION
EXTENSION
LATERAL FLEXION

SACRUM s

Posterior sacral foramen
S1 superior articular surface
Auricular surface for iliac bone
Sacral cornu

POSTERIOR SURFACE

Anterior sacral foramen
Auricular surface for iliac bone

ANTERIOR SURFACE

MEDIAN SECTION
Facet
Median sacral crest
Ossified discs
Auricular surface for iliac bone

Ilium
Femur

COCCYX Co

The **bony thorax** (rib cage) is the skeleton of the chest, harboring the heart, lungs, other organs, vessels, and nerves. The superior thoracic aperture or thoracic inlet is a passageway between the neck and the chest, conducting the esophagus, trachea, nerves, and important ducts and vessels. The inferior thoracic aperture (outlet) is essentially sealed by the musculotendinous thoracic diaphragm through which pass the aorta, inferior vena cava, and esophagus (page 133). The thoracic diaphragm separates the thoracic and abdominal cavities, and is responsible for about 75% of the respiratory effort.

There are 12 pairs of ribs; all but 2 of them connect anteriorly, directly or indirectly, with the lateral aspects of the sternum. The fibrocartilaginous joint between the **manubrium** and the **body** of the **sternum** (sternal angle, sternomanubrial joint) makes subtle hinge-like movements during respiration, especially important in enabling expansion of the lungs during inspiration. The **xiphoid** (zi-foyd) makes a fibrocartilaginous (xiphisternal; symphysis) joint with the body of the sternum. The sternum is largely cancellous bone containing red marrow.

The anterior ends of all ribs are cartilaginous (**costal cartilages**). The cartilage and bone of each rib are connected by a cartilaginous (costochondral) joint. The upper-most (1st) costal cartilage forms a cartilaginous (sternocostal) joint with the manubrium. The 2nd through 7th costal cartilages are attached to the sternum by sternocostal, gliding type synovial joints. The ribs 1–7 connecting directly to the sternum are called **true ribs**. The interchondral joints between costal cartilages 6 and 7, 7 and 8, and 8 and 9 are synovial plane joints; the joints between ribs 9 and 10 are fibrous (syndesmosis). As these lower 5 ribs do not articulate directly with the sternum, they are called **false ribs**. Ribs 11 and 12 have no anterior attachment, and are called **floating ribs**. These ribs end in the lateral abdominal musculature, their anterior ends tipped with costal cartilage (that may ossify in later life). The region between each pair of ribs is the intercostal space, containing muscle, fasciae, vessels, and nerves (page 48).

Posteriorly, all 12 **ribs** form synovial joints with **thoracic vertebrae** 1–12 (costovertebral joints). Within each of the costovertebral joints 2 through 9, the rib forms a synovial joint with a **demifacet** of the upper vertebral body and a demifacet of the lower vertebral body (costocorporeal joints). In addition, the tubercle of the rib articulates with a cartilaginous **transverse facet** at the tip of the transverse process of the lower vertebra (costotransverse joint). Ribs 1, 10, 11, and 12 each join with one vertebra, and ribs 11 and 12 have no costotransverse joints.

The rib cage is a dynamic structure; collective rib movement is responsible for about 25% of the respiratory effort (inhalation, exhalation). This effort can be enhanced when out of breath: while standing, bend forward to place your hands on your knees with your elbows extended. This allows the upper limb muscles that originate from the rib cage to act as movers of the thorax, enhancing the respiratory effort.

STERNUM
*MANUBRIUM*A
*BODY*B
*XIPHOID PROCESS*C

12 RIBS
*7 TRUE RIBS*D
*5 FALSE RIBS*E
*(2 FLOATING RIBS)*E'

*COSTAL CARTILAGE (12)*F
*THORACIC VERTEBRA (12)*G

CN: Use the same colors as were used on page 26 for true ribs, D; thoracic vertebrae, G; rib facets, H; demifacets, I; and transverse facets, J. Use bright colors for A–C. (1) Color the anterior, posterior, and lateral views of the bony thorax. Color each rib completely before going on to the next. (2) When coloring the rib joints below, note that the rib facets, H, drawn with dotted lines, are to be colored even though they are on the deep side of the rib.

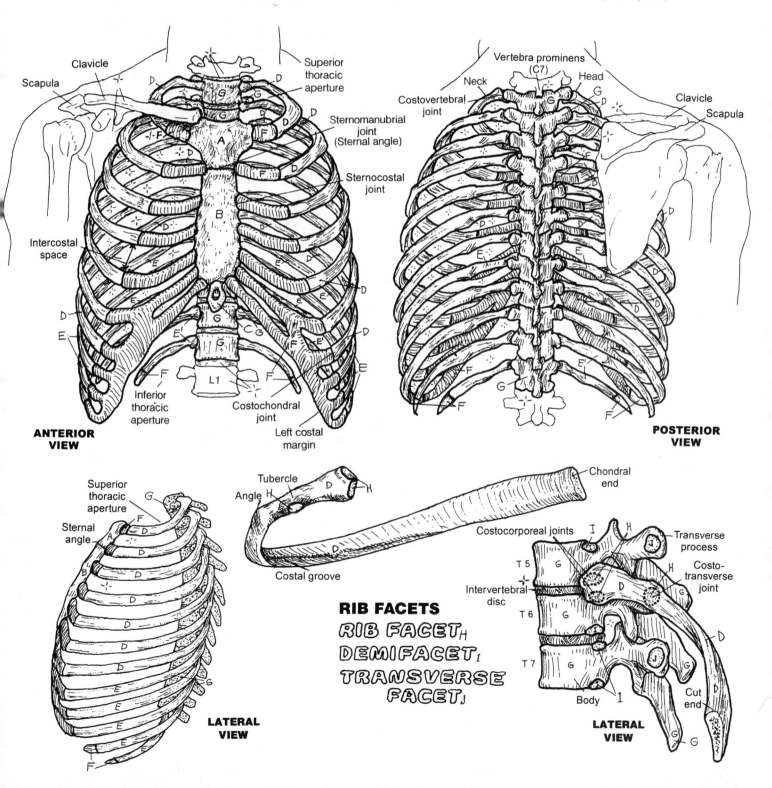

RIB FACETS
*RIB FACET*H
*DEMIFACET*I
*TRANSVERSE FACET*J

The mobility of the upper limb depends largely on the **pectoral girdle**, composed of two **scapulae** and two **clavicles**. This "girdle," which almost completely encircles the upper thoracic cage, is best appreciated in the superior view at the bottom of the page. The *only* bony connection of the girdle to the axial skeleton is by way of the paired sternoclavicular joints (saddle type, synovial; with articular disc). This disc sustains significant loads with falls on the shoulder. Ligament-bound, the disc is rarely displaced; with such falls, it is more likely that the strut-like clavicle will break. The lateral aspect of the scapula is the site of the freely movable shoulder joint; it needs room to operate. The clavicle keeps the scapula (and the shoulder joint) away from the bony body wall. The distal extremity of each clavicle articulates with the acromion of the scapula in a gliding-type synovial joint termed the *acromioclavicular (AC) joint*. The AC joint is commonly disjointed (separated shoulder) with certain activities, an event not to be confused with shoulder joint dislocation.

The scapulae have no direct bony connection to the axial skeleton. Rather, they are dynamically suspended by a number of muscles that reach out from these bones to different parts of the axial skeleton. These "mooring" muscles give each scapula remarkable security as well as mobility over the posterior thoracic wall. The thin, flat part (*blade*) of the scapula is rarely fractured, packaged in muscle as it is.

The **humerus** is joined to the scapula at the glenohumeral joint, a ball and socket joint (page 30). At this joint, the humerus enjoys a broad range of motion, enhanced by scapular mobility (scapulo-thoracic motion). If the opportunity arises, while visiting a zoo in or around your community, take time to watch the acrobatic activities of the gibbon, a southeast Asian ape. A small arboreal animal, its scapulae are more laterally placed than humans, giving them truly remarkable fore and aft mobility while brachiating (swinging from branch to branch and tree to tree with their long upper limbs, which are longer than their lower limbs!).

Fractures of the humerus generally occur at the surgical neck, mid-shaft, or the distal extremity. The sharp sensation generated by striking the ulnar nerve under the medial epicondyle gives birth to the term "crazy bone." It is humorous that the humerus is also known as the "funny bone."

CN: Use very light colors to retain surface detail. (1) Color each view completely before going on to the next. (2) Color gray the various ligaments of the sternoclavicular joint at the top of the page and the ligaments of the glenohumeral and acromioclavicular joints in the inset in the middle of the page.

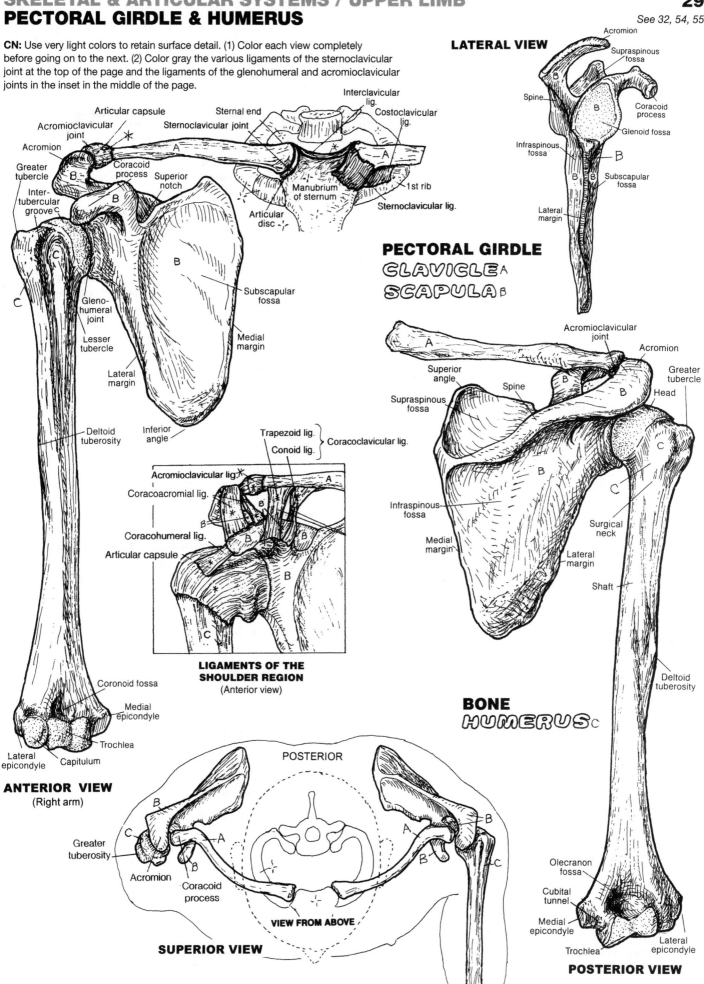

LATERAL VIEW

Acromion

Supraspinous fossa

Spine

Coracoid process

Glenoid fossa

Infraspinous fossa

Subscapular fossa

Lateral margin

Articular capsule

Acromioclavicular joint

Acromion

Greater tubercle

Intertubercular groove

Coracoid process

Superior notch

Interclavicular lig.

Sternal end

Sternoclavicular joint

Costoclavicular lig.

Manubrium of sternum

1st rib

Sternoclavicular lig.

Articular disc

Glenohumeral joint

Lesser tubercle

Lateral margin

Subscapular fossa

Medial margin

PECTORAL GIRDLE

CLAVICLE A

SCAPULA B

Acromioclavicular joint

Acromion

Greater tubercle

Head

Superior angle

Spine

Supraspinous fossa

Infraspinous fossa

Medial margin

Lateral margin

Surgical neck

Shaft

Deltoid tuberosity

Inferior angle

Trapezoid lig.

Conoid lig.

Coracoclavicular lig.

Acromioclavicular lig.

Coracoacromial lig.

Coracohumeral lig.

Articular capsule

LIGAMENTS OF THE SHOULDER REGION
(Anterior view)

BONE

HUMERUS C

Coronoid fossa

Medial epicondyle

Trochlea

Lateral epicondyle

Capitulum

ANTERIOR VIEW
(Right arm)

POSTERIOR

Greater tuberosity

Acromion

Coracoid process

VIEW FROM ABOVE

SUPERIOR VIEW

Olecranon fossa

Cubital tunnel

Medial epicondyle

Trochlea

Lateral epicondyle

POSTERIOR VIEW

The **glenohumeral (shoulder) joint** is a synovial, ball-and-socket-type, multiaxial articulation between the glenoid fossa of the **scapula** and the head of the **humerus**. The scapular fossa and the humeral head are each covered with a thin layer of articular (hyaline) cartilage. The shallow fossa is deepened by the fibrocartilaginous **glenoid labrum** around its rim.

Compare this fossa with that of the hip joint (page 37), and question the weight-bearing function of the latter: Has that had any adaptive influence on the hip joint's shape and depth?

The glenoid labrum of the scapula and the head of the humerus are encapsulated within a **fibrous joint capsule** lined internally with a **synovial membrane** and containing a small amount of synovial fluid. The fibrous joint capsule consists of three layers of collagen, two of them in parallel between the humerus and the glenoid labrum (in the coronal plane) and one between the supraspinatus tendon and the tendon of subscapularis. The posterior aspect of the joint capsule is considerably thinner than its anterior fellow, as it has no specific ligaments within its capsule. The anterior aspect of the joint capsule incorporates thickened bands of the glenohumeral **ligaments**: superior, middle, and inferior.

Usually isolated from the joint capsule and its cavity (but not always!) are numerous fibrous, synovial-lined sacs of synovial fluid (**bursae**). The bursae intervene between muscles and tendons crossing bones, and other tendons and muscles, serving to reduce irritation from frictional contact. One of these, the subacromial bursa is commonly subjected to overuse and irritation (see page 53). Between the superior and middle glenohumeral ligaments, the subscapular bursa (between the neck of the scapula and the subscapularis muscle) communicates with the joint cavity; it is commonly associated with joint capsule synovitis. Depending on the tension on the joint capsule, there may be several outpocketings or recesses on the capsular wall. A rather distinct outpocketing of the joint capsule occurs between the inferior glenohumeral ligament and the posterior joint capsule (axillary recess).

The shoulder joint capsule/ligament complex is reinforced by a musculotendinous cuff (page 53) that offers great flexibility and dynamic stability to shoulder motion, something that ligaments (which function passively) cannot do.

The **tendon** of the long head of the **biceps brachii** arises from the scapula's supraglenoid tubercle and adjacent bone just above the 12 o'clock position of the glenoid labrum (looking at the glenoid fossa as the face of a clock). Ensheathed by synovium, the tendon passes over the head of the humerus within the fibrous capsule and emerges below the capsule in the intertubercular groove to join the short head (muscle) of the biceps brachii coming off the coracoid process of the scapula.

The joint commonly suffers from overuse in athletics and overhead work, as does its fellow, the acromioclavicular joint. Capsules become abnormally lax, the labrum becomes torn from its attachments, the tendon of the long head of biceps becomes frayed and torn, and repetitive dislocations of the humeral head may induce articular cartilage damage.

CN: Use the same colors for A and B as you did for B and C on page 29. (1) Color all ligaments gray. Because the glenohumeral ligaments are thickenings of the joint capsule, E, they are colored both gray and the color assigned to E. (2) In the lateral view at lower left, the tendon of biceps has been pulled medially to better expose the joint capsule, E, and the articular cartilage of the scapular socket, C.

SCAPULA A
GLENOHUMERAL JOINT
HUMERUS B

ANTERIOR VIEW

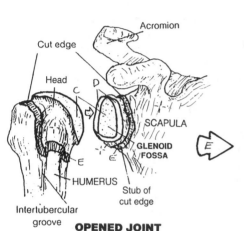

OPENED JOINT

Cut edge
Acromion
Head
C
D
E
E
HUMERUS
SCAPULA
GLENOID FOSSA
Stub of cut edge
Intertubercular groove

Acromioclavicular joint
Coracoid process
CLAVICLE
E
Axillary recess

ENCAPSULATED JOINT

Acromion
Subacromial bursa
Subdeltoid bursa
F
Coracohumeral ligament
E
Glenohumeral ligament
Subscapular bursa
Glenohumeral ligaments
F
G
I

LIGAMENTS ✳

CAPSULAR LIGAMENTS

JOINT STRUCTURES
ARTICULAR CARTILAGE c
GLENOID LABRUM d
JOINT CAPSULE e
BURSA f
SYNOVIAL MEMBRANE g
SYNOVIAL CAVITY h•
TENDON OF BICEPS
　BRACHII MUSCLE i

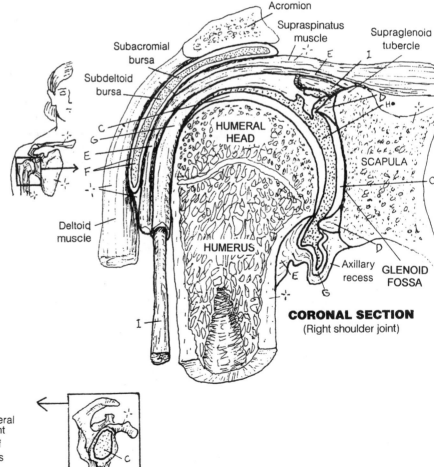

Acromion
Supraspinatus muscle
Supraglenoid tubercle
Subacromial bursa
Subdeltoid bursa
C
E
F
HUMERAL HEAD
HUMERUS
SCAPULA
C
Axillary recess
GLENOID FOSSA
Deltoid muscle
I
E
G
H•
E
I
D

CORONAL SECTION
(Right shoulder joint)

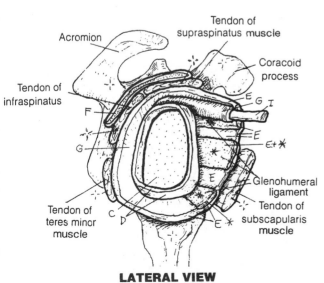

Acromion
Tendon of supraspinatus muscle
Coracoid process
Tendon of infraspinatus
F
E G I
E
E + ✳
Glenohumeral ligament
G
E
Tendon of subscapularis muscle
Tendon of teres minor muscle
C
D
E ✳

LATERAL VIEW
(Opened joint with humerus removed)

SCAPULA
C

The two bones and related joints of the forearm are a bit of a mechanical wonder; like two brothers, one is strong on security and strength, and the other (the smaller) is more likely to twist and turn in its operations. Place your fingers on your *olecranon*, feeling its extent, and then feel down the shaft of the **ulna** until you run into the wrist bones on the little finger side. The ulna definitely gets smaller distally; it terminates as the head of the ulna, articulating with the radius and abuts (but does not form a "formal" joint with) the lunate and triquetral bones by way of a fibrocartilaginous (articular) disc. Now, grasping the ulna at mid-shaft, rotate your hand one way or the other, and note that the ulna does *not* rotate. Feel the olecranon again and rotate your hand back and forth. No, the ulna definitely does not rotate. But your hand did. Hmmm…

The **radius** is the other bone of the forearm, on the thumb side. Feel the side of its *head* (just below the lateral epicondyle of the humerus). This head is shaped like a mesa (flat top with steep sides) on a hill or small mountain. Notice how it can rotate like a pivot under the rounded capitulum of the humerus. The radius enlarges significantly from elbow to wrist, forming a substantial, potentially load-bearing radiocarpal (wrist) joint. Now, rotate your hand back and forth while you stare at your thumb: yes, the radial head/radius rotates — all the way to the thumb! The hand rotates with the radius. Now the final proof: hold on to your olecranon and rotate your hand back and forth. The radius rotates (twists and turns around the ulna); the ulna doesn't.

Now look at the three illustrations labeled "Supination / Pronation" at the bottom of the page, and practice. Start by avoiding the term *"rotate"* here, and using "supination" and "pronation" instead. In the anatomical position, note that the forearm bones are parallel. The *proximal* radioulnar joint is supinated. Now pronate the proximal radioulnar joint and note that the palm of the hand is pronated. Palm up: supinated; palm down: pronated. An important ligament in these operations is the interosseous membrane binding the ulnar and radial shafts (which you have colored or will color gray). Nice job!

ULNA_A
RADIUS_B

CN: Use very light colors for A and B. (1) Color the bones in all three views. (2) Color the supination/pronation diagrams.

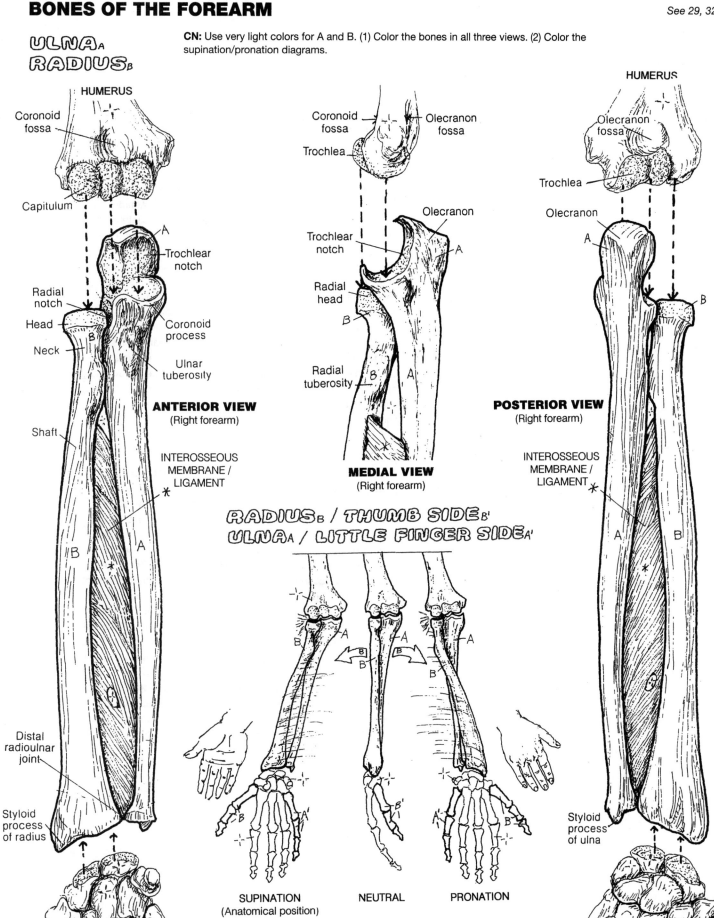

ANTERIOR VIEW
(Right forearm)

MEDIAL VIEW
(Right forearm)

POSTERIOR VIEW
(Right forearm)

RADIUS_B / THUMB SIDE_{B'}
ULNA_A / LITTLE FINGER SIDE_{A'}

SUPINATION
(Anatomical position)

NEUTRAL

PRONATION

SUPINATION / PRONATION

The **elbow joint** is the hinge joint between the articular surfaces of the trochlea and capitulum of the **humerus**, and the cartilaginous surfaces of the trochlear notch of the **ulna** and the head of the **radius**. These joints can be seen clearly in the boxed illustration titled "Annular Ligament." These two articulations share the same *fibrous capsule*, which is strong posteriorly, weaker anteriorly, and reinforced by the medial (radial) and lateral (ulnar) collateral ligaments. Movements of the elbow joint are limited to flexion and extension. Note that the C-shaped, **articular cartilage**-lined trochlear notch of the ulna rotates around the pulley-shaped trochlea of the humerus during these movements. In flexion, the coronoid process of the ulna fits into the coronoid fossa of the humerus; feel the olecranon at the proximal end of the ulna as you do this movement. The elbow can take a lot of abuse in life; feel its bony extent. In extension, the upper part of the trochlear notch fits into the olecranon fossa of the posterior humerus. On your own elbow, in extension, with the forearm supinated, the forearm may be seen to be angled laterally relative to the humerus. Comparing this angle among a group of you, both males and females, one should be able to determine that women generally have a more significant "carrying angle" (by about 10 degrees) than men. Is this a functional adaptation?

The joint between the radius and the ulna (**proximal radioulnar joint**) permits the radial head to pivot within the radial notch of the ulna, making possible supination and pronation of the forearm. The rounded head of the radius pivots around the capitulum of the humerus. The ulna cannot pivot around anything because of the constraints of the **humeroulnar joint**. In the medial view below, note the three parts of the ulnar collateral ligament. The **annular ligament** is attached at both ends to the sides of the radial notch of the ulna, and is narrower below than above (i.e., it is beveled). It surrounds and secures the radial head (above) and the neck (below) of the radius and resists its displacement when the hand is pulled away from the shoulder. However, it is not unusual, when a small child is swung by the hands, round and round in play, for the immature radial heads (bilaterally) to slip partly or wholly out of the confinement of the annular ligaments, resulting in bilateral **radioulnar** translocations/subluxations. The deep surface of the annular ligament is lined with synovium. The **joint capsule** and the **radial collateral ligament** reinforce the retaining function of the annular ligament.

ELBOW & RELATED JOINTS
See 29, 31, 33

CN: Use the same colors for the three bones as were used on 29 and 31. Use light blue for H in the boxed-in diagram, and yellow for K in the sagittal section middle right. (1) Begin with the three joints of the elbow region. Note that each articulating surface (dotted) receives the color of its bone. (2) Color the remaining views of the joint capsule and ligaments.

BONES
HUMERUS A
ULNA B
RADIUS C

3 JOINTS
1. *HUMERO* A *ULNAR* B
2. *RADIO* C *HUMERAL* A
3. *RADIO* C *ULNAR* B

LIGAMENTS
ULNAR COLLATERAL D
RADIAL COLLATERAL E
ANNULAR F

JOINT COMPONENTS
JOINT CAPSULE G
ARTICULAR CARTILAGE H
SYNOVIAL MEMBRANE I
SYNOVIAL CAVITY J
FAT PAD K
BURSA L

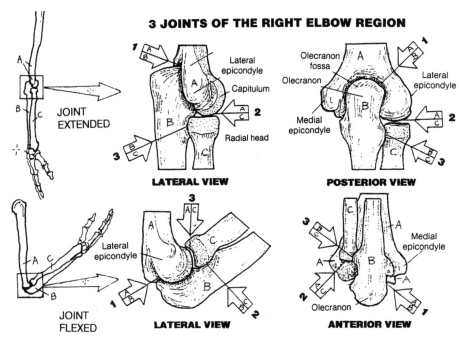

3 JOINTS OF THE RIGHT ELBOW REGION

JOINT EXTENDED

LATERAL VIEW
Lateral epicondyle
Capitulum
Radial head

POSTERIOR VIEW
Olecranon fossa
Olecranon
Lateral epicondyle
Medial epicondyle

JOINT FLEXED

LATERAL VIEW
Lateral epicondyle

ANTERIOR VIEW
Medial epicondyle
Olecranon

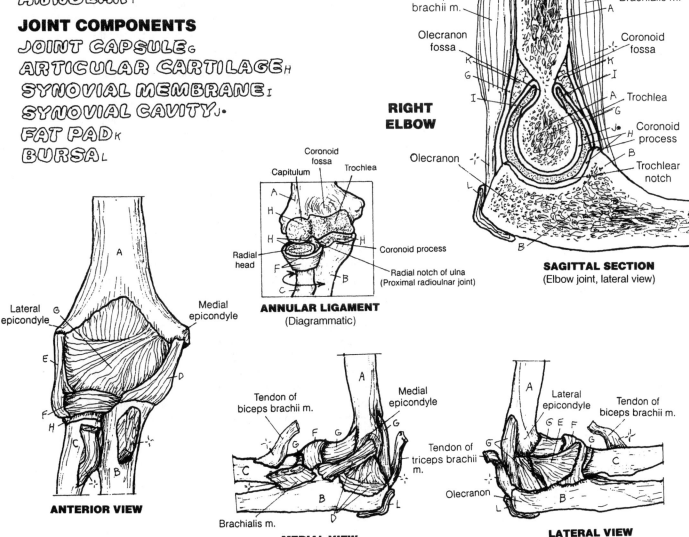

RIGHT ELBOW
Triceps brachii m.
Olecranon fossa
Olecranon
Brachialis m.
Coronoid fossa
Trochlea
Coronoid process
Trochlear notch

SAGITTAL SECTION
(Elbow joint, lateral view)

ANTERIOR VIEW
Lateral epicondyle
Medial epicondyle

ANNULAR LIGAMENT
(Diagrammatic)
Coronoid fossa
Capitulum
Trochlea
Radial head
Coronoid process
Radial notch of ulna
(Proximal radioulnar joint)

MEDIAL VIEW
Tendon of biceps brachii m.
Medial epicondyle
Brachialis m.

LATERAL VIEW
Lateral epicondyle
Tendon of biceps brachii m.
Tendon of triceps brachii m.
Olecranon

The **wrist** (carpus) consists of two rows of **carpal bones**. The distal row (from lateral to medial: **trapezium, trapezoid, capitate,** and **hamate**) articulates with the **metacarpal** bones (carpometacarpal or CM joints). The first CM joint is the most unique of the lot (synovial; saddle or biaxial joint). On yourself, note the mobility that the first CM joint gives to the thumb, as in opposing (touching) thumb pad and the pad of the little finger, and circumduction of the thumb (recall page 21).

Of the proximal row of carpal bones (from lateral to medial: **scaphoid, lunate, triquetrum,** and **pisiform**), the scaphoid and lunate articulate with the distal radius, the triquetrum articulates with the articular disc during adduction of the wrist joint (see below). The *pisiform* is essentially a sesamoid bone giving mechanical advantage to the flexor carpi ulnaris muscle (page 56). Note that the ulna does *not* articulate with the carpus, but it does articulate with the radius at the distal radioulnar joint, a pivot joint (page 31).

The articular disc (lower central illustration; also known as the triangular fibrocartilage complex or TFCC) is part cartilage and part ligament. It helps absorb the load placed on the ulna and the carpal joints during a fall on the hands (pronated radiocarpal joint). Traumatic compaction of the disc often results in tears of the disc and a dysfunctional distal radioulnar joint.

The radiocarpal joint is the *wrist joint* (synovial; ellipsoid; see page 31). Notice the broad distal extremity of the radius that articulates, lateral to medial, with the scaphoid and lunate bones. Movements here are flexion, extension, adduction (ulnar deviation), and abduction (radial deviation). The *wrist joint* and *carpal joints* are secured by palmar and dorsal radiocarpal and ulnocarpal ligaments and by radial and ulnar collateral ligaments. The *intercarpal joints,* between the proximal and distal rows of carpal bones, contribute to wrist movement.

Imagine a trough between the *trapezium* (E) and *hamate* (H) bones running proximal to distal on the anterior aspect of the carpus (see anterior view; see page 57, deep palmar view). Such a trough exists and provides a passageway for the long flexor tendons to the thumb and fingers, as well as the median nerve. The trough becomes a tunnel when covered by the *transverse carpal ligament* (not shown) that lies just below those palpable tendons on the palmar surface of the wrist. Chronic compression of this **ligament,** which can happen to those who type for hours a day (like yourself?) without a cushion under the wrist, can irritate the underlying median nerve, causing a buzzing or burning sensation going out from the wrist to the pads of the thumb and index fingers. Such symptoms (paresthesias or numbness) suggest a depressed function of the median nerve (carpal tunnel syndrome).

BONES / JOINTS OF THE WRIST & HAND

CN: Use light colors; light blue for K. Relate your study of joint movement to the satellite sketches of wrist and hand movement on the right side of the page. (1) Color the three views of the bones of the hand and fingers. (2) Color the articular surfaces K of the carpal bones, the bases of the proximal phalanges, and the radius and ulna in the lower central illustration. *Carefully* color the synovial cavities, L•, with a sharp black pencil. Do not color the articular disc.

CARPAL BONES (8)

SCAPHOID_A LUNATE_B TRIQUETRUM_C
PISIFORM_D TRAPEZIUM_E TRAPEZOID_F
CAPITATE_G HAMATE_H

BONES OF THE HAND

METACARPALS (5)_I PHALANGES (14)_J

ARTICULAR CARTILAGE_K
SYNOVIAL CAVITY_L•
LIGAMENT_M*

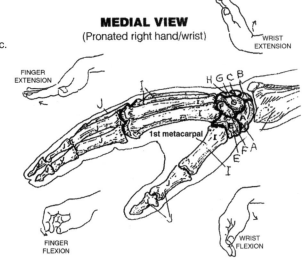

MEDIAL VIEW
(Pronated right hand/wrist)

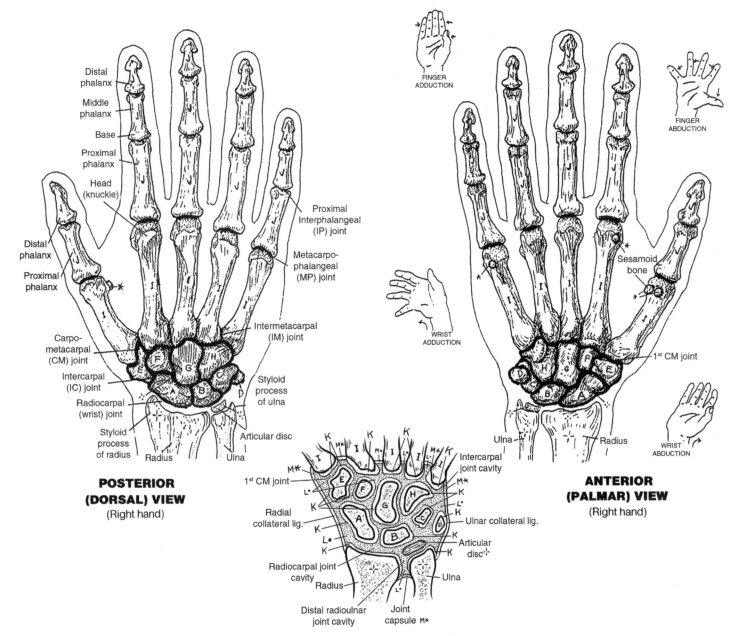

Distal phalanx
Middle phalanx
Base
Proximal phalanx
Head (knuckle)
Distal phalanx
Proximal phalanx
Carpo-metacarpal (CM) joint
Intercarpal (IC) joint
Radiocarpal (wrist) joint
Styloid process of radius
Radius
Ulna

Proximal Interphalangeal (IP) joint
Metacarpo-phalangeal (MP) joint
Intermetacarpal (IM) joint
Styloid process of ulna
Articular disc

POSTERIOR (DORSAL) VIEW
(Right hand)

FINGER ADDUCTION
FINGER ABDUCTION
WRIST ADDUCTION

Sesamoid bone
1st CM joint
Ulna
Radius
WRIST ABDUCTION

ANTERIOR (PALMAR) VIEW
(Right hand)

1st CM joint
Radial collateral lig.
Intercarpal joint cavity
Ulnar collateral lig.
Articular disc
Radiocarpal joint cavity
Radius
Joint capsule M*
Distal radioulnar joint cavity
Ulna

JOINTS OF WRIST & CARPAL BONES
(Dorsal view of frontal section)

The **upper limb** is remarkable for its mobility. The mechanism for this begins with the scapula, which is dynamically tethered by muscle to the posterior thoracic wall. On yourself, reach over your shoulder to palpate the scapular spine and acromion (recall page 31). Looking into a mirror over your shoulder, move your shoulders up and down, wrap your arms around yourself, stretch your arms out, and reach upward and then downward to see the scapula move.

The *humerus* can be palpated easily from just distal to the shoulder down to the elbow. There, the medial and lateral epicondyles, as well as the olecranon, can be felt. Can you feel the ulnar nerve under the medial epicondyle? Feel hard enough and it might "speak" to you all the way down to your little finger!

Starting with joints of the fingers, and working up to the shoulder joint, it is instructive to move each joint of the upper limb that you can, identify it, and test its range of motion. Keep a log! After all, it's *your* upper limb.

CN: Write in the name of the bone with the same color as used for the corresponding bone in the two large illustrations. (1) Color the arrows pointing to places where bones can be seen or palpated. (2) Write in black pencil as many names of the numbered joints as you can recall.

(See Appendix A for answers.)

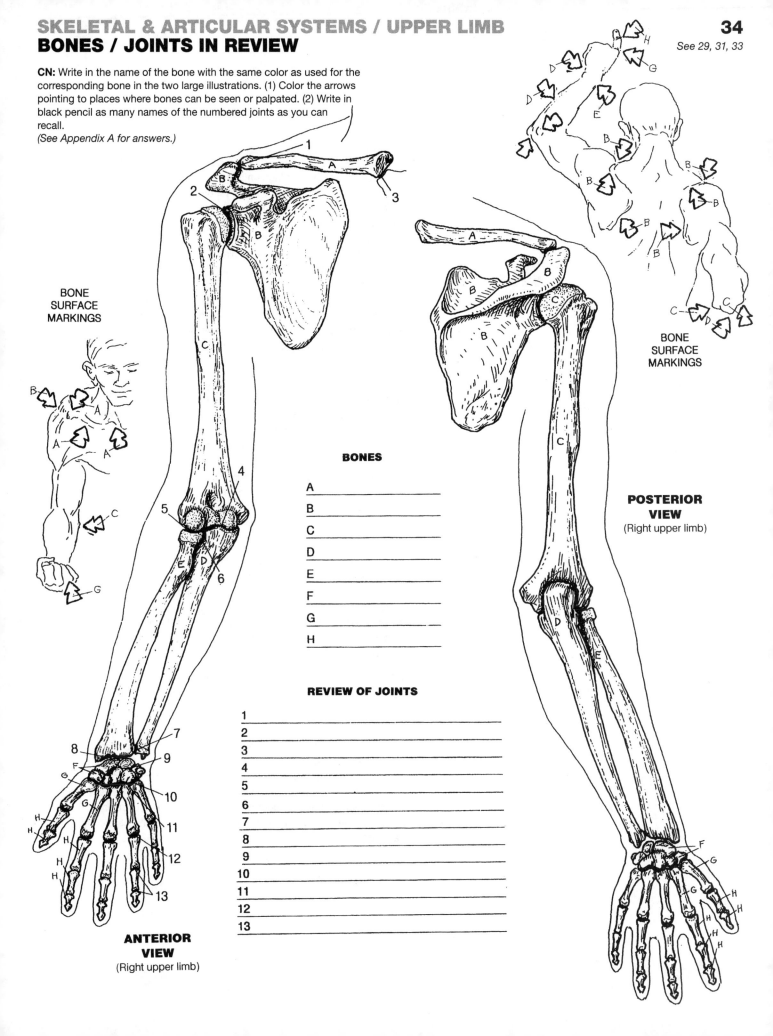

BONE
SURFACE
MARKINGS

BONE
SURFACE
MARKINGS

POSTERIOR
VIEW
(Right upper limb)

BONES

A _____
B _____
C _____
D _____
E _____
F _____
G _____
H _____

REVIEW OF JOINTS

1 _____
2 _____
3 _____
4 _____
5 _____
6 _____
7 _____
8 _____
9 _____
10 _____
11 _____
12 _____
13 _____

**ANTERIOR
VIEW**
(Right upper limb)

The **hip bone** (pelvic bone, os coxae) actually consists of three bones connected by cartilage until fused in the acetabulum in the second decade of life: the **ilium**, **ischium**, and **pubis**. The acetabulum is the socket for the head of the femur, and is named after a cup used for dipping food in vinegar in ancient Rome. The hip bone has been likened to a propeller: the slightly torqued broad wing (ala) of the ilium is one blade of the propeller, and the somewhat rotated ischiopubic bone would be the other in this twisted analogy. The weight of the head, torso, and upper limbs is transmitted from the sacroiliac joint to the acetabulum through the body of the ilium. The bilateral ischial bones are significant for their tuberosities upon which one sits. The paired pubic bones form the pubic symphysis (cartilaginous; partly movable) that adds to the stability of the two pelvic bones.

The two hip bones constitute the **pelvic girdle**. It does not include the sacrum. In concept, the pelvic girdle encircles or binds about the sacrum. Compare with the pectoral girdle of the upper limb (page 29): the clavicles and scapulae "encircle" the upper vertebral column. The sacrum is no more a part of the pelvic girdle than the cervical and thoracic vertebrae are a part of the pectoral girdle. The two girdles do have similarities: the ischiopubic bones are somewhat similar in shape and function to the clavicles, and the iliac bones to the two scapulae. Because of its weight-bearing function, the pelvic girdle is considerably less mobile than its pectoral counterpart.

The two hip bones and the **sacrum** form the **pelvis**. See the lowest set of illustrations. The cavity of the pelvis consists of a false (greater) and a true (lesser) pelvis. The broad bowl-shaped cavity at the level of the iliac fossae is the *greater or* **false pelvis**. The perimeter of the floor of the false pelvis is a definitive ring of bone (linea terminalis). The cavity below the ring is the **true pelvis**. It can be identified by its cylindrical shape.

Note that the false pelvis has no bony anterior wall; the wall is muscular. Confirm this by palpating your own anterior abdominal wall and seeing page 49.

The *true* pelvic cavity has both bony and muscular walls and contains numerous structures (pages 50, 144). Looking at the medial view of the pelvis at lower right, note the plane of the inferior pelvic aperture (**pelvic outlet**), along a line from the inferior aspect of the pubis to the tip of the **coccyx;** it is much more horizontal than that of the **inlet**. The floor of the pelvic outlet is muscular (page 50). The floor of the pelvic cavity is the roof of the perineum (page 51).

CN: Use very light colors for bones A–D[1]. (1) Color the names and lateral and medial views of the hip bones at the top of the page. Take particular note of the auricular surface and the ischial tuberosity. (2) Color the two views of the pelvic girdle. *Note that the sacrum is not to be colored in these views.* (3) Color the views of the pelvis and note the two parts of the pelvic cavity.

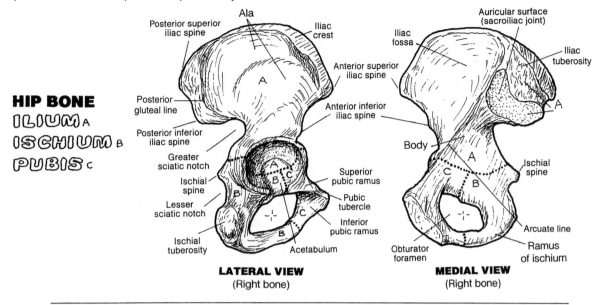

HIP BONE
ILIUM A
ISCHIUM B
PUBIS C

LATERAL VIEW
(Right bone)

MEDIAL VIEW
(Right bone)

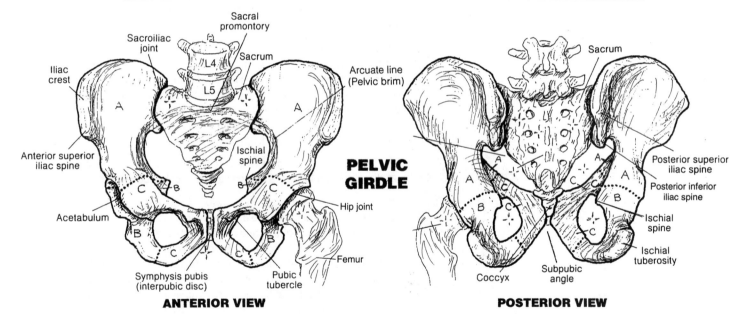

PELVIC GIRDLE

ANTERIOR VIEW

POSTERIOR VIEW

SACRUM D
COCCYX D'

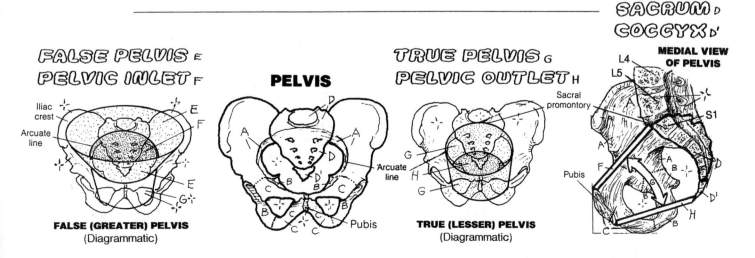

FALSE PELVIS E
PELVIC INLET F

PELVIS

TRUE PELVIS G
PELVIC OUTLET H

MEDIAL VIEW OF PELVIS

FALSE (GREATER) PELVIS
(Diagrammatic)

TRUE (LESSER) PELVIS
(Diagrammatic)

Female and **male** bony **pelves** often differ. These differences have been investigated and analyzed for many reasons, including forensic identification of bodies, gynecologic evaluations, and anthropologic and anatomic research. A primary interest of pelvic dimensions and physical characteristics is in the clinical prenatal examination. Such examination includes measuring pelvic dimensions and capacity of the pelvis to assure an unimpeded birth canal for delivery of the fetus. Obstetric-related measurements (pelvimetry) are accomplished by hands-on clinical techniques and by various imaging devices, including ultrasound and MR imaging.

In general, female pelves are wider than male pelves in all dimensions. Females have a wider **subpubic angle** than males. This angle can be measured easily on a laboratory skeleton by placing the hand against the pubis such that the thumb covers one inferior pubic ramus and the index finger covers the other. If the angle created by these two digits is superimposed rather precisely over the subpubic angle of the pelvis being measured, it is probably a female pelvis. If the subpubic angle fits between index and middle fingers, it is probably a male pelvis.

When two different pelves are compared side by side. female pelves tend to have broader true and false pelves than male pelves. The **pelvic inlet** and **outlet** are generally larger in women. The space between the ischial tuberosities is greater in females, as is the space between ischial spines and the ischial spine and the **sacrum**. There tends to be a larger **sacral curvature** in females, as well as a larger sciatic notch.

Posture, bone conditions such as osteomalacia, and a number of other factors can influence pelvic shape and pelvic capacities.

The pelvic girdle is stabilized by bony joints and binding **ligaments**. In the pectoral girdle, some of that stability has to be given up to achieve mobility, and muscular stabilization becomes an important element in that function (recall page 29; glance ahead to pages 52 and 53). Pelvic ligamentous stability is particularly important in locomotion, physical activity, childbearing, and weight-bearing. Note that the iliolumbar and anterior longitudinal ligaments bind the sacrum to the vertebral column, as do the fibers of the posterior longitudinal ligament, ligamentum flavum, supraspinous, and interspinous ligaments (not shown). The strong sacroiliac ligaments (anterior, posterior, interosseous) stabilize the critical sacroiliac joints (look ahead to page 37). Note that each part of the hip bone contributes a ligament for the stability of the hip joint. The sacrotuberous and sacrospinous ligaments not only secure the sacrum to the ischium, but also cross one another in such a way as to create passageways (greater and lesser sciatic foramina) for transiting nerves, vessels, and tendons/muscles from the pelvis. (These passageways are listed in the Glossary: Foramina: greater and lesser sciatic).

CN: Use very light colors for A and B. (1) Only color the two pelves at the top of the page, and the name and diagram of the sub-pubic angle. (2) Color the additional comparisons and corresponding names below the two pelves. (3) Color gray the pelvic ligaments below. Their names give evidence of their attachments.

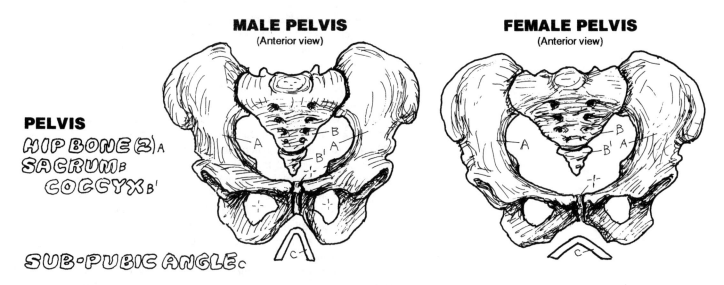

MALE PELVIS
(Anterior view)

FEMALE PELVIS
(Anterior view)

PELVIS

HIP BONE (2) A
SACRUM B
COCCYX B'

SUB-PUBIC ANGLE C

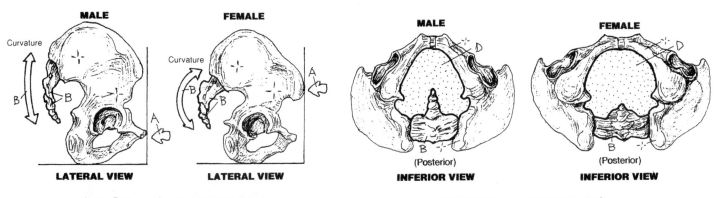

ADDITIONAL COMPARISONS

MALE

Curvature

FEMALE

Curvature

MALE

FEMALE

LATERAL VIEW

LATERAL VIEW

(Posterior)
INFERIOR VIEW

(Posterior)
INFERIOR VIEW

SACRAL CURVE B

PELVIC OUTLET D

PELVIC LIGAMENTS

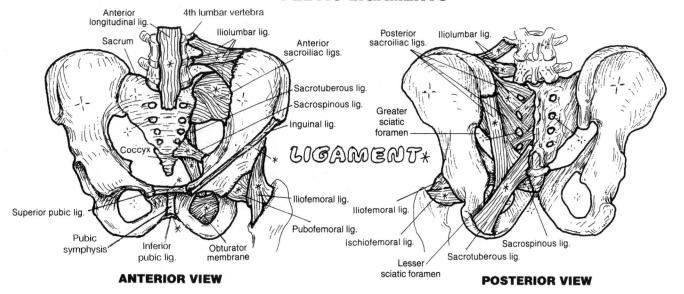

Anterior longitudinal lig.

4th lumbar vertebra

Sacrum

Iliolumbar lig.

Anterior sacroiliac ligs.

Posterior sacroiliac ligs.

Iliolumbar lig.

Sacrotuberous lig.

Sacrospinous lig.

Inguinal lig.

Greater sciatic foramen

Coccyx

LIGAMENT

Superior pubic lig.

Iliofemoral lig.

Iliofemoral lig.

Pubic symphysis

Inferior pubic lig.

Obturator membrane

Pubofemoral lig.

Ischiofemoral lig.

Lesser sciatic foramen

Sacrospinous lig.

Sacrotuberous lig.

ANTERIOR VIEW

POSTERIOR VIEW

The stability of the **hip** and **sacroiliac joints**, in conjunction with the pubic symphysis (interpubic joint), is crucial to painless locomotion. It is critical in bending and lifting operations involving the lower torso and limbs, especially in consideration of shifting gravitational forces.

It is through these joints that the collective weight of the torso, upper limbs, and head is transferred to the femora of the lower limbs. As you can see, the triangular sacrum wedges in between the two ilia of the hip bones to form the left and right sacroiliac (SI) joints. Note that this joint has both cartilaginous and bony/fibrous surfaces (frontal section and medial view). In effect, the sacrum is a keystone in an arch that consists of the **sacrum**, two hip (pelvic) bones, and two lower limbs. The functional difference between this living arch and the early Roman masonry arch is simply human locomotion. Take out the keystones of these ancient arches, and the arches would come tumbling down; loosen or irritate the sacroiliac ligaments or the SI joint, subject the SI joints to an imbalance of muscular forces, and there would be a net effect of some serious, painful instability and reduced locomotion. Hence, the common complaint: "Oh, my aching sacroiliac!"

The plane of each SI joint is essentially sagittal. The anterior aspect of the articular surface of each bone is ear-shaped (**auricular**) and cartilaginous; the posterior surfaces (iliac/sacral tuberosities) are rough and to the surface of each bone are attached the **posterior** and **interosseous sacroiliac ligaments** (see frontal section and lateral/medial views at upper right). Contained in one joint capsule on each side, the SI joints allow a degree of gliding and rotational movements. This motion may be increased during pregnancy. In the final analysis, SI movement is sharply limited by the irregularity of the articular surfaces and by the dense, thick posterior sacroiliac, the interosseous ligament, and the thinner anterior sacroiliac ligaments. The SI joint is subject to early degeneration, more so in men. The joint degenerates and ossifies in later years. In such cases, any movement at the joint is unlikely.

The hip joint is a ball and socket, synovial joint between the **acetabulum** of the **hip bone** and the head of the **femur**. The joint permits flexion, extension, adduction, abduction, medial and lateral rotation, and circumduction. Each joint surface is lined with **articular cartilage**; that of the acetabulum is C-shaped. The incomplete bony socket of the acetabulum is completed by the transverse acetabular ligament and is enhanced by a 360° fibro-cartilaginous labrum. The joint is encapsulated; the three strong iliofemoral, ischiofemoral, and pubofemoral ligaments reinforce the fibrous capsule. Arising within the acetabulum between the arms of the acetabular cartilage is the ligament of the head of the femur (ligamentum teres). It offers little resistance to forced distraction, but it does transmit vessels to the femoral head. An adequate blood supply to the joint requires both femoral circumflex vessels in addition to the vessels in the **ligamentum teres**.

SACROILIAC & HIP JOINTS

CN: (1) Color the upper 2 illustrations. At upper left, note the auricular surface of the sacrum, C, through a cut-out of the ilium, A . The "window frame" reflects the frontal section through the sacroiliac joint on the right. (2) Color the large center illustration and the two inset views; correlate these views with the frontal view. (3) Finish with the lower two figures.

HIP BONE & SACRUM
(Right lateral surface))

FRONTAL SECTION

Anterior sacroiliac ligament

Ilium

Sacrum

Anterior sacroiliac ligament

Greater sciatic foramen

SACROILIAC JOINT

SACRUM B
AURICULAR
HYALINE CARTILAGE C

HIP BONE A
AURICULAR FIBRO-
CARTILAGE C'
SYNOVIAL CAVITY D•
INTEROSSEOUS
SACROILIAC
LIGAMENT E

SACROILIAC JOINT

LATERAL / ANTERIOR VIEW

Sacral tuberosity

Iliac tuberosity

Auricular surface ("ear-shaped")

MEDIAL VIEW

Ilium

Ilium

Posterior inferior iliac spine

Ilium

L 5

SACROILIAC JOINT

ACETABULUM *

HIP JOINT

Greater trochanter

Ilium

Head

Neck

Pubis

Ischium

Transverse acetabular lig.

Lesser trochanter

Line of joint capsule attachment

HIP JOINT

HIP BONE A
ACETABULUM *
ACETABULAR LABRUM F
ARTICULAR CARTILAGE C²
SYNOVIAL MEMBRANE G
LIGAMENTUM TERES H
SYNOVIAL CAVITY D•
FEMUR I
ARTICULAR CARTILAGE C³
JOINT CAPSULE K

HIP JOINT
(Lateral/anterior view)

FRONTAL SECTION OF JOINT

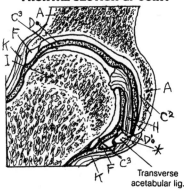

Transverse acetabular lig.

The **femur** is the bone of the thigh; the bones of the leg are the *tibia* and *fibula.* This may be confusing for those who, in the past, have referred to their entire dependent lower limb as the "leg." The greater and lesser trochanters are the site of insertion of muscles of the hip. The formation of these trochanters was influenced by the muscles pulling on them during the immature years. The shaft, gently curved anteriorly along its length, is rounded circumferentially, except posteriorly where a ridge (linea aspera) forms along the long axis of the bone and gives origin to and receives the insertions of a number of muscles. Distally, the shaft widens to form the massive femoral condyles that articulate with the tibial condyles at the knee joint. The **patella** articulates with the cartilage of the femur between the two condyles. It is a sesamoid bone that develops within the tendon of the quadriceps femoris.

The **tibia** is the major weight-bearing bone of the leg. It is the only bone of the leg that contributes to the knee joint. This stout bone has large slightly concave condyles proximally that articulate with the more rounded femoral condyles. The palpable tibial tubercle just distal to the condyles receives the patellar ligament. The tibial shaft is triangular in cross section; the apex is the sharp anterior border (shin), easily palpated. The anteromedial surface is barren of muscle; the anterolateral surface is muscle-covered. The expanded, distal extent of the tibia has a slightly concave horizontal surface for articulating with the more rounded talus of the ankle. The short vertical portion is quite palpable as the medial malleolus which also articulates with the talus (see page 40). Soon you will be seeing the muscles that balance the body mass on the single tibiotalar joint when standing on one leg!

The **fibula,** not directly weight-bearing, is a site of muscular attachment along the upper two-thirds of its shaft. Its head joins with the underside of the lateral tibial condyle (proximal tibiofibular joint; synovial; plane type). The shaft of the fibula forms an *intermediate* tibiofibular joint (interosseous ligament; syndesmosis) with the shaft of the tibia. Distally, the fibula joins with the tibia (distal tibiofibular joint; syndesmosis). The lateral aspect of the fibula is the palpable lateral malleolus, which articulates with the talus. The distal extremities of the fibula and tibia form a joint with the talus (ankle or talocrural joint).

The knee joint is quite vulnerable to injury in rotation and abduction/adduction; not so much in flexion/extension. Its impoverished capacity for rotation spells trouble for many who like to display fancy footwork on the boards of a basketball court. Tendons and muscles crossing and moving the joint reinforce the ligamentous stabilizers of the knee. Fibrous expansions from the medial and lateral members of the quadriceps muscle merge with the fibrous capsule on each side of the patella to form the medial and lateral retinacula.

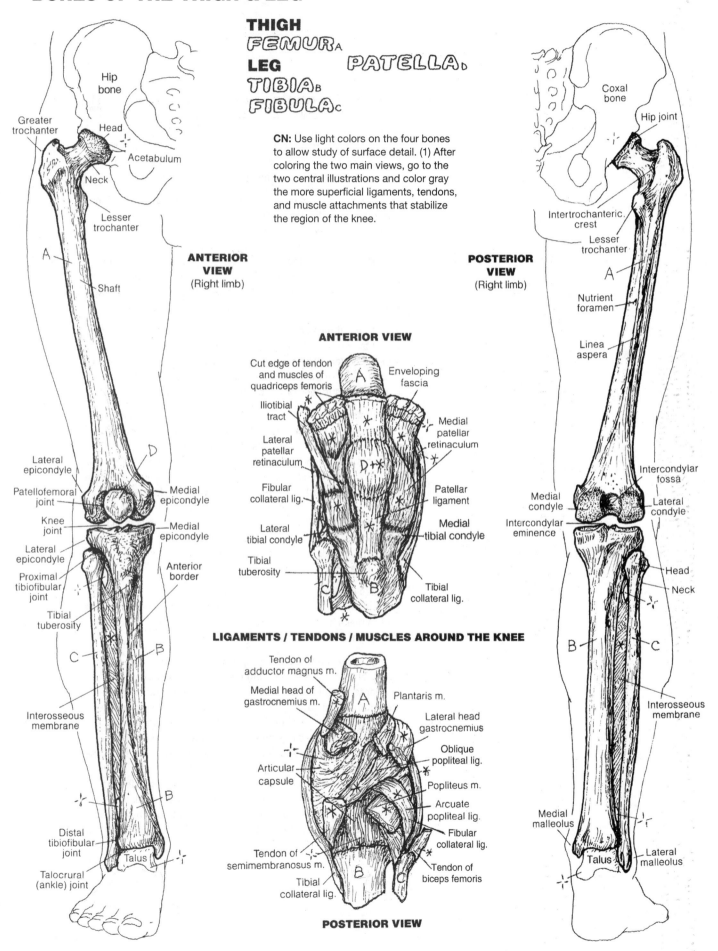

THIGH
*FEMUR*ₐ
LEG *PATELLA*ᴅ
*TIBIA*ʙ
*FIBULA*ᴄ

CN: Use light colors on the four bones to allow study of surface detail. (1) After coloring the two main views, go to the two central illustrations and color gray the more superficial ligaments, tendons, and muscle attachments that stabilize the region of the knee.

Hip bone
Greater trochanter
Head
Acetabulum
Neck
Lesser trochanter
A
Shaft

ANTERIOR VIEW
(Right limb)

Lateral epicondyle
Patellofemoral joint
Knee joint
Lateral epicondyle
Proximal tibiofibular joint
Tibial tuberosity
Medial epicondyle
Medial epicondyle
Anterior border
D
C
B
Interosseous membrane
B
Distal tibiofibular joint
Talus
Talocrural (ankle) joint

ANTERIOR VIEW

Cut edge of tendon and muscles of quadriceps femoris
Enveloping fascia
Iliotibial tract
Lateral patellar retinaculum
Medial patellar retinaculum
Fibular collateral lig.
Patellar ligament
Lateral tibial condyle
Medial tibial condyle
Tibial tuberosity
Tibial collateral lig.
A
D
C
B

LIGAMENTS / TENDONS / MUSCLES AROUND THE KNEE

Tendon of adductor magnus m.
Medial head of gastrocnemius m.
Plantaris m.
Lateral head gastrocnemius
Oblique popliteal lig.
Articular capsule
Popliteus m.
Arcuate popliteal lig.
Fibular collateral lig.
Tendon of semimembranosus m.
Tibial collateral lig.
Tendon of biceps femoris
A
B
C

POSTERIOR VIEW

Coxal bone
Hip joint
Intertrochanteric crest
Lesser trochanter
A
Nutrient foramen
Linea aspera

POSTERIOR VIEW
(Right limb)

Medial condyle
Intercondylar eminence
Intercondylar fossa
Lateral condyle
Head
Neck
B
C
Interosseous membrane
Medial malleolus
Talus
Lateral malleolus

The **knee joint** consists of two condylar synovial joints between the femoral and tibial condyles, and a gliding synovial joint between the patella and the femur. Note that the fibula and the tibiofibular joint are *not* part of the knee joint. The movements of the knee joint, consisting essentially of flexion and extension with varying degrees of rotation and gliding, can be seen on page 62.

In the sagittal view of the joint, note the **articular cartilage**-lined patellofemoral articulation. The patella is a sesamoid bone that develops in the tendon of the quadriceps femoris muscle. It resists wear-and-tear stresses on the tendon during knee flexion and extension. Note the two facets of the patella in the anterior view and the corresponding patellar articular surface on the femur. The various **bursae** shown are variable in size. The *suprapatellar bursa* is an extension of the synovial joint cavity.

The **fibrous (joint) capsule** is incomplete around the joint, reinforced by ligaments where absent or deficient and replaced by the patella anteriorly. The synovial membrane (not shown) lines the internal surface of the fibrous capsule; it does not cover the *menisci* and the joint surfaces or the posterior fibrous capsule.

The **menisci** can be seen from the side in the sagittal view and from above in the superior view of the joint. They are semilunar-shaped fibrocartilaginous discs attached to the tibial condyles by ligaments. They enhance the depth of fit of the femoral condyles. The ends of the menisci (horns) are attached in the tibial intercondylar region. These horns are richly innervated, a fact reinforced to one experiencing a painful tear of the posterior horn of the medial meniscus. The medial meniscus is more fixed on the tibia than is the lateral. Thus, it is less flexible and more easily torn during excessive rotation and forced abduction of the knee joint while bearing weight.

The knee joint is without bony security. It is, however, secured by ligaments and the tendons of the muscles that cross it. You might want to make a list of these muscles that cross the knee joint, gathering the information from these pages of illustration.

The ligaments are particularly important in limiting ranges of motion of the knee and securing the menisci. The **collateral ligaments** resist unwanted sideward movements at the knee. The **anterior cruciate** is named for its anterior **tibial attachment**, and the **posterior cruciate** for its posterior tibial connection. Proximally, they cross one another. The anterior cruciate passes *posteriorly and laterally* to end on the posteromedial aspect of the lateral femoral condyle; the posterior cruciate passes *anteriorly and medially* to end on the medial aspect of the medial femoral condyle. They essentially resist forward/backward displacement of the tibia/femur; indeed, a torn cruciate ligament generally results in excessive anteroposterior movements of the tibia on the femur.

KNEE JOINT

CN: The femur, tibia, fibula, and bony surface of the patella are not to be colored on this page. (1) In the sagittal section, color A blue and B black. The synovial membrane that lines the cavity is not shown. (2) In the anterior view below, note and color the articular facets, A, on the posterior surface of the patella. (3) Color the relationship between attachments and function of the cruciate ligaments, E and E[1].

JOINT STRUCTURES

ARTICULAR CARTILAGE_A
SYNOVIAL CAVITY_B•
JOINT CAPSULE_C
BURSA_D
CRUCIATE LIGAMENT
 ANTERIOR_E
 POSTERIOR_E'
MENISCUS
 LATERAL_F
 MEDIAL_F'
PATELLAR LIGAMENT_G
COLLATERAL LIGAMENT
 TIBIAL_H
 FIBULAR_H'

See 38

RIGHT KNEE JOINT

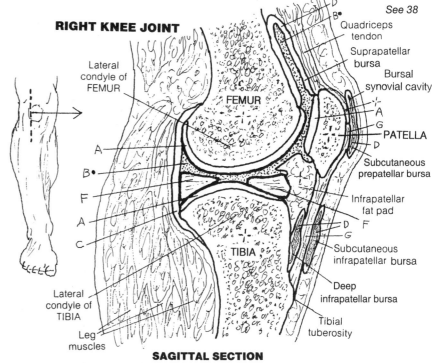

SAGITTAL SECTION

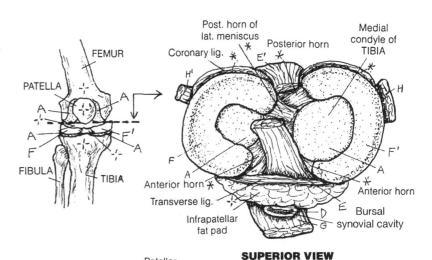

SUPERIOR VIEW

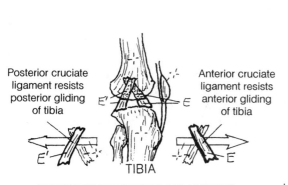

Posterior cruciate ligament resists posterior gliding of tibia

Anterior cruciate ligament resists anterior gliding of tibia

CRUCIATE "CROSSED" LIGAMENTS

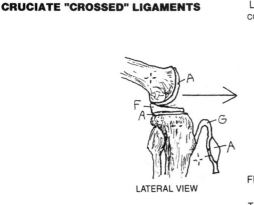

LATERAL VIEW

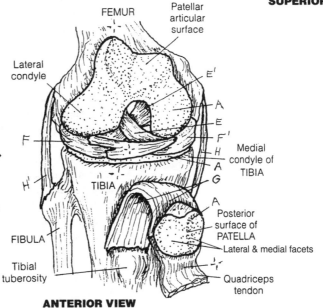

ANTERIOR VIEW
(Exposed joint)

The **foot** is a mobile, *weight-bearing* structure. To function dependably, the distal **tibia** and **fibula** (leg or crural bones) must be secured, and this is done by the *interosseous ligament (membrane)* between the tibial and fibular shafts, and the distal tibiofibular joint (syndesmosis) that effectively locks the distal fibula into the fibular notch of the tibia (not shown). The distal tibia and fibula form an inverted, U-shaped articular surface that accepts the head of the talus in a mortise-like configuration (talocrural joint). This is the **ankle joint** (a *hinge-type* synovial joint), and its structure permits only flexion (plantar flexion; toes down) and extension (dorsiflexion; toes up). Attempts to do otherwise may be met with pain and swelling (ankle sprain) or worse.

The foot is clinically described as the hindfoot (**calcaneu**s and **talus**), the midfoot (**navicular, cuboid, cuneiforms**), and the forefoot (**metatarsals** and **phalanges**). During running or walking, the movements of the joints of the hindfoot, midfoot, and forefoot do not operate in precisely the same vertical or sagittal plane.

Not all walking surfaces are flat; to be functional, the foot must adjust to tilted, uneven surfaces. Happily, the talocalcaneal (*subtalar*), talocalcaneonavicular and calcaneocuboid (*transverse tarsal*) joints accommodate such surfaces. The movements of the foot here are generally referred to as inversion and eversion of the subtalar and transverse talar joints. In inversion of the subtalar joint, invertor muscles pull the medial aspect of the foot upward; in eversion, evertor muscles pull the lateral aspect of the foot upward (pages 63 and 64). Due to the torqued construction of the foot, the actual movements are a shade more complicated. For example, when the hindfoot (tarsal bones) is inverted, the forefoot (metatarsals and phalanges) is everted, pronated, and abducted. When the hindfoot is everted, the forefoot is inverted, supinated, and adducted. Imagine that, if you will...practice the movements.

In the three views of the ankle ligaments, note those that seem prone to disruption with sideward (inversion/eversion) movements of the ankle. The ankle has strong medial ligamentous support (deltoid ligaments) and weaker lateral ligamentous support. The relatively high frequency of inversion sprains (tearing of the lateral ligaments) over eversion sprains seems to reflect this relative weakness.

The bony architecture of the foot includes a number of arches (domes and pillars) that are reinforced and maintained by ligaments and influenced by muscles during transfers of weight. With the feet placed side by side, the *transverse arch* is created by the bases of the metatarsals, the cuboid, and the cuneiforms. The anterior pillar of the largest arch (*medial longitudinal arch*) is the three metatarsal heads, the cuneiforms, and the navicular; the posterior pillar is the calcaneus. The keystone is the talus. The small *lateral longitudinal arch* has the lateral cuneiforms and cuboid as its anterior pillar, and the calcaneus as the posterior pillar. Both longitudinal arches function in absorbing shock loads, balancing the body, and adding "spring" to the gait.

ANKLE JOINT & BONES OF THE FOOT

ANKLE JOINT

*TIBIA*a *FIBULA*b *TALUS*c

BONES OF THE FOOT

7 TARSALS: *TALUS*c *CALCANEUS*d
*CUBOID*e *NAVICULAR*f *3 CUNEIFORMS*g
*5 METATARSALS*h
*14 PHALANGES*i

CN: (1) Color the names of the bones of the ankle joint at upper left. Then color the three bones of the ankle joint in the upper center illustration. The tibia and fibula are not colored elsewhere on this page. (2) Color the names of the bones of the foot and the bones wherever they appear on the page. (3) Color gray all of the ligaments and the arches shown in the lower part of the page.

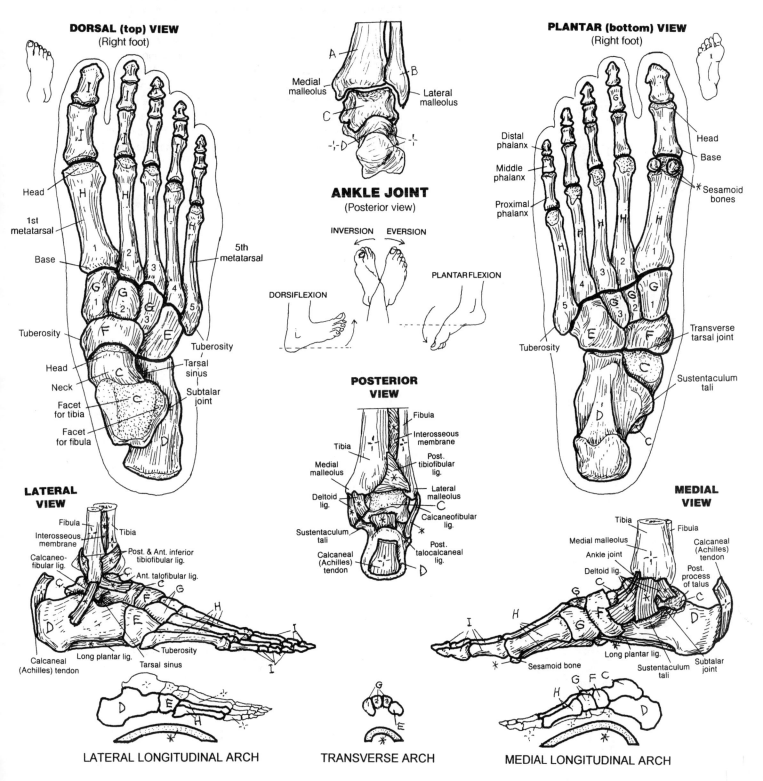

DORSAL (top) VIEW (Right foot)

Head
1st metatarsal
Base
Tuberosity
Head
Neck
Facet for tibia
Facet for fibula
5th metatarsal
Tuberosity
Tarsal sinus
Subtalar joint

ANKLE JOINT (Posterior view)

Medial malleolus
Lateral malleolus

INVERSION EVERSION
DORSIFLEXION PLANTAR FLEXION

POSTERIOR VIEW

Fibula
Interosseous membrane
Tibia
Post. tibiofibular lig.
Medial malleolus
Lateral malleolus
Deltoid lig.
Calcaneofibular lig.
Sustentaculum tali
Post. talocalcaneal lig.
Calcaneal (Achilles) tendon

PLANTAR (bottom) VIEW (Right foot)

Distal phalanx
Middle phalanx
Proximal phalanx
Head
Base
* Sesamoid bones
Tuberosity
Transverse tarsal joint
Sustentaculum tali

LATERAL VIEW

Fibula
Tibia
Interosseous membrane
Post. & Ant. inferior tibiofibular lig.
Calcaneo-fibular lig.
Ant. talofibular lig.
Calcaneal (Achilles) tendon
Long plantar lig.
Tarsal sinus
Tuberosity

MEDIAL VIEW

Tibia
Fibula
Medial malleolus
Calcaneal (Achilles) tendon
Ankle joint
Deltoid lig.
Post. process of talus
Long plantar lig.
Sesamoid bone
Sustentaculum tali
Subtalar joint

LATERAL LONGITUDINAL ARCH

TRANSVERSE ARCH

MEDIAL LONGITUDINAL ARCH

The structure of a part reflects an adaptation for function. This statement is borne out by comparing the bones of the **upper** and **lower limbs** in a biped (human) with those of a **quadruped** (in this case, a dog). The pectoral girdle provides a basis for mobility; the more sturdy pelvic girdle provides stability in both locomotion and weight bearing. The bones of the lower limb are large and solid, consistent with weight-bearing function; the related joints are structurally secure, except the knee, which gives up a degree of stability for flexibility. In the upper limb, the bones are lighter and the joints are more flexible and generally capable of greater ranges of motion (compare shoulder with hip, elbow with knee, wrist with ankle). Of course there are exceptions among those who have achieved unusual levels of physical skill. Although the forearm and leg each have two bones, there is little functional correlation between those pairs of bones. The ulna/radius permit significant movement at the wrist, and the tibia/fibula are more concerned with stability and weight bearing. The foot is clearly adapted for locomotion and weight bearing, the hand (especially the thumb) for mobility and dexterity.

BONES & JOINTS IN REVIEW

CN: Use light colors. (1) Color the bones of the lower limb. Write in their names with the same color. Repeat the process for the upper limb. (2) Color the arrows pointing to surface markings of the bones. (3) In black pencil, write the names of the joints of the lower limb. (4) Color the bones of the fore/hindlimbs of the quadruped. Bone names are the same as their human counterparts.

(See Appendix A for answers.)

A _____
B _____
C _____
D _____
E _____
F _____
G _____
H _____

UPPER LIMB

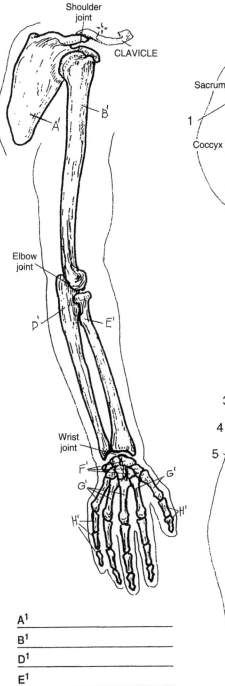

A¹ _____
B¹ _____
D¹ _____
E¹ _____
F¹ _____
G¹ _____
H¹ _____

LOWER LIMB

BONE SURFACE MARKINGS

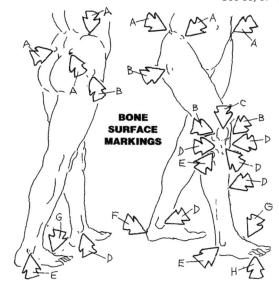

JOINTS OF THE LOWER LIMB

1 _____
2 _____
3 _____
4 _____
5 _____
6 _____
7 _____
8 _____
9 _____
10 _____
11 _____
12 _____

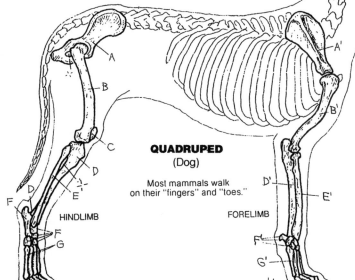

QUADRUPED
(Dog)

Most mammals walk on their "fingers" and "toes."

HINDLIMB

FORELIMB

SKELETAL MUSCLE

A typical **skeletal muscle** (e.g., biceps brachii) is a discrete entity, characterized by a muscle mass (**belly**) with fibrous **tendons** at each end. The muscle consists of **muscle cells** and three degrees of layers of protective connective tissue **coverings**. The muscle and its coverings are packaged in deep fascia along with other muscles and neurovascular bundles.

Each skeletal muscle is arranged into **fascicles**. The outer covering of the muscle is the fibrous **epimysium**. Each fascicle of the muscle is wrapped in a thinner fibrous tissue, **perimysium**, along with nerves, small arteries, and small veins (neurovascular bundles). These nerve fibers and small vessels branch off to reach individual muscle cells. Each muscle fiber is surrounded by a thin sheath of fibrous tissue (**endomysium**), which secures the important neurovascular structures for that muscle fiber. Each of these fibrous coverings contributes to ensuring the uniform distribution of muscle tension during contraction, and to maintaining the natural elasticity of muscle, permitting it to recoil to its resting length following stretching. The merging of these fibrous layers at the ends of the muscle fibers forms the *tendons* that integrate with and secure the muscle to its attachment site(s), such as the periosteum or another tendon.

MUSCLE LEVER SYSTEM

Skeletal muscles work like simple machines, such as levers, to increase the efficiency of their contractile work about a joint. Mechanically, the degree of muscular effort required to overcome resistance to movement at a **joint (fulcrum)** depends on: (1) the force of that **resistance (weight)**; (2) the relative distances from the anatomical fulcrum to the anatomical sites of *muscular effort;* and (3) the anatomical sites of *resistance* (joints). The position of the joint relative to the site of muscle pull and the site of imposed load determines the class of the lever system in use.

In a **1st class lever**, the joint lies between the muscle and the load. This is the most efficient class of lever.

In a **2nd class lever**, the load lies between the joint and the pulling muscle. This lever system operates in lifting a wheelbarrow (the wheel is the fulcrum) as well as lifting a 75 kg (165 lb) body onto the metatarsal heads at the metatarsophalangeal joints.

In a **3rd class lever**, the muscle lies between the joint and the load and gives little mechanical advantage.

INTRODUCTION TO SKELETAL MUSCLE

CN: The list of names of colorable structures for this page is arranged from large to small. *However, the coloring sequence is from small to large.* (1) Begin by coloring the muscle fiber, C, and its name, a moderately dark color. (2) Color the endomysial covering, C¹, of the muscle fibers a much lighter color than, C. (3) Color the endomysium in the cross sections of fascicles, avoiding the septa of perimysium, and then color over the cross sections again with the darker color of the muscle fibers. (4) Color the perimysium and its septa, B¹, a light color. (5) Color the epimysium of the muscle belly, A¹, a light color. (6) Color the muscle belly, A, and tendon, D, at the top of the page. (7) Color the lower illustrations of muscle lever systems in the body.

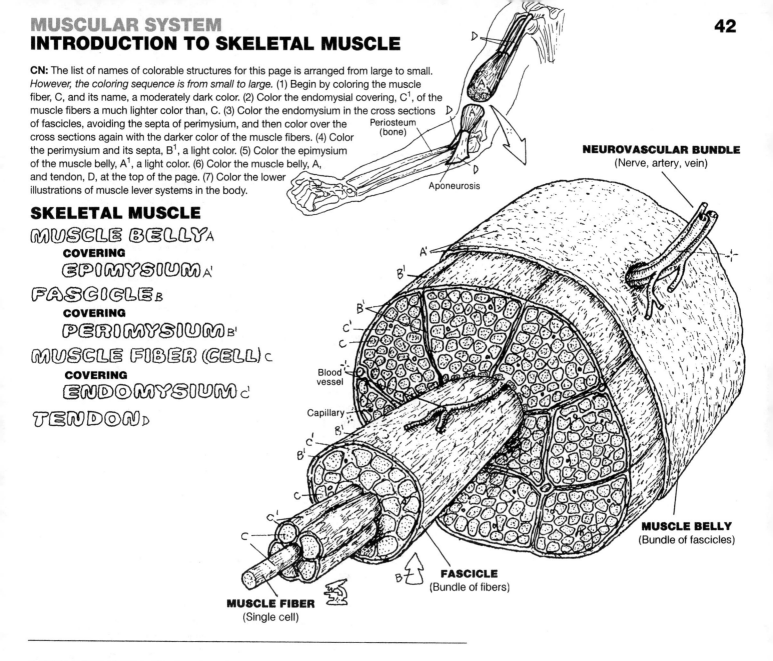

Periosteum (bone)

Aponeurosis

NEUROVASCULAR BUNDLE
(Nerve, artery, vein)

SKELETAL MUSCLE

MUSCLE BELLY A
COVERING
EPIMYSIUM A'
FASCICLE B
COVERING
PERIMYSIUM B'
MUSCLE FIBER (CELL) C
COVERING
ENDOMYSIUM C'
TENDON D

Blood vessel

Capillary

MUSCLE BELLY
(Bundle of fascicles)

FASCICLE
(Bundle of fibers)

MUSCLE FIBER
(Single cell)

MUSCLE LEVER SYSTEM

FULCRUM E (JOINT) E'
EFFORT A² (MUSCLE) A
RESISTANCE F (WEIGHT) F'

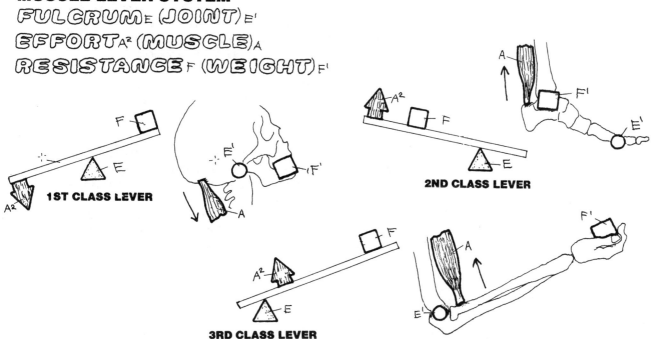

1ST CLASS LEVER

2ND CLASS LEVER

3RD CLASS LEVER

INTEGRATION OF MUSCLE ACTION

Here we investigate the simple case of flexing the elbow joint. The fixed (nonmoving) bone is the humerus; the moving bone is the radius. The muscle attachments at the fixed bone are the *origins* (O) of the muscles (biceps, triceps). The attachments at the moving bone are the *insertions* (I) of those muscles. Here, biceps is the **agonist (prime mover)** and triceps is the **antagonist** for the action of elbow flexion. Starting at a neutral position (center), contraction of the biceps brachii brings the hand closer to the shoulder. At the same time, the muscle triceps brachii stretches with some resistance (contraction) to accommodate the desired movement. With both sets of muscles at rest, the limb is said to be "neutral." In this situation, both biceps and triceps are relaxed with a mild degree of background muscle tone. Conversely, in elbow extension, the agonist shortens while the antagonist is **stretched**.

In summary, the prime mover is the primary muscle effecting a desired joint movement. Secondary movers in such a joint movement may be called **synergists**. Synergists often act as neutralizers, assisting intended movements or resisting unintended movements. Muscles opposing a prime mover's action are antagonists. **Fixators** serve to "fix" more proximal muscles to stabilize the background conditions for a specific joint movement, as trapezius is doing in the action at lower left and right. Agonists, synergists, antagonists, and fixators often work together to move a limb into a desired position (integration of muscle action).

ELBOW FLEXION, SUPINATION, & PRONATION OF THE FOREARM

Here we focus on four muscles that act on the right elbow joint and the proximal and distal radioulnar joints of a right-handed person in the act of holding up the right hand gripping a screwdriver and driving a screw clockwise into the frame of a door. In the first case (lower left illustration), the forearm is repeatedly supinated (and repeatedly pronated to return the forearm to a new starting point for each act of supination) as the screw is driven into the wood. Here biceps is the prime mover and supinator is a synergist in this action of supination. This is so because the rotation of the radius during supination puts tension on the insertion of biceps brachii, inducing its contraction in the face of the desired action (supination). Biceps is stronger than supinator. Test this on yourself: as you supinate the forearm, feel biceps contract.

In the second case (lower right illustration) the forearm is pronated repeatedly which backs the screw out of the wood. Pronation of the forearm is the weaker of the two rotational actions. Contraction of biceps is limited when supination of the forearm is resisted by pronator teres and pronator quadratus. Try it. If pronation is the weaker action, isn't it possible one can't get the screw out? Nah...bring in the cordless impact driver, and click it in reverse.

CN: (1) Color the names at upper right, and relate them to the small arrows A and C, the large outline letters O and I, and the flexor and extensor muscles of the elbow joint. Note the directions of the arrows. Color left to right. The relaxed muscles of a neutral elbow have a degree of tension (tone) even though they are relaxed. (2) Color the muscle actor names A[1] to E relating to supination and pronation of the forearm and apply those colors to the muscles in the two lower illustrations.

MUSCLE ACTION

CONTRACTED A
RELAXED B
STRETCHED C

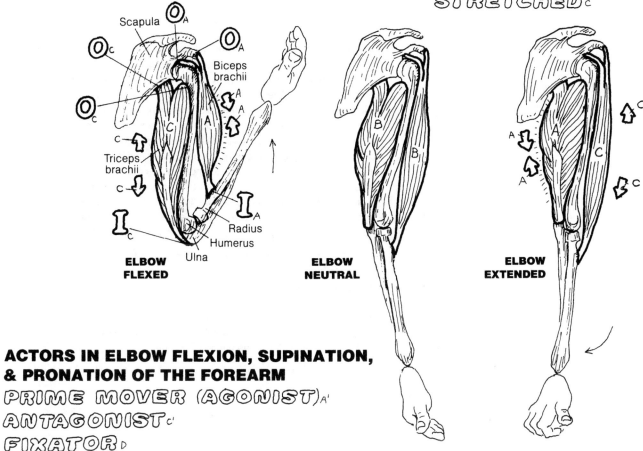

ELBOW FLEXED

ELBOW NEUTRAL

ELBOW EXTENDED

Scapula

Biceps brachii

Triceps brachii

Radius

Humerus

Ulna

ACTORS IN ELBOW FLEXION, SUPINATION, & PRONATION OF THE FOREARM

PRIME MOVER (AGONIST) A'
ANTAGONIST C'
FIXATOR D
SYNERGIST E

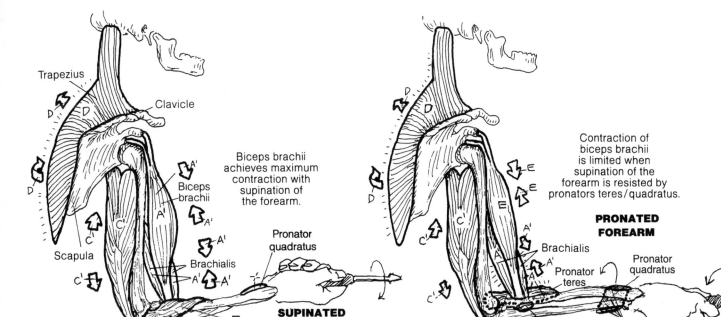

Trapezius

Clavicle

Biceps brachii achieves maximum contraction with supination of the forearm.

Biceps brachii

Scapula

Brachialis

Pronator quadratus

SUPINATED FOREARM

Supinator

Contraction of biceps brachii is limited when supination of the forearm is resisted by pronators teres/quadratus.

PRONATED FOREARM

Brachialis

Pronator teres

Pronator quadratus

Insertion of brachialis

The **muscles of facial expression** are generally thin, flat bands arising from a facial bone or cartilage and inserting into the dermis of the skin or the fibrous tissue enveloping the sphincter muscles of the orbit or mouth. These muscles are generally arranged into the following regional groups: (1) the epicranial group (*occipitofrontalis*, moving the scalp); (2) the orbital group (*orbicularis oculi*, **corrugator supercilii**); (3) the nasal group (*nasalis*, **procerus**); (4) the oral group (*orbicularis oris*, **zygomaticus major** and **minor**, the **levators** and the **depressors** of the lips and angles of the mouth, **risorius**, *buccinator*, and part of **platysma**); and (5) the group moving the ears (**auricular muscles**). The general function of each of these muscles is to move the skin wherever they insert. As you color each muscle, try contracting it on yourself while looking into a mirror.

The **orbicularis oculi** and **orbicularis oris** are sphincter muscles, tending to close the skin over the eyelids and tighten the lips, respectively. Contractions of the cheek muscle **buccinator** makes possible rapid changes in the volume of the oral cavity, as in playing a trumpet or squirting water. The **nasalis** muscle has both compressor and dilator parts, which influence the size of the anterior nasal openings (as in the flaring of nostrils).

The muscles of facial expression are innervated by the 7th cranial or facial nerve (page 83).

CN: Use your lightest colors for O and Q. Use cheerful colors for names and muscles on the cheerful side and sad colors for the names and muscles on the non-smiling side. (1) Begin with the smiling side (muscles A-H). (2) Color the names and muscles on the sad side. (3) Color the names and muscles in the profile view below.

"CHEERFUL" MUSCLES

ORBICULARIS OCULI_A

NASALIS_B

LEVATOR LABII SUPERIORIS ALAEQUE NASI_C

LEVATOR LABII SUPERIORIS_D

LEVATOR ANGULI ORIS_E

ZYGOMATICUS MAJOR_F

ZYGOMATICUS MINOR_G

RISORIUS_H

"SAD" MUSCLES

FRONTALIS_I

CORRUGATOR SUPERCILII_J

ORBICULARIS ORIS_K

DEPRESSOR ANGULI ORIS_L

DEPRESSOR LABII INFERIORIS_M

MENTALIS_N

PLATYSMA_O

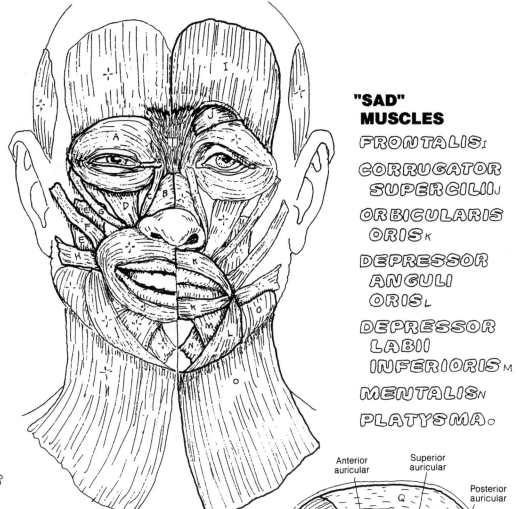

ADDITIONAL MUSCLES

BUCCINATOR_P

GALEA APONEUROTICA_Q

OCCIPITALIS_R

AURICULAR MUSCLES_S

PROCERUS_T

Mastication is the act of chewing. The **muscles of mastication** move the temporomandibular joint and are largely responsible for elevation, depression, protrusion, retraction, and lateral motion of the mandible. These muscles function bilaterally to effect movements of the single bone (mandible) at two joints. Chewing motions are a product of the action of the elevator muscles (*temporalis* and *masseter*) on one side combined with the contraction of the *lateral pterygoid* muscle on the opposite side.

In studying the origins and insertions of these muscles, make use of the smaller illustrations as well as the larger views above to get the full picture.

Note the insertion of temporalis on the anterior border of the coronoid process and the anterior ramus of the **mandible** in the "Elevation" and "Retraction" illustrations.

The origin of **masseter** is best seen in the upper left "superficial" view, under "Muscles of Mastication"; this muscle arises from the anterior surface of the lower border of the zygomatic arch (represented by the grainy site of origin labeled "Origin of masseter m."). Masseter also arises from the deep (medial) surface of the zygomatic arch. This muscle essentially inserts on the entire lateral surface of the coronoid process of the mandible as well as the upper half of the ramus.

The **temporalis** and *masseter* **muscles** are often contracted unconsciously (clenching teeth) during stress, giving rise to potentially severe bitemporal and preauricular headaches. The muscles can easily be palpated when contracted. The masseter is easily palpated on the external surface of the ramus of the mandible. Place your fingers there and then contract the muscle (clench your teeth). The temporalis, in contrast, inserts on the internal surface of the coronoid process and is best be palpated at the side of the head. Its dense fascia prevents the bulging you experienced with the masseter.

The **medial** and **lateral pterygoids** are in the infratemporal fossa and cannot be palpated.

The muscles of mastication are all innervated by branches of the fifth cranial nerve (trigeminal) mandibular division.

CN: Use a yellowish "bone" color for the mandible, E. (1) Begin with the upper left illustration and proceed to the two dissected views exposing the deeper muscles of mastication. On the smaller skull, two colors A + E are needed to indicate the insertion of temporalis on the deep side of the mandible. Three colors A + B + E are needed to color the part of the external surface where the broad insertion of the masseter also covers part of the representation of the temporalis on the underside. (2) Color the directional arrows and the muscles that move the mandible.

MUSCLES *See 24, 44*

*TEMPORALIS*ᴀ
*MASSETER*ʙ
*MEDIAL PTERYGOID*ᴄ
*LATERAL PTERYGOID*ᴅ

BONE

*MANDIBLE*ᴇ

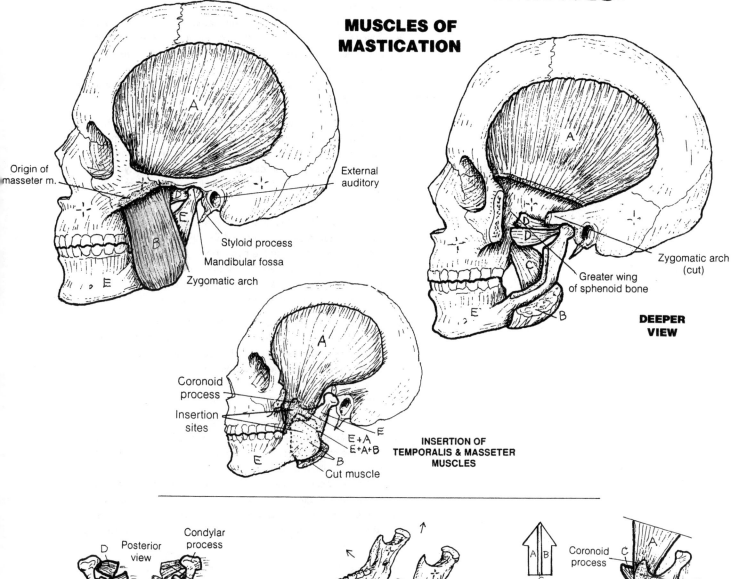

MUSCLES OF MASTICATION

Origin of masseter m.

External auditory

Styloid process

Mandibular fossa

Zygomatic arch

DEEPER VIEW

Zygomatic arch (cut)

Greater wing of sphenoid bone

Coronoid process

Insertion sites

E+A
E+A+B

Cut muscle

INSERTION OF TEMPORALIS & MASSETER MUSCLES

ACTION OF MUSCLES ON MANDIBLE

Posterior view

Condylar process

LATERAL

ELEVATION

Coronoid process

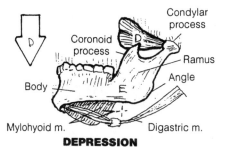

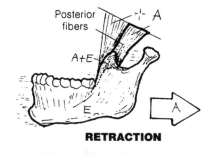

PROTRUSION

Posterior fibers

RETRACTION

Condylar process

Coronoid process

Ramus

Angle

Body

Mylohyoid m.

Digastric m.

DEPRESSION

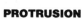

The neck is a complex tubular region of muscles, viscera, vessels, and nerves surrounding the cervical vertebrae. The muscles of the neck are arranged in superficial and deep groups. Here we will concentrate on the superficial muscles. The trapezius is not to be colored as it is not in the anterior and lateral regions of the neck; it is, however, the most superficial posterior and posterolateral muscle of the neck (page 52). The deep posterior muscles are covered on page 47. The platysma is the most superficial anterior muscle of the neck (page 44). The *sternocleidomastoid muscle* divides the anterior and lateral muscle groups into triangular areas.

The anterior region of the neck is divided in the midline; each half forms an **anterior triangle**. The borders of the anterior triangle of superficial neck muscles are illustrated. The **hyoid bone**, suspended from the styloid processes of the skull by the **stylohyoid** ligaments, divides each anterior triangle into upper *suprahyoid* and lower *infrahyoid* regions.

The **suprahyoid muscles** arise from the tongue (glossus), mandible (**mylo-, genio-,** anterior **digastric**), and skull (stylo-, posterior digastric) and insert on the hyoid bone. They elevate the hyoid bone, influencing the movements of the floor of the mouth and the tongue, especially during swallowing. With a fixed hyoid, the suprahyoid muscles, especially the digastrics, depress the mandible.

The **infrahyoid muscles** generally arise from the sternum, thyroid cartilage of the larynx, or the scapula (*omo-*) and insert on the hyoid bone. These muscles partially resist elevation of the hyoid bone during swallowing. The **thyrohyoid** elevates the larynx during production of high-pitched sounds; the **sternohyoid** depresses the larynx to assist in production of low-pitched sounds.

The **posterior triangle** consists of an array of muscles covered by a layer of deep (investing) cervical fascia just under the skin between the sternocleidomastoid and trapezius. The borders of the triangle are illustrated. Muscles of this region arise from the skull and cervical vertebrae; they descend to and insert upon the upper two ribs (**scalenes**), the upper scapula (**omohyoid, levator scapulae**), and the cervical/thoracic vertebral spines (**splenius capitis, semispinalis capitis**). These muscles' function becomes clear when you visualize their attachments.

The **sternocleidomastoid muscle**, acting unilaterally, tilts the head laterally on the same side while simultaneously rotating the head and pulling the back of the head downward, lifting the chin, and rotating the front of the head to the opposite side. Both muscle bellies acting together move the head forward (anteriorly) while extending the upper cervical vertebrae, lifting the chin upward.

ANTERIOR & LATERAL MUSCLES

CN: Except for the hyoid bone, E, use your lightest colors throughout the plate. (1) Begin with the diagrams of the triangles of the neck, A and C, and the sternocleidomastoid, B. Color over all the muscles within the triangles. (2) Then work top and bottom illustrations simultaneously, coloring each muscle in as many views as you can find it. Note the relationship between muscle name and attachment.

ANTERIOR TRIANGLE OF THE NECK

SUPRAHYOID MUSCLES

STYLOHYOID D'
DIGASTRIC D²
MYLOHYOID D³
HYOGLOSSUS D⁴
GENIOHYOID D⁵

HYOID BONE E

INFRAHYOID MUSCLES

STERNOHYOID F'
OMOHYOID F²
THYROHYOID F³
STERNOTHYROID F⁴

ANTERIOR TRIANGLE A

POSTERIOR TRIANGLE C

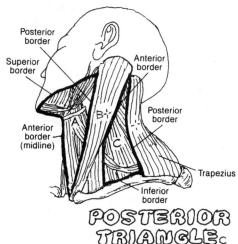

Posterior border
Superior border
Anterior border
Anterior border (midline)
Inferior border
Posterior border
Trapezius

POSTERIOR TRIANGLE OF THE NECK

SEMISPINALIS CAPITIS C'
SPLENIUS CAPITIS C²
LEVATOR SCAPULAE C³
SCALENUS ANTERIOR C⁴
SCALENUS MEDIUS C⁵
SCALENUS POSTERIOR C⁶

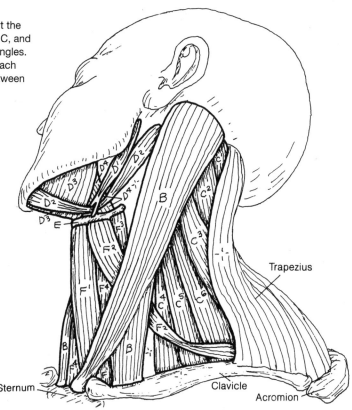

Trapezius
Sternum
Clavicle
Acromion

STERNOCLEIDOMASTOID B

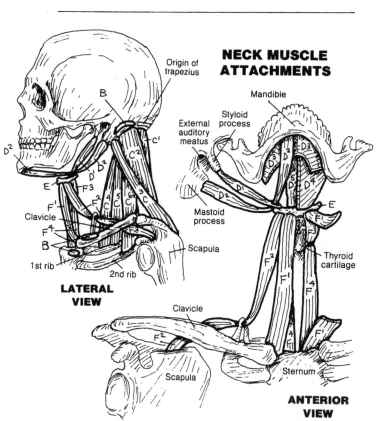

Origin of trapezius
B
Clavicle
1st rib
2nd rib
Scapula
LATERAL VIEW

NECK MUSCLE ATTACHMENTS

Mandible
Styloid process
External auditory meatus
Mastoid process
Scapula
Clavicle
Thyroid cartilage
Sternum
ANTERIOR VIEW

The **deep muscles of the back and posterior neck** extend, rotate, or laterally flex one or more of the 24 paired facet joints and the 22 intervertebral disc joints of the vertebral column. The long muscles move several motion segments (page 25) with one contraction, while the short muscles can move one or two motion segments at a time (see **intrinsic movers**).

The **splenius** muscles extend and rotate the neck and head in concert with the opposite sternocleidomastoid muscle which can be seen on page 46. The *splenius capitis* covers the deeper muscles of the upper spine.

The **erector spinae group** comprises the principal extensors of the vertebral motion segments. Oriented vertically along the longitudinal axis of the back, they are thick, quadrilateral muscles in the lumbar region, splitting into smaller, thinner separate bundles attaching to the ribs (**iliocostalis**), and upper vertebrae and head (**longissimus**, **spinalis**). The erector spinae muscles arise from the lower thoracic and lumbar spines, the sacrum, ilium, and intervening ligaments.

The **transversospinalis group** extends the motion segments of the back, and rotates the thoracic and cervical vertebral joints. These muscles generally run from the transverse processes of one vertebra to the spine of the vertebra above, spanning three or more vertebrae. The **semispinales** are the largest muscles of this group, reaching from mid-thorax to the posterior skull; the **multifidi** consist of deep fasciculi spanning 1–3 motion segments from sacrum to C2; the **rotatores** are well defined only in the thoracic region (the lumbar vertebrae, for the most part, do not rotate).

These small, deep-lying **(deepest) muscles** cross the joints of only one motion segment. They are collectively important for making small adjustments among the cervical and lumbar vertebrae. Electromyographic evidence has shown that these short muscles remain in sustained contraction for long periods of time during movement and standing/sitting postures. They are most prominent in the cervical and lumbar regions. The small muscles set deep in the posterior, suboccipital region (deep to semispinalis and erector spinae) rotate and extend the joints between the skull and C1 and C2 vertebrae.

Intrinsic movers are the small muscles that cross the joints of one motion segment, and include the deepest muscles noted above. These function in stabilization and facilitate getting proprioceptive information to the spinal cord and brain.

DEEP MUSCLES OF THE BACK & POSTERIOR NECK

CN: Use very light colors on the vertical, B–B³, and oblique, C–C³, muscle groups. Note that the splenius, A, and semispinalis, C, each have more than one part (e.g., cervicis, capitis); each is identified in the illustration. (1) Color the muscles of the main figure one group at a time. The function of these muscles is related to their orientation (vertical, oblique). (2) Color the suboccipital muscle group, F, in the upper boxed inset along with the sites of origin of the overlying muscles. (3) Color the intrinsic movers and their names below.

COVERING MUSCLE
SPLENIUS A

VERTICAL MUSCLES
ERECTOR SPINAE B
SPINALIS B'
LONGISSIMUS B²
ILIOCOSTALIS B³

OBLIQUE MUSCLES
TRANSVERSOSPINALIS GROUP
SEMISPINALIS C
MULTIFIDUS C'
ROTATORES C²

DEEPEST MUSCLES
INTERTRANSVERSARII D
INTERSPINALIS E
SUBOCCIPITAL MUSCLES F

INTRINSIC MOVERS
EXTENSOR E
ROTATOR C³
LATERAL FLEXOR D

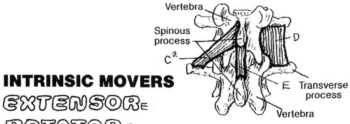

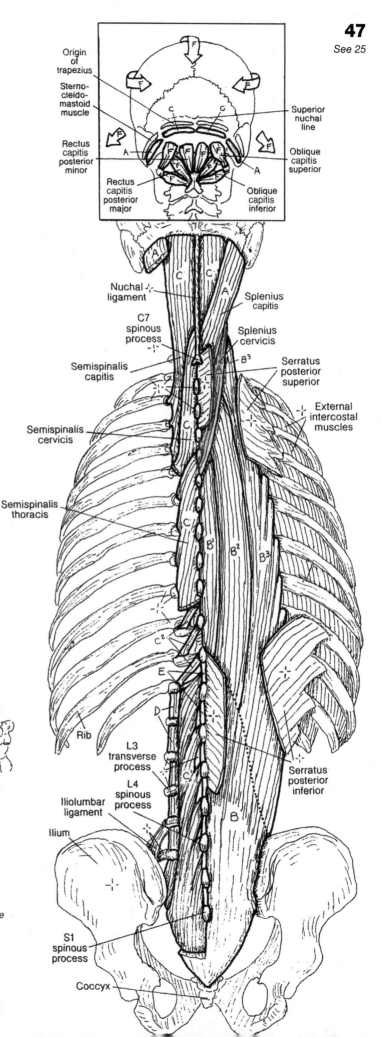

The thoracic diaphragm is a broad, thin muscle spanning the thoracoabdominal cavity, arising posteriorly from the lumbar vertebrae as muscular crura and aponeurotic arches (lumbar part), from the internal surfaces of the lower six ribs and costal cartilages (costal part), and from the internal surface of the xiphoid process (sternal part); these muscular fibers converge toward the center forming a great musculotendinous oval dome of which the top is the tendinous insertion known as the *central tendon.* At the level of T12, the descending thoracic aorta courses posterior to the diaphragm through the aortic hiatus (foramen) to become the abdominal **aorta.** The azygos vein and the thoracic duct have been known to pass through this hiatus as well. The esophageal hiatus can be found at the level of T10 among the fibers of the right crus as it joins the central tendon. It transmits the right and left vagal nerves as well as the **esophagus.** The **inferior vena** passes through a tendinous hiatus/foramen in the central tendon. The function of the thoracic diaphragm is shown on page 133.

The diaphragm is innervated by the phrenic nerve (C3–C5). How is it that the thoracic diaphragm is supplied by branches of the cervical plexus (of the neck)? Hint: look to embryology.

The **intercostal muscles,** primarily the **external** and **internal intercostals,** alter the dimensions of the thoracic cavity by collectively moving the ribs, resulting in 25% of the total respiratory effort. The **innermost intercostals** are an inconstant layer and here include the transversus thoracis and subcostal muscles.

Below the level of the **12th rib,** the *quadratus lumborum* and the **psoas** (so-az) **major** and **minor** muscles of the posterior abdominal wall span the posterior lumbar gap from the diaphragm to the iliac crests bilaterally. The psoas major and minor are muscles of the lower limb. The major arises from the transverse processes of T12 and the lumbar vertebrae as well as the bodies of the lumbar vertebrae; it passes under the inguinal ligament to join with the fibers of the **iliacus,** converging to a single insertion (**iliopsoas**) on the lesser trochanter of the femur. The iliacus primarily arises from the iliac fossa. The iliopsoas, a strong flexor of the hip joint, is a powerful flexor of the lumbar vertebrae; a weak psoas may contribute to low back pain. The **quadratus lumborum** arises from the posterior iliac crest and inserts on the lower part of the 12th rib and the transverse processes of the upper four lumbar vertebrae. It is an extensor of the lumbar vertebrae bilaterally and a lateral flexor unilaterally.

MUSCLES OF THE BONY THORAX & POSTERIOR ABDOMINAL WALL

CN: Use blue for E, red for G. Color all names as you color the related structures. (1) On the left, color the diaphragm on the posterior abdominal wall to the 12th rib. (2) Color the back of the diaphragm, its lighter central tendon of insertion, and the paired 12th ribs (posterior view). To its left, color the side view of the curved diaphragm between xiphoid and the 12th rib; color its passengers E, F, and G. (3) Color the intercostal muscles at upper right.

MUSCLES OF THORACIC WALL

THORACIC DIAPHRAGM A
EXTERNAL INTERCOSTAL B
INTERNAL INTERCOSTAL C
INNERMOST INTERCOSTAL D

INFERIOR VENA CAVA E
ESOPHAGUS F
AORTA G

12TH RIB M

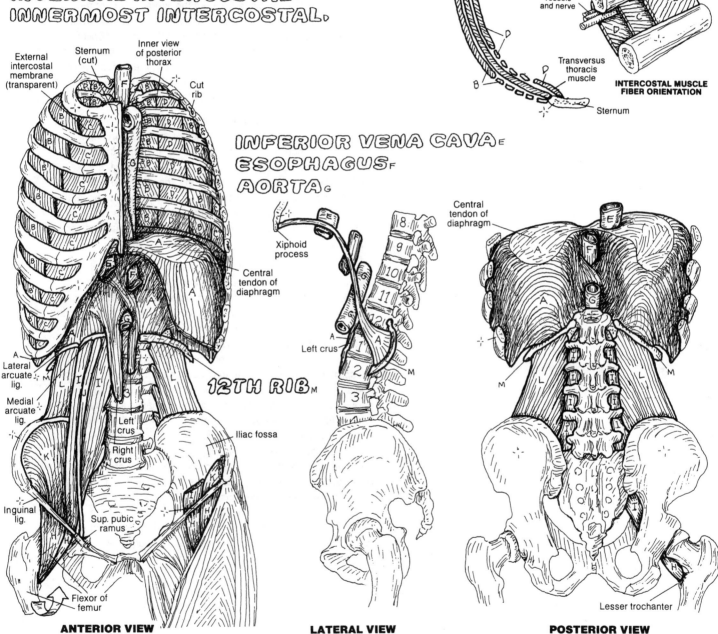

INTERCOSTAL MUSCLES

CROSS SECTION AT LEVEL T5 (Ribs removed)

Subcostal muscle

Intercostal membrane (transparent)

5th thoracic vertebra

Cut rib

Intercostal vessels and nerve

Transversus thoracis muscle

INTERCOSTAL MUSCLE FIBER ORIENTATION

Sternum

External intercostal membrane (transparent)

Sternum (cut)

Inner view of posterior thorax

Cut rib

Xiphoid process

Central tendon of diaphragm

Central tendon of diaphragm

Lateral arcuate lig.

Medial arcuate lig.

Left crus

Right crus

Iliac fossa

Left crus

Inguinal lig.

Sup. pubic ramus

Flexor of femur

Lesser trochanter

ANTERIOR VIEW **LATERAL VIEW** **POSTERIOR VIEW**

POSTERIOR ABDOMINAL WALL MUSCLES

ILIOPSOAS H
PSOAS MAJOR I MINOR J
ILIACUS K
QUADRATUS LUMBORUM L

The **anterior abdominal wall** consists of three layers of flat muscles: the **transversus abdominis**, the **internal oblique**, and the **external oblique**. The tendons (aponeuroses) of these muscles interlace in the midline, forming an incomplete sheath around a vertically oriented pair of segmented muscles (*rectus abdominis*). The left and right aponeuroses interlace in the midline (linea alba) The flat muscles arise bilaterally from the lateral aspect of the torso (*inguinal ligament*, iliac crest, thoracolumbar fascia, lower costal cartilages, ribs). The lowest fibers of the external oblique roll inward to form the *inguinal ligament*. These three muscles act to support the abdominal contents; compress the abdominal contents during expiration, regurgitation, urination, and defecation; and may indirectly facilitate flexion of the spine.

Each segmented **rectus abdominis muscle** arises from the pubic crest and tubercles and inserts on the lower costal cartilages and xiphoid process (sternum). Clearly, the sheath of the rectus becomes more superficial from below upward. Below the arcuate line, there is no posterior layer of the sheath; in the middle, all three flat aponeuroses contribute equally to the sheath above, the anterior sheath is formed from external oblique; posteriorly, the rectus contacts the costal cartilages. They are flexors of the vertebral column.

The **inguinal region** is the lower medial part of the abdominal wall, characterized by a canal with inner (deep) and outer (superficial) openings or rings. This canal carries the **spermatic cord** (ductus deferens and its vessels, testicular vessels, lymphatics) in the male and the round ligament of the uterus in the female. The testes and spermatic cords "descend" (by differential growth) into outpocketings of the anterior abdominal wall, collectively called the *scrotum*. In their descent, they push in front of them layers of fibers from the three flat muscles of the abdominal wall and their aponeuroses, much as a finger might push against four layers of latex to form a four-layered finger glove. These are the coverings of the cord: internal, cremasteric, and external spermatic fasciae. The lower fibers of the internal oblique are unique in that they continue in loops around the spermatic cord as the **cremaster muscle**; the two are connected by cremasteric fascia. The canal area is a weak point in the construction of the anterior abdominal wall, subject to protrusions of fat or intestine (hernias) from within the abdominal cavity, either directly through the wall (direct inguinal hernia) or indirectly through the canal (indirect inguinal hernia).

MUSCLES OF THE ANTERIOR ABDOMINAL WALL & INGUINAL REGION

CN: Use a dark color for J, a bright one for B, and a light one for I. (1) Color the three layers of the anterior abdominal wall above. (2) Color gray the sheath of the rectus abdominis, E, as well as the layers of the abdominal wall in the lower left illustration. (3) Beginning with J and K, and followed by H, color the coverings of the spermatic cord. Use different values of the same color for the epididymis and testis, K.

ANTERIOR ABDOMINAL WALL

TRANSVERSUS ABDOMINIS_A
RECTUS ABDOMINIS_B
INTERNAL OBLIQUE_C
EXTERNAL OBLIQUE_D

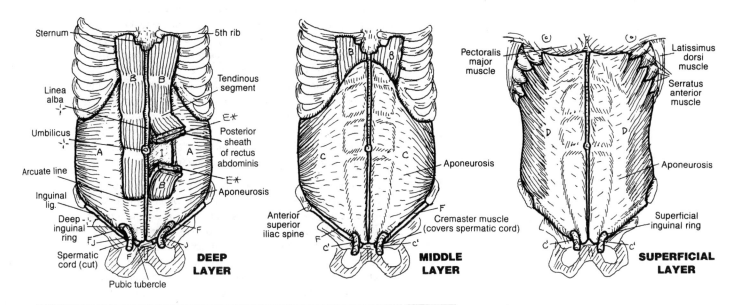

DEEP LAYER — Sternum, 5th rib, Tendinous segment, Linea alba, Umbilicus, Posterior sheath of rectus abdominis, Arcuate line, Aponeurosis, Inguinal lig., Deep inguinal ring, Spermatic cord (cut), Pubic tubercle

MIDDLE LAYER — Anterior superior iliac spine, Cremaster muscle (covers spermatic cord)

SUPERFICIAL LAYER — Pectoralis major muscle, Latissimus dorsi muscle, Serratus anterior muscle, Aponeurosis, Superficial inguinal ring

SHEATH OF RECTUS ABDOMINIS E*

Below arcuate line there is no aponeurotic sheath behind rectus

Inguinal canal, Superficial inguinal ring, Scrotum, Penis, Falx inguinalis (conjoint tendon), Deep inguinal ring

INGUINAL REGION

INGUINAL LIGAMENT_F
CREMASTER MUSCLE_{C'}
PYRAMIDALIS MUSCLE_G
PERITONEUM_H
TRANSVERSALIS FASCIA_I
SPERMATIC CORD_J
TESTIS / EPIDIDYMIS_K

Cord vessels, nerves, and ductus deferens

COVERINGS OF THE CORD — Internal spermatic fascia, Cremasteric fascia, External spermatic fascia, Superficial fascia, Epididymis, Skin and fat of scrotum, Dartos muscle

The muscles of the pelvis form the **pelvic floor** in the pelvic out-let *(coccygeus* and the *levator ani)* and contribute to the pelvic "wall" *(obturator internus, piriformis).* The **pelvic wall** includes part of the bony pelvis, and the **sacrotuberous** and **sacrospinous ligaments**. The fascia-covered pelvic floor muscles constitute the pelvic diaphragm, separating pelvic viscera from the perineal structures inferiorly. Like all muscular diaphragms (thoracic, uro-genital), it is a dynamic structure. It is also incomplete; posteriorly, the fusion of the two coccygeus muscles is interrupted by the coccyx and anteriorly the levator ani provides an opening (hiatus) for the anal canal, the vagina, and the urethra.

The **levator ani** arises anteriorly on each side from the pubic bone, the ischial spine, and the pelvic wall, where a thickening of the obturator fascia *(tendinous arch)* gives attachment to the levator ani. It droops downward as it passes toward the midline, and inserts on the anococcygeal ligament, the coccyx, and the contralateral levator ani. The muscle essentially has four parts: **levator prostatae/vaginalis, puborectalis, pubococcygeus, and iliococcygeus)**. The **coccygeus** is the posterior-most muscle of the pelvic floor; it is on the same plane as and immediately posterior to the iliococcygeus. The pelvic diaphragm counters abdominal pressure, and, with the thoracic diaphragm, assists in micturition, defecation, and childbirth. It is an important support mechanism for the uterus in resisting vaginal, bladder, and rectal prolapse.

The **obturator internus** is a lateral rotator of the hip joint. It arises, in part, from the margins of the obturator foramen on the pelvic side. It passes downward and posterolaterally past the obturator foramen to and through the lesser sciatic foramen, inserting on the medial surface of the greater trochanter of the femur.

The **piriformis** is a lateral rotator of the hip joint, arises from the sacral component of the pelvic wall, above and posterior to the obturator internus, and exits the pelvis through the greater sciatic foramen. The relationship of the piriformis to neighboring vessels, nerves, and tendons here can be learned from the Glossary; see Foramina, greater and lesser sciatic.

CN: Use light colors so as not to obscure detail and the identifying letters. (1) Color the pelvic diaphragm (pelvic floor) at upper left and the muscles that constitute it, as well as their names. (2) Color the muscles at upper right that make up the pelvic floor and walls, and their names at lower left. (3) Color the muscles in the middle tier. (4) Color the muscles in the three views below.

VIEW FROM ABOVE
(Male pelvis)

PELVIC DIAPHRAGM / FLOOR

LEVATOR ANI :-
 LEVATOR PROSTATAE / VAGINAE ᴀ
 PUBORECTALIS ʙ
 PUBOCOCCYGEUS ᴄ
 ILIOCOCCYGEUS ᴅ
COCCYGEUS ᴇ

PELVIC FLOOR & WALL
(Coronal section, anterior view)

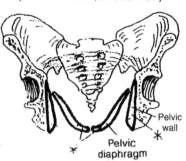

Pelvic wall *

Pelvic diaphragm *

VIEW FROM ABOVE
(Male pelvis)

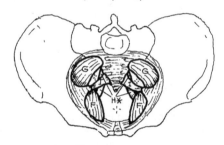

PELVIC WALL

OBTURATOR INTERNUS ꜰ
PIRIFORMIS ɢ
SACROTUBEROUS LIGAMENT ʜ*
SACROSPINOUS LIGAMENT ɪ*
TENDINOUS ARCH ᴊ

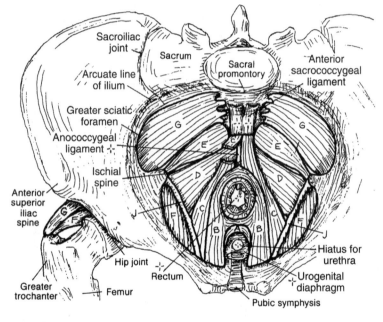

Sacroiliac joint
Sacrum
Sacral promontory
Anterior sacrococcygeal ligament
Arcuate line of ilium
Greater sciatic foramen
Anococcygeal ligament :-
Ischial spine
Anterior superior iliac spine
Hiatus for urethra
Urogenital diaphragm
Hip joint
Rectum :-
Greater trochanter
Femur
Pubic symphysis

VIEW FROM ABOVE
(Male pelvis)

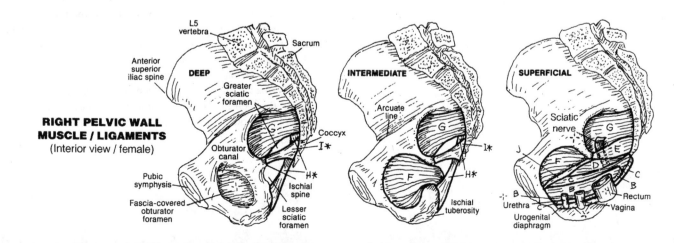

RIGHT PELVIC WALL MUSCLE / LIGAMENTS
(Interior view / female)

L5 vertebra
Sacrum
Anterior superior iliac spine
DEEP
Greater sciatic foramen
Coccyx
Obturator canal
I*
Pubic symphysis
Ischial spine
H*
Fascia-covered obturator foramen
Lesser sciatic foramen

INTERMEDIATE
Arcuate line
I*
H*
Ischial tuberosity

SUPERFICIAL
Sciatic nerve
Urethra
Urogenital diaphragm
Vagina
Rectum

The **perineum** is the region below the pelvic diaphragm within the outlet of the pelvis. The *perineal "floor"* is skin and fascia. Its superior border is the *pelvic diaphragm* and the *bilateral ischio-pubic rami* (see coronal section of the urogenital triangle). The perineum is bordered by the **symphysis pubis, ischiopubic rami, ischial tuberosities, sacrotuberous ligaments,** and **coccyx.** It is divided into urogenital and anal regions called triangles.

A triangular muscular diaphragm characterizes the **urogenital region (triangle).** It is attached bilaterally to the bony ischiopubic rami. The deep transverse perineal and external urethral sphincter muscles (not shown in detail), and their fasciae, largely make up this diaphragm. These muscles stabilize the perineal body, support the membranous urethra and prostate in the male and the urethra and vagina in the female.

The inferior fascial layer of this diaphragm (perineal membrane, I) is significantly thicker than the superior fascia; it gives attachment to the vagina and erectile bodies of the penis. Now correlate the coronal section through the urogenital triangle with the illustrations of the muscles of the female and male perinei at the bottom of the page.

The **superficial transverse perineal muscles** are attached to the posterior edge of the urogenital diaphragm, and support/fix the perineal body in both sexes. In the male, the **bulbospongiosus muscle** arises from the median raphe of the penis and the perineal body and inserts on the perineal membrane and the corpus spongiosum (erectile body). It assists in erection of the penis. The **ischiocavernosus muscles** largely arise from the ischiopubic rami and insert on the crura and corpora of the erectile corpora cavernosa (page 157).

The **perineal body** is composed of fibromuscular tissue and is situated between the anus and the vagina/bulb of the penis. It is the site of insertion of a number of muscles, including the levator ani, the external sphincter ani, and all the perineal muscles. It offers stability to the pelvic viscera, especially during childbirth. Disruption or tearing of the perineal body can lead to prolapse of the bladder or uterus through the vagina or ureth. The attachments of the superficial perineal muscles in the female are similar (with respect to the clitoris) but much reduced in size. The bulbospongiousus muscle arises from the perineal body, and splits to wrap around the bulb of the vestibule and the vagina; it also sends muscle fibers around the body of the clitoris (corpus clitoridis). The ischiocavernosus muscles arise from the ischiopubic rami and wrap around the crura of the corpus clitoridis (page 158).

The **anal triangle** contains the anal canal and orifice and supporting entourage: the **external sphincter ani muscle,** the **anococcygeal ligament** posteriorly, and the perineal body anteriorly. The cavity of this region—the *ischiorectal fossa*—is divided into two fossae separated by the anal canal and its muscle. These fossae are filled with adipose tissue (not shown) that can give way to an expanding anal canal during a voluminous defecation. The anterior recesses of the ischiorectal fossa pass deep to the **urogenital diaphragm.**

1) Color the names and the boundaries of the perineum above.
(2) Color the two upper triangular outlines, and the names and coronal section through the male urogenital region. (3) Color the names/components of the male/female urogenital regions in the perinei below. (4) Color the two lower triangular outlines and the related names. Color the anal triangles and their component structures in the perinei below.

PERINEUM ✳ (Boundaries)
SYMPHYSIS PUBIS_A
COCCYX_B
ISCHIAL TUBEROSITY_C
SACROTUBEROUS LIGAMENT_D
ISCHIOPUBIC RAMUS_E

BOUNDARIES OF THE PERINEUM
(Seen from below)

Pubic tubercle · A · Obturator foramen · Anterior superior iliac spine · Acetabulum · E · C · D · B

UROGENITAL TRIANGLE ✳¹
ISCHIOCAVERNOSUS M._F
BULBOSPONGIOSUS M._G
SUPERIOR TRANSVERSE PERINEAL M._H
UROGENITAL DIAPHRAGM_I

MALE — Urethra — ✳¹
FEMALE — Urethra — Vagina — ✳¹

UROGENITAL TRIANGLE
(Coronal section, male)

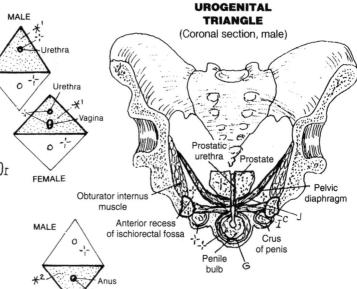

Prostatic urethra · Prostate · Pelvic diaphragm · Obturator internus muscle · Anterior recess of ischiorectal fossa · Penile bulb · Crus of penis · Pelvic diaphragm

ANAL TRIANGLE ✳²
LEVATOR ANI M._J
EXTERNAL SPHINCTER ANI M._K
ANOCOCCYGEAL LIGAMENT_L

MALE — Anus — ✳²
FEMALE — Anus — ✳²

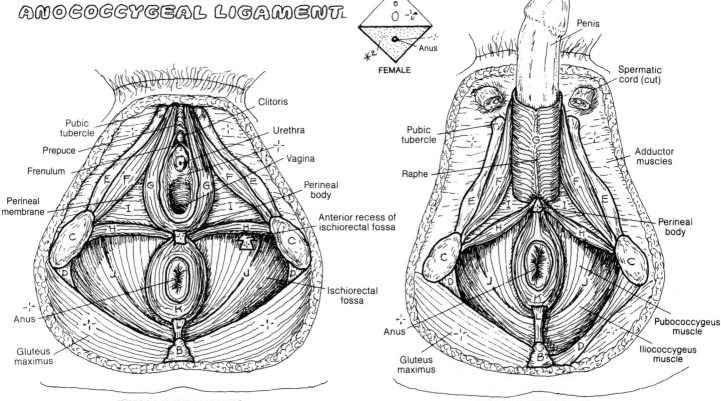

Clitoris · Pubic tubercle · Prepuce · Frenulum · Perineal membrane · Urethra · Vagina · Perineal body · Anterior recess of ischiorectal fossa · Ischiorectal fossa · Anus · Gluteus maximus

FEMALE PERINEUM

Penis · Spermatic cord (cut) · Pubic tubercle · Raphe · Adductor muscles · Perineal body · Pubococcygeus muscle · Iliococcygeus muscle · Anus · Gluteus maximus

MALE PERINEUM

The scapulae slide on the posterior thorax, roughly from T2 to T8. It has no direct bony attachment with the axial skeleton. Enveloped by muscle, it glides over the fascia-covered thoracic wall during upper limb movement (scapulothoracic motion). Bursae have been reported between the thorax and the scapula; so has bursitis. The scapula is dynamically moored to the axial skeleton by the six **muscles of scapular stabilization**. These muscles make possible considerable scapular mobility and, therefore, upper limb mobility. Note the roles of these six muscles in scapular movement and note how the shoulder and arm are affected. The **pectoralis minor** assists the **serratus anterior** in protraction of the scapula, such as in pushing against a wall; it also helps in depression of the shoulder and downward rotation of the scapula. Consider the power resident in the serratus anterior and *trapezius* in pushing or swinging a bat. Note the especially broad sites of attachment of the **trapezius** muscle. This muscle commonly manifests significant tension with hard work—mental or physical. A brief massage of the upper and mid back (trapezius) often brings quick relief.

MUSCLES OF SCAPULAR STABILIZATION

CN: (1) Color the muscles in the three main views, the nuchal ligament, and their names. (2) Color the insertion sites at upper right. (3) In the five illustrations below, note that three different parts of the trapezius, A, make possible different scapular movements. Color gray the scapulae and the direction-of-movement arrows.

MUSCLES

*TRAPEZIUS*ₐ
*RHOMBOID MAJOR*ᵦ *MINOR*ᵦ'
*LEVATOR SCAPULAE*c
*SERRATUS ANTERIOR*ᴅ
*PECTORALIS MINOR*ᴇ

ATTACHMENT SITES

Spine

Clavicle

Coracoid process

Posterior view

Anterior view

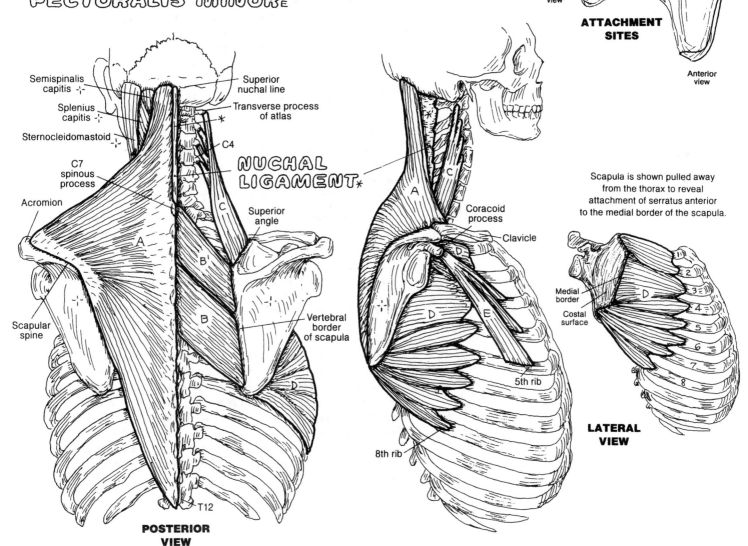

Semispinalis capitis

Splenius capitis

Sternocleidomastoid

C7 spinous process

Acromion

Scapular spine

Superior nuchal line

Transverse process of atlas

C4

NUCHAL LIGAMENT

Superior angle

Vertebral border of scapula

T12

POSTERIOR VIEW

Coracoid process

Clavicle

5th rib

8th rib

Scapula is shown pulled away from the thorax to reveal attachment of serratus anterior to the medial border of the scapula.

Medial border

Costal surface

LATERAL VIEW

MOVEMENTS OF THE SCAPULA

RETRACTION
Military posture ("squaring the shoulders")

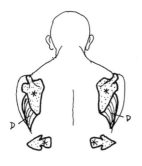

PROTRACTION
Pushing forward with outstretched arms and hands.

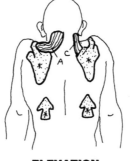

ELEVATION
Shrugging the shoulders or protecting the head.

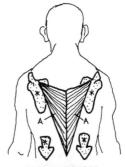

DEPRESSION
Straight arms on parallel bars, holding weight.

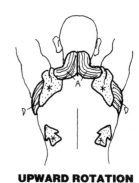

UPWARD ROTATION
Lifting or reaching over head.

The socket at the glenohumeral joint (glenoid fossa) is too shallow to offer any bony security for the head of the humerus. As ligaments would severely limit joint movement, muscle tension must be employed to pull the humeral head in to the shallow scapular socket during shoulder movements. Four muscles fulfill this function: the **supraspinatus**, **infraspinatus**, **teres minor**, and **subscapularis** ("SITS") muscles. These muscles form a musculotendinous cuff around the head of the humerus, enforcing joint security. Especially effective during robust shoulder movements, they generally permit the major movers of the joint to work without risking joint dislocation in normal, reasonable applications. Long-term abuse and overuse are quite another matter.

The **SITS muscles** have come to be known as the *rotator cuff muscles,* even though one of them, the supraspinatus, is an **abductor** of the shoulder joint and not a rotator. Indeed, among some health care providers, the supraspinatus is known as the *rotator cuff* in the context of a "rotator cuff tear."

The shoulder joint and the supraspinatus muscle/tendon are subject to early degeneration from overuse. The problem is generally one of impingement (chronic physical contact and friction) and degeneration among the acromion (1), the coracoacromial ligament (2), the distal clavicle and related acromioclavicular (AC) joint (3), the tendon of the supraspinatus as it passes under the acromion (4), and the subacromial bursa (5), which takes the heat of friction…to a point. Those with a down-turned acromion or a previously dislocated, offset acromioclavicular joint are especially vulnerable to impingement (supraspinatus tendinitis and subsequent tearing, subacromial bursitis, acromioclavicular joint degeneration, limitation of shoulder motion, and pain). All overhead activities (such as those of professional drapery hangers, ceiling plasterers, baseball pitchers, etc.) and acromial loading (hose-carrying firemen, those carrying heavy purses/bags by straps over the shoulder, mail delivery persons, etc.) if pursued over a sustained period, can induce changes (bony spurring, bursal destruction) with painful signs and symptoms.

CN: (1) Color the four muscles, their names, the open arrows, and the terms describing their actions. (2) Color the muscular attachment sites and the functional diagrams/arrows of these muscles at mid- and lower right. (3) Color the shoulder problem sites at the bottom of the page.

MUSCLES

SUPRASPINATUS ₐ

INFRASPINATUS ᵦ

TERES MINOR ᴄ

SUBSCAPULARIS ᴅ

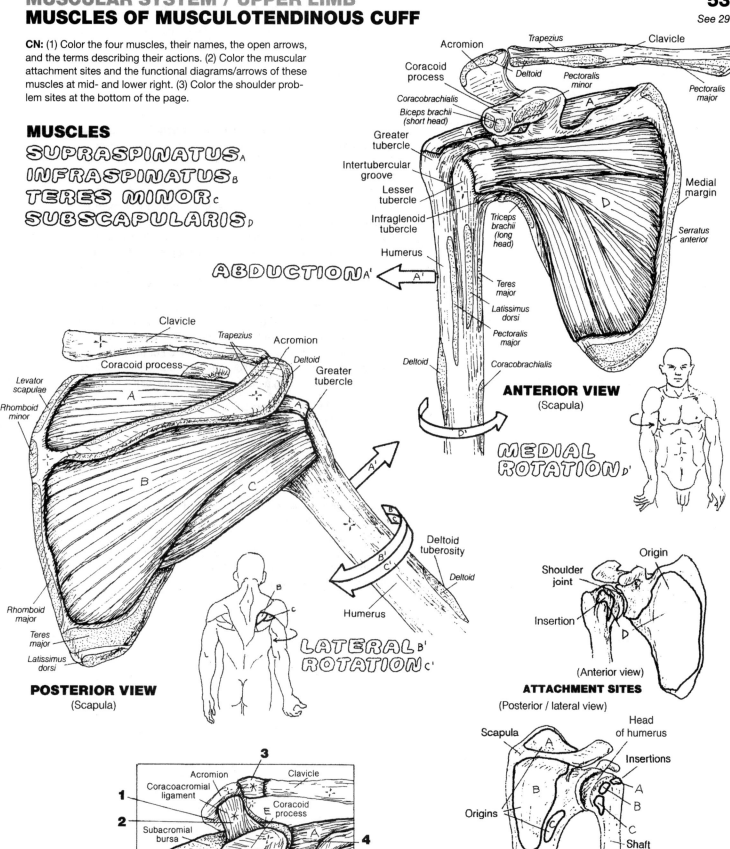

ABDUCTION ₐ'

ANTERIOR VIEW
(Scapula)

MEDIAL ROTATION ᴅ'

POSTERIOR VIEW
(Scapula)

LATERAL ROTATION ᴄ'

ATTACHMENT SITES
(Posterior / lateral view)

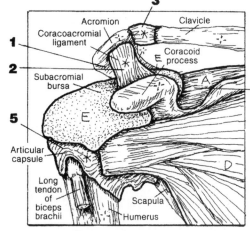

PROBLEM SPOTS IN
SHOULDER REGION
((Anterior view)

BURSA ᴇ
LIGAMENT *

The *principal movers* of the freely movable **shoulder (glenohumeral) joint** are shown here from three different views. They work in conjunction with the rotator cuff muscles to move the humerus powerfully in lifting, pushing, pulling, and twisting loads. The **deltoid**, characterized by a multipennate form of construction, a broad origin, and a remarkably short lever arm, is a powerful mover of the humerus in flexion, extension, and abduction. The anterior fibers of deltoid adduct the shoulder joint. The clavicular (upper) fibers of the **pectoralis major** are effective in flexing the shoulder joint; the sternal/abdominal (lower) fibers *extend* the *flexed* joint. Both are effective medial rotators as well.

The **teres major,** a muscle of the posterior shoulder, is a major medial rotator of the shoulder joint because its tendon of insertion is on the *anterior* aspect of the humerus; it therefore has an excellent mechanical advantage for this movement. For the same reason, the **latissimus dorsi** is also a medial rotator of the shoulder joint, in addition to being a major extensor of the joint.

Both heads of the **biceps brachii** are active in resisted flexion of the shoulder joint when the forearm is fixed and immobile. Otherwise, its chief function is supination of the forearm (see pages 43 and 55). Note that the biceps brachii has two insertions: one to the radial tuberosity and one to the deep fascia of the forearm by way of an aponeurosis (lacertus fibrosus).

The **coracobrachialis** is a relatively insignificant mover of the shoulder joint in flexion. It does function in shoulder adduction to a modest degree, due to its insertion into the medial border of the humerus. The **long head of the triceps brachii**, arising as it does from the infraglenoid tuberosity of the scapula, is a weak adductor and extensor of the shoulder joint.

DELTOID A. PECTORALIS MAJOR B.
LATISSIMUS DORSI C. TERES MAJOR D.
CORACOBRACHIALIS E. BICEPS BRACHII F.
TRICEPS BRACHII (LONG HEAD) G.

CN: (1) Begin with both posterior views; note that the biceps and triceps are not shown on the lateral view. (2) When coloring the muscles below, note the actions of different parts of the deltoid, A, and pectoralis major, B.

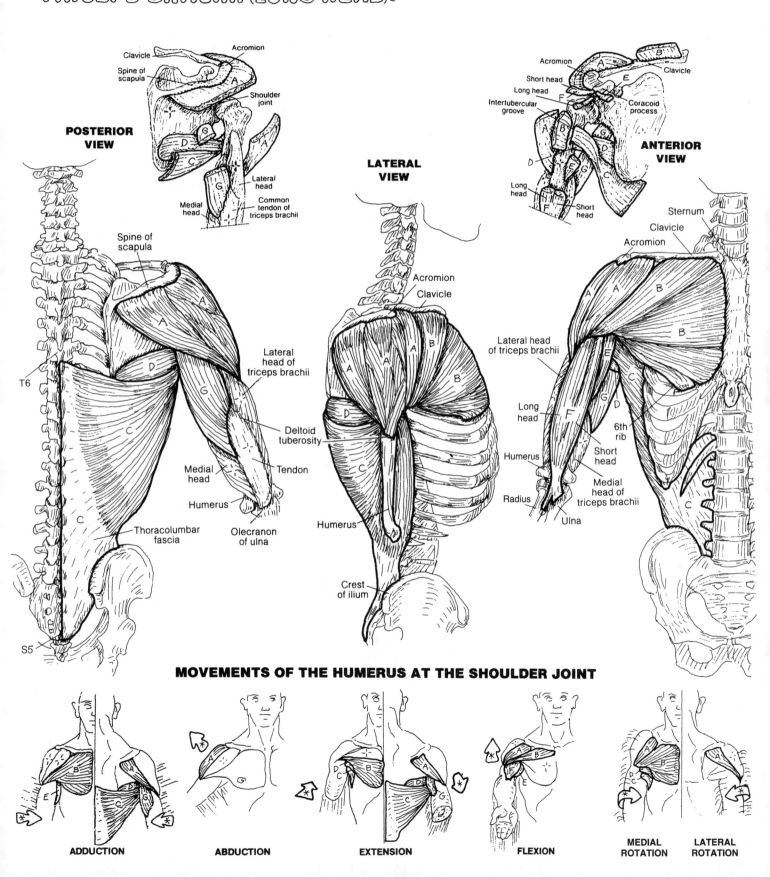

POSTERIOR VIEW

LATERAL VIEW

ANTERIOR VIEW

MOVEMENTS OF THE HUMERUS AT THE SHOULDER JOINT

ADDUCTION

ABDUCTION

EXTENSION

FLEXION

MEDIAL ROTATION

LATERAL ROTATION

The **brachialis muscle** is the principal flexor of the **elbow joint**, because its attachment sites provide the best mechanical advantage in responding to loads on the joint—certainly better than the **biceps brachii**, as you can see. Yet it's the bulge of a contracted biceps that gets all the visual attention! The key to understanding this lies in the insertion of the tendon of the biceps brachii on the tuberosity of the radius. Try flexing the elbow joint with the palm and curled fingers down (pronated forearm). Lift a load with the hand in that position. The biceps muscle has a poor mechanical advantage; the brachialis has a better one, so the brachialis does the work. Now slowly supinate the forearm with that same load, feeling the strength coming into the biceps muscle as it supinates the forearm. Clearly, the biceps brachii is the prime mover in forearm supination, adding to the power of the brachialis. The combined load brings on a bulging biceps brachii. Note the additional attachment of the biceps aponeurosis into the deep fascia of the common flexor group (not shown) in the forearm.

The **brachioradialis** is active in flexion of the elbow and rapid resistance to the powerful elbow extensors of the **triceps brachii**. This three-headed muscle, with its massive tendon of insertion, is the principal extensor of the elbow joint. Of the three heads, the medial head may be the primary antagonist to the brachialis. In fact, it may be not a medial head at all, but a *deep* head of the muscle. Many an olecranon fracture has been prevented by the interface of the thick tendon of the three heads of triceps between the proximal ulna and a potentially injurious force striking the olecranon. The smaller *anconeus*, considered an extension of the medial head of the triceps, assists in the function of elbow extension. The **anconeus** is a very thin muscle almost lost in the fascia on the posterior aspect of the olecranon and upper posterior ulna.

The **pronator teres**, crossing the proximal forearm on its *anterior* aspect, assists in elbow flexion as well as pronation of the forearm. The **supinator** crosses the proximal forearm on its *posterior* aspect; it is an important supinator of the forearm though secondary to the biceps brachii in that function. The tendon of the biceps inserting on the radial tuberosity (see lowest illustration, anterior view) is what gives advantage to the power of supination over pronation when the radioulnar joint is supinated. You might review page 43 ("Integration of Muscle Action") on this topic.

The **pronator quadratus** is the principal pronator of the elbow joint, superior in its mechanical advantage over the **pronator teres**. Pronating the forearm (palm down) involves medial rotation of the radius. Because only the radius can rotate in the forearm, the pronators clearly cross the radius on the anterior side of the forearm, and their origin is ulnar.

CN: Use the same colors for the biceps brachii, A, and triceps brachii, E, as you did on page 54. (1) Color the four flexors, their names, and their attachment sites on the drawing at far left. Repeat with the extensors on the right. (2) Color the forearm supinators and pronators below, the arrows demonstrating their actions, and their attachment sites at upper left and upper right.

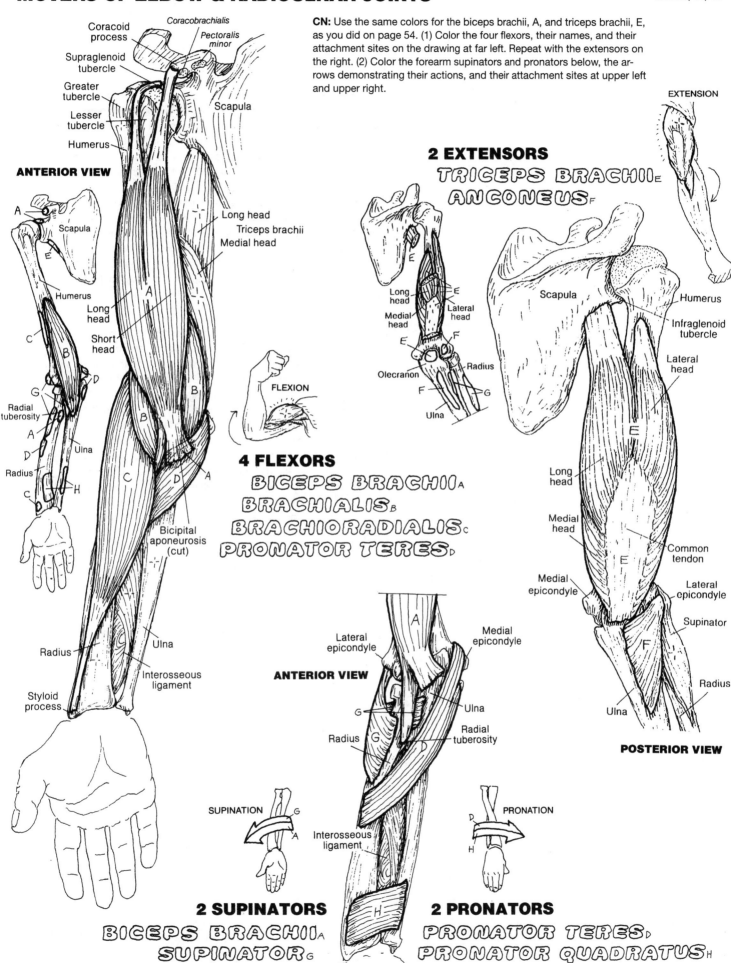

Coracoid process
Coracobrachialis
Pectoralis minor
Supraglenoid tubercle
Greater tubercle
Lesser tubercle
Humerus
Scapula

ANTERIOR VIEW

A
Scapula
Humerus
Long head
Short head
Radial tuberosity
Ulna
Radius

Long head
Triceps brachii
Medial head

Bicipital aponeurosis (cut)

Radius
Ulna
Interosseous ligament
Styloid process

FLEXION

4 FLEXORS
BICEPS BRACHII A
BRACHIALIS B
BRACHIORADIALIS C
PRONATOR TERES D

2 EXTENSORS
TRICEPS BRACHII E
ANCONEUS F

EXTENSION

Long head
Medial head
Lateral head
Olecranon
Radius
Ulna

Scapula
Humerus
Infraglenoid tubercle
Lateral head
Long head
Medial head
Common tendon
Medial epicondyle
Lateral epicondyle
Supinator
Radius
Ulna

POSTERIOR VIEW

Lateral epicondyle
Medial epicondyle
ANTERIOR VIEW
Radius
Ulna
Radial tuberosity
Interosseous ligament

SUPINATION

PRONATION

2 SUPINATORS
BICEPS BRACHII A
SUPINATOR G

2 PRONATORS
PRONATOR TERES D
PRONATOR QUADRATUS H

The **flexors** of the wrist (carpus) and fingers (digits) take up most of the anterior compartment of the forearm, arising as a group from the medial epicondyle, the upper radius and ulna, and the intervening interosseous membrane. The deep layer of muscles in the anterior forearm (**flexor pollicis longus** or FPL in the radial half, **flexor digitorum profundus** or FDP in the ulnar half) lies in contact with the radius and ulna. The superficial layer of muscles (wrist flexors: the **carpi muscles** and **palmaris longus**) is seen just under the skin and thin superficial fascia. The intermediate layer (**flexor digitorum superficialis**, FDS) lies between the superficial and deep groups. In the anterior (palmar) fingers, note how the tendons of the FDS, which insert on the sides of the middle phalanges, split at the level of the proximal phalanges, permitting the deeper (posterior) tendons of the FDP to pass on through to the bases of the distal phalanges.

The **extensors** of the wrist and fingers arise from the lateral epicondyle and upper parts of the bones and interosseous membrane of the forearm, forming an extensor compartment on the posterior side of the forearm. The wrist extensors insert on the distal carpal bones or metacarpals. The finger extensors form an expansion of tendon over the middle and distal phalanges to which the small intrinsic muscles of the hand insert. The wrist extensors are critical to hand function: With your left wrist *extended,* use the fingers of that same hand to grasp the index finger of the other hand as tightly as you can. Now, maximally *flex* the left wrist, and *keep it flexed* while once again grasping the index finger of the other hand with the fingers in your left hand. What sports or hobbies can you think of that depend on an extended wrist joint to play or work?

MOVERS OF WRIST & HAND JOINTS (Extrinsics)

CN: A more detailed view of the tendons of these muscles (with the same designations) can be seen among the intrinsic muscles of the hand on the next plate. (1) Begin with the flexors; note that the deeper muscles have been omitted from the superficial view. Color gray the entire flexor mass in the smaller illustration. (2) Continue with the extensors, coloring gray the entire extensor mass in the smaller illustration.

ANTERIOR VIEW

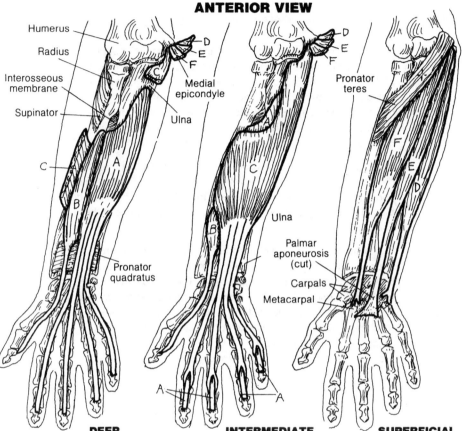

Humerus
Radius
Interosseous membrane
Supinator
C
A
B
Pronator quadratus
Medial epicondyle
Ulna
D
E
F
C
B
A
A
Pronator teres
F
E
D
Ulna
Palmar aponeurosis (cut)
Carpals
Metacarpal

DEEP **INTERMEDIATE** **SUPERFICIAL**

Biceps brachii
Brachioradialis

FLEXORS
DEEP LAYER

F. DIGITORUM PROFUNDUS$_A$
F. POLLICIS LONGUS$_B$

INTERMEDIATE LAYER

F. DIGITORUM SUPERFICIALIS$_C$

SUPERFICIAL LAYER

F. CARPI ULNARIS$_D$
PALMARIS LONGUS$_E$
F. CARPI RADIALIS$_F$

EXTENSORS
DEEP LAYER

E. INDICIS$_G$
E. POLLICIS LONGUS$_H$
E. POLLICIS BREVIS$_I$

SUPERFICIAL LAYER

E. CARPI ULNARIS$_J$
E. DIGITI MINIMI$_K$
E. DIGITORUM$_L$
E. CARPI RADIALIS LONGUS$_M$
E. CARPI RADIALIS BREVIS$_N$

ABDUCTOR POLLICIS LONGUS$_O$

POSTERIOR VIEW

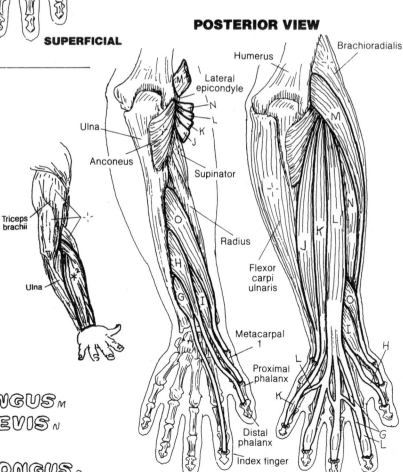

Humerus
Brachioradialis
Lateral epicondyle
M
N
L
K
J
Ulna
Anconeus
Supinator
Radius
Triceps brachii
Flexor carpi ulnaris
Ulna
O
H
G
I
Metacarpal 1
Proximal phalanx
Distal phalanx
Index finger
M
N
L
K
J
O
I
H
G
L

DEEP **SUPERFICIAL**

Note the palpable bulge of muscle (**thenar eminence**) just proximal to the thumb on your own hand. Integrated with the action of the other thumb movers, these three muscles (the **opponens pollicis, abductor pollicis brevis,** and **flexor pollicis brevis**) make possible complex movements of the thumb. The thenar muscles arise/insert in the same general area as one another; however, their different orientation allows different functions.

The hypothenar muscles (**hypothenar eminence**) move the fifth digit; they are complementary to the thenar muscles in attachment and function. Note the two **opponens muscles** in the thumb and the fifth digit. The function of opposition is basic to some of the complex grasping functions of the hand.

The **adductor pollicis,** in concert with the first **dorsal interosseus muscle**, provides great strength in grasping an object between thumb and index finger…try it. The **interossei** and **lumbrical muscles** insert into expanded finger extensor tendons (extensor expansion; see posterior view), forming a complex mechanism for flexing the metacarpophalangeal joints and extending the interphalangeal joints. By their phalangeal insertions, the interossei abduct/adduct certain digits.

MOVERS OF HAND JOINTS (Intrinsics)

See 56

CN: The extrinsic wrist and finger joint movers were covered on page 56; their tendons are shown in dark line and labeled here for reference but not for coloring. (1) Color the muscles of the two anterior views, as well as the flexor retinaculum (gray). (2) Color the posterior view. (3) In the illustration of finger abduction (at the bottom of the page), note that the little finger is not moved by the dorsal interosseus, U.

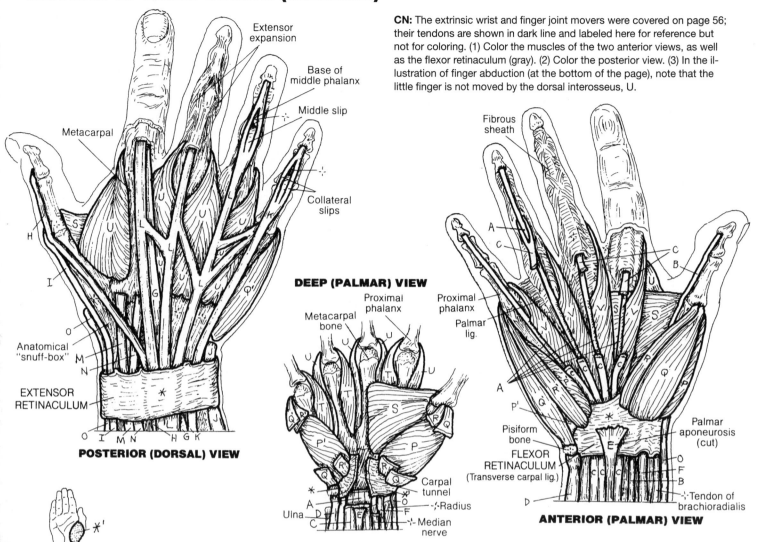

Extensor expansion
Base of middle phalanx
Middle slip
Metacarpal
Collateral slips
Anatomical "snuff-box"
EXTENSOR RETINACULUM

POSTERIOR (DORSAL) VIEW

DEEP (PALMAR) VIEW

Proximal phalanx
Metacarpal bone
Carpal tunnel
Radius
Ulna
Median nerve

Fibrous sheath
Proximal phalanx
Palmar lig.
Pisiform bone
FLEXOR RETINACULUM
(Transverse carpal lig.)
Palmar aponeurosis (cut)
Tendon of brachioradialis

ANTERIOR (PALMAR) VIEW

THENAR EMINENCE *'
OPPONENS POLLICIS ₚ
ABDUCTOR POLLICIS BREVIS ᵩ
FLEXOR POLLICIS BREVIS ᵣ

HYPOTHENAR EMINENCE *²
OPPONENS DIGITI MINIMI ₚ'
ABDUCTOR DIGITI MINIMI ᵩ'
FLEXOR DIGITI MINIMI BREVIS ᵣ'

DEEP MUSCLES

ADDUCTOR POLLICIS ₛ
PALMAR INTEROSSEUS ₜ
DORSAL INTEROSSEUS ᵤ
LUMBRICAL ᵥ

ACTIONS OF INTRINSIC MUSCLES

FLEXION ABDUCTION ADDUCTION CIRCUMDUCTION

ON THE THUMB

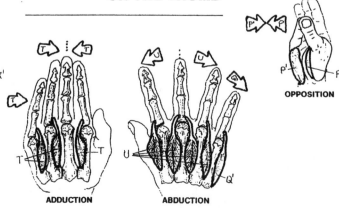

OPPOSITION

ADDUCTION ABDUCTION

ON THE FINGERS

CN: Start with the three muscles labeled "A." On the lines provided, write the names of the superficial muscles shown with the color used for each labeled muscle. Some of these muscles have more than one function assigned to them by these categories.
(See Appendix A for answers.)

MUSCLES ACTING PRIMARILY ON THE SCAPULA

A _____
A[1] _____
A[2] _____

MUSCLES MOVING THE SHOULDER JOINT

B _____
B[1] _____
B[2] _____
B[3] _____
B[4] _____
B[5] _____
B[6] _____

MUSCLES MOVING ELBOW & RADIOULNAR JOINTS

C _____
C[1] _____
C[2] _____
C[3] _____
C[4] _____
C[5] _____

MUSCLES MOVING WRIST & HAND JOINTS

D _____
D[1] _____
D[2] _____
D[3] _____
D[4] _____
D[5] _____
D[6] _____
D[7] _____

FOREARM MUSCLES MOVING THE THUMB

E _____
E[1] _____
E[2] _____

THENAR MUSCLES MOVING THE THUMB

F _____
F[1] _____
F[2] _____

HYPOTHENAR MUSCLES MOVING THE 5TH DIGIT

G _____
G[1] _____
G[2] _____

OTHER MUSCLES ACTING ON THE THUMB & FINGERS

H _____
H[1] _____
H[2] _____

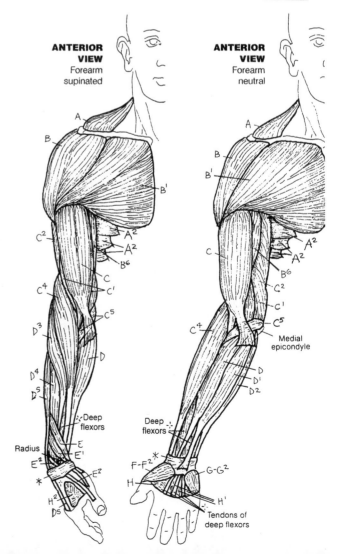

POSTERIOR VIEW
Forearm pronated

LATERAL VIEW
Forearm neutral

ANTERIOR VIEW
Forearm supinated

ANTERIOR VIEW
Forearm neutral

The **gluteal muscles** (A, B, and C) are arranged in three layers, with the gluteus maximus being superficial-most, and the gluteus minimus buried deep to the gluteus medius. **Gluteus maximus** arises from the tendinous fibers of the erector spinae muscles (seen here as an impression under the skin), along the posterior gluteal line of the postero-superior aspect of the ilium (page 35, lateral view), from the sacrotuberous ligament, and the lateral edge of the sacrum and coccyx. This huge muscle covers most of the other two gluteal muscles, and covers all of the six lateral rotators of the hip joint as it courses inferiorly and laterally to insert along the upper *iliotibial tract* and the gluteal tuberosity of the femur. It lies just below the skin and superficial fascia that in some people abounds with adipose tissue. It is the most powerful hip extensor of the lot, and adducts and laterally rotates the hip joint. It is a tensor of the fasciae latae.

The large sciatic nerve (roughly the size of your thumb; see page 88) arises from the sacral plexus on the deep surface of the **piriformis muscle**, one of the lateral rotators of the hip joint. The nerve emerges from the greater sciatic foramen, under piriformis, and comes to lie deep to the gluteus maximus muscle in the lower medial quadrant of the buttock. The thickness of the gluteus maximus varies. Intramuscular injections are delivered to the upper and outer quadrant of the buttock.

The **gluteus medius** is a prime mover in abduction of the hip joint and an important stabilizer (leveler) of the pelvis when the opposite lower limb is lifted off the ground. The gluteus minimus is also a major contributor to the abduction effort of the hip joint.

The deepest layer of gluteal muscles includes the **gluteus minimus** and the **deep lateral rotators** of the hip joint. They cover up/fill the greater and lesser sciatic notches. These muscles generally insert at the posterior aspect of the greater trochanter of the femur. The gluteal muscles (less gluteus maximus) correspond to some degree with the rotator cuff of the shoulder joint: lateral rotators posteriorly, abductor (gluteus medius) superiorly, and medial rotators (gluteus medius and minimus, tensor fasciae latae) anteriorly. The identity of nerves and vessels that pass through the greater and lesser sciatic foramina (page 36) can be ascertained in the Glossary. See Foramen, greater and lesser sciatic.

The **iliotibial tract**, a thickening of the deep fascia (fascia lata) of the thigh, runs from ilium to tibia and helps stabilize the knee joint laterally. The **tensor fasciae latae** muscle, a frequently visible and palpable flexor and medial rotator of the hip joint, inserts into this fibrous band, tensing it.

MUSCLES OF THE GLUTEAL REGION

CN: In the posterior and lateral views of superficial dissections, the upper fibers of the iliotibial tract have been cut and pulled away, exposing gluteus medius. (1) Color the names and structures of the three gluteal muscles in all views. (2) Color the six deep lateral rotators and their names. Color the directional arrows. The origin of the piriformis, E, can be seen on page 50.

3 GLUTEAL MUSCLES

GLUTEUS MAXIMUS_A
GLUTEUS MEDIUS_B
GLUTEUS MINIMUS_C

TENSOR FASCIAE LATAE_D

6 DEEP, LATERAL ROTATORS

PIRIFORMIS_E
OBTURATOR INTERNUS_F
OBTURATOR EXTERNUS_G
QUADRATUS FEMORIS_H
GEMELLUS SUPERIOR_I
GEMELLUS INFERIOR_J

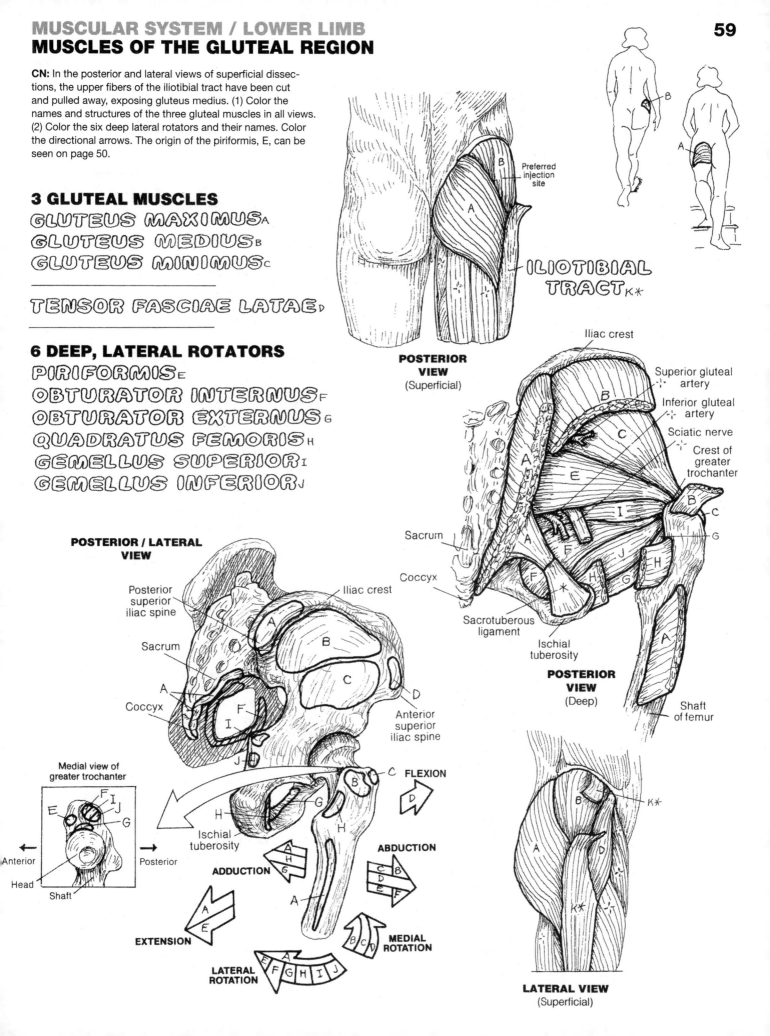

Preferred injection site

ILIOTIBIAL TRACT K*

POSTERIOR VIEW (Superficial)

Iliac crest
Superior gluteal artery
Inferior gluteal artery
Sciatic nerve
Crest of greater trochanter
Sacrum
Coccyx
Sacrotuberous ligament
Ischial tuberosity

POSTERIOR VIEW (Deep)

Shaft of femur

POSTERIOR / LATERAL VIEW

Posterior superior iliac spine
Iliac crest
Sacrum
Coccyx
Anterior superior iliac spine

Medial view of greater trochanter
Anterior
Head
Shaft
Posterior

Ischial tuberosity

FLEXION

ABDUCTION

ADDUCTION

EXTENSION

MEDIAL ROTATION

LATERAL ROTATION

LATERAL VIEW (Superficial)

The musculature of the **posterior thigh** consists of three muscles: **semimembranosus**, **semitendinosus**, and **biceps femoris**. They are often referred to as the "**hamstrings**," the "ham" referring to the muscle/fat in the back of the porcine hindlimb, and the extraordinarily long (and vulnerable) related tendons ("strings").

Note the origins of these muscles. All three have at least one head that arise from the ischial tuberosity of the ilium. One of the muscles (biceps femoris) has a head that arises on the posterior thigh. See the illustration. Since these muscles cross the hip joint on the posterior aspect, they act on that joint by extending it. Check this on yourself.

Note that the tendons of these three muscles also cross the knee joint posterolaterally (biceps femoris) and posteromedially (semimembranosus and semitendinosus). The biceps inserts on the *lateral* aspect of the head of the fibula; the other two muscles insert on the posterior aspect of the medial tibial condyle and the medial aspect of the upper tibia. These muscles, therefore, flex the knee joint. The long tendons of the hamstrings can be palpated just above and behind the partially flexed knee on either side of the joint's midline. The knee joint is capable of a small degree of rotation. The semitendinosus and semimembranosus muscles can medially rotate the knee joint, and biceps femoris can laterally rotate it. The insertion of semitendinosus is intimately associated with the tendons of insertion of sartorius and gracilis (SGT). Part of this collection of tendons, shaped like a goose foot (*pes anserinus*), can be seen here on the medial aspect of the knee joint. (See also pages 61 and 62.)

Discomfort on stretching tight hamstrings can result from overuse to underuse (chronic couch potato syndrome). Test your own hamstrings from a standing posture. Bend forward without locking your knees; stop when you feel tension. It is written that most young people can touch their toes in this maneuver. Tight hamstrings, by their ischial origin, pull the posterior pelvis down, lengthening (stretching) the erector spinae muscles and flattening the lumbar lordosis, potentially contributing to limitation of lumbar movement and low back pain. Low back discomfort on stretching the hamstrings is common, and can usually be resolved simply by bending the knees, taking the tension off the tendons. Sharp low back pain radiating to the leg (below the knee) and/or foot while stretching the hamstrings can be something else again. Such pain suggests the sciatic nerve was stretched along with the tendons; in such a case, standing up and plantar flexing the ankle joint of the affected limb will often relieve the painful sensation.

CN: Use light colors. (1) Color each hamstring muscle in the deep view before going on to the superficial. Color the two smaller muscle diagrams with respect to flexion and extension of the hip and knee joints. (2) Color gray the two diagrams of stippled muscles at upper right.

"HAMSTRINGS"

SEMIMEMBRANOSUS ₐ
SEMITENDINOSUS ᵦ
BICEPS FEMORIS c

Tight hamstrings limit flexion of hip when knee joint is extended

Lordotic curve
Pelvis

Tight hamstrings (at right) tilt pelvis backward, flattening lordotic curve of lower back.

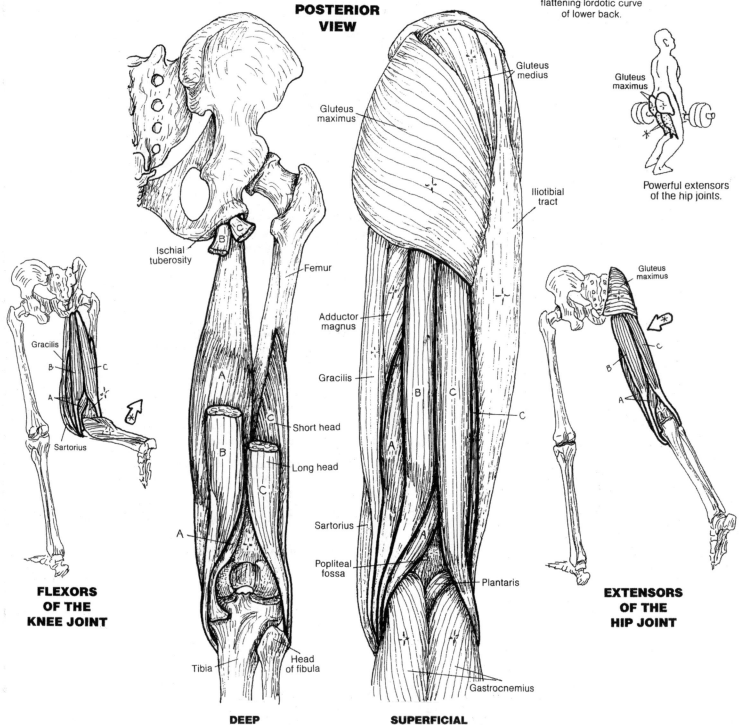

POSTERIOR VIEW

Gluteus medius

Gluteus maximus

Iliotibial tract

Ischial tuberosity

Femur

Adductor magnus

Gracilis

B
C

A

Short head

Long head

Sartorius

Popliteal fossa

Plantaris

Tibia

Head of fibula

Gastrocnemius

Gracilis
B
C
A
Sartorius

FLEXORS OF THE KNEE JOINT

Gluteus maximus

C
B
A

EXTENSORS OF THE HIP JOINT

Powerful extensors of the hip joints.

Gluteus maximus

DEEP

SUPERFICIAL

The **medial thigh muscles** consist of the hip joint *adductors* (**pectineus, adductor brevis, adductor longus**, *adductor magnus*, and *gracilis*) and the *obturator externus*, a lateral rotator of that joint. These can all be seen in the illustration, and their relationship to one another at their origin is a relationship you should spend some time with. They are a powerful set of muscles.

The **obturator externus** is part of the medial thigh group because of its location within the adductor group and because it is innervated by the obturator nerve which supplies the adductors. The insertion site of "externus" has a mechanically disadvantaged location to qualify as a hip adductor; it is more likely a lateral rotator of the hip (recall page 59). Unfortunately, electromyographic study of this muscle in the living does not seem to be currently possible. However, it is compartmentalized by fasciae in the medial thigh, covers the external surface of the obturator foramen in the deep upper medial thigh, and receives the same innervation as the adductors. Thus, it is considered by many authorities to be an adductor of the hip joint.

The **gracilis**, longest of the adductor group, crosses the medial knee (flexing it), and inserts only on the medial tibia (not the linea aspera); its tendon joins the tendons of the sartorius and semitendinosus to form its insertion, the *pes anserinus* (recall page 60).

The **adductor magnus** is the most massive of the group (see posterior view). In its lower half, adductor magnus fibers give way to passage of the femoral artery and vein through a separation of muscle fibers called the *adductor hiatus*. Passing through this canal within the muscle, the vessels enter the popliteal fossa above and behind the knee (see page 110).

Look carefully at the posterior view and focus on the medial aspect of the muscle adjacent to gracilis (E). Note the column of straight, descending fibers that reach down to the distal medial surface of the femur where it attaches to the adductor tubercle (see far left illustration just above the medial condyle). These fibers are not adductors; they are flexors of the knee joint, essentially a hamstring muscle! The more lateral fibers of the adductor magnus attach to the linea aspera and the supracondylar line of the femur and therefore function as an adductor of the hip joint.

This fact is worth repeating: all of the adductor muscles, except the gracilis, insert on the vertical rough line (linea aspera) on the posterior surface of the femur.

Innervation of the adductor muscles, for the most part, is by the obturator nerve (see page 88). The sciatic nerve innervates the "hamstring fibers" of the adductor magnus.

MUSCLES OF THE MEDIAL THIGH

CN: (1) Color one muscle at a time through the five main views before going to the next one. (2) The dotted lines at far left represent the sites of insertion (linea aspera) for muscles A, B, C, and D on the *posterior* aspect of the femur.

MUSCLES

*PECTINEUS*ₐ
*ADDUCTOR BREVIS*ʙ
*ADDUCTOR LONGUS*c
*ADDUCTOR MAGNUS*ᴅ
*GRACILIS*ᴇ
*OBTURATOR EXTERNUS*ꜰ

Mass of adductors occupy the medial thighs.

ANTERIOR VIEW

ATTACHMENT SITES

Coxal bone

Inter-trochanteric fossa (on posterior surface)

Superior pubic ramus

A
F
C
B
E
F
D

Inferior pubic ramus

Obturator foramen

D
A
B
C

Femur

D

Adductor tubercle (on posterior surface)

Knee joint

D
Patella

E
Insertion of sartorius semitendinosus

Fibula

Tibia

DEEP

F

C

B
E

A
D

B

C

D

Adductor hiatus for femoral artery and vein

E

POSTERIOR VIEW

F

D

E

Linea aspera

Adductor hiatus

INTERMEDIATE

Iliac crest

Sacrum

Anterior superior iliac spine

Greater trochanter

F
A

Lesser trochanter

B

C

D
E

SUPERFICAL

Psoas major

Psoas minor

Iliacus

Iliopsoas

Inguinal ligament

Tensor fasciae latae

Sartorius

Vastus lateralis

Rectus femoris

Vastus medialis

A

C

E

Iliotibial tract

Pes anserinus

E

What we have here in the **anterior muscles of the thigh** is a very powerful and fascinating group of muscles. They are all innervated by branches of the lumbar plexus (L1–4), most often in the form of the femoral nerve (L2, 3, 4) and its branches.

The **sartorius**, called the "tailor's muscle" for its role in enabling a crossed-legs sitting posture, one used for centuries to sit and be able to create a posture that takes up little room and so readily facilitates hand work, as in sewing, drawing, etc. The muscle arises from the anterior superior iliac spine, and crosses obliquely medially as it descends to insert on the superior medial surface of the tibia. It is a flexor and lateral rotator of the hip joint and a flexor of the knee joint, as you can infer from its illustrated attachments. It is innervated by the femoral nerve.

The **quadriceps femoris** muscle arises from four heads. The **rectus femoris** arises from the anterior inferior iliac spine. The **vastus medialis** and **lateralis** each arise from the linea aspera on the posterior aspect of the femur; the **vastus intermedius** arises from the anterior and lateral femoral shaft. The four tendons converge at the patella as the tendon of quadriceps femoris.

The **patella** is the largest sesamoid bone in the body. It developed as a cartilaginous body in the tendon of quadriceps femoris as it passed over the anterior inferior surface of the femur and anterior superior surface of the tibia. Absent the patella, the tendon of quadriceps femoris would be subjected to serious abrasive forces when the tendon is brought into contact with the femur over which it is passing during flexion and extension of the knee joint. The patella thus incorporates the tendon of quadriceps in its bony structure. At the inferior aspect (apex) of the patella, the tendinous fibers of quadriceps continue to the tibial tuberosity as the **patellar ligament**.

The rectus femoris, a strong hip joint flexor, is the only member of the quadriceps to cross the hip joint. The four heads of the quadriceps femoris are the only knee extensors. The significance of the role of quadriceps becomes clear to those having experienced a knee injury; the muscles tend to atrophy and weaken rapidly with disuse, and "quad" exercises are essential to maintain structural stability of the joint. The muscle also suffers from insufficient stretching, except by athletes who depend on it. A "tight quad" can be a real pain, not to mention subtracting from a fully functioning and powerful knee extensor

The **iliopsoas** is the most powerful flexor of the hip, having a broad origin from the iliac fossa, iliac crest and the sacrum and sacroiliac ligaments (in the form of iliacus), as well as the narrow triangular psoas major and the much more slender psoas minor (see page 48). These muscles all attach at the lesser trochanter at the proximal end of the femoral shaft.

CN: The patellar ligament, G★, is colored gray but the patella is left uncolored.
(1) Begin with the deep view of the thigh and then complete the superficial view.
(2) On the far left, color the visualized portions of the quadriceps that are antagonists to the hamstring group. (3) Complete the action diagrams along the right margin.

MUSCLES

SARTORIUS_A

QUADRICEPS FEMORIS ÷

RECTUS FEMORIS_B

VASTUS LATERALIS_C

VASTUS INTERMEDIUS_D

VASTUS MEDIALIS_E

ILIOPSOAS_F

PATELLAR
LIGAMENT_{G★}

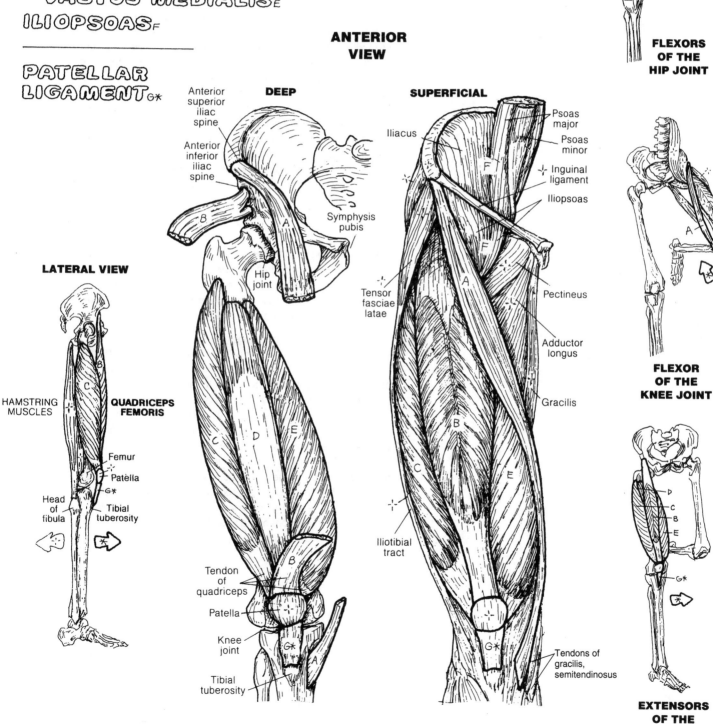

ANTERIOR VIEW

DEEP

SUPERFICIAL

LATERAL VIEW

FLEXORS OF THE HIP JOINT

FLEXOR OF THE KNEE JOINT

EXTENSORS OF THE KNEE JOINT

The **muscles of the leg** are arranged into anterolateral, lateral, and posterior compartments. These muscles attached to the anterolateral surface of the tibia, the anterior aspect of the fibula, and the intervening interosseous membrane/ligament. The anteromedial surface of the tibia is bare of muscle attachments (as you can feel on yourself). The muscles of the posterior compartment (page 64) arise from the fibula, tibia, and the interosseous membrane. Insertions of these muscles are discussed below.

Three muscles arise in the anterolateral compartment: the **tibialis anterior** largely originates on the tibia, and its fellows the **extensor hallucis longus** and **extensor digitorum longus** arise from the interosseous membrane and the fibula. All of the anterior leg muscles are dorsiflexors (extensors) of the ankle; the extensors hallucis and digitorum longus are toe extensors; the tibialis anterior is an invertor of the subtalar joint as well, and the **fibularis tertius** (the fifth tendon of the extensor digitorum) is an evertor of the subtalar joint. Due to rotation of the lower limb during embryonic development, these extensors are anterior to the bones of attachment in the anatomical position (unlike the upper limb wrist extensors, which are posterior). In walking, the three anterolateral muscles of the leg are particularly helpful in lifting the foot up (plantar flexion) during the swing phase and avoiding "stubbing" of the toes.

The **fibular (peroneal) muscles** (*longus* and *brevis*) make up the lateral compartment of the leg. They arise largely from the fibula and interosseous membrane. They are principally evertors of the foot, and are especially active during plantar flexion (walking on the toes or pushing off with the great toe).

Look now at the diagram of foot movements at lower right and the plantar view above of the foot with muscle attachments. Tendons from certain anterior, lateral, and posterior muscle groups come around the side of the foot to attach to the plantar surfaces of certain tarsal and metatarsal bones. When these muscles contract, they pull up the side of the foot to which they are attached. Simply defined, these movements are **inversion** if the great-toe side of the foot is lifted, and **eversion** if the little-toe side of the foot is lifted. Clearly, then, the muscles inverting the foot will pass around the medial aspect of the foot; muscles everting the foot will pass around the lateral aspect of the foot. Remember: the muscles from the lateral leg compartment of the foot (fibularis longus and brevis) are both evertors of the subtalar joint.

CN: The interosseous ligament (site of origin) has been left out of the attachment-sites illustration for simplification. Insertion sites on the plantar surface of the foot are shown at upper right. (1) Color the anterior muscles and related names, starting with the attachment sites (with a sharp pencil!). Note the insertion of tibialis anterior at the plantar surface of the foot in the small upper drawing. (2) Color the muscles in the lateral view and the plantar view. (3) Color the "Movements of the Foot" diagram and related muscles and arrows.

LATERAL LEG

FIBULARIS LONGUS_E

FIBULARIS BREVIS_F

ANTERIOR LEG

TIBIALIS ANTERIOR_A

EXTENSOR DIGITORUM LONGUS_B

EXTENSOR HALLUCIS LONGUS_C

FIBULARIS TERTIUS_D

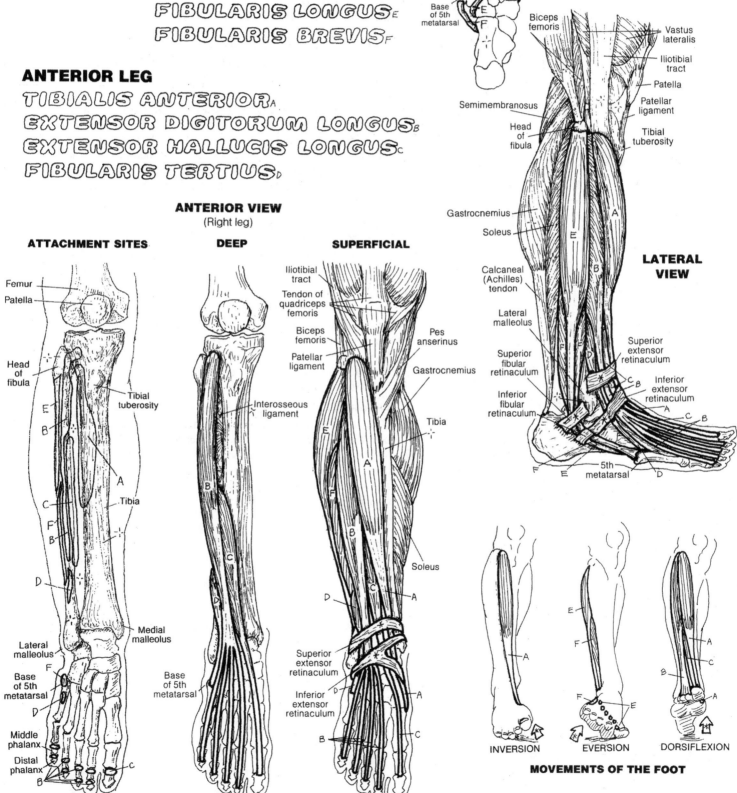

PLANTAR VIEW (Bottom)

ANTERIOR VIEW (Right leg)

ATTACHMENT SITES **DEEP** **SUPERFICIAL**

LATERAL VIEW

MOVEMENTS OF THE FOOT

INVERSION EVERSION DORSIFLEXION

The **muscles of the posterior leg** (calf) are arranged into deep and superficial compartments between which is a fascial septum (barrier): the deep transverse fascia (not shown). The four muscles of the deep compartment arise from the tibia, the fibula, and/or the intervening interosseous membrane (see the "Deep View" and the "Attachment Sites"). The **popliteus** is all by itself in the upper part of the deep compartment, where it flexes the knee joint and rotates the tibia. The **tibialis posterior** occupies the center position in the deep compartment. Its tendon swings to the big-toe side, wraps around the medial aspect of the foot, and inserts on a host of bones on the plantar surface of the foot (cuboid, cuneiforms, navicular, and the base of the metatarsals). It flexes and inverts the foot. The tendons of **flexors hallucis longus** and **digitorum longus** wrap around the medial arch to reach the plantar surface of the great toe and the plantar surface of the bones of the forefoot. The deep fascial compartments of the posterior leg muscles are fairly inelastic. Muscle swelling secondary to vascular insufficiency can result in serious muscle compression with loss of the muscles (compartment syndrome) in the absence of fascial (surgical) decompression.

You might want to spend some time with the illustrations on pages 63–65 and work to fully understand the disposition of these tendons that arise from anterior, lateral, and posterior leg muscles to insert on the plantar aspect of the foot. It can be confusing if you don't.

The superficial group (**gastrocnemius, soleus**) of muscles insert on the calcaneus by way of a common tendon, the tendocalcaneus (Achilles tendon; see Glossary). These muscles collectively lift the posterior calcaneus (heel) up in plantar flexion of the foot, leaving the toes to carry the weight of the body. The gastrocnemius crosses the knee joint and is therefore a flexor of that joint.

Plantaris is a small muscle that arises just above the lateral femoral condyle and continues distally as a variably narrow, thin, pencil-size tendon to insert in the tendocalcaneus just above the latter's insertion on the calcaneus. Players of court games (tennis, racquetball, squash, etc.) may become familiar with the tendon of this muscle when it "snaps" (more like "pops") under excessive tension during dorsiflexion (extension) of the ankle joint. Its loss is of no significant consequence.

MUSCLES

TIBIALIS POSTERIOR~G~
FLEXOR DIGITORUM LONGUS~H~
FLEXOR HALLUCIS LONGUS~I~
POPLITEUS~J~
PLANTARIS~K~
SOLEUS~L~
GASTROCNEMIUS~M~

CN: Use light colors different from those used on page 63. (1) Color one muscle at a time, from deep to superficial, in each of the posterior views. Note that, soleus, L, and gastrocnemius, M, share the same tendon (tendocalcaneus, M). (2) Color the upper and lower medial views, noting the arrangements of tendons on the plantar surface. (3) Color the attachment sites of the posterior leg muscles at far left.

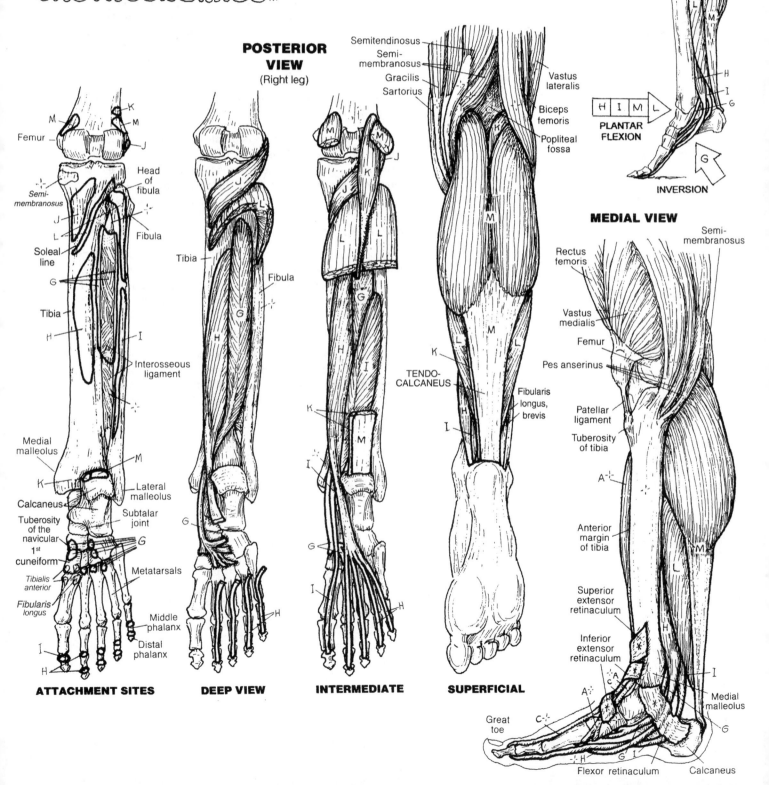

POSTERIOR VIEW
(Right leg)

PLANTAR FLEXION

INVERSION

MEDIAL VIEW

ATTACHMENT SITES

DEEP VIEW

INTERMEDIATE

SUPERFICIAL

The dorsal intrinsic **muscles of the foot** (those that arise and insert within the dorsum of the foot) are limited to two small extensors of the toes (the **extensor digitorum brevis** and the **extensor hallucis brevis**), shown at right. Most of the extensor function is derived from extrinsic extensors.

The intrinsic muscles of the plantar region of the foot are shown here in four layers. The **plantar interossei**, wedged between the metatarsal bones, constitute the deepest (**fourth**) **layer**. They adduct toes 3–5, flex the metatarsophalangeal (MP) joints of these toes, and contribute to extension of the interphalangeal (IP) joints of these toes through the mechanism of the extensor expansion. The **dorsal interossei** abduct toes 3–5 and facilitate the other actions of the plantar interossei.

The **third layer** of muscles acts on the great toe (hallux) and fifth digit (digiti minimi).

The **second layer** includes the **quadratus plantae**, which inserts into the lateral border of the common tendon (H) of the flexor digitorum longus (FDL). It assists that muscle in flexion of the toes. The **lumbricals** arise from the individual tendons of the FDL and insert into the medial aspect of the extensor expansion (dorsal aspect). They flex the MP joints and extend the IP joints of toes 2–5 via the extensor expansion.

The superficial (**first**) **layer** consists of the abductors (**abductor hallucis** and **abductor digiti minimi**) of the first and fifth digits and the **flexor digitorum brevis**. The plantar muscles are covered by the thickened deep fascia of the sole and the plantar aponeurosis, extending from the calcaneus to the fibrous sheath of the flexor tendons.

It seems an injustice to only know these complex, critical muscle layers by virtue of walking on them under all sorts of difficult conditions. When they work, you work. When they don't, you don't...and you may soon make friends with your podiatrist or other appropriate health care provider.

CN: Only color the muscles whose names are listed on this page. Letter labels taken from the previous page are for identification purposes only. You may have to use the same color more than once. (1) Attachment sites of extrinsic foot muscles can be found on the two preceding pages. (2) Begin with the fourth (deepest) layer and complete each illustration before going on to the next.

MUSCLES

FOURTH LAYER
3 PLANTAR INTEROSSEI_P
4 DORSAL INTEROSSEI_Q

THIRD LAYER
FLEXOR HALLUCIS BREVIS_R
ADDUCTOR HALLUCIS_S
FLEXOR DIGITI MINIMI BREVIS_T

SECOND LAYER
QUADRATUS PLANTAE_U
4 LUMBRICALS_V

FIRST LAYER
ABDUCTOR HALLUCIS_W
ABDUCTOR DIGITI MINIMI_X
FLEXOR DIGITORUM BREVIS_Y

DORSAL SURFACE
EXTENSOR DIGITORUM BREVIS_N
EXTENSOR HALLUCIS BREVIS_O

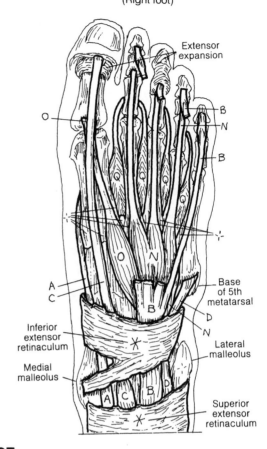

DORSAL SURFACE
(Right foot)

PLANTAR SURFACE
(Right foot)

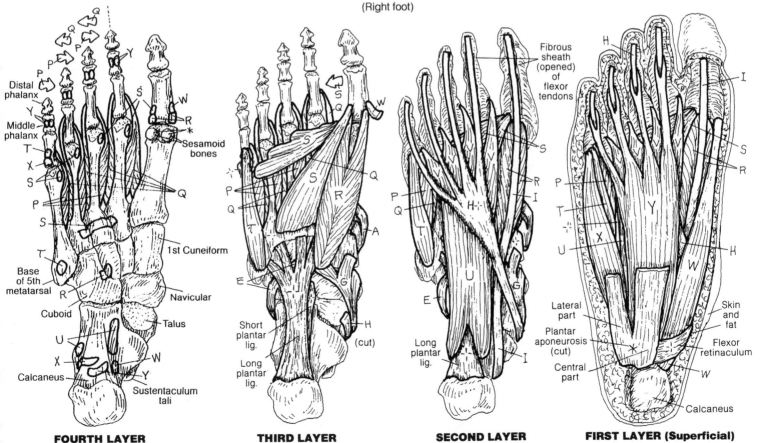

FOURTH LAYER

THIRD LAYER

SECOND LAYER

FIRST LAYER (Superficial)

CN: Follow the same procedure as you did with page 58. Be sure to look for the muscle in each of the four drawings before committing its name to writing. The key word in the listings is "primarily."

(See Appendix A for answers.)

MUSCLES ACTING PRIMARILY ON THE HIP JOINT

A _____
A¹ _____
A² _____
A³ _____
A⁴ _____
A⁵ _____
A⁶ _____
A⁷ _____

MUSCLES ACTING PRIMARILY ON THE KNEE JOINT

B _____
B¹ _____
B² _____
B³ _____
B⁴ _____
B⁵ _____
B⁶ _____
B⁷ _____

MUSCLES ACTING PRIMARILY ON THE ANKLE JOINT

C _____
C¹ _____
C² _____
C³ _____
C⁴ _____
C⁵ _____
C⁶ _____
C⁷ _____
C⁸ _____

MUSCLES ACTING PRIMARILY ON THE SUBTALAR JOINT

D _____
D¹ _____

MUSCLES ACTING ON THE DIGITS OF THE FOOT

E _____
E¹ _____
E² _____

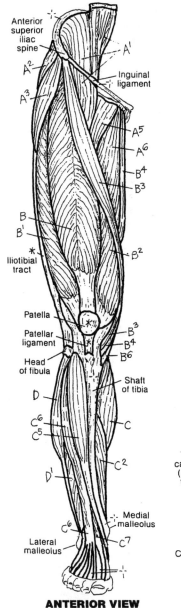

ANTERIOR VIEW

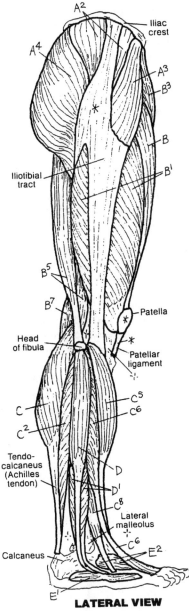

LATERAL VIEW

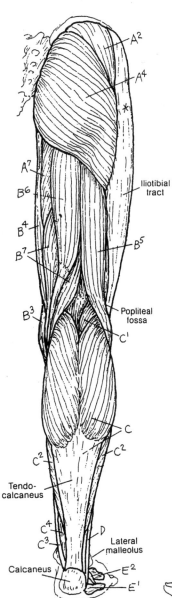

POSTERIOR VIEW

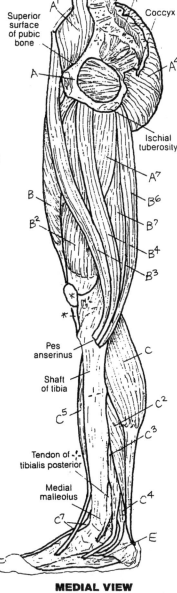

MEDIAL VIEW

Having completed coloring the A and B muscles in the three illustrations, consider the following as you review your handiwork.

The upper body joint **flexors** can be very helpful in taking on loads and getting work done (bending, lifting, pushing, pulling, etc.). Their arrangement makes it handy for picking up stuff and carrying it. Almost anything you do with your upper limbs involves a lot of joint flexion. When you are done, you need your antigravity **extensors** to get you back to an upright posture. Most of these muscles cannot be seen in this illustration, as they are deep muscles supporting the vertebral column. What side of the vertebral column are they on? These muscles are collectively represented in the lower illustration by the "Erector spinae and deeper muscles." You can see that these extensors keep you upright, maintaining an extensor platform (an erect body) to which one can return following upper limb work and from which one can start again. If the deep extensors fail you, you are going to fall down under the influence of gravity. The abdominal muscles (A) work to offer compression to the abdominal cavity when needed. These muscles are also powerful flexors of the trunk. Tightly contracted, they resist intrusive forces and thus protect the abdominal viscera.

Now color the **scapular stabilization** muscles (F). The six of them secure the scapula to the posterior body wall and at the same time make possible a remarkably mobile scapulo-thoracic frame from which the shoulder joints can work.

Now color the **rotator**, **abductor**, and **adductor muscles** (C, D, and E) as you did above. These provide added mobility and performance of the upper and lower limbs during work and sport. At the extremes of their mobility, rotators and abductors are often vulnerable to injury.

The **evertor** and **invertor** muscles of the foot are not shown to good advantage on this page; they are presented in some detail on pages 40, 63, and 64.

Finally, recall that extension of weight-bearing joints is often an antigravity function. The relationship of flexors and extensor muscles of the trunk is one of second-by-second tradeoffs. In the lower drawing, note the line of gravity and its relationship to the vertebral, hip, knee, and ankle joints. The center of gravity of an average human being standing with theoretically perfect posture is just anterior to the motion segment of S1–S2. Flexion of the neck and torso move the center of gravity forward, loading the posterior cervical, thoracic, and lumbar paraspinal (extensor) muscles in resistance.

FUNCTIONAL OVERVIEW

FUNCTIONAL ACTORS

FLEXOR_A ROTATOR_E
EXTENSOR_B SCAPULAR STABILIZER_F
ABDUCTOR_C EVERTOR_G
ADDUCTOR_D INVERTOR_H

CN: (1) First check the text and color in conjunction with its organization. Color the muscles labeled A on the left side. Then color the unlabeled A muscles on the opposite side of the same figure. Repeat this sequence with the muscles B through H. (2) Go to the opposite figure (on the right) and color the muscles as you did on the left. (3) Color the A and B muscles in the lower figure.

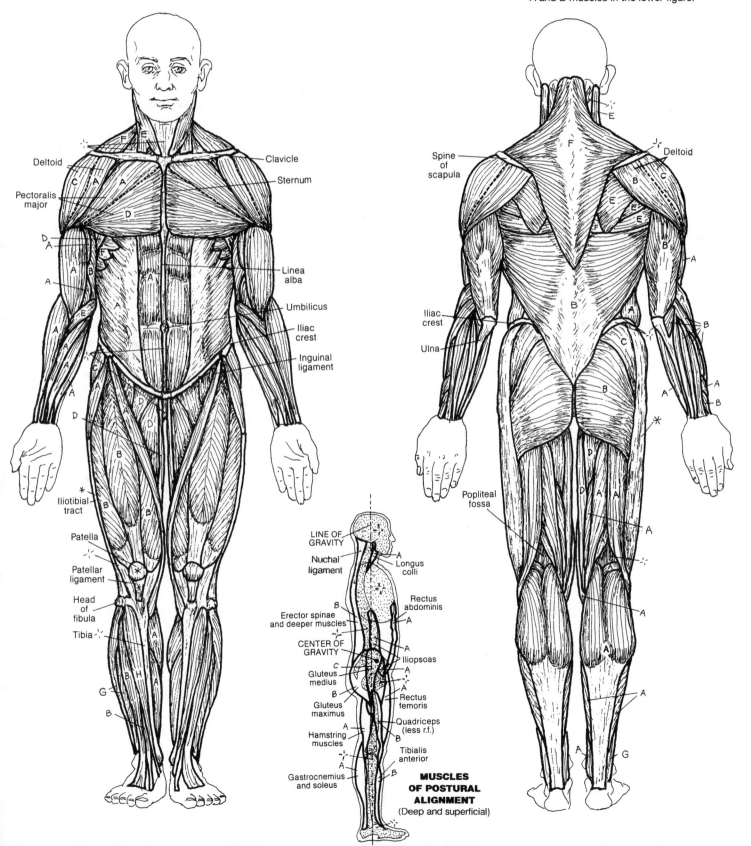

MUSCLES OF POSTURAL ALIGNMENT (Deep and superficial)

The excitable **nervous system** consists of neurons (cell bodies and processes) arranged into a highly integrated central part (**central nervous system** or **CNS** and a more diffuse **peripheral nervous system** or **PNS**). The CNS consists of the *brain* in the head and the *spinal cord* in the vertebral column of the torso. The PNS is a vast collection of bundled neuronal processes (*nerves*) located throughout the body, as well as islands of neuronal cell bodies (ganglia). These neurons are supported by nonconducting *neuroglia* and a rich blood supply. Neurons of the CNS are interconnected to form centers (nuclei; gray matter) and long and short axon bundles (tracts; white matter). The brain and spinal cord are packaged in fibrous membranes called meninges (not shown).

The **brain** is the center of sensory awareness and movement (except for spinal reflexes), emotions, rational thought and behavior, foresight and planning, memory, speech, language, and the interpretation of language.

The **spinal cord**, an extension of the brain, begins at the foramen magnum of the skull, traffics in ascending/descending impulses, and is a center for spinal reflexes. It provides motor commands for muscles and is a receiver of sensory input below the head.

The PNS consists largely of bundles of sensory and motor axons (nerves) radiating from the brain (**cranial nerves**) and spinal cord (**spinal nerves**) segmentally and bilaterally and reaching to all parts of the body, somatic and visceral, through a highly organized pattern of distribution. **Branches** of spinal nerves are often called *peripheral nerves*. Nerves conduct all sensations/sensory input from the body to the brain and spinal cord. Nerves conduct motor commands to all the smooth and skeletal muscles of the body.

The **ANS** or **autonomic (visceral) nervous system** is a subset of ganglia and nerves in the PNS dedicated to muscular activity and glandular secretion in organs with cavities (viscera). That is, the ANS is a motor system only; visceral sensations are conducted to the spinal cord and brain by peripheral nerves in the same manner as somatic structures. There are two divisions of the ANS: (1) the **sympathetic (thoracolumbar) division,** responsible for driving fight or flight activities in which the extremes of function are called upon for the sake of safety and survival; and (2) the **parasympathetic (craniosacral) division,** responsible for maintaining vegetative functions of the respiratory tract, ingestion and digestion of food, and disposal of wastes.

ORGANIZATION

See 72

CN: Use light colors wherever there is a risk of obscuring detail with dark colors. (1) Color the names and structures of the CNS in the illustration at left. Do not color the vertebral column. Do color the diagram of the spinal cord regions and the spinal nerves. (2) Color the cranial nerves in the ventral view of the brain at upper right. (3) Color the names and structures of the spinal nerves and the autonomic nervous system structures at lower right.

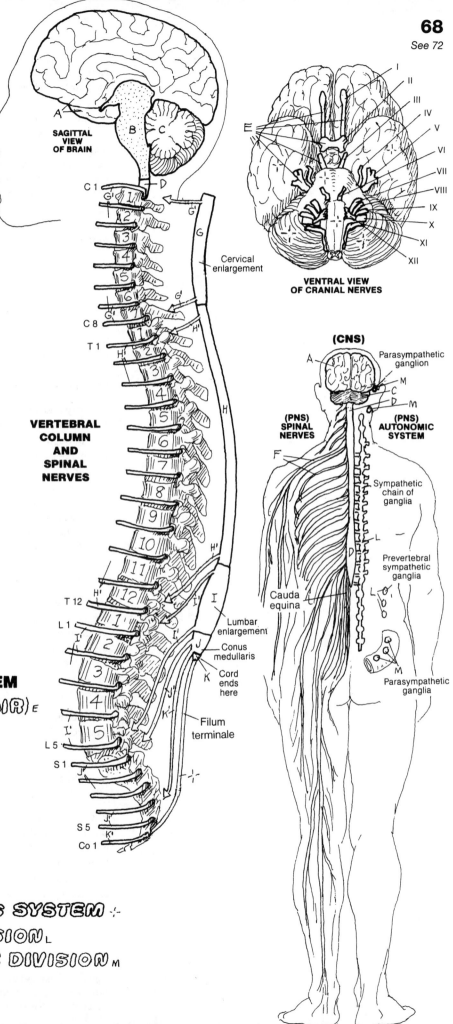

SAGITTAL VIEW OF BRAIN

Cervical enlargement

VENTRAL VIEW OF CRANIAL NERVES

VERTEBRAL COLUMN AND SPINAL NERVES

Lumbar enlargement

Conus medullaris

Cord ends here

Filum terminale

(CNS)

Parasympathetic ganglion

(PNS) SPINAL NERVES

(PNS) AUTONOMIC SYSTEM

Sympathetic chain of ganglia

Prevertebral sympathetic ganglia

Cauda equina

Parasympathetic ganglia

CENTRAL NERVOUS SYSTEM

BRAIN ⁺⁄₋

 CEREBRUM ₐ
 BRAINSTEM ʙ
 CEREBELLUM c

SPINAL CORD ᴅ

 CERVICAL ɢ
 THORACIC ʜ
 LUMBAR ɪ
 SACRAL ⱼ
 COCCYGEAL ᴋ

PERIPHERAL NERVOUS SYSTEM

CRANIAL NERVES (12 PAIR) ᴇ
SPINAL NERVES & BRANCHES ꜰ

 CERVICAL (8) ɢ'
 THORACIC (12) ʜ'
 LUMBAR (5) ɪ'
 SACRAL (5) ⱼ'
 COCCYGEAL (1) ᴋ'

AUTONOMIC NERVOUS SYSTEM ⁺⁄₋
 SYMPATHETIC DIVISION ʟ
 PARASYMPATHETIC DIVISION ᴍ

Neurons generally function in one of three modes: (1) sensory (**afferent**, an alternative term meaning conduction of impulses *toward* a center) neurons receive electrochemical impulses from receptors in the body and conduct those impulses to the central nervous system (CNS); (2) motor (**efferent**, an alternative term meaning conduction of impulses *away* from a center) neurons conduct motor command impulses from the CNS to muscles of the body; or (3) *associative*. In the latter, neurons form a network of billions of interconnecting cells with extensive interconnecting processes in the CNS, where these **"association" neurons** work out all the details between simple sensory input and complex motor responses.

If the sensory or motor neurons relate to musculoskeletal structures or the skin and fascia (collectively formed from somites in the embryo), the prefix "somatic" may be applied to the term "neuron," as distinguished from "visceral," which refers to organs with hollow cavities that have a fundamentally different origin in the body. Although the sensory neurons of the body wall and viscera are essentially the same, the visceral efferents of these two areas are quite different (somatic efferent vs. visceral efferent, aka "autonomic" nervous system).

Sensory neurons are the afferent side of neuronal interactions. They form an association with untold numbers of sensory **receptors** throughout the entire body, including receptors sensitive to touch, pressure, pain, joint position, muscle tension, chemical concentration, and light and sound waves. At any point in time, these receptors collectively provide information on *changes* in the external and internal environment of and around the body. Most sensory neurons are apparently unipolar (or pseudounipolar) or bipolar, based on the numbers of their cellular processes. The **peripheral processes** bring impulses to the *cell body* and **central processes** conduct impulses into the spinal cord or brain for central processing.

Motor neurons conduct impulses from **cell bodies** located in the CNS through **axons** that leave the CNS and subsequently divide into branches, each of which becomes incorporated into the cell membrane of a muscle cell (**motor end plate**). At the end plate, the neuron releases its neurotransmitter, which induces the muscle cell to shorten. All skeletal muscles require efferent innervation; not so cardiac and smooth muscle.

Autonomic motor neurons function as paired units connected at a ganglion by a synapse. The first or **preganglionic neuron** arises in the CNS, and its *axon* embarks for a ganglion located some distance from the CNS. There it *synapses* with the *cell body* or dendrite of *a* **postganglionic neuron** whose axon proceeds to the effector organ: smooth muscle, cardiac muscle, or glands.

Association neurons make up the bulk of the neurons of the brain and spinal cord. Dr. Marian Cleeves Diamond, neuroanatomist and past director of the Lawrence Hall of Science, put it well: "**Interneurons** are responsible for the modification, coordination, integration, facilitation, and inhibition that must occur between sensory input and motor output. They are the source of the seemingly unlimited array of responses to our environment."[1]

[1]*Source*: Reprinted by permission from Diamond, Marian C., Scheibel, Arnold B., and Elson, Lawrence M. *The Human Brain Coloring Book*. Harper Perennial, New York, 1985.

CN: Begin coloring this page in the middle section ("Peripheral Nervous System"). (1) Color the names, neurons, and parts of the peripheral nervous system. There are no cell parts to color in the visceral motor (efferent) neurons; only the two neurons. (2) Color the names and structure of the CNS interneuron at the bottom of the page. (3) Color the summary illustration at the top of the page.

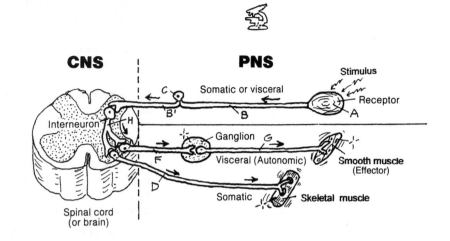

PERIPHERAL NERVOUS SYSTEM (PNS)

RECEPTOR A

AXON
(PERIPHERAL
PROCESS) B

CELL BODY C

AXON
(CENTRAL
PROCESS) B'

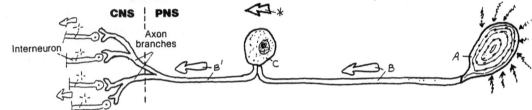

DENDRITE D

CELL BODY C'

AXON B²

MOTOR END PLATE E

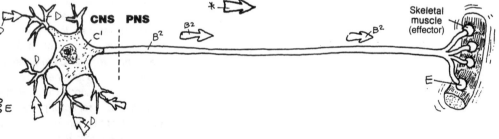

PREGANGLIONIC
NEURON F

POSTGANGLIONIC
NEURON G

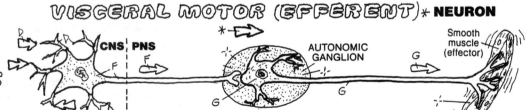

CENTRAL NERVOUS SYSTEM (CNS)

INTERNEURON
(ASSOCIATION
NEURON) H

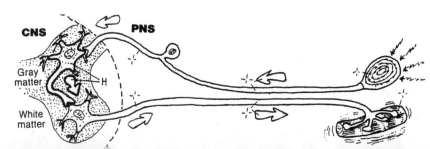

Connections between and among neurons are called **synapses**. The great majority are noncontact connections in which *chemical* **neurotransmitters** carry the impulse from one neuron to another. **Electrical synapses** (where electrically charged atoms or ions pass from one neuron to another by way of protein channels; not shown) also exist in the brain and embryonic nervous tissue, but are far less common. Most synapses are **axodendritic**; that is, the **axon** of one neuron synapses with the **dendrite** or dendritic spine of another neuron. The neuron in front of the synapse is said to be *presynaptic*. The second neuron is said to be *postsynaptic*.

Here we show a number of different neuronal relationships in synapses. Note the more infrequently seen complex of synapses (a **glomerulus**) between three axons and a dendritic spine, all surrounded by a neuroglial sheath (recall page 13).

Synapses permit the conduction of electrochemical impulses among myriad neurons almost instantly. The more synapses, the greater the possibilities. Synapses vary from simple reflex arcs (see page 85) to polysynaptic pathways in the brain and spinal cord that involve millions of synapses. A single motor neuron of the spinal cord may have as many as 10,000 synapses on its body and dendrites! The ability to integrate, coordinate, associate, and modify electrochemical impulses throughout the brain is directly related to the number of synapses in the pathway. From a neuronal point of view, it's not so important what you know (neuronal content) as it is *who* you know (numbers of contacts/synapses). Start working on that crossword puzzle!

The **typical chemical synapse** is shown in action through steps (1) through (6) in the lower half of the page, to help you understand how an electrochemical axodendritic synapse occurs. The **presynaptic axon** transmits the impulse toward the synapse (1). As the impulse reaches the axon terminal, calcium ion (Ca^{++}) channels are opened in the cell membrane, and extracellular Ca^{++} pours into the axon terminal from the extracellular space. (2) **Synaptic vesicles**, loaded with neurotransmitter (e.g., acetylcholine, norepinephrine, glutamate, etc.), influenced by the incoming Ca^{++}, migrate toward the **presynaptic membrane** and fuse with it (3). Following fusion, neurotransmitter is spilled from the vesicles into the tiny synaptic cleft (*exocytosis*). Neurotransmitter molecules bind to receptor proteins (J^1) on the **postsynaptic membrane** (J) of the dendrite; ion channels are opened, and the altered membrane potential (impulse) is propagated along the dendrite (4). Inactivated neurotransmitter **fragments** are taken up by the presynaptic membrane (5; **endocytosis**), enclosed in a synaptic vesicle, and resynthesized (6).

The electrical activity of the postsynaptic membrane may be facilitated or inhibited by the neurotransmitter. If sufficiently excited by multiple facilitatory synapses, the postsynaptic neuron will depolarize and transmit an impulse to the next neuron or effector (muscle cell, gland cell). If sufficiently depressed by multiple inhibitory synapses, the neuron will not depolarize and will not transmit an impulse.

CN: Light colors are recommended for A, B, and C.
(1) Only color the labeled parts of the upper drawing. Each synapse has two parts to be colored (presynaptic, postsynaptic). Color the arrows (representing nerve impulses) a hot color. (2) Let the numbered steps guide your coloring sequence of the chemical synapse below.

AXON ₐ
CELL BODY (SOMA) ᵦ
DENDRITE ᴄ

CHEMICAL SYNAPSES

AXO ₐ AXONIC ₐ
AXO ₐ SOMATIC ᵦ
AXO ₐ DENDRITIC ᴄ
AXO ₐ SPINO ᴄ'DENDRITIC ᴄ
DENDRO ᴄ DENDRITIC ᴄ
SOMATO ᵦ SOMATIC ᵦ
GLOMERULUS ⊹

NERVE IMPULSE ᴅ

ELECTRICAL SYNAPSE (Not shown)

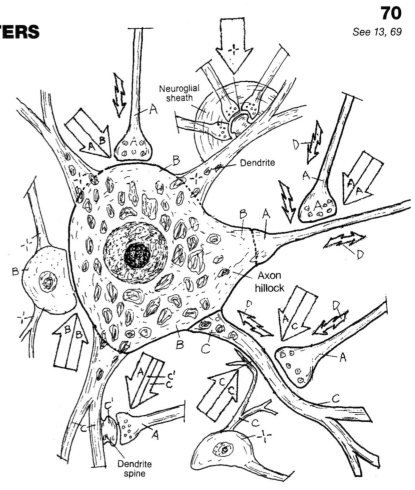

TYPICAL CHEMICAL SYNAPSE

PRESYNAPTIC AXON ₐ
SYNAPTIC VESICLE ꜰ
 NEUROTRANSMITTER ɢ
PRESYNAPTIC MEMBRANE ₑ
 EXOCYTOSIS ₕ
SYNAPTIC CLEFT ᵢ
POSTSYNAPTIC MEMBRANE ⱼ
 RECEPTOR ⱼ
NEUROTRANSMITTER
 FRAGMENT ɢ'
ENDOCYTOSIS ₖ

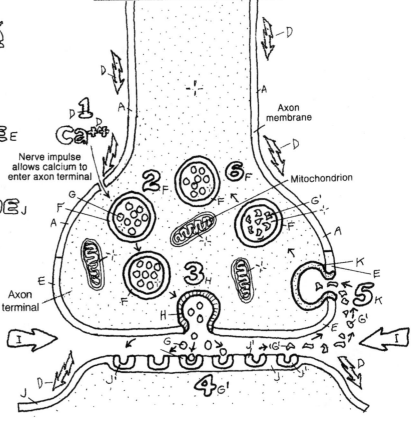

An axon, and its branches, of a single motor neuron and the skeletal muscle fibers it innervates constitute a **motor unit**. The specific connection of an axon with the muscle fiber is called a **neuromuscular junction**. Within any given skeletal muscle, the number of muscle fibers innervated by a single motor neuron largely determines the specificity of contraction of that muscle. The fewer the number of muscle fibers in each motor unit, the more selective and refined the degree of contraction of the skeletal muscle.

Skeletal muscle consists of innumerable **muscle fibers** (cells). Skeletal muscle requires an intact nerve (innervation) to shorten (contract). Such a nerve, called a **motor nerve**, consists of numerous **axons** of motor neurons. A motor neuron is dedicated solely to stimulating muscle fibers to contract. Each single muscle fiber in a skeletal muscle is innervated by a **branch of an axon**. The microscopic site at which the axon branch attaches to the skeletal muscle fiber is called the neuromuscular junction. Each neuromuscular junction consists of an **axon terminal** closely applied to an area of convoluted muscle fiber sarcolemma called the **motor end plate**. There is a gap between the two surfaces. When a skeletal muscle fiber is about to be stimulated, the axon terminal releases a chemical neurotransmitter, called acetylcholine, into the gap. The neurotransmitter induces a change in the permeability of the sarcolemma to sodium (Na^+), which initiates muscle fiber contraction. *A muscle fiber can only contract maximally* ("all or none" law). All muscle cells innervated by the branches of a single motor axon contract maximally.

Given the fact of "all or none" contractions by individual skeletal muscle fibers, **grades of contraction** of a skeletal muscle are made possible by activating a number of motor units and not activating others (see "Grades of Contraction" at the lower part of the illustrations).

We show here a muscle **at rest** with no motor units activated. Such a condition has two exceptions: (1) receptors responding *involuntarily* to stretch (muscle spindles) and (2) muscle tone *involuntarily* set by subcortical motor centers. So, in fact, even among resting muscles, a variable number units are in contraction at any one time even though the muscle is not consciously working.

In a **partial contraction**, only some of the motor units are activated. In **maximal contraction** of a skeletal muscle, all motor units are activated. The gluteus maximus consists of skeletal muscle fibers having a nerve-to-muscle ratio of 1:1000 or more. There is no possibility of controlled, refined contractions from this muscle. The facial muscles, in contrast, have a much lower nerve-to-muscle ratio, closer to 1:10. Here small numbers of muscle fibers can be contracted by implementing one or a few motor units, generating very fine control on the muscular effect (facial expression) desired, such as "the Mona Lisa smile."

CN: Use very light colors for A and E, and a bright color for F. (1) Begin with the skeletal muscle, A, shown lifting the heel of the foot; complete the motor unit and the enlarged view of the neuromuscular junction. (2) Color the grades of contraction and related titles at the bottom of the page: only the discharging motor units (in dark outline) are to be colored. Note that the words "at rest" and "partial" are not colored.

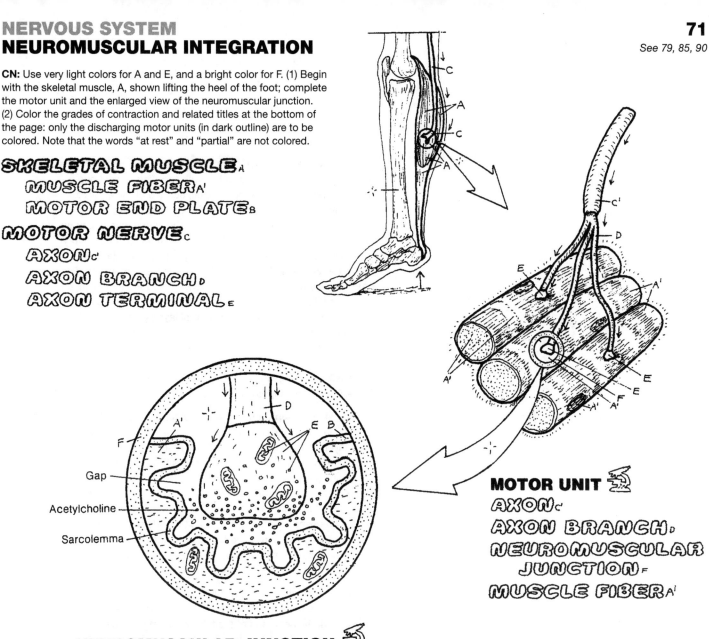

SKELETAL MUSCLEₐ
MUSCLE FIBERₐ'
MOTOR END PLATEв

MOTOR NERVEc
AXONc'
AXON BRANCHᴅ
AXON TERMINALᴇ

Gap
Acetylcholine
Sarcolemma

MOTOR UNIT 🔬
AXONc'
AXON BRANCHᴅ
NEUROMUSCULAR JUNCTIONꜰ
MUSCLE FIBERₐ'

NEUROMUSCULAR JUNCTION 🔬
NEUROMUSCULAR JUNCTIONꜰ
AXON TERMINALᴇ
MOTOR END PLATEв

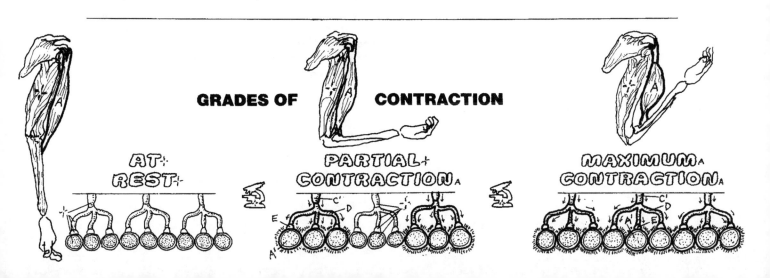

GRADES OF CONTRACTION

AT REST

PARTIAL CONTRACTIONₐ

MAXIMUM CONTRACTIONₐ

At **20 days** after fertilization, the embryo is in the amniotic cavity, attached on its ventral side to the yolk sac. The dissections on this page reveal the posterior (dorsal) surface of the embryo in the amniotic cavity during days 20–24 of its embryonic development. The head end is above; the caudal end is below. The 3-dimensional cross sections are taken through the embryo in planes labeled 1 and 2 at 20 days, plane 3 at **22 days**, and plane 4 at **24 days**. During this period of development, the three *basic germ layers* are formed from two. Ectoderm (dorsal layer) develops into epidermis/nails, the central and peripheral nervous systems, and more. Endoderm (ventral layer) gives rise to the gastrointestinal tract, liver, and more. Mesoderm, formed between the ectoderm and endoderm layers, forms most muscle, heart, blood, the dermis, connective tissues, and more. Neural crest cells (neuroectoderm) give rise to the ganglia of the PNS and ANS, the meninges, and more.

Referring to **development of the neural tube** at about 21–22 days, the nervous system develops from the dorsal surface (ectodermal germ layer) of the embryo. In the 20- to 21-day embryo, a *longitudinal* **neural groove** begins to form on a thickened layer of the germ layer (**neural plate***)*. In the central part of the plate, the groove deepens, forming **neural folds** on either side. The **neural crest** cells split off from the ectodermal layer. Deepening of the neural groove proceeds toward the head and tail ends of the embryo. By 22 days, the dorsal part of the folds fuse in the central part of the groove, forming the **neural tube**. During this process, the neural tube separates from the ectodermal layer.

By 24 days, formation of the neural tube has progressed to the extreme ends of the embryo. Much of the neural tube will form the spinal cord; the head end of the tube will form the brain.

By the end of three weeks of embryonic development, three regions of the developing brain are apparent: **forebrain**, **midbrain**, and **hindbrain**. With further growth (8 weeks), the forebrain expands to form the massive **telencephalon** (endbrain; future cerebral hemispheres) and the more central **diencephalon** ("between" brain; future top of the brain stem). The midbrain retains its largely tubular shape as the **mesencephalon** (midbrain; future upper brain stem). The hindbrain differentiates into the upper **metencephalon** ("change" brain; future middle brain stem) with a large dorsal outpocketing (future cerebellum), and the lower **myelencephalon** (spinal brain; lowest part of the future brain stem). The brain stem narrows to become the **spinal cord** at the level of the foramen magnum of the skull.

DEVELOPMENT OF THE
CENTRAL NERVOUS SYSTEM (CNS)

CN: Use light colors throughout. The uppermost illustration is for reference only, and is not to be colored. (1) Note but do not color the dorsal views of the 20- and 22-day-old embryos; first color the 3 related cross sections on their right. (2) Now color the arrows on the 20, 22, and 24-day-old embryos sequentially, noting what's happening to the neural groove. (3) Color the 24-day-old cross section, and relate it to the dorsal view of the embryo. (4) Color the stages of brain development in the head end of the neural tube.

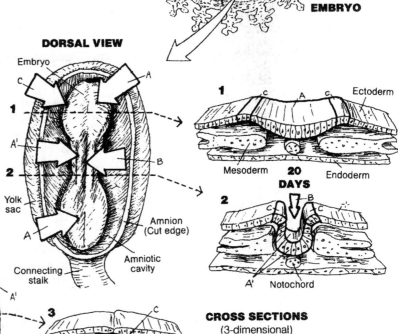

20-DAY EMBRYO

Chorion — Yolk sac — Embryo — Amnion — Connecting stalk

NEURAL TUBE

NEURAL PLATE A
FOLD A'
TUBE A²
NEURAL GROOVE B
NEURAL CREST C

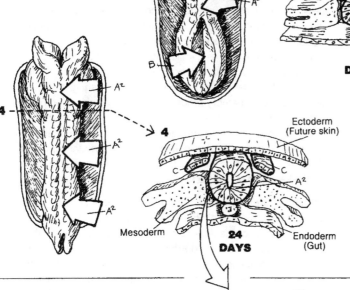

DORSAL VIEW

Embryo
Yolk sac
Connecting stalk
Amnion (Cut edge)
Amniotic cavity

1 — Ectoderm
Mesoderm — 20 DAYS — Endoderm

2 — A' — Notochord

CROSS SECTIONS
(3-dimensional)

3 — 22 DAYS

DEVELOPMENT
OF NEURAL TUBE

4 — 24 DAYS
Ectoderm (Future skin)
Mesoderm — Endoderm (Gut)

BRAIN

FOREBRAIN D
TELENCEPHALON E
DIENCEPHALON F
MIDBRAIN G
(MESENCEPHALON) G
HINDBRAIN H
METENCEPHALON I
MYELENCEPHALON J

SPINAL CORD K

4 WEEKS

6 WEEKS

8 WEEKS

16 WEEKS

DEVELOPMENT
OF BRAIN

The paired **cerebral hemispheres**, constituting the cerebrum, consists of four major elements bilaterally (see illustration upper right): (1) an outer **cerebral cortex** of gray matter, the topography of which reveals fissures (deep grooves), gyri (hills), and sulci (furrows); (2) underlying **subcortical white matter** consisting of (a) association tracts distributing electrochemical impulses from one cortical area to another/others, and (b) projection tracts that include ascending afferent (sensory) pathways to the cortex from the spinal cord and brain stem and descending efferent (motor) pathways from the cortex to the brain stem and spinal cord; (3) discrete masses of gray matter at the base of the cerebrum (**basal nuclei/ganglia**) that serve motor areas of the cortex; and (4) paired lateral ventricles of the cerebral hemispheres.

The cerebral cortex is the highest-functioning area of the brain. About 2–4 mm thick, the cortex is divided for descriptive purposes into four lobes distinctly bordered by sulci or fissures. Parts of three of these four lobes are older, in evolutionary terms, and contribute to the **limbic system**. All cortical areas are concerned, to one degree or another, with the storage of experience (memory). The neurons of the **frontal lobe** participate in intellectual functions (reasoning and abstract thinking), emotional behavior/states/feelings, olfaction (smell) and memory, articulation of meaningful sound (*speech*), and voluntary movement (**precentral gyrus**). The **parietal lobe's postcentral gyrus** is concerned with body **sensory** awareness, including taste, language processing, abstract reasoning, and body imaging. The **temporal lobe** is concerned with language interpretation and hearing; it also constitutes a major memory processing area (e.g., hippocampus; for short term memory). Its limbic portion contributes powerfully to expressions of emotions and related feelings. The **occipital lobe** receives, interprets, and discriminates among **visual** stimuli from the optic tract and associates those visual impulses with other cortical areas (e.g., memory).

The **limbic area/system** (Latin; *limbus*, border) provides for the expression of emotional states (fear, anger, love, etc.). Principal limbic areas (E) of the right cerebral cortex can be seen in the large illustration as darkly dotted areas to be colored over on the medial, anterior, and anterior-inferior surfaces of the frontal and temporal lobes, and a small portion of the parietal lobe. These areas appear as an incomplete border around the medial aspect of each hemisphere, thus its name. These areas (see illustration) include: (1) the *orbital and medial prefrontal cortex*, (2) the *cingulate gyrus of the medial frontal cortex*, (3) the *parahippocampal gyrus of the medial temporal cortex*, and (4) the *amygdala* (actually a complex of nuclei) in the anterior-medial temporal lobe (at the tip); the amygdala on the right is shown dotted to suggest "seeing through the lobe" to its location on the medial aspect).

The cerebral hemispheres appear structurally as mirror images of one another, but functionally they are not. For example, **Broca's speech area** tends to develop on the left side only. The left hemisphere has more influence on verbal functions, and the right hemisphere on visual, spatial, and musical expression.

CN: Use light colors throughout. (1) Color the coronal section at upper right. (2) Color the lobes A-D; then go back and color over the parts of lobes A, B, and C representing the limbic system, E, (shown darkly dotted) with a bright color. Just inferior to the head of the corpus callosum, the ventral basal ganglia is to be colored gray, and A and E colors. On the medial aspect of the right temporal lobe, arrow F points to the rounded amygdala which is to receive C and E colors. Color gray the diagrams at lower left. The left amygdala is seen "looking through" (dotted circle) the tip of the left temporal lobe to its medial aspect.

CEREBRAL CORTEX

FRONTAL LOBE A
PRECENTRAL GYRUS (MOTOR) A'
BROCA'S SPEECH AREA A²

PARIETAL LOBE B
POSTCENTRAL GYRUS (SENSORY) B'

TEMPORAL LOBE C
AUDITORY AREA C'
WERNICKE'S AREA C²

OCCIPITAL LOBE D
VISUAL AREA D'

LIMBIC AREA E

CEREBRAL CORTEX *
SUBCORTICAL WHITE MATTER +
BASAL NUCLEI / GANGLIA *'

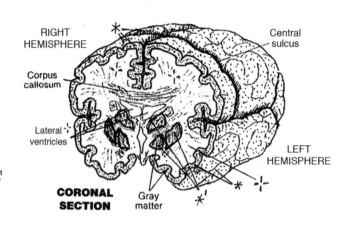

LONGITUDINAL FISSURE F
CENTRAL SULCUS G
LATERAL FISSURE H

CORTICAL CONVOLUTIONS INCREASE SURFACE AREA

Each of the two **cerebral hemispheres** embodies a lateral ventricle, various masses of gray matter at the base of the hemisphere, and a wide array of subcortical white matter.

The principal nuclei at the base of the brain are the **basal ganglia**, consisting of five pairs of cell groups arranged around the thalamus (views 1–4): the **caudate nucleus**, the **putamen**, the **globus pallidus**, the **substantia nigra**, and the **subthalamic nuclei**. The latter two are located in the midbrain but have extensive connections with the basal ganglia. The putamen and globus pallidus make a lens-shaped form and are often referred to as the *lenticular* or *lentiform nucleus*. The caudate nucleus and the putamen have a striated appearance, probably due to the close proximity of a heavy concentration of fibers in the internal capsule; together they are often called the *striatum*. The caudate has a head, body, and a tail. One can learn some important relationships by studying the course of the caudate nucleus from head to tail in relation to the thalamus, the internal capsule, and the lentiform nucleus. The head of the caudate merges with the putamen anteriorly and ventrally, forming the ventral striatum or ventral basal ganglia; it is part of the limbic system (page 73). The substantia nigra and the subthalamic nuclei (views 1 and 2) are both strong components of the basal ganglia. Neurons of the dorsal substantia nigra are dopaminergic; that is, they produce the neurotransmitter dopamine, which is critical for normal motor function; in its absence, one develops rigidity, tremors at rest, and an abnormal gait (Parkinson disease). The basal ganglia have extensive connections among themselves, with the cerebral cortex, and with nuclei of the diencephalon. *They are concerned with the maintenance of muscle tone and the programming of subconscious, sequential postural adjustments.* They monitor and mediate descending motor commands from the **cerebral cortex**.

The **subcortical white matter** of the hemispheres is arranged into bundles or bands (**tracts**) of largely myelinated axons essentially arranged in three axes. They conduct impulses among various areas of the cortex. Of the three **commissures** (two are not shown), the largest is the **corpus callosum**. It conducts impulses from one hemisphere to the other. It roofs the subcortical nuclei (see views 1 and 5). **Association tracts** connect the cerebral cortices in each hemisphere (see views 5 and 6), existing as both short and long tracts.

The most spectacular tract in the cerebrum is the broad, fan-shaped array of fibers called the **corona radiata** ("radiating crown"; see views 1 and 7). This projection system consists of ascending and descending fibers connecting with all areas of the cortex; it narrows into the **internal capsule** (see view 1), where fibers enter/depart the basal nuclei/ganglia and diencephalon destined for the midbrain or higher/lower. Ascending fibers from the spinal cord and brain stem generally synapse in the thalamus. Long fibers can start in the motor cortex and travel nonstop to synapse in the lumbar spinal cord!

TRACTS / NUCLEI OF CEREBRAL HEMISPHERES

CEREBRAL CORTEX A*

SUBCORTICAL AREAS

BASAL NUCLEI / BASAL GANGLIA

CAUDATE NUCLEUS B
PUTAMEN C
GLOBUS PALLIDUS D
SUBSTANTIA NIGRA E
SUBTHALAMIC NUCLEUS F

WHITE MATTER TRACTS

COMMISSURES G
 CORPUS CALLOSUM G'
PROJECTION TRACTS H-
 CORONA RADIATA H'
 INTERNAL CAPSULE H²
ASSOCIATION TRACTS I

LATERAL VENTRICLE J

CN: Use very light colors for F and G. (1) Color gray the views of the cerebral cortex without coloring the cortical surfaces. Start with the view of the coronal section, 1, and color the designated structures in views 2 through 7.

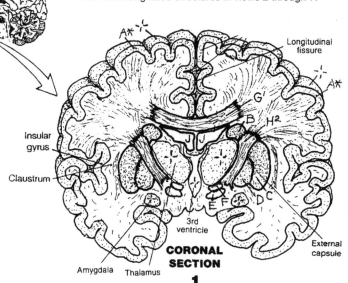

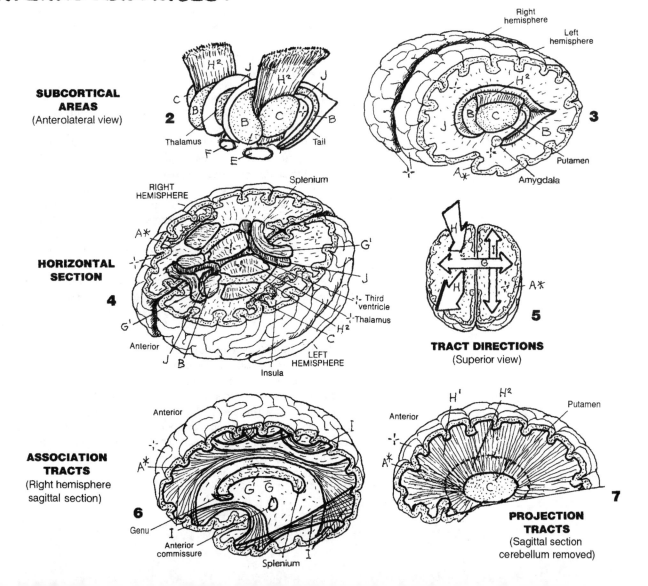

Longitudinal fissure

Insular gyrus

Claustrum

3rd ventricle

External capsule

Amygdala
Thalamus

CORONAL SECTION
1

SUBCORTICAL AREAS
(Anterolateral view)
2

Thalamus
Tail

Right hemisphere
Left hemisphere

3

Putamen
Amygdala

HORIZONTAL SECTION
4

RIGHT HEMISPHERE
Splenium

Third ventricle
Thalamus

Anterior

LEFT HEMISPHERE

Insula

TRACT DIRECTIONS
(Superior view)
5

ASSOCIATION TRACTS
(Right hemisphere sagittal section)
6

Anterior

Genu
Anterior commissure
Splenium

Anterior

Putamen

PROJECTION TRACTS
(Sagittal section cerebellum removed)
7

The **diencephalon**, the smaller of the early forebrain's two derivatives, fits between but is not considered part of the surrounding cerebral hemispheres. It consists largely of paired masses of nuclei and related tracts of white matter arranged around the thin, purse-like third (III) ventricle.

On each side of the third ventricle, note the *thalamus, subthalamus,* and *hypothalamus*. The *epithalamus* or *pineal gland* is a midline structure appearing to hang off the posterior thalamus. The relationship of these nuclei to the basal nuclei and internal capsule should be carefully studied while coloring to ensure orientation.

The **thalamus** (1–4) consists of several groups of cell bodies and processes that, in part, process all incoming impulses from sensory pathways (except olfactory). It has broad connections with the motor, general sensory, visual, auditory, and association cortices. Not surprisingly, the corticothalamic (cortex to thalamus) fibers contribute significantly to the *corona radiata*. Still other thalamic nuclei connect to the hypothalamus and other brainstem nuclei. Thalamic activity (1) integrates sensory experiences resulting in appropriate motor responses, (2) integrates specific sensory input with emotional (motor) responses (e.g., a baby crying in response to hunger), and (3) regulates and maintains the conscious state (awareness), subject to facilitating/inhibiting influences from the cortex. The three *subthalamic nuclei* are concerned with motor activity and have connections with the basal ganglia.

The **hypothalamus** packs several nuclear masses and associated tracts in a small area on either side of the lower **third ventricle**. The hypothalamus maintains neuronal connections with the frontal and temporal cortices, the thalamus, and the brain stem. The anterior hypothalamus regulates blood pressure, body temperature, and the autonomic nervous system in general. It synthesizes hormones and releases them into capillaries in the median eminence of the anterior pituitary, influencing the secretion of anterior pituitary hormones; posterior hypothalamic secretory neurons release antidiuretic hormone (ADH; inhibiting diuresis) and oxytocin into the circulation in the posterior pituitary gland. The hypothalamus strongly influences visceral responses to emotional stimuli. It responds to feeding by inducing feelings of satiety. In short, the hypothalamus responds to changes in well-being by working to maintain homeostasis, primarily through the autonomic nervous system.

The **epithalamus (pineal gland)** consists primarily of the pineal body and related nuclei and tracts that have connections with the thalamus, hypothalamus, basal nuclei, and medial temporal cortex. It produces melatonin (a pigment-enhancing hormone), the synthesis of which is related to diurnal cycles or rhythms (body activity in day or sunlight as opposed to dark or nocturnal periods). It may influence the onset of puberty through inhibition of testicular/ovarian function. Remarkably, the pineal gland is the only unpaired structure in the brain.

CN: Use light colors for A and B, and a very bright color for C. (1) Color the name, thalamus, A, and where ever it appears on the page before going on to the next name and repeating the process. Color the horizontal section and relate to the median view and the coronal section. (2) Color the hypothalamic nuclei in the lower two views. (3) Color the pineal gland, C, at upper right.

DIENCEPHALON
THALAMUS A
HYPOTHALAMUS B
EPITHALAMUS
(PINEAL GLAND) C
THIRD VENTRICLE D

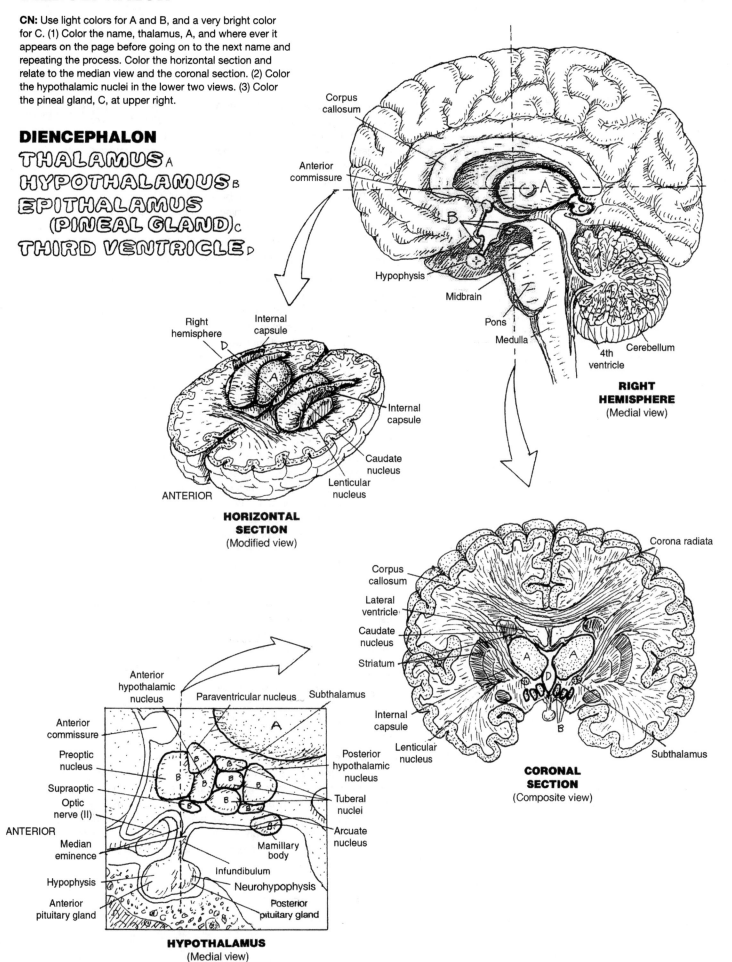

Corpus callosum

Anterior commissure

Hypophysis

Midbrain

Pons

Medulla

4th ventricle

Cerebellum

RIGHT HEMISPHERE
(Medial view)

Right hemisphere

Internal capsule

Internal capsule

Caudate nucleus

Lenticular nucleus

ANTERIOR

HORIZONTAL SECTION
(Modified view)

Corona radiata

Corpus callosum

Lateral ventricle

Caudate nucleus

Striatum

Internal capsule

Lenticular nucleus

Subthalamus

CORONAL SECTION
(Composite view)

Anterior hypothalamic nucleus

Paraventricular nucleus

Subthalamus

Anterior commissure

Preoptic nucleus

Supraoptic

Optic nerve (II)

ANTERIOR

Median eminence

Hypophysis

Anterior pituitary gland

Posterior hypothalamic nucleus

Tuberal nuclei

Arcuate nucleus

Mamillary body

Infundibulum

Neurohypophysis

Posterior pituitary gland

HYPOTHALAMUS
(Medial view)

The **brain stem** includes the *diencephalon, midbrain, pons,* and *medulla oblongata.* It does not include the *cerebellum.* The brain stem carries out specific functions associated with cranial nerve nuclei, it runs long ascending and descending tracts to higher centers and to the spinal cord (pages 78, 90, and 98). From the tegmentum of the midbrain on either side of the cerebral aqueduct to the medulla oblongata, there is a core of short axon neurons super-integrated into synaptic chains called the *reticular formation.* This diffuse network is "the bureaucracy" of the brain, and is specifically associated with coming to consciousness, alertness, and going to sleep. It is involved in many visceral and somatic reflexes, such as respiratory and cardiac, working "behind the scenes," and not requiring conscious or volitional effort.

Brain stem nuclei, including the reticular formation, refines the "messages" from the basal ganglia and motor cortex, modifying ascending input, including dispatching critical input to the thalamus. These brain stem nuclei integrate and modulate muscle tone and posture-related impulses in support of the corticospinal tract to the lower motor neurons. This is the *final common neuronal pathway* to the skeletal muscles of the body. It assists in the execution of precise movements done in sequence, and at the desired moment. Such movements are best appreciated when watching contesting Olympic athletes or similarly trained performers.

The **cerebral peduncles** of the **midbrain** carry long descending (corticospinal) tracts and short (corticopontine) tracts as well. The tegmentum of the midbrain includes the reticular formation, the nuclei of cranial nerves III and IV, and multiple tracts. The **superior cerebellar peduncles** consist of the spinocerebellar and other ascending tracts. The **superior colliculi** make possible visual reflexes and the **inferior colliculi** auditory reflexes (rapid and involuntary responses to visual and auditory stimuli).

The massive anterior bulge of the **pons** consists of bands of white matter that bridge the **fourth ventricle** (*pons,* bridge) to reach the cerebellum as the **middle cerebellar peduncles,** transmitting afferent fibers in the pontocerebellar tract. Cranial nerve nuclei V, VI, VII, and VIII are located in the pons.

The **medulla oblongata** controls the centers of respiration, heart rate, and vasomotor function. Nuclei for cranial nerves VIII, IX, X, XI, and XII exist here. The **inferior cerebellar peduncles** conduct both sensory and motor-related impulses to the spinal cord and brainstem. The pons and medulla are home to the fourth ventricle.

The **cerebellum** consists of two hemispheres with a **cerebellar cortex,** central masses of motor-related (**deep cerebellar) nuclei,** and a three-dimensional, tree-shaped arrangement of white matter (arbor vitae, tree of life). The cerebellum is concerned with equilibrium and position sense, fine movement, control of muscle tone, and overall coordination of muscular activity in response to proprioceptive input and descending traffic from higher centers.

CN: Use darker colors for C, E, and M and a light color for K. (1) Color each name and its structure in all relevant views before moving on to the next name. (2) Relate each view of the brain stem to the other two views as you color each structure.

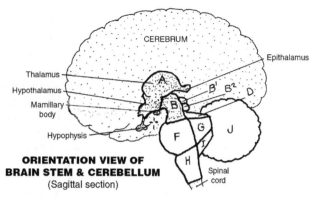

**ORIENTATION VIEW OF
BRAIN STEM & CEREBELLUM**
(Sagittal section)

BRAIN STEM

DIENCEPHALONₐ

MIDBRAINʙ
 CEREBRAL AQUEDUCTc
 SUPERIOR COLLICULUSʙ¹
 INFERIOR COLLICULUSʙ²
 CEREBRAL PEDUNCLEʙ³
 **SUPERIOR CEREBELLAR
 PEDUNCLE**ᴅ

HINDBRAIN∴
 4TH VENTRICLEᴇ
 PONSꜰ
 **MIDDLE CEREBELLAR
 PEDUNCLE**ɢ
 MEDULLA OBLONGATAʜ
 **INFERIOR CEREBELLAR
 PEDUNCLE**ɪ

CEREBELLUMᴊ
 ARBOR VITAEᴋ
 CEREBELLAR CORTEXʟ*
 **DEEP CEREBELLAR
 NUCLEUS**ᴍ

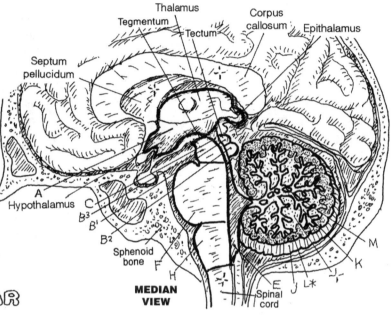

**MEDIAN
VIEW**

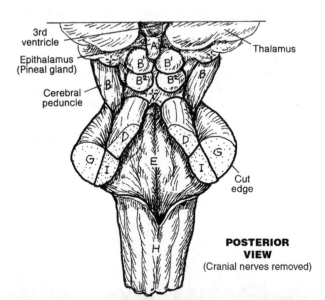

**POSTERIOR
VIEW**
(Cranial nerves removed)

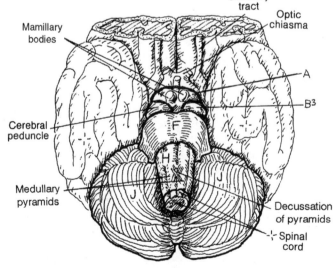

**INFERIOR & ANTERIOR
VIEW**
(Cranial nerves removed)

The **spinal cord** is the lower component of the central nervous system. It takes off from the medulla oblongata at the foramen magnum of the skull. It bulges slightly in the lower cervical and lumbar segments (*cervical* and *lumbar enlargements*) to accommodate the extra roots of the spinal nerves destined for the upper and lower limbs, respectively. The cord ends at the *conus medullaris* at the level of the L2 vertebra. The spinal cord, like the brain, is ensheathed by three coverings (**meninges**): the thin, vascular *pia mater* closely applied to the spinal cord, the translucent, cobweb-like **arachnoid mater** stuck to the dura and separated from the pia by the **subarachnoid space** in which thin beams of loose connective tissue (trabeculae) come off the arachnoid and attach to the pia mater. The outer fibrous **spinal dura mater** is a prolongation of the cranial dura mater.

The **pia mater** forms triangular sheets that project away from the cord to the dura between pairs of nerve roots. These sheets *(denticulate ligaments)* presumably stabilize the spinal cord (see lower left). The spinal cord ends as the conus medullaris at L2; the pia continues inferiorly as a thin cord-like **pial filum terminale**. It ends with the dural sac at the vertebral level of S2. This cavity, the lumbar cistern, contains cerebrospinal fluid (CSF). The dural sac continues inferiorly as the **dural filum terminale**, and attaches to the coccyx.

External to the dura is the **epidural space,** best seen in the cross section at lower left, containing loose connective tissue, adipose tissue, and a system of veins. Injections of pain and steroid medication into the epidural space is a common form of pain management. The veins here are part of an external and internal vertebral venous plexus that forms a network within and around the vertebral canal for its entire length. It is an essential part of the system of collateral circulation.

Throughout the length of the cord is a central column of gray matter arranged in the form of an H, forming "four horns" surrounded by columns of white matter (*funiculi*). The **gray matter** consists largely of neuronal cell bodies, neuroglia, and unmyelinated fibers. The **white matter** consists largely of ascending and descending tracts of axons that appear white due to a surrounding layer of fatty myelin. The amount of white matter predictably decreases as the cord progresses inferiorly, seen especially well in the sacral section. The **posterior horns** receive central processes of sensory neurons and direct incoming impulses to the adjacent white matter for conduction to other cord levels or higher centers. The **anterior horns** consist of interneurons and lower motor neurons that represent the "final common pathway" for motor commands to skeletal muscle. **Lateral horns** exist only in the thoracic and upper lumbar cord, and include autonomic motor neurons supplying smooth muscle in vessels, viscera, and glands. It is in the gray matter that spinal reflexes occur in conjunction with facilitatory and inhibitory influences from higher centers.

CN: (1) Color only the spinal cord, A, in the drawing at right. (2) In the cross section below, color the structures indicated and their names. (3) Color the spinal cord edge, A, and the gray matter, D*, in the four cross sections of the spinal cord; the white matter is to be uncolored. (4) In the figure at right, the posterior arches of the vertebrae are removed to expose the spinal cord, A, subarachnoid space, B, and the cut edge of the dura mater, C. The pia, A¹, and arachnoid, B¹, are so close to the dura and spinal cord, respectively, they cannot be colored there. Only A, C, A², and C¹ are colorable in this drawing.

SPINAL CORD A

MENINGES / SPACES +
PIA MATER A'
PIAL FILUM TERMINALE A²
SUBARACHNOID SPACE B +
ARACHNOID MATER B'
SPINAL DURA MATER C
DURAL FILUM TERMINALE C'
EPIDURAL SPACE C +

GRAY MATTER D*
POSTERIOR HORN E
ANTERIOR HORN F
LATERAL HORN (T1-L2) G
INTERMEDIATE ZONE H
GRAY COMMISSURE I

WHITE MATTER J +
POSTERIOR FUNICULUS K
LATERAL FUNICULUS L
ANTERIOR FUNICULUS M

SECTIONS OF SPINAL CORD
(Anterosuperior view)

CERVICAL LEVEL

THORACIC LEVEL

LUMBAR LEVEL

SACRAL LEVEL

L 2

Conus medullaris

Cauda equina (Nerve roots)

Sacrum (cut)

End of dural sac

S 2

Coccyx

SPINAL CANAL & CONTENTS
(Posterior view)

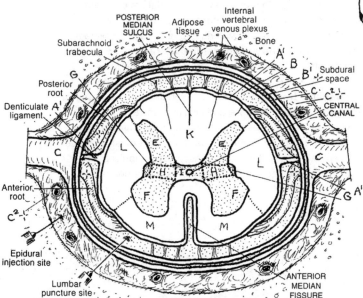

POSTERIOR MEDIAN SULCUS
Adipose tissue
Internal vertebral venous plexus
Bone
Subarachnoid trabecula
Subdural space
CENTRAL CANAL
Posterior root
Denticulate ligament
Anterior root
Epidural injection site
Lumbar puncture site
ANTERIOR MEDIAN FISSURE

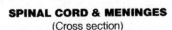

SPINAL CORD & MENINGES
(Cross section)

Ascending tracts or **pathways** consist of linearly arranged neurons, the axons of which travel in a common bundle (tract) primarily conducting impulses toward the thalamus, cerebral cortex, or cerebellum. In the examples shown here, each of the pathways begins with a *sensory neuron*. These sensory pathways permit body surface sensations and muscle/tendon stretch information (below the head) to reach cortical, thalamic, cerebellar, and brain stem centers for response and cortical centers for awareness.

Pain and **temperature receptors** on the body surface and elsewhere below the head generate impulses that travel to the spinal cord by axons of **sensory neurons** (first-order neurons). The central process (*axon*) of each sensory neuron enters the posterior horn and synapses with the second-order neuron whose axon crosses (*decussates*) to the contralateral side, enters the lateral funiculus, and ascends as part of the **lateral spinothalamic tract**. This neuron ascends to the **thalamus**, where it synapses with relay (third-order) neurons, the axons of which traverse the internal capsule and corona radiata (**thalamocortical tract**) to reach the postcentral gyrus of the cerebral cortex (**sensory cortex**).

Touch and **pressure receptors** below the head generate electrochemical impulses that travel to the spinal cord through sensory neurons that enter the posterior horn and join/ascend the posterior funiculus (posterior columns) to the medulla. Here they synapse with second-order neurons in the **nuclei cuneatus** and **gracilis**. The axons of these neurons sweep to the opposite side (decussate as **internal arcuate fibers**) to form an ascending bundle (**medial lemniscus**) in the brainstem that terminates in the *thalamus*. There, these axons synapse with third-order relay neurons whose axons reach the postcentral gyrus of the cerebral cortex via the *thalamocortical tract*.

Impulses from muscle spindles and other proprioceptors (receptors responsive to **muscle stretch**/loads) are conducted by sensory neurons *to* the spinal cord. Single-receptor input is conducted by second-order neurons that ascend the ipsilateral lateral funiculus (**posterior spinocerebellar tract**) and enter the cerebellum via the **inferior cerebellar peduncle**. More global proprioceptive input ascends the contralateral **anterior spinocerebellar tract** and enters the cerebellum via the **superior cerebellar peduncle**. By these and similar pathways that function in the absence of awareness, the cerebellum maintains an ongoing assessment of body position, muscle tension, muscle overuse, and movement. In turn, it mediates descending impulses from cortical and subcortical centers destined for motor neurons.

CN: Use bright colors for A–C and a light color for F.
(1) Start with the overview of these three pathways above.
(2) Color the names and related pain/temperature pathway A, beginning with the small diagram below the list of names. Then color the sensory neuron, A^1, on the lower left side of the large spinal cord schematic and begin your journey to the sensory cortex. (3) Repeat the above with pathway B. (4) Repeat the above with pathway C.

ASCENDING TRACTS (PATHWAYS)

PAIN/TEMPERATURE A
 SENSORY NEURON A^1
 LATERAL SPINOTHALAMIC TRACT A^2
 THALAMUS $*^1$
 THALAMOCORTICAL TRACT A^3
 SENSORY CORTEX $*^2$

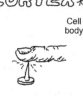
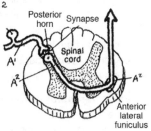

TOUCH/PRESSURE B
 SENSORY NEURON B^1
 NUCLEI CUNEATUS & GRACILIS B^2
 INTERNAL ARCUATE FIBERS B^3
 MEDIAL LEMNISCUS B^4
 THALAMUS $*^1$
 THALAMOCORTICAL TRACT B^5
 SENSORY CORTEX $*^2$

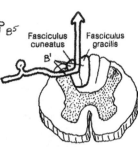

MUSCLE STRETCH/POSITION SENSE C
 SENSORY NEURON C^1
 POSTERIOR SPINOCEREBELLAR TRACT C^2
 INFERIOR CEREBELLAR PEDUNCLE D
 ANTERIOR SPINOCEREBELLAR TRACT C^3
 SUPERIOR CEREBELLAR PEDUNCLE E
 CEREBELLAR CORTEX F

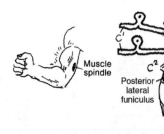
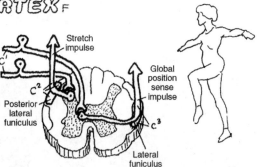

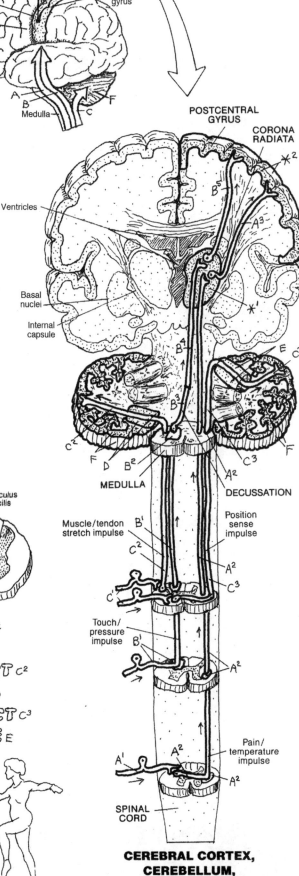

**CEREBRAL CORTEX,
CEREBELLUM,
& SPINAL CORD**
(Schematic)

The principal neural pathway for voluntary movement is the **corticospinal tract**. Its neuronal cell bodies are in the precentral gyrus of each frontal lobe (**motor cortex**). The axons of these neurons descend—without synapse—through the corona radiata, internal capsule, cerebral peduncles, pons, and medulla into the spinal cord. Pathways are often named according to their origin and their termination, in that order; hence, cortico- (refers to cortex) spinal (refers to the spinal cord). The corticospinal tracts form bulges, called *pyramids*, on the anterior surface of the medulla, hence the name **pyramidal tract**. Eighty percent of these tracts cross (decussate) to the contralateral side in the medulla (*decussation of the pyramids*); 20% do not. In the spinal cord, many corticospinal fibers terminate on interneurons (recall page 71) at the base of the posterior horn (not shown); the majority end by synapsing with anterior horn motor neurons. Interneurons are important because they add diversity to the mix. The corticospinal input to the lower motor (anterior horn) neurons are only one of many inputs for desired skeletal muscle function.

Each **lower motor neuron** receives axons from multiple descending tracts, many of which conduct impulses related to body position, memory, and a host of other commands necessary for any given movement. These collective inputs from the cerebral cortex, basal nuclei, cerebellum, and elsewhere arrive at the appropriate lower motor neurons by a number of descending pathways, none of which pass through the **medullary pyramids** (hence **extrapyramidal system** or *tracts*). Two major extrapyramidal tracts are shown here: the **reticulospinal tract** from the brain stem reticular nuclei, and the **vestibulospinal tract** from the vestibular nuclei in the brain stem. Other tracts include the rubrospinal and tectospinal tracts (not shown, but see glossary). In the illustration, the nuclei of these axons are located in the midbrain and pons. They are seen with uncolored axons synapsing with them from the basal ganglia. These uncolored neurons do not reach the medulla and are, therefore, not part of the extrapyramidal tracts. The synaptic connections of these axons with each lower motor neuron (often by way of **interneurons**) are in the thousands. Depending on the neurotransmitter produced by the presynaptic neuron, the synapse may facilitate or inhibit production of an excitatory impulse from the lower motor neuron. Discharge of the lower motor neuron, or lack of it, is dependent on the sum of the facilitatory and inhibitory impulses impinging on it at any moment. Once generated, the electrochemical impulse moving down the axon of the lower motor neuron reaches the effector without further mediation. Thus, the anterior horn motor neuron is truly the **final common pathway** for the ultimate expression of all nervous activity: muscular contraction.

DESCENDING TRACTS

CN: Use light colors. (1) Color the name, A, and pyramidal tract, A, in the sagittal view. (2) Color the pyramidal tract (A, A^1) in the coronal section at upper right, starting at the motor cortex. Color the percentage figures, B and C. (3) Color the two extrapyramidal tracts below, and the final common pathway, D and E.

PYRAMIDAL TRACT
(Schematic)

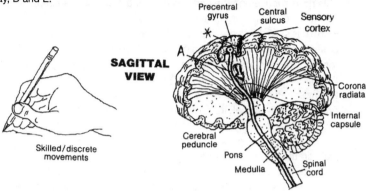

SAGITTAL VIEW

Precentral gyrus · Central sulcus · Sensory cortex · Corona radiata · Internal capsule · Cerebral peduncle · Pons · Medulla · Spinal cord

Skilled/discrete movements

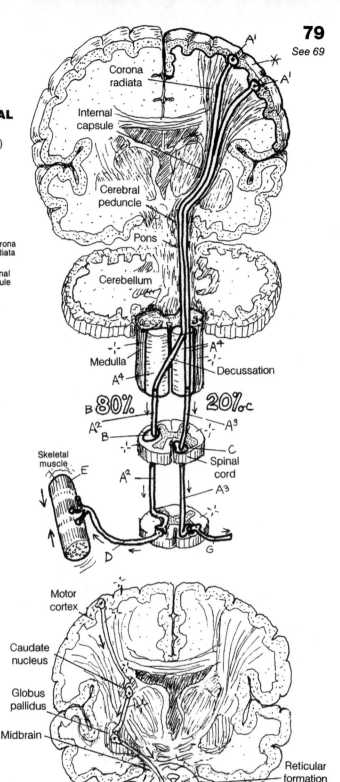

Corona radiata · Internal capsule · Cerebral peduncle · Pons · Cerebellum · Medulla · Decussation · Skeletal muscle · Spinal cord

B **80%** · **20%**C

A^1 · A^4 · A^2 · A^3 · B · C · D · G · E

PYRAMIDAL TRACT / RELATED AREAS

MOTOR CORTEX ✱
PYRAMIDAL TRACT A
 CORTICOSPINAL TRACT A^1
 LATERAL A^2
 ANTERIOR A^3
 MEDULLARY PYRAMID A^4
LATERAL FUNICULUS B
ANTERIOR FUNICULUS C

FINAL COMMON PATHWAY

LOWER MOTOR NEURON D
EFFECTOR E

EXTRAPYRAMIDAL SYSTEM

PONTINE RETICULOSPINAL TRACT F
VESTIBULOSPINAL TRACT G
INTERNEURON H

Motor cortex · Caudate nucleus · Globus pallidus · Midbrain · Reticular formation · Cerebellum · Pons · Medulla · Spinal cord

PARTS OF EXTRAPYRAMIDAL SYSTEM
(Schematic)

Basic movements

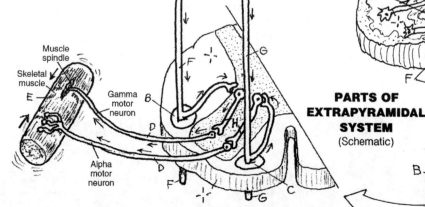

Muscle spindle · Skeletal muscle · Gamma motor neuron · Alpha motor neuron · E · B · D · F · G · H · C

This page focuses on the development of the cavity of a simple neural tube into an interconnected group of mature cavities (**ventricles**) of different shapes and sizes in the Central Nervous System (CNS). The expansion of the ventricular system in the rostral (superior) forebrain (**telencephalon**) is extraordinary. Note these **lateral ventricles** in the upper illustration at far right and in the lateral and superior views below. As each *cerebral hemisphere* grew anteriorly, it took its ventricle with it, creating the *anterior horn of the lateral ventricle (1 or 2)* (see lateral and superior views). As the hemisphere grew posteriorly, it took its ventricle with it as well, creating the *posterior horn of the lateral ventricle*. The growth of the temporal lobe of each hemisphere created the most interesting form: As the brain tissue and its component of the ventricle moved in a slightly lateral and downward direction, it also curved anteriorly and came along side the frontal and parietal lobes on each side. In doing so, it pulled its part of the lateral ventricle with it, forming the *inferior horn of the lateral ventricle*.

The ventricles may be identified by name, Roman numerals (I, II, III, IV, etc.), or Arabic numerals (1, 2, 3, 4).

The neural tube of the **diencephalon** came to be pressed bilaterally by the developing hemispheres and the paired nuclei of the thalamus, forming the **third ventricle** into the shape of a thin purse. The front of the third ventricle is drawn anteriorly and caudally into an infundibular recess in the region of the hypothalamus (page 75). Posteriorly, the third ventricle is pulled into the pineal recess next to the pineal gland.

The neural cavity of the **mesencephalon** or midbrain undergoes relatively little distortion during development, retaining its tubular shape as the **cerebral aqueduct**.

The neural cavity of the hindbrain is called the fourth ventricle. The more rostral part of the hindbrain is part of the **metencephalon**, and the more caudal region is part of the **myelencephalon**. The cavity of the metencephalon undergoes lateral and posterior expansion as a consequence of the emergence of the developing cerebellum. The fourth ventricle does not project into the cerebellum. The roof of the fourth ventricle in the myelencephalon consists of a thin plate (medullary velum).

In the medial walls of the lateral ventricles and the roof of the third and fourth ventricles, the pia mater comes in contact with the single layers of neuroglia-derived cells that line the ventricular surface (ependymal cells or layer). These vascularized tissues form the **choroid plexus** that secretes cerebrospinal fluid (CSF) into the ventricles.

VENTRICULAR DEVELOPMENT

NEURAL CAVITY OF *

FOREBRAIN A

TELENCEPHALON B

DIENCEPHALON C

MESENCEPHALON D

HINDBRAIN E

METENCEPHALON F

MYELENCEPHALON G

SPINAL CORD H

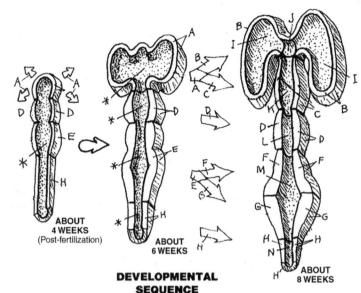

ABOUT 4 WEEKS (Post-fertilization)

ABOUT 6 WEEKS

ABOUT 8 WEEKS

DEVELOPMENTAL SEQUENCE
(Schematic longitudinal section)

DERIVATIVES

LATERAL VENTRICLE (1&2) I

INTERVENTRICULAR FORAMEN J

3RD VENTRICLE K

CEREBRAL AQUEDUCT L

4TH VENTRICLE M

CENTRAL CANAL N

CHOROID PLEXUS O

CN: Use a light color for A. Use red for O. (1) Color the three drawings of "Ventricular Development." The neural cavities in the first two drawings are colored gray; the names and parts of the neural cavity in the third drawing correspond to the derivatives of the early neural tube. (2) Color the derivatives, I-N, in the lower four illustrations. The regions of the brain, D, F, G, and H, can be colored in the sagittal section as well. Color the choroid plexus, O, in the lower two sections.

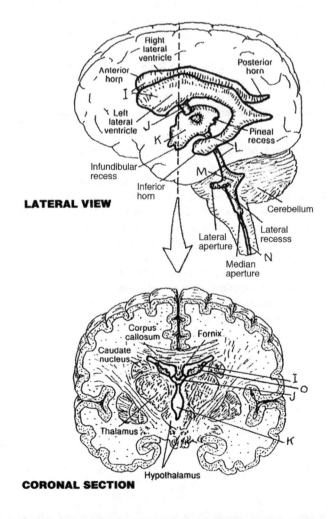

LATERAL VIEW

CORONAL SECTION

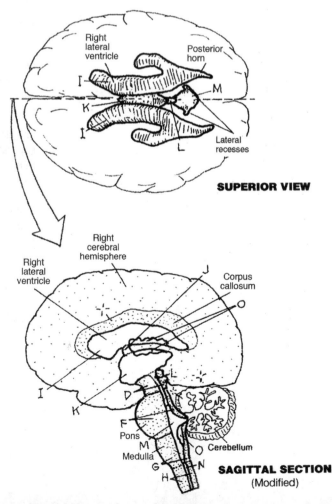

SUPERIOR VIEW

SAGITTAL SECTION
(Modified)

The **meninges** are the fibrous coverings that envelop the brain and spinal cord. The meninges of the spinal cord (page 77) are the inferior extension of the cranial membranes presented here.

The **dura mater** is the outermost covering of the brain and the spinal cord (*spinal dura mater*). It has two layers: the **outer layer** lining the internal surface of the cranium and vertebral canal (**periosteum**), and the **inner** or **meningeal layer** enclosing the entire brain (*cranial dura mater*) and forming dural septa or partitions between lobes.

The single **falx cerebri** is a midline septum formed from the joining of two layers of meningeal dura. Superiorly, the two layers arise from the cranial roof and enclose the **superior sagittal sinus**. The falx descends like a blade into the longitudinal cerebral fissure between the two cerebral hemispheres (see reference drawing above). Its lower border is free and curved, supports the inferior sagittal sinus, and is flush with the surface of the corpus callosum. The floor of the anterior falx is formed from the periosteal layer of dura on the floor of the anterior cranial fossae; posteriorly, the falx forms from the two sides of the tent-like tentorium cerebelli. The **tentorium cerebelli** support the occipital lobes and separate them from the cerebellum below, set deeply in the posterior cranial fossae. The free edges of the tentorium curve outwardly on both sides to form a notch (*incisura*) that accommodates the brain stem, specifically the midbrain, and run anteriorly to the dorsum sellae (posterior wall of the sella turcica of the sphenoid bone; the pituitary gland lives in the sella). Notice the dural roof of the sella (diaphragma sellae), perforated to transmit the infundibulum of the hypothalamus (page 150). The *falx cerebelli* (not shown, but perhaps you can imagine it) is a vertical triangular sheet in the midline under the tentorium. It incompletely separates the cerebellar hemispheres and supports the occipital sinus.

The filmy, delicate **arachnoid mater** lies deep to the inner dura, separated by a potential subdural space. The arachnoid is separated from the deeper pia mater by the subarachnoid space, which contains CSF. This space becomes relatively voluminous at various locations (cisterns; page 82). The **pia mater** is a vascular layer of loose fibrous connective tissue, supporting the vessels reaching the brain (and spinal cord) by means of trabeculae between the pia and the arachnoid in the **subarachnoid spaces**. It appears inseparable from the surface of the brain and cord, but not entirely so. In the walls of the ventricles, vessels in the pia form a complex secretory plexus with the ependymal (lining) cells of the ventricles. Called *choroid plexuses*, they secrete cerebrospinal fluid.

CRANIAL MENINGES

DURA MATER A⁻
OUTER (PERIOSTEAL) LAYER A'
INNER (MENINGEAL) LAYER B
FALX CEREBRI C
TENTORIUM CEREBELLI D
FALX CEREBELLI E ÷ (N.S.)
SUPERIOR SAGITTAL SINUS S

ARACHNOID F
VILLUS F'
SUBARACHNOID SPACE F² ÷

PIA MATER G

CN: Use light and contrasting colors for A¹–D. (1) The upper drawing is for reference only, and not to be colored. (2) Color the meninges of the brain in the enlarged coronal section, and related terms in the list of names. Color the superior sagittal sinus a dark blue. (3) Color the infoldings of the dura mater, B–D, below. The left half of the inner dural layer, B, has been cut away to reveal the more interior dural structure.

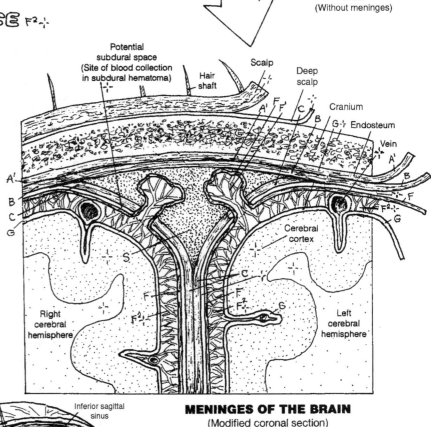

MODIFIED CORONAL VIEW
(Without meninges)

MENINGES OF THE BRAIN
(Modified coronal section)

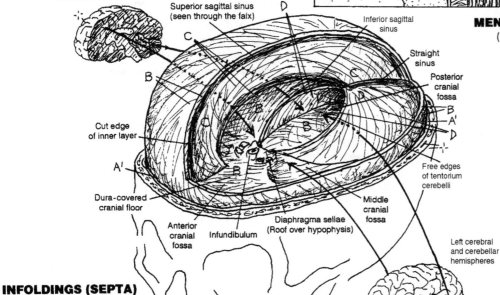

INFOLDINGS (SEPTA) OF DURA MATER
(Brain and calvaria removed)

Cerebrospinal fluid (CSF) is a clear, largely acellular, plasma-like fluid surrounding the brain. CSF actually suspends the brain and spinal cord within the **dura mater** in a virtually no-load, gravity-free condition, preserving their structural integrity. Fluid is incompressible, and it flows. Functioning as a cushion within the dura mater, CSF blocks the brain's movement following a head strike. CSF is secreted by the **choroid plexus** and by minute vessels near the ventricular walls into the **lateral, third,** and **fourth ventricles**. About 150 mL of CSF circulate through the ventricles and around the subarachnoid spaces (including cisterns) every 24 hours.

Coloring the illustrations on this page gives you the opportunity to color the **circulatory pattern of CSF** in the ventricles and the subarachnoid spaces, and to understand their relationship to their source tissues and "the end of the line": the superior sagittal sinus. The structures of the ventricular system containing the CSF are listed on the adjacent page for reference only; they are not to be colored, as the focus here is "CSF flow."

Particularly important aspects of this page include:

(1) The location of the *choroid plexus* in each of the four ventricles, colored appropriately (red) as the vascular source of CSF the flow of which you are coloring.

(2) The CSF (A) of the ventricular system departs the fourth ventricle by way of the **median** and **lateral apertures** (I and I^1), draining into the *subarachnoid space*. Here we differentiate the ventricular CSF from the CSF (B) in the subarachnoid spaces; but, of course, they are the same fluid.

(3) The arrangement of the **subarachnoid spaces** around the brain and spinal cord, including the dilated portions of those spaces called **cisterns** (B^2); take note how the brain is truly provided a fluid buffer by the CSF surrounding the entire brain. This is a life-saving feature in many head falls and strikes.

(4) The transfer of CSF to the superior sagittal sinus. Seen with the unaided eye, the **arachnoid villi** alongside the midline of the venous sinus appear as granulations just under the dura; they consist of multiple, arachnoid-lined passageways that project into the superior sagittal sinus (without the dura) and release CSF into the venous circulation.

(5) The cavity of the **superior sagittal sinus**, which is formed between the periosteal (outer) layer of dura and the meningeal layer. Cerebral veins travel in the subarachnoid spaces and pass through the dura directly to enter the dural venous sinuses.

CN: Use bright red for the choroid plexuses C-C². Use light contrasting colors for CSF A in the ventricles and CSF B in the subarachnoid spaces around the brain and spinal cord. Use blue for J. (1) Begin by coloring the choroid plexuses in the lateral, 3rd, and 4th ventricles. (2) Color the CSF A; begin in the lateral ventricle and follow the flow → to the 4th ventricle; there color the median/lateral apertures I and I¹. (3) Using the color chosen for CSF B, color the flow → into and through the subarachnoid spaces B¹ and B² and into the arachnoid villi AM¹. (4) Color carefully the meninges DM, AM, and PM around the brain and upper spinal cord. (5) Color the coronal section through the superior sagittal sinus J and villi AM¹ at the top of the page. (6) Color the components of the lumbar cistern below.

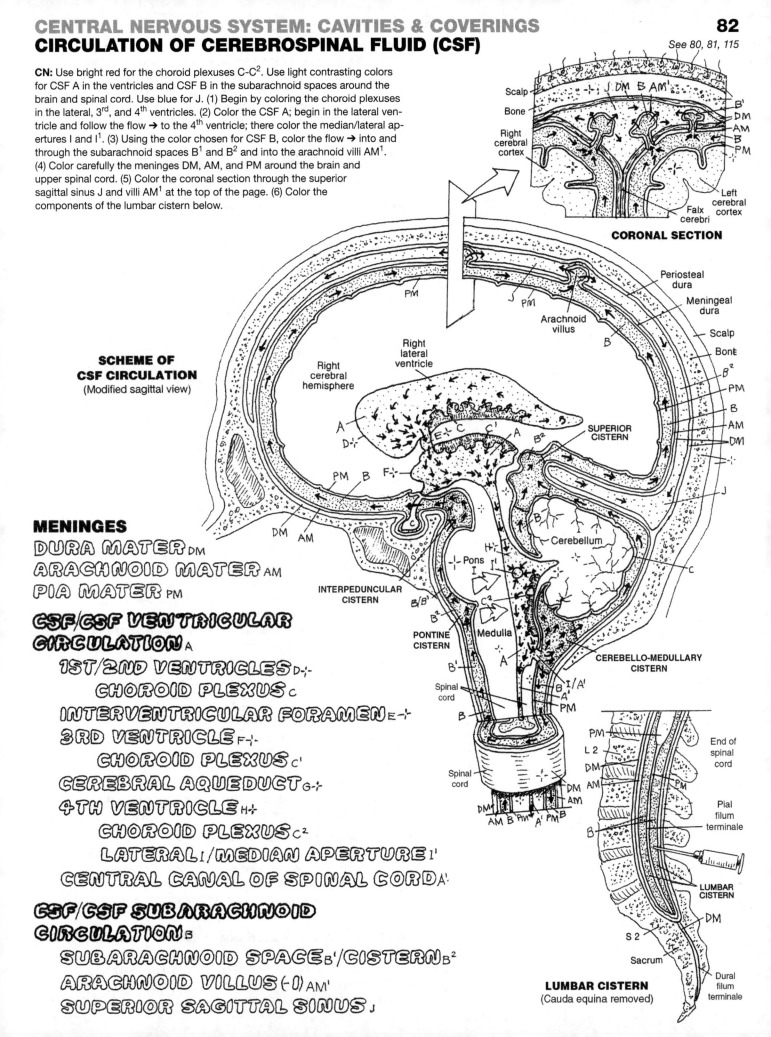

CORONAL SECTION

SCHEME OF CSF CIRCULATION
(Modified sagittal view)

LUMBAR CISTERN
(Cauda equina removed)

MENINGES
DURA MATER DM
ARACHNOID MATER AM
PIA MATER PM

CSF/CSF VENTRICULAR CIRCULATION A
1ST/2ND VENTRICLES D
CHOROID PLEXUS C
INTERVENTRICULAR FORAMEN E
3RD VENTRICLE F
CHOROID PLEXUS C¹
CEREBRAL AQUEDUCT G
4TH VENTRICLE H
CHOROID PLEXUS C²
LATERAL I/MEDIAN APERTURE I¹
CENTRAL CANAL OF SPINAL CORD A¹

CSF/CSF SUBARACHNOID CIRCULATION B
SUBARACHNOID SPACE B¹ / **CISTERN** B²
ARACHNOID VILLUS (-I) AM¹
SUPERIOR SAGITTAL SINUS J

The 12 pairs of **cranial nerves** are referred to in Roman numerals (I through XII), I being the most rostral, XII being the most caudal. Cranial nerves I and II are derived from the forebrain. Cranial nerve XI was once held to be a cranial nerve but definitive research finds that it is actually a spinal nerve. Cranial nerve II is a derivative of the diencephalon; as such, the optic nerve is an externalized projection of the tract of the brain. Cranial nerves are functionally classified on an embryologic basis. For an explanation of definitions and classifications, see glossary (Cranial Nerve Functional Classification).

All motor nerves cited include proprioceptive fibers (sensory for muscle, tendon, and joint movement).

I **SVA:** special visceral afferent fibers; smell-sensitive (**olfactory**) receptors in roof/walls of nasal cavity.

II **SSA:** special somatic afferent fibers; light-sensitive (visual) receptors in the retina of the eye.

III **GSE:** general somatic efferent fibers; to extrinsic eye muscles (except lateral rectus and superior oblique); **GVE:** general visceral efferent fibers; parasympathetic to ciliary and pupillary sphincter muscles via ciliary ganglion in the orbit.

IV **GSE:** general somatic efferent; to superior oblique muscle of the eye.

V **GSA:** general somatic afferent; from face via three divisions (V_1, V_2, V_3) indicated; **SVE:** special visceral efferent; via V_3 to muscles of mastication, tensor tympani, tensor veli palatini, mylohyoid, and digastric muscles (developed from embryonic gill arches).

VI **GSE:** to lateral rectus muscle of the eye.

VII **SVA:** from taste receptors anterior tongue; **GSA:** from external ear; **SVE:** to muscles of facial expression, stapedius (middle ear), stylohyoid, posterior digastric muscles; **GVE:** to parasympathetic glands of nasal/oral cavity, lacrimal gland (via pterygopalatine ganglion in fossa of same name), submandibular/sublingual salivary glands (via submandibular ganglion in region of same name).

VIII **SSA:** cochlear part is sound sensitive: vestibular part is sensitive to head balance and movement (equilibrium).

IX **GSA:** from external ear and auditory canal; **SVA:** from taste receptors posterior one-third of tongue; from mucous membranes of posterior mouth, pharynx, auditory tube, and middle ear; **GVA:** from pressure and chemical receptors in carotid body and common carotid artery; **SVE:** to superior constrictors of the pharynx and stylopharyngeus; **GVE:** parasympathetic fibers to parotid gland (via otic ganglion in infratemporal fossa).

X **SVA:** from taste receptors at base of tongue and epiglottis; **GSA:** from external ear and auditory canal; **GVA:** from pharynx, larynx, and thoracic and abdominal viscera; **SVE:** to muscles of palate, pharynx, and larynx; **GVE:** parasympathetic to muscles of thoracic and abdominal viscera (via intramural ganglia).

XI **GSE:** spinal root (C1–C5) ascends through foramen magnum and departs through the jugular foramen; to trapezius and sternocleidomastoid muscles; classification pending.

XII **GSE:** to extrinsic and intrinsic muscles of tongue.

CN: Use light colors. (1) Beginning with the first cranial nerve, color the name at upper left; the large Roman numeral, the cranial nerve seen on the ventral brain stem, and the related function arrow at lower left; and the Roman numeral and accompanying illustration at upper right. Repeat with each nerve. (2) Note the direction of the function arrows at lower left; sensory is incoming; motor is outgoing.

CRANIAL NERVES

OLFACTORY (O)ı
OPTIC (OO)ıı
OCULOMOTOR (OOO)ııı
TROCHLEAR (IV)ıv
TRIGEMINAL (V)v
ABDUCENS (VO)vı
FACIAL (VOO)vıı
VESTIBULOCOCHLEAR (VOOO)vııı
GLOSSOPHARYNGEAL (OX)ıx
VAGUS (X)x
ACCESSORY (XO)xı
HYPOGLOSSAL (XOO)xıı

Retina

Olfactory receptors

Ophthalmic branch
Muscles of mastication (motor)
Maxillary — V²
Mandibular — V³

Superior oblique m.
IV ıv
Lateral rectus m.
VI vı

Muscles of facial expression
VII vıı
Glands
Taste receptors
VII
Salivary glands

VIII
Vestibular branch
Cochlear branch

Olfactory bulb
Olfactory tract
Optic chiasm

Oı
OOıı
OOOııı
IVıv
Vv
VIvı
VIIvıı
VIIIvııı
IXıx
Xx
XIxı
XIIxıı

Mamillary body
Pons
N. intermedius
Medulla
Spinal cord

Pharynx
Larynx
Trachea
Heart
Lung
Stomach
External ear
Small intestine

IX ıx
Taste receptors
Parotid gland
Pharynx

XI xı
XII xıı

Sternocleido-mastoid m.
Trapezius m.

ANTERIOR-INFERIOR SURFACE
(Left brain, brain stem, and cerebellum)

A **spinal nerve** is a collection of axons of sensory and motor neurons (see the drawing at lower left). The axons of sensory neurons conduct impulses into the posterior horn of the spinal cord. There they make synaptic connections with long and short tracts directed rostrally and caudally in the spinal cord. The pseudounipolar cell bodies of these sensory neurons are packaged in swollen-looking areas in the posterior roots of the spinal nerve, called the **posterior root ganglia**. The axons on the spinal-cord side of the ganglion are called *central processes*; the axons peripheral to the **cell bodies** are the *peripheral processes* of the spinal nerve. The multipolar cell bodies of the motor neurons are located in the anterior horn of the spinal cord's gray matter. These axons proceed from the cord in a bundle, forming the anterior or motor root of the spinal nerve. The posterior and **anterior roots** form a single structure, the **spinal nerve**, just outside the **intervertebral foramen** (see the illustration "Cross section through T9").

Spinal nerves and their roots are arranged segmentally (from cervical to coccygeal vertebral levels) and bilaterally along the length of the vertebral column (see page 86). Recall the central relations of these spinal nerves/roots on pages 78 and 79. Soon after they are formed, the spinal nerves branch into **anterior** and **posterior rami**.

Spinal nerves and their roots have rather tight quarters in the **spinal canal**, **lateral recesses**, and the intervertebral foramina. The relations of these nerves and roots can best be appreciated in the two views at right. Nerve roots are vulnerable to irritation (radiculitis) from encroaching, hypertrophic bone in the lateral recesses and intervertebral foramina (degenerative joint disease); from bulging intervertebral discs (degenerative disc disease); or from cysts, meningeal tumors, and comminuted vertebral fractures. Compression of axons or blood vessels supplying the axons can result in functional deficits (radiculopathy: sensory loss, motor loss, and/or tendon reflex change).

The spinal nerves do not have the precise functional classification of neurons as do cranial nerves (recall page 83). However, the axons of sensory neurons are often referred to as "afferents" (toward a center, e.g., spinal cord or higher center), and axons of motor neurons as "efferents" (from a center, e.g., motor cortex). Sensory axons are the same whether somatic or visceral. Somatic motor axons are structurally and functionally different from visceral motor axons; these will be presented with the autonomic nervous system (pages 91–93).

SPINAL NERVE ROOT

POSTERIOR ROOT ᴀ
 SENSORY AXON ʙ
 CELL BODY ᴄ
 POSTERIOR ROOT GANGLION ᴅ
ANTERIOR ROOT ᴇ
 MOTOR AXON ꜰ
 CELL BODY ɢ

SPINAL NERVE ʜ
 ANTERIOR RAMUS ʜ'
 POSTERIOR RAMUS ʜ²

NERVE ROOT RELATIONS

VERTEBRA ⋮
 BODY ɪ
 LAMINA ᴊ
 TRANSVERSE PROCESS ᴋ
SPINAL CANAL ʟ
 LATERAL RECESS ʟ'
INTERVERTEBRAL FORAMEN ᴍ

CN: Use light colors for the parts of the vertebra I, J, and K in the lower right illustration. (1) Begin with the names and illustration at lower left, finishing with the directional arrows. (2) Color the cross-sectional view through the ninth thoracic vertebra at lower right. (3) Color all three pairs of spinal nerves and their roots as they emerge from the intervertebral foramina, M, in the drawing at upper right.

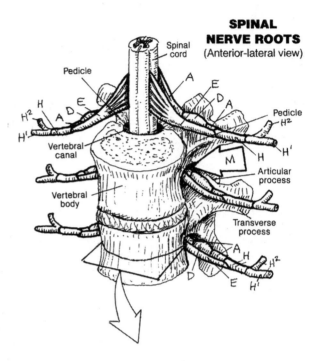

SPINAL NERVE ROOTS
(Anterior-lateral view)

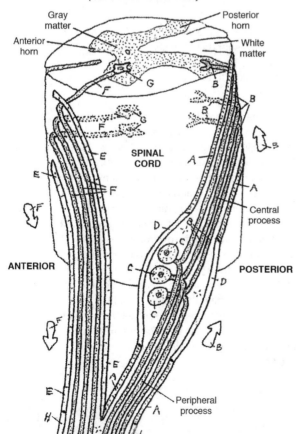

SPINAL NERVE AXONS
(Schematic lateral view)

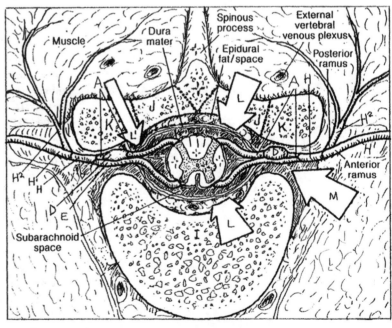

CROSS SECTION THROUGH T9
(Seen from above)

A *reflex* is an involuntary muscle response to a stimulus. A *stimulus* is an event that induces a sensory neuron to respond. Having the pointy end of a reflex hammer applied painlessly to the patellar ligament of the knee will do the trick. With no thought on your part, the muscle that extends the knee joint will mildly and reflexively contract, causing your knee joint to "jerk" (extend). It's a fundamental activity of the nervous system. Most body movements, including those of viscera, are reflexive (e.g., heart rate, respiratory rate, peristaltic contraction of gastrointestinal muscles, etc.). This useful feature allows you to run on "automatic" while concentrating on more sophisticated thoughts. **Spinal reflexes** involve sensory receptors, sensory neurons, usually interneurons of the spinal cord, motor neurons, and effectors (muscles).

A *stretch* (**monosynaptic** or *myotatic* **reflex**), the simplest spinal reflex, involves two neurons and one synapse. The knee jerk is such a reflex. It is activated by stretching the tendon (as in striking it gently with a reflex mallet) of a specific muscle, such as the tendon of the quadriceps femoris at the knee. The *receptors* responsive to such a stretch are (1) the *neurotendinous organs* in the patellar ligament and (2) the muscle spindles in the belly of the quadriceps muscle. Neurotendinous organs are tendons with receptors specifically sensitive to distortion or stretch. **Muscle spindles** are encapsulated, specialized muscle fibers within muscle bellies that have nerve endings sensitive to muscle stretch. Referring to the uppermost drawing, electrochemical ("nerve") impulses generated in these receptors by a stimulus are (1) conducted by **sensory neurons** (2) to the **spinal cord** (3); these neurons synapse in the gray matter of the cord with the anterior horn **motor neurons** (4). The motor neuron conducts the electrochemical impulses to the **end plates** of the **effector muscle** (the muscle that responds to the stimulus with an effect, specifically shortening) (5). The muscle contracts sufficiently, in the case of the knee reflex, to extend ("jerk") the knee joint momentarily (6).

Polysynaptic reflexes have more than two neurons in the circuit. They range from simple withdrawal reflexes (shown below) to complex reflexes involving several segments of the spinal cord and brain. The complexity of a polysynaptic reflex relates to the number of interneurons in the reflex and the number of synaptic contacts between stimulus and response. In this case, temperature receptors (not shown) and **pain receptors** respond to the sharp increase in heat; **sensory neurons** conduct the impulses to the spinal cord. An **interneuron** receives the impulse. Branches of the interneuron excite two interneurons, one **facilitatory** and one **inhibitory**. The excitatory interneuron facilitates (+) the firing of the motor neuron that induces the extensor muscle to contract, lifting the fingers from the flame. Simultaneously, the inhibitory neuron depresses (–) the firing of the second motor neuron (C3) and the antagonist flexor muscle is stretched without contracting, permitting the fingers to be withdrawn from the flame.

CN: Use light colors for D, and use the same colors for the spinal nerve roots as you did on the preceding page. (1) Color the upper two illustrations simultaneously, in numerical sequence 1–5, including the arrows. The small arrows at the end of the muscle segments indicate contraction (pointing toward each other) or stretch (pointing away from one another). (2) Color the lower two illustrations similarly. Note that the motor neuron synapsing with the inhibitory interneuron, and the inhibited effector, are not colored.

MONOSYNAPTIC REFLEX

STRETCH RECEPTOR (N-T ORGAN)ₐ
STRETCH RECEPTOR (MUSCLE SPINDLE)ₐ'
SENSORY NEURONₐ²
SPINAL CORDᵦ
MOTOR NEURONᵪ
 END PLATEᵪ'
EFFECTOR MUSCLEᴅ

SPINAL NERVE / ROOTS

SPINAL NERVEₑ
 BRANCHₑ'
POSTERIOR ROOTᶠ
 GANGLIONᶠ'
ANTERIOR ROOTᵧ

POLYSYNAPTIC REFLEX

PAIN RECEPTORₐ³
SENSORY NEURONₐ²
INTERNEURONₕ
 FACILITATORY (+)ₕ'
 INHIBITORY (−)ₕ²
(+) MOTOR NEURONᵪ /EFFECTORᴅ
(−) MOTOR NEURONᵪ' /EFFECTORᴅ'

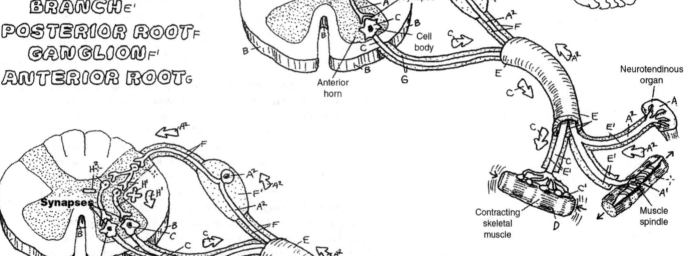

KNEE JERK REFLEX

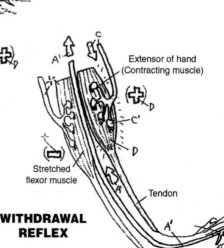

WITHDRAWAL REFLEX

Thirty-one pairs of **spinal nerves**, arising from anterior (largely motor) and posterior (sensory) roots of the **spinal cord**, receive sensory impulses and send motor commands to skeletal muscles throughout the body wall from neck to foot.

There are eight **cervical spinal nerves (C1–C8)**, formed from anterior (motor and some sensory) and posterior (sensory) roots. These roots pass through the intervertebral foramina, with the exception of C1, which departs the vertebral column between the occipital bone and the first cervical vertebra (Co–C1). The anterior rami of the first four cervical spinal nerves form the **cervical plexus**. The nerves of this plexus are largely sensory and end as cutaneous nerves of the posterior head, lateral neck, and shoulder. A significant exception is the phrenic nerve (C3–5), a motor nerve that innervates the thoracic diaphragm. The lower cervical nerves (C5–C8) form the lion's share (virtually all) of the **brachial plexus** (see page 87).

There are eight cervical nerves and seven cervical vertebrae. The C1–C7 spinal nerves exit the intervertebral foramina *superior to the corresponding vertebra* (of the same name). The C8 and all inferior spinal nerves pass through the intervertebral foramina *inferior to the corresponding vertebra* (of the same name). When one is evaluating the signs and symptoms of a lower lumbar spinal nerve root compressed by a herniated disc, these elementary facts must come to mind instantly.

The 12 **thoracic spinal nerves** form no plexuses; upon division of the nerves into **anterior** and **posterior rami**, the anterior rami become the **intercostal nerves** (12th excepted), pass between the ribs in company with an intercostal artery and paired veins, and innervate the intercostal muscles. Laterally, the intercostal nerves give off a **lateral cutaneous branch** that divides into anterior and posterior cutaneous branches. The posterior rami leave the spinal nerve, turn immediately into the muscles of the back and terminate by forming **medial** and **lateral cutaneous branches**. The first thoracic nerve (T1) is the largest of the thoracic nerves, and gives a significant branch to the brachial plexus. The 12th thoracic (subcostal) nerve runs below the 12th rib (and is, therefore, not an intercostal nerve); it passes down the abdominal wall, and terminates as a cutaneous nerve.

Four of the five lumbar spinal nerves form the **lumbar plexus** that supplies motor innervation of the anterior and medial muscle groups of the thigh.

The thoracic and lumbar (T1 to L2) spinal nerves carry preganglionic visceral efferent fibers to the sympathetic chain of ganglia running alongside the vertebral column bilaterally. (Look ahead to page 91.) The fourth and fifth lumbar spinal nerves form the **lumbosacral trunk**. It joins the five sacral spinal nerves (**sacral plexus**) to collectively become the sciatic nerve (L4, 5, S1–S3). The sacral plexus contributes to the superior and inferior gluteal nerves, the lateral femoral cutaneous nerve, and direct branches to some lateral rotators of the thigh.

A cross section through any nerve reveals coverings similar to those of muscle (page 42) previously colored.

DISTRIBUTION OF SPINAL NERVES

See 48, 84

CN: Begin with the left side of the upper illustration. Use fine point coloring instruments for the spinal nerves/branches throughout this page. (1) Color the various spinal nerves and plexuses as you proceed down the list of their names on the right. Use one color for the cervical nerve roots, cervical plexus, brachial plexus, and cervical spinal nerves. (2) Color the thoracic spinal (intercostal) nerves and the 12th thoracic (subcostal) nerve. (3) Color the lumbar nerves, plexus, and the lumbosacral trunk. (4) Color the sacral plexus. (5) Color the typical thoracic spinal nerve distribution around the torso in the cross-sectional view at lower right. (6) Color the nerve coverings, taken from a cutaneous nerve, G, in the lower illustration.

CERVICAL NERVES (C1-C8)ᴀ
PLEXUS (C1-C4)ᴀ'
BRACHIAL PLEXUS (C5-T1)ᴀ²

THORACIC SPINAL NERVES (T1-T12)ʙ
INTERCOSTAL NERVES (T1-T11)ʙ'

SPINAL NERVES & PLEXUSES
(Posterior view)

LUMBAR NERVES c
PLEXUS (L1-L4) c'
LUMBOSACRAL TRUNK (L4,L5) c²
SACRAL PLEXUS ᴅ

SPINAL CORD
ANTERIOR ROOT ᴇ
POSTERIOR ROOT ꜰ

THORACIC SPINAL NERVE ʙ
ANTERIOR RAMUS / INTERCOSTAL NERVE ʙ'
LATERAL CUTANEOUS BRANCH ɢ
ANTERIOR CUTANEOUS BRANCH ʜ
POSTERIOR RAMUS ɪ
MEDIAL CUTANEOUS BRANCH ᴊ
LATERAL CUTANEOUS BRANCH ᴋ

NERVE COVERINGS
EPINEURIUM ɢ'
PERINEURIUM ʟ
ENDONEURIUM ᴍ

PATTERN OF A TYPICAL THORACIC SPINAL NERVE
(Cross section through mid-thorax, viscera removed)

NERVE SECTION

The peripheral nerves of the upper limb arise from the *brachial plexus*, the **roots** of which are the anterior rami of spinal nerves C5–T1, and occasionally anterior rami of C4 and T2. The two upper rami and the two lower rami join the middle ramus (C7) to form the three **trunks** of the plexus. The three trunks share and receive axons (**divisions**) to form three **cords**. From these cords arise the five major *peripheral nerves* to the limb. Note that the posterior cord has a broader array of root fibers (C5–T1) than the other two cords. Note that the fibers issuing from the lateral and medial cords form an M-shape well anterior to the posterior cord's axillary and radial nerves.

The **brachial plexus** is subject to injury (plexopathy) from excessive stretching or traction (e.g., rapid, forceful pulling of the upper limb) and compression (e.g., long-term placement of body weight on crutches). In such injuries, there is great variation in the degree of deficit, signs, and symptoms.

The **musculocutaneous nerve (C5–C7)** of the **lateral cord** is a small nerve in the upper anterior arm; it supplies the brachialis, biceps brachii, and coracobrachialis and is cutaneous in the forearm. Packaged in muscle, it is rarely traumatized. However, C5 and/or C6 nerve root compression can weaken the anterior arm muscles.

The **median nerve (C5–C8, T1)**, or "carpenter's nerve" of the medial/lateral cords, has no branches in the arm; it supplies wrist and hand flexor muscles in the forearm and the thenar (thumb) muscles. It can be compressed at the carpal tunnel (recall page 33), resulting in some degree of sensory deficit to fingers 1–3 and weakness in thumb movement (*carpal tunnel syndrome*). Similar symptoms may be associated with a C6 nerve root compression.

The **ulnar nerve (C8–T1)**, or "musician's nerve" of the medial cord, supplies the flexor digitorum profundus and flexor carpi ulnaris of the forearm, and most intrinsic muscles of the hand minus the thumb. It is subject to trauma as it rounds the elbow in the cubital tunnel, possibly resulting in ulnar-side finger pain, hand weakness, or abnormal posture of fingers 4 and 5.

The **axillary nerve (C5–C6)** from the **posterior cord** wraps around the neck of the humerus to supply the deltoid and teres minor muscles. It is vulnerable to harm with humeral neck fractures; damage to this nerve may result in a weak or paralyzed deltoid muscle.

The **radial nerve (C5–C8, T1)** runs through the posterior arm, supplying the triceps; winds around close to the mid-humerus, supplying brachioradialis in the upper forearm; and goes deep to supply the wrist and digit extensor muscles in the posterior forearm. Its superficial fellow is cutaneous to the posterior digits. Arising from a fracture of the mid-shaft of the humerus, radial nerve injury (causing "wrist drop") can be devastating. Wrist drop can be simulated: flex your wrist maximally and while doing that, try to work your fingers.

CN: Use light colors for A-D. (1) Color the names, and the letters and numbers identifying the five roots of the brachial plexus in the upper drawing. Note but do not color the small branches of the plexus as you color the plexus itself. In the lower illustration, the entire plexus is to be colored gray. (2) As you color each of the major nerves arising from the plexus, color it in the lower illustration as well. As you color each nerve, try to visualize its location on your own limb.

BRACHIAL PLEXUS

ROOTS C5, C6 A
 UPPER TRUNK B
ROOT C7 A'
 MIDDLE TRUNK B'
ROOTS C8, T1 A²
 LOWER TRUNK B²

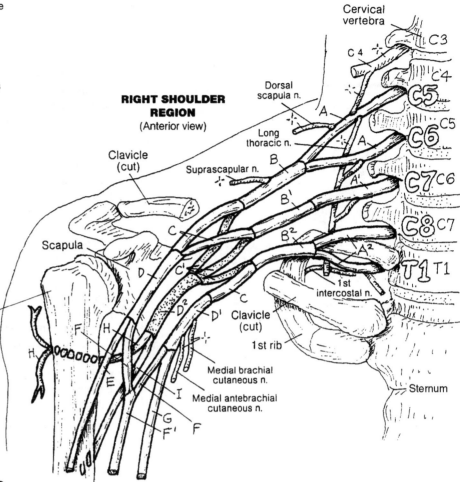

RIGHT SHOULDER REGION
(Anterior view)

Cervical vertebra

Dorsal scapula n.
Long thoracic n.
Suprascapular n.
Clavicle (cut)
Scapula
Humerus
Clavicle (cut)
1st rib
1st intercostal n.
Medial brachial cutaneous n.
Medial antebrachial cutaneous n.
Sternum

MAJOR BRANCHES

ANTERIOR DIVISION c
 LATERAL CORD (C5-C7) D
 MUSCULOCUTANEOUS NERVE E
 BRANCH TO MEDIAN N. F
 MEDIAL CORD (C8-T1) D'
 BRANCH TO MEDIAN N. F
 MEDIAN N. F'
 ULNAR N. G
POSTERIOR DIVISION (C5-T1) C'
 POSTERIOR CORD D²
 AXILLARY N. (C5-C6) H
 RADIAL N. (C5-T1) I

MAJOR NERVES OF THE UPPER LIMB
(Right limb, anterior view)

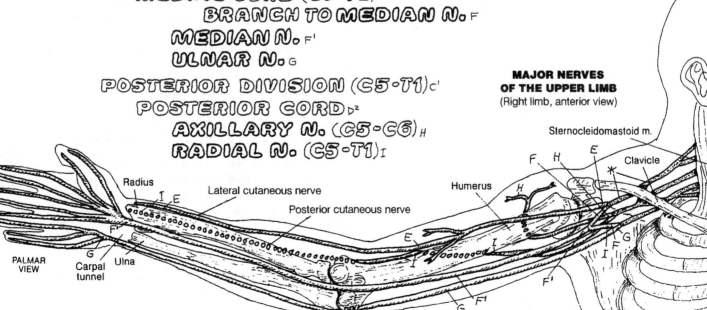

Radius
Lateral cutaneous nerve
Posterior cutaneous nerve
Humerus
Sternocleidomastoid m.
Clavicle
PALMAR VIEW
Carpal tunnel
Ulna
Cubital tunnel
Medial epicondyle

The **lumbar plexus**, formed from the anterior rami of **L1–L4** spinal nerves, and occasionally a twig from T12, can be found in the psoas major muscle on the upper posterior abdominal wall. The **femoral nerve (L2–L4)** passes through the psoas in its descent, emerging lateral to the muscle in the pelvis. Here it is subject to injury from a hematoma overlying iliopsoas, as is the obturator nerve. As the nerve passes under the inguinal ligament, it lies on the muscle's anterior surface. The femoral nerve breaks up into a leash of nerves in the proximal thigh, supplying the four heads of the quadriceps femoris muscle and the sartorius muscle. Medially, the cutaneous **saphenous nerve** descends to the medial knee and beyond to the ankle. In mid-thigh, it passes through the adductor canal (see page 61) into the posterior femoral compartment, with the femoral artery and vein.

The **obturator nerve (L2–L4)** passes along the internal lateral pelvic wall on the obturator internus muscle. It penetrates the obturator foramen to enter the medial thigh, supplying the adductor muscles. Loss of the femoral nerve results in weakness in hip flexion, hip abduction (outward swing gait), and loss of knee extension. However, the adductor magnus is also innervated by the sciatic nerve, so the loss of hip abduction can be somewhat mitigated.

The **lumbosacral trunk (L4–L5)** joins with the sacral spinal nerves to form the **sacral plexus (S1–S4)**. From this plexus, the **superior gluteal nerve** (L4, L5, S1) passes through the greater sciatic foramen (page 50), *above* the piriformis muscle, to supply the gluteus medius (and sometimes minimus) (see page 59). The **inferior gluteal nerve** (L5, S1, S2) comes into the gluteal region *below* the piriformis to supply the gluteus maximus (page 59).

The **sciatic nerve (L4–5, S1–3)** joins the posterior femoral cutaneous nerve and the inferior gluteal nerve to pass through the greater sciatic foramen *below* the piriformis muscle, deep to the gluteus maximus (but not innervating it). It descends between the ischial tuberosity and the greater trochanter of the femur. Within the posterior femoral compartment, above the knee, the sciatic nerve splits into the tibial and common fibular nerves. The **tibial nerve** supplies the posterior leg muscles and the plantar muscles of the foot. The **common fibular nerve** supplies the lateral leg muscles (**superficial fibular nerve**) and the muscles of the anterolateral leg compartment (**deep fibular nerve**). In a low percentage of the population, all or a part of the sciatic nerve may pass through the piriformis muscle and cause buttock pain (piriformis syndrome). The **pudendal nerve (S2-4)** supplies the perineum.

One or more of the sciatic nerve roots can be compromised by narrowing of the intervertebral foramina at L4-S1 (and elsewhere) due to osteoarthritis or pressure applied to a nerve root there by a herniated disc. The pain experienced can go down the lower limb to the foot.

LUMBAR & SACRAL PLEXUSES: NERVES TO THE LOWER LIMB

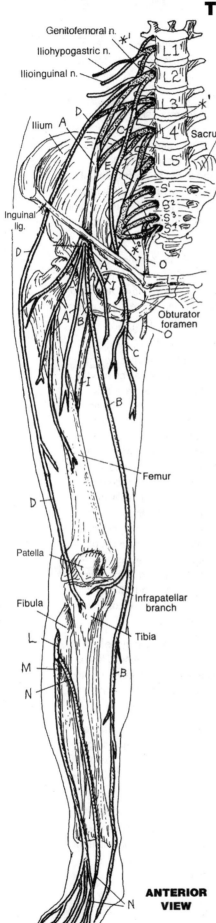

Genitofemoral n.
Iliohypogastric n.
Ilioinguinal n.
Ilium
Inguinal lig.
Obturator foramen
Femur
Patella
Fibula
Infrapatellar branch
Tibia

L1
L2
L3
L4
L5
Sacrum
S1
S2
S3
S4

ANTERIOR VIEW

CN: (1) Begin with the anterior view. Color the lumbar and sacral plexuses gray; they have been dotted for easy identification. (2) Color the femoral nerve A and its branches, the longest of which is the saphenous nerve B. (3) Color the obturator nerve C. (4) Color the lateral femoral cutaneous nerve. (5) Color the nerves in the posterior view. The heel of the foot has been lifted to give a view of the plantar surface of the foot.

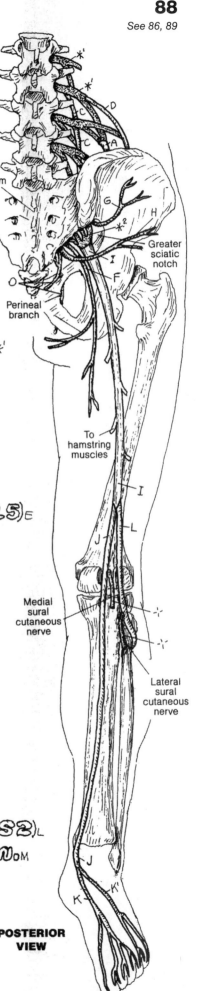

Sacrum
Greater sciatic notch
Perineal branch
To hamstring muscles
Medial sural cutaneous nerve
Lateral sural cutaneous nerve

POSTERIOR VIEW

LUMBAR PLEXUS (L1-L4) $*^1$
FEMORAL NERVE A
SAPHENOUS N. B
OBTURATOR N. C
LATERAL FEMORAL CUTANEOUS N. D

LUMBOSACRAL TRUNK (L4-L5) E

SACRAL PLEXUS (L4-S4) $*^2$
POSTERIOR FEMORAL CUTANEOUS N. F
SUPERIOR GLUTEAL N. G
INFERIOR GLUTEAL N. H

SCIATIC N. (L4-S3) I
TIBIAL N. (L4-S3) J
MEDIAL PLANTAR N. K
LATERAL PLANTAR N. K'
COMMON FIBULAR N. (L4-S2) L
SUPERFICIAL FIBULAR N. M
DEEP FIBULAR N. N
PUDENDAL N. (S2-4) O

Recall page 83 regarding the functional classification of cranial nerves. **Spinal nerves** can be classified similarly, but absent the Special classification (SSA, SVA, etc.). See also the glossary, Cranial Nerves Classification.

A **dermatome** *is a specific area of skin (derma-, skin; -tome, cut up) innervated by the sensory fibers of a single spinal nerve.* The body's entire surface is conceptualized into dermatomes based on the segmental distribution of sensory (general somatic afferent; GSA) fibers of spinal nerves and those of the **trigeminal (fifth) cranial nerve**. Whereas spinal GSA fibers transmit sensory impulses directly to the spinal cord, trigeminal GSA fibers transmit information from sensors in the facial skin to ganglia and nuclei located mid-brain to the medulla (not shown).

In each spinal dermatome, the general somatic afferent neurons transmit touch, temperature, pressure, and pain-related impulses from sensory receptors to the spinal cord. Dermatomes are identified by region and number of the related spinal nerve: for example, the fifth **cervical spinal nerve (or C5) dermatome**.

Testing of general sensations, by cotton swab or pinprick, can reveal deficits in specific dermatomes—but sometimes do not. These dermatomes are correlated with the spinal nerves and the location of their nerve roots in the central canal, lateral recess, and/or intervertebral foramina of the vertebral column. The accuracy of dermatomal representation has generally been corroborated in cases of spinal sensory root deficit, trigeminal nerve irritation, and spinal cord deficits (myelopathy). The most common deficits associated with nerve root compression and injury are found in the hands and feet, where the innervation density (of sensory receptors) is greatest and deficits are most likely to be discovered. For example, a C6 deficit represented as numbness in the thumb and forefinger are common with carpal tunnel syndrome and with nerve root compression by a herniation of the C5–6 intervertebral disc; a C8 deficit represented as numbness of the little finger (fifth digit) may be found with cubital tunnel compression of the ulnar nerve (C8–T1); and L5 and S1 deficits reflected in the great toe and little toe, respectively, are often associated with herniated discs at L4–5 and L5–S1.

Interpretation of nerve root complaints and testing may be influenced by dermatomal overlap (see lower left illustration). Here a cutaneous branch of an overlapping sensory nerve may be tested and give negative evidence for nerve root compromise in the territory of a symptomatic nerve root.

Dermatomal pain reflects both cutaneous pain *and non-cutaneous (visceral)* pain referred to the skin; e.g., a painful inflamed lung lining (pleurisy) may be referred to the skin of the shoulder because both (skin and lung lining or pleura) are innervated by C3–C5 spinal nerves (phrenic nerve).

C1 has no dermatome because it has no sensory root, though it may ride with C2. C4 and T2 dermatomes overlap the chest wall because spinal nerves C5–T1 are committed to the upper limbs. L3 and S3 dermatomes overlap the low back because L4–S1 nerves are committed to the leg and foot.

DERMATOMES

CN: Begin by reading the text. The diagram at lower left depicts the sensory innervation of an area of skin (dermatome) and the degree of overlap among contiguous spinal nerve cutaneous branches and the dermatomes they supply. (1) Color gray the three spinal nerves in the diagram at lower left and the rectangular border of the central dermatome. Note the overlap. (2) Use very light colors for the five groups of dermatomes. Use one color for all dermatomes with the letter V, another color for the dermatomes marked with a C, and so on with T, L, and S. Suggestion: Carefully color the borders of the *total* collection of C dermatomes with the color used for C, then color in the enclosed area, focusing on the skin areas serviced by the related spinal nerve; repeat with the T, L, and S dermatomes.

DERMATOMES OF

TRIGEMINAL NERVE v
V1 - V3 v
CERVICAL NERVES c
C2 - C8
THORACIC NERVES t
T1 - T12 t
LUMBAR NERVES L
L1 - L5 L
SACRAL NERVES s
S1 - S5 s

SPINAL NERVE* DERMATOME*'

CUTANEOUS NERVE OVERLAP

Posterior (dorsal) spinal nerve root

C4

Ganglion Sensory axon

C5

C6

Spinal cord

Area of overlap

Area of overlap

SKIN AREA (Dermatomes)

C4

C5

C6

ANTERIOR VIEW

C2, V1, V2, V3, C3, C4, C5, T2, T3, T4, T5, T6, T7, T8, T9, T10, T11, T12, L1, L2, L3, C6, C7, C8, T1, L5, L4, S1

Nipple

Umbilicus

Area of inguinal ligament

Genital

Middle finger

Knee

Lateral leg

Lateral foot

POSTERIOR VIEW

C2, C3, C4, C5, C6, T2, T3, T4, T5, T6, T7, T8, T9, T10, T11, T12, L1, L2, T1, C7, C8, S1, S2, S3, S4, S5, L3, L4, L5

Shoulder

Lateral arm

Medial forearm

Anal

Perineum

Posterior thigh

Heel

Plantar surface

Big toe

After Foerster

Sensory receptors provide information to the brain about the body's internal and external environment. Most receptors are transducers: they convert mechanical, chemical, electrical, or light stimuli to electrochemical impulses that can be conducted by the nervous system. Once stimulated, informational or sensory receptor-generated impulses travel to the CNS via sensory neurons, ultimately reaching the thalamus. Here, impulses are relayed to the sensory cortex (conscious interpretation) or to the motor centers for appropriate (reflexive) response. See the diagram in the upper right.

Exteroceptors are located near the body surface. Special exteroceptors (not shown) include photoreceptors of the retina (light stimuli; page 94), taste receptors (chemical stimuli; page 99), and auditory receptors (sound stimuli; page 98). General exteroceptors are cutaneous sensory endings, either encapsulated or free. **Free nerve endings** (D, in skin block) either single or in networks, are found in the epidermis and virtually all of the connective tissues of the body. They may serve as thermoreceptors (heat/cold), mechanoreceptors (light touch), or pain receptors (nociceptors). Spiral endings of free nerve endings wrap around hair follicles and are sensitive to hair-shaft movement. Dendritic **Merkel cells** are associated with free nerve endings in the stratum basale of the epidermis (see page 15); they contain neurotransmitters suggesting a neuroendocrine function. They appear to be sensitive to touch (tactile sensitivity). **Meissner corpuscles** are encapsulated nerve endings in the dermis and are sensitive to tactile stimuli. **Ruffini endings** are encapsulated corpuscles, found in thick skin, that are sensitive to mechanical forces (stretch and twisting (i.e., torque).

Proprioceptors are found in deeper tissues (e.g., fasciae, tendons, ligaments, joint capsules, and muscles, and joint capsules). They are sensitive to stretch, motion, pressure, and changes in position. The **Pacinian corpuscles** are large layered mechanoreceptors that generate electrochemical impulses in response to pressure and distortion. **Muscle spindles**, or *muscle stretch receptors*, consist of two types of special (nuclear bag and nuclear chain) muscle fibers entwined with spiral or flower-spray sensory endings. These muscle fibers shorten in response to stretch only (by gamma efferent fibers), following which sensory endings fire an afferent volley to the cerebellum. Reflexive motor commands lead to the tightening of the special muscle fibers in the spindle and thus resistance to stretch. By these spindles, the CNS controls muscle tone and muscle contraction. **Neurotendinous organs** (Golgi) are nerve endings enclosed in capsules located at or near muscle/tendon junctions. They generate electrochemical impulses in response to tendon deformation (stretch).

Interoceptors (not shown) are free or encapsulated nerve endings, often found in association with special epithelial cells, located in the walls of vessels and viscera (not skin). These receptors include chemoreceptors (sensitive to oxygen or carbon dioxide levels in peripheral blood), baroreceptors (sensivitve to blood and respiratory pressures), and nociceptors (sensitive to pain).

CN: (1) Color the names at upper right and the overview of a sensory pathway. Color the receptor, A, the sensory axon, B, and the ascending pre-thalamic tract, C. Color the thalamus, C, the post-thalamic tract, C^1, and the sensory cortex gray. (2) Color the names under the heading "Exteroceptors," D-E^2, including the boxed D^1 in the related drawing at right; color the receptors, D-E^2, and their sensory axons. (3) Color the names under the heading "Proprioceptors" and related receptors, F^1-F^3. The Pacinian corpuscle, F^1, a proprioceptor, is at the bottom of the block of skin at right. (4) Color over the entire muscle spindle, F^2, but not the surrounding extracapsular muscle fibers. Color the neurotendinous organ and axon, F^3, in the small box at the bottom of the page.

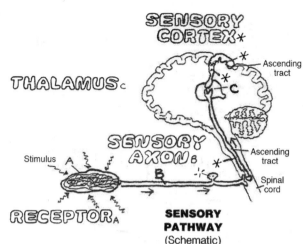

SENSORY PATHWAY
(Schematic)

SENSORY RECEPTORS

EXTEROCEPTORS

FREE NERVE ENDINGS / AXON ᴅ

MERKEL (TACTILE) CELL / AXON D¹

ENCAPSULATED ENDINGS ᴇ-

MEISSNER (TACTILE) CORPUSCLE / AXON E¹

RUFFINI (DEFORMATION) ENDINGS / AXON E²

PROPRIOCEPTORS

PACINIAN (PRESSURE) CORPUSCLE / AXON F¹

MUSCLE SPINDLE / MIXED AXONS F²

NEUROTENDINOUS ORGAN / AXON F³

INTEROCEPTORS (Not shown)

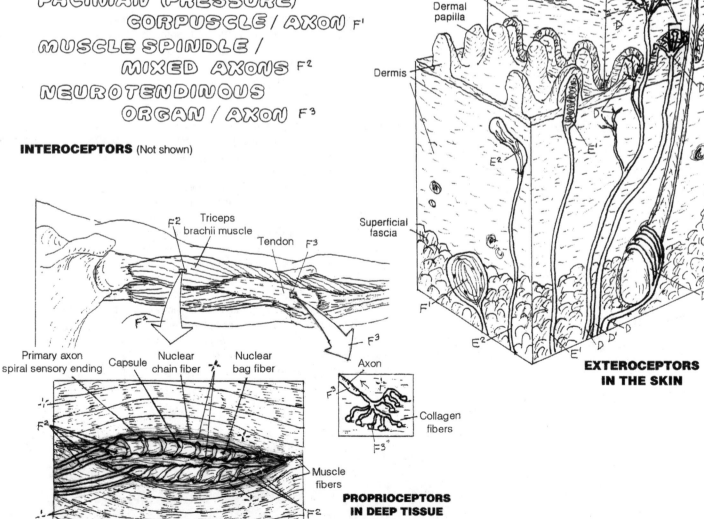

PROPRIOCEPTORS IN DEEP TISSUE

EXTEROCEPTORS IN THE SKIN

A two-neuron linkage uniquely characterizes the **autonomic nervous system (ANS)**, a motor system for smooth muscle, regulation of cardiac muscle activity, and glands (effectors). The main actors are the *preganglionic* and *postganglionic neurons*.

The autonomic nervous system (ANS) or visceral nervous system (VNS) is part of the peripheral nervous system (PNS) and consists of the sympathetic and parasympathetic divisions. The **sympathetic (thoracolumbar) division** is concerned with degrees of "fight or flight" responses to stimuli: pupillary dilation, increased heart and respiratory rates, increased blood flow to brain and skeletal muscles, contraction of sphincter muscles, and inhibition of glandular secretion with the exception of sweat glands of the skin. The **parasympathetic (craniosacral) division** is the "vegetative" division that drives visceral activity (intestinal motility, glandular secretion, etc.; see page 93). The two divisions work together to achieve internal stability in all phases of life (homeostasis).

Sensory impulses from viscera are conducted by visceral sensory neurons (GVA) which are equivalent to somatic sensory neurons (GSA). These neurons are not part of the ANS motor system (see glossary, Cranial Nerves, for reference regarding terms GVA, GSA, etc). Impulse conduction through both divisions of the ANS begins with the **preganglionic neuron**. The somata of these neurons are located in the lateral horns of spinal cord segments T1–L2 (see page 84A and the view at upper right this page). The preganglionic (myelinated) axons leave the spinal cord through the anterior (motor) roots, travel a short distance in the spinal nerve, then divert to join the **white rami** that take the myelinated fibers to the **sympathetic chain (trunk) of ganglia** running alongside the anterolateral aspect of the vertebral column bilaterally (page 84A, lower right illustration; see anterior/anterior-lateral views; and see the pathways on this page). A **preganglionic axon** can take one of four courses: (1) Upon entering the chain, the axon may synapse with a **postganglionic neuron** at that level of synapse, or it may ascend (2) or descend (3) within the chain two or more levels before synapsing. The *post*ganglionic axon will then leave the chain by way of the **gray ramus** at the level of the synapse and join the spinal nerve. These **postganglionic axons** innervate the smooth muscle in arteries (and some veins) within the distribution pattern of the spinal nerve, and innervate the sweat glands, arrector pili muscles, and the smooth muscle in the arteries of the skin. The preganglionic axons entering the chain continue out of the chain anteriorly—without synapsing—as **splanchnic nerves** (4) heading for ganglia and plexuses of sympathetic and parasympathetic neurons on the anterior wall of the abdominal aorta. The fate of these splanchnic nerves can be seen on the following page.

CN: Plan to color pages 91–93 in the same time frame. Employ sharply contrasting colors for preganglionic (B, B¹) and postganglionic (G, G¹) neurons. (1) Color the routes of impulse conduction starting at upper right with the preganglionic cell bodies, B, located within the border, A, representing the spinal cord segments T1-L2. (2) Color D, E, and F in the drawing at upper left, then follow the arrows to the boxed illustration and color the enlarged elements. (3) Color the "Pathways of Preganglionic and Postganglionic Neurons" at lower left. Start with pathway 1 followed by pathways 2, 3, and 4. (4) Finish up by coloring the supporting parts A and H* in the lower two illustrations.

ANS: SYMPATHETIC DIVISION (1)

SPINAL CORD SEGMENTS T1-L2 A

PREGANGLIONIC CELL BODY B

PREGANGLIONIC AXON B'

WHITE RAMUS C+

SPLANCHNIC NERVE D

PREVERTEBRAL GANGLIA / PLEXUS E

SYMPATHETIC CHAIN (GANGLIA) F

POSTGANGLIONIC CELL BODY G

POSTGANGLIONIC AXON G'

GRAY RAMUS H*

SPINAL NERVE I

SPINAL CORD SEGMENTS
(Schematic, showing cell bodies of sympathetic preganglionic neurons)

Midbrain

Medulla

Spinal cord

A

B

T1, T2, T3, T4, T5, T6, T7, T8, T9, T10, T11, T12, L1, L2

T1 Vertebra

F

Bony thorax (Cut)

T5

T10

T12

L2

D

E

Sacrum

ANTERIOR VIEW
(Schematic)

PATHWAYS OF PREGANGLIONIC AND POSTGANGLIONIC NEURONS
(Schematic)

Lateral horn

Spinal cord segment T5

Anterior (ventral) root

Abdominal viscus

SYMPATHETIC STRUCTURES
(Enlargement of a portion of the anterior view, turned slightly laterally)

Vertebral body

Sympathetic innervation of skin (and viscera as well) begins with the preganglionic neurons in the thoracolumbar part of the spinal cord (L1–2). See the left side of the spinal cord diagram. The preganglionic axons leave the cord via the anterior rami of spinal nerves and within a short distance leave the spinal nerves to join the *white* communicating *rami* to the sympathetic chain.

Preganglionic axons ascend, descend, or remain at the same level they entered to synapse with postganglionic neurons destined for the skin. These postganglionic axons leave the chain via the *gray* communicating *rami*, enter the spinal nerves from C1 through Co1, and reach the skin via cutaneous nerves. These axons induce secretory activity in sweat glands (but not other glands), contraction of arrector pili muscles, and vasoconstriction in vessels except arteries to the head/brain, skeletal muscles, and skin. There are no parasympathetic counterparts to the skin. Nerves to blood vessels ride with spinal nerves and reach the intended vessels by means of perivascular networks. In sum, *sympathetics prepare the body for flight, and if that doesn't work, fight.* Established sympathetic activities track this fundamental tenet.

Postganglionic neurons to the head (vessels and glands) leave the superior cervical ganglia and entwine about arteries en route to the head (in the absence of spinal nerves) to reach their target organs. Postganglionics to the heart and lungs leave the upper ganglia of the chain, reaching these organs via the cardiac nerves/ plexus and the pulmonary plexus. These neurons induce vasodilation of heart muscle, increased heart rate, and bronchial dilation by the local release of catecholamines (epinephrine, norepinephrine, etc.).

Preganglionics to abdominal and pelvic viscera leave the cord at levels T5–L2, enter the white communicating rami, and pass through the sympathetic chain without synapsing. They form three pairs (greater, lesser, and least) of **splanchnic nerves** between the chain and the prevertebral ganglia on the aorta. These axons synapse with the postganglionic neurons in the prevertebral ganglia and plexuses, resulting in decreased intestinal motility, tightening of sphincters, and decreased glandular secretion (remember "flight or fight"). They stimulate the adrenal medulla to secrete mostly epinephrine and some norepinephrine. The lowest (sacral) ganglia of the sympathetic chain issue postganglionic axons by way of gray rami (recall: no white rami above T1 or below L2). These ride with somatic spinal nerve axons to the pelvic (and neighboring) plexuses from which the postganglionic axons reach the lower colon, rectum, anal canal, anus, urinary tract in the pelvis/perineum, prostate, uterus, and genital structures, inducing contraction of sphincters, decreasing intestinal motility, relaxing bladder muscles, constricting anal and urinary sphincters, stimulating secretion of male and female genital glands, stimulating uterine contractions, and contracting perineal and urethral muscles to effect ejaculation.

CN: Use the same colors for B, D, and G as you did on page 91. (1) Start with the names and preganglionic neurons on the left, B, to the skin, G, and its effectors, G³, at upper left. (2) Color the names and *pre*ganglionic neurons, B, on the right and the splanchnic nerves, D, to the abdominal viscera. (3) Color the names and the *post*ganglionics (G, G¹, G²) to the head and thorax, and the *post*ganglionics (G⁴, G⁵) from the prevertebral ganglia to the abdominal and pelvic/perineal organs.

SYMPATHETIC DIVISION
(Explanation of schema of the two chains, **1** and **2**, shown below)

1 On the left, the connections are limited to preganglionic neurons leading to postganglionic neurons to the skin via gray rami and spinal nerves.

2 On the right, the connections are limited to preganglionic neurons, splanchnic nerves to abdominal viscera, and postganglionic fibers to the head, chest, pelvic, and perineal plexuses from which target organs are innervated.

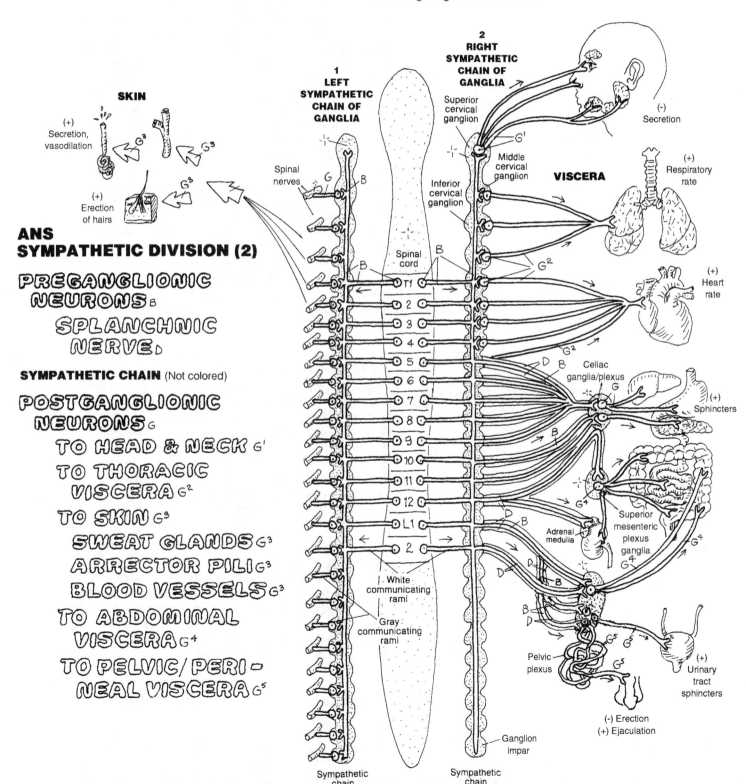

ANS
SYMPATHETIC DIVISION (2)

PREGANGLIONIC NEURONS ᴮ
SPLANCHNIC NERVE ᴅ

SYMPATHETIC CHAIN (Not colored)

POSTGANGLIONIC NEURONS ᴳ
TO HEAD & NECK ᴳ¹
TO THORACIC VISCERA ᴳ²
TO SKIN ᴳ³
SWEAT GLANDS ᴳ³
ARRECTOR PILI ᴳ³
BLOOD VESSELS ᴳ³
TO ABDOMINAL VISCERA ᴳ⁴
TO PELVIC/PERI-NEAL VISCERA ᴳ⁵

The **parasympathetic**, or craniosacral, **division** of the ANS is concerned with vegetative functions (e.g., encouraging secretory activity by mucous and digestive glands, and dilating sphincters). Functionally, the two divisions of the ANS seem to be essentially polar opposites. On the whole, they work together well, one perhaps with a bit more personality than the other. Still, the peace that comes following a good meal without digestive upset or the relief that follows elimination after a long car ride can be as welcome as being the first to cross the finish line after a grueling run. **Preganglionic neurons** (GVE) arise in the midbrain; joining the **oculomotor (III) cranial nerve** (B^1), these axons enter the orbit through the superior orbital fissure to synapse with postganglionic cells in the **ciliary ganglion** (E^1) of the orbit (pages 94 and 96). The postganglionic fibers (G^1) project to the posterior eyeball, pierce it, and continue to the iris, where they innervate the pupillary constrictor. Preganglionic neurons (GVE) associated with the *facial nerve* (B^2) arise from the brain stem between the pons and the medulla. Some fibers head for the pterygopalatine fossa (lateral to the posterior nasal cavity and the nasopharynx), where they synapse with postganglionics in the **pterygopalatine ganglion** (E^2). Postganglionic fibers (G^2) innervate glands of the oral and nasal mucosa as well as the lacrimal gland in the superior and lateral corner of the orbit. Preganglionic neurons (B^3; GVE) associated with the glossopharyngeal nerve (IX) in the upper posterior medulla reach for the **otic ganglion** (E^4) by a remarkable route: they go out the jugular foramen, up through the middle ear cavity, pierce the roof of the middle ear cavity, join fibers from the facial nerve to descend into the infratemporal fossa, and synapse with ganglion cells in the otic ganglion. Postganglionic fibers (G^3) innervate the comparatively large parotid gland (in front of the ear). The GVE fibers of the vagus nerve (X) reach into all quarters from the chest to the pelvis. The preganglionic fibers are unusually long, descending the neck from the lower brain stem, joining with the internal carotid artery and the internal jugular vein, and running through the posterior mediastinum and the esophageal hiatus of the diaphragm to reach the gastrointestinal tract. These preganglionic axons extend as far as the descending colon. The ganglia for these preganglionics are in the muscular walls of the organ they supply (**intramural ganglia**). Thus, the postganglionic axons are very short, terminating in smooth muscle and glands.

The cell bodies of the sacral preganglionic neurons are found in the lateral horns of sacral spinal segments 2, 3, and 4 of the spinal cord. Their axons leave the cord via the anterior rami and form their own nerves (**pelvic splanchnics**). These nerves mix with sympathetic postganglionics in the pelvic plexus, and depart for their target organs. They synapse with the postganglionic neurons at intramural ganglia in the organ wall. These fibers stimulate contraction of rectal and bladder musculature and induce vascular dilation in the penis and clitoris (erection).

CN: Continue using the same colors you used on pages 91 and 92 for subscripts B, D, and G. Use a bright color for E. This drawing shows the parasympathetic scheme on one side of the body only (nerve distribution is identical bilaterally). (1) Color the preganglionic somata and axons, B^1–B^3, and the related ganglia, E^1–E^4, and postganglionic axons to the organs indicated, G^1–G^3. (2) Repeat the above with B^4, the related ganglia, E^5, and the postganglionic axons, G^4–G^5, to the organs indicated. (3) Continue with the sacral preganglionics and postganglionics, noting the target organs, G^4–G^5.

LOCATION OF GANGLIA IN THE ANS

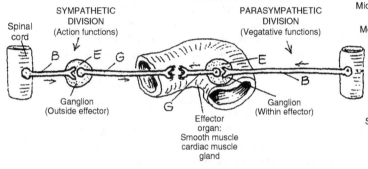

PARASYMPATHETIC DIVISION

PREGANGLIONIC NEURONS B~
 III CRANIAL NERVE B^1
 VII CRANIAL N. B^2
 IX CRANIAL N. B^3
 X CRANIAL N. B^4
 PELVIC SPLANCHNIC N. D

GANGLIA E
 CILIARY E^1
 PTERYGOPALATINE E^2
 SUBMANDIBULAR E^3
 OTIC E^4
 INTRAMURAL E^5

POSTGANGLIONIC NEURONS G
 EYE G^1
 NASAL/ORAL CAVITIES G^2
 SALIVARY GLANDS G^3
 THORACIC/ABDOMINAL VISCERA G^4
 PELVIC/PERINEAL VISCERA G^5

PARASYMPATHETIC DIVISION
(Schema showing only one side)

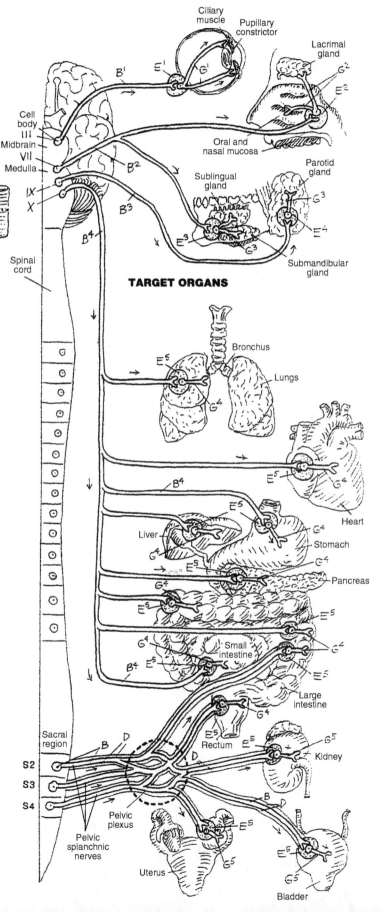

TARGET ORGANS

The **eye** is a layer of photoreceptor cells and associated neurons (retina) packaged within a white, fibrous, rubbery protective globe (**sclera**) that has a transparent anterior part (*cornea*). The **cornea**, composed of five layers of epithelial and fibrous tissue, is the chief refractive medium of the eye, focusing light rays onto the retina. The **lens** (tightly packed, encapsulated nonelastic fibers derived from epithelial cells) also refracts light and, up to middle age, varies its shape and refractive index. The **aqueous humor** (extracellular fluid) filling the eye's anterior and posterior chambers, and the more gelatinous (99% water) **vitreous humor** taking up 80% of the globe's volume, function as refractive media. The inner surface of the posterior two-thirds of the sclera is lined with a vascular, highly pigmented layer (**choroid**) that absorbs and prevents the scattering of light. The choroid thickens anteriorly as the pigmented, fibromuscular **ciliary body** that surrounds the lens. The ciliary body projects outpocketings (processes) to which **suspensory ligaments** from the lens attach. On the anterior aspect of the ciliary body, a thin, pigmented, epithelial and fibromuscular layer (**iris**) circumscribes the hole (*pupil*) in front of the lens.

The **retina** lines the posterior half of the interior of the globe, and a bit more, ending anteriorly at the ora serrata. The visual axis (an imaginary line passing from the midpoint of the visual field to the retina) leads to a yellow-pigmented area (**macula lutea**). Within the macula lutea is a depressed area (**fovea centralis**) that is, under lighted conditions, the center of greatest visual acuity for form and color. This center reflects a dense accumulation of color-sensitive cells (cones). About 3 mm to the nose side of the macula, axons stream out through the optic disc to become the optic nerve. The **optic disc** is devoid of light-sensitive cells and is, therefore, a blind spot. The **pigmented epithelial layer** of the retina (refreshing pigment to the adjacent rods/cones) is closest to the choroid.

The photoreceptor layer consists of color-sensitive **cone cells** and color-insensitive but remarkably light-sensitive **rod cells**. You can check this out at night: look into an area where the light is very dim or nonexistent; find a tree or structure you can barely see. Look straight at it, and then look aside, keeping the structure in your peripheral vision...using your rod cells. Then look at it directly again. Where did it go? You see? Rod cells can give you a helpful degree of night vision! Bipolar cells receive and mediate input from rod and cone cells and conduct the resultant impulses to the ganglion cell layer. Among these two more-peripheral layers are interwoven numerous horizontal cells (not shown for visual clarity) that influence neuronal activity. The axons of the ganglion cells, the final common pathway of retinal activity, form the fibers of the optic nerve.

CN: Use orange for E, yellow for G, red for M and M^1, blue for N and N^1, and very light colors for C, H, I, and K. Use gray for the rod cells, O^1, as they are insensitive to color. The lens is colorless. (1) Color the sagittal section of the eyeball and the uppermost illustrations together.
(2) When coloring the retinal layers, color gray the arrows (in dark outlines) representing the nerve impulse; the light ray arrows receive no color.

EYE LAYERS

SCLERA A / CORNEA A' ⫶

CHOROID B

CILIARY BODY C / PROCESS C'

IRIS D

RETINA E

 OPTIC DISC F

 MACULA LUTEA G

 FOVEA CENTRALIS G'

FLUIDS

VITREOUS BODY H

AQUEOUS HUMOR I

OTHER STRUCTURES

LENS J ⫶

 SUSPENSORY LIGAMENT K

OPTIC NERVE L

RETINAL ARTERY M / BRANCH M'

RETINAL VEIN N / BRANCH N'

LAYERS OF THE RETINA

AXON L' / AXON LAYER L'

GANGLION CELL L^2 / LAYER L^2

BIPOLAR CELL L^3 / LAYER L^3

PHOTORECEPTOR LAYER O ⫶

 ROD CELL O^1 *

 CONE CELL O^2

PIGMENTED EPITHELIAL LAYER P

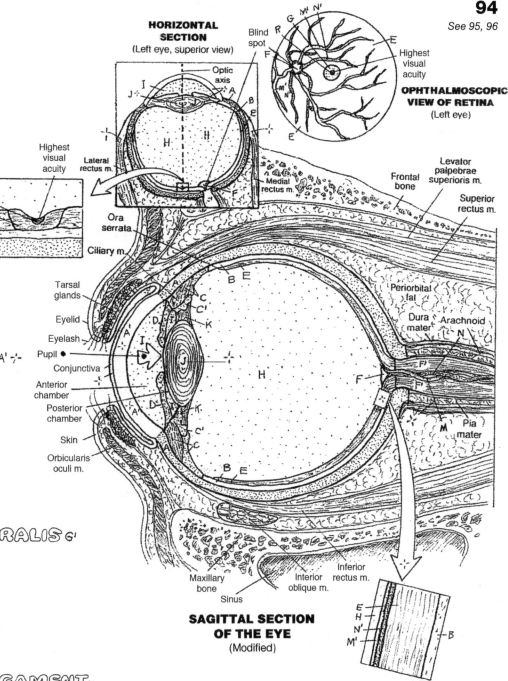

HORIZONTAL SECTION
(Left eye, superior view)

OPHTHALMOSCOPIC VIEW OF RETINA
(Left eye)

SAGITTAL SECTION OF THE EYE
(Modified)

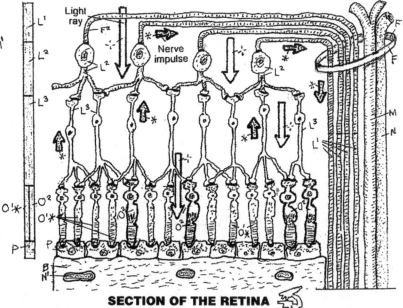

SECTION OF THE RETINA

Fluid (**tears**) forms a layer between the **conjunctivae** of the eyelid and the cornea to facilitate easy movement of the lids over the **cornea** without inducing irritation. Blinking your eyelid compresses the secretory glands and forces the fluid (tears) out of the duct on to the surface of the conjunctiva. This generally helps clear debris. Tears also function as a vehicle for moving epithelial debris and microorganisms from the corneal surface and undersurface of the eyelids into the nasal cavity via the **lacrimal apparatus**. This is the anatomic basis for blowing your nose after a good cry. The absence of tears can cause remarkable pain and even blindness. The principal gland for tears is the **lacrimal gland**, located in the anterior, superior, and lateral (temporal) aspect of the orbit. Other glands and sources of tears include unicellular (goblet) glands of the conjunctiva and **tarsal glands** of the lids. Episodic blinking (rapid cycle of lid approximation and retraction) maintains a film of tears on the conjunctiva and resists "dry eye." Routine closing of the lids occurs with muscle relaxation; active closure requires the orbicularis oculi muscle. Retraction of the eyelids is accomplished by smooth muscle fibers (tarsal muscle of Müller; sympathetic innervation) and the levator palpebrae muscle in the upper lid.

Aqueous humor, a clear, plasma-like fluid in the **anterior** and **posterior chambers** of the eye, is secreted into the posterior chamber by cells of the **ciliary processes** (see lowest drawing). Fluid and electrolytes also enter by diffusion from the **ciliary body**. After circulating through the anterior chamber, the fluid is filtered into the **canal of Schlemm** (scleral venous sinus), a modified vein filled with fibrous trabeculae, located at the sclerocorneal junction. Fluid in the canal drains into nearby veins. Obstruction to drainage is one of several causes of increased **intraocular pressure (IOP)**, in which the increasing pressure in the anterior/posterior chambers presses on the lens, which in turn presses on the **vitreous** (99% water) **body**. As water cannot be compressed, pressure is applied to the adjacent retina. Unrelenting pressure compresses vessels to the axons and neurons of the retina, damages neurons, and can result in blindness (glaucoma).

CN: Use the same colors as you used on the preceding page (with different subscripts) for structures J, K, L, M, N^1, and O. Use light colors for A, G, and H. Note that various structures in the central illustration also appear in the illustration below it.

ACCESSORY STRUCTURES
LACRIMAL APPARATUS

LACRIMAL GLAND$_A$

TEAR$_{A'}$

DUCT$_B$

LACRIMAL PUNCTA$_C$

CANAL$_D$

LACRIMAL SAC$_E$

NASOLACRIMAL DUCT$_F$

INFERIOR MEATUS OF
NASAL CAVITY$_G$

TARSAL PLATE / GLAND$_H$

CONJUNCTIVA$_I$

SECRETION / DRAINAGE
OF AQUEOUS HUMOR

FLOW OF AQUEOUS HUMOR$_J$

SCLERA$_K$

CORNEA$_{K'}$

CILIARY BODY$_L$

PROCESS$_{L'}$

POSTERIOR CHAMBER$_{J'}$

IRIS$_M$

ANTERIOR CHAMBER$_{J^2}$

CANAL OF SCHLEMM$_N$

VEIN$_{N'}$

VITREOUS BODY$_O$

INTRAOCULAR PRESSURE (IOP)$_P$

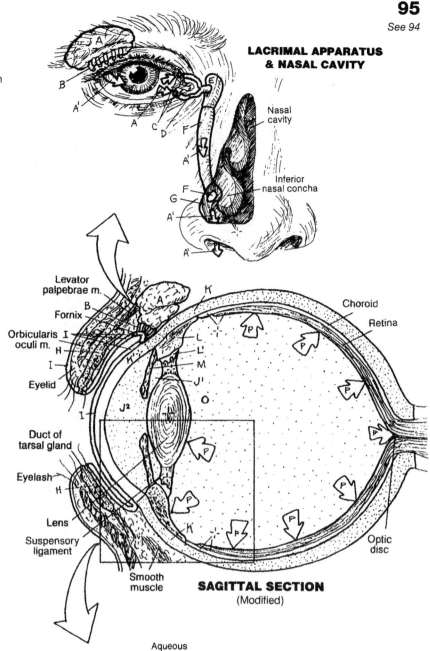

LACRIMAL APPARATUS & NASAL CAVITY

Nasal cavity

Inferior nasal concha

Levator palpebrae m.

Fornix

Orbicularis oculi m.

Eyelid

Duct of tarsal gland

Eyelash

Lens

Suspensory ligament

Smooth muscle

Choroid

Retina

Optic disc

SAGITTAL SECTION
(Modified)

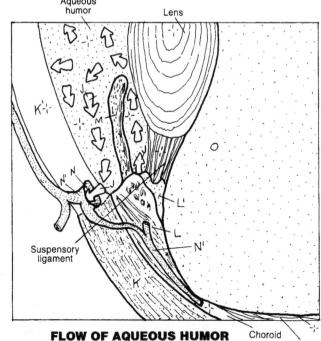

Aqueous humor

Lens

Suspensory ligament

Choroid

Retina

FLOW OF AQUEOUS HUMOR

The **extraocular (extrinsic) muscles** of the eye provide it with a remarkable tracking capacity. CNS mechanisms permit conjugate (binocular) movement of both eyes. There are six extrinsic skeletal muscles, of which two are obliquely oriented. They are innervated by cranial nerves III, IV, and VI (recall page 83). The true functions of these muscles are more complex than shown, partially because eye rotation and torsion require multiple muscular actions. Deviation from co-equal alignment of the eyes is called *strabismus*.

The **intrinsic muscles** are located in the ciliary body (**ciliary muscle**) and the iris (pupillary dilator and sphincter). See the illustration on ciliary muscle action: (1) contraction of the ciliary muscles (2) wrinkles the ciliary body tissue and puts slack in the processes, giving laxity to the suspensory ligaments of the lens (3), permitting the lens to round up due to intrinsic tension in the lens fibers. Innervated by parasympathetic nerves, these ciliary muscles function during near vision in which greater refractivity is desired. The **dilator pupillae** consists of myoepithelial cells that pull the iris toward the ciliary body, dilating the pupil. This action brings in more light and enhances visibility. This dilator muscle is innervated by sympathetic postganglionic fibers. The **sphincter pupillae** circumscribes the inner iris; its parasympathetically induced contraction constricts the iris, making the pupil smaller. See the drawing on muscular action at upper right.

On completing your coloring, note that the axons (K^2) from the retinas on the temporal side of the optic axis do not cross at the **optic chiasma**. Note the anatomic relationship of the hypophysis to the optic chiasma; can you see how an expanding tumor of the hypophysis is likely to impair visual acuity in the *temporal* visual fields ("tunnel vision")? The thalamus (**lateral geniculate body**) functions as a visual relay center, informing multiple memory areas and other centers of the stimulus. The **superior colliculi** are visual reflex centers, making possible rapid head and body movements in response to a visual threat. Finally, note that the dual image of the stimulus impinging on the **visual cortex** (K and J) is the reverse of that which was actually seen (J and K). Integration of visual information with memory at the visual cortex permits perception of the image as it is actually seen (J/K).

CN: Use light colors for A-F, H, and I. (1) After coloring each eye muscle, color its functional arrow in the upper diagram on the right. (2) In the drawing "Ciliary Muscle Action," color only the contracted ciliary muscles, G. (3) Color the visual pathways: (a) Color the two visual fields, J and K, in contrasting colors. (b) Light travels in straight lines. Color the two straight lines, K^1, from visual field K to the temporal half of one retina, K^2, and the nasal half of the other, K^2. (c) Color the two paths K^3-K^9 without referring to their names just yet. (d) Color gray all the names listed under "Visual Pathways," beginning with J and K. As you color each name gray, use the color J or K for the part of the visual pathway it refers to.

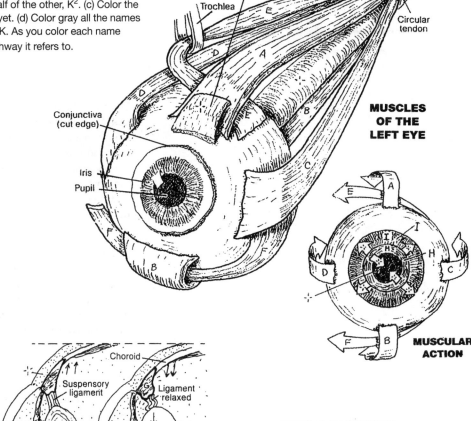

MUSCLES OF THE LEFT EYE

MUSCULAR ACTION

EXTRAOCULAR MUSCLES

SUPERIOR RECTUS (ELEVATOR)A

INFERIOR RECTUS (DEPRESSOR)B

LATERAL RECTUS (ABDUCTOR)C

MEDIAL RECTUS (ADDUCTOR)D

SUPERIOR OBLIQUE (ROTATOR RIGHT)E

INFERIOR OBLIQUE (ROTATOR LEFT)F

INTRINSIC MUSCLES

CILIARYG

SPHINCTER PUPILLAEH

DILATOR PUPILLAEI

CILIARY MUSCLE ACTION

VISUAL PATHWAYS

VISUAL FIELDJ / VISUAL FIELDK

LIGHT WAVE *(J¹,K¹)

RETINA *(J²K²)

OPTIC NERVE *(J³K³)

OPTIC CHIASMA *(J⁴K⁴)

OPTIC TRACT *(J⁵K⁵)

LATERAL GENICULATE BODY *(J⁶,K⁶)

SUPERIOR COLLICULUS *(J⁷,K⁷)

OPTIC RADIATION *(J⁸,K⁸)

VISUAL CORTEX *(J⁹, K⁹)

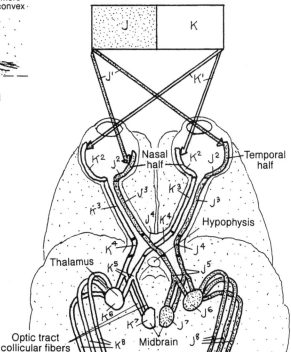

VISUAL PATHWAYS
(Horizontal brain section, schematic)

The ear is the organ of hearing and equilibrium (**auditory and vestibular systems**). It is organized into external, middle, and internal parts. The **external ear** includes the **auricle** (collector of sound energy) and the **external auditory meatus** or canal (a narrow passageway conducting sound energy to the **tympanic membrane**). This tympanic membrane, lined externally by skin and internally by respiratory mucosa, converts sound energy into mechanical energy by resonating in response to incoming sound waves.

The **middle ear** is a small, highly structured area including three small bones (ossicles: **malleus, incus, stapes**) joined together at synovial joints. These ossicles vibrate with movement of the tympanic membrane, amplifying and conducting mechanical energy to the waters of the inner ear at the flexible, watertight **oval window** (middle ear/inner ear interface). At the anterior-medial aspect of the middle ear cavity, the **auditory tube** runs to the nasopharynx, permitting equilibration of air pressure between the nasal cavity (outside) and the middle ear.

The **inner ear**, carved out within the petrous (rocky) portion of the temporal bone (seen on page 23), consists of a series of interconnecting bony-walled chambers and passageways (**bony labyrinth: vestibule, semicircular canals**, and **cochlea**) filled with perilymph (extracellular-like) fluid. Fitting within that bony labyrinth is a *second* series of interconnecting membranous chambers and passageways (**membranous labyrinth: saccule, utricle, cochlear duct**, and **semicircular ducts**), filled with an intracellular-like fluid called *endolymph*. The **endolymphatic duct**, derived from the saccule, ends in a blind sac under the dura mater near the internal auditory meatus (see page 25). It drains endolymph and discharges it into veins in the subdural space. Within the coiled, membranous **cochlear duct**, supported by bone and the fibrous **basilar membrane**, a ribbon of specialized receptors (**hair cells**) exists integrated with **supporting cells**. Both are covered with a flexible, fibrous glycoprotein blanket (**tectorial membrane**). This device (**organ of Corti**) converts the mechanical energy from the oscillating tectorial membrane scraping against the receptor hair cells into electrical energy. The impulses generated are conducted along bipolar sensory (auditory) neurons of the **eighth cranial nerve**. (Continued on next page.)

CN: Use yellow for Z, and light colors for A, B, G, I, M, N, W, and X. Organize a coloring plan; you may need to duplicate colors. Try to keep them separate. (1) Begin by coloring the diagram at the top of the page, then color your way down the list and the related structures. (2) The coloring continues on to the next page.

EXTERNAL EAR

AURICLE A
EXTERNAL AUDITORY MEATUS B
TYMPANIC MEMBRANE C

MIDDLE EAR

MALLEUS (HAMMER) D
INCUS (ANVIL) E
STAPES (STIRRUP) F
AUDITORY TUBE G

INTERNAL EAR

BONY LABYRINTH H
 VESTIBULE I
 OVAL WINDOW J
 SEMICIRCULAR CANAL K
 COCHLEA L
 SCALA VESTIBULI M
 SCALA TYMPANI N
 ROUND WINDOW O

MEMBRANOUS LABYRINTH P
 SACCULE Q /UTRICLE Q'
 ENDOLYMPHATIC DUCT R
 SEMICIRCULAR DUCT S
 COCHLEAR DUCT T
 TECTORIAL MEMBRANE U
 ORGAN OF CORTI V
 HAIR CELL W
 SUPPORTING CELL X
 BASILAR MEMBRANE Y
 CRANIAL NERVE VIII Z

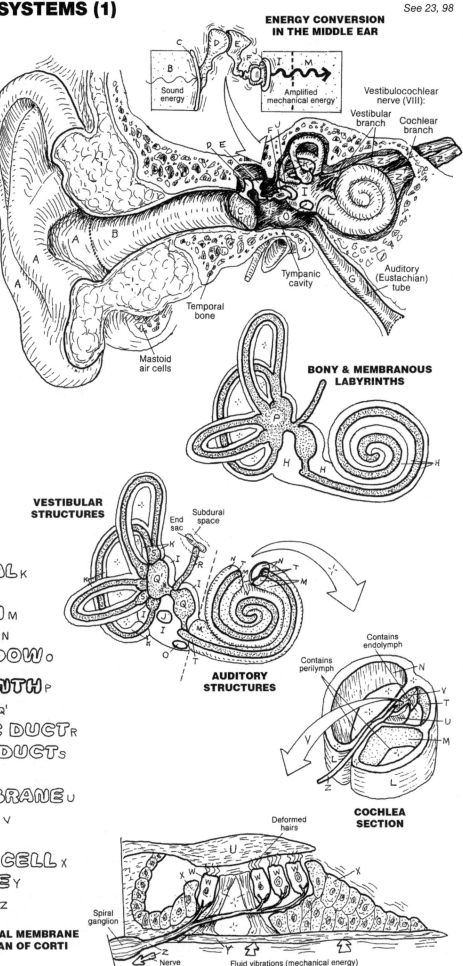

ENERGY CONVERSION IN THE MIDDLE EAR

Sound energy

Amplified mechanical energy

Vestibulocochlear nerve (VIII):
Vestibular branch
Cochlear branch

Temporal bone

Tympanic cavity

Auditory (Eustachian) tube

Mastoid air cells

BONY & MEMBRANOUS LABYRINTHS

VESTIBULAR STRUCTURES

End sac

Subdural space

AUDITORY STRUCTURES

Contains endolymph

Contains perilymph

COCHLEA SECTION

Deformed hairs

Spiral ganglion

Nerve impulse

Fluid vibrations (mechanical energy)

TECTORIAL MEMBRANE & ORGAN OF CORTI

AUDITORY SYSTEM

In review: the external ear collects sound waves and channels them to the tympanic membrane (1) which converts the sound energy into mechanical energy. The linkage of ossicles (2) increases the amplitude of the energy and transmits the force to the oval window of the bony labyrinth of the inner ear. Vibratory movements of the stapes (3) in the oval window are transmitted to the perilymph in the vestibule of the bony labyrinth, creating wave-like motions of the fluid. These waves spread throughout the short **vestibule**, then enter and move through the **scala vestibuli** of the cochlea to the *helicotrema* (4) at the apex of the cochlea (2-1/2 turns) and on around to the **scala tympani** (5), which terminates at the **round window** (6). Here, fluid waves and vibrations are dampened.

See now page 97, lower right, illustration of the tectorial membrane and organ of Corti: The fluid motion in the scala vestibuli vibrates the roof of the membranous cochlear duct, creating endolymph waves in the cochlear duct. This motion stirs the tectorial membrane, which rubs against and bends the hair-like processes of the **receptor (hair) cells**, depolarizing them and inducing electrochemical impulses. These impulses are conducted by the sensory neurons of the cochlear division of the eighth cranial nerve.

VESTIBULAR SYSTEM / EQUILIBRIUM

In review: The vestibular system is located in the inner ear. The bony **semicircular canals** are oriented at 90° to one another. The membranous **semicircular ducts** are within these canals. Directly communicating at one end with the utricle in the vestibule of the bony labyrinth, each membranous duct terminates at the other end in an **ampulla**. The **saccule** is also in the vestibule, and communicates with the membranous cochlear duct. Within the saccule/utricle and ampullae are sensors responsive to fluid (endolymph) movement. Each ampulla has a hillock of cells (**crista** or crest) consisting of hair cell receptors and supporting cells. The hair-like processes of these receptor cells are embedded in a top-heavy, gelatinous **cupola** (like an inverted cup). Movement of endolymph in response to head turning, and especially rotation, pushes these cupolas, bending the hair cells and causing them to depolarize, generating an electrochemical impulse. The impulses travel out the vestibular part of the eighth nerve to the vestibular nuclei in the lower brain stem. When the body is rotated rapidly, horizontal, oscillatory eye movements occur (*nystagmus*). Ampullary sensory input to the brain stem mediates these eye movements. Such movements represent the brain's attempt to maintain spatial orientation (by momentary visual fixation) during head and/or body rotation. Sensations of rotational movement in the absence of body rotation are called *vertigo*.

Within the utricle/saccule, hair cells and their **supporting cells** are covered with a **gelatinous layer** in which are embedded small calcareous bodies (**otoliths**). Movement of the endolymph induces movement of the gelatinous layer against the hair cells, with responses identical to those of the ampullary receptors. Receptor activity in the utricle/saccule is influenced by linear (horizontal and vertical but nonrotational) acceleration of the body.

CN: The names relevant to the drawing of the auditory system here are printed on the previous page; this is a continuation of page 97. Refer to them as you color the related structures. (1) In the upper illustration, the functional sequence is numbered 1 through 6. Color the numerals with the appropriate color as you follow the sequence of events in this simplified diagram. Refer to the previous page for the more precise anatomical structure. (2) Color the parts of the vestibular system concerned with the maintenance of dynamic and static balance. Three new structures are introduced on this page, identified as 1, 2, and 3 in the vestibular system drawings.

AUDITORY SYSTEM

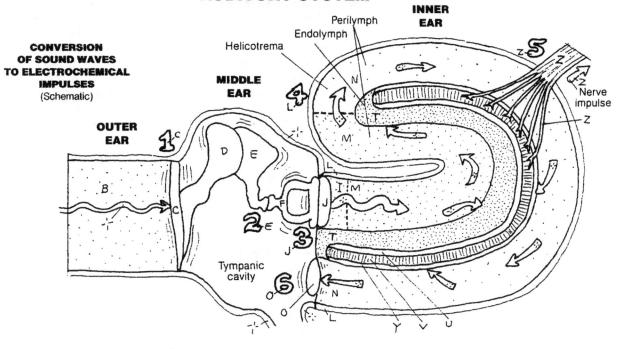

CONVERSION OF SOUND WAVES TO ELECTROCHEMICAL IMPULSES (Schematic)

Helicotrema
Endolymph
Perilymph
INNER EAR
MIDDLE EAR
OUTER EAR
Nerve impulse
Tympanic cavity

VESTIBULAR SYSTEM / EQUILIBRIUM

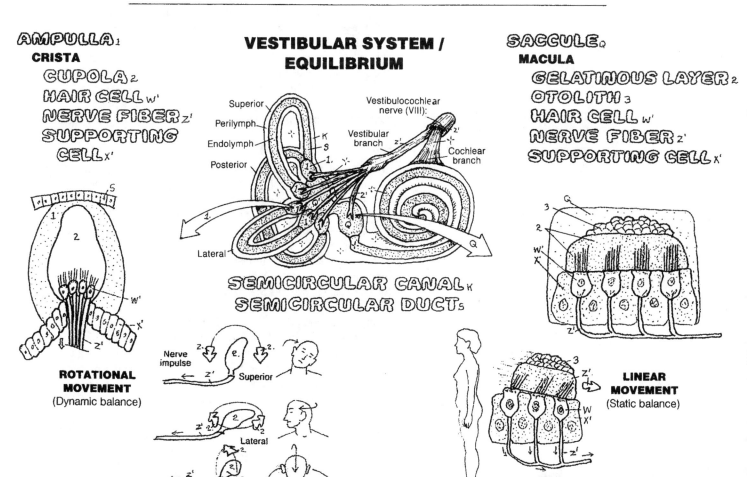

AMPULLA₁
CRISTA
CUPOLA₂
HAIR CELL w'
NERVE FIBER z'
SUPPORTING CELL x'

ROTATIONAL MOVEMENT
(Dynamic balance)

Superior
Perilymph
Endolymph
Posterior
Lateral

Vestibulocochlear nerve (VIII):
Vestibular branch
Cochlear branch

SEMICIRCULAR CANAL κ
SEMICIRCULAR DUCT s

Nerve impulse
Superior
Lateral
Posterior

SACCULE₀
MACULA
GELATINOUS LAYER₂
OTOLITH₃
HAIR CELL w'
NERVE FIBER z'
SUPPORTING CELL x'

LINEAR MOVEMENT
(Static balance)

Nerve impulse
Posture

TASTE (GUSTATION)

The tongue is a mobile organ composed largely of skeletal muscle, both intrinsic (arising and ending in the tongue) and extrinsic (arising bilaterally largely from the hyoid bone, mandible, and palate). The dorsal surface of the tongue is covered with a stratified squamous-lined mucous membrane. An inverted V-shaped groove (*sulcus terminalis*; apex facing posteriorly) divides the tongue into anterior and posterior parts. The posterior part is largely lingual tonsil tissue; the anterior part has a rough texture and is largely covered with small **filiform papillae**. Lined up on the anterior border of the sulcus terminalis is a V-shaped line of **vallate papillae**. These papillae are characterized by deep moats (see upper right).

Taste (gustatory) receptors, or **taste buds,** are located within the stratified squamous epithelial lining of the sides (moats) of circumvallate, foliate (not shown), and **fungiform papillae** on the tongue. To a lesser extent, they are located on the soft palate and lingual side of the epiglottis. They are not seen in the tiny filiform papillae. Each taste bud consists of a number of **receptor cells** (F) and their **supporting cells** (G). The apex of this oval cell complex faces the moat; here it opens onto the papillary surface via a **pore canal** (E). Dissolved material enters the pore, stimulating the gustatory (taste; chemoreceptor) cells. The impulses generated are conducted along sensory axons that reach the brain stem via cranial nerves VII, IX, and X (recall page 83). Taste interpretation occurs at the lower reaches of the sensory cortex (postcentral gyrus). Classical basic tastes of sweet, sour, salt, and bitter notwithstanding, interpretation of taste, as a practical matter, is a function of smell, food texture, and temperature in association with taste bud sensations. Gustatory sensations are conducted on the anterior tongue by the facial cranial (VII) nerve; on the posterior tongue by the glossopharyngeal cranial (IX) nerve; and on the soft palate, epiglottis, and pharynx by the vagus cranial (X) nerve.

SMELL (OLFACTION)

Receptors of **smell (olfaction)** are modified peripheral processes (**axons**) of bipolar sensory neurons (*receptor cells*) buried in the olfactory mucosa at the roof of the nasal cavity. Olfactory mucosa occupies the upper surface of the nasal cavity (adjacent to the floor of the anterior cranial fossa) and is not the same tissue as the typical respiratory mucosa lining the respiratory tract. Olfactory mucosa includes tubulo-alveolar **olfactory glands** that function to keep the chemoreceptor endings clean and, along with nasal mucous secretions, dissolve the chemicals that are sensed by these receptors. The axons of olfactory neurons ascend the roof of the nasal cavity, through the cribriform plate of the ethmoid bone, and synapse with second-order neurons in the **olfactory bulb**. The axons of these neurons form three olfactory bundles (*stria*) as part of the **olfactory tract**, depart the bulb and terminate in the inferior frontal and medial temporal lobes. Here exists the neural basis for olfactory relationships with memory, eating, survival, and sexual behavior.

CN: Use yellow for H and light colors for A, B, C, G, and I. (1) Do not color the taste buds in the vallate papillae in the modified section at right. (2) In the lowest illustration, color over the neurons within the olfactory bulb.

TASTE (GUSTATION)
PAPILLAE

VALLATE ₐ
FUNGIFORM ʙ
FILIFORM c

TASTE BUD ᴅ∴
PORE CANAL ᴇ
RECEPTOR CELL ꜰ
SUPPORTING CELL ɢ
NERVE FIBER ʜ

SMELL (OLFACTION)

OLFACTORY MUCOSA ɪ
OLFACTORY GLAND ᴊ
OLFACTORY NEURON ᴋ
OLFACTORY CILIA ᴋ¹
AXON ᴋ²
SUPPORTING CELL ɢ¹
OLFACTORY BULB ʜ¹
OLFACTORY TRACT ʜ²

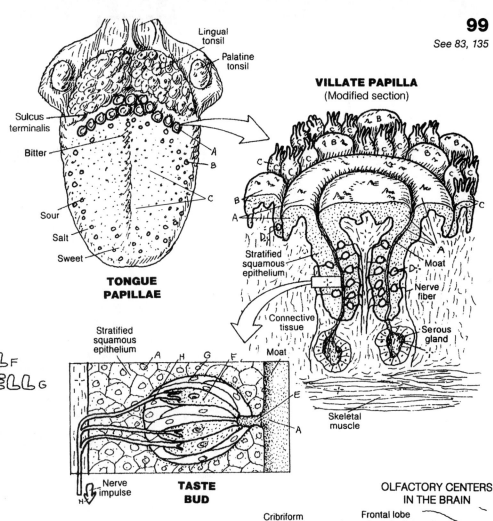

TONGUE PAPILLAE

VILLATE PAPILLA (Modified section)

TASTE BUD

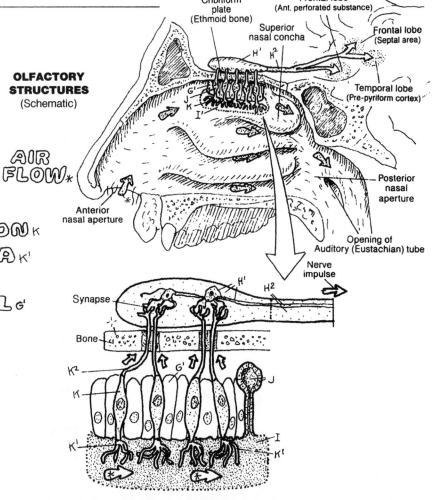

OLFACTORY STRUCTURES (Schematic)

OLFACTORY CENTERS IN THE BRAIN

AIR FLOW *

Blood consists of **plasma**, the liquid phase; and the **formed elements** (cells and platelets). Allowed to remain in a test tube following centrifugation, blood will separate into plasma (55% of the volume) and the formed elements (45% of the volume). Decant off the plasma, and the erythrocytes will occupy 99% of the volume, and the 1% leukocyte and platelet fraction ("buffy coat") rises to the top. The erythrocyte fraction is called the *hematocrit* in the clinical laboratory; generally, males have a slightly higher hematocrit (45–49% than females (37–47%). A significantly low hematocrit can be an indication of several disorders, including anemia and hemorrhage.

Erythrocytes (*erythro-*, red; *-cyte*, cell; red blood cells, RBCs) number approximately 4.5–6.2 million in each cubic millimeter (mm^3) µl of blood in men and 4–5.5 million in each cubic mm^3 µl in women. They are formed in the bone marrow as true cells (i.e., they are nucleated). As they approach maturity, each erythrocyte *loses its nucleus and most of its organelles* prior to entering the peripheral blood. Recently released immature erythrocytes may retain some ribosomes, giving a slightly reticulated appearance when stained (*reticulocytes*). The circulating erythrocyte is a non-rigid, biconcave-shaped, membrane-lined sac of hemoglobin. Hemoglobin is a protein that contains iron to which oxygen binds and which gives a red color to the erythrocytes. Hemoglobin is the principal carrier of oxygen in the body, plasma being the second. Erythrocytes pick up oxygen in the lungs and release it in the capillaries to be taken up by nearby tissues/cells. After 120 days, aged erythrocytes are removed from the circulation in the spleen.

Thrombocytes (platelets) (150,000–400,000/µl of blood; 2–5 µm in diameter) are small bits of cytoplasm from giant cells (*megakaryocytes*) of the bone marrow. They play a significant role in limiting hemorrhage: aggregation of platelets releases thromboplastin, which enhances formation of clots (*coagulation*). When blood is allowed to clot, the cells disintegrate (*hemolysis*), forming a thick yellow fluid called *serum* (not shown). Serum is plasma minus the clotting elements.

Leukocytes are white blood cells that primarily have a protective function. They may be **granular** (granulocytes include neutrophils, eosinophils, and basophils) or **nongranular** (lymphocytes, monocytes).

Segmented **neutrophils** arise in the bone marrow and live short lives in the blood and connective tissues (hours–4 days). Immature forms ("bands") may be seen in the blood during acute infections. Neutrophils destroy microorganisms and take up cellular debris.

Eosinophils exhibit colorful granules when properly stained. Eosinophils are phagocytic in immune reactions with allergens, and particularly against parasites.

Basophils contain dark-staining granules. Basophils are mediators of allergic reactions and parasitic infections.

Lymphocytes (20–45% of WBCs), which arise from bone marrow, roam lymphoid tissues as well as blood. Lymphocytes are associated with immunity. See page 120.

Monocytes (2–8% of WBCs) arise in the bone marrow, mature in the blood, and then leave the circulation to enter the extracellular spaces as **macrophages**.

CN: (1) Color the names and percentages of A and B and the contents of A and B of the tube at left yellow and red, respectively. (2) Color the large arrow B pointing to the middle rectangular tube; color the name and percentage B^1, the border B of the middle tube and its primary contents, B^1. Do not color the names and percentages at the top of the middle tube. (3) Color the name "Thrombocytes," C, and particles in the center of the page. (4) Leave the name "Leukocytes" below uncolored; color the six leukocytes below according to the color code: B blue, LB light blue, O orange, LO light orange, P purple, DP dark purple, LP light purple. Stipple the granules with the darkest color. (5) Color the five bands of leukocytes in the tube at upper right reflecting the relative distribution of these cells and their percentages in peripheral blood.

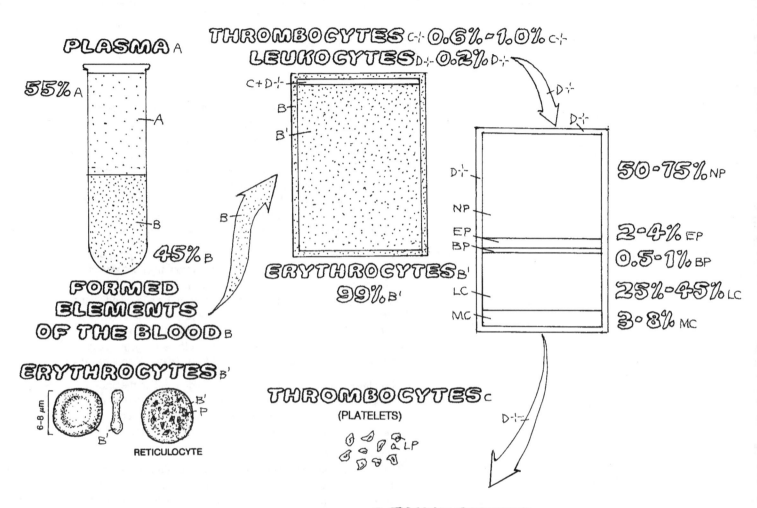

PLASMA A

55% A

THROMBOCYTES C 0.6%-1.0% C

LEUKOCYTES D 0.2% D

C+D

B

B'

ERYTHROCYTES B'
99% B'

45% B

FORMED ELEMENTS OF THE BLOOD B

NP

EP
BP

LC

MC

50-75% NP

2-4% EP

0.5-1% BP

25-45% LC

3-8% MC

ERYTHROCYTES B'

6-8 μm

B'

B'
P

RETICULOCYTE

THROMBOCYTES C
(PLATELETS)

LP

LEUKOCYTES D
(WHITE BLOOD CELLS)

GRANULAR

NONGRANULAR

NEUTROPHIL NP

LYMPHOCYTE LC

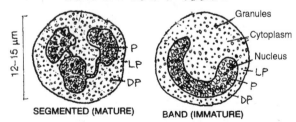

12-15 μm

P

LP

DP

Granules
Cytoplasm
Nucleus
LP
P
DP

SEGMENTED (MATURE) BAND (IMMATURE)

LO
P

6-18 μm

MONOCYTE MC

EOSINOPHIL EP

BASOPHIL BP

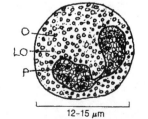

O
LO
P

12-15 μm

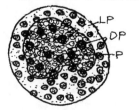

LP
DP
P

LP
P

12-20 μm

Blood circulation begins with the heart, which pumps blood into arteries and receives blood from veins. Regardless of the amount of oxygen (oxygenation) in that blood, arteries conduct blood away from the heart and veins conduct blood toward the heart. *Capillaries* are networks of extremely thin-walled vessels throughout the body tissues that permit the exchange of gases and nutrients between the vessel interior (vascular space) and the area external to the vessel (extracellular space). Capillaries receive blood from small arteries and conduct blood to small veins.

There are two circuits of blood flow: (1) the **pulmonary circulation** that conveys oxygen-depleted blood from the right side of the heart to the lungs for oxygenation/release of carbon dioxide and takes fresh blood back to the left side of the heart; and (2) the **systemic circulation**, which carries **oxygen-rich blood** from the left side of the heart to the body tissues and returns **oxygen-poor blood** to the right side of the heart. The color red is generally used for depicting oxygenated blood, and blue for oxygen-poor blood.

Capillary blood is mixed; it is largely oxygenated on the arterial side of the capillary bed, and is more deoxygenated on the venous side. This is a consequence of delivering oxygen to and picking up carbon dioxide from the tissues it supplies.

One *capillary network* generally exists between an artery and a vein. There are exceptions: the portal circulation of the liver involves two sets of capillaries between artery and vein (on this page, see the portal vein and the additional capillary network between the capillaries of the gastrointestinal tract and the heart); for more detail, see page 118. Other portal systems exist between the hypothalamus and the pituitary gland (the hypophyseal portal system; page 150); and within the kidney, between the glomerulus and the peritubular capillary plexus (page 148).

CN: (1) Color the upper central terms A-C first; use blue for A, purple for B, and red for C. Use colors for D and E that do not distract from A, B, and C. (1) Color the terms "Systemic Circulation," D, and "Pulmonary Circulation," E, the two figures, and the two capillaries, B, purple. (2) Color the brackets (D, E) of the circulatory scheme. Begin in the right atrium of the heart (BEGIN HERE) and color the flow of oxygen-poor blood, A, into the lungs. The blood is oxygenated in the lungs, B to C. (3) The oxygenated blood, C, returns to the left side of the heart, and is pumped out into the systemic circulation to capillary networks throughout the body. Deoxygenated blood, A, is returned to the heart, to repeat the cycle.

OXYGEN-POOR BLOOD A

CAPILLARY BLOOD B

OXYGEN-RICH BLOOD C

SYSTEMIC CIRCULATION D

PULMONARY CIRCULATION E

SCHEME OF BLOOD CIRCULATION

Carbon dioxide
waste products

Oxygen
nutrients

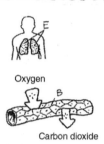

Oxygen

Carbon dioxide

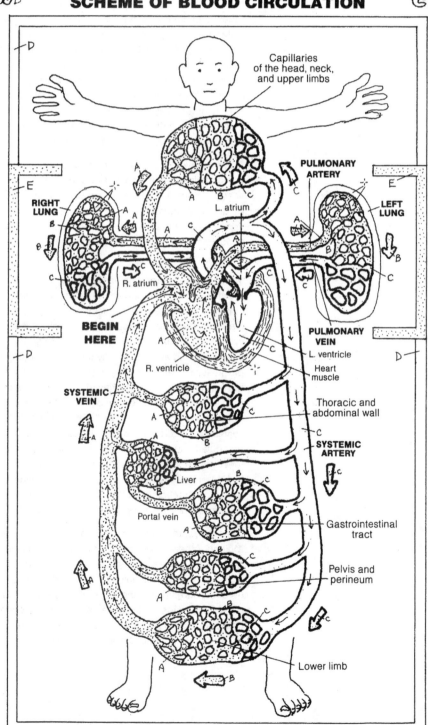

Capillaries
of the head, neck,
and upper limbs

PULMONARY
ARTERY

RIGHT
LUNG

L. atrium

LEFT
LUNG

R. atrium

BEGIN
HERE

PULMONARY
VEIN

L. ventricle

R. ventricle

Heart
muscle

SYSTEMIC
VEIN

Thoracic and
abdominal wall

SYSTEMIC
ARTERY

Liver

Portal vein

Gastrointestinal
tract

Pelvis and
perineum

Lower limb

The *vascular system* is the name for the collection of **blood vessels** and lymph vessels of the body. Arteries take blood away from the heart (pump) and deliver it to capillary networks for distribution to cells and tissues. Veins bring the blood back to the heart from the capillary networks. See page 120 for the lymph vascular section.

Arteries are characterized by smooth muscle and one or two elastic laminae in their walls. The layers of an arterial wall are generally distinctive except in the largest (endothelial-lined elastic tubes) and smallest (precapillaries). Small arteries (**arterioles**; resistance vessels) can cut off blood to a maze of capillaries when required. **Medium arteries** tend to be vessels of distribution, diverting flow as needed. **Large arteries** are the equivalent of elastic aqueducts, moving large volumes of blood out of the heart or aorta to distant parts (head, lower limbs, etc.). All arteries have a fibrous outer layer (**tunica externa** or adventitia). Within this tunic, much smaller nutrient blood vessels (*vasa vasorum*) and motor/sensor nerves (*nervi vasorum*) are found.

Arteries have the ability to respond to changing circumstances by vasodilating to increase flow and decrease blood pressure, by vasoconstricting to decrease flow and increase blood pressure, by diverting/redirecting blood flow, and literally shutting circulation down in a particular locale (e.g., capillary blanching when in shock, or suspension of bleeding in a traumatically amputated limb).

Veins generally lack significant layers of smooth muscle and elastic tissue in their walls. They function largely as conduits with considerable increased capacity when subjected to pressure loads. Large veins are especially capacious (see dural sinuses, page 115). **Venules** (small veins) are formed by the merging of capillaries and are of basically the same construction. Veins get progressively larger as they approach the heart. Veins, like rivers, have tributaries, not branches (except in portal circulations). Most medium veins of the neck and extremities have a series of small pockets, called *valves*, formed from the endothelial layer. These valves are paired and point in the direction of blood flow. They are particularly numerous in the lower limbs. Though offering no resistance to blood flow, a reversed blood flow closes the valves (and the lumen) of the vein. Venous flow in the lower limbs is enhanced by the contraction of skeletal muscles, whose contractile bulges give an antigravity boost to the movement of blood.

Capillaries, the smallest of the lot, are thin-walled, potentially porous endothelial tubes with some fibrous support. Lacking muscle and elastic tissues, capillaries are concerned with the release of nutrients, gases, and fluids to surrounding tissue, and the taking-up of carbon dioxide and other "unnecessary" gases and microparticulate matter. Capillaries can generally accommodate the passage of cells between endothelial cells. Specialized capillaries of this nature are called *sinusoids* (see page 124).

CN: Use red for A, purple for B, and blue for C (colors you used in the previous page) for the names and related types of blood vessels above. (1) Begin with the name "Large Arteries" in the upper illustration, and color all the vessels and names. (2) Color the names of the blood vessel types in the section titled "Vessel Structure," and their characteristic components. Use very light colors for D, F, and H. (3) Note that the vas and nervus vasorum in the fibrous tissue layer, H, of the lower arterial cross section are not to be colored. (4) In the two diagrams of the vein, C¹, at far right, note the closed venous valves in the lower vein, and the functioning valves in the upper vein. The blood between the two valves in the upper drawing is to be colored gray so as not to be confused with the vein structure.

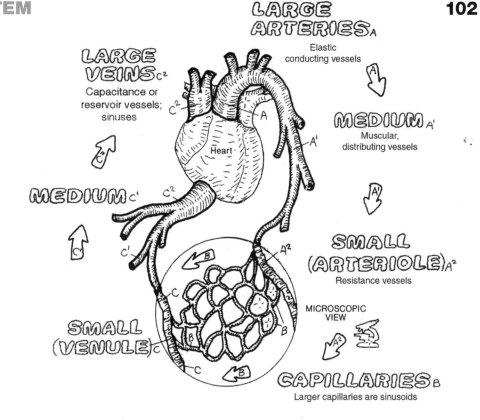

LARGE VEINS_C²
Capacitance or reservoir vessels; sinuses

LARGE ARTERIES_A
Elastic conducting vessels

MEDIUM_C'

MEDIUM_A'
Muscular, distributing vessels

Heart

SMALL (VENULE)_C

SMALL (ARTERIOLE)_A²
Resistance vessels

MICROSCOPIC VIEW

CAPILLARIES_B
Larger capillaries are sinusoids

VESSEL STRUCTURE

TUNICA INTERNA
ENDOTHELIUM_D
INTERNAL ELASTIC LAMINA_E

TUNICA MEDIA
SMOOTH MUSCLE_F
EXTERNAL ELASTIC LAMINA_G

TUNICA EXTERNA
FIBROUS TISSUE_H

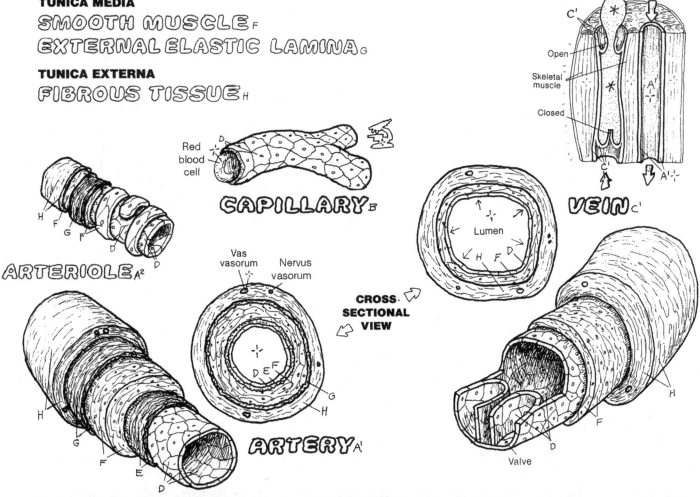

VENOUS VALVE ACTION

C'

Open

Skeletal muscle

Closed

Red blood cell

CAPILLARY_B

Lumen

VEIN_C'

ARTERIOLE_A²

Vas vasorum

Nervus vasorum

CROSS-SECTIONAL VIEW

ARTERY_A'

Valve

The **mediastinum** (median partition) is a highly populated region in the thorax between and *excluding* the lungs. This is largely so because heart has many incoming and outgoing vessels that make up a significant fraction of the structure in the thorax. Learning the contents of the mediastinum by subdivision is a fairly standard academic drill because it is the best way to get a handle on the arrangement of key structures in a very crowded and busy area of the body. Note in the two upper illustrations the floor of the mediastinum, the thoracic *diaphragm*; the roof is fascial, surrounding structure entering/leaving the **superior mediastinum**; the lateral walls are parietal pleural membranes; the **posterior wall** is the anterior aspect of the thoracic vertebrae; the **anterior wall** is the sternum and costal cartilages. The mediastinum is divided into subdivisions (see sagittal view). Most (but not all) of the organs/vessels/nerves of significance in these subdivisions are listed at middle left and can be seen in the two views of the illustration page. The learning objective is to define the **subdivisions of the mediastinum** and cite the major contents in each.

The **heart wall** (lower part of the page) consists of an inner layer of simple squamous epithelium (**endocardium**) lining the cavities; it overlies a variably thick **myocardium** (cardiac muscle). External to the myocardium is a three-layered sac (**pericardium**). The innermost layer of this sac is the **visceral pericardium** (epicardium), clothing the heart. At the origin of the aortic arch, this layer turns (reflects) outward to become the **parietal pericardium** that surrounds the heart and encloses an empty **pericardial cavity**. Imagine a fist clutching the edges of a closed paper bag. Push the bag down and around the fist while it is still clutching the edges. Note that two layers of the paper bag, as well as the collapsed cavity of the bag, surround your fist—yet your fist is *not* inside the bag itself. The relationship of your fist that is outside the two layers of the bag is the relationship of the heart to the visceral and parietal pericardia. Except for serous fluid that allows friction-free movement of the heart in its sac, the pericardial cavity is empty.

The **fibrous pericardium** is the outer lining of the parietal pericardium. It is fibrous and fatty, and is strongly attached to the sternum, the great vessels, and the diaphragm. It keeps the twisting, contracting, squeezing heart within the middle mediastinum.

SUBDIVISIONS OF THE MEDIASTINUM

SUPERIOR ᴀ
INFERIOR ⁺
 ANTERIOR ʙ
 MIDDLE ᴄ
 POSTERIOR ᴅ

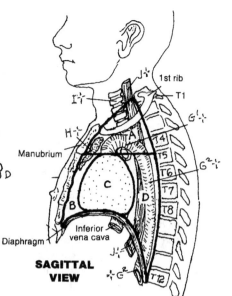

SAGITTAL VIEW

1st rib
T1
T4
T5
T6
T7
T8
T12
Manubrium
Inferior vena cava
Diaphragm

CN: Use your lightest colors for A-D; use blue for F and red for G. Begin with the "Subdivisions of the Mediastinum." (1) Color the names of the subdivisions and the four regions of the mediastinum at upper left. (2) Color the major structures within the mediastinum in the anterior view, and the related names at left. Do not color the lungs. The thymus, seen in the sagittal view, has been deleted in the anterior view to show the great vessels deep to it. (3) Color the walls of the heart and layers of pericardium, and their names, below. The pericardial cavity has been greatly exaggerated for coloring. It is normally only a potential space (contiguous membranes with a fluid interface).

STRUCTURES OF THE MEDIASTINUM

PERICARDIUM-LINED HEART ᴇ
GREAT VESSELS
 SUPERIOR VENA CAVA ꜰ
 PULMONARY TRUNK ꜰ¹
 PULMONARY ARTERY ꜰ²
 PULMONARY VEIN ɢ
 AORTIC ARCH ɢ¹
 THORACIC AORTA ɢ² ⁺

THYMUS ʜ ⁺
TRACHEA ɪ
ESOPHAGUS ᴊ
VAGUS NERVE ᴋ
PHRENIC NERVE ʟ

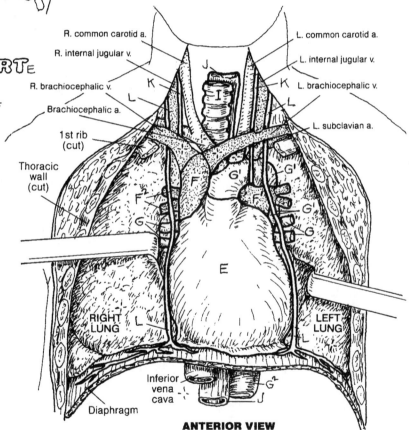

R. common carotid a.
R. internal jugular v.
R. brachiocephalic v.
Brachiocephalic a.
1st rib (cut)
Thoracic wall (cut)
L. common carotid a.
L. internal jugular v.
L. brachiocephalic v.
L. subclavian a.
RIGHT LUNG
LEFT LUNG
Inferior vena cava
Diaphragm

ANTERIOR VIEW
(Lungs retracted to visualize deeper structures)

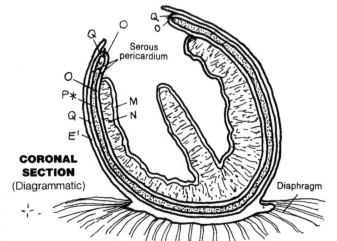

Serous pericardium

CORONAL SECTION
(Diagrammatic)

Diaphragm

WALLS OF THE HEART / PERICARDIUM

ENDOCARDIUM ᴍ
MYOCARDIUM ɴ
VISCERAL PERICARDIUM ᴏ
 PERICARDIAL CAVITY ᴘ ✱
PARIETAL PERICARDIUM ǫ
FIBROUS PERICARDIUM ᴇ¹

The heart is the muscular pump of the blood vascular system. It contains four cavities (chambers): two on the right side (pulmonary heart) and two on the left (systemic heart).

The pulmonary heart includes the **right atrium** and **right ventricle**. The thin-walled right atrium receives poorly oxygenated blood from the **superior** and **inferior vena cavae** and from the coronary sinus (draining the cardiac vessels). The thin-walled **left atrium** receives richly oxygenated blood from **pulmonary veins**. Atrial blood is pumped at a pressure of about 5 mm Hg into the **right** and **left ventricles** simultaneously through the atrioventricular orifices, guarded by the three-cusp **tricuspid valve** on the right and the two-cusp **bicuspid valve** on the left. The cusps are like panels of a parachute, secured to the **papillary muscles** in the ventricles by **chordae tendineae** (tendons). These muscles contract with the ventricular muscles, tensing the cords and resisting cusp over-flap as ventricular blood bulges into them during ventricular contraction (*systole*). The right ventricle pumps oxygen-deficient blood to the lungs via the **pulmonary trunk** at a pressure of about 25 mm Hg (right ventricle), and the left ventricle simultaneously pumps oxygen-rich blood into the **ascending aorta** at a pressure of about 120 mm Hg. This pressure difference is reflected in the thicker walls of the left ventricle compared to the right. The pocket-like **pulmonary** and **aortic semilunar valves** guard the trunk and aorta, respectively. As blood falls back toward the ventricle from the trunk/aorta during the resting phase of the heartbeat (*diastole*), these pockets fill, closing off their respective orifices and preventing reflux into the ventricles.

CN: Use blue for A–A⁴; dotted arrows represent venous blood flow in both illustrations. Use red for H–H⁴; clear arrows represent arterial blood flow in both illustrations. Use light colors for heart cavities B, C, I, and J. (1) Begin with arrows A⁴ in the left side of upper drawing above and below the right atrium, B; color A and A¹ In the list of names. Color the structures in the order of the list, A–H³. (2) Color the circulation chart below, beginning with the arrow A⁴ leading into the right atrium (numeral 1). Color the numerals, and their related arrows, in order from 1 to 4. Do not color the chambers or the vessels in the drawing at lower right.

SUPERIOR VENA CAVA_A
INFERIOR VENA CAVA_A'

–A⁴

RIGHT ATRIUM_B

RIGHT VENTRICLE_C
A-V TRICUSPID VALVE_D
CHORDAE TENDINEAE_E
PAPILLARY MUSCLE_F

PULMONARY TRUNK_A²
PULMONARY SEMILUNAR VALVE_G
PULMONARY ARTERY_A³

–H⁴

PULMONARY VEIN_H
LEFT ATRIUM_I

LEFT VENTRICLE_J
A-V BICUSPID (MITRAL) VALVE_D'
CHORDAE TENDINEAE_E'
PAPILLARY MUSCLE_F'

ASCENDING AORTA_H'
AORTIC SEMILUNAR VALVE_G'
AORTIC ARCH_H²
THORACIC AORTA_H³

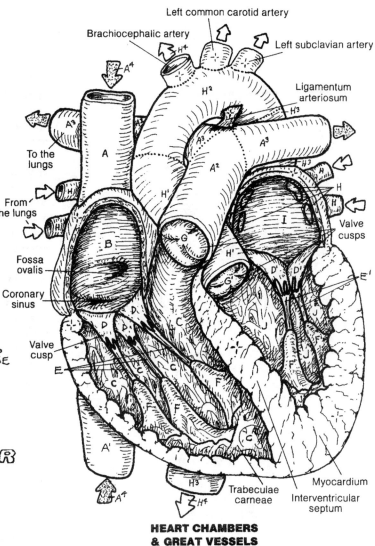

Left common carotid artery
Brachiocephalic artery
Left subclavian artery
Ligamentum arteriosum
To the lungs
From the lungs
Fossa ovalis
Coronary sinus
Valve cusp
Valve cusps
Myocardium
Trabeculae carneae
Interventricular septum

HEART CHAMBERS & GREAT VESSELS
(Anterior view)

OXYGENATED BLOOD ⇨ H⁴
DEOXYGENATED BLOOD ⇨ A⁴

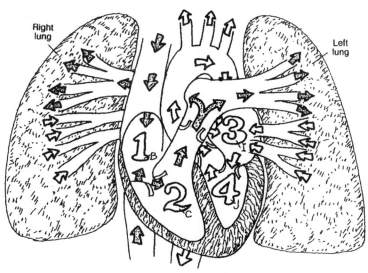

Right lung
Left lung

CIRCULATION THROUGH THE HEART
(Diagrammatic)

Cardiac muscle cells contract spontaneously. They do not require motor nerves to shorten. However, the intrinsic contraction rate of these cells is too slow and too unorganized for effective pumping of the heart. Happily, groups of more excitable but noncontractile cardiac cells take responsibility for initiating and conducting electrochemical impulses throughout the cardiac musculature. Such cells cause a coordinated, rhythmic sequence of cardiac muscle contractions that result in blood being moved through the cavities of the heart with appropriate volumes and pressures. These cells constitute the **cardiac conduction system**. Impulses generated at the **sinoatrial (SA) node** are distributed throughout the **atria** and to the **atrioventricular (AV) node** by way of nondiscrete **internodal pathways**. Impulses travel from the AV node, down the **AV bundle** and its **branches**, to the **Purkinje plexus** of cells embedded in the ventricular musculature.

The cardiac conduction system generates voltage changes around the heart. Some of these changes can be monitored, assessed, and measured by **electrocardiography (ECG; aka EKG)**. An ECG is essentially a voltmeter reading. It does not measure hemodynamic changes. Electrodes are placed on a number of body points on the skin. Recorded data (various waves of varying voltage over time) are displayed on an oscilloscope or a strip of moving paper. The shape and direction of wave deflections are dependent upon the spatial relationship of the electrodes (leads) on the body surface.

When the SA node fires, excitation/depolarization of the atrial musculature spreads out from the node. This is reflected in the ECG by an upward deflection of the resting (isoelectric) horizontal line (**P wave**). This deflection immediately precedes contraction of the atrial musculature and filling of the ventricles. The **P-Q interval** (**P-R interval** in the absence of a Q wave) reflects conduction of excitation from the atria to the Purkinje cell plexus in the ventricular myocardium. Prolongation of this interval beyond .20 seconds may reflect an AV conduction block. The **QRS complex** reflects depolarization of the ventricular myocardium. The term *complex* here refers to the combination of the three waves (Q, R, and S) immediately preceding ventricular contraction, wherein blood is forced into the pulmonary trunk and ascending aorta. The **S-T segment** reflects a continuing period of ventricular depolarization. Myocardial ischemia may induce a deflection of this normally horizontal segment. The **T wave** is an upward, prolonged deflection and reflects ventricular repolarization (recovery), during which the atria passively fill with blood from the vena cavae and pulmonary veins. The QT interval, corrected for heart rate (QTc), reflects ventricular depolarization and repolarization. Prolongation of this segment may suggest abnormal ventricular rhythms (arrhythmias). In a healthy heart at a low rate of beat, the P-Q, S-T, and **T-P segments** all are isoelectric (horizontal).

CARDIAC CONDUCTION SYSTEM & THE ECG

CN: Use blue for D and red for E. Use a very light color for B so that the patterns of dots identifying segments B–B³ of the ECG remain visible after coloring. The QRS complex and the S-T segment (ECG diagram) are colored similarly; they both reflect ventricular depolarization. (1) Begin at upper right and color the four large arrows identifying the atria, A², and ventricles, B³, as well as their names; do not color the atria and ventricles. Color the internodal and interatrial pathway arrows, A¹. (2) In the middle of the page, color the stages of blood flow through the heart and their related letters; they relate to voltage changes in the ECG below. (3) Color the ECG and related letters, starting at the left. (4) Color the horizontal bar below the time line.

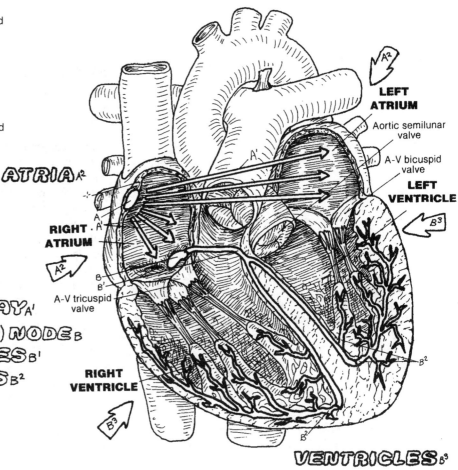

CONDUCTION SYSTEM

*SA (SINOATRIAL) NODE*ₐ
*INTERNODAL PATHWAY*ₐ'
*AV (ATRIOVENTRICULAR) NODE*ʙ
*AV BUNDLE / BRANCHES*ʙ'
*PURKINJE PLEXUS*ʙ²

BLOOD FLOW

*OXYGEN-POOR*ᴅ
*OXYGEN-RICH*ᴇ

ELECTROCARDIOGRAM (ECG)

*P WAVE*ₐ³
P-Q (P-R) INTERVAL ʙ-ʙ²
*QRS COMPLEX*ʙ³
*S-T SEGMENT*ʙ³
*T WAVE*ʙ³
*T-P SEGMENT*ᴄ

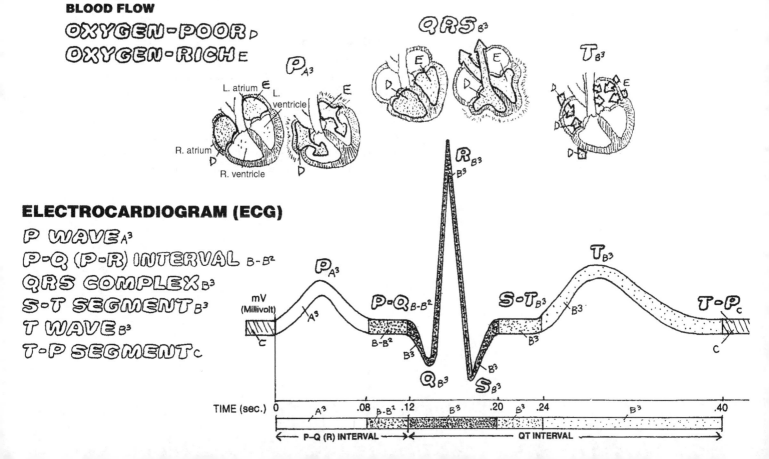

CORONARY ARTERIES

The coronary arteries form an upside-down crown (L. corona) on the surface of the heart. The arteries lie in grooves, or sulci, often covered over by the epicardium.

Both **left** and **right coronary arteries** arise from small openings (*aortic sinuses*) just above the two aortic semilunar valve cusps. Generally, the left coronary artery is somewhat larger than the right. During the cardiac cycle, the flow rate through the left is greater in most people than that through the right. There may be considerable variation in the anastomotic pattern of the left and right arterial branches. These branches terminate in multitudes of arterioles supplying the vast capillary network among the muscle fibers. The apparent multiple communications among the left and right coronary arteries notwithstanding, varying degrees of vascular insufficiency occur when there is significant obstruction of one or both coronary arteries. There is some extra-coronary arterial supply to the heart from epicardial vessels (branches of internal thoracic arteries) and aortic vasa vasorum.

Damage to the intimal layer of coronary arteries can occur with lipid deposition or inflammation. Platelet aggregation at these sites contributes to the formation of **plaque** (cell material, lipid, platelet, fibrin). Plaque builds up within the vessels, forming thrombi that occlude the vessels in progressively greater degrees. Significantly reduced blood flow to the myocardium (*ischemia*) can cause sharp pain (angina) to the chest, back, shoulder, and arm as well as permanent damage to the **myocardium** (**infarction**), not to mention disability and death.

CARDIAC VEINS

The **cardiac veins** travel with the coronary arteries, but incompletely. Vast anastomoses of veins occur throughout the myocardium; most drain into the right atrium by way of the **coronary sinus**. The **anterior cardiac veins** conduct blood directly into the right atrium. Other small veins may drain directly into the right atrium as well. Some deep (arteriosinusoidal) veins drain directly into the atria and ventricles. Extracardiac venous drainage can also occur through the vasa vasorum of the vena cavae.

CORONARY ARTERIES & CARDIAC VEINS

RIGHT CORONARY ARTERYᴀ
 MUSCULAR BRANCHᴀ'
 MARGINAL BRANCHʙ
 POSTERIOR INTERVENTRICULAR (DESCENDING) BRANCHᴄ

LEFT CORONARY ARTERYᴅ
 ANTERIOR INTERVENTRICULAR (DESCENDING) BRANCHᴇ
 MUSCULAR BRANCHᴇ'
 CIRCUMFLEX BRANCHꜰ

CN: Color only the arteries and veins on this page; do not color the heart. Use your brightest colors for A, D, and L. (1) When coloring the arteries, include the broken lines that represent vessels on the posterior surface of the heart. (2) Do the same with the veins. (3) Color the artery in front of the plaque in the circled view.

CORONARY ARTERIES

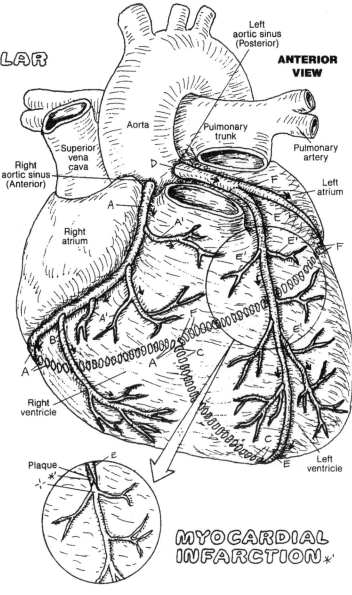

ANTERIOR VIEW

Left aortic sinus (Posterior)

Aorta

Pulmonary trunk

Pulmonary artery

Left atrium

Superior vena cava

Right aortic sinus (Anterior)

Right atrium

Right ventricle

Left ventricle

Plaque

MYOCARDIAL INFARCTION＊'

CARDIAC VEINS

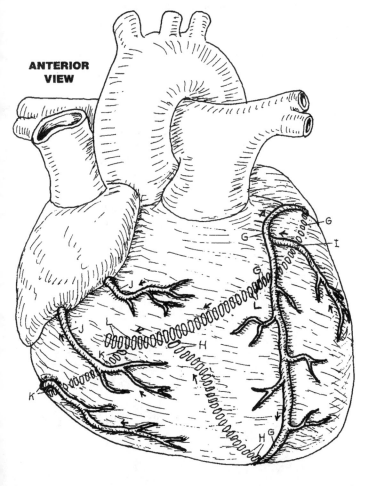

ANTERIOR VIEW

GREAT CARDIAC V.ɢ
MIDDLE CARDIAC V.ʜ
MARGINAL V.ɪ
ANTERIOR CARDIAC V.ᴊ
SMALL CARDIAC V.ᴋ
CORONARY SINUSʟ

Arteries to the head and neck, principally the **subclavian** and the **common carotid arteries**, arise indirectly by way of the **brachiocephalic trunk** on the right side, and directly from the aortic arch on the left side. There are embryologic bases for this difference that can be visualized on the illustration page at lower right. The blood supply to the brain, by way of the vertebral and the internal carotid arteries, will be the subject of page 108.

On the drawing at left, note the branches of the **right subclavian artery** (the branches of the left are not shown here, but see the anterior view). The branches of the **left subclavian** are essentially identical. The subclavian artery supplies the upper limb through the axillary artery (page 109).

The first branch of the subclavian artery is the **internal thoracic artery**, an important anastomotic artery between upper and lower limbs (page 114). Many vessels supplying the neck come from the **thyrocervical** and **costocervical trunks**. Particularly important is the **inferior thyroid artery**, to the thyroid gland, from the thyrocervical trunk.

Now follow the **external carotid artery** after the bifurcation of the common carotid. Note that its first branch is the **superior thyroid artery** supplying the critical larynx and thyroid gland (page 152). Follow out the arterial branches to the tongue (**lingual**), the facial muscles (**facial**), and the occipital region (**occipital**). At this point, the external carotid finishes by separating into **maxillary** and **superficial temporal arteries**. Branches of the maxillary artery include the **middle meningeal artery**, a critical vessel that supplies the dura mater while riding in a groove of the temporal bone (see page 23). It is a potential site of arterial rupture with a hard fall on or a blow to the side of the head (epidural hematoma). If you are a baseball fan, you may have wondered why the batter wears a helmet with an extension covering the pitcher's side of his head. A thrown baseball striking the temple (side of the head level with the top and front of the ear) can cause a middle meningeal bleed that can be life-terminating if not discovered early. The maxillary artery is also important because it supplies the teeth, lower jaw, the pterygoid region, the nasal cavity and nose, the hard and soft palate, and the temporomandibular joint.

CN: Use red for A and dark or bright colors for B and L.
(1) Begin with the anterior view at lower right, coloring the names above it as well. (2) Color the lateral view at left, beginning with the brachiocephalic trunk, A. The broken lines at the side of the face represent vessels that run more deeply than the arteries with solid lines. (3) Color the arrows pointing to the four sites where the arterial pulse may be palpated.

BRACHIOCEPHALIC TRUNK A

RIGHT SUBCLAVIAN B
INTERNAL THORACIC c
VERTEBRAL D
THYROCERVICAL TRUNK E
 INFERIOR THYROID F
 SUPRASCAPULAR G
 TRANSVERSE CERVICAL H
COSTOCERVICAL TRUNK I
 DEEP CERVICAL J
 HIGHEST INTERCOSTAL K

RIGHT COMMON CAROTID L
INTERNAL CAROTID M
 OPHTHALMIC N
EXTERNAL CAROTID O
 SUPERIOR THYROID P
 LINGUAL Q
 FACIAL R
 OCCIPITAL S
 MAXILLARY T
 INFERIOR ALVEOLAR U
 SUPERIOR ALVEOLAR U'
 MIDDLE MENINGEAL V
 POSTERIOR AURICULAR W
 SUPERFICIAL TEMPORAL X
 TRANSVERSE FACIAL Y

Parietal branch

Frontal branch

Spinous processes (C3, C4)

Bifurcation of common carotid

Ascending cervical a.

Dorsal scapular a.

Superficial cervical a.

Hyoid bone

Thyroid cartilage

Thyroid gland

Clavicle

Axillary a.

1st rib

Costal cartilage

LATERAL VIEW
(Right side)

PULSE SITES

LEFT SUBCLAVIAN A. B'
LEFT COMMON CAROTID A. L'

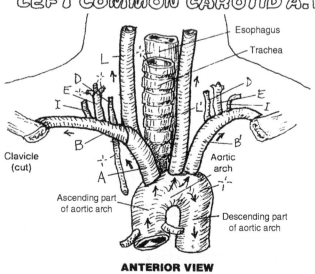

Esophagus

Trachea

Clavicle (cut)

Aortic arch

Ascending part of aortic arch

Descending part of aortic arch

ANTERIOR VIEW

Two pairs of arteries provide the blood supply to the brain: the **internal carotid artery system** and the **vertebral artery system** (recall the previous page). The two internal carotid arteries ascend the neck to reach the *carotid canals* in the base of the skull (see page 23) to arrive in the middle cranial fossa just lateral to the optic chiasma. In the upper center illustration, note the cut ends of the internal carotid arteries (A). Each internal carotid artery ends by dividing into **anterior** and **middle cerebral arteries**. Just before that division, the internal carotid gives off the ophthalmic artery to the orbit via the superior orbital fissure (not shown).

The anterior cerebral arteries continue rostrally, close to one another where an **anterior communicating artery** connects them. The area of coverage for the anterior cerebral artery can be seen in all three views of arterial distribution. The **middle cerebral artery** heads laterally in the lateral fissure between the insula and the temporal lobe, giving off small, short lenticulo-striate arteries at right angles, directed to the basal ganglia. These "stroke arteries," as they are called, are common sources of intracerebral hemorrhage, often resulting in at least partial paralysis of the limb muscles on the side of the body opposite (contralateral to) the hemorrhage. Note the distribution of the anterior, middle, and posterior cerebral arteries on the surface of the cerebrum.

In the central illustration, note how vessels arising directly or indirectly from the vertebral arteries (F) supply the brain stem. The **anterior spinal arteries** arise from the paired **vertebral arteries**, as do the posterior inferior cerebellar arteries (PICAs). The vertebral arteries form the **basilar artery** at the pontine-medullary junction. On the anterior surface of the pons, the basilar artery sends branches to the cerebellum, the inner ear (labyrinthine arteries), and the pons, and terminates by splitting into two **posterior cerebral arteries** (the inferior part of the cerebral arterial circle).

The **posterior communicating artery** is the single direct connection of the vertebral system with the carotid system. There is, however, considerable variation in the components of the arterial circle as seen angiographically, including anomalies and severely narrowed vessels.

CN: (1) Color the vessels of the carotid system A–E. (2) Color the vessels of the vertebral system F–J, with contrasting colors. (3) Color the diagram at upper right. (4) Color the diagram of the arterial circle at left, beginning with A. (5) Color the vessels on the lateral and medial surface of the cerebral hemisphere.

INTERNAL CAROTID A
ANTERIOR CEREBRAL B
 ANTERIOR COMMUNICATING C
MIDDLE CEREBRAL D
POSTERIOR COMMUNICATING E

VERTEBRAL F
BASILAR G
 CEREBELLAR (3) H
 POSTERIOR CEREBRAL I
ANTERIOR SPINAL J

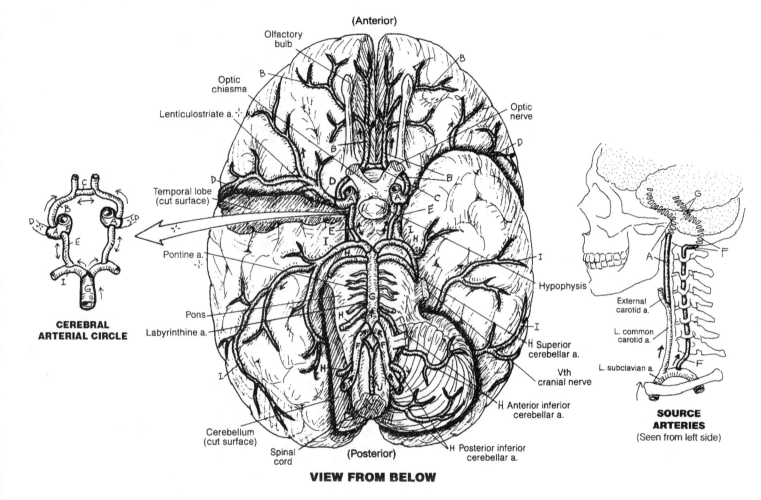

(Anterior)

Olfactory bulb
Optic chiasma
Lenticulostriate a.
Temporal lobe (cut surface)
Pontine a.
Pons
Labyrinthine a.
Cerebellum (cut surface)
Spinal cord
(Posterior)

VIEW FROM BELOW

Optic nerve
Hypophysis
H Superior cerebellar a.
Vth cranial nerve
I
H Anterior inferior cerebellar a.
H Posterior inferior cerebellar a.

CEREBRAL ARTERIAL CIRCLE

External carotid a.
L. common carotid a.
L. subclavian a.

SOURCE ARTERIES
(Seen from left side)

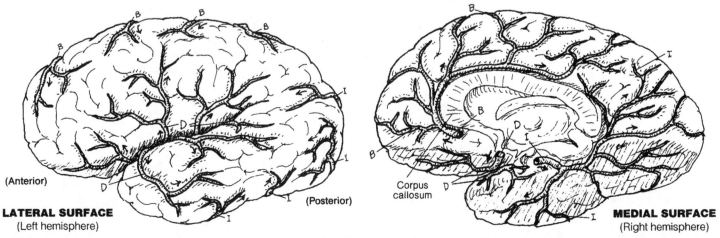

(Anterior)

LATERAL SURFACE
(Left hemisphere)

(Posterior)

Corpus callosum

MEDIAL SURFACE
(Right hemisphere)

ARTERIES

The principal artery to the free upper limb comes as an extension of the **brachiocephalic** and the **subclavian arteries** in the root of the limb deep to the clavicle: the **axillary artery**. On this page, looking at the arrangement of arteries, one can see a generally straight line of an artery (**brachial artery**) through the anterior-medial arm with a significant branch (**profunda** or **deep brachial artery**) descending the posterior arm and below the elbow. A complex of interconnecting vessels, constituting a pattern of collateral circulation, exists around the scapula (not shown) whereby branches of the subclavian, axillary, and brachial arteries form *circumscapular anastomoses* around the scapula, offering a route of blood flow to the forearm in the event the lower axillary and brachial arteries are blocked. There are anastomotic channels around the major joints: (1) the acromion and shoulder (*acromial rete* or network) involving branches of the **thoraco-acromial, lateral thoracic,** and **suprascapular arteries**; (2) neck of the humerus (**circumflex scapular** and **anterior/posterior circumflex humeral arteries**), (3) the shoulder (anterior and posterior circumflex humeral arteries), and (4) around the elbow (**profunda brachial, superior** and **inferior ulnar collateral arteries, radial** and **radial recurrent arteries,** and **common** [posterior and anterior] **interosseous arteries**).

The principal arteries of the forearm are the **radial** and **ulnar arteries.** Descending on either side of the interosseous membrane (ligament) are the anterior and posterior interosseous arteries (not shown, but see the interosseous membrane on the right). At the wrist, the radial and ulnar arteries contribute to the anastomoses of the wrist and hand, including the **deep** and **superficial palmar arches**. Common digital arteries contribute to the dorsal and palmar digital arteries.

VEINS

The veins of the upper limb, like the veins in the lower limb, are variable in number and pattern. There are two sets of interconnecting veins: deep and superficial. The deep set follows the arteries and is identically named (e.g., radial artery, **radial vein**). Not so with the superficial veins, e.g., **basilic, cephalic, median cubital** (*cubital*, referring to the elbow; for example, veins often employed for intravenous injections are located in the antecubital fossa). Often traveling in pairs (*venae comitantes*) with the arteries, the deep veins of the hand, forearm, and lower arm are not shown on this page; but know they travel with the arteries. The broken lines represent superficial (subcutaneous) veins on the posterior aspect of the forearm. At the elbow, the veins within the boxed area are frequent sites for blood sampling and administration of intravenous medication.

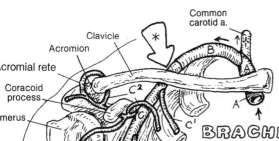

Internal jugular v.
External jugular v.

ANTERIOR VIEW
(Left limb)

CN: (1) Color the arteries A-F² on the left in the direction of blood flow. (2) Color the pulse points gray. (3) Color the veins G¹-O on the right, starting at the bottom of the page.

◀ **ARTERIES**

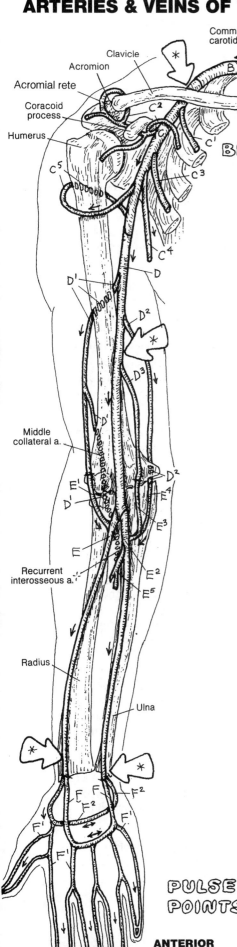

Common carotid a.
Clavicle
Acromion
Acromial rete
Coracoid process
Humerus
Middle collateral a.
Recurrent interosseous a.
Radius
Ulna

BRACHIOCEPHALIC A
SUBCLAVIAN B

AXILLARY C
SUPERIOR THORACIC C¹
THORACO-ACROMIAL & BRANCHES C²
LATERAL THORACIC C³
SUBSCAPULAR C⁴
ANTERIOR/POSTERIOR CIRCUMFLEX HUMERAL C⁵

BRACHIAL D
PROFUNDA BRACHII & BRANCH D¹
SUPERIOR ULNAR COLLATERAL D²
INFERIOR ULNAR COLLATERAL D³

RADIAL E
RADIAL RECURRENT E¹
ULNAR E²
ANTERIOR ULNAR RECURRENT E³
POSTERIOR ULNAR RECURRENT E⁴
COMMON INTEROSSEOUS E⁵

SUPERFICIAL PALMAR ARCH F
COMMON PALMAR DIGITAL F¹
DEEP PALMAR ARCH F²

VEINS ▶

DORSAL DIGITAL G & NETWORK G¹

BASILIC H
MEDIAN V. OF FOREARM I
CEPHALIC J
MEDIAN CUBITAL K
BRACHIAL L

AXILLARY M
SUBCLAVIAN N
BRACHIOCEPHALIC O

PULSE POINTS *

ANTERIOR VIEW
(Right limb)

The **stem artery to the lower limb** begins in the lateral wall of the pelvis. Here the bilateral **common iliac arteries** taking off from the terminal abdominal aorta (right side shown here) give off the **internal iliac artery** supplying the pelvic wall and viscera. From this latter artery is derived some vessels of significance to the lower limb, including the **superior/inferior gluteal arteries** that exit the pelvis through the greater sciatic foramen above/below the piriformis muscle, respectively (page 59), to supply the glutei medius and minimus. The **obturator artery** and its fellow nerve pass through the obturator foramen; the artery primarily supplies the hip joint. Note the contribution of the inferior gluteal artery to the anastomoses around the hip joint.

The **external iliac artery** gives off a very important **inferior epigastric artery** just before reaching the inguinal ligament. This artery climbs up the deep surface of the anterior abdominal wall to the sheath of the rectus abdominis, where it connects with the superior epigastric artery (see page 111). This is a major collateral route of flow to the lower limb in the event of occlusion of the abdominal aorta. The external iliac artery becomes the **femoral artery** upon passing under the inguinal ligament in company with the vein and nerve of the same name.

The femoral artery sends off the **profunda femoris artery** early in its course, then dives deep to the sartorius and pierces the medial muscular compartment (adductor canal) to gain access to the back of the knee and leg. Due in part to the considerable muscle mass in the posterior thigh, the profunda femoris artery is quite large, and its descending **perforating branches** are extensive. Note how the **medial** and **lateral circumflex arteries** contribute to the anastomoses about the femoral head/neck and the hip joint. The blood supply to the hip joint area can be compromised in several ways.

The **popliteal artery** is the distal continuation of the femoral artery at the top of the popliteal fossa. It is a relatively short artery, as it ends by dividing into **anterior** and **posterior tibial arteries**. The **genicular arteries** form a significant anastomotic pattern about the knee joint in company with the **circumflex fibular** and **anterior tibial recurrent arteries**. They can keep everything alive around the knee if there is an obstruction of the popliteal artery. The **anterior tibial artery** descends along the interosseous membrane, as does the **fibular artery** that supplies both lateral and posterior leg compartments. The **posterior tibial** and **fibular arteries** run deep to the gastrocnemius and soleus muscles. The anterior tibial artery exits the posterior leg compartment just below the knee, and descends on the interosseous membrane's anterior surface. In the event of occlusion of the posterior tibial artery, the fibular artery expands to pick up the load through multiple communicating vessels.

The primary artery to the dorsal foot is the **dorsalis pedis artery**, the pulse of which is palpable over the tarsal bones. The primary artery to the plantar region is the posterior tibial artery.

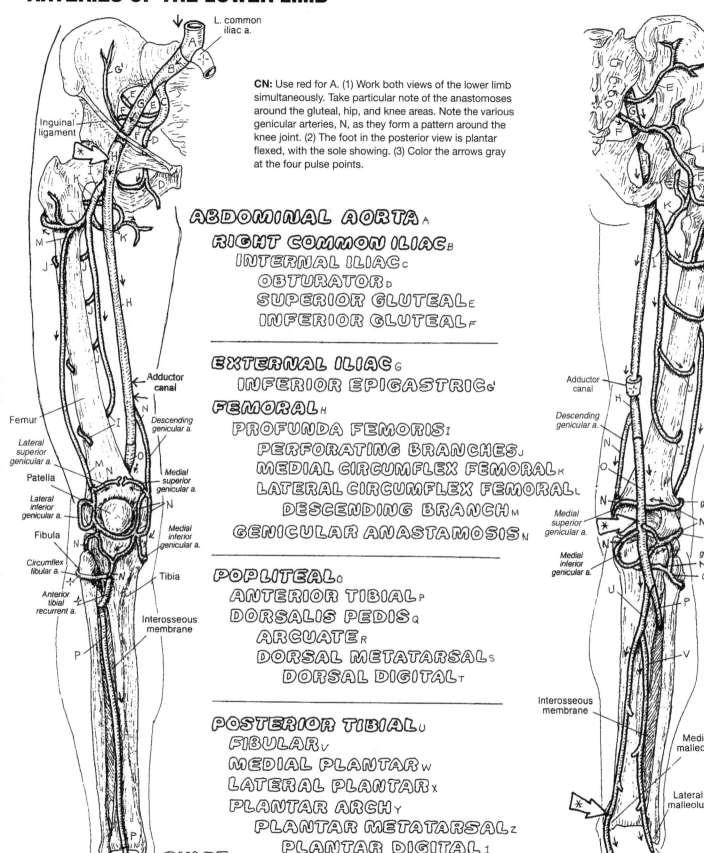

L. common iliac a.

Inguinal ligament

CN: Use red for A. (1) Work both views of the lower limb simultaneously. Take particular note of the anastomoses around the gluteal, hip, and knee areas. Note the various genicular arteries, N, as they form a pattern around the knee joint. (2) The foot in the posterior view is plantar flexed, with the sole showing. (3) Color the arrows gray at the four pulse points.

Hip joint

ABDOMINAL AORTA A
RIGHT COMMON ILIAC B
INTERNAL ILIAC C
OBTURATOR D
SUPERIOR GLUTEAL E
INFERIOR GLUTEAL F

EXTERNAL ILIAC G
INFERIOR EPIGASTRIC G'
FEMORAL H
PROFUNDA FEMORIS I
PERFORATING BRANCHES J
MEDIAL CIRCUMFLEX FEMORAL K
LATERAL CIRCUMFLEX FEMORAL L
DESCENDING BRANCH M
GENICULAR ANASTAMOSIS N

POPLITEAL O
ANTERIOR TIBIAL P
DORSALIS PEDIS Q
ARCUATE R
DORSAL METATARSAL S
DORSAL DIGITAL T

POSTERIOR TIBIAL U
FIBULAR V
MEDIAL PLANTAR W
LATERAL PLANTAR X
PLANTAR ARCH Y
PLANTAR METATARSAL Z
PLANTAR DIGITAL 1

PULSE POINTS *

Adductor canal
Femur
Lateral superior genicular a.
Patella
Lateral inferior genicular a.
Fibula
Circumflex fibular a.
Anterior tibial recurrent a.
Descending genicular a.
Medial superior genicular a.
Medial inferior genicular a.
Tibia
Interosseous membrane

ANTERIOR VIEW
(Right limb)

Adductor canal
Descending genicular a.
Medial superior genicular a.
Medial inferior genicular a.
Lateral superior genicular a.
Lateral inferior genicular a.
Circumflex fibular a.
Interosseous membrane
Medial malleolus
Lateral malleolus

POSTERIOR VIEW
(Right foot plantar flexed)

The aorta arises from the superior aspect of the left ventricle as the **ascending aorta;** the ascending part of the aortic arch. This large vessel is a classic "large artery" with a wall almost entirely composed of elastic tissue. It is characterized by a pair of **coronary arteries** that begin as two orifices in the first part of the ascending aorta. These open into two of the three cusps of the aortic valve. During systole, the blood is ejected from the left ventricle under high pressure, and the aortic valve cusps are pressed against the aortic wall. During diastole, the blood in the ascending aorta flows retrograde (backward), fills the cusps, and flows into the two coronary arteries. In this manner, the heart helps itself to the freshest blood in town! The aortic arch is at the level of the fourth thoracic vertebra.

From your right to your left, the branches of the **aortic arch** are the **brachiocephalic trunk**, the **left common carotid artery**, and the **left subclavian artery**. The descending thoracic aorta begins at the third rib (T5 vertebra), closely applied to the posterior thoracic wall on the left side of the midline. Small **bronchial** and **esophageal arterie**s come off the anterior wall of the thoracic aorta. The supreme (highest) intercostal artery, a branch of the **costocervical trunk** (recall page 107), supplies the first and second posterior intercostal spaces. The thoracic aorta gives off nine pairs of posterior intercostal arteries. Twelve ribs, eleven intercostal spaces. Where do the first two intercostal arteries come from?

Note the left **internal thoracic artery** (F) coming off the inferior surface of the subclavian artery. It lies in the anterior intercostal spaces deep to the costal cartilages. It gives off the anterior intercostal arteries (not shown) that meet in the intercostal spaces with the posterior intercostal arteries. Follow this artery to the sixth intercostal space; here it divides into the **musculophrenic** (ending on the diaphragm) and the **superior epigastric arteries**. The latter artery descends down the anterior abdominal wall deep to the sheath of the rectus abdominis (not shown but see page 49, deep layer, upper left of page). Its terminal branches connect with the terminal branches of the inferior epigastric artery coming up from the external iliac artery (see page 110). *This is one of the most important anastomoses in the body*: by these connections, blood can get to the lower limbs even with a serious occlusion of the abdominal aorta.

The branches of the abdominal aorta are either visceral or parietal. The parietal branches are small, bilateral, segmental (**lumbar**) arteries supplying the body wall. These arteries are largely responsible for providing arterial blood to the spinal cord. The visceral branches may be paired (e.g., **gastric, renal, ovarian/testicular**) or not (e.g., **celiac, superior mesenteric, inferior mesenteric**). These parietal and visceral branches of the aorta are clearly shown and should be colored carefully. They will be presented in more detail with the relevant system of which they are a part.

AORTA, BRANCHES, & RELATED VESSELS

CN: Use red for A, A^1, and A^2. (1) Color the aortic arch and its branches, A–E. Color the vessels supplying the anterior and posterior intercostal spaces 1–11, F–H. (2) Color the bronchial and esophageal arteries on the bronchi and esophagus. (3) Color the superior epigastric artery. (4) Color the branches of the abdominal aorta. The inferior vena cava (stippled) is shown for reference.

AORTIC ARCH$_A$
CORONARY$_B$
BRACHIOCEPHALIC TRUNK$_C$
LEFT COMMON CAROTID$_D$
LEFT SUBCLAVIAN$_E$
INTERNAL THORACIC$_F$
MUSCULOPHRENIC$_{F'}$
SUPERIOR EPIGASTRIC$_{F^2}$
COSTOCERVICAL TRUNK$_G$
HIGHEST INTERCOSTAL$_H$

THORACIC AORTA$_{A'}$
BRONCHIAL$_I$
ESOPHAGEAL$_J$
POSTERIOR INTERCOSTAL (9)$_K$

ABDOMINAL AORTA$_{A^2}$
CELIAC TRUNK$_L$
LEFT GASTRIC$_M$
SPLENIC$_N$
COMMON HEPATIC$_O$
SUPERIOR MESENTERIC$_P$
RENAL$_Q$
TESTICULAR / OVARIAN$_R$
LUMBAR$_S$
INFERIOR MESENTERIC$_T$
COMMON ILIAC$_U$

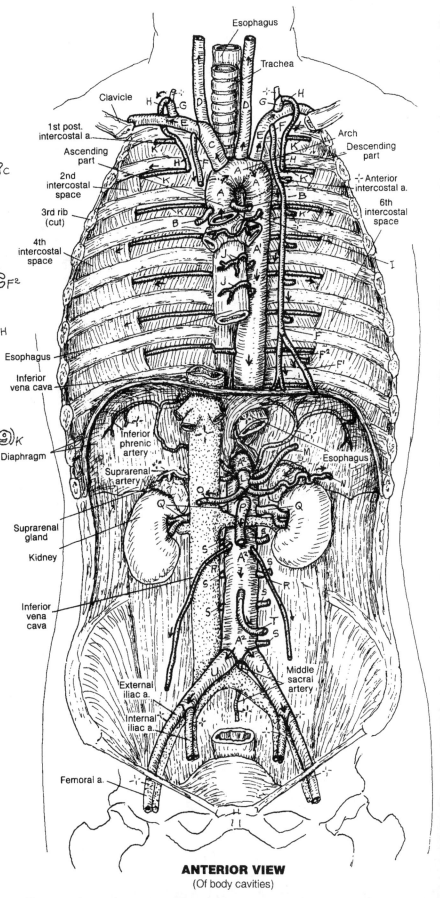

Esophagus

Trachea

Clavicle

1st post. intercostal a.

Ascending part

2nd intercostal space

3rd rib (cut)

4th intercostal space

Esophagus

Inferior vena cava

Diaphragm

Inferior phrenic artery

Suprarenal artery

Suprarenal gland

Kidney

Inferior vena cava

External iliac a.

Internal iliac a.

Femoral a.

Arch

Descending part

Anterior intercostal a.

6th intercostal space

Esophagus

Middle sacral artery

ANTERIOR VIEW
(Of body cavities)

The **celiac trunk**, the first single visceral artery off the abdominal aorta, comes off the abdominal **aorta** within the aortic hiatus of the thoracic diaphragm. It is a very short vessel that divides immediately into arteries to the liver, spleen, stomach, duodenum, and pancreas. Note the rich anastomotic pattern of arteries to the stomach. Both **left** and **right gastric arteries** cover the lesser curvature of the stomach, with branches of the left reaching and supplying the lower esophagus. The term -*epiploic* refers to the omentum, which is the fold of peritoneum between the stomach and the liver (lesser omentum), and between the stomach and the transverse colon (greater omentum; look ahead to page 138). The **gastroepiploic arteries** supply the greater curvature of the stomach and run in the greater omentum.

The **superior mesenteric artery** supplies most of the small intestine, the head of the pancreas, the cecum, the ascending colon, and part of the transverse colon. It travels in the common mesentery that comes off the parietal peritoneum of the posterior abdominal wall. Anastomoses exist between the celiac and superior mesenteric arteries in the curve of the duodenum. The superior and inferior mesenteric arteries also interconnect via a marginal artery that runs along the length of the large intestine and is fed by both these arteries. The arteries to the ileum/jejunum (O, P) run in the common mesentery.

The **inferior mesenteric artery** supplies the transverse colon down to the rectum and anal canal. Its branches lie, for the most part, posterior to the peritoneum (*retroperitoneal*); the principal exception is the group of vessels to the sigmoid colon that run in the sigmoid mesocolon on the left. Note the anastomoses between branches of the **superior rectal artery** (from the inferior mesenteric artery) and those of the middle and inferior rectal arteries that come from the internal iliac artery, as does the internal pudendal artery.

ARTERIES TO GASTROINTESTINAL TRACT & RELATED ORGANS

CN: Color the aorta, A, red. Use the same colors for arteries labeled here B, J, K, L, and Q that were used for those arteries with different labels under the heading "Abdominal Aorta" on the preceding page. (1) Begin with the illustration at upper right for orientation. (2) Color the larger illustration in descending order.

AORTA A

CELIAC TRUNK B

HEPATIC: COMMON C / LEFT C' / RIGHT C²

RIGHT GASTRIC D

GASTRODUODENAL E

RIGHT GASTROEPIPLOIC F

LEFT GASTROEPIPLOIC G

PANCREATICO-DUODENAL (SUPERIOR) H

CYSTIC I

LEFT GASTRIC J

SPLENIC K

SUPERIOR MESENTERIC L

PANCREATICO-DUODENAL (INFERIOR) H'

MIDDLE COLIC M

RIGHT COLIC N

ILEO-COLIC O

BRANCHES TO SMALL INTESTINE P

INFERIOR MESENTERIC Q

LEFT COLIC R

SIGMOID BRANCHES S

SUPERIOR RECTAL T

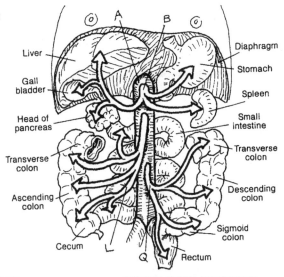

THREE MAIN ARTERIES TO GI TRACT

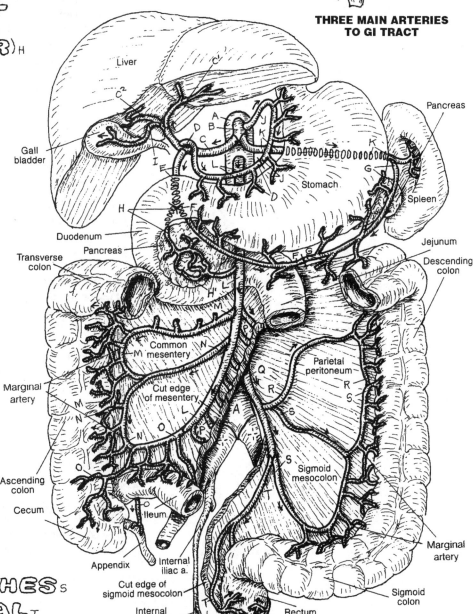

ANTERIOR VIEW
(Diagrammatic)

The **internal iliac artery** is the primary source of blood to the **pelvis** and **perineum**. Its branches are usually organized into posterior (parietal) and anterior (visceral) divisions/trunks. The vascular pattern is variable; the one shown is characteristic. From the **posterior trunk**, the **superior gluteal artery** passes through the *greater sciatic foramen above* the piriformis muscle to the upper buttock. The **inferior gluteal** and **internal pudendal arteries**, from the anterior trunk, depart the pelvis through the *lesser sciatic foramen below* the piriformis. The inferior gluteal artery supplies the lower buttock and maintains anastomotic channels with vessels at the hip joint. Proximal to the formation of the inferior gluteal and pudendal arteries, the **anterior trunk** of the internal iliac gives off four branches in both males and females. (1) The **superior vesical artery**, which arises from the proximal part of the **fetal umbilical artery**. When the umbilical cord is cut, the distal part of the artery atrophies, forming the medial umbilical ligament; the remaining umbilical artery becomes the superior vesical artery, supplying the upper bladder and ductus deferens. (2) The second branch is the **obturator artery** to the medial thigh region. (3) The third branch is the **uterine artery**; in the male, it is the **inferior vesical artery**. The **vaginal artery** comes off the uterine artery. The arteries to the prostate and seminal vesicles (not shown) come off the inferior vesical artery. (4) The fourth branch is the **middle rectal artery** that contributes to the significant set of rectal anastomoses around the rectum and anal canal (see page 112).

The left and right **internal pudendal arteries** supply the external genital structures. The pudendal vessels (and nerve) leave the pelvic cavity by way of the lesser sciatic foramen, and descend through the **pudendal canal** in the lateral wall of the ischiorectal fossa along the inner surface of the inferior pubic ramus. The artery enters the deep perineal space. There the **artery to the bulb of the penis**, the **deep artery of the penis**, and the *dorsal artery of the penis* branch off to enter the posterior aspect of the bulb of the penis, the posterior aspect of the corpus cavernosum, and the dorsum of the penis, respectively. In the male, these arteries provide blood to the vascular spaces of erectile tissue of the corpus spongiosum and the larger corpus cavernosum, as well as the glans (dorsal artery). The corpus spongiosum terminates at the glans penis. The deep and dorsal arteries dilate in response to parasympathetic stimulation, increasing blood flow into the erectile tissues, expanding the erectile bodies, and erecting and hardening the penis. The erectile tissue of the glans is generally softer than that of the cavernous bodies, thus facilitating a softer entry in intercourse.

In the female, the branching pattern of the internal pudendal artery is similar to that in the male, with arterial branches to the bulb of the vestibule and the corpus cavernosum of the clitoris. The dorsal artery of the clitoris supplies the glans.

CN: Take note of the aorta in the two illustrations at right that is to be left uncolored. (1) Color the medial views of both pelves simultaneously. (2) Color both halves of the dissected perineum seen from below (inferior view). (3) The names listed under "Perineum" can be seen in one or more of the three views presented.

PELVIS

INTERNAL ILIAC $_A$

POSTERIOR TRUNK $_{A^1}$
ILIOLUMBAR $_B$
SUPERIOR GLUTEAL $_C$
LATERAL SACRAL $_D$

ANTERIOR TRUNK $_{A^2}$
UMBILICAL (FETAL) $_{E\div}$
SUPERIOR VESICAL /
A. TO VAS DEF. $_F$
OBTURATOR $_G$
UTERINE $_H$
VAGINAL $_I$
INFERIOR VESICAL $_J$
MIDDLE RECTAL $_K$
INFERIOR GLUTEAL $_L$

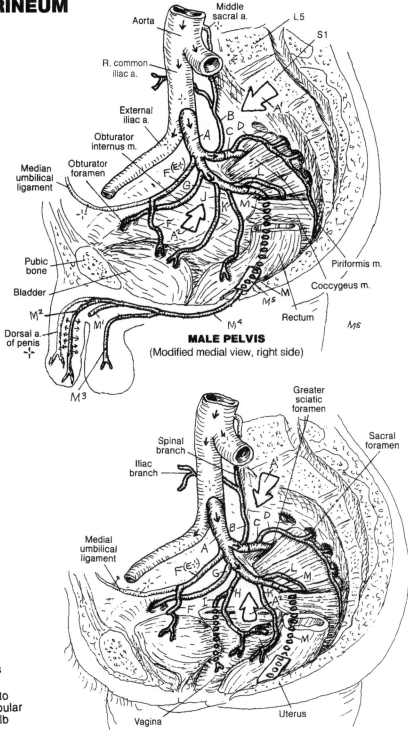

MALE PELVIS
(Modified medial view, right side)

FEMALE PELVIS
(Modified medial view, right side)

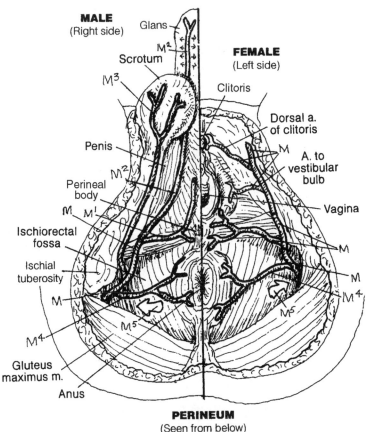

MALE
(Right side)

FEMALE
(Left side)

PERINEUM
(Seen from below)

PERINEUM

PUDENDAL $_M$
A. TO THE BULB OF PENIS $_{M^1}$
DEEP A. OF THE PENIS $_{M^2}$
POSTERIOR SCROTAL $_{M^3}$
INFERIOR RECTAL $_{M^4}$
PUDENDAL CANAL $_{M^5}$

CARDIOVASCULAR SYSTEM
REVIEW OF PRINCIPAL ARTERIES

CN: The arteries are shown bilaterally in the limbs only. Note that the figure is in the anatomical position, palms facing forward. (1) Using the preceding pages for reference as necessary, start with A and color in the order listed. You may wish to write each name with a graphite pencil to facilitate corrections (you may change your mind!), in which case, circle the letter or number at the beginning of the line with the appropriate color.
(See Appendix A for answers.)

A _____

ARTERIES OF THE UPPER LIMB
B _____
C _____
D _____
E _____
F _____
G _____
H _____
I _____
J _____

ARTERIES OF THE HEAD AND NECK
K _____
L _____
M _____

ARTERIES OF THE CHEST
A _____
A^1 _____
N _____
O _____
P _____
Q _____
R _____
S _____

ARTERIES OF THE ABDOMEN AND PELVIS
A^2 _____
T _____
U _____
V _____
W _____
X _____
Y _____
Z _____
1 _____
2 _____

ARTERIES OF THE LOWER LIMB
3 _____
4 _____
5 _____
6 _____
7 _____
8 _____
9 _____
10 _____
11 _____
12 _____
13 _____
14 _____

The brain lies in a bony cavity (cranium) with a bony "roof" (calvaria). Because the skull roof is composed of several bones, the term for the roof must be plural (-ia) rather than singular (-ium). The surface of that bony cavity is periosteal and constitutes the outer or periosteal layer of the dura mater. The inner (or meningeal) layer of the dura forms the dural sac that envelops the brain and spinal cord; it also splits off from the outer layer to form fibrous partitions that support and separate parts of the cerebrum and cerebellum (recall page 81).

Between the inner and outer layers of dura are endothelial-lined spaces called *dural venous sinuses*. Dural sinuses conduct blood from veins in the brain to the internal jugular veins, the facial veins, and the pterygoid plexuses of veins. These venous sinuses also take offerings from *diploic veins* between the tables of compact bone in skull bones, as well as the meningeal and *emissary veins* that pass through foramina of the skull to join veins and venous plexuses outside the cranium.

The deep cerebral veins, which collect venous blood from the thalamus, basal ganglia, and the diencephalon, merge into two *internal cerebral veins* under the splenium (posterior aspect) of the corpus callosum, and above the cerebellum (see page 75) to form the **great cerebral vein** *(of Galen)*. Here, the great vein drains into the anterior end of the **straight sinus**. The confluence of dural sinuses (**occipital**, *straight, transverse,* and **inferior** and **superior sagittal**) takes place near the occipital bone where the tent-shaped tentorium cerebelli merges with the midline falx cerebri (page 81). The confluence of venous blood drains into the paired **transverse sinuses** and on to the internal jugular vein via the paired **sigmoid sinuses**.

Venous blood from the anterior and middle cranial fossae and the facial veins flow into the paired **cavernous sinuses** by way of the ophthalmic veins. In the lateral walls of these sinuses can be found the oculomotor (third), trochlear (fourth), ophthalmic (V^1) and maxillary (V^2) (fifth) cranial nerves. Passing *through* the cavernous sinuses are the abducens (sixth) cranial nerve and the internal carotid artery. The cavernous sinuses drain into the **superior** and **inferior petrosal sinuses** that flow into the **internal jugular vein**.

On a practical note, the facial skin around the nose and cheeks often reveals little reddened mounds topped with pus (pustules). Squeezing these *pimples (blackheads, whiteheads)* with one's fingers or fingernails is dangerous and can lead to the uptake of infected debris by the ophthalmic veins. These veins deliver the debris to the cavernous sinus, which may then become obstructed. This may develop into a serious condition called *cavernous sinus thrombosis*, characterized by raccoon (black) eyes, periorbital swelling, and much worse. Think antiseptic!

VEINS OF THE HEAD & NECK

CN: Note the lists of tributaries; each indented *above* the vein with which they merge, and arranged in the direction of flow. This arrangement will hold for all pages concerning veins. Use lighter colors for the sinuses, A–K, represented in the lateral view by broken lines. (1) Begin above with the venous Sinuses of the Dura Mater. When coloring the falx and tentorium gray, color lightly over the vessels contained within: A, B, D, and E. Do not color the superior cerebral veins that join the superior sagittal sinus, A. The occipital sinus, K, is shown only in the lateral view below. (2) Color the veins of the head and neck at lower left.

SINUSES OF DURA MATER

SUPERIOR SAGITTAL SINUS A

INFERIOR SAGITTAL SINUS B
GREAT CEREBRAL V. C
STRAIGHT SINUS D

TRANSVERSE SINUS E
SIGMOID SINUS F

SUPERIOR OPHTHALMIC V. G
CAVERNOUS SINUS H
SUPERIOR PETROSAL SINUS I
INFERIOR PETROSAL SINUS J

OCCIPITAL SINUS K

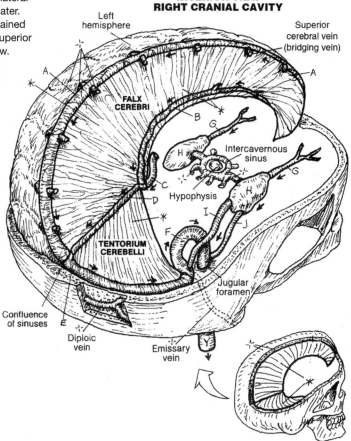

**INTERIOR VIEW
RIGHT CRANIAL CAVITY**

Left hemisphere — FALX CEREBRI — Superior cerebral vein (bridging vein) — Intercavernous sinus — Hypophysis — TENTORIUM CEREBELLI — Jugular foramen — Confluence of sinuses — Diploic vein — Emissary vein

VEINS OF HEAD & NECK

PTERYGOID PLEXUS L
MAXILLARY M
RETROMANDIBULAR N
SUPERFICIAL TEMPORAL O

POSTERIOR AURICULAR P
ANTERIOR JUGULAR Q
EXTERNAL JUGULAR R

ANGULAR S
DEEP FACIAL T
FACIAL U
LINGUAL V
SUPERIOR THYROID W
MIDDLE THYROID X
INTERNAL JUGULAR Y

DEEP CERVICAL Z
VERTEBRAL 1
RIGHT SUBCLAVIAN 2
RIGHT BRACHIOCEPHALIC 3

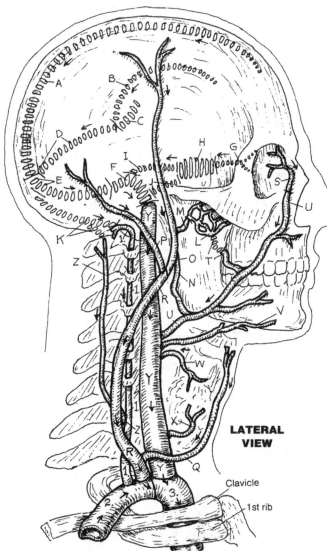

LATERAL VIEW

Clavicle

1st rib

The **superior vena cava** drains the head, neck, and upper limbs and flows directly into the right atrium of the heart. In addition, it drains the posterior intercostal and lumbar regions by way of a variable collection of veins called the **azygos system**. In conjunction with the veins of the vertebral canal (vertebral venous plexus), the azygos system (*azygos, accessory hemiazygos,* and *hemiazygos veins*) provides a secondary means of returning blood to the heart from the lower limbs and the posterior body wall in the event of obstruction of the **inferior vena cava**.

In general, arteries develop with a higher set of pressures than veins. As a consequence, veins (under lower pressure) are more numerous than arteries, more irregular in flow pattern, and their wall construction is thinner. Nowhere are these facts better seen than in the azygos system, for which there is no arterial corollary.

The **first posterior intercostal veins**, left and right, draining the first intercostal spaces, join directly with the brachiocephalic veins *on both sides*. The left and right second and third intercostal veins drain into a common vessel, the **superior intercostal vein**, but… surprise! The left superior intercostal joins the **left brachiocephalic vein**; the right superior intercostal joins the azygos vein. On the left, posterior intercostal veins 4–7 join up with the **accessory hemiazygos vein**, which turns to joins the azygos; lower on the left, posterior intercostal veins 8–12 join the **hemiazygos vein**, which crosses the vertebral column to join the azygos. On the right, the posterior intercostal veins flow segmentally into the azygos vein. The **azygos vein** originates at the inferior vena cava on the right; the hemiazygos vein arises from the **ascending lumbar vein** on the left. The azygos vein passes into the thorax through the aortic hiatus of the diaphragm. The azygos vein terminates on the posterior aspect of the superior vena cava at the level of the second costal cartilage. The anterior intercostal veins (not shown) drain into the internal thoracic veins (F), which join the subclavian vein bilaterally—the converse of the intercostal arteries with which you are already familiar (page 111, 114). The inferior vena caval and azygos systems have no major tributaries draining the gastrointestinal tract, gall bladder, and pancreas. See page 118. The liver, however, is drained by hepatic veins into the inferior vena cava, just below the diaphragm and the right atrium.

Note that the right testicular vein merges with the inferior vena cava on the right at an angle of about 20°, generating very little, if any, resistance to blood flow in the vein. On the left, the **testicular vein** joins the **renal vein** at a right angle (90°). The resistance to blood flow in the testicular vein created by the cross-current in the renal vein tends to push down the plexus of veins around the left testis, thus often (but not always) leaving the left testis a bit lower than the right.

CN: Use blue for the superior and inferior venae cavae, H and H¹. Note that a large segment of the latter has been deleted to reveal the azygos vein, N. Use bright colors for the first posterior intercostal, D, and internal thoracic, F, veins, both of which drain into the brachiocephalic. Note that the majority of the posterior intercostal veins drain into the azygos vein, N, on the right, and the accessory hemiazygos, L, and hemiazygos veins, M, on the left.

SUPERIOR VENA CAVAL SYSTEM

SUPERIOR THYROID A
MIDDLE THYROID B
INTERNAL JUGULAR c
1ST POSTERIOR INTERCOSTAL D
INFERIOR THYROID E
INTERNAL THORACIC F
RIGHT BRACHIOCEPHALIC G
LEFT BRACHIOCEPHALIC G'
SUPERIOR VENA CAVA H

AZYGOS SYSTEM

POSTERIOR INTERCOSTAL D'
SUPERIOR INTERCOSTAL I
LUMBAR J
ASCENDING LUMBAR K
HEMIAZYGOS (ACCESSORY) L
HEMIAZYGOS M
AZYGOS N

INFERIOR VENA CAVAL SYSTEM

COMMON ILIAC O
TESTICULAR / OVARIAN P
RENAL Q
HEPATIC R
INFERIOR VENA CAVA H'

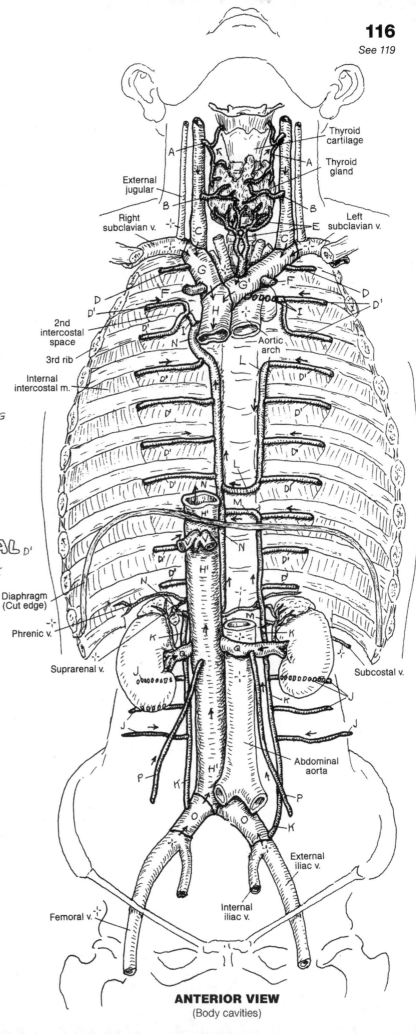

ANTERIOR VIEW
(Body cavities)

Deep veins travel in deep fascia with the arteries of the same name or destination. Like tributaries of rivers flowing into larger rivers, deep veins flow into larger veins. In the list of names of "Deep Veins," the larger vein is the last vein listed in each of the four groups of veins. Thus, A is a tributary of D that is a tributary of G that is a tributary of K that is a tributary of P. P takes the blood to the heart.

The **superficial veins** are drained by the **small saphenous vein**, a tributary of the **popliteal vein**, and the **great saphenous vein**, a tributary of the **femoral vein**.

The flow of blood in the deep veins of the lower limb is generally an uphill course. In concert with gravity, prolonged horizontal positioning of the legs (and other conditions) can result in slowed flow (*stasis*) in the deep veins, producing venous distention and inflammation (*phlebitis*). Formation of clots (*thrombi*) may follow (*deep vein thrombosis*) and inflammation as well (*thrombophlebitis*). In these conditions, thrombi may become detached and released into the venous circulation (*embolism*). The emboli continue up the venous pathway of ever-increasing size, easily pass into the right heart, and are pumped into the progressively *smaller* vessels of the lung, where they become stuck (*pulmonary embolism*).

Although deep veins generally travel with the arteries (*venae comitantes*), superficial veins do not. Instead, they travel with cutaneous nerves in the superficial fascia; many are easily visualized in the limbs. The blood in these long veins has to overcome gravity for a considerable distance, and their valves (page 102) often come under weight-bearing stress. Happily, there exist a number of communicating vessels (*perforating veins*, or *perforators*, not shown) between superficial and deep veins that permit runoff into the deep veins. This significantly offsets the effect of incompetent valves that lead to pooling of blood and swelling in the lower superficial veins, with potential inflammation. In the chronic condition, the saphenous veins and their tributaries can become permanently deformed and dysfunctional (*varicosities*).

The blood *must* keep moving! Blood that is not moving will clot. To move the blood in leg veins along the lower limb to the inferior vena cava, it is helpful (even necessary) to routinely move the muscles of the foot and leg so that the venous blood gets some assistance in moving heartward. The muscles actually knead the veins and assist the movement of blood toward the heart. Imagine what exercise can do!

CN: Use blue for P, light colors for the deep veins, and dark colors for the superficial veins (drawn with darker outlines). The tributaries of the superficial veins can be seen in the two lower insets. (1) Begin with the deep veins, A, in the order of the list of names, working both views together. (2) Color the superficial veins Q^1–V, finishing with the small illustrations.

DEEP VEINS
PLANTAR DIGITAL A / METATARSAL A'
DEEP PLANTAR VENOUS ARCH B
MEDIAL PLANTAR C
LATERAL PLANTAR C'
POSTERIOR TIBIAL D
DORSAL E
ANTERIOR TIBIAL F
POPLITEAL G
LATERAL CIRCUMFLEX FEMORAL H
MEDIAL CIRCUMFLEX FEMORAL H'
PROFUNDA FEMORIS I
FEMORAL J
EXTERNAL ILIAC K
SUPERIOR L / INFERIOR GLUTEAL L'
OBTURATOR M
INTERNAL ILIAC N
RIGHT COMMON ILIAC O
INFERIOR VENA CAVA P

SUPERFICIAL VEINS
DIGITAL Q / METATARSAL Q'
DORSAL VENOUS ARCH R
LATERAL MARGINAL S
MEDIAL MARGINAL T
GREAT SAPHENOUS U
SMALL SAPHENOUS V

Coxal bone

L. common iliac v.

Inguinal ligament

Femur

Tibia

Fibula

Medial malleolus

Lateral malleolus

Great saphenous vein and tributaries (anterior thigh)

ANTERIOR VIEW
(Dorsum of the foot)

Medial malleolus

Lateral malleolus

Small saphenous vein and tributaries (posterior thigh)

POSTERIOR VIEW
(Foot in plantar flexion)

A *portal system* of veins is a system of vessels that transports blood from one capillary network to another without having gone through the heart between networks. It is the equivalent of loading crude oil into a length of oil-tank railroad cars, and taking the train to an oil refinery and unloading the crude oil for processing. In the human body, the liver is in the processing business. Its capillaries take in ingested nutrients and related molecules from the first capillary network in the intestines and process them in a second capillary network (sinusoids of the liver).

The **hepatic portal system** begins with the capillaries of the gastrointestinal tract, gallbladder, pancreas, and spleen. **Tributaries** of the hepatic portal vein drain these vessels. They are not branches; they are tributaries (like the tributaries of a river, merging with and flowing in the same direction as the river). Within the liver, *branches* of the portal vein (like those of an artery) discharge blood into capillaries (*sinusoids*) surrounded by liver cells (see page 142). These cells remove digested (molecular) lipids, carbohydrates, amino acids, vitamins, and iron from the sinusoids. They then store them, alter their structure, and/or distribute them to the body tissues (and, in the case of unnecessary/undesirable molecules or degraded remains of toxic substances, the kidneys). The distribution process begins with the selective release of molecular substances from liver cells into the small tributaries of the three **hepatic veins**. The hepatic veins join the **inferior vena cava** immediately below the diaphragm, which is immediately below the right atrium.

The veins draining the viscera of the abdominal cavity generally follow the arteries supplying those viscera, and use the same name as the arteries.

Liver disease begins with the death of liver cells, followed by an inflammatory response with the laying-down of fibrous tissue around and among the dead cell debris. Liver cells cannot reproduce fast enough to avoid the ravages of fibrous tissue invasion following inflammation). As the amount of fibrous (scar) tissue increases, it invades the liver sinusoids and begins to block the blood flow through the involved part of the liver. As a consequence, over time, the **portal vein** and its tributaries enlarge significantly. This event is related to the lack of valves in the portal vein and its tributaries, as well as the inferior vena cava and its tributaries. Back flow of venous blood induces the formation of paths of lesser resistance. Venous blood must return to the right atrium of the heart, and it will find a way.

Such "ways" (routes; i.e., *1, *2) develop by way of **anastomoses** between and among veins of the portal system and veins of the inferior caval, superior caval, azygos, and vertebral venous systems. It's called **collateral circulation**. In time, with progression in the absence of treatment, these thin-walled anastomotic vessels (especially the esophageal and rectal) become enlarged and tortuous (*varices*), thin-walled, and subject to recurrent if not lethal hemorrhage.

CN: Use blue for I and a dark color for J. (1) Color the veins, A–J¹, and the related arrows. There are both left *and* right gastro-epiploic (D, D¹) and left *and* right gastric (G, G¹) veins. For the darkly outlined directional arrows adjacent to blood vessels, use the color of the adjacent blood vessel. (2) Color gray the term "Collateral Circulation & Site of Anastomosis", *³, and the three large related colorable arrows, *³, pointing out the connections between the portal circulation and the tributaries of the inferior vena cava, *¹, and the tributaries of the inferior vena cava, *².

HEPATIC PORTAL SYSTEM

SUPERIOR RECTAL A
INFERIOR MESENTERIC B
PANCREATIC C
LEFT GASTRO-
 EPIPLOIC D
SPLENIC E
RIGHT GASTRO-
 EPIPLOIC D'
SUPERIOR
 MESENTERIC F
RIGHT GASTRIC G
LEFT GASTRIC G'
CYSTIC H
PORTAL I
HEPATIC VEIN J
 & TRIBUTARIES J'
INFERIOR VENA CAVA *
 TRIBUTARY *'
TRIBUTARY OF
 SUPERIOR
 VENA CAVA *²

COLLATERAL CIRCULATION
& SITE OF ANASTOMOSIS *³

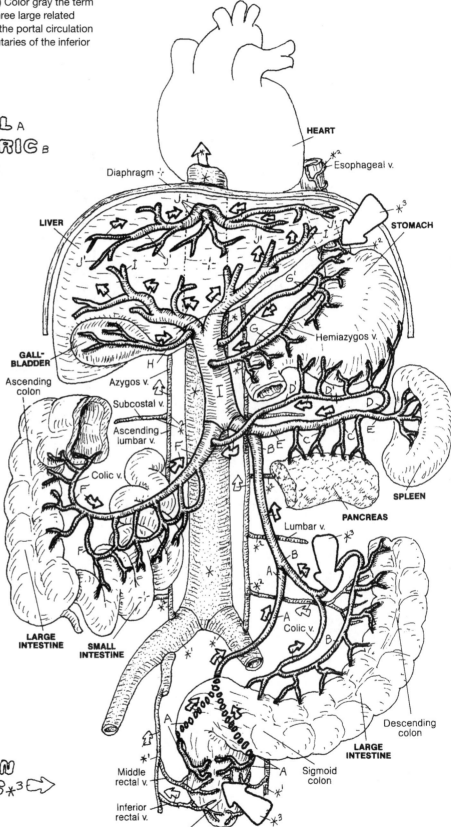

**PORTAL VEINS
& TRIBUTARIES**
(Anterior view, diagrammatic)

As all phlebotomists know, some veins are extremely variable in size and location. Why do they know this? Because they spend hours, over the length of a career, searching for a vessel in the antecubital fossa (front of elbow), for example, that is supposed to be there and, in this person, is not. There are folks who display a host of veins in front of the elbow for drawing blood, and others who don't seem have a single one within needle range!

Deep veins run with arteries of the same name (though the direction of flow is opposite). In the limbs, the veins are often paired (venae comitantes); the artery rarely so. Superficial veins generally have no companion arteries; they do tend to travel with cutaneous nerves. In review, it should be clear that arteries and portal veins have branches. All other veins have tributaries. Finally, it should be recognized that there are substantially more veins in the body than arteries.

Missing from this illustration are some of the anastomotic venous pathways between the upper chest and the lower limb, providing for venous return to the heart in the event the inferior vena cava is compromised in some way. You may recall the anastomosis between the superior and inferior epigastric arteries (page 111); the venous equivalents are veins of the same name, running in the same place (deep to the rectus abdominis), and terminating close to their arterial counterparts. There is also a collateral route between the lateral thoracic vein (from the axillary) and the superficial epigastric vein (a tributary of the great saphenous vein). These veins were not presented graphically or in the text.

REVIEW OF PRINCIPAL VEINS

CN: Superficial veins of the limbs are shown on the left and deep veins are shown on the right. Only a few are shown bilaterally. Palms are facing forward. (1) Using the preceding pages for reference as necessary, start with A (right hand) and color in the order listed. As you color each vein, write the name of the vein in graphite pencil (to make corrections easier), but circle the identifying numbers or letters in color. After completing the superficial veins in the limbs, color through the deep veins, starting at the hand/foot. (2) Recall that the deep veins travel with the arteries of the same name.
(See Appendix A for answers.)

VEINS OF THE UPPER LIMB
A _____
B _____
C _____
D _____
E _____
F _____
G _____
H _____
I _____
J _____
K _____
L _____
M _____
N _____

VEINS OF THE HEAD AND NECK
O _____
P _____

VEINS OF THE CHEST
Q _____
R _____
S _____
T _____

VEINS OF THE LOWER LIMB
U _____
V _____
W _____
X _____
Y _____
Z _____
1 _____
2 _____
3 _____
4 _____
5 _____
6 _____
7 _____
8 _____
9 _____

VEINS OF THE PELVIS AND ABDOMEN
10 _____
11 _____
12 _____
13 _____
14 _____
15 _____
16 _____
17 _____
18 _____
19 _____
20 _____
21 _____

SUPERFICIAL VEINS

Heart

Lung

Liver

DEEP VEINS

Thoraco-epigastric vein

Superficial veins on the posterior aspect

DORSAL VEINS

PLANTAR VEINS

Body water (60% of body weight) is compartmentalized into cells (intracellular fluid, ICF) and extracellular spaces/tissue (extracellular fluid, ECF). ECF includes both tissue fluid and the fluid of blood (plasma). These fluids pass freely from one ECF compartment to the other, subject to local diffusion and other pressures, as well as the hydrostatic forces associated with the movement of molecules and fluids from one compartment to another. Excess fluid/ions/molecules taken out of the interstitial tissues by lymphatic capillaries is called *lymph*. Excess fluid in the ECF is called *lymphedema*.

Lymphocytes are small white blood cells found throughout the extracellular fluid spaces (recall page 100). They are the primary cells of the immune system (see page 122). A visual summary of **lymphocyte circulation** can be seen in the lower illustration—just follow the numbers. Lymphocytes are formed in hematopoietic tissue of the red bone marrow. Certain of these cells will be further differentiated in the thymus gland (1) where they become T cells associated with cellular immunity, as contrasted with B cells concerned with humoral immunity (page 122). The lymphocytes enter the blood circulation (2) and pass through the capillary network (3). They can leave the capillary network and return to the heart via the venous system, or they may enter the ECF spaces (4). In these tissues, they may be directed to an antigen for identification and marking. **Lymphatic capillaries** are thin-walled, endothelial tubes formed in the loose connective tissues (see lower inset). Unlike blood capillaries, they arise closed at one end ("blind tubes"; see lower left illustration) and merge with other lymphatic capillaries that collectively progress to larger **lymphatic vessels**. Lymph/lymphocytes generally enter **lymph nodes** (5) through afferent lymphatic vessels; see page 125. Passing through the node, lymphocytes may remain or depart through efferent lymphatic vessels (6), ultimately to enter a tributary of the thoracic or right lymph duct (7). Lymphocytes can also enter the deep cortex of lymph nodes directly by slipping between the lining cells of venules characterized by large, "plump" cuboidal endothelium (high endothelial venules or HEV (6); see page 125).

Lymph flow is facilitated by nearby muscle contractions, which increase interstitial tissue pressures; and lymphatic valves, which prevent retrograde lymph flow. Larger lymphatic vessels have smooth muscles in their walls, and their contractions also enhance lymph flow.

Lymphatic vessels run in both superficial and deep patterns. Superficial lymphatic vessels run in the extremities and head and neck, and are "filtered" through one of the more prominent lymph node collections in the neck (**cervical**), the axilla (**axillary**), and the inguinal region (**inguinal**). Deeper lymphatic vessels join the intercostal, lumbar, and intestinal **trunks** that flow into the large **cisterna chyli**. From this cistern, the **thoracic duct** moves the lymph to the left lower neck, where it picks up the jugular and subclavian lymph trunks and pours its lymph into the junction of the left internal jugular and subclavian veins. It is similar on the right (**right lymph duct**).

LYMPHATIC DRAINAGE
& LYMPHOCYTE CIRCULATION

CN: Use blue for H, red for I, and purple for J; use colors for the lymphatic vessels/nodes that distinctly contrast with those used for the blood vessels. (1) Color the names and structures/ fluids in the scheme of "Lymphocyte Circulation" at lower left; follow the numbers. (2) Color the inset at lower left; color only the lymphocytes, N; the blood capillary, J; and the lymphatic capillary, K. (3) Color the lymphatic vessels, the cisterna chyli, and the lymph nodes in the illustration at upper right.

SUPERFICIAL DRAINAGE

SUPERFICIAL LYMPH VESSEL A
CERVICAL LYMPH NODE B
AXILLARY LYMPH NODE B'
INGUINAL LYMPH NODE B²

DEEP DRAINAGE

LYMPHATIC TRUNK C
CYSTERNA CHYLI D
THORACIC DUCT E
RIGHT LYMPH DUCT F

**SUPERFICIAL &
DEEP LYMPHATIC
DRAINAGE**

**SCHEME OF
LYMPHOCYTE CIRCULATION**

LYMPHOCYTE CIRCULATION

BONE MARROW G / THYMUS G'
VENOUS BLOOD H
ARTERIAL BLOOD I
BLOOD CAPILLARIES J
LYMPHATIC CAPILLARIES K
ECF SPACE L
AFFERENT LYMPH VESSEL M
LYMPH NODE M'
EFFERENT LYMPH VESSEL M²
LYMPHOCYTE N

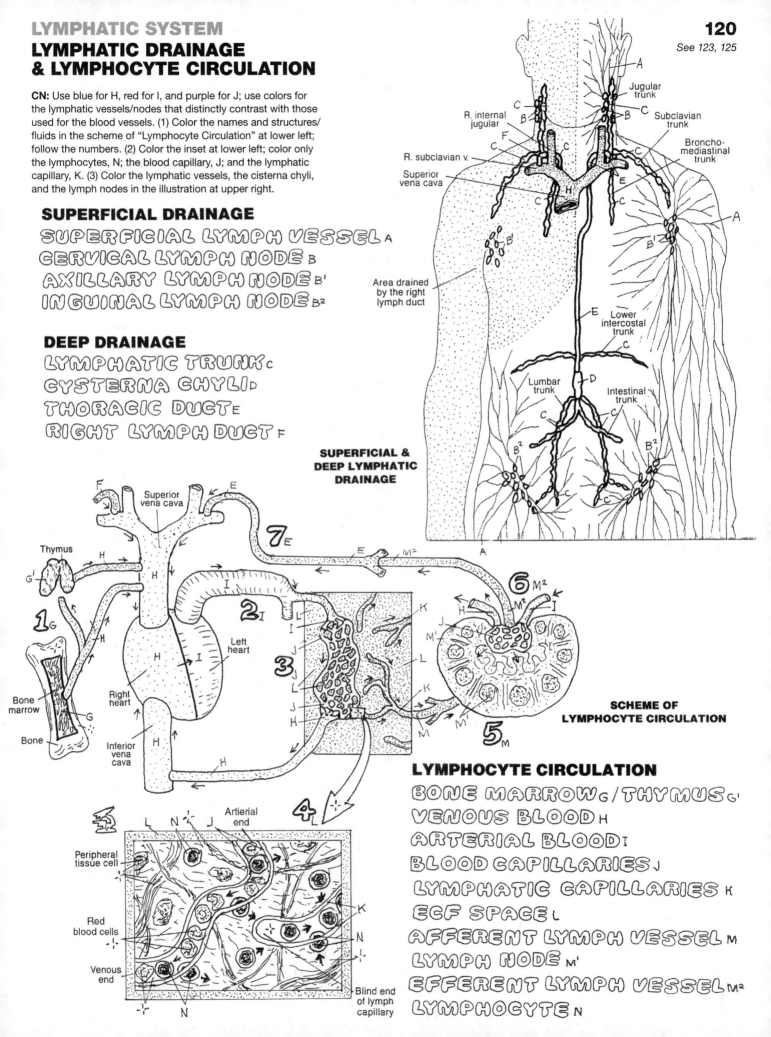

The lymphoid system is the anatomical component of the immune system. It responds to microorganisms entering the body and to cells/cell parts no longer recognizable as "self." The system provides two forms of immunity: the innate immune response and the adaptive immune response (see page 122). The first is immediately reactive to challenge; it is inborn and it is non-specific. Its primary vehicle for expression is the inflammatory response (page 122). The second response takes a little longer, as it assesses the chemistry of the pathogen that stimulated the response (**antigen**), but it creates lifelong immunity against each specific challenger with the aid of memory cells. The lymphoid system consists of tissues and organs characterized by collections of uncommitted and committed lymphocytes, phagocytes, fibroblasts in a milieu of extracellular fluid, lymph, and vascular/lymphatic capillaries supported by a meshwork of reticular fibers and reticular cells.

The red **bone marrow** and **thymus** are the primary sources of lymphoid cells that populate lymphoid organs. The bone marrow contains the precursors of all lymphocytes and disburses them into the circulation. It consists largely of various blood cells in different stages of maturation, phagocytes, reticular cells and fibers, and fat cells. Some of the lymphocytes mature and undergo structural and biochemical revision (*differentiation*) in the bone marrow to become B lymphocytes. Large lymphocytes enter the circulation from the bone marrow and function as natural killer (NK) cells.

The thymus is located in the superior and anterior (inferior) mediastinum. It receives uncommitted (*naïve*) lymphocytes from the bone marrow. It is actively engaged in T lymphocyte proliferation and differentiation during embryonic and fetal life and during the first decade of extrauterine life. The thymus begins to undergo degeneration (involution) after puberty.

Secondary lymphoid organs are structures predominantly populated by lymphocytes that migrated from the **primary lymphoid organs**. They range from a diffuse disposition of lymphocytes throughout the loose connective tissues to encapsulated, complex structures (**spleen** and **lymph nodes**).

B lymphocytes (B = bone marrow-derived) differentiate along specific lines, one of which becomes plasma cells. **Plasma cells** secrete protein molecules (**antibodies**) into tissue fluids (humoral immunity). Antibodies interact with and destroy both antigens and free or attached cell parts that elicit activation of the B cells.

T lymphocytes (T = thymus-derived) differentiate into a number of cells, including **helper** (T_H), **cytotoxic** (T_C), and memory cells (not shown). Activated by antigen stimulation, T_H cells stimulate and regulate specific and nonspecific immune operations against cells without necessarily being assisted by B cells. They convey cell-mediated immunity. T_C cells kill cells targeted by other T cells or lymphokines. They do not recirculate through the blood vascular circulation.

Natural killer (NK) cells are essentially undifferentiated lymphocytes; they are part of the innate immune system. They are not activated (adapted) by other cells or lymphokines. NK cells primarily destroy tumor cells and virus-infected cells in association with T_C cells.

Phagocytes are tissue macrophages that destroy antigen and cell debris by phagocytosis. They function as antigen-presenting cells (APC) for T cells. In turn, T cells activate phagocytes.

CN: The thymus, T, shown here is one seen from birth to puberty. It produces the T_H and T_C cells; color these cells the same color as T. Use bright colors for D, E, F, G, Ag, and Ab; use light colors for the cells. M.A.L.T., E, are representations of a continuous array of cells throughout the mucosa of all viscera; for more detailed representations, see page 126. The subscripts of cells listed are abbreviations of the cell name. (1) Color over the entire cells; the identifying symbols in the nuclei of the cells are used universally; see text. (2) Color in the order of the list of names at left. Try to use the same light color for each cell type wherever it appears in pages 122–128. It will help in recall of their names.

PRIMARY ORGANS

BONE MARROW ₐ
THYMUS ⟝

SECONDARY ORGANS

SPLEEN c
LYMPH NODE ᴅ
MUCOSAL ASSOCIATED
 LYMPHOID TISSUE
 (M.A.L.T.) ᴇ
TONSILS ꜰ
APPENDIX ɢ

CELLS

B LYMPHOCYTE ʙ
 PLASMA CELL ᴘᴄ
T (HELPER) LYMPHOCYTE ᴛʜ
T (CYTOTOXIC) CELL ᴛᴄ
NATURAL KILLER CELL ɴᴋ
PHAGOCYTE ᴘ

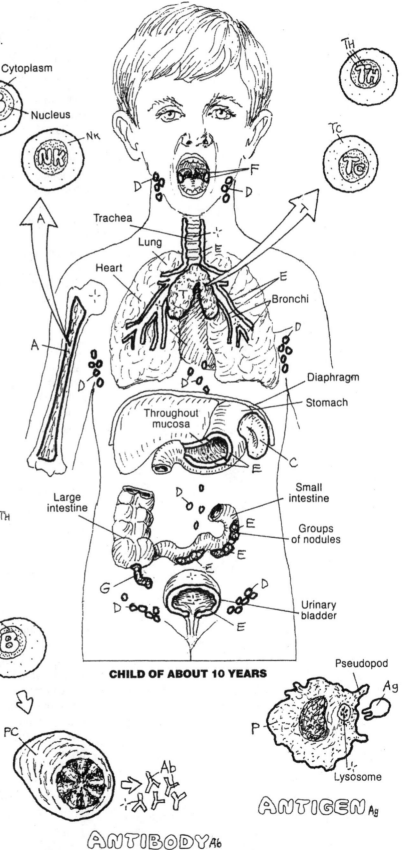

CHILD OF ABOUT 10 YEARS

ANTIBODY ₐᵦ

ANTIGEN ₐg

Immunity is a response of the body to harmful and possible life-terminating pathogenic organisms. As you learned from page 121, **innate (natural) immunity** consists of natural, nonspecific barriers to infection, as illustrated in the upper part of the page. It is a fast-acting response that begins with the first violation of the skin or mucosa. Shortly before birth and following, one progressively acquires a more specific, **adaptive (acquired) immunity** in which certain lymphocytes in the peripheral blood, lymphatic tissues, and lymphoid organs and tissues are activated by encounters with an **antigen** (any material that induces an immune response). The process of lymphocytic activation takes a day or two to spool up to the challenge.

Innate immunity operates indiscriminately against **microorganisms** and degenerated cells, cellular parts, and cellular and fibrous debris. **Anatomic barriers** (1), such as skin or mucous membranes, physically resist invasions of microorganisms. However, once violated, the torn skin releases factors that begin the clotting mechanisms and induce the process of *inflammation*: Dilation of local capillaries causes tell-tale redness on the surface of the skin, as well as releasing heat to the surface; consequent swelling of the local tissues due to the accumulation of fluid is accompanied by the onset of pain. Neutrophils and monocytes sweep into the area from the local capillaries under the influence of cytokines and other chemical mediators. Thousands of **phagocytes**/macrophages approach their prey from the blood (2) or connective tissues (3), and engulf them (4, phagocytosis), destroying them with lysosomal enzymes (5). Certain soluble proteins in body fluids, called **complement**, bind to microorganisms, enhancing their phagocytosis.

Adaptive immunity involves diverse but specific lymphocyte responses to the presence of antigen. Each reaction is characterized by the activation and proliferation of lymphocytes followed by the destruction of antigens. Based on lymphocyte types, two kinds of acquired immunity are possible: humoral immunity and cellular immunity. Specificity and diversity of response, retention of cellular memory of antigen, and the ability to distinguish self from non-self among the body's proteins are inherent in both kinds of immunity.

Humoral (fluid-related) immunity is characterized by **B lymphocytes** being activated by antigens (Ag) (1); proliferating, forming **memory cells** (Bm), and secreting antibodies (Ab) (2); and forming **plasma cells** (PC) (3), which secrete antibodies (4). **Antibodies** are complex proteins formed in response to a specific antigen and attached to it at the antigenic determinant site (5), facilitating its phagocytosis.

Cellular immunity is characterized by **T lymphocytes** being activated by antigens attached to antigen-presenting cells: phagocytes (P) (1). Most T cells differentiate into **helper T lymphocytes** (T_H) and cytotoxic T lymphocytes (T_C). T_H lymphocytes (2) enhance humoral immunity by activating B cells, augmenting the **inflammatory response**, activating phagocytes with stimulating factors (lymphokines), and forming memory cells (T_M). **Cytotoxic T lymphocytes** (3) bind to and destroy **infected cells** and form memories of the occasion (T_M cells). **Memory cells** recognize specific structural characteristics of the antigens encountered ("memory") and facilitate rapid immune responses on subsequent exposure to those antigens.

CN: Use pink for the large upper circle labeled IR depicting an inflammatory response. Use the same colors you used on page 121 wherever possible. Radial lines surrounding a cell indicate activation. All elements have been magnified and schematized for coloring. (1) Color the list of names and the elements under "Innate Immunity," following numbers 1–5. (2) Color "Humoral Immunity," following the numbers 1–5. (3) Do the same with "Cellular Immunity following numbers 1–3."

INNATE IMMUNITY

MICROORGANISM A

ANATOMIC BARRIER ABa

COMPLEMENT c

PHAGOCYTE P

INFLAMMATORY RESPONSE IR

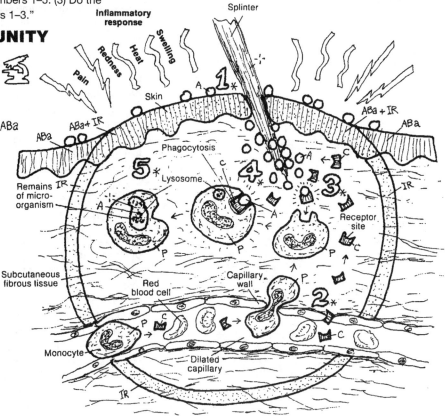

ADAPTIVE IMMUNITY

ANTIGEN Ag

HUMORAL IMMUNITY B-

B LYMPHOCYTE B

MEMORY CELL BM

PLASMA CELL PC

ANTIBODY Ab

INFECTED CELL IC

CELLULAR IMMUNITY T-

T LYMPHOCYTE T

MEMORY CELL TM

HELPER CELL (TH) TH

CYTOTOXIC CELL (TC) TC

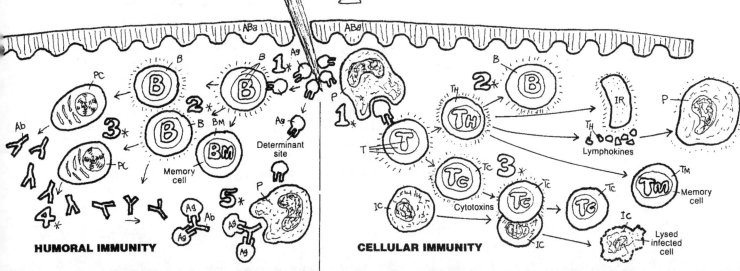

HUMORAL IMMUNITY

CELLULAR IMMUNITY

The **thymus** consists of two lobes of glandular tissue in the anterior and superior mediastinum. It seeds the entire body with T lymphocytes, the protagonists of cellular immunity. In the late fetus/newborn, the thymus is functional and relatively large (15 g). It continues to grow and function during the preteen years, and declines in size and activity in the following years.

The functional thymus consists of microscopic lobules partitioned by septa containing blood vessels. Each lobule has an outer **cortex** dense with lymphocytes (called *thymocytes* while in the thymus), and a much less dense central **medulla**. The supporting tissue of the thymus consists of fibrous trabeculae (extensions of fibrous tissue) that give boundaries to the lobules, and a reticuloepithelial (RE) meshwork of cells that form the background for the lymphocytes and phagocytes in both cortex and medulla. It seems likely that the RE cells, in conjunction with thymocytes, may produce various cytokines that influence the development of thymocytes.

T stem cells, released from the bone marrow, enter the cortex of the thymus by way of thymic arteries, and begin the process of differentiation as **immature** thymocytes. Most of the cortical thymocytes, though committed to becoming active T cells, flunk final examination by failing to recognize certain antigens. These thymocytes are then processed for phagocytosis and taken out. The limited number of cells that are permitted to migrate into the medulla show signs of advanced development; that is, they reveal changes in their cell membrane composition that permits them to form cytotoxic CD8+ T lymphocytes or helper CD4+ T lymphocytes. Graduating cells leave the thymus by venules to enter the systemic circulation. Encountering antigen outside the thymus activates them. Some T lymphocytes enter **lymph vessels** destined for mediastinal lymph nodes and beyond.

The medulla contains, in addition to an RE meshwork and a low density of thymocytes, a number of distinctive bodies consisting of concentric rings of keratinized epithelioreticular cells (Hassal's (thymic) corpuscles). Their role in the development of thymocytes has yet to be fully discerned. They are believed to provide cytokines influential in thymocyte development.

Red marrow (recall page 17) is densely populated with a great variety of blood cells in various stages of development, collectively called *hematopoietic tissue*. The supporting framework of marrow is composed of reticular fibers and **stromal** cells (nonlymphoid cells that influence the differentiation of lymphocytes). Fed by arterioles from the nutrient artery of the bone, the capillaries within the marrow are enlarged to the extent of being small sinuses (**sinusoids**). They reveal transient cytoplasmic "pores" for the immediate passage of cells into the circulation. Lymphocyte precursors (T and B stem cells) are among the developing blood cells. They are stimulated to divide by certain **growth factors**. The progeny of these cells are mostly small and some large lymphocytes. **B lymphocyte** (B cell), **natural killer cell** (large lymphocyte), and **T stem cell** development all occur in the bone marrow. These lymphocytes enter the sinusoids and venous outflow to be distributed throughout the body.

CN: Use red for G, blue for H, purple for H[1], and green for J. (1) Color the name red marrow, A, at the bottom of the page; color the red marrow, A, in the newborn's humerus at the top of the page. Return to the red marrow at the bottom of the page and complete the names and illustrations. (2) Color the thymus section and the diagrammatic depiction of lymphocyte maturation in the thymus. Note that the borders of the diagram represent the cortex (left) and medulla (right) of the thymus. (3) Color the schematic overview of thymic function.

THYMUS c
FIBROUS SEPTUM d
CORTEX e
UNDIFFERENTIATED LYMPHOCYTE u
IMMATURE T LYMPHOCYTE i
MEDULLA f
MATURE T LYMPHOCYTE t

ARTERIAL VESSEL g
VENOUS VESSEL h
LYMPH VESSEL j

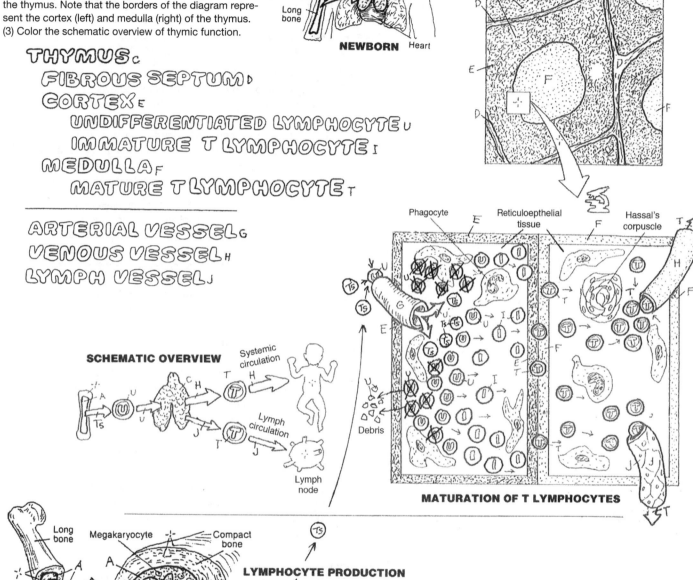

THYMUS SECTION

MATURATION OF T LYMPHOCYTES

SCHEMATIC OVERVIEW

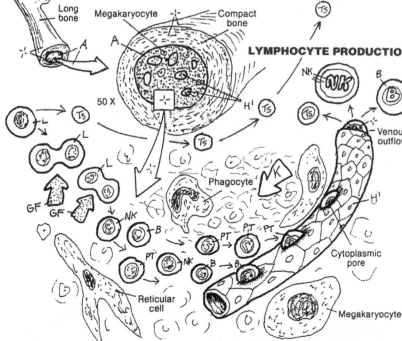

LYMPHOCYTE PRODUCTION

RED MARROW a
LYMPHOCYTE STEM CELL l
GROWTH FACTOR gf
B LYMPHOCYTE b
T STEM CELL ts
NATURAL KILLER CELL nk
SINUSOID h[1]
STROMA k

The **spleen** is soft, blood-filled, and dark purple. It lies posteriorly in the upper left abdominal quadrant, just above the left kidney, at about the level of the 11th and 12th ribs. It is generally about the size of your closed fist. The capsule of the spleen projects inward extensions (**trabeculae**) that support the organ and incoming/outgoing vessels. The microscopic view of the spleen is complicated by what appears to be an endless sea of lymphocytes, macrophages/phagocytes, red blood cells, discarded blood cell debris, arterioles, and venous sinuses. Don't be discouraged; help is in the next paragraph.

The spleen is described on the basis of two visual features: **white pulp**, consisting of **lymphoid follicles** characterized by less dense (hence white) germinal centers of **mitotic lymphocytes**; and **red pulp**, consisting of chains of lymphocytes (*splenic cords*), and varieties of cells and RBC parts all intimately associated with **venous sinusoids** (splenic sinuses) in the form of open and closed circulatory networks. These sinusoids are drained by trabecular veins, themselves tributaries of the splenic **vein**.

In the lowest illustration, start with the branches of the splenic **artery** (upper left) that penetrate the splenic **capsule** and travel in the fibrous trabeculae. Branching out from these arteries, central **arterioles** enter the white pulp surrounded by **T lymphocytes**, and pass through the lymphoid follicles consisting almost entirely of **B lymphocytes**. These collections of T lymphocytes around the central arterioles are called *periarteriolar lymphoid sheaths (PALS)*. As the macrophages deliver and the lymphocytes of the white pulp encounter antigen, the lymphocytes become activated, adapting to the various antigenic challenges. The follicles enlarge with this antigenic stimulation: large **mitotic lymphocytes** (in various stages of cell division) increase in appearance in the central part of each follicle (germinal center) following stimulation, creating a zone less dense than the surrounding, cell-packed area of the follicle. The PALS **arterioles** pass through the germinal centers. Upon leaving the white pulp, they become straight (like the strands of a brush) and are named *penicillar arterioles* as they enter the red pulp.

As the penicillar arterioles leave the white pulp, they lose their muscular tunics and (1) open directly into venous sinusoids surrounded by phagocytic cells; or (2) they open into the tissue spaces by means of gaps in the vessel (*open circulation*), described in one text as "spaces between the staves of a barrel."[1] **Phagocytes**/macrophages gang up around these spaces, trapping, sequestering, and consuming or discarding aged red blood cells. The view here in the red pulp is one of stacks of lymphocytes (splenic cords) arranged around and among large endothelial-lined venous sinusoids (splenic sinuses), with lymphocytes, **plasma cells**, red blood cells, various phagocytes, and platelets roaming about the meshwork or *stroma* of reticular cells and fibers. The spleen is the consummate scavenger: it recycles all that comes through it. The sinusoids drain into **venules**, the tributaries of trabecular veins.

The major activities of the spleen are antibody production and phagocytosis.

[1]Mescher, A. L. *Junqueira's Basic Histology.* McGraw-Hill Medical, New York, 2010.

SPLEEN

CN: The white pulp, D, follicle, D[1], and sinusoids, G, are not to be colored. Use reddish purple for A, red for F, and blue for H. Continue with the same colors as were used on the preceding pages for the cells. (1) Color the upper two illustrations and related names. (2) Color the sectional view; use light red for E. (3) Color the largest illustration; start with the boundaries A, D, and E. Color the various cells. For clarity, coloring of the sinusoids is not recommended. Color lightly over the entire red pulp, keeping visible all details in the illustration.

SPLEEN ₐ
CAPSULE ₐ'
 TRABECULA c
WHITE PULP D⁺
 LYMPHOID FOLLICLE D'⁺
RED PULP ₑ

BLOOD VESSELS

ARTERY F
 ARTERIOLE F'
VENOUS SINUSOID G⁺
 VENULE H
VEIN H'

CELLS

T LYMPHOCYTE T
B LYMPHOCYTE B
MITOTIC LYMPHOCYTE ML
PHAGOCYTE P
PLASMA CELL PC

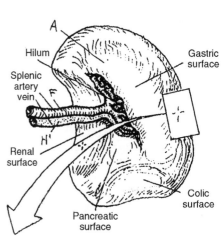

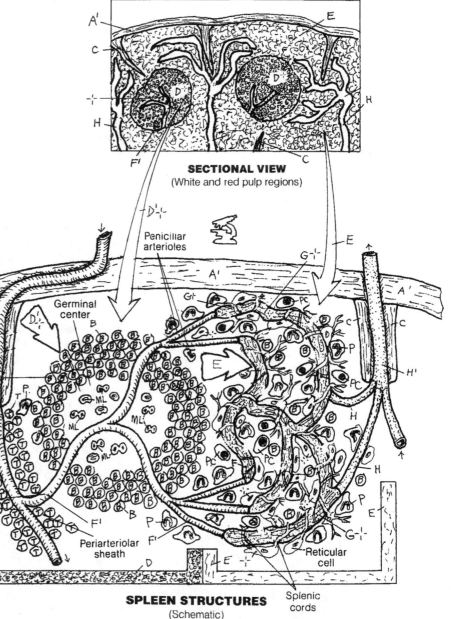

SECTIONAL VIEW
(White and red pulp regions)

SPLEEN STRUCTURES
(Schematic)

The **lymph node** has a fibrous **capsule** from which trabeculae of fibers invade the organ, dividing it incompletely into compartments. Fine reticular fibers and cells spread out from the **trabeculae** to form a thicket of interwoven supportive reticular cells and fibers throughout the node (**reticular network**). The capsule accepts **afferent lymph vessels** at various points around the lymph node; the **lymph** (fluid and lymphocytes) then works its way through the **subcapsular** and **trabecular sinuses** into the superficial cortex, deep cortex, and **medullary sinuses**. In and through each of these areas, phagocytes, lymphocytes, and plasma cells move freely. The reticular fibers in these sinuses (see magnification #1) form a spatial framework from which phagocytes can readily engage antigens in the lymph flow. Lymph leaves the medullary sinuses and the node by way of the **efferent lymph vessels**.

The lymph node is characterized by a superficial **cortex** deep to the **subcapsular sinus** (see magnifications #2 and #3). Particularly dense masses of B lymphocytes, called **lymph (lymphoid) nodules**, are found here. The central parts of these nodules, called **germinal centers**, have less dense areas of **mitotic B lymphocytes** (see #4). The greater the mitotic activity, the larger the germinal center; in the presence of significant amounts of **antigen**, the mitotic activity of the B cells increases rapidly. The **deep cortex** (*paracortex*; see # 5) has a more diffuse arrangement of **phagocytes**, large numbers of T cells, and some B cells. The endothelial cells of postcapillary venules in the deep cortex are of special interest (see #7). These **high endothelial venules (HEV)** exhibit tall, cuboidal endothelial cells that accommodate the migration of lymphocytes from the blood vascular system into the lymph sinuses (*diapedesis*); this activity creates a slight pressure difference that draws lymph and electrolytes through the sinuses and into the vascular system. The HEV also provide lymphocyte homing receptors that influence the localization of T and B cells within the lymph node. The **medulla** (see #6) contains a concentrated array of **medullary cords** and interconnecting lymph sinuses, with phagocytes and **plasma cells** in significant numbers.

As the lymph meanders through the throngs of reticular fibers in the sinuses, phagocytes pick off the antigens and present them to the T cells in the deep cortex. Activated B cells in the nodules, facilitated by helper (T_H) cells, transform into plasma cells and memory cells. The plasma cells and B cells secrete antibodies with receptors that bind a portion of the antigen, facilitating destruction of the antigen. Major antigenic challenges promote the formation of germinal centers. Further immune activity occurs in the paracortical and inner medullary areas.

In summary, the lymph node is the site of both humoral-mediated (B cell) and cell-mediated (T cell) immune responses to antigens in the lymph. Palpable enlargement of cervical lymph nodes during a questioned diagnosis of upper respiratory infection, for example, gives testimony to the presence of such microorganisms.

LYMPH NODE

LYMPH NODE A-
LYMPH O
AFFERENT LYMPH VESSEL J
CAPSULE A'
 SUBCAPSULAR SINUS H
TRABECULA C
 TRABECULAR SINUS H'
CORTEX E
 RETICULAR NETWORK D
 LYMPH NODULE F
 GERMINAL CENTER G
DEEP CORTEX I
 HEV N'
MEDULLA K
 MEDULLARY SINUS H²
 MEDULLARY CORDS B/T

CN: Use red for M, blue for N, and green for O. Use the same colors for cells as you did previously. (1) Begin with arrows, O, at the afferent vessels, J, and color in the order of the list of terms above. (2) Color the seven numbered circular magnifications identifying the dominant scene in each of the seven regions of the lymph node.

EFFERENT LYMPH VESSEL L
ARTERY M
VEIN N

CELLS

PHAGOCYTES P
T LYMPHOCYTES T
B LYMPHOCYTES B
 MITOTIC LYMPHOCYTES P
 PLASMA CELLS Pc
 ANTIGEN Ag

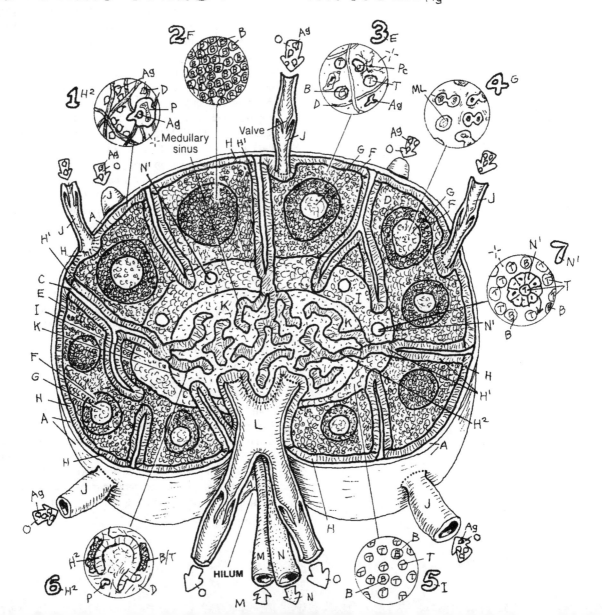

Unencapsulated lymphoid tissue abounds throughout the epithelial and connective tissues of the body. Here we deal with lymphoid tissue in the mucosa and submucosa of viscera. If you don't recall the mucosa visually, see page 14. Lymphoid tissue may simply be a squad of mobile loose or dense collections of lymphocytes, often working with the phagocytes to function as antigen-presenting cells as well as destroyers. Single or multiple nodules of organized lymphoid tissue, as seen in lymph nodes and the spleen, also fit this category. These nodules may disappear and then form anew in response to antigenic challenge. The adaptive immune response of **mucosal** (or submucosal) **associated lymphoid tissue (M.A.L.T.)** to antigenic challenge is to identify and catalogue the **antigen** and then produce antibodies or T-cell generated cytokines that destroy the antigen.

Tonsils are masses of **primary lymphoid follicles** in the oral mucosa. The tonsils shown are palatine tonsils, as distinguished from pharyngeal tonsils (adenoids) (see page 135). They are located between the palatoglossal and glossopharyngeal arches bilaterally (recall page 121). They have no definitive lymph sinuses; however, lymph capillaries can be seen draining into **efferent lymphatic vessels** (see "Follicle Section," left). Inflammation of the tonsil (*tonsilitis,* an innate immune response) commonly occurs with antigenic stimulation. An **inflamed tonsil** is swollen, red (often with streaks of vessels ranging across the mucosal surface), unusually warm, and painful. As the infecting microorganism comes into contact with phagocytes and **B lymphocytes**, the infecting organism activates the lymphocytes, and the adaptive immune response is triggered! Mitosis begins, **germinal centers** are formed, the numbers of B and **T lymphocytes** increase, **phagocytes** and **plasma cells** appear, **antibody** is produced that is specific to the infecting microorganism, and T cells prepare a brew of cytokines that soon destroys the invading organisms. Considered a culturally accepted rite of passage in the past, tonsilectomies are now performed only for good cause (obstructed airways, chronic infections seeding other infections).

Peyer's patches are aggregates of lymphoid follicles in the submucosa of the distal ileum. Seen sporadically throughout the intestine, lymphoid follicles are more concentrated here. With antigenic stimulation, these follicles enlarge in much the same manner as tonsils, and the adaptive immune response begins.

The **vermiform appendix** is a thin, tubular extension of the cecum (large intestine). It contains a number of lymphoid follicles that extend from the submucosa up to the epithelial lining of the mucosa. The mucosa of the appendix experiences fairly frequent insults (tomato seeds, popcorn kernels, sunflower seeds, and ingested foreign matter), and inflammatory events (*appendicitis*) are fairly common. The adaptive immune response is typical: phagocytic response, identification of the infecting organism, activation of T and B lymphocytes, enlargement of lymphoid nodules/follicles, appearance of germinal centers, formation of plasma cells and subsequently specific antibody and cytokine responses.

CN: Use green for C and the same cell colors you used previously. (1) Begin with the names at upper left and the representations of normal and inflamed tonsils, using pink and red, respectively. Color in sequence from above to below. Include the circular magnification identifying the dominant cells within the follicle and germinal center. (2) Color the microscopic view of Peyer's patches in section. (3) Color the split cross sections of the vermiform appendix, including the magnified section showing the activated T cells, the phagocyte, and the plasma cell. Color pieces of Ag black.

PRIMARY FOLLICLE A
GERMINAL CENTER A-¦-
EFFERENT LYMPH VESSEL c

LYMPHOID CELLS
MITOTIC LYMPHOCYTE ML
PHAGOCYTE P
B LYMPHOCYTE B
T LYMPHOCYTE T
PLASMA CELL PC
ANTIBODY Ab
ANTIGEN Ag
BLOOD VESSEL BV

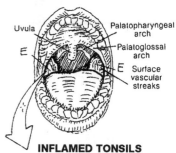

TONSIL D

NORMAL TONSILS

INFLAMED TONSIL E

Uvula
Palatopharyngeal arch
Palatoglossal arch
Surface vascular streaks

INFLAMED TONSILS

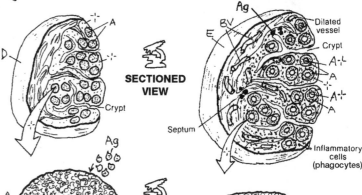

SECTIONED VIEW

Crypt

Ag
BV
E
Dilated vessel
Crypt
A-L
A
A-L
A
Septum
Inflammatory cells (phagocytes)

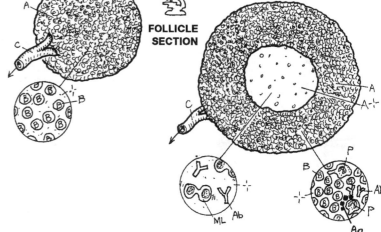

Ag

A
C
B

FOLLICLE SECTION

A
A-¦-
C
B
P
B
ML Ab
Ab
P
Ag

PEYER'S PATCHES -¦-

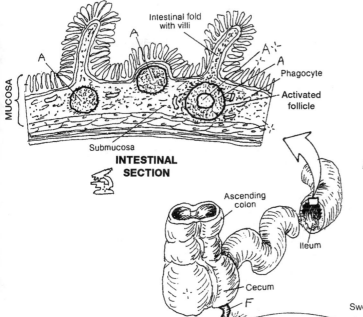

Intestinal fold with villi
A
A-¦-
A
Phagocyte
Activated follicle
MUCOSA
A
Submucosa
INTESTINAL SECTION

Ascending colon
Ileum
Cecum
F

VERMIFORM APPENDIX F

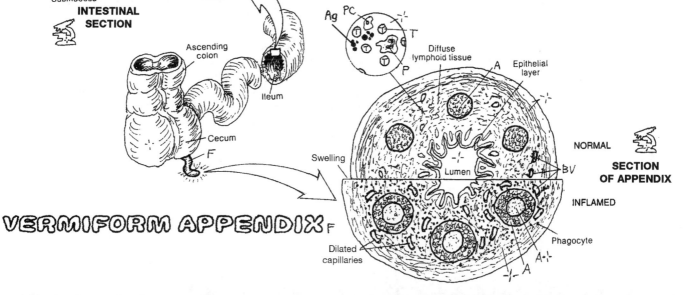

Ag PC
T
P
T
T

Diffuse lymphoid tissue
A
Epithelial layer

Swelling
Lumen
BV

NORMAL

SECTION OF APPENDIX

INFLAMED

Phagocyte
Dilated capillaries
A
-¦- A

The **respiratory tract**, with the assistance of the thoracic diaphragm and intercostal muscles, conducts air to the respiratory units of the lungs (*inspiration*), on average, in 500-milliliter quantities so that oxygen can be readily absorbed by the blood and carbon dioxide-laden air can be exhausted to the external atmosphere. The larynx (pronounced *lair-inks*) develops and refines sounds into potentially intelligible vocalization and can produce a range of sounds from beautiful melody to ripping angry invective. The tract helps to maintain the acid–base balance of the blood by blowing off excess acid in the form of carbon dioxide. Nowhere else in the body does the outside world, with all its creatures of microscopic dimension, have such easy access to the protected interior cavities of the body as it does at the air/blood interfaces of the lung. The body, however, does have a portfolio of means to protect itself, as you shall see. The respiratory tract consists of both air-conducting and respiratory (gas-exchange) parts.

The air-conduction tract includes an upper (**nasal cavity, pharynx, larynx**) and a lower tract (**trachea, primary bronchi, and bronchial tree**). The upper tract is lined with **respiratory mucosa**, except in the lower pharynx where it has a stratified squamous epithelial surface. Except for the nose and pharynx, the frame of the respiratory tract is cartilaginous down to the smallest airways (*bronchioles*), where the cartilage is replaced by smooth muscle. The parts associated with gas exchange are the smallest bronchioles and alveoli (respiratory units), which take up much of the lung's volume.

The muscular **diaphragm** provides much of the force necessary for the inspiration and expiration of air. Another 25% of that force is generated by the intercostal muscles moving the ribs.

The mucosa of the respiratory tract is largely lined with **pseudostratified columnar** and (in the bronchioles) simple cuboidal **epithelia** with mucus-secreting, goblet-shaped gland cells and cilia on the free surface. These cells transition to simple squamous epithelia in the respiratory bronchioles and alveoli (air cells). Just above these transition cells, excreted mucus traps foreign particulate matter on the bronchiolar/bronchial surfaces (well above the alveoli), where the power strokes of the cilia move the mucus toward the pharynx for excretion. Inhaled air is hydrated, putting oxygen in solution, and the air is heated from underlying **blood vessels**. The epithelial cells are supported by a loose, fibrous, vascular **lamina propria**, replete with fibroblasts, lymphocytes, and lymphoid follicles where phagocytic and immune responses are at work. Deep to this connective tissue layer is the submucosa, characterized by tubular seromucous **glands**, the ducts of which excrete mucus onto the surface of the trachea. The supporting tissue deep to the submucosa varies: It is bone in the nasal cavity; striated and some smooth muscle in the pharynx; hyaline cartilage in the larynx, trachea, and bronchi; smooth muscle in the bronchioles; and thin fibers supporting the air cells.

CN: Use red for L and light colors throughout. (1) Begin with the structures of the respiratory tract. (2) Finish up with the cross section of the trachea, D, and the microscopic section of respiratory mucosa.

RESPIRATORY TRACT

NASAL CAVITYₐ
PHARYNXв
LARYNXᴄ
TRACHEAᴅ
PRIMARY BRONCHI ᴇ
 BRONCHIAL TREE ꜰ
RIGHT LUNGɢ
LEFT LUNGɢ'
DIAPHRAGMн

RESPIRATORY MUCOUSAɪ
PSEUDOSTRATIFIED
 COLUMNAR EPITHELIUMⱼ
LAMINA PROPRIAᴋ
 ARTERYʟ / VEINʟ'
 GLANDₘ

Nasopharynx
Oropharynx
Laryngopharynx
Esophagus
Oral cavity
Epiglottis
Clavicle (cut)

RESPIRATORY TRACT
(Anterior view)

2nd rib (cut)

POSTERIOR
Trachealis (smooth muscle)
Cartilage
TRACHEAL SECTION
ANTERIOR

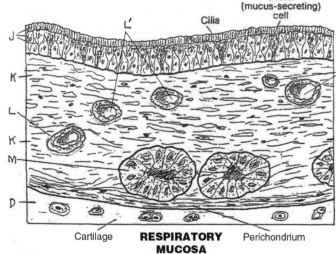

Goblet (mucus-secreting) cell
Cilia
Cartilage
RESPIRATORY MUCOSA
(Microscopic section)
Perichondrium

The **external nose** is external to the skull proper. It is largely cartilaginous—but for the small **nasal bones**, it would be entirely cartilaginous. Its orifices (*nares*, or *nostrils*) open into the anterior aspect of the **nasal cavity** of the skull, which is a bony tunnel divided in the midline by a **nasal septum** that is partly cartilaginous and partly bone. Posteriorly, the nasal cavity opens into the muscular pharynx through the *choanae*, two bony-walled posterior apertures separated from one another by the **vomer**.

The nose, situated in front of the face as it is, often receives the brunt of a facial impact. In such an event, it is not unusual for the **cartilage of the nasal septum** to break off from the perpendicular plate of the ethmoid bone. This *deviated septum* may obstruct airflow through the narrowed half of the cavity.

The skin-lined **vestibule of the nose** has long hairs (*vibrissae*) that serve to discourage chance entry by small organisms. The nasal cavity is carpeted with a mucosal lining characterized by ciliated pseudostratified epithelial cells and mucous glands. These two work well together to keep the place clean: one secretes mucus, trapping small foreign debris and dried mucus, and the cilia of the other sweeps the small particulate matter into the nasopharynx.

The bony **lateral wall** of the nasal cavity is not shown here in detail. It can usually be seen in the lab with bones of the skull and a prepared skull (sagittal section). If you have one, take a look. If you have an anatomy atlas, take a look as well. The bony lateral wall of the nasal cavity from anterior to posterior, and from above to below, is composed of the **nasal bone**, frontal process of the maxilla, ethmoid bone and superior/middle conchae, lacrimal bone, body of the maxilla, inferior concha, medial pterygoid plate, and perpendicular plate of the palatine bone. Just lateral to these walls on each side are the maxillary sinuses (see page 129).

The three bony conchae (so called because of their resemblance, in frontal section, to the curvaceous conch shell) increase the surface area of the nasal cavity, significantly boosting the local temperature and moisture content. The **inferior concha** on each side is attached to the ethmoid bone by an immovable joint (suture); the **superior** and **middle conchae** are part of the ethmoid bone. Each space under a concha (*meatus*) is open to an air-filled paranasal sinus, the subject of page 129. Note that the roof of the nasal cavity (**cribriform plate**) transmits the olfactory nerve fibers; resting on or near this plate are the frontal lobes of the brain. Also note that the floor of the nasal cavity is (1) the **hard palate**, which functions as the roof of the oral cavity, and (2) the **soft palate**, a muscular extension of the bony palate.

CN: Use very light colors for H and I. (1) Begin with the upper illustration.
(2) Color the nasal septum and its structure in the nasal cavities diagram.
(3) Color the elements of the lateral wall of the nasal cavity and relations
in the lowest illustration.

EXTERNAL NOSE

NASAL BONE A
CARTILAGE OF NASAL SEPTUM B
LATERAL NASAL CARTILAGE C
ALAR CARTILAGE D
FIBRO-FATTY TISSUE E

NASAL SEPTUM

CARTILAGE OF NASAL SEPTUM B
ALAR CARTILAGE D
PERPENDICULAR PLATE
 OF ETHMOID BONE F
VOMER BONE G

NASAL CAVITY & RELATIONS

NASAL BONE A
FRONTAL BONE H
SPHENOID BONE I
CRIBRIFORM PLATE
 OF ETHMOID F'
VESTIBULE OF NOSE D'
SUPERIOR CONCHA J
MIDDLE CONCHA K
INFERIOR CONCHA L
HARD PALATE M
SOFT PALATE N
LATERAL WALL O*

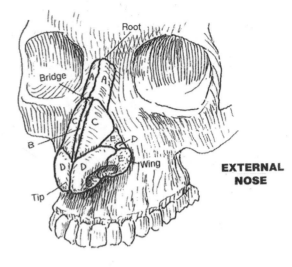

EXTERNAL NOSE

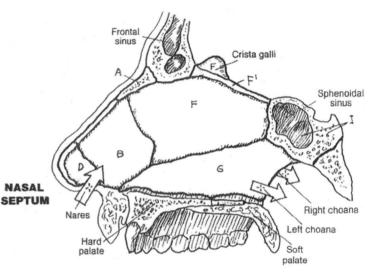

NASAL SEPTUM

NASAL CAVITIES
(Diagrammatic)

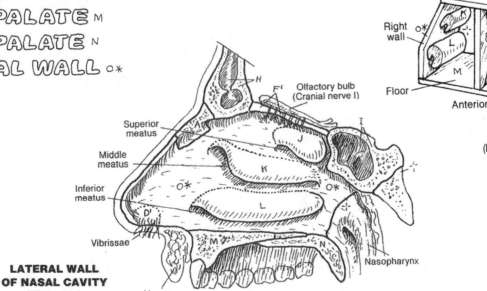

**LATERAL WALL
OF NASAL CAVITY**
(Right side)

The skull has a number of cavities. You are familiar with some of them (mouth, nose, external ear, orbits), but perhaps not so familiar with others. These are spaces in the **frontal, maxillary, sphenoid, ethmoid**, and temporal bones that are not *directly* open to the outside of the body except by way of the nasal cavity. These are the **paranasal air sinuses** (to be contrasted with venous, lymph, pericardial, and other bony sinuses).

The air sinuses lighten the skull, add timbre to the voice, and give grief to many. They are lined with respiratory-type epithelium that is immediately continuous with the epithelium of the **nasal cavity** and nasopharynx, and in fact with the entire respiratory tract. The mucus secretions from these epithelial linings pass down canals and enter the nasal cavity just under the **conchae** (meatuses). Their specific **drainage sites** are indicated in the illustrations by arrows. Should these passageways become blocked by inflammatory swelling—and they do with all too much frequency for some—pressure within the sinuses can build to a point where considerable pain is experienced (sinusitis, sinus pain, sinus headache). Decongestant and anti-inflammatory agents generally constrict blood vessels, thus helping to reduce swelling and reestablish proper drainage of the sinuses. The **mastoid** air cells in the mastoid process of the temporal bone just behind and below the external ear, and some distance from their fellows, drain into the middle ear (tympanic) cavity. Mastoid air cells communicate, by way of the **auditory** (pharyngotympanic) **tube**, with the nasopharynx just posterior to the nasal cavity.

Paranasal air sinuses are small to nonexistent at birth. They remain so until the development of permanent teeth and puberty, at which time the sinuses enlarge, significantly influencing the shape of the facial skull and the appearance of the face.

The nasolacrimal duct receives secretions from the lacrimal gland, which functions to keep the covering (conjunctiva) of the eye globe moist. Tears drain into slits at the medial aspect of the eyelids, which open into sacs that narrow into the **nasolacrimal ducts**. These ducts pass downward along the lateral walls of the nasal cavity and open into the meatus of the **inferior concha** on each side.

CN: Use the same colors for the bones, A, B, C, and the conchae, F, G, and H, that you used for those structures on page 128. Use a light gray for the nasal cavities. (1) Color the "Sinus Drainage Sites" in the lateral wall of the nasal cavity. Include the edges of the conchae, which have been cut away to reveal the meatuses and related drainage sites. (2) Color the coronal section. It is a composite view, showing openings into the nasal cavity that do not appear in any one single coronal plane. (3) Color the lower drawings. Note that the nasolacrimal duct and the duct of the frontal sinus are shown on one side only.

AIR SINUSES

FRONTAL A

SPHENOID B

ETHMOID C

MAXILLARY D

MASTOID E

NASAL CONCHAE

SUPERIOR F

MIDDLE G

INFERIOR H

OPENING OF AUDITORY TUBE I

NASOLACRIMAL DUCT J

NASAL SEPTUM K

NASAL CAVITY L*

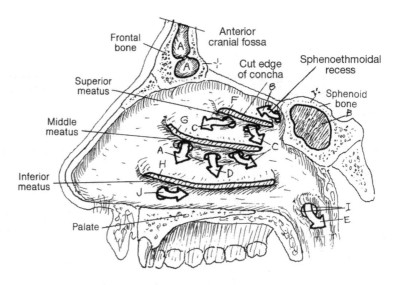

SINUS DRAINAGE SITES
(Right lateral wall of nasal cavity,
nasal conchae removed)

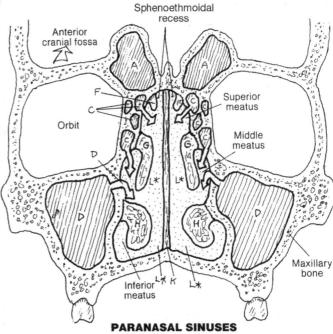

PARANASAL SINUSES
(Diagrammatic, composite,
coronal section)

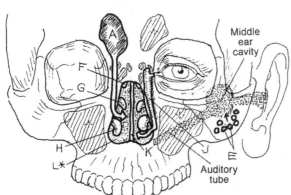

PARANASAL SINUS AND DUCTS

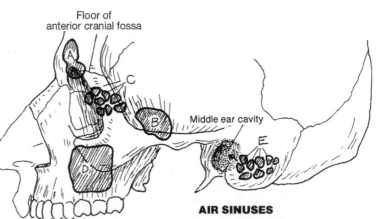

AIR SINUSES

The **pharynx** is a muscular tube that is open posterior to the nasal cavity (**nasopharynx**) and oral cavity (**oropharynx**). These cavities employ this tube to get air into the upper respiratory tract (larynx) and dinner into the upper digestive tract. The trick is to avoid pushing food into the airway (aspiration) or air into the esophagus (burp!). The pharynx is essentially composed of skeletal muscle, the most obvious of which are the superior, middle, and inferior constrictors (page 137). The rhythmic, sequenced contractions of these muscles, in addition to several others that secure the pharynx to the base of the skull, produce the motive force, in conjunction with gravity, to move food to be swallowed into the esophagus (*deglutition*, page 137). Coordinated muscular activity in the pharynx underlies the mechanism of swallowing. The movement of air through the pharynx is a function of differential air pressures and volumes created by the muscles of respiration (page 133).

The **larynx** is first a passageway for air to and from the lungs. In conjunction with that function, it can mechanically close off the airway (with its vocal folds) to prevent aspiration of solid material. Secondarily, it provides a mechanical means for producing sound, with variations of pitch, tone, and volume.

The larynx has a frame of hyaline cartilage connected by ligaments. The lumen of the larynx is continuous above with the **laryngopharynx** and continuous below with the trachea. Its anterior surface is adjacent to loose fascia and skin. Its posterior neighbor is the laryngopharynx and the **cervical esophagus**. The cervical spine is posterior to the esophagus, and between them is the retropharyngeal space of variable width. Filled with blood vessels, it is a potential reservoir for hemorrhage in traumatic hyperextension of the cervical spine. Generally, the larynx is located between vertebrae C2 and C6.

Although associated with the larynx, the **hyoid bone** is not a laryngeal structure. It gives attachment to the thyrohyoid membrane (ligament) from the **thyroid cartilage**. Note that this cartilage has no posterior surface. The laryngeal prominence (*Adam's apple*) can be palpated and generally seen in postpubescent males. The **cricoid** is shaped like a signet ring, facing posteriorly, and resting on the first tracheal ring. The **arytenoid cartilages** articulate with the top of the cricoid, pivoting on it. The **vocal folds** (*cords*) are mucosa-lined ligaments stretching between thyroid and arytenoid cartilages. Vocal fold tension (changing pitch) is effected by tilting the thyroid cartilage up and down. Abduction/adduction of the arytenoid cartilages varies the opening of the **rima glottidis**. In breathing they are abducted; in coughing, they are momentarily fully adducted (closing the rima and permitting intrathoracic pressure to build), and then abducted to discharge the trapped air. During phonation, the vocal folds are generally adducted, varying somewhat with pitch and volume changes. The **vestibular folds** (false vocal cords) are fibrous and only move passively. When swollen, they can and do obstruct the airway.

CN: Use bright colors for N, O, and Q. (1) Begin
with the overview diagram in the upper right corner.
(2) Complete the large composite sagittal section;
color gray the arrows representing air flow. Take
note of the non-colorable structures surrounding
the pharynx/larynx as a frame of reference. (3) Color
all six laryngeal views simultaneously.

PHARYNX A
NASOPHARYNX B
 PHARYNGEAL TONSIL C
OROPHARYNX D
 PALATINE TONSIL E
LARYNGOPHARYNX F

HYOID BONE G

LARYNX H
LARYNGEAL CAVITY H'
EPIGLOTTIS I
THYROID CARTILAGE J
THYROHYOID MEMBRANE K
CRICOID CARTILAGE L
 CRICOTHYROID LIGAMENT M
ARYTENOID CARTILAGE N
 CORNICULATE CARTILAGE O
VESTIBULAR FOLD P
VOCAL FOLD Q
 RIMA GLOTTIS R *

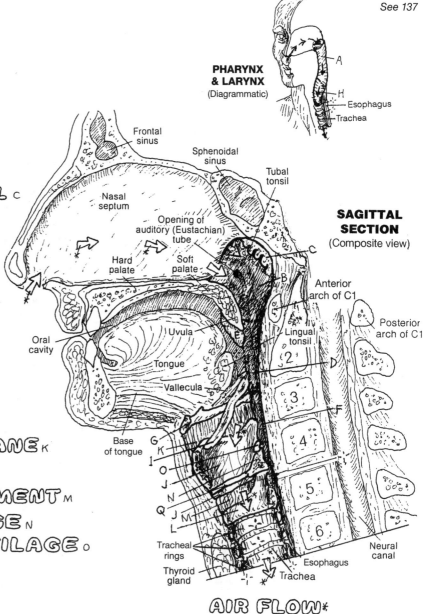

PHARYNX & LARYNX
(Diagrammatic)

Esophagus
Trachea

SAGITTAL SECTION
(Composite view)

Frontal sinus
Sphenoidal sinus
Tubal tonsil
Nasal septum
Opening of auditory (Eustachian) tube
Hard palate
Soft palate
Anterior arch of C1
Posterior arch of C1
Oral cavity
Uvula
Lingual tonsil
Tongue
Vallecula
Base of tongue
Tracheal rings
Thyroid gland
Trachea
Esophagus
Neural canal

AIR FLOW *

VIEWS OF THE LARYNX

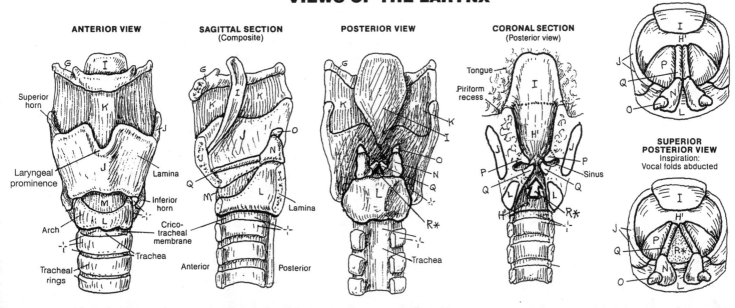

ANTERIOR VIEW

Superior horn
Laryngeal prominence
Lamina
Inferior horn
Arch
Crico-tracheal membrane
Trachea
Tracheal rings

SAGITTAL SECTION
(Composite)

Lamina
Anterior

POSTERIOR VIEW

Lamina
Trachea
Posterior

CORONAL SECTION
(Posterior view)

Tongue
Piriform recess
Sinus

SUPERIOR POSTERIOR VIEW
Phonation: Vocal folds adducted

SUPERIOR POSTERIOR VIEW
Inspiration: Vocal folds abducted

The lungs are the primary organs of the respiratory system. They consist of cells of air (alveoli), and a system of tubes (bronchi, bronchioles, and alveolar ducts; see page 132) that brings air to the alveoli during inspiration and draws air out from the alveoli during expiration. Being largely air, the lungs are light and spongy. The lungs occupy the lateral two-thirds of the thoracic cavity; the median third is taken up by the mediastinum (page 103). The root of each lung, the *hilum*, is where the bronchi exit the lung, the pulmonary arteries enter the lung, and the pulmonary veins leave. The lowest surface of each lung is adjacent to the thoracic diaphragm, the principal muscle of respiration (page 48). The posterior, lateral, and anterior surface of each lung is bordered by the vertebral column (page 25), the ribs (page 28), and the intercostal muscles (page 48). The right lung is arranged into three **lobes** separated by the horizontal fissure above and the oblique fissure below; the two lobes of the left lung are divided by an oblique fissure.

Each lung is completely separated from the other by the mediastinum. Each lung is enveloped in **visceral pleura**, a thin serous layer of mesothelium (simple squamous epithelium) with a dash of light fibrous tissue. The visceral pleura turns away from each lung at its roots (reflects) to become the **parietal pleura** lining the interior surface of the chest wall, the lateral mediastinum, and much of the diaphragm. The layers of parietal pleura are identified by the organs or structures adjacent to them (i.e., mediastinal, costal, diaphragmatic, and cervical). The parietal pleura rises through the superior thoracic aperture and caps off the lung in what is known as the *pleural dome*.

Where they are in contact, a thin layer of fluid (watery, glycoprotein) intervenes. This pleural cavity is a potential cavity only; with certain diseases, when extracellular fluid seeps in between the two pleurae, the space can expand, at the expense of the lung, to accommodate increasing amounts of fluid (*pleural effusion*), resulting in a reduction of total lung capacity. The normally thin layer of serous fluid between adjacent layers of pleura maintains a degree of surface tension between them, resisting separation of visceral and parietal layers.

It is important that the parietal pleura remains intact. The interpleural environment is subatmospheric, and a disruption of the parietal pleura would permit the elastic lung to collapse against its root (*pneumothorax*).

During quiet expiration, the inferior and anterior margins of the visceral pleura-lined lungs do not reach the parietal pleura, leaving a narrow space or recess between the two. This is the *costomediastinal recess* between the rib cage and the mediastinum (not shown), and the *costodiaphragmatic recess* between the rib cage and **diaphragm** (see coronal section, left side).

CN: Use bright colors for A–E, very light colors for F and G, and a reddish-brown color for H. The thickness of the pleurae, F and G, has been enlarged for coloring purposes. (1) Color the anterior view. The ribs and intercostal muscles have been removed (see page 48). Layers of pleurae (F, G) have been stripped away and separated to reveal the pleural cavity. This potential space is drawn as a dark line. (2) Color the coronal section. (3) At upper right, color the cross section through T5 (lobes of the lung, pleurae, bronchi, and vessels) seen from above.

LOBES

RIGHT UPPER A
RIGHT MIDDLE B
RIGHT LOWER C
LEFT UPPER D
LEFT LOWER E

PLEURAE

VISCERAL PLEURA F
PLEURAL SPACE +
PARIETAL PLEURA G

DIAPHRAGM H

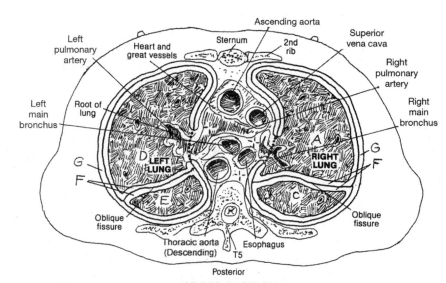

**CROSS SECTION
SEEN FROM ABOVE**
(Through T5, seen from above)

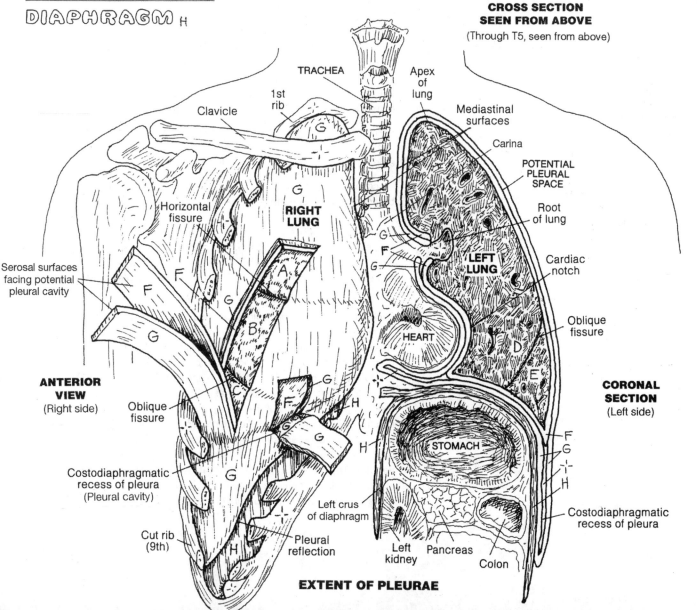

ANTERIOR VIEW
(Right side)

CORONAL SECTION
(Left side)

EXTENT OF PLEURAE

The **lower respiratory tract** consists of the trachea, the **bronchial tree**, and respiratory units. The **trachea** consists of a length of incomplete cartilaginous rings in which each pair is connected by fibroelastic tissue. The ends of each incomplete ring are bound posteriorly by smooth muscle (*trachealis*). The trachea begins at the inferior border of the cricoid cartilage of the larynx at the C6 vertebral level. The trachea continues inferiorly to its *bifurcation*, where it divides into left and right **main (primary) bronchi** at the vertebral level of T4 (level of the aortic arch).

Each main bronchus enters the lung at the *hilum*. The right main bronchus is shorter, more vertical, and wider than the left. The *right* main bronchus generally gives off three **lobar (secondary) bronchi** to three **lobes: superior, middle,** and **inferior**. The *left* main bronchus divides into two lobar bronchi for the superior and inferior lobes. Each lobe is divided by fibrous septa into pyramid-shaped, surgically resectable, anatomical and functional units called **bronchopulmonary segments.** Each segment has one segmental (tertiary) bronchus, and each segment is supplied by a segmental artery and drained by segmental veins and lymphatic vessels.

There can be some variation in the number of lobes and segments of a lung. Here we show the right and left lung each composed of 10 segments. In this case, segments #4 and #5 of the right lung (R. L.) are not located in the same sites in the left lung (L. L.). In some cases, the **apical** and **posterior** segments are combined as one, and the **anterior basal** and **medial basal** segments are also combined, leaving 8 segments in the left lung (not shown).

Knowledge of the tridimensional arrangement of segments is of special significance to pulmonary surgeons and clinicians seeking a precise localization of a lesion in the lung.

Within each bronchopulmonary segment, a segmental bronchus branches into several **bronchioles**, each less than 1 mm in diameter, absent cartilage, and supported by smooth muscle. These bronchioles branch into smaller terminal bronchioles, characterized by ciliated cuboidal cells *without glands*. If gland (goblet) cells were to exist below the level of cilia, fluid would accumulate in the air cells—not a healthy situation. The terminal bronchioles represent the end of the air-conducting pathway.

Each terminal bronchiole divides into two or more **respiratory bronchioles,** characterized by occasional alveolar sacs on their walls. Each respiratory bronchiole supplies a **respiratory unit,** a discrete group of air cells (**alveoli**) arranged in **alveolar sacs** and fed by **alveolar ducts.** Extending from its source bronchiole, each respiratory bronchiole extending inferiorly has more and more alveolar sacs. The walls of the alveoli, composed of simple squamous epithelia and supported by thin interwoven layers of elastic and reticular fibers, are surrounded by capillaries that arise from **pulmonary arterioles** and become the tributaries of **pulmonary venules.** The walls of these capillaries merge with the structurally similar alveoli. Oxygen and carbon dioxide rapidly diffuse through these walls secondary to pressure gradients.

CN: Save blue for H, purple for I, and red for J. (1) Use 10 different colors for the segments of both lungs, and key those colors to the 10 segmental bronchi of each lung. (2) Follow the arrows to the respiratory unit. Use one light color for the alveoli, G¹, and the alveolar sacs, G. In the gas exchange diagram, note that red blood cells in the capillary I receive three different colors according to their stage of oxygenation.

TRACHEA A
MAIN PRIMARY BRONCHUS B
LOBAR (SECONDARY) BRONCHUS C

1 APICAL 2 POSTERIOR 3 ANTERIOR 4 LATERAL (R.L.)
4 SUPERIOR (L.L.) 5 MEDIAL (R.L.) 5 INFERIOR (L.L.)
6 SUPERIOR 7 MEDIAL BASAL 8 ANTERIOR BASAL
9 LATERAL BASAL 10 POSTERIOR BASAL

RIGHT LUNG

Upper lobe

Middle lobe

Lower lobe

RIGHT LATERAL VIEW

BRONCHOPULMONARY SEGMENTS

R. main bronchus

Upper lobe

Root of the lung

Middle lobe

Basal (diaphragmatic) surface

Lower lobe

RIGHT MEDIAL VIEW

BRONCHIAL TREE

R. superior lobar bronchus

L. superior lobar bronchus

R. middle lobar bronchus

R. inferior lobar bronchus

1-10 SEGMENTAL

L. inferior lobar bronchus

1-10 SEGMENTAL

Segmental bronchus

LEFT LUNG

Upper lobe

Lower lobe

LEFT LATERAL VIEW

BRONCHOPULMONARY SEGMENTS

L. main bronchus

Upper lobe

Root of the lung

Lower lobe

Basal (diaphragmatic) surface

LEFT MEDIAL VIEW

TERMINAL RESPIRATORY UNIT

BRONCHIOLE D
RESPIRATORY BRONCHIOLE E
ALVEOLAR DUCT F
ALVEOLAR SAC G
ALVEOLUS G¹
PULMONARY ARTERIOLE H
CAPILLARY NETWORK I
PULMONARY VENULE J

Contiguous basal laminae

Alveolus wall

Capillary wall

Carbon dioxide

GAS EXCHANGE

Red blood corpuscle

Oxygen

The mechanism of respiration makes breathing possible. Breathing consists of bringing air into the lungs (*inhalation, inspiration*) and returning oxygen-depleted air (*exhalation, expiration*) to the surrounding atmosphere. Like the contraction of heart muscle, respiration is a lifelong phenomenon: life begins with it, and ends when it ends.

The physical principle underlying air movement in/out of the thorax is the inverse relationship of pressure and volume: as one goes up, the other goes down. Nature abhors a vacuum; increase the amount of space in the thoracic cavity, and air will be sucked in through the mouth and nose. Decrease the amount of space in the thoracic cavity, and air will spill out through the nose and mouth.

In normal, quiet breathing, increasing the volume of the thoracic cavity will decrease the intrathoracic pressure 1–2 mm Hg and air will be drawn into the lungs from the nose and mouth. It's called **inspiration**. To increase that intrathoracic volume:

(1) Increase the vertical dimension of the thoracic cavity. This can be accomplished by:
 a. Contracting the thoracic **diaphragm**. When it contracts, it flattens, and the superior-inferior dimension of the thoracic cavity is increased.
 b. Contracting the **external intercostal muscles**. This pulls the ribs up relative to the vertebral column. As a consequence, the ribs push the **sternum** outward; the lower, larger ribs come up; and the anterior-posterior dimension of the thoracic cavity is increased.
 c. Using the sternocleidomastoid to pull the clavicles and the rib cage upward. As a result of these movements, about 500 mL of air are drawn into the lungs by way of the nasal and/or oral cavities, pharynx, larynx, trachea, and the bronchial tree. The thoracic diaphragm accomplishes about 75% of the inspiratory effort, the external intercostal muscles about 25%.

Expiration occurs when the volume of air within the lungs is decreased, increasing the air pressure and driving the air to find more suitable surroundings (lower pressure).

(1) Reducing the intrathoracic dimensions of the thoracic cavity can be accomplished by:
 a. Relax the thoracic diaphragm, allowing it to be pushed up by the abdominal viscera (liver, stomach, spleen). This decreases the superior-inferior dimension of the thoracic cavity and thus decreases the volume in the lungs. This increases the pressure in the lungs, inducing the air to leave (exhale) by the only route available: out the nose and mouth.
 b. Relax the external intercostal muscles (induced by the respiratory center of the brain) and contract the **internal intercostal muscles** (just deep to the external intercostal muscles). The orientation of their muscle fibers is the opposite of the external intercostals. Contraction of the internal intercostals lowers the rib cage and brings the sternum back toward the center, thus decreasing the antero-posterior dimension and decreasing the volume in the lungs. The pressure in the lungs increases and about 500 mL of air moves into the airway and rushes out the nose and mouth during normal exhalation.

CN: Use light colors except for a bright or dark color for E.
(1) Color the names B, D, E, F and related structures at lower left
("Inspiration"). The relaxed diaphragm (dotted, curved line E) and
the contracted diaphragm (solid, straight line E). Note the color-
able arrows depicting directions of muscle contractions (E, F) and
cage movement, C. Color the incoming air movement arrows,
H, and the indicated subatmospheric pressure. (2) Color the
"Expiration" diagram and related name, G. Color the relaxation
of the diaphragm/related arrows, E, the contraction/direction of
contraction of G, and outgoing air movement arrows, H. (3) Color
the illustration at upper right on respiratory movements.

MOVEMENTS OF STERNUM

MOVEMENTS OF THORACIC WALL & DIAPHRAGM

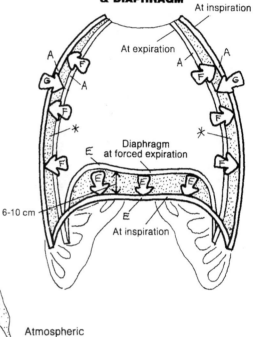

THORACIC WALL A
RIB & COSTAL CARTILAGE B
STERNUM C
THORACIC VERTEBRAE D

MUSCLES OF INSPIRATION

DIAPHRAGM E
EXTERNAL INTERCOSTAL F

AIR FLOW H

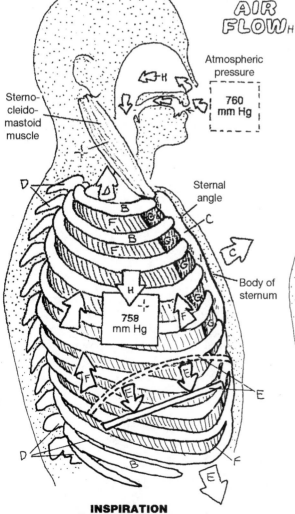

INSPIRATION

MUSCLE OF EXPIRATION

INTERNAL INTERCOSTAL G

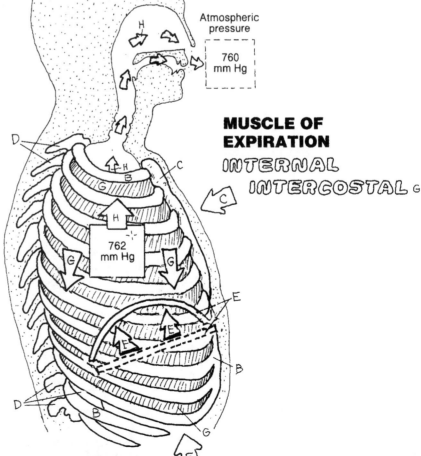

EXPIRATION

The digestive system consists of an **alimentary canal** with **accessory organs**. The canal begins with the **oral cavity**, where the **teeth** pulverize ingested food while it is softened and partly digested by **salivary gland** secretions. The **tongue** aids in mechanical manipulation of the food (bolus) and literally flips the food into the fibromuscular **pharynx** during swallowing.

The **esophagus** moves the bolus along to the **stomach** by peristaltic muscular contractions. There, the bolus is treated to mechanical and chemical digestion, then passed into the highly coiled **small intestine** for more enzymatic and mechanical digestive processes. Bile, produced by the **liver** and stored in the **gallbladder**, is discharged into the **duodenum** by a **bile duct**. It assists in the breakdown of fats. Digestive enzymes from the **pancreas** enter the duodenum as well. Nutrients of molecular size are extracted primarily from the lumen of the small intestine, absorbed by lining cells, and transferred to blood and lymph capillaries for eventual delivery to the liver for processing. The **large intestine** is concerned with absorption of minerals and water (proximal half) and storage. Undigested, unabsorbed material continues to the **rectum** for discharge through the **anal canal** and anus.

CN: Use your lightest colors for D, E, T, V, and W. When organs or structures overlap each other, each overlapping portion receives the color of both. (1) After coloring the alimentary canal, review the structures before completing the accessory organs. The central section of the transverse colon, J, has been removed to show deeper structures. (2) Color gray the diagrammatic depiction of the alimentary canal in relation to the body in the upper right corner.

ALIMENTARY CANAL

ORAL CAVITY A
PHARYNX B
ESOPHAGUS C
STOMACH D
SMALL INTESTINE
 DUODENUM E
 JEJUNUM F
 ILEUM G
LARGE INTESTINE
 CECUM H
 VERMIFORM APPENDIX H'
 ### COLON
 ASCENDING COLON I
 TRANSVERSE COLON J
 DESCENDING COLON K
 SIGMOID COLON L
 RECTUM M
 ANAL CANAL N

ACCESSORY ORGANS

TEETH O
TONGUE P
SALIVARY GLANDS
 SUBLINGUAL Q
 SUBMANDIBULAR R
 PAROTID S
LIVER T
GALLBLADDER U
BILE DUCTS V
PANCREAS W

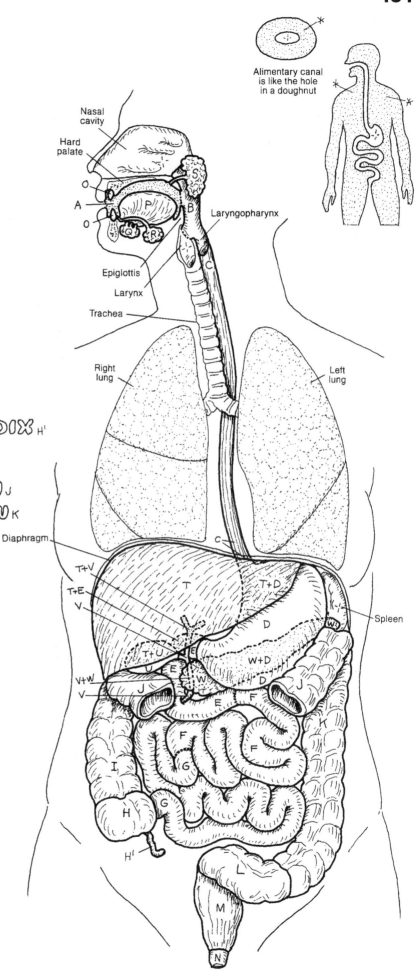

Alimentary canal is like the hole in a doughnut

Nasal cavity
Hard palate
Laryngopharynx
Epiglottis
Larynx
Trachea
Right lung
Left lung
Diaphragm
Spleen

The **oral cavity** (mouth) is essentially concerned with preparing food for swallowing. The **teeth** (see page 136) pulverize the food through the act of chewing (mechanical digestion). This is made possible by the muscles of mastication and the temporomandibular joint (page 45), which permits mouth opening to an interincisor distance of 35–50 mm. Wetting the food is a function of the thousands of mucous and serous glands in the tongue and the mucosa lining the oral cavity. Wetting and enzymatic action are also functions of the salivary glands (discussed below). Mechanical digestion is enhanced by the **papillae** on the surface (dorsum) of the **tongue**. These provide a site for taste receptors (except **filiform papillae**) and an abrasive surface for breaking down food.

The roof of the oral cavity is the palate; you can palpate the **hard palate** with the tip of your tongue. The nasal cavity is immediately above it. As you move your tongue toward the pharynx, you can feel the transition to the **soft palate**. At this point, move your tongue to the left or right and feel the **palatoglossal arch**. Posterior to this is the **palatopharyngeal arch**. Between the two arches is the palatine tonsillar fossa and the **palatine tonsils** (which may have been removed). If you have them, they are likely quite visible when the mouth is open and light is projected toward the pharynx. There is also tonsillar tissue at the posterior aspect of the tongue (generally not visible without a reflecting mirror): the **lingual tonsil**. The pharyngeal tonsil is in the pharynx, largely hidden by the palatopharyngeal arch; it is shown here at the lateral aspect of the arch. The **uvula** is the extremity of the soft palate seen in the midline of the open mouth. Just below it, at the posterior aspect of the tongue, sense receptors initiate the "gag reflex" when touched (cranial nerves IX and X).

Salivary glands secrete an enzyme-rich fluid into the mouth during periods of eating or anticipated eating. The largest is the **parotid gland**, situated bilaterally in front of and below each external auditory canal, partly overlying the masseter muscle. Its duct arches over the masseter, penetrating the cheek mucosa to enter the oral cavity opposite the upper second molar. Its glandular cells are serous. The smallest of the salivary glands, the mucous-type **sublingual glands**, lie under the tongue below the oral mucosa. The **submandibular glands** are U-shaped and wrap around the mylohyoid muscle (page 46). They consist of ducts and mixed glands, primarily mucous.

An example of a mixed (mucoserous) gland is shown in the illustration at lower right. The serous glands consist of circular arrays of pyramid-shaped cells forming rounded, grape-shaped alveoli or *acini* (P), whose center forms the duct (page 8). The mucous-secreting tubular glands are cylinder shaped with a central duct. Contractile myoepithelial cells within the basal laminae of both duct and gland cells are responsible for forcing the secretions into the ducts and out of the glands.

CN: Use pink or red for I and very light colors for N, O, and P. (1) Color the two upper views of the oral cavity simultaneously. Use closely related colors for the parts of the soft palate. (2) In the middle drawing of the tongue, color the papillae of the tongue with the color chosen for the tongue, I, but leave the tongue itself uncolored. (3) Color the three salivary glands and the cellular diagram to their right. Note that the lumen of the duct is not colored.

ORAL CAVITY

TEETH A∹
GINGIVA (GUM) B
HARD PALATE C
SOFT PALATE D
 UVULA E
 PALATOGLOSSAL ARCH F
 PALATINE TONSIL G
 PALATOPHARYNGEAL ARCH H

TONGUE I
 LINGUAL TONSIL J
 VALLATE PAPILLAE I'
 FOLIATE PAP. I²
 FUNGIFORM PAP. I³
 FILIFORM PAP. I⁴

SALIVARY GLANDS

SUBLINGUAL K
SUBMANDIBULAR L
PAROTID M

GLAND STRUCTURES

DUCT N
MUCOUS TUBULE O
SEROUS ACINUS P
MYOEPITHELIAL
 CELL Q

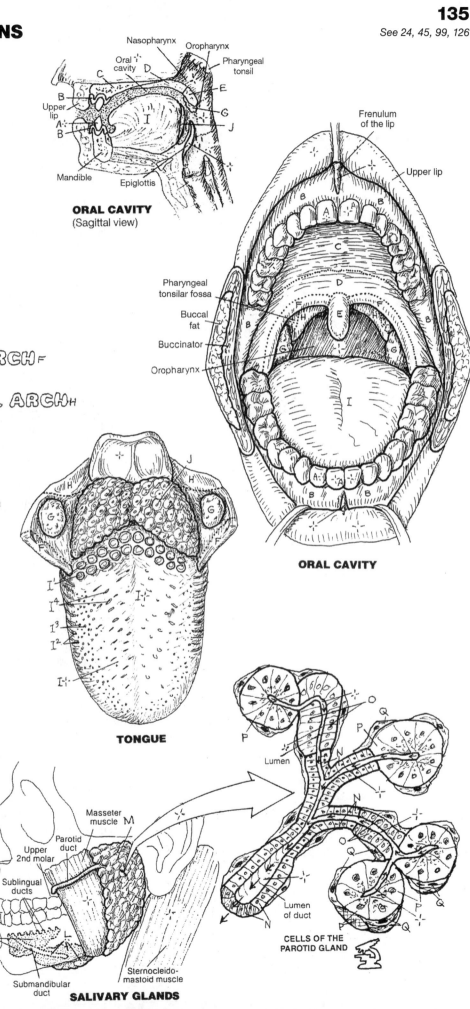

ORAL CAVITY
(Sagittal view)

Nasopharynx · Oropharynx · Pharyngeal tonsil · Oral cavity · Upper lip · Mandible · Epiglottis

Frenulum of the lip · Upper lip · Pharyngeal tonsilar fossa · Buccal fat · Buccinator · Oropharynx

ORAL CAVITY

TONGUE

Masseter muscle M · Parotid duct · Upper 2nd molar · Sublingual ducts · Sternocleidomastoid muscle · Submandibular duct

SALIVARY GLANDS

Lumen · Lumen of duct

CELLS OF THE PAROTID GLAND

In this longitudinal section of a **molar**, two roots are shown. The core substance of the tooth is **dentin**. It is composed of tightly packed microscopic tubules. Dentin is pain sensitive and avascular. It is dense like bone, though more mineralized (70% by weight). Dentin is capped by a 1.5-mm layer of insensitive enamel, 95% mineral by weight and less than 1% organic. **Enamel** consists of microscopic circular rods filled with hydroxyapatite (bone) crystals, and is the hardest material in the body. The dentin of each tooth has a hollow pulp cavity that extends into each root of the tooth; this is the **root canal**. At the apex of each root, an opening (apical or root foramen) permits the passage of blood vessels and nerves into/from the alveolar bone. Each tooth has a **crown**, extending above the gingiva (gum line), and a **neck** (at the level of the gum; here the enamel ends and abuts the cementum), and one or more **roots** buried in alveolar bone of the maxilla (upper teeth) or mandible (lower teeth). Incisors and canine teeth each have a single root canal; premolars and molars may have one to three roots (this varies among individuals and specific teeth). Except for the incisiors, which have only a cutting edge, tubercle-like cusps separated by fissures characterize the surface of the crown. Canines have one cusp (cuspid); premolars have two (bicuspids), and molars have four or five cusps. Multiple cusps enhance the grinding and abrasive functions of the teeth.

The fibrous **periodontal ligament**, about 0.2 mm thick, interfaces the cementum (lining the root of the tooth) and the **alveolar bone**. The **cementum** is a highly mineralized substance. Collagen fibers stuck in the cementum penetrate the ligament to insert into the alveolar bone. The **gingiva** (gum) is a mucous membrane with stratified squamous epithelia that attaches to the enamel by a thickened basal lamina. The lamina propria of the membrane is strongly anchored to the underlying alveolar bone.

There are naturally 32 teeth in an adult—8 in each of 4 quadrants (right and left, in both upper and lower dental arches). Two sets of teeth (dentition) develop in a lifetime: deciduous and permanent. The deciduous set (20) is absorbed/shed in early life; the permanent set (32) is not naturally shed. Babies are born with the deciduous dentition submerged under the gingiva, for which breastfeeding mothers are grateful. In general, the deciduous **incisors** are the first to erupt, at six months. The entire deciduous dentition (see boxed area at right) emerges by 18 months and is shed by 12 years. The first permanent tooth is the first molar. It appears at about six years; the last to erupt is the **third molar (wisdom tooth)**, which appears at about 18 years. This molar, of all the teeth, is the most likely to have problems (usually carles or tooth decay), due to chronic, often silent infection by lactobacilli or *Staphylococcus*.

CN: Use yellow for F, red for G, blue for H, and light colors for A, B, L, and the teeth named below. Each name has more than one label for its color: numbers for permanent teeth and letters for deciduous teeth. (1) Begin with the small tooth above, then color the upper large drawing; color gray the names and arrows/ bands arranged vertically to the left of the upper drawing. (2) Color the teeth below.

Crown
Neck — A
Root — B

TOOTH
ENAMEL A
DENTIN B
PULP CAVITY C
 PULP E
ROOT CANAL D
 NERVE F
 ARTERY G
 VEIN H
CEMENTUM I
PERIODONTAL LIGAMENT J
GINGIVA K
ALVEOLAR BONE L

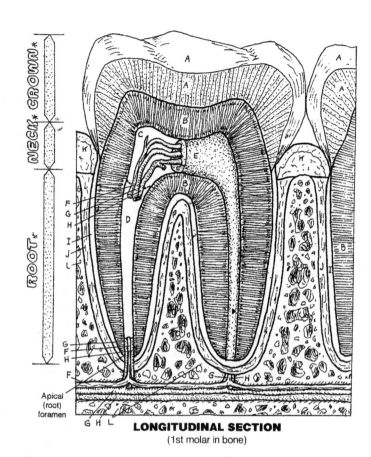

LONGITUDINAL SECTION
(1st molar in bone)

Apical (root) foramen

G H L

ADULT / CHILD DENTITION
CENTRAL INCISOR 8, 9, 24, 25, E, F, O, P
LATERAL INCISOR 7, 10, 23, 26, D, G, N, Q
CANINE 6, 11, 22, 27, C, H, M, R
1ST PREMOLAR 5, 12, 21, 28
2ND PREMOLAR 4, 13, 20, 29
1ST MOLAR 3, 14, 19, 30, B, I, L, S
2ND MOLAR 2, 15, 18, 31, A, J, K, T
3RD MOLAR (WISDOM) 1, 16, 17, 32

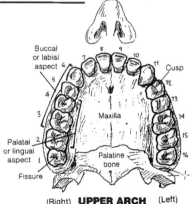

Buccal or labial aspect
Cusp
Maxilla
Palatal or lingual aspect
Palatine bone
Fissure

(Right) **UPPER ARCH** (Left)

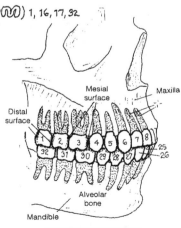

DECIDUOUS AND PERMANENT TEETH
(5 years of age / alveolar wall removed)

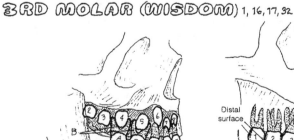

Mesial surface
Maxilla
Distal surface
Alveolar bone
Mandible

PERMANENT TEETH IN OCCLUSION
(21 years of age)

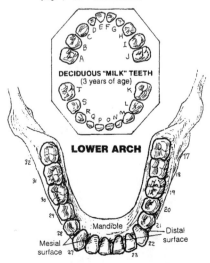

DECIDUOUS "MILK" TEETH
(3 years of age)

LOWER ARCH

Mandible
Mesial surface
Distal surface

Swallowing (**deglutition**) begins with food (P') in the **oral cavity**, presumably physically prepared for the commitment ahead. A **bolus of food** is *voluntarily* carried upward and backward into the **oropharynx** by the **tongue**. The **soft palate** is tensed (tensor palati) and lifted (levator palati) against the **nasopharynx** to prevent entry of the bolus into the nasal cavity. In association with this action, the bilateral **palatopharyngeal muscles** (folds) partially close off the oral cavity from the **pharynx**, selectively permitting appropriately sized boluses to enter the pharynx. Up to this point, the process has been voluntary. The following events are *involuntary*.

Committed to the oral pharynx, and with the nasopharynx blocked off, the bolus must be directed into the **laryngopharynx** without entering the **larynx**. A key structure in what follows is the **hyoid bone**. The suprahyoid muscles (recall page 46) pull the hyoid bone up and forward or backward depending on the material being moved into the pharynx. The extrinsic muscles of the tongue (genioglossus, hyoglossus, palatoglossus) raise the posterior tongue to the palate and block off the oral cavity, while at the same time pressing the bolus against the oral pharynx in preparation of its imminent descent. With a fixed hyoid bone, the thyrohyoid, stylopharyngeus, and other muscles extrinsic to the pharynx elevate the larynx and move it anteriorly, posterior to the hyoid, and elevate the pharynx as well.

To feel the ascent and descent of the hyoid bone during swallowing, place your thumb and index finger around the front of your mid-neck at the level of the palpable hyoid bone and swallow (see page 46).

With the larynx and pharynx elevated, the pharyngeal opening of the **esophagus** is enlarged. The intrinsic laryngeal muscles close the laryngeal opening and the **epiglottis** is passively forced posteriorly, covering the airway. The vocal folds are tightly approximated as additional insurance against accidental aspiration. The **superior** and **middle constrictor muscles** of the pharynx, assisted by gravity, sequentially contract from above to drive the bolus downward into the laryngopharynx. The contractions of the palatopharyngeal muscles orient the descent of the bolus downward and slightly backward. The contractions of the inferior constrictor muscle direct the bolus into the esophagus.

PHARYNX & SWALLOWING

CN: Use pink for L. Color gray the boluses of food, P, in all views. (1) Color drawings 1 and 2 of deglutition. (2) Color the three lower illustrations simultaneously. In the posterior view of the interior of the pharynx, the posterior pharyngeal wall is divided and retracted so you can note the relationship of internal pharyngeal structure to the constrictor muscles (A, B, C) and the subdivisions of the pharynx (D, G, I). (3) Follow the text when coloring the deglutition diagrams.

MUSCULAR WALL OF PHARYNX
See 46, 130

SUPERIOR CONSTRICTOR A
MIDDLE CONSTRICTOR B
INFERIOR CONSTRICTOR C

INTERIOR OF PHARYNX & RELATIONS

NASOPHARYNX D
SOFT PALATE E
UVULA F
OROPHARYNX G
PALATOPHARYNGEAL MUSCLE H
LARYNGOPHARYNX I

ESOPHAGUS J

RELATED STRUCTURES

ORAL CAVITY K
TONGUE L
HYOID BONE M
EPIGLOTTIS N
LARYNX O
BOLUS OF FOOD P*

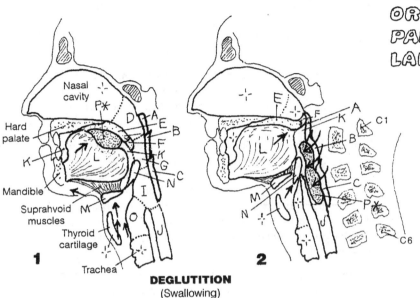

1

Nasal cavity
Hard palate
Mandible
Suprahyoid muscles
Thyroid cartilage
Trachea

2

DEGLUTITION
(Swallowing)

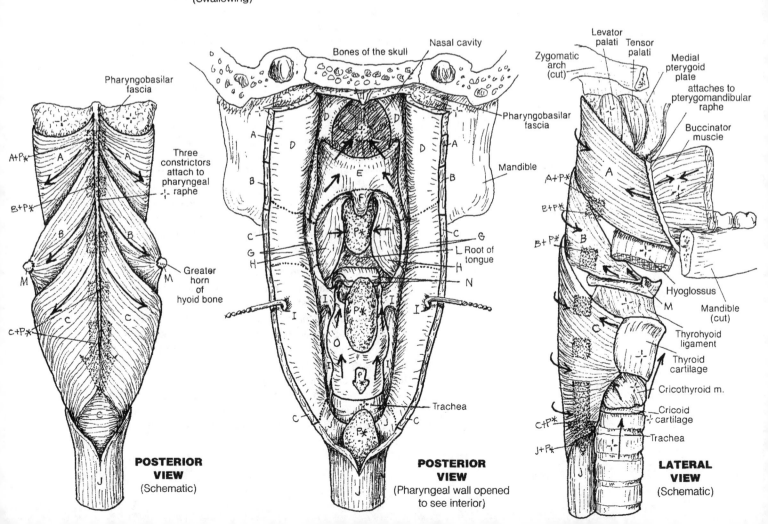

Pharyngobasilar fascia

A+P*
Three constrictors attach to pharyngeal raphe

B+P*

M
M
Greater horn of hyoid bone

C+P*

J

POSTERIOR VIEW
(Schematic)

Bones of the skull
Nasal cavity
Pharyngobasilar fascia
Mandible
L Root of tongue

Trachea

POSTERIOR VIEW
(Pharyngeal wall opened to see interior)

Levator palati
Tensor palati
Zygomatic arch (cut)
Medial pterygoid plate
attaches to pterygomandibular raphe
Buccinator muscle

A+P*

B+P*

B+P*

Hyoglossus
Mandible (cut)
Thyrohyoid ligament
Thyroid cartilage
Cricothyroid m.
Cricoid cartilage
Trachea

C+P*

J+P*

LATERAL VIEW
(Schematic)

Peritoneum is the serosal membrane of the abdominal cavity. The disposition of the peritoneum is similar to that of other serosal membranes (see pages 103, 131). Peritoneum attached to the body wall is *parietal*; if attached to the outer visceral wall, it is *visceral*. The potential space between the two layers (**peritoneal cavity**) is empty. It has a thin watery layer (serous fluid) between the two layers that accommodates slipping/sliding movements. Structures deep to the posterior **parietal peritoneum** are *retroperitoneal*.

Imagine the developing abdominal organs (of a fetus) lying under a blanket of peritoneum on the posterior abdominal wall. As the organs grow, twist, and turn, they take with them the peritoneum covering them.

Over time, it becomes a convoluted story. By the time of birth, organs that remained attached to the posterior body wall are covered by parietal peritoneum and thus are retroperitoneal. On the deep surface of these organs, there is no peritoneum.

Organs that moved away from the body wall took the peritoneum with them. The two peritoneal layers suspending such an organ from the body wall constitute a **mesentery**; that part of the peritoneum enveloping the organ (#1) is **visceral peritoneum**. When another organ (#2), such as the stomach, becomes enclosed in the mesentery between the body wall and organ #1, the double layer of peritoneum between the two organs is called an **omentum** (pl. *omenta*).

The continuity of these peritoneal membranes can be appreciated in the sagittal view: note how the organs are directly or indirectly coming off the posterior body wall. All of the blood vessels and nerves that supply the abdominal organs come off vessels and the spinal cord (all of them retroperitoneal). A vessel or nerve reaches the organs in the mesenteries by staying under the peritoneum until it finds a mesentery or an omentum where it can travel between peritoneal layers to the organ it supplies/innervates. Recall that the source vessels and nerves all start out deep to the peritoneum (retroperitoneal).

The view at upper right shows intestines and their mesenteries/omenta separated from one another (in life, they are as close together as strands of coiled wet rope). The **omental bursa** is a peritoneal-lined sac created by rotation of the stomach during fetal life. *It is open on the right* at the epiploic foramen between the lesser omentum and the parietal peritoneum. Here the omental bursa (lesser sac) communicates with the collapsed, empty peritoneal cavity (greater sac).

Illustration 1: the anterior abdominal wall with peritoneum is opened. The **greater omentum** connects the transverse colon to the stomach (see illustration 2).
Illustration 2: the stomach and greater omentum is lifted and the double-layered, **transverse mesocolon, F,** between the transverse colon and parietal peritoneum, A, can be seen. Note the two mesenteries (G and H).
Illustration 3: all mesenteries removed; retroperitoneal structures (aorta, inferior vena cava, kidneys, ureters, pancreas, duodenum, ascending/descending colon) are retroperitoneal (deep to A). Many nerves and vessels travel in this retroperitoneal space.

PERITONEUM

CN: Use a very light color for the parietal A, and visceral I, peritoneum. (1) Color the sagittal view. Use a darker gray or black for the omental bursa, E. The space of the peritoneal cavity, B, has been greatly exaggerated for clarity of peritoneal membranes. Do not color the organs/organ walls. (2) Color the lower three diagrams in numerical order. Note that the digestive organs are covered with visceral peritoneum, I; their walls are not to be colored.

PERITONEAL MEMBRANES

PARIETAL PERITONEUM A
PERITONEAL CAVITY B✳
LESSER OMENTUM C
OMENTAL BURSA E•
GREATER OMENTUM D
TRANSVERSE MESOCOLON F
COMMON MESENTERY G
SIGMOID MESOCOLON H
VISCERAL PERITONEUM I

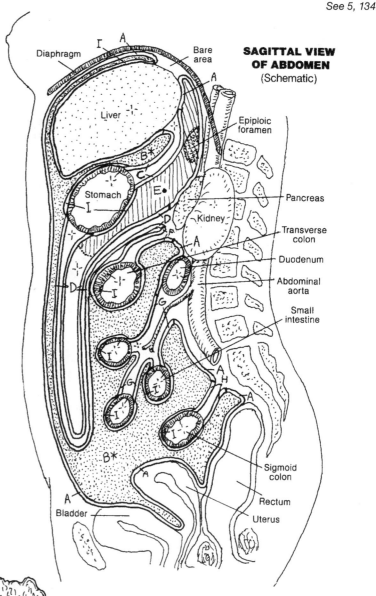

SAGITTAL VIEW OF ABDOMEN (Schematic)

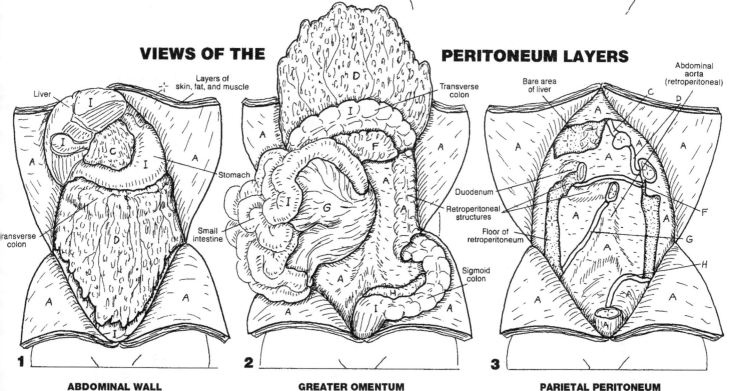

VIEWS OF THE PERITONEUM LAYERS

1 ABDOMINAL WALL OPENED

2 GREATER OMENTUM LIFTED

3 PARIETAL PERITONEUM OF POSTERIOR BODY WALL

The **esophagus** begins at the inferior extremity of the laryn-gopharynx at a vertebral level of C6. It fits snugly between the larynx and trachea anteriorly and the longus colli muscle and vertebral column posteriorly. The pharyngeal walls are lined with nonkeratinized stratified squamous epithelia and supported by skeletal muscle in the neck. Those two tissues continue into the wall of the esophagus. The esophagus is closely related laterally to the carotid sheaths (each binding the carotid arteries, internal jugular vein, and vagus nerve) in its descent through the neck. It passes just posterior to the aortic arch (page 103) and the heart, immediately behind the bifurcation of the trachea at about T5. As the descending thoracic aorta finds its place in the posterior mediastinum, the esophagus becomes its anterior neighbor. The esophagus passes through the esophageal hiatus of the thoracic diaphragm to become the stomach. Here the epithelial tissue tran-sitions to simple columnar epithelia with glands, an organ more compatible with digestive functions, and the skeletal muscle tran-sitions to smooth muscle. The smooth muscle layer is arranged in both longitudinal and circular orientations, with a thin layer for the **muscularis mucosae**.

The gastroesophageal junction has an area of specialized circu-lar muscle (lower esophageal sphincter) that permits passage of a food bolus by muscle relaxation during swallowing. The right crus of the diaphragm also contributes fibers to the esophagus (external sphincter) and functions to resist gastroesophageal re-flux (reverse flow) during inspiration.

The **stomach** is the first part of the gastrointestinal tract. It is generally located in the upper left quadrant of the abdomen, although a full stomach can droop into the pelvis and one with severe gastroesophageal reflux disease can bulge into the thorax. At the duodenal end, the stomach narrows to a muscular pyloric sphincter.

Classically, the stomach has four **regions** whose shapes vary with the quantity of its contents. The stomach mechanically manipu-lates ingested material, acidifies it to enhance protein digestion, secretes proteolytic enzymes (pepsin), and induces secretion of bile from the gallbladder and enzymes from the pancreas, both of which enter the duodenum. Microorganisms do not generally sur-vive these activities.

Note the arrangement of the **stomach wall** and the various cells that make up the epithelial layer of the **mucosa**. The epithelial cells are the working cells, providing a cocktail of digestive prod-ucts whose main target is protein. The **lamina propria** provides vascular and mechanical support for the **gastric pits**. The muscle layer of the mucosa and the external muscle layers produce peri-staltic contractions to assist in mechanical digestion and moving the residue of digestion along the tract. The fibrous **submucosa** supports lymphoid follicles, vessels, and nerves.

The blood supply to the stomach can be seen on page 112. The autonomic nervous system innervates the stomach and esopha-gus and can be seen on pages 91–93.

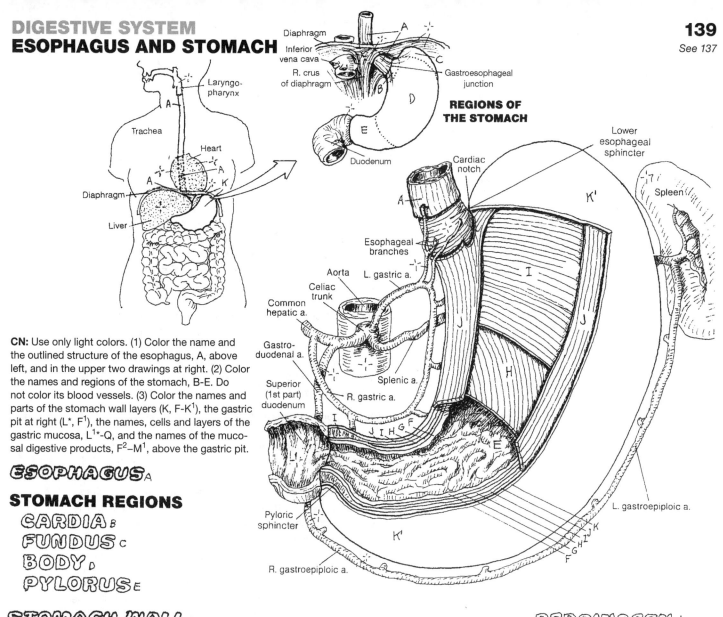

Laryngo-pharynx

Trachea

Heart

Diaphragm

Liver

Diaphragm
Inferior vena cava
R. crus of diaphragm
Gastroesophageal junction

REGIONS OF THE STOMACH

Duodenum

Lower esophageal sphincter

Cardiac notch

Spleen

Esophageal branches

Aorta

Celiac trunk

Common hepatic a.

L. gastric a.

Gastro-duodenal a.

Superior (1st part) duodenum

Splenic a.

R. gastric a.

L. gastroepiploic a.

Pyloric sphincter

R. gastroepiploic a.

CN: Use only light colors. (1) Color the name and the outlined structure of the esophagus, A, above left, and in the upper two drawings at right. (2) Color the names and regions of the stomach, B-E. Do not color its blood vessels. (3) Color the names and parts of the stomach wall layers (K, F-K^1), the gastric pit at right (L*, F^1), the names, cells and layers of the gastric mucosa, L^1*-Q, and the names of the mucosal digestive products, F^2-M^1, above the gastric pit.

ESOPHAGUS A

STOMACH REGIONS

CARDIA B
FUNDUS C
BODY D
PYLORUS E

STOMACH WALL K
MUCOSAL SURFACE (RUGAE) F
SUBMUCOSA G
MUSCULARIS EXTERNA ÷
 OBLIQUE M. H
 CIRCULAR M. I
 LONGITUDINAL M. J
SEROSA K^1

MUCOSA
EPITHELIAL LAYER
 GASTRIC PIT L*
 MUCOUS CELL F^1
 GASTRIC GLAND L*
 PARIETAL CELL M
 CHIEF CELL N
 ENDOCRINE CELL O

LAMINA PROPRIA P
MUSCULARIS MUCOSAE Q

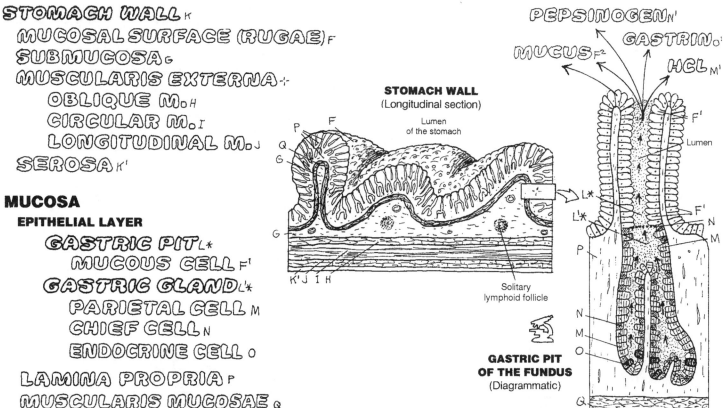

STOMACH WALL
(Longitudinal section)

Lumen of the stomach

Solitary lymphoid follicle

PEPSINOGEN N^1
GASTRIN O^1
MUCUS F^2
HCL M^1

Lumen

GASTRIC PIT OF THE FUNDUS
(Diagrammatic)

The **small intestine** is a highly convoluted, thin-walled tube that undertakes much of the chemical and mechanical digestive process and almost the whole of the absorptive process. The **first or superior part** of the duodenum is suspended by the lesser omentum. The **second (descending)** and **third (horizontal) parts** are retroperitoneal. The **fourth (ascending) part** emerges anteriorly to become embraced by the common mesentery, pulled upward and suspended by a band of smooth muscle at the duodenojejunal junction. The **jejunum** is highly coiled, suspended by the common mesentery between the peritoneal layers through which travel its blood and nerve supply and draining **veins**. The thinner but longer **ileum** also is suspended by the common mesentery. It opens into the cecum of the large intestine at the lower right quadrant of the abdomen.

The internal or luminal surface of the small intestine, especially the jejunum, consists of a continuous series of circumferential (ring-like) folds (**plicae circulares**) composed of mucosal and submucosal tissue. Myriad conical, finger-like projections (**villi**) and deep tubular glands (intestinal **crypts**) characterize the mucosal surface. Simple columnar epithelia, mostly *goblet*-shaped **mucous cells** and **absorptive cells,** line the villi and crypts. In the crypts, the cells are secretory and produce a watery medium, enhancing uptake of minerals and nutrients. **Enteroendocrine cells** secrete a number of hormones that encourage glandular secretion (e.g., cholecystokinin and secretin). Potentially phagocytic **Paneth cells** secrete lysozymes into the broth in the deep crypts. This digestive enzyme destroys bacterial cell walls. The loose-fibrous, vascular **lamina propria** supports the **lacteal-,** blood vessel-, and axon-containing villi and the glands of the crypts. The **submucosa** supports large blood/lymph vessels and the cell bodies/axons of **parasympathetic neurons**. Both submucosa and lamina propria contain masses of lymphoid nodules (Peyer's patches; recall page 126). Specialized epithelial M or membranous cells (not shown) at the epithelium-lymphoid nodule interface play a role in taking antigen to immune-reactive lymphocytes. In the duodenum, the submucosal glands of Brünner secrete bicarbonate-containing mucus that neutralizes the hydrochloric acid entering from the stomach.

CN: Use green for N, red for Q, purple for R, blue for S, yellow for T, and a very light color for H. (1) Begin with the three divisions of the small intestine. (2) Color the parts of the duodenum and its wall. The lamina propria, L, can be colored only in the lowest drawing.

SMALL INTESTINE

DUODENUM_A
 SUPERIOR (1ST) PART_B
 DESCENDING (2ND) PART_C
 HORIZONTAL (3RD) PART_D
 ASCENDING (4TH) PART_E
JEJUNUM_F
ILEUM_G

INTESTINAL WALL

PLICA CIRCULARES_H
 MUCOSA
 VILLUS_{H'} / CRYPT_{H^2}
 EPITHELIUM_{H-}
 ABSORPTIVE CELL_{H^3}
 MUCOUS (GOBLET) CELL_I
 ENTEROENDOCRINE CELL_J
 PANETH CELL_K
 LAMINA PROPRIA_L
 MUSCULARIS MUCOSAE_M
 LYMPHOID NODULE_N
 SUBMUCOSA_O
 DUODENAL GLAND_P
 ARTERY_Q
 CAPILLARY_R
 VEIN_S
 LACTEAL_{N'}
 PARASYMPATHETIC /
 POSTGANGLIONIC NEURON_T
MUSCULARIS EXTERNA_{U-}
 CIRCULAR_U
 LONGITUDINAL_{U'}
SEROSA_{D'}

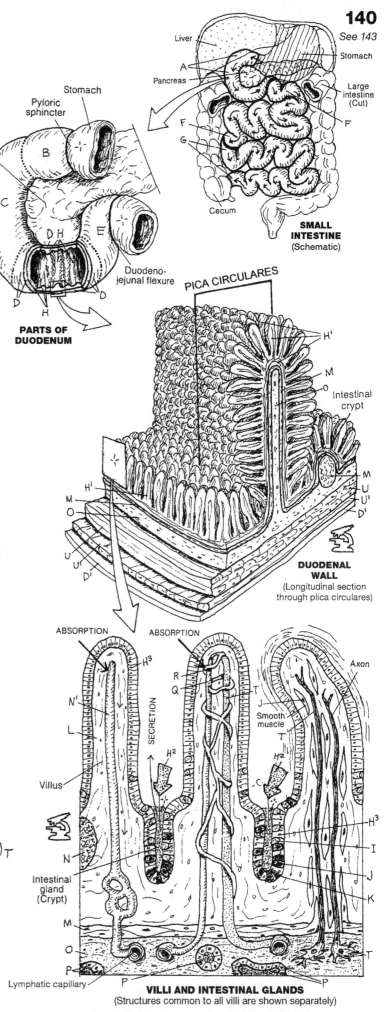

SMALL INTESTINE (Schematic)

PARTS OF DUODENUM

PICA CIRCULARES

DUODENAL WALL (Longitudinal section through plica circulares)

VILLI AND INTESTINAL GLANDS (Structures common to all villi are shown separately)

The **large intestine** follows the ileum of the small intestine at the ileocecal junction. This large intestine includes the cecum, **ascending colon**, transverse colon, sigmoid colon, rectum, and anal canal.

The **cecum** and colon are characterized by large sac-like bulges (*sacculations*) called *haustrae*. Strips of longitudinal muscle in the muscularis externa (**taenia coli**) maintain these sacs. Fat pads (**appendices epiploica**) are attached to the serosal surface of the ascending, transverse, and descending colon—but not the cecum. The significance of this is not clear. The cecum is clothed in peritoneum, and occupies the right lower lateral quadrant of the abdomen (right iliac fossa).

The **ileocecal valve** weakly controls the passage of its contents into the cecum as well as the opposite direction. It generally functions in concert with other valves in the gastrointestinal tract. The **vermiform appendix** varies in length (2–20 cm); it may lie anterior, posterior, or inferior to the cecum. Its lymphoid function is discussed on page 126. Studies reveal that the appendix is located behind the cecum more often than not, a fact that influences the clinical approach to a case of appendicitis.

The **ascending** and **descending colons** are retroperitoneal; the **transverse colon** is suspended by a mesentery (transverse mesocolon; not shown, but see page 138). Note the colic flexures and their relationships. At the pelvic inlet (not shown), the colon turns medially, gains a mesentery (sigmoid mesocolon; see page 138), and is named the **sigmoid colon**. Variable in its extent and shape, it becomes the **rectum** at the level of the S3 vertebra. Here the haustrae, the appendices epiploica, and the taenia are no longer seen.

About 12 cm long, the rectum has a dilated lower part (ampulla). The lower part of the rectum has lost its peritoneal covering. Feces entering the rectum dilate it and stimulate the desire for defecation on the part of the owner; thus, it is generally not a long-term storage site, though there are exceptions. As the rectum narrows in its descent into the anal triangle, it becomes the **anal canal** surrounded by sphincter muscles (levator ani).

The wall of the large intestine is generally characteristic of the organization of the small intestine: mucosal surface without villi or plicae, underlying vascular **submucosa**, and a two-layered **muscularis externa** lined with peritoneal **serosa**. The epithelial lining is simple columnar except in the anal canal, where it becomes stratified squamous. The glands are tubular and secrete mucus. Lymphoid nodules are seen in the lamina propria. At the anorectal junction, about 2 cm above the anus, a remarkably large number of veins can be seen in the lamina propria (not shown). Varicose dilations of these veins (rectal or hemorrhoidal plexus) are called *hemorrhoids*. The large intestine functions in absorption of water, vitamins, and minerals as well as the secretion of mucus to facilitate defecation.

LARGE INTESTINE

CECUM A
 ILEOCECAL VALVE B
 VERMIFORM APPENDIX C
ASCENDING COLON D
TRANSVERSE COLON E
DESCENDING COLON F
SIGMOID COLON G
RECTUM H
 ANAL CANAL I
 INTERNAL SPHINCTER ANI J
 EXTERNAL SPHINCTER ANI K
TAENIA COLI L
APPENDICES EPIPLOICA M

INTESTINAL WALL

MUCOSA
 EPITHELIUM/MUCUS GLANDS N
 LAMINA PROPRIA O
 MUSCULARIS MUCOSAE P
SUBMUCOSA Q
MUSCULARIS EXTERNA ⊹
 CIRCULAR MUSCLE R
 LONGITUDINAL MUSCLE L'
SEROSA D'

CN: If you use the same colors here as you did for the parts of the intestinal wall on the preceding page you can demonstrate the similarities between the small and large intestines. The epithelium/mucus glands, N, should receive the same color as the villi, H^1, of page 140. Use a very light color for B. (1) Begin with the top section.

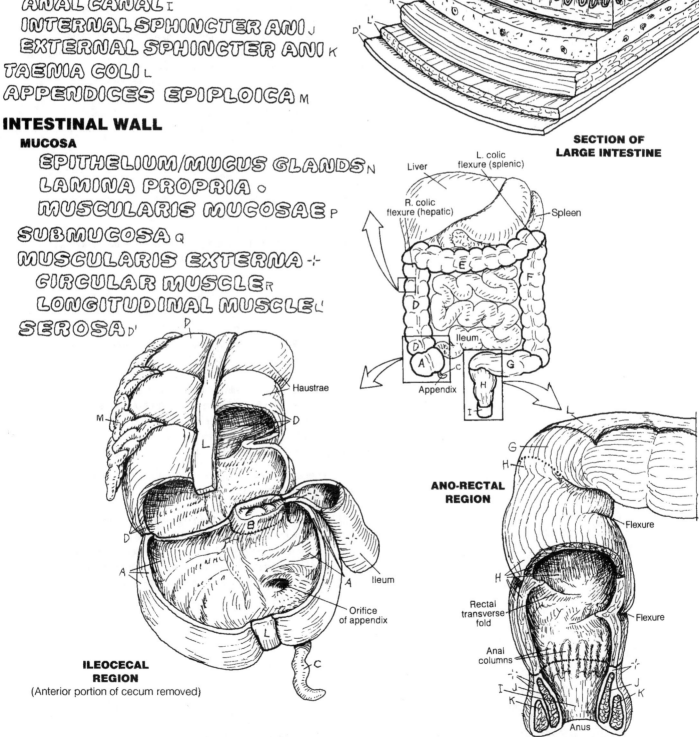

Opening of intestinal gland

SECTION OF LARGE INTESTINE

Liver

L. colic flexure (splenic)

R. colic flexure (hepatic)

Spleen

Ileum

Appendix

Haustrae

Ileum

Orifice of appendix

ILEOCECAL REGION
(Anterior portion of cecum removed)

ANO-RECTAL REGION

Flexure

Rectal transverse fold

Flexure

Anal columns

Anus

Referring to the uppermost anterior view, note the **right** and **left lobes** of the liver. The **falciform ligament** indicates the point of division. The upper (superior) surface of the liver is rounded and fits under the diaphragm. The lower (inferior) surface is a knife-edge. Thus, the liver is wedge-shaped, sharp side down. The front (anterior aspect) of the liver is one side of the wedge; the posterior aspect of the wedge is the deep or visceral side of the liver (see the next lower illustration). Notice the impressions on the liver made by its contact with various other organs (viscera).

Look at the center of this visceral surface and note the vessels approaching the interior of the liver through a space (*porta hepatis*): hepatic artery, hepatic portal vein, and bile duct. Note the **caudate lobe** above (superior to) the porta, and the **quadrate lobe** below the porta. The inferior vena cava runs a superior/inferior track alongside the caudate lobe. The hepatic veins (draining the liver) can be seen (dark circles) merging with the inferior vena cava at the visceral surface just before it passes through the diaphragm and enters the right atrium of the heart. See page 118.

From the porta: the **hepatic portal vein** delivers unoxygenated blood rich with absorbed nutrients to the hepatic cells of the liver lobules. The **hepatic artery** supplies oxygenated blood to the hepatic cells. The **bile duct** drains bile from canaliculi (little canals) among the cells of the liver lobules. These vessels, and the microscopic lobules of which they are a part, are the functional units of the liver—the ultimate mechanism for distribution.

One **lobule** (lower right) is shown, dissected to see its interior. Note the three interlobular vessels (**triad**) at *each* corner of the lobule. From each triad, the artery supplies nutrient blood to the liver cells; the vein delivers portal blood to the liver cells for extraction of goods; and the bile duct drains bile from the liver cells. The venous **sinusoids** receive portal blood; the liver cells extract material to be processed. The lining cells of these sinusoids include phagocytic Kupffer cells, which take out microorganisms and undesirables. The portal blood is drained from the sinusoids by the **central vein**. The central veins are drained by the tributaries of the hepatic veins. Bile is drained into larger ducts that are the tributaries of the common bile duct seen at the porta.

Within the collection of these three-dimensional lobules, the **hepatic cells** (*hepatocytes*) store and release proteins, carbohydrates, lipids, iron, and certain vitamins (A, D, E, K); manufacture urea from amino acids, and bile from pigments and salts; and detoxify many harmful ingested substances. Bile is released from the cells into tributaries of bile ducts. The **central veins** are **tributaries** of larger veins that merge to form three **hepatic veins** at the posterior superior aspect of the liver. These veins join the inferior vena cava just inferior to the diaphragm.

DIGESTIVE SYSTEM
LIVER

CN: Use blue for I, red for J, and yellow for K. Use very light colors for A, B, and L. (1) Color the two upper views simultaneously. (2) Color the group of lobules, and then the enlargement to the right. Begin there with the vessels of the triad, and work inward. (3) Color the overview of blood and bile circulation; begin with arterial flow, J, and color the numbers.

LOBES
RIGHT LOBE A
LEFT LOBE B
QUADRATE LOBE C
CAUDATE LOBE D

LIGAMENTS
CORONARY L▫E
TRIANGULAR L▫F
LESSER OMENTUM G
FALCIFORM L▫H

PORTA
PORTAL VEIN I
HEPATIC ARTERY J
BILE DUCT K

LOBULES

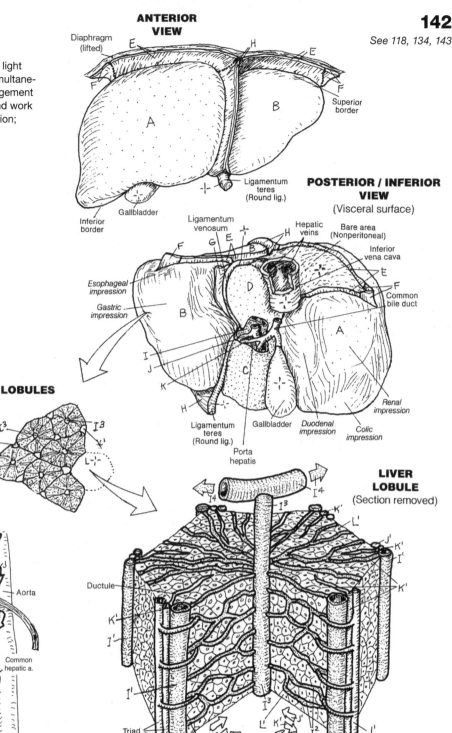

ANTERIOR VIEW

POSTERIOR / INFERIOR VIEW
(Visceral surface)

LIVER LOBULE
(Section removed)

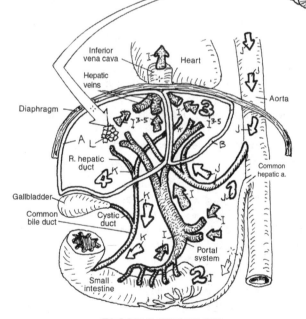

BLOOD & BILE FLOW
(Schematic)

1 ARTERIAL BLOOD J
2 PORTAL VENOUS BLOOD I
3 HEPATIC VEIN BLOOD I³⁻I⁵
4 BILE FLOW K

LIVER LOBULE L
TRIAD *'
BRANCH OF PORTAL VEIN I'
BRANCH OF HEPATIC ARTERY J'
BILE DUCT K'
SINUSOID I²
HEPATIC CELL L'
CENTRAL VEIN I³
TRIBUTARY OF HEPATIC VEIN I⁴
HEPATIC VEIN I⁵

The **biliary system** consists of an arrangement of ducts transporting bile from the liver cells that manufacture it to the gallbladder, for storage and release, and the second part of the duodenum.

Bile is formed in the liver (not the gallbladder!). It is a fluid consisting largely of water (97%), with bile salts and pigments (from the breakdown products of hemoglobin in the spleen). Once formed, bile is discharged from **hepatic cells** (hepatocytes) into surrounding bile canaliculi. These small canals merge to form bile ductules that join the converging bile ducts traveling in company with the intrahepatic branches of the portal vein and hepatic artery. The bile is brought out of the liver by the **right** and **left hepatic ducts** that merge at the porta hepatis to form the **common hepatic duct**. That duct descends between the layers of the lesser omentum and receives the 4-cm-long **cystic duct** from the gallbladder. The gallbladder is pressed against the visceral surface of the right lobe of the liver, which is covered with visceral peritoneum. The **bile duct** is formed by the cystic and common hepatic ducts. About 8 cm long, it descends behind the first part of the duodenum, deep to or through the head of the pancreas. It usually joins with the main **pancreatic duct**, forming an ampulla in the wall of the second part of the duodenum. There, the duct opens into the lumen of the duodenum. There can be variations in the union of these two ducts.

The **gallbladder** serves as a storage chamber for bile discharged from the liver. Bile is concentrated here several times. This fact is reflected in the multiple microvilli on the luminal surfaces of the simple columnar epithelial cells that absorb water from the dilute bile. In response to the gastric or duodenal presence of fat, secretion of cholecystokinin is induced, which stimulates the gallbladder to discharge its contents into the cystic duct. Peristaltic contractions of the duct musculature squirt bile into the duodenal lumen through the ampullary sphincter. Bile saponifies and emulsifies fats, making them water soluble and amenable to digestion by enzymes (lipases).

The **pancreas** is a gland in the retroperitoneum, consisting of a head, neck, body, and tail. Most of the pancreas consists of sac-like (acinar) exocrine glands that secrete enzymes and sodium bicarbonate, at a rate of about 2,000 mL per day, into the tributaries of the pancreatic duct and into the duodenum through one or two papillae, guarded by an ampullary sphincter. These enzymes are responsible for a major part of the chemical digestion in the small intestine (to name a few: lipase for fat, trypsin for protein, amylase for carbohydrates, and others). Pancreatic secretion is regulated by hormones (primarily cholecystokinin and secretin) from entero-endocrine cells and by the vagus nerves (acetylcholine). The endocrine function of the pancreas is covered on page 154.

CN: Use the same colors as you used on page 142 for the hepatic cells and bile ducts, and a very light color for H. (1) Color simultaneously the diagram of bile formation/transport and the large central illustration. Avoid coloring but note the duodenum, spleen, and background vessels. (2) Color the diagram describing bile storage.

HEPATIC CELL ₐ
 BILE ᵦ
 RIGHT HEPATIC DUCT c
 LEFT HEPATIC DUCT c'
 COMMON HEPATIC DUCT ᴅ
GALLBLADDER ₑ
 CYSTIC DUCT ꜰ
BILE DUCT ɢ

PANCREAS ₕ
 PANCREATIC DUCT ᵢ
HEPATO-DUODENAL AMPULLA ᴊ

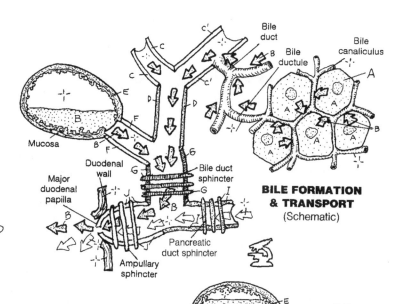

Bile duct
Bile ductule
Bile canaliculus

Mucosa

Duodenal wall
Major duodenal papilla
Bile duct sphincter
Pancreatic duct sphincter
Ampullary sphincter

BILE FORMATION & TRANSPORT
(Schematic)

BILE STORAGE

Sphincter closed

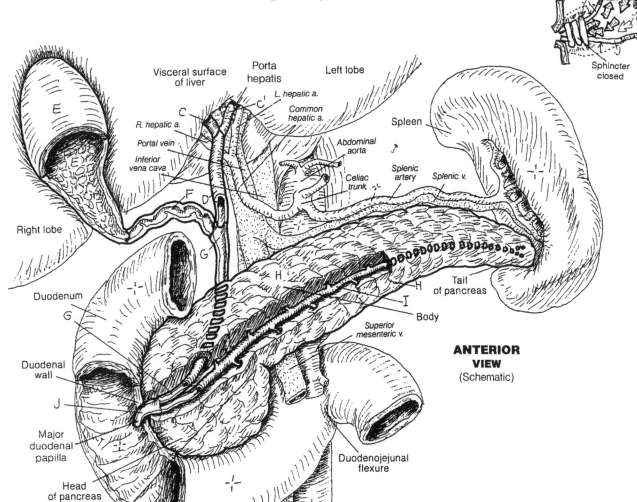

Visceral surface of liver
Porta hepatis
Left lobe
L. hepatic a.
Common hepatic a.
R. hepatic a.
Portal vein
Inferior vena cava
Abdominal aorta
Celiac trunk
Spleen
Splenic artery
Splenic v.

Right lobe

Duodenum

Duodenal wall

Major duodenal papilla

Head of pancreas

Neck

Superior mesenteric v.

Body
Tail of pancreas

Duodenojejunal flexure

ANTERIOR VIEW
(Schematic)

The **urinary tract** consists of paired kidneys and ureters in the retroperitoneum, a single urinary bladder, and a urethra. The urinary tract represents a pathway for the elimination of metabolic byproducts and toxic and other nonessential molecules, all dissolved in a small volume of water (*urine*). The **kidneys** are not simply instruments of excretion; they function in the conservation of water and maintenance of acid–base balance in the blood. The process is dynamic; that which is excreted as waste in one second may be retained as precious in the next.

The **ureters** are fibromuscular tubes, lined by a transitional epithelial layer of a highly convoluted mucosa like that of the esophagus (recall page 8). The muscular layer deep to the mucosa is thicker than the mucosa itself. Each ureter has an adventitial layer as well. Three areas of the ureters are relatively narrow and prone to being obstructed by mineralized concretions (*stones*) from the kidney (see arrows).

The fibromuscular **urinary bladder** lies in the true pelvis, its superior surface covered with peritoneum. The mucosa is lined with transitional epithelium. The bladder may contain as little as 50 mL of urine, but can hold as much as 700 to1,000 mL without injury. As it distends, it rises into the abdominal cavity and bulges posteriorly. The mucosal area between the two ureteral orifices and the urethral orifice is called the *trigone*.

The fibromuscular, glandular **urethra**, lined with transitional epithelium except near the skin, is larger in males (20 cm) than in females (4 cm). Hence, urethritis is more common in men, cystitis more common in women. In males, the urethra is described in three parts: prostatic, membranous, and spongy. The ductus deferens and ducts of the seminal vesicles join the **prostatic urethra**, though the latter may join the former before entering the urethra. The **membranous urethra**, secured among muscle layers in the urogenital diaphragm, is short and vulnerable to rupture with trauma to the low anterior pelvis. The **spongy urethra** in the body of the penis is about 15 cm long and lined with stratified columnar or pseudostratified columnar epithelium. It opens to the outside at the urinary meatus (external urethral orifice).

In the female, the urethra immediately enters the deep perineal space after leaving the bladder. It enters the superficial perineal space between the vestibular bulbs and opens to the outside.

URINARY TRACT
*KIDNEY*A
*URETER*B
*URINARY BLADDER*C
*URETHRA*D
 *PROSTATIC U. (MALE)*D¹
 *MEMBRANOUS U. (MALE)*D²
 *SPONGY U. (MALE)*D³

KIDNEY RELATIONS
*SUPRARENAL GLAND*E
*LIVER*F
*DUODENUM*G
*TRANSVERSE COLON*H
*SPLEEN*I
*STOMACH*J
*PANCREAS*K
*JEJUNUM*L

CN: Use very light colors on this page. (1) Color the three views of the urinary tract together. Color the kidneys in the anterior view in relation to the organ contact areas shown above. The kidneys in that upper view are shown as underlying, shaded silhouettes and receive no color. (2) Note and color the openings of the ureters, B, into the bladder in the anterior view. (3) Color gray the three arrows marking sites of potential ureteric obstruction by "stones."

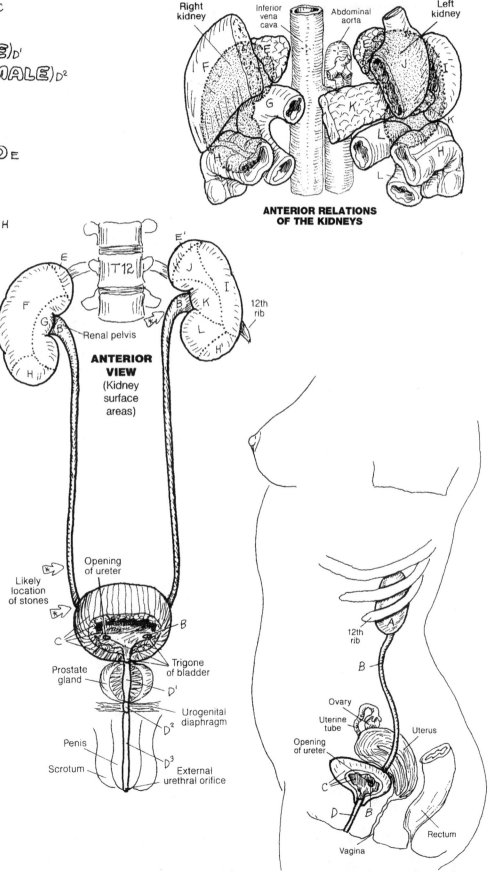

ANTERIOR RELATIONS
OF THE KIDNEYS

Right kidney — Inferior vena cava — Abdominal aorta — Left kidney

ANTERIOR VIEW (Kidney surface areas)

T12
Renal pelvis
12th rib

Likely location of stones
Opening of ureter
Trigone of bladder
Prostate gland
Urogenital diaphragm
Penis
Scrotum
External urethral orifice

Rectum
Opening of ureter
Seminal vesicle
Ductus deferens
Prostate gland
Epididymis
Testis
Penis
Scrotum

12th rib
Ovary
Uterine tube
Opening of ureter
Uterus
Rectum
Vagina

The paired kidneys and ureters lie posterior to the parietal peritoneum of the abdominal cavity, in the retroperitoneum (see X in the left side of the largest illustration). We show the parietal peritoneum partly covering deeper structure. Look carefully at what structure is retroperitoneal. On the right, we show structure free of its peritoneal covering. During fetal development, some abdominal structures arise in the retroperitoneum (e.g., kidneys) and some become retroperitoneal as a result of movement of visceral organs during development (e.g., ascending/descending colon, pancreas). The **abdominal aorta**, its immediate branches, the **inferior vena cava**, and its immediate tributaries are all retroperitoneal. Arteries and veins travel *between* layers of peritoneum (greater omentum, mesenteries) to reach the organs they supply/drain; they never penetrate the peritoneum under normal circumstances. Lymph nodes, lumbar trunks, and the cisterna chyli (not shown) are all retroperitoneal. The **ureters** descend in the retroperitoneum (under the parietal peritoneum) to reach the posterior and inferior aspect of the bladder. Pelvic viscera and vessels lie deep to the parietal peritoneum.

Deep to the parietal peritoneum, each **kidney** is surrounded by pararenal fat, secured by a tight layer of *renal fascia*, and a deeper layer of perirenal fat (see cross section). These compartments do not communicate between left and right. Such a support system permits kidney movement during respiration but secures them against impact forces.

KIDNEYS & RELATED RETROPERITONEAL STRUCTURES

CN: Use red for B, blue for L, and a very light color for X. (1) Color the retroperitoneal structures in the large view of the abdominal cavity. The parietal peritoneum, whose name is at upper right, X, is shown partly covering these structures on the left. (2) At upper right, note the relationship of the retroperitoneum, Y, to the parietal peritoneum.

KIDNEY A
 URETER A'
 URINARY BLADDER A²

AORTA B & BRANCHES -:-
 CELIAC A. & BRS. C
 SUPRARENAL A. D
 SUPERIOR MESENTERIC A. E
 RENAL A. F
 TESTICULAR A. G
 INFERIOR MESENTERIC A. H
 COMMON ILIAC A. I
 INTERNAL ILIAC A. J
 EXTERNAL ILIAC A. K

INFERIOR VENA CAVA L
& TRIBUTARIES -:-
 INTERNAL ILIAC V. M
 EXTERNAL ILIAC V. N
 COMMON ILIAC V. O
 TESTICULAR V. P
 RENAL V. Q
 SUPRARENAL V. R
 HEPATIC VS. S

ORGANS & DUCTS -:-
 ESOPHAGUS T
 SUPRARENAL GLAND U
 RECTUM V
 DUCTUS (VAS) DEFERENS W

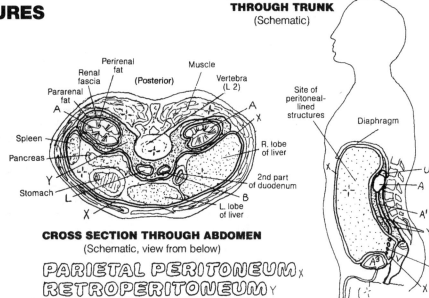

SAGITTAL SECTION THROUGH TRUNK
(Schematic)

Cross section labels: Perirenal fat, Renal fascia, Pararenal fat, (Posterior), Muscle, Vertebra (L 2), Spleen, Pancreas, Stomach, R. lobe of liver, 2nd part of duodenum, L. lobe of liver

Sagittal labels: Site of peritoneal-lined structures, Diaphragm

CROSS SECTION THROUGH ABDOMEN
(Schematic, view from below)

PARIETAL PERITONEUM X
RETROPERITONEUM Y

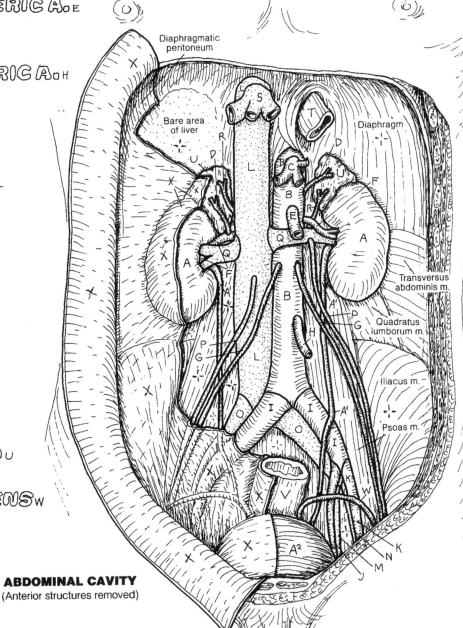

Labels: Diaphragmatic peritoneum, Bare area of liver, Diaphragm, Transversus abdominis m., Quadratus lumborum m., Iliacus m., Psoas m.

ABDOMINAL CAVITY
(Anterior structures removed)

The **kidney** is composed of filtering capsules, tubules, and blood vessels tightly pressed together into what is called the *parenchyma* of the kidney. About three liters (L) of blood circulate through the kidneys; the kidneys (glomeruli) filter 180 L of blood every 24 hours. Three liters of plasma pass through the kidney 60 times a day; 1% is excreted as **urine**! Conclusion: The kidney is in the water, and necessary solutes, conservation business.

The parenchyma of the kidney is arranged into an outer **renal capsule**-covered **cortex** of blood filters (glomeruli) and largely convoluted tubules, and an inner **medulla** of pyramidal-shaped arrays of tubules and collecting ducts, many of which take the formative urine to storage while conserving water (page 147). Those parts of the cortex that reach down between the **pyramids** are called *renal columns*. The apex of each medullary pyramid forms a **renal papilla** (containing numerous collecting duct apertures) that fits into a small cup-shaped transitional epithelial-lined funnel called the **minor calyx**. These funnels, numbering 8–18, open into three much larger **major calyces**, all of which open into the cavity called the **renal pelvis**.

The concavity of the kidney (the indented part) is the **renal hilum**, and within that area can be seen a bit of the renal sinus. The **renal sinus** is the kidney space less the working tissue (filters, tubules, ducts, vessels, and related cells); its walls are an inward continuation of the renal capsule. Its floor includes the papillae, and the lining of the minor and major calyces. The renal sinus contains the branches and tributaries of the **renal artery** and **vein**, as well as the nerves that come in and leave by way of the sinus. The renal pelvis narrows to form the proximal **ureter** here, sharing the area with the renal artery and vein, all of which enter/depart the kidney through the renal hilum.

The ureter, conveying urine to the urinary bladder, is a continuation of the renal pelvis. The working tissue (**mucosa**) is highly folded except in the circumstance of a full cavity, at which time the **transitional epithelial** (*urothelium*) **layer** can be stretched to three cell layers thick to accommodate the load. The supporting fibrous **lamina propria** is thin relative to the pronounced layers of smooth muscle (**muscularis***):* **inner longitudinal, middle circular,** and **outer longitudinal**. The outer layer of the ureter is a thin, lightly fibrous, and vascular **serosa** (parietal peritoneum).

KIDNEY STRUCTURE

*KIDNEY*ₐ
 *RENAL CAPSULE*ₐ'
*RENAL CORTEX*ᵦ
RENAL MEDULLA (PYRAMID)꜀
 *RENAL PAPILLA*ᴅ
*RENAL HILUM*ₑ
 *MINOR CALYX*ꜰ
 *MAJOR CALYX*ɢ
 *RENAL PELVIS*ₕ
 *RENAL SINUS*ᵢ
*RENAL ARTERY*ⱼ
 *OXYGEN-RICH BLOOD*ⱼ'
*RENAL VEIN*ₖ
 *OXYGEN-POOR BLOOD*ₖ'

URETER STRUCTURE

*URETER*ʟ
MUCOSA
 *TRANSITIONAL EPITHELIA*ₘ
 *LAMINA PROPIA*ₙ
MUSCULARIS
 *INNER LONGITUDINAL*ₒ
 *MIDDLE CIRCULAR*ₒ'
 *OUTER LONGITUDINAL*ₒ²
COVERING
 *SEROSA*ʟ'

―――――――――――
*URINE*ₚ

CN: Color this and the next page together. Use red for J, blue for K, yellow for P, and very light colors for B, F, G, H, and I. (1) Begin with the kidneys in situ. (2) In the kidney illustration, the thickness of the renal capsule is exaggerated for coloring. Color the cut edges of blood vessels, K¹, in renal cortex, B. Color the amounts and arrows of blood and urine flow, as well as large arrow, E, pointing to the renal hilum. (3) Color the cross section of the ureter at lower left.

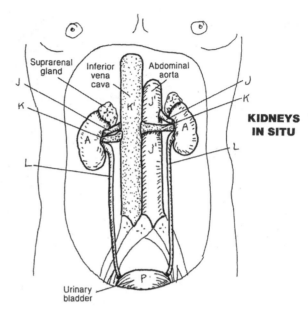

KIDNEYS IN SITU

Suprarenal gland · Inferior vena cava · Abdominal aorta · Urinary bladder

1300 mL/min ⱼ'
(Into both kidneys)

1299 mL/min ₖ'
(Out of both kidneys)

Blood vessel

Minor and major calyces are cut open

Renal column

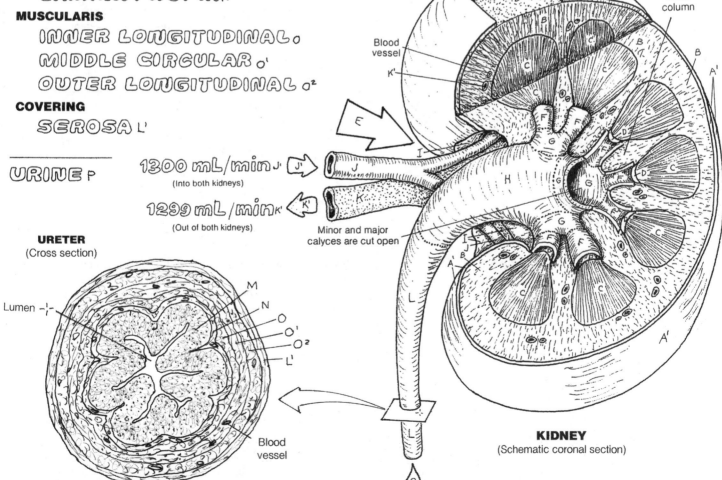

URETER
(Cross section)

Lumen

M · N · O · O' · O² · L'

Blood vessel

KIDNEY
(Schematic coronal section)

The primary functional unit of the kidney is the **nephron**, consisting of the **renal corpuscle**, and the proximal/distal convoluted and straight tubules and **loop of Henle** (**renal tubule**). The nephron ends as it joins the **collecting tubule/duct**.

The renal corpuscles occupy the cortex; **juxtamedullary nephrons** are more deeply set in the cortex than **cortical nephrons**, which are reported to be the more common (about 70–80%) of the two. Note that the thin straight tubules of the juxtamedullary nephrons are significantly longer and dip deeper into the medulla than those of the cortical nephrons. The functional difference between them is expressed in different degrees of **urine** concentration in the loop of Henle (see page 148).

The renal corpuscle is composed of an encapsulated cluster of porous (*fenestrated*), specialized capillaries, called the **glomerulus**, fed by an **afferent arteriole** on one side and drained by an **efferent arteriole** on the same side. Phagocytic mesangial cells share space at the vascular pole (not shown).

Each glomerulus is developmentally pushed into a blind capsule, invaginating it (see text, page 103). This capsule is the **glomerular capsule** (*capsule of Bowman*). The side of the capsule into which the glomerulus invaginated is called the *vascular pole*. See now the cross section of the renal corpuscle at the lower part of the page; note that the side opposite the vascular pole (the urinary pole) opens into the **proximal convoluted tubule** (first part of the renal tubule).

The cavity created by invagination of the glomerulus into the capsule is the **capsular space**. It receives the plasma filtrate from the glomerular capillaries. The outer wall of the capsule is the **parietal layer**. The inner wall is the **visceral layer**, composed of elongated, octopus-like epithelial cells (**podocytes**) with long extensions reaching along a length of capillary and multiple short finger-like processes on one or both sides (*pedicels*) that reach out to attach to the underlying capillary. The plasma passes through the capillary fenestrations between pedicels and enters the capsule through these minute passageways (*filtration sites*). This fluid in the capsule is now *filtrate*.

The cells of the renal tubules of the nephron function to (1) *reabsorb* certain substances from the tubular lumen, as well as the interstitial fluid and local capillaries, such as sodium, potassium, bicarbonate, calcium, other electrolytes, and water; (2) *secrete* (return) certain substances from the tubular cells into the tubular lumen; and (3) *excrete* (transport) the constantly varying amount of leftovers (urine) through collecting ducts for eventual storage. In this way the tubules keep a neutral acid–base balance in the body fluids and concentrate the filtrate passing through the tubules, minute by minute, to retain body water. On average, 99% of the filtrate is reabsorbed by the tubules of the nephron and the collecting ducts and returned to the fluid spaces of the body. In this function, the distal convoluted and straight tubules and the collecting ducts play a most important role.

URINARY SYSTEM
THE NEPHRON

CN: Use red for G and G[1]; use the colors you used on the previous page for similar structures which may have different labels. (1) Begin by coloring the "Kidney Region" at the top of the page. (2) Color the two types of nephrons in the smaller wedge. (3) Color the detailed view of the cortical nephron. (4) At the bottom of the page, color the cross section of the renal corpuscle on the right. The capsular space, H^3, is to be left uncolored. (5) At lower left, color the podocytes around the glomerular capillary at left, relating it to the glomerulus at right.

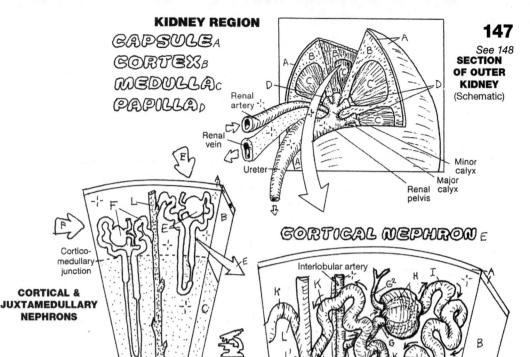

KIDNEY REGION

CAPSULE ᴀ
CORTEX ʙ
MEDULLA ᴄ
PAPILLA ᴅ

Renal artery
Renal vein
Ureter

147
See 148
SECTION OF OUTER KIDNEY
(Schematic)

Minor calyx
Major calyx
Renal pelvis

NEPHRON

CORTICAL NEPHRON ᴇ
JUXTAMEDULLARY NEPHRON ꜰ

RENAL CORPUSCLE

AFFERENT ARTERIOLE ɢ
GLOMERULUS ɢ¹
GLOMERULAR CAPSULE ʜ
PARIETAL LAYER ʜ¹
VISCERAL LAYER (PODOCYTE) ʜ²
CAPSULAR SPACE ʜ³⁺
EFFERENT ARTERIOLE ɢ²

RENAL TUBULE

PROXIMAL CONVOLUTED TUBULE ɪ
LOOP OF HENLE ᴊ
DISTAL CONVOLUTED TUBULE ᴋ

COLLECTING TUBULE ʟ
COLLECTING DUCT ʟ¹
PAPILLARY DUCT ʟ²

URINE ᴍ

CORTICAL & JUXTAMEDULLARY NEPHRONS

Cortico-medullary junction

CORTICAL NEPHRON ᴇ

Interlobular artery
Loop of Henle
Thick segments
Thin segment
Minor calyx
Area cribrosa

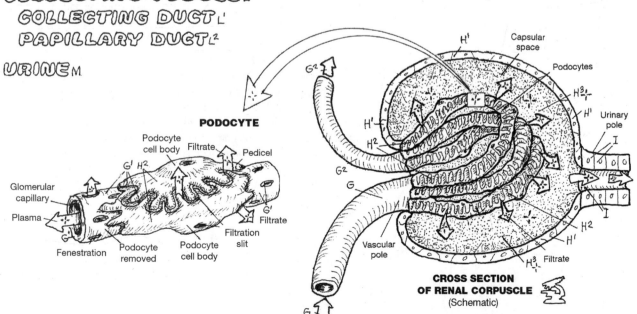

PODOCYTE

Podocyte cell body
Filtrate
Pedicel
Glomerular capillary
Plasma
Fenestration
Podocyte removed
Podocyte cell body
Filtration slit
Filtrate

CROSS SECTION OF RENAL CORPUSCLE
(Schematic)

Capsular space
Podocytes
Urinary pole
Vascular pole
Filtrate

Glomerular filtrate is formed in the renal capsular space. It is poor in plasma proteins and rich in ions, small molecules, and water. As the filtrate passes into the first part of the proximal convoluted tubule, much of it (water, sodium and other ions, glucose, and amino acids) is reabsorbed by the cells of the tubule and returned to the body by way of the interstitial fluid and the local (peritubular) capillaries. The renal corpuscles of the nephrons are located in the cortex; about 70% of these nephrons are in the upper cortex, and 30% are close to the cortical-medullary junction (juxtamedullary, shown here).

An overview of the vascular architecture of the kidney is shown at upper left. The **renal artery** enters the hilum of the kidney and gives off **segmental** branches that pass up into the medulla between medullary pyramids as **interlobar arteries**. When these arteries reach the medullary-cortical border, they turn 90 degrees to become the **arcuate arteries**. From these vessels, **interlobular arteries** reach toward the capsule. As they do, they give off the **afferent arterioles** to the glomeruli. Here, in the renal corpuscle, the plasma of the glomerular blood is filtered, preserving cells and large molecules, and the residue enters the glomerular capsular space as the *glomerular filtrate* (recall page 147).

The remaining blood leaves the glomerular capillaries through the **efferent arteriole**. In the cortical area, capillaries downstream from the efferent arteriole (**peritubular capillaries**) form a network around the proximal and distal convoluted tubules and their descending and ascending limbs. These vessels are continuous with the venules that transport the blood back through veins that largely parallel the arteries, except that the **interlobar veins** drain directly into the renal veins (no segmental veins). The **juxtamedullary nephrons** have much longer straight tubules than cortical nephrons. The efferent arterioles of these nephrons leave the glomeruli of origin and descend with the long (descending, ascending, collecting) tubules as the **vasa recta** (straight vessels). These vessels, in conjunction with the long straight tubules, form a mechanism that profoundly influences the tubular reuptake of water and critical ions, thus concentrating the working filtrate in the lumina (plural of lumen) of the long medullary tubules and at the same time increasing the volume of blood in the tributaries of the vasa recta that flow into the **interlobular** and **arcuate veins**.

Renin-secreting **juxtaglomerular** *(JG) cells*, made of modified smooth muscle and located in the afferent and efferent arterioles at the vascular pole of the glomerulus, sense pressure changes (*pressoreceptors*). Modified epithelial cells in the adjacent distal tubule (*macula densa*) sense sodium and chloride concentrations (*mechanoreceptors*). The combination of high blood pressure and high levels of sodium initiates a chain reaction to lower the local blood pressure by modulating the glomerular filtration rate and arteriolar blood pressure.

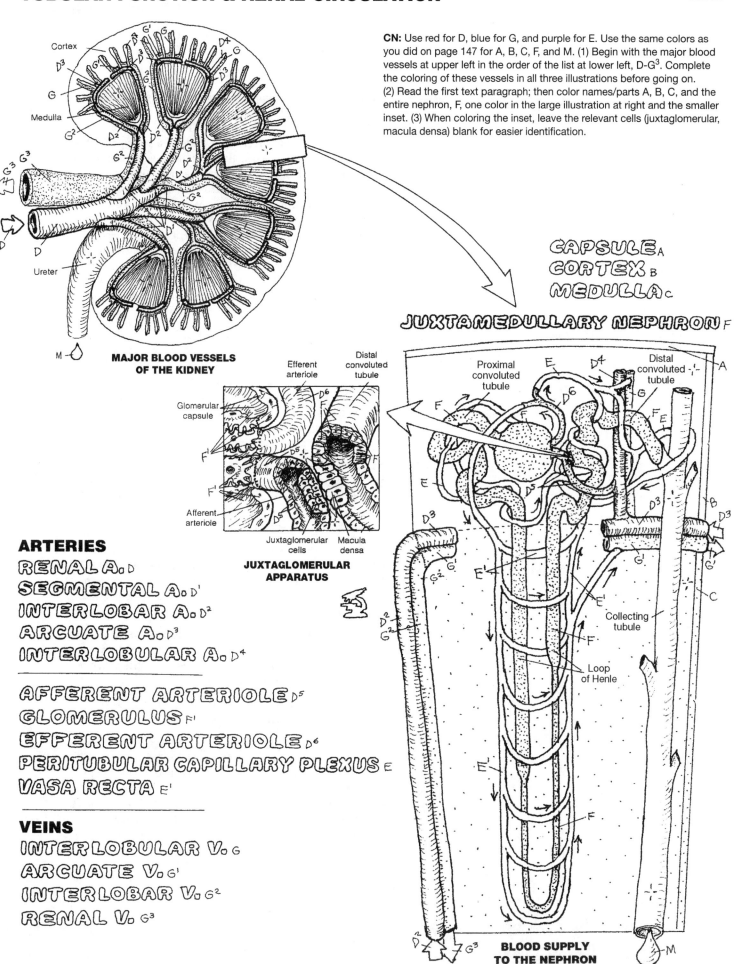

CN: Use red for D, blue for G, and purple for E. Use the same colors as you did on page 147 for A, B, C, F, and M. (1) Begin with the major blood vessels at upper left in the order of the list at lower left, D-G³. Complete the coloring of these vessels in all three illustrations before going on. (2) Read the first text paragraph; then color names/parts A, B, C, and the entire nephron, F, one color in the large illustration at right and the smaller inset. (3) When coloring the inset, leave the relevant cells (juxtaglomerular, macula densa) blank for easier identification.

CAPSULE A
CORTEX B
MEDULLA C

JUXTAMEDULLARY NEPHRON F

Cortex
Medulla
Ureter

MAJOR BLOOD VESSELS OF THE KIDNEY

Efferent arteriole
Distal convoluted tubule
Glomerular capsule
Afferent arteriole
Juxtaglomerular cells
Macula densa

JUXTAGLOMERULAR APPARATUS

Proximal convoluted tubule
Distal convoluted tubule
Collecting tubule
Loop of Henle

BLOOD SUPPLY TO THE NEPHRON

ARTERIES
RENAL A. D
SEGMENTAL A. D¹
INTERLOBAR A. D²
ARCUATE A. D³
INTERLOBULAR A. D⁴

AFFERENT ARTERIOLE D⁵
GLOMERULUS F¹
EFFERENT ARTERIOLE D⁶
PERITUBULAR CAPILLARY PLEXUS E
VASA RECTA E¹

VEINS
INTERLOBULAR V. G
ARCUATE V. G¹
INTERLOBAR V. G²
RENAL V. G³

Classically, **endocrine glands** and **tissues** are discrete masses of secretory cells and their supporting tissues in close proximity to blood capillaries into which these cells secrete their hormones. *Hormones* are chemical agents usually effective among cells (**target organs**) located some distance from their source. **Hormonal secretion** results in positive or negative feedback control mechanisms in the target tissue(s). In the broader scope, in the face of current and recent past research, it is generally agreed that the classical definition may have to be expanded to accommodate new findings with regard to *local* chemical control. Chemical agents that are effective in the same fluid environment as the cells that secreted them (local "target" cells) are known as *paracrines*. There are also cells that secrete chemical agents outside the cell's membrane and induce a response among receptors in or on the same cell (*autocrines*). Such cells, at least in part, are self-regulatory.

Hormonal activity results in growth, reproduction, and metabolic stability in the internal (chemical) environment. In this internal environment, cells, tissues, and organs contribute and respond to chemical input results in stabilizing influences on cellular activity under a broad set of conditions, and maintains a long-lasting "normal" environment called *homeostasis* (*homeo*, normal; *stasis,* a state of equilibrium among opposing forces or tendencies).

The classical endocrine glands shown here are presented on the following pages, with the exception of the **pineal gland** (see page 75) and the **thymus** (see page 123). In addition to the classical endocrine glands, a few of the myriad tissues/cells that secrete chemical agents influential in cellular activities are listed here.

The atria of the **heart** secrete atrial natriuretic peptide (ANP) during periods of heightened blood pressure. The effect of this chemical agent is to limit the influence of the renin-angiotensin-aldosterone mechanism and permit increased excretion of water and sodium.

The juxtaglomerular cells of the **kidney** (see page 148) secrete renin, an enzyme that converts angiotensinogen to angiotensin I and indirectly induces increased blood pressure and conservation of body fluids, such as during hemorrhage.

The cells of the **gastrointestinal tract** secrete numerous endocrine factors that influence intestinal motility and enzyme secretion.

The **placenta** secretes many hormones, including human chorionic gonadotropin (hCG), estrogen, progesterone, lactotropic (breast development and milk production support) hormones, and relaxin. During the first 90 days after fertilization, hCG contributes to the support of embryonic growth by stimulating the growth of the corpus luteum.

See 8

CN: Use a very light color for the thyroid, C, and a darker one for the parathyroids, D (actually located on the posterior surface of the thyroid). After coloring the endocrine glands and tissues, color the functional scheme at lower right.

ENDOCRINE GLANDS

HYPOPHYSIS
(PITUITARY) A
PINEAL B
THYROID C
PARATHYROID (4) D
THYMUS E
ADRENAL
(SUPRARENAL) (2) F
PANCREAS G
OVARY (2) H
TESTIS (2) I

ENDOCRINE TISSUES

HYPOTHALAMUS J
HEART K
KIDNEY (2) L
GASTROINTESTINAL
TRACT M
PLACENTA N

ENDOCRINE FUNCTION

ENDOCRINE GLAND O
HORMONAL SECRETION P
TARGET ORGAN Q

Cerebellum

SAGITTAL VIEW

Thyroid cartilage

Located on surface of thyroid

Trachea

Lung

Bronchi

Diaphragm

Stomach

Small intestine

Large intestine

Embryo

Umbilical cord

Uterus

Uterine tube

Penis

Scrotum

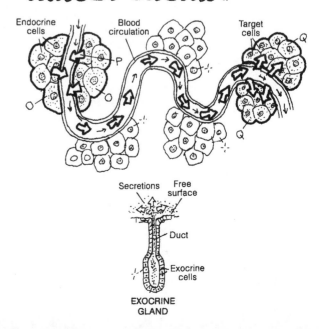

Endocrine cells

Blood circulation

Target cells

Secretions

Free surface

Duct

Exocrine cells

EXOCRINE GLAND

The **pituitary gland (hypophysis)** is located in a recess of the sphenoid bone called the *sella turcica*, connected to the hypothalamus by the *infundibulum*. The **anterior pituitary** consists of an **anterior lobe** (*adenohypophysis*), a **tuberal part**, and an **intermediate lobe**. The **posterior pituitary** consists of a **posterior lobe** (*neurohypophysis*) and the **infundibulum**. The three parts of the anterior pituitary are derived from an upward extension of the developing roof of the mouth. Indeed, the gland was once thought to form mucus (*pituita*) that was secreted into the nose. Developmentally, the posterior lobe is a downward migration from the floor of the **hypothalamus**. That floor, inferior to the third ventricle, consists of what was a hollow infundibulum (stem, stalk) surrounded by the median eminence, a nucleus of cells of the hypothalamus. The lowest part of the infundibulum (below the median eminence) at maturity is still part of the hypothalamic floor, but is no longer hollow and is continuous with the posterior lobe. The three (infundibulum, median eminence, and posterior lobe) are often considered the *neurohypophysis*.

The tuberal nucleus of the anterior pituitary embraces the infundibular stem and the median eminence of the anterior hypothalamus. Neurons of the hypothalamus here secrete releasing and inhibiting hormones into a capillary network fed by the superior hypophyseal artery and drained by **hypothalamic-hypophyseal portal veins**. The portal veins transport the hormones to the **sinusoids** and **capillaries** of the anterior lobe, where secretory cells there are induced (or inhibited) to secrete their hormones (see page 151). The **inferior hypophyseal vein** drains the anterior lobe.

The intermediate lobe reveals no known functionally significant secretory activity.

The posterior lobe has no secretory cells of its own. Axons of **secretory neurons** in the supraoptic and paraventricular nuclei of the hypothalamus extend down through the infundibulum to capillary networks in the posterior lobe, a pathway known as the **hypothalamo-hypophyseal tract**. The axon terminals release oxytocin and antidiuretic hormones into the circulation (see page 151).

CN: Use red for E, purple for F and G, blue for I, and a very light color for H. (1) Begin at the top of the page. (2) Color the anterior lobe schematic, following the order of the list of names. (3) Continue with the schematic of the posterior lobe, following the order of the list of names. (4) Color gray the names (⋆, ⋆¹) and the two large arrows pointing to the infundibular region of both lobes.

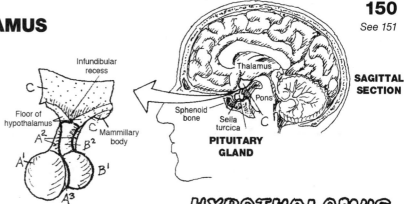

PITUITARY GLAND (HYPOPHYSIS)

ANTERIOR PITUITARY A-
ANTERIOR LOBE A'
TUBERAL PART A²
INTERMEDIATE LOBE A³
POSTERIOR PITUITARY B-
POSTERIOR LOBE B'
INFUNDIBULUM B²

ANTERIOR LOBE A'
HYPOTHALAMO-HYPOPHYSEAL PORTAL SYSTEM ⋆
SECRETORY NEURON/SECRETION D
SUPERIOR/INFERIOR HYPOPHYSEAL ARTERY E
ARTERIOLE E'
CAPILLARY PLEXUS F
PORTAL VEIN G
SINUSOID/CAPILLARY PLEXUS F'
SECRETORY CELLS/HORMONES H
INFERIOR HYPOPHYSEAL VEIN I

POSTERIOR LOBE B'
HYPOTHALAMO-HYPOPHYSEAL TRACT ⋆'
SECRETORY NEURON/SECRETION D'
CAPILLARY PLEXUS F'
INFERIOR HYPOPHYSEAL VEIN I'
INFERIOR HYPOPHYSEAL ARTERY E²

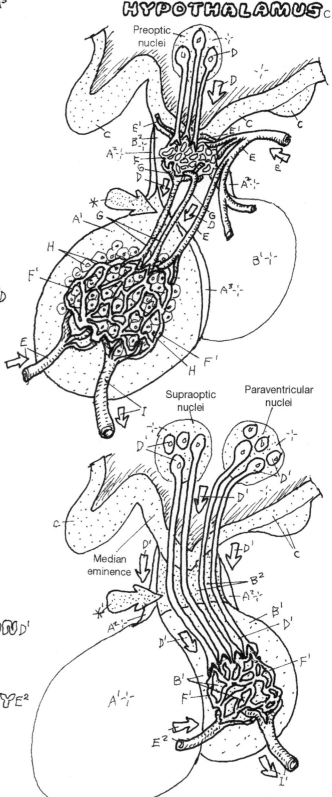

Hypothalamic *releasing* or *inhibiting* **hormones** act on the **anterior lobe** of the pituitary. These hormones stimulate/inhibit the target cells in the anterior lobe to increase/decrease their hormone secretion. However, inhibition of pituitary hormone secretion is most often controlled by negative **feedback** from the **target organs** themselves. For example, the hypothalamus is sensitive to the concentration of **estrogen** in the hypothalamic and hypophyseal circulation via branches of the superior hypophyseal artery (or one or more of several deep cortical branches of the anterior, middle, and posterior cerebral arteries that supply the thalamus and hypothalamus). As estrogen levels in the blood diminish, certain hypothalamic nuclei sense this change and may increase their secretion of gonadotropin-releasing hormone (GRH). GRH is released from secretory nerve endings in the hypophyseal portal system in the median eminence (recall page 150). GRH reaches the sinusoids of the anterior lobe most directly by way of the hypothalamic-hypophyseal portal system and stimulates certain basophils to secrete follicle-stimulating hormone. **Follicle-stimulating hormone (FSH)** is released into the circulation and has a stimulatory influence on the growth of ovarian follicles (as well as spermatogenesis in the male). Significantly increased levels of estrogen are sensed by the hypothalamus (feedback), which then turns off its secretion of GRH (negative feedback).

Hormones of the anterior pituitary include the gonadotropin **luteinizing hormone (LH).** LH stimulates **testosterone** secretion, ovulation, development of the corpus luteum, and estrogen/**progesterone** secretion. **Thyroid stimulating hormone (TSH)** induces secretion of the thyroid hormone **thyroxin** (see page 152). As with FSH and LH, releasing and inhibiting hormones of the hypothalamus also regulate secretion of TSH.

Adrenocorticotropic hormone (ACTH) stimulates the release of adrenal cortical hormones (e.g., cortisol) that have powerful influence over lipid, protein, and carbohydrate metabolic activity. ACTH is a steroid molecule; the previously mentioned hormones are mostly small proteins (peptides). ACTH also has melanocyte-stimulating (MSH) properties, dispersing pigment in the skin (see page 15).

Growth hormone (GH) stimulates body growth, especially of bone. **Prolactin** mediates milk secretion (see page 162) and is inhibited by prolactin-inhibiting hormone in the hypothalamus.

Oxytocin and antidiuretic hormone (ADH, vasopressin) are products of secretory neurons in the supraoptic and paraventricular nuclei of the hypothalamus. The secretory material is transported down the long axons of the hypothalamo-hypophyseal tract to capillaries in the **posterior lobe**, where they are released into the general circulation via the hypophyseal vein. Oxytocin induces ejection of milk and stimulates uterine contractions.

Antidiuretic hormone (ADH) (see page 153) causes retention of body water by the kidneys. Its secretion is induced by osmoreceptors in the hypothalamus. ADH is also a powerful vasoconstrictor.

PITUITARY GLAND & TARGET ORGANS

CN: Use the same color you used on page 150 for hypothalamic hormones, A, and secretions, A[1]. (1) Note the major headings distributed throughout the illustration; color the related names, and the arrows and circles representing the hormones and secretions of both lobes. (2) Color the large and smaller arrows representing the target organ hormones performing their feedback function.

PITUITARY GLAND HORMONES

ANTERIOR LOBE

FOLLICLE-STIMULATING H. (FSH)ʙ
LUTEINIZING H. (LH)ᴄ
THYROID STIMULATING H. (TSH)ᴅ
ADRENOCORTICOTROPIC H. (ACTH)ᴇ
GROWTH H. (GH)ꜰ
PROLACTINɢ

POSTERIOR LOBE

OXYTOCINʜ
ANTIDIURETIC H. (ADH)ɪ

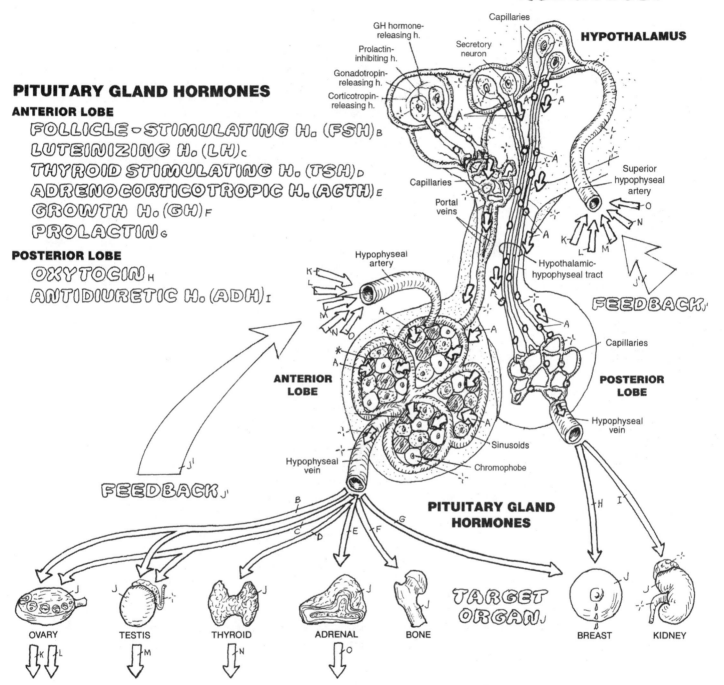

HYPOTHALAMIC HORMONES A

HYPOTHALAMUS

GH hormone-releasing h.
Prolactin-inhibiting h.
Gonadotropin-releasing h.
Corticotropin-releasing h.
Secretory neuron
Capillaries

Superior hypophyseal artery

Capillaries
Portal veins

Hypothalamic-hypophyseal tract

FEEDBACK ᴊ

Hypophyseal artery

ANTERIOR LOBE

POSTERIOR LOBE

Capillaries

Sinusoids
Chromophobe

Hypophyseal vein

Hypophyseal vein

PITUITARY GLAND HORMONES

FEEDBACK ᴊ

TARGET ORGAN ᴊ

OVARY TESTIS THYROID ADRENAL BONE BREAST KIDNEY

STRUCTURAL/FUNCTIONAL EFFECT/FEEDBACK ᴊ

TARGET ORGAN HORMONES

ESTROGENᴋ
PROGESTERONEʟ
TESTOSTERONEᴍ
THYROXINɴ
ADRENAL CORTICAL H.ᴏ

The **thyroid** gland, covering the anterior surfaces of the second to fourth tracheal rings, is bound by a fibrous capsule whose posterior layer encloses the four parathyroid glands. The thyroid gland is composed of right and left lobes connected by an isthmus. It consists of clusters of **follicles** (like grapes) supported by loose fibrous tissue rich in blood vessels. A microscopic section through a follicle reveals a single layer of cuboidal epithelial cells forming the follicular wall. The follicle contains **colloid**, a glycoprotein (thyroglobulin) produced by the follicle cells. These cells take up thyroglobulin and dismantle it to form a number of hormones, primarily **thyroxin** (T4, tetraiodothyronine). Thyroxin is then secreted into the adjacent capillaries. Thyroid hormones contain iodide (a reduced form of iodine), which is absorbed by the follicle cells from the blood. Thyroxin formation and secretion is stimulated by thyroid-stimulating hormone (TSH) from the anterior pituitary. The relationship operates on a negative feedback mechanism: increased secretions of thyroxin inhibit further secretion of TSH.

Thyroxin increases oxygen consumption in practically all tissues, and thus maintains the metabolic rate. It is involved at many levels in growth and development. Excessive secretion of thyroxin generally results in weight loss, extreme nervousness, and an elevated basal metabolic rate. Hypothyroidism results in diminished mental activity, voice changes, reduced metabolic activity, and the accumulation of mucus-like material under the skin (myxedema), giving a puffy appearance.

Like all endocrine glands, the thyroid is highly vascular. The vessels shown here warrant very careful attention when considering undertaking an emergency tracheostomy or cricothyrotomy; the pattern of these vessels is not always predictable. Especially note the inferior thyroid veins on the anterior surface of the trachea.

The **parathyroids** consist of small buttons of highly vascular tissue containing two cell types, one of which (*chief cells*) secretes **parathormone**. Parathormone maintains plasma calcium levels by inducing osteoclastic activity (bone breakdown), freeing calcium ions. Normal muscle activity and blood clotting depend on normal calcium levels in the plasma. Reduced parathyroid function lowers calcium levels and below certain levels causes muscle stiffness, cramps, spasms, and convulsions (tetany).

CN: Use red for H, blue for I, and light colors for E, F, and G. (1) Color the three upper views simultaneously, taking note of the arteries and veins that penetrate the thyroid. (2) Color the microscopic sections of hypoactive and hyperactive thyroid follicles; normal tissue lies between the two extremes. (3) Color the diagram of thyroid and parathyroid function.

THYROID ᴀ
 THYROID FOLLICLE ᴀ-
 FOLLICLE CELL ʙ
 COLLOID ᴄ
 THYROXIN ᴀ'

PARATHYROID (4) ᴅ
 PARATHORMONE ᴅ'

RELATED STRUCTURES

TRACHEA ᴇ
PHARYNX ꜰ
ESOPHAGUS ɢ
ARTERIES ʜ
VEINS ɪ

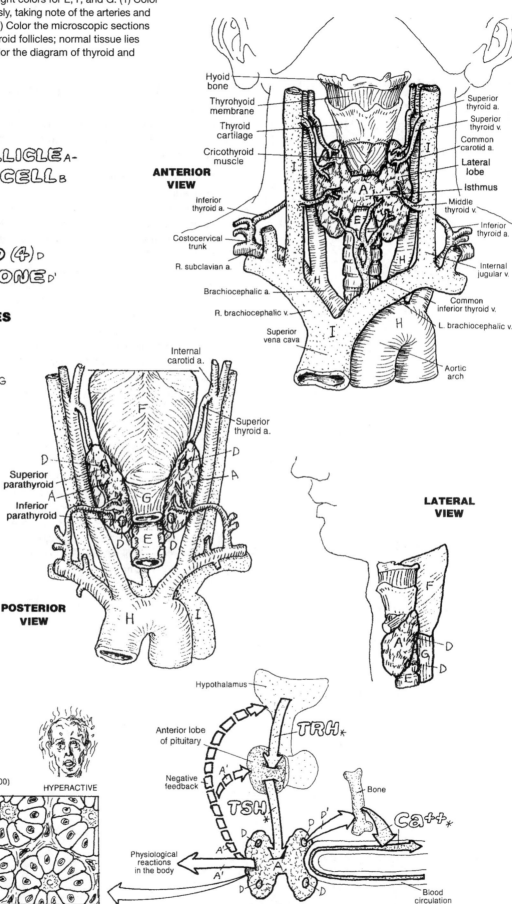

ANTERIOR VIEW

Hyoid bone
Thyrohyoid membrane
Thyroid cartilage
Cricothyroid muscle
Inferior thyroid a.
Costocervical trunk
R. subclavian a.
Brachiocephalic a.
R. brachiocephalic v.
Superior vena cava

Superior thyroid a.
Superior thyroid v.
Common carotid a.
Lateral lobe
Isthmus
Middle thyroid v.
Inferior thyroid a.
Internal jugular v.
Common inferior thyroid v.
L. brachiocephalic v.
Aortic arch

POSTERIOR VIEW

Internal carotid a.
Superior thyroid a.
Superior parathyroid
Inferior parathyroid

LATERAL VIEW

Hypothalamus
Anterior lobe of pituitary
Negative feedback
Physiological reactions in the body
Bone
Blood circulation

TRH ✳
TSH ✳
Ca++ ✳

HYPOACTIVE

Cross sections through follicles (Approximately x 200)

HYPERACTIVE

THYROID FOLLICULAR ACTIVITY

THYROID & PARATHYROID FUNCTION

The **adrenal (suprarenal) glands** lie in the retroperitoneum within the renal fascia on the superior and medial aspects of each kidney (T11–T12 vertebral levels). The adrenals are two different glands encapsulated as one: the outer cortex and the inner medulla. Like other endocrine glands, the adrenals are abundantly vascularized.

The **adrenal cortex** is organized into three regions: the outer zona glomerulosa, the middle zona fasciculata, and the inner zona reticularis. When presented with a decrease in fluid volume, as with hemorrhage, the cells of the **zona glomerulosa** synthesize and secrete hormones called **mineralocorticoids**. Aldosterone is the best known of these. Mineralocorticoids act primarily on the distal tubules of the kidney, the sweat glands, and the gastrointestinal tract, inducing the absorption of sodium (and water) and the secretion of potassium. Cells of the **zona fasciculata**, mediated by ACTH, secrete **glucocorticoids**. These hormones (primarily cortisol and secondarily corticosterone) stimulate the formation of glucose in the liver. Cells of the **zona reticularis** secrete the androgen dehydroepiandrosterone (DHEA) in small amounts. DHEA can convert to testosterone. These cells also secrete female **sex hormones (steroids)** (estrogen and progesterone) in small amounts. These adrenal androgens and estrogens have a limited effect during a lifetime.

The **medulla** consists of cords of secretory cells supported by reticular fibers, and an abundant collection of capillaries. Fibers of the **greater splanchnic nerve** pass through the celiac ganglia without synapsing to enter the adrenal gland. These fibers terminate on and stimulate the medullary secretory cells, 80% of which produce and release **epinephrine**; the rest secrete **norepinephrine**. These secretory cells are modified postganglionic neurons. Their secretions elicit the "fight or flight" reaction in response to life-threatening situations, as diagrammatically represented at right.

ADRENAL GLAND A

 CAPSULE A'

 ADRENAL CORTEX

 ZONA GLOMERULOSA B

 ZONA FASCICULATA C

 ZONA RETICULARIS D

 MEDULLA E

ARTERIES

SUPERIOR SUPRARENAL A. F

MIDDLE SUPRARENAL A. F'

INFERIOR SUPRARENAL A. F²

VEINS

RIGHT SUPRARENAL VEIN G

LEFT SUPRARENAL VEIN G'

SUPRARENAL PLEXUS

GREATER SPLANCHNIC N. H

CELIAC GANGLION H'

 PLEXUS H²

CN: Use red for F, blue for G, yellow for H, and a very light color for E.
(1) In the upper view, only color the labeled vessels. (2) Color the cross section through the adrenal, and related arrows and hormones. (3) Color the various organs associated with the "fight or flight" reaction, noting the listed effects.

ANTERIOR VIEW

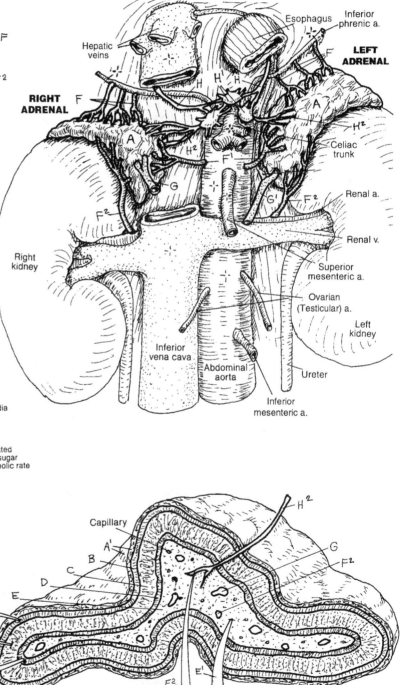

Esophagus · Inferior phrenic a.
Hepatic veins
LEFT ADRENAL
RIGHT ADRENAL
Celiac trunk
Renal a.
Renal v.
Superior mesenteric a.
Right kidney
Ovarian (Testicular) a.
Left kidney
Inferior vena cava
Abdominal aorta
Ureter
Inferior mesenteric a.

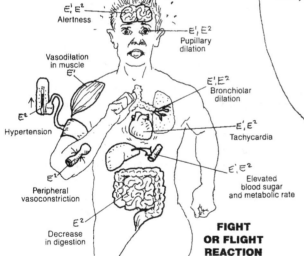

E', E² Alertness
E', E² Pupillary dilation
Vasodilation in muscle E'
E', E² Bronchiolar dilation
E² Hypertension
E', E² Tachycardia
E² Peripheral vasoconstriction
E', E² Elevated blood sugar and metabolic rate
E² Decrease in digestion

FIGHT OR FLIGHT REACTION

MINERALOCORTICOIDS B
(INCLUDING ALDOSTERONE)

GLUCOCORTICOIDS C
(INCLUDING CORTISOL)

SEX STEROIDS D
(ESTROGENS, PROGESTERONE, ANDROGENS)

HORMONES OF THE CORTEX

Capillary

HORMONES OF THE MEDULLA

EPINEPHRINE E'

NOREPINEPHRINE E²

The **pancreas** is supplied by numerous arteries springing from the celiac and **superior mesenteric arteries**. The hepatic portal vein drains the capillary networks of the exocrine tissue as well as the endocrine portion of the pancreas. Having no ducts, this endocrine portion consists of microscopic islands (**islets of Langerhans**) and are dependent upon surrounding capillaries to conduct their secreted products—*insulin*, *glucagon*, and a much smaller amount of *somatostatin*—to the liver and beyond for general circulation. Virtually every tissue in the human body is a target organ for these secretions! You may recall from page 143 that the pancreas also has a busy practice in exocrine secretions from the major part (in terms of volume) of the pancreas. These pass through a duct system (see drawing of pancreas in relation to duodenum at left of microscopic block of pancreatic tissue) that eventually terminates at the second part of the duodenum.

These islands (*islets*) of endocrine tissue (and their capillaries) in the pancreas are literally islands of loose cells (lowest left) among a much greater number of of exocrine gland cells arranged in clusters (acini) around ducts lined with cuboidal cells. These cells secrete their enzyme product directly into the duct. Interspersed among these acini and ducts are the islets revealing three or four different cell types, having no particular arrangement within the group, but associated with large numbers of capillaries. **Alpha (A) cells**, generally located in the periphery of each islet, secrete **glucagon**, a polypeptide hormone that binds to glycogen **receptors** on liver cell membranes. Glucagon induces the enzymatic breakdown of **glycogen** (a complex starch; stored form of glucose), in a process called *glycolysis*. Glucagon facilitates *gluconeogenesis*, the formation of **glucose** from glycogen in the liver. Effect: blood glucose rises.

Beta (B) cells, constituting 70% or more of the islet cell population. They secrete **insulin**, a polypeptide, in response to increasing plasma levels of glucose. Insulin acts quickly; it has a very short half-life of about 5 minutes; and then disappears. The liver and kidney take up most insulin, but almost all cells can metabolize it. Insulin expedites the removal of glucose from the circulation by increasing the number of proteins that transport glucose (glucose carriers) across cell membranes in muscle cells, fat cells, leukocytes, and others (but not liver cells). Insulin increases the synthesis of glycogen from glucose in liver cells. Uptake of insulin is facilitated by **insulin receptors** (proteins) on the external and internal surfaces of many—but not all—cell membranes. Decreased insulin secretion or decreased numbers or activity among insulin receptors leads to hyperglycemia and diabetes mellitus. The effects of insulin activity are far-reaching: mediating electrolyte transport and the storage of nutrients (carbohydrates, proteins, fats); facilitating cellular growth; and enhancing liver, muscle, and adipose tissue metabolism. **Delta (D) cells** occupy the periphery of the islet and make up about 5% of the islet cell population. They secrete *somatostatin* (growth hormone) and inhibit the secretion of glucagon and insulin.

CN: Use purple for N, and light colors for K and L. (1) In coloring the upper drawing, include the broken lines representing arteries within or on the posterior surface of the pancreas. (2) Color the microscopic section of the pancreas at lower left and the enlarged view of an islet. (3) Color the arrows and the diagram reflecting the role of glycogen and insulin receptors in liver cells with respect to glucose and glycogen.

ARTERIES TO THE PANCREAS

GASTRODUODENAL & BRANCHES A
ANTERIOR PANCREATICO-DUODENAL A. B
POSTERIOR PANCREATICO-DUODENAL A. C
SPLENIC & BRANCHES D
DORSAL PANCREATIC A. E
INFERIOR PANCREATIC A. F
GREAT PANCREATIC A. G
SUPERIOR MESENTERIC A. H
INFERIOR PANCREATICO-
DUODENAL A. I

PANCREATIC ISLET
(ENDOCRINE) J
ALPHA CELL K
GLUCAGON K'
RECEPTOR K²
BETA CELL L
INSULIN L'
RECEPTOR L²
DELTA CELL M
BLOOD CAPILLARY N

GLYCOGEN O GLUCOSE P

BLOOD SUPPLY TO PANCREAS

Labels on upper figure: L. gastric a., L. gastroepiploic a., STOMACH, Abdominal aorta, Celiac trunk, Common hepatic a., PANCREAS, SPLEEN, JEJUNUM, DUODENUM

PANCREATIC ISLET

Labels: Pancreatic duct, Digestive enzymes, Duodenum, Pancreatic acini (exocrine glands), **MICROSCOPIC SECTION**

REGULATION OF GLUCOSE LEVELS IN BLOODSTREAM

Labels: BLOODSTREAM, EXOCRINE GLAND (Acinus), ENDOCRINE GLAND (Pancreatic Islet), Glucagon receptor, Insulin receptor, Enzyme actions, Glycogen breakdown, GLYCOGEN, Protein synthesis, Fatty acid synthesis, Glycogen synthesis

LIVER CELL (Low blood sugar conditions)

LIVER CELL (High blood sugar conditions)

The **male reproductive system** consists of the testes, a series of ducts, a number of glands, and the **penis.** Pronounced "tes-tees" (sing. *testis*), the **testes** are the primary organs of the system. The testes appear to be (but are not) suspended by the paired **spermatic cords** within a sac of skin and thin layer of fibromuscular tissue (*scrotum*).

Development of the male germinating cells (*sperm, spermatozoa*) in the testes requires a temperature slightly lower than that of the body (about 35°C or 95°F); this can be achieved in the **scrotum**, where the germ cells are separated from the warmer body and body cavities. The temperature within the scrotum can be adjusted slightly by the contraction/relaxation of smooth muscle (*dartos muscle*) in the scrotal wall, tightening or loosening the tension (tightness) of the scrotal skin about the testes.

Mature sperm are stored in the **epididymis**. With stimulus, in addition to their own motive power, sperm cells are induced to move quickly through the epididymis and **ductus deferens** by rhythmic contractions of the smooth muscle in the ductal walls. The ductus deferens, with its blood vessels and coverings, enters the superficial inguinal ring (at the medial attachment of the inguinal ligament). It passes through the abdominal wall (*inguinal canal*) for about 4 cm to emerge through the deep inguinal ring, wrapped in a layer of transversalis fascia (internal spermatic fascia) deep to the oblique muscles of the abdomen (see page 49). Each ductus deferens enters the retroperitoneal pelvic cavity, passes over the iliac vessels, crosses the ureter, and bends sharply behind the urinary bladder to descend and join with the duct of the **seminal vesicle** in the posterior wall of the **prostate gland** to form the pencil-point-shaped **ejaculatory duct** that opens into the *prostatic* **urethra**. Here the nutrient-rich secretions of the prostate gland and seminal vesicles are added to the population of sperm (*semen*). Prior to the expulsion of semen (*ejaculation*), the **bulbourethral glands** add secretions to the *spongy* urethra providing lubrication during intercourse.

Each **testicular artery** (see page 111) arises from the abdominal aorta just below the renal arteries. The *testicular vein* leaves the testis as the **pampiniform plexus of veins** (see lower illustration). In this view, the relationships of the testicular artery and the ductus deferens to the venous plexus can be seen. A small part of the internal spermatic fascia (K) can be seen as well (recall page 49). For the larger view of the merging of the testicular veins with the inferior vena cava (right side) and left renal vein, see page 116.

SCROTUM ᴀ
TESTIS ᴮ
EPIDIDYMIS ᴄ
DUCTUS DEFERENS ᴅ
SEMINAL VESICLE ᴇ
EJACULATORY DUCT ꜰ
URETHRA ɢ
BULBOURETHRAL GLAND ʜ
PROSTATE GLAND ɪ
PENIS ᴊ

CN: Use red for L, blue for M, and very light colors for A, J, and K.
(1) Color the composite sagittal and composite coronal section/anterior views together. (2) Color the anterior view below; be especially observant while coloring the dissected view of the coverings and constituents of the spermatic cord.

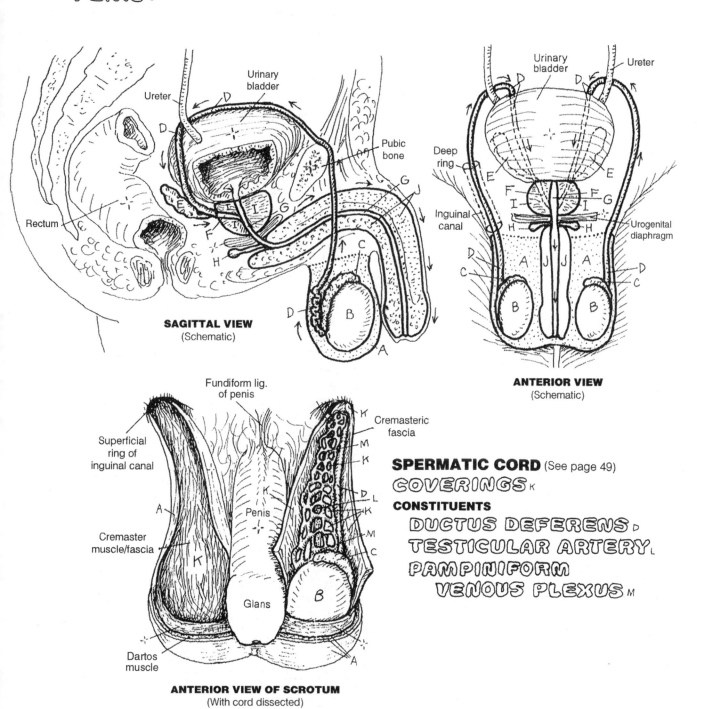

SAGITTAL VIEW
(Schematic)

ANTERIOR VIEW
(Schematic)

ANTERIOR VIEW OF SCROTUM
(With cord dissected)

SPERMATIC CORD (See page 49)
COVERINGS ᴋ
CONSTITUENTS
DUCTUS DEFERENS ᴅ
TESTICULAR ARTERY ʟ
PAMPINIFORM
 VENOUS PLEXUS ᴍ

The **testes** have two principal functions: development of male germ cells (**sperm** or **spermatozoa**) that, in conjunction with female germ cells (see page 159) make possible perpetuation of the species. They also secrete *testosterone*, the male sex hormone.

Each testis has a dense, fibrous outer capsule (**tunica albuginea**), from which **septa** (sing., **septum**) are directed centrally to compartmentalize the testis into lobules. One to four highly coiled **seminiferous tubules**, each lined by a **basement membrane** (*basal lamina*), take up each lobule. It is in these tubules that spermatozoa develop. These convoluted tubules converge toward the posterior side of their lobules, straighten out (*tubuli recti*), and join a network of epithelial-lined spaces (**rete testis**). **Efferent ducts** leave the rete to form the head of the **epididymis**. The convoluted duct of the epididymis (**head, body, tail**) is lined with pseudostratified columnar epithelium, one type of which contains long, immobile cilia (*stereocilia*; not shown). At the lower portion of the epididymis, each tubule turns upward to form the **ductus deferens**. The wall of this duct, lined with pseudostratified columnar epithelium with stereocilia, contains significant smooth muscle. The rhythmic contractions of these muscle cells drive sperm toward the prostate gland during emission.

Each seminiferous tubule consists of a basement membrane-lined tubule with a central lumen and layers of compact, organized cells (**spermatogenic epithelia**) and a lesser number of larger **Sertoli (supporting) cells**. The basement membranes incorporate flat, thin cells called *fibromyocytes* (peritubular or myoid cells) that lay down fibrous tissue and have the ability to shorten, assisting the movement of cells within and through the tubules.

Spermatogenesis begins with sperm-developing cells called **spermatogonia**. These divide, and the daughter cells are pushed out toward the lumen where they differentiate into **primary spermatocytes**, the largest of the developing germ cells. When they divide to become **secondary spermatocytes**, the chromosome number is reduced from 46 to 23 (by meiosis). Each pair of newly formed secondary spermatocytes rapidly divides again to form four **spermatids**. These small cells mature by developing tails, condensing their nuclei and cytoplasm, and developing caps or **acrosomes** with an arsenal of enzymes to break down the wall of the ovum and permit penetration.

The mature sperm cell (**spermatozoon**) consists of a **head** *of* 23 chromosomes (nucleus), including the acrosome; a **middle piece** featuring **mitochondria** to power cell movement; and a **tail** (essentially, a single flagellum), whose flagellations provide the cell's motive force. However, early spermatozoa are essentially immotile and incapable of fertilizing ova. They are swept into the epididymis from the rete testis and efferent ducts by ciliary action and fluid flow. There they mature into potent and motile sperm cells.

The **interstitial cells** are dispersed in the vascular interstitial tissue around the tubules. They include fibroblasts and secretory cells (**of Leydig**), known to produce and secrete testosterone and stimulate the development of ducts and glands of the male reproductive tract at puberty (generally between 11 and 14 years of age) as well as secondary sex characteristics (see glossary).

CN: Use the colors employed for the testis, epididymis, and ductus deferens on page 155 with those same structures here, A, E, and F. Use red for U and light colors for G, H, I, S, and T. (1) Note that the spermatogenic epithelium is colored gray in the cross section through the tubules and that the tubular lumen is not to be colored.

TESTIS A
 TUNICA ALBUGINEA A'
 SEPTUM A²
 SEMINIFEROUS TUBULE B
 RETE TESTIS C
 EFFERENT DUCT D

EPIDIDYMIS E
 HEAD E'
 BODY E²
 TAIL E³

DUCTUS DEFERENS F

SPERMATOGENIC EPITHELIUM

SPERMATOGONIUM G
PRIMARY SPERMATOCYTE H
SECONDARY SPERMATOCYTE I
SPERMATID J
SPERMATOZOON K
 HEAD
 ACROSOME L
 NUCLEUS M
 TAIL
 NECK N
 MIDDLE PIECE O
 MITOCHONDRION P
 PRINCIPAL PIECE Q
 END PIECE R

SERTOLI (SUPPORTING) CELL S
BASEMENT MEMBRANE B'
INTERSTITIAL CELL (OF LEYDIG) T
BLOOD VESSEL U

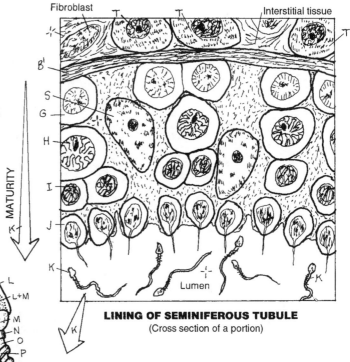

Urinary bladder

FLOW OF SPERM

Seminal vesicle

Prostate gland

Bulbourethral gland

Connective tissue

Lobules

Testosterone

Capillary

Lumen

SECTIONAL VIEW OF TESTIS
(Schematic)

Tubuli recti

Fibroblast

Interstitial tissue

MATURITY

LINING OF SEMINIFEROUS TUBULE
(Cross section of a portion)

Head

Body

Tail

SPERMATOZOON
(Sperm cell)

Before coloring, please review pages 50 (pelvic muscles), 51 (perineal muscles), 113 (arteries of the pelvis and perineum), and 155 (male reproductive system).

The **urethra** in the male is 20 cm or so long. It has three parts. The **prostatic urethra** (the first part of the urethra) is located entirely within the substance of the prostate gland. There the urethra receives urine from the urinary bladder, semen from the ejaculatory ducts bilaterally, seminal fluid from the seminal vesicles bilaterally at the termination of the ductus deferens, and secretions from numerous prostatic tubuloalveolar glands that open into the urethra via several ducts. Reflex contraction of the bladder neck muscles prevents voiding of urine during the expulsion of semen. The base of the prostate is separated from the urogenital diaphragm (perineal membrane) by a layer of fascia, with thin fibers of the levator prostatae from the pelvic diaphragm (see page 50).

The second part of the urethra is the **membranous urethra** that descends through the deep perineal space/membrane. Recall from your study of the **urogenital diaphragm** (UGD; page 51) that the deep perineal membrane consists of two (superior and inferior) fascial layers (like the two slices of bread in a sandwich), and the sandwich "meat" in between: the sphincter muscle of the urethra, the bulbourethral glands, and the deep transverse perineal muscles. The urethra here is well fixed; indeed, perhaps *too* fixed, as it is subject to trauma (such as laceration or transection) in blunt or sharp force trauma to the perineum, as occurs in some automobile collisions or falls from heights.

The **spongy urethra** passes through the **bulb of the penis** and the **corpus spongiosum**. Numerous mucus glands exist in the urethral mucosa. The ducts of the **bulbourethral glands** empty into the spongy urethra immediately inferior to the UGD. The urethra is open to the outside of the body through the meatus or orifice at the end of the **glans penis.**

The **penis** consists of three bodies of erectile tissue, ensheathed in two layers of fasciae. The **corpora cavernosa** (the two lateral bodies) arise from the ascending rami of the pubic bones. The central **corpus spongiosum** arises as a **bulb** suspended from the inferior fascia of the UGD. Each erectile body (erectile tissue) consists of endothelial-lined fibroelastic spaces (cavernous sinuses), with some smooth muscle, and is encapsulated with a fibrous capsule (*tunica albuginea*). The three bodies are bound together in a dense stocking of **deep perineal fascia** and hang as a unit suspended by the deep suspensory and more superficial fundiform ligaments. Between the tunica albuginea and the skin is a layer of **superficial fascia**. During sexual activity, arteries here dilate secondary to increased parasympathetic activity, and the volume of blood entering the cavernous sinuses increases, expanding the erectile tissue. As a result, the veins at the periphery of the erectile bodies deep to the tunica albuginea are pressed against the capsule and unable to drain blood. The penis enlarges and hardens (*erection*); the glans remains nonrigid.

MALE UROGENITAL STRUCTURES

CN: Use blue for I, red for J, yellow for K, and very light colors for D, E, and G. (1) Color the two views on the right side together. Note that the superficial and deep fascia, G and H, have been omitted from the coronal view. (2) Color the structural view and the cross section of the penis.

URETHRA
PROSTATIC U. A
MEMBRANOUS U. B
SPONGY U. C

PENIS
CORPUS CAVERNOSUM D
CRUS OF PENIS D'
CORPUS SPONGIOSUM E
BULB OF PENIS E'
GLANS PENIS E²
PREPUCE (FORESKIN) F

RELATED STRUCTURES
SUPERFICIAL FASCIA G
DEEP FASCIA H
VEIN I
ARTERY J
NERVE K
SUSPENSORY LIGAMENT L
LEVATOR ANI (PELVIC DIAPHRAGM) M
UROGENITAL DIAPHRAGM N
BULBOURETHRAL GLAND O

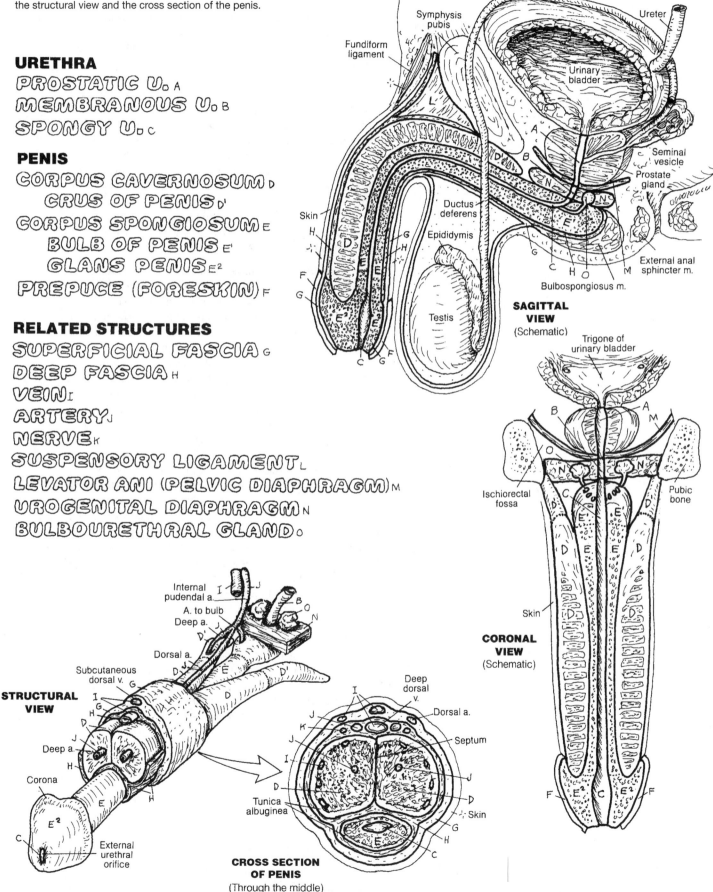

SAGITTAL VIEW (Schematic)

CORONAL VIEW (Schematic)

STRUCTURAL VIEW

CROSS SECTION OF PENIS (Through the middle)

The primary organ of the female reproductive system is the **ovary**, which produces the female germ cells (*ova*) and secretes the hormones *estrogen* and *progesterone*. Each ovary arises on the posterior abdominal wall in the lumbar region during early fetal development. Like the descent of the testes, the ovary is interrupted early in its downward journey by the round ligament and is retained in the true pelvis. The **uterus** serves as a site for implantation and nourishment of the developing embryo/fetus. The **uterine tubes** provide a conduit for the newly fertilized or unfertilized ovum en route to the uterus; the uterine end of the tube can also be an implant site for a confused fertilized ovum that implants there (ectopic pregnancy; a potentially life-threatening event). The **vagina**, a fibromuscular sheath, receives the penis in sexual intercourse, provides a path for the semen to reach the uterus, and acts as a birth canal for the newborn entering a new and really different world. See pages 159 and 160.

The female **external genitals** (*vulva*) are structures associated with the facilitation of a successful and possibly productive union by sexual partners, and delivery of a newborn that is successful for both the mother and child. The external genitals are located in the superficial perineum (page 51). The **labia majora** are fat-filled folds of skin that arise anteriorly from the anterior commissure of the vulva and never quite merge posteriorly as they become part of the skin over the perineal body. Medial to the labia majora, and on either side of the vagina and urethra, are two thin, non-fatty folds of skin (**labia minora**). The space or cavity between them is the **vestibule** into which the vagina and urethra open. These smaller labia can be followed anteriorly to the **glans** and **body** of the **clitoris**, around which folds of the labia minora pass over the head and body of the clitoris like a shawl (**prepuce**) and under the head (**frenulum**) like the ends of the shawl tied together under the chin. Posteriorly, the minor labia come together (*fourchette*) over the perineal body. This fusion is indistinct after sexual activity begins. Like the penis, the clitoris has an erectile **crus** (pl., *crura*) arising from each ischiopubic ramus; the two crura join in the midline to form the erectile **body** or corpus. This body is enclosed in fascia and capped by a skin-covered, vascular, sensitive **glans clitoridis**. The rigidity of the clitoris is accomplished by the same mechanism operative in the penis; however, the clitoris, unlike the penis, does not incorporate the urethra. The erectile **bulbs of the vestibule** are homologous with the bulb of the penis, but separated into two bodies. They are covered by the bulbospongiosus muscle and protrude into the vagina during sexual stimulation. The immature vaginal orifice is often closed or partly so by a thin mucosal membrane (**hymen**); the mature vaginal orifice is often surrounded by a thin remnant of this mucosa that was often torn with general physical or sexual activity.

CN: (1) Color the two upper views of the internal reproductive structures together. In the medial view, color the double line representing the cut edge of the parietal peritoneum and the broader peritoneal lining, Q, of the abdominal and pelvic walls a light gray. (2) In both lower drawings, color the vestibule, N, a very light gray after coloring orifices D¹ and O, and the inner walls of F.

INTERNAL ORGANS
OVARY A
UTERINE (FALLOPIAN) TUBE B
UTERUS C
VAGINA D

EXTERNAL GENITALS
LABIUM MAJUS E
LABIUM MINUS F
FRENULUM G
PREPUCE H
CLITORIS I
GLANS I'
BODY J
CRUS K
BULB OF THE VESTIBULE L
VESTIBULAR GLAND/DUCT M
VESTIBULE N*
URETHRAL ORIFICE O
VAGINAL ORIFICE D'
HYMEN P
PARIETAL PERITONEUM Q

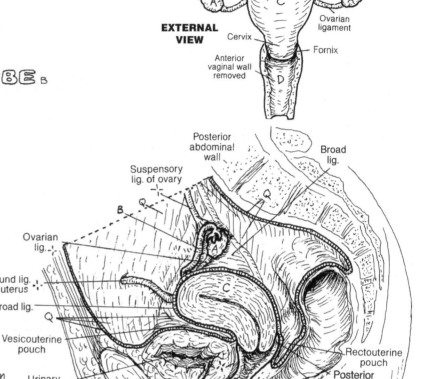

EXTERNAL
VIEW

Ovarian ligament
Cervix
Fornix
Anterior vaginal wall removed

Posterior abdominal wall
Suspensory lig. of ovary
Broad lig.
Ovarian lig.
Round lig. of uterus
Broad lig.
Vesicouterine pouch
Urinary bladder
Pubic bone
Urethra
Rectouterine pouch
Posterior fornix
Rectum
Anus
Anal canal

MEDIAL VIEW
(Right side, genitourinary structures)

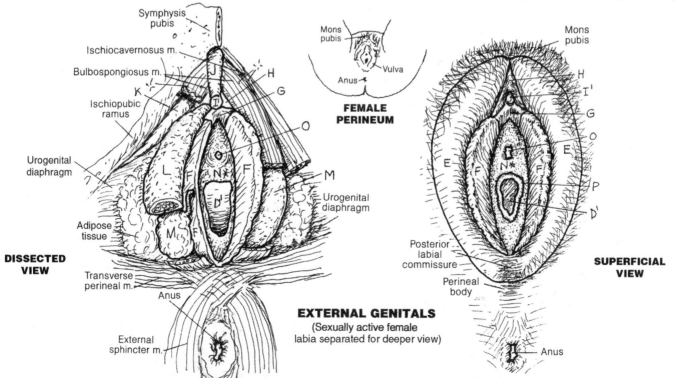

Symphysis pubis
Ischiocavernosus m.
Bulbospongiosus m.
Ischiopubic ramus
Urogenital diaphragm
Adipose tissue

DISSECTED VIEW

Transverse perineal m.
Anus
External sphincter m.

Mons pubis
Vulva
Anus

FEMALE PERINEUM

Urogenital diaphragm

Mons pubis

Posterior labial commissure
Perineal body

SUPERFICIAL VIEW

Anus

EXTERNAL GENITALS
(Sexually active female labia separated for deeper view)

The **ovaries**, each 3 cm long and 1.5 cm wide, or smaller, are on the side of the true pelvis and attached to the posterior layer of a double fold of parietal peritoneum (**broad ligament**), draped over the ovaries, uterine tubes, and uterus like a blanket hanging over a clothesline runs from side to side. See page 160. Between the ovary and the opening (*fimbria*) of the **uterine tube** is a space continuous with the peritoneal cavity into which few enter and none return. On expulsion from the ovary, the ovum must avoid this abyss or be lost in space and miss the opportunity of a lifetime.

The ovary is lined with a single layer of cuboidal cells derived from mesothelium. Primordial ova migrate from the embryonic yolk sac into the **ovarian stroma** and proliferate. Hundreds of thousands of these develop; only a few hundred ever reach maturity.

The two primary activities of the ovary are (1) the development of female germ cells (*ova*) in the follicular phase, and (2) the secretion of *estrogen* and *progesterone* in the luteal or secretory phase. The ovary reveals many follicles in various stages of development in a cushion of cells and loose connective tissue (*ovarian stroma*). An ovarian follicle consists of an immature epithelial germ cell (**oocyte**) surrounded by one or more layers of nongerminating support cells.

Development of an **ovum** starts with the **primordial follicle**—an oocyte with one layer of follicular cells. The oocyte increases in size and maturity as the follicle cells increase in number around it, forming a **primary follicle**. In **secondary follicles**, a small cavity (*antrum*) appears, filled with follicular fluid. This antrum continues to expand at the expense of the follicle cells, which are pushed away from the oocyte except for a single layer of cells (**mature** or **Graafian follicle**). Those cells secrete estrogen during the follicular phase of the reproductive cycle. Follicles that cease to develop at any stage are said to be "atretic."

On about the 14th day of the cycle (see "Ovarian Cycle"), a glycoprotein coat—the *zona pellucida*—surrounds the ovum of the mature follicle, fully prepared for ovulation. A *corona radiata* of cells and the zona pellucida-lined ovum burst from the follicle into the waiting fingers (**fimbriae**) of the uterine tube. The **ruptured follicle**, its oocyte discharged, involutes. Some bleeding and clotting goes on (**corpus hemorrhagicum**) as the follicle cells transition into a **corpus luteum**, characterized by accumulating large amounts of lipid necessary for subsequent secretion of steroid hormones.

The corpus luteum secretes estrogen and progesterone during this *luteal phase* of the cycle; in the event of pregnancy, it will support the developing embryo/fetus for up to three months with these secretions. Should fertilization not ensue, the corpus luteum will degenerate as a **corpus albicans**. Follicles and corpora albicans/lutea collectively, relating to two or more different but sequential cycles, can usually be seen in the ovary at any one time.

OVARIAN STRUCTURES

EPITHELIUM / TUNICA ALBUGINEA A
CONNECTIVE TISSUE STROMA B*

OOCYTE DEVELOPMENT

OOCYTE / OVUM c
PRIMORDIAL FOLLICLE D
PRIMARY FOL. E
SECONDARY FOL. F
MATURING FOL. G
MATURE (GRAAFIAN) FOL. H
RUPTURED FOL. I
DISCHARGED OVUM c'
ATRETIC FOL. J
CORPUS HEMORRHAGICUM K
YOUNG CORPUS LUTEUM L
MATURE CORPUS LUTEUM L'
CORPUS ALBICANS L²+

RELATED STRUCTURES

UTERINE TUBE M
FIMBRIAE M'
BROAD LIGAMENT N
MESOSALPINX O
MESOVARIUM P
SUSPENSORY LIGAMENT
OF OVARY Q
OVARIAN ARTERY R
OVARIAN VEIN S
UTERINE ARTERY R'
UTERINE VEIN S'
OVARIAN LIGAMENT T

CN: Use the colors from page 158 for the ovary, A, and uterine tube, M. Use red for K and R, yellow for L, blue for S, and very light colors for C–J, M, O, and P. (1) Color the development of the female germ cell in both upper and lower views of the sectioned ovary. The oocyte, C, is colored through ovulation. In the large illustration, color the background stroma, B, gray.

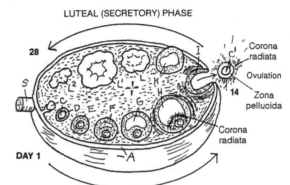

LUTEAL (SECRETORY) PHASE

28

DAY 1

Corona radiata
Ovulation
Zona pellucida
Corona radiata

FOLLICULAR (PROLIFERATIVE) PHASE

OVARIAN CYCLE

Uterus

UTERUS & OVARIES
(Posterior view)

Tubal branch
of uterine
artery and vein

Blood vessel

Branches of
ovarian a. and v.

Zona
pellucida

Cut edge
of mesosalpinx

**POSTERIOR
VIEW**
(Schematic)

Antrum

Stroma

Cut edge
of broad lig.

Cut edges
of mesovarium

The **uterus** and **uterine tubes** are covered by the fold (an upside down "U"–shaped) of the **broad ligament.** The uterine tubes, suspended in a part of the broad ligament (*mesosalpinx*), are lateral extensions of the uterus. The tubes are lined with nutrient-loaded ciliated columnar epithelium supported by connective tissue and smooth muscle. The rhythmic contractions of this muscle aid the ovum in its trek from the fimbriae to the **uterine cavity** (assuming it avoids the abyss!), and the lining cells support it nutritionally. The tube is about four inches long and has three rather distinct parts: The distal **fimbriae** (finger-like projections), which catch the discharged ovum and whisk it into the tubular lumen; the **ampulla**, or widest part of the tube; and the **isthmus**, the lumen of which narrows as it enters the uterine cavity.

The uterus is a pear-shaped structure about three inches long; it gets bigger in pregnancy. The upper part (above the tubal orifices) is the **fundus**; the central part is the **body** or *corpus*, and the lower one inch is the **cervix**.

The uterus is anterverted (tilted forward) and anteflexed (bent for-ward) relative to the vagina. Its neck (cervix) fits into the upper part of the vagina at about a right angle (anteflexed) and the uterine body (fundus) is bent (anteflexed) and tilted (anteverted) anteriorly over the bladder. Backward bending/tilting (retroflexion/retrover-sion) of the uterus is not uncommon, particularly in women who have given birth. The retroflexed uterus is predisposed to mild slipping into the vagina (*prolapse*), as the uterus is more in the axis of the cervix/vagina. Such a happening is generally resisted by the pelvic and urogenital diaphragms, the perineal body, and numerous fibrous ligaments (broad ligament and condensations of the pelvic fasciae, not shown) that moor the uterus and its tubes to the pelvic wall and sacrum. The wall of the uterus is largely smooth muscle (**myometrium**) lined with a glandular surface layer of variable thickness (**endometrium**) that is extremely sensitive to the hormones estrogen and progesterone.

The *cervix* of the uterus, one inch or so in length, has two parts: the superior supravaginal and the lower vaginal part. The muco-sal lining of the cervix is characterized by intersecting ridges that resist bacterial onslaughts post-menses. The cervical mucosa does not participate in the periodic thickenings and thinnings experienced by the uterine body's mucosa.

The **vagina** is an elastic, fibromuscular tube with a mucosal lin-ing of stratified squamous epithelium. The anterior and posterior mucosal surfaces are normally in contact. The anterior vaginal wall incorporates the short (4 cm) urethra. The mucosa of the vagina lacks glands; secretory activity during sexual stimulation is derived from a transudate of plasma from local capillaries and glands in the cervix, and secretion from the male bulbourethral glands. The vaginal lining reveals few sensory receptors. Where the cervix fits into the vagina, a circular moat or trough is formed around it (*fornix, fornices*). The fibroelastic posterior **fornix** is capable of significant expansion during intercourse.

UTERUS, UTERINE TUBES, & VAGINA

CN: Use red for N, blue for O, and light colors for D, E, and Q. (1) Begin with the left half of the large illustration. Only parts of the ovarian and uterine veins are shown. Nerves and lymph vessels that may accompany arteries and veins are not shown. (2) Color the two views of the anteflexed and the retroflexed uterus; above, color the major ligaments.

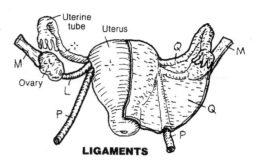

LIGAMENTS

ANTERIOR VIEW
(Structures on right side dissected in coronal and sagittal planes)

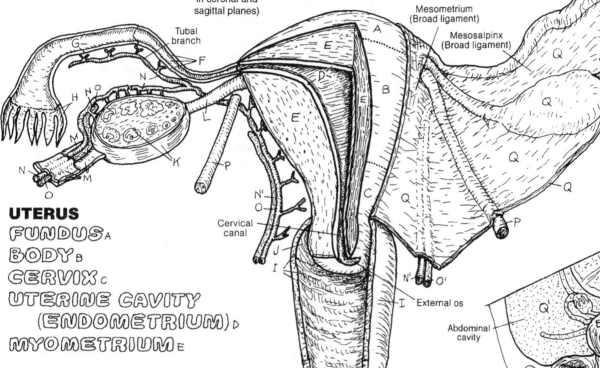

Tubal branch

Mesometrium (Broad ligament)

Mesosalpinx (Broad ligament)

Cervical canal

External os

UTERUS

FUNDUS A

BODY B

CERVIX C

UTERINE CAVITY
(ENDOMETRIUM) D

MYOMETRIUM E

UTERINE TUBE

ISTHMUS F

AMPULLA G

FIMBRIA H

VAGINA I

FORNIX OF VAGINA J

RELATED STRUCTURES

OVARY K

OVARIAN LIGAMENT L

SUSPENSORY LIG. OF OVARY M

OVARIAN ARTERY N

OVARIAN VEIN O

ROUND LIG. OF UTERUS P

UTERINE ARTERY N'

UTERINE VEIN O'

BROAD LIG. Q (PERITONEUM) Q'

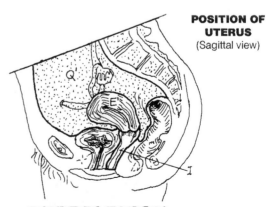

Abdominal cavity

Urinary bladder

Rectum

RETROFLEXION (TIPPED) E'

POSITION OF UTERUS
(Sagittal view)

ANTEFLEXION (NORMAL) E'

The 28-day human female reproductive cycle, initiated and maintained by hormones, involves significant alterations in follicular and endometrial structure. The cycle, which begins at about 12 years of age (*menarche*) and ends at about 45 years of age (*menopause*), is characterized by periods of endometrial breakdown and discharge (**menstruation**). During each cycle, the progressive changes that occur in the ovary and uterus serve to develop and release the female germ cell for possible fertilization by the male germ cell and to prepare the endometrium for implantation of the fertilized ovum.

The *menstrual period* constitutes the first five days of the cycle, with loss of endometrial tissue and attendant bleeding. Endometrial growth begins on about the fifth day of the **menstrual cycle**. This growth is precipitated by hormones from the ovarian follicles (regulated by hormones from the anterior pituitary gland [FSH and LH]). The hormonal levels are relatively flat, but look at the endometrial growth! During the last few days of the previous cycle and the first several days of the next, these hormones (**FSH** and LH) and estrogen drive uterine development and stimulate follicular development.

Follicular development starts to produce estrogen on about day 7; note the increase in estrogen levels and its influence on endometrial growth. On about day 14, the spike in LH blood level, in conjunction with the rising titers of FSH and estrogen, brings on **ovulation**. This leads to bursting of the **mature ovarian follicle** and release of the immature ovum into the fimbriae of the uterine tube. Following ovulation, the burst follicle undergoes significant reconstruction (**corpus luteum**) influenced by luteinizing hormone (**LH**). On about the 21st day, the corpus luteum secretes **progesterone** and **estrogen**, a winning combination for enhancing endometrial **gland** development. The fibrous stroma soon becomes edematous with secretions. **Spiral arteries** are physically forced to take tortuous turns around the many proliferating glands. If fertilization occurs on or about day 16, the corpus luteum becomes the principal source of hormones for the next 90 days.

In the absence of fertilization, the corpus luteum begins to involute (forming a **corpus albicans**) about day 26, and estrogen/progesterone levels drop precipitously. In the absence of hormonal stimulation, the endometrium experiences reduced glandular secretion while fluid absorption by the local veins continues unabated, and in a short time the tissues collapse like a delicate cake in the oven when the oven door is slammed shut! The spiral arteries are flexed by these events, rupture, and **hemorrhage** with considerable hydraulic force, disrupting the epithelial lining, glands, and fibrous tissues. But for its stratum basale, the structural integrity of the endometrium is essentially destroyed. Reflex vasoconstriction limits hemorrhage. Disrupted tissue (menstruum, glandular tissue, and secretions), blood, and one or more unfertilized ova gravitate toward the vagina. After 3–5 days of **menstruation**, only about 1 mm (in height) of endometrium remains for regeneration. Within the next two weeks, it will regenerate 500% to a height of about 5 mm.

OVARIAN CYCLE

PRIMORDIAL FOLLICLE A

PRIMARY FOL□ A'

SECONDARY FOL□ A²

MATURE FOL□ A³

OVULATION A⁴

CORPUS LUTEUM B, B'

CORPUS ALBICANS B²:·

HORMONAL CYCLE

HYPOPHYSEAL HORMONES

FSH C

LH D

OVARIAN HORMONES

ESTROGEN E

PROGESTERONE F

MENSTRUAL CYCLE

PHASES

MENSTRUATION G

PROLIFERATIVE H

SECRETORY I

ENDOMETRIUM

EPITHELIUM J

GLAND I'

SPIRAL ARTERY G'/HEMORRHAGE G²

CN: Use yellow for B, red for G–G², and a very light color for A. (1) Color the time bar of the menstrual cycle at the bottom of the main diagram. Color the arrows C and D in the "Hormonal Influences" drawing. Then color the hormonal curves C and D in the main diagram, followed by the different stages of follicular development of the ovarian cycle at the top of the main diagram, A, B, noting how these hormones influence the follicular changes. (2) Color the arrows E and F and the endometrium in the "Hormonal Influences" diagram. Color the hormonal curves E and F in the main diagram, followed by the changes in the uterine glands/tissues in the menstrual cycle, noting how these hormones influence endometrial growth and menstruation. Color only the epithelial surface, glands, and vessels of the endometrium; do not color the connective tissue. (3) The days indicated are averaged (approximate). The hormonal curves reflect relative plasma hormone levels and are not absolute values.

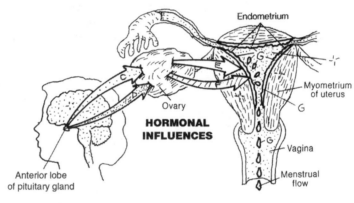

HORMONAL INFLUENCES

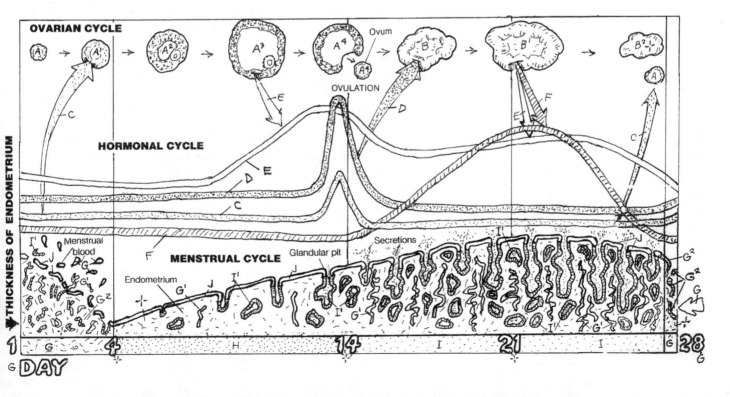

The **breast** (in both males and females) is in the **superficial** (subcutaneous) **fascia** overlying the **pectoralis major muscle** on the anterior chest wall. It is an area of fatty (adipose and loose areolar) fibrous tissue, with associated nerves and blood and lymphatic vessels. The fatty tissue is supported by extensions of the **deep fascia** overlying the muscle (**suspensory ligaments**) and functions most prominently in the young, well-developed, postpubescent female breast. Packed within the adipose tissue is a collection of branching ducts (*lactiferous ducts*). In the male and in the nonpregnant (nonlactating) female, these ducts are undeveloped. Few or no glands (alveoli) are associated with the ducts in those populations. At puberty, the increased secretion of estrogen from the ovaries (and perhaps the adrenal glands) in the female influences an enlargement of the nipple and areola and a generally marked increase in local fat proliferation. As a result, the breast enlarges to some degree, though it is highly variable.

In the early stages of pregnancy, the **lactiferous duct** system undergoes profound proliferation, and small, inactive **tubular** and **alveolar (tubuloalveolar) glands** form, opening into alveolar ducts. A **lobule** consists of a number of these ducts and glands. A **lobe** (of which there are 15–20) consists of a number of lobules and an interconnecting *interlobular duct*. The interlobular ducts converge to form as many as 20 **lactiferous ducts**. These ducts dilate to form **lactiferous sinuses** just short of the nipple, and then narrow again within the nipple. These sinuses probably function as milk reservoirs during lactation. The **nipple** consists of pigmented skin with some smooth muscle fibers set in fibrous tissue. Erection of the nipple may enhance flow of milk through the ducts. The circular **areola**, also pigmented more highly than the surrounding skin, contains sebaceous glands that may act as a skin lubricant during periods of nursing. In the latter stages of pregnancy, the alveolar glands undergo maturation and begin to form milk. Milk production peaks after delivery of the newborn, as the result of the action of several hormones influencing the gland cells. The movement of milk toward the ducts (called *letdown*) and excretion of the milk to the nipple is the result of a neuroendocrine reflex mechanism initiated by the baby's sucking on the nipple.

The lymphatic vessels are an important part of the breast; they drain the fat portion of the milk produced during lactation. They also transfer infected material or neoplastic (cancer) cells from the breast to more distant parts. The potential lymphatic avenues for metastasis or spread of infection are shown at left.

CN: Use yellow for E; pink or tan for K, and a similar but darker color for J; and light colors for A, D, and G. (1) Color the two illustrations of the breast and underlying breast structures together. (2) Color the arrows indicating the direction of lymph flow and the lymph nodes of the chest. Note network of lymph vessels. (3) Color the diagrams of breast development. (4) Color the enlarged view of glands and ducts in the lower right corner.

BONE
RIB ₐ
CLAVICLE ₐ'

MUSCLE & FASCIA
INTERCOSTAL MUSCLE ʙ
PECTORALIS MAJOR MUSCLE ᴄ
DEEP FASCIA ᴅ

BREAST
SUPERFICIAL FASCIA (FAT) ᴇ
SUSPENSORY LIGAMENT ꜰ
GLANDULAR LOBE ɢ
LACTIFEROUS DUCT ʜ
LACTIFEROUS SINUS ɪ
NIPPLE ᴊ
AREOLA ᴋ

LYMPHATIC DRAINAGE ʟ

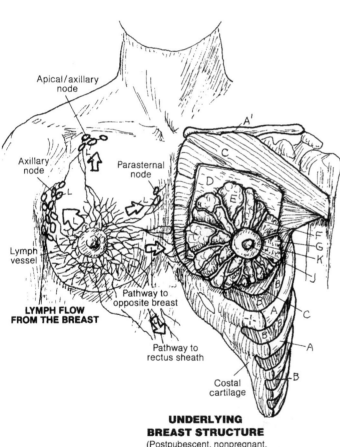

Apical/axillary node

Axillary node

Parasternal node

Lymph vessel

LYMPH FLOW FROM THE BREAST

Pathway to opposite breast

Pathway to rectus sheath

Costal cartilage

UNDERLYING BREAST STRUCTURE
(Postpubescent, nonpregnant, nonlactating)

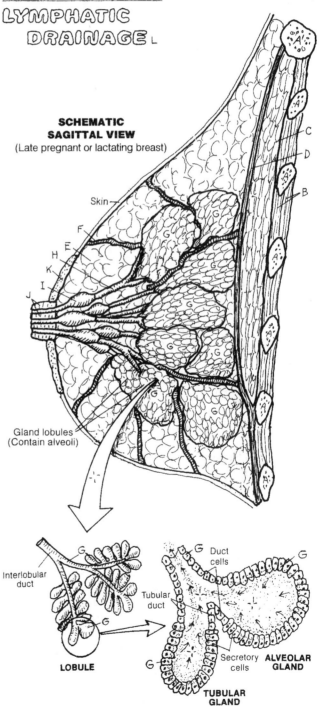

SCHEMATIC SAGITTAL VIEW
(Late pregnant or lactating breast)

Skin

Gland lobules (Contain alveoli)

Interlobular duct

Tubular duct

LOBULE

Duct cells

Secretory cells

ALVEOLAR GLAND

TUBULAR GLAND

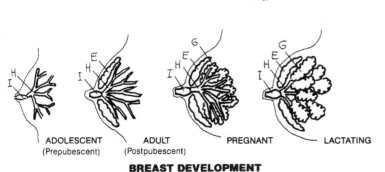

ADOLESCENT
(Prepubescent)

ADULT
(Postpubescent)

PREGNANT

LACTATING

BREAST DEVELOPMENT

BIBLIOGRAPHY AND REFERENCES

Alberts, B., Johnson, A., Lewis, J., Raff, M., Roberts, K., and Walter, P. *Molecular Biology of the Cell*, 4th ed. Garland Science, New York, 2002

Blumenfeld, H. *Neuroanatomy through Clinical Cases.* Sinauer and Associates, Sunderland, MA, 2002

Burkitt, H.G., Young, B., and Heath, J.W. *Wheater's Functional Histology.* Churchill Livingstone, Edinburgh, 1993

Diamond, M.C., Scheibel A.B., and Elson, L.M. *The Human Brain Coloring Book.* HarperCollins, New York, 1985

Dickenson, R.L. *Human Sex Anatomy*, 2nd ed. Williams & Wilkins, Baltimore, 1949

Dorland's Illustrated Medical Dictionary, 30th ed. Saunders/Elsevier, Philadelphia, 2003

DuBrul, L. *Sicher's Oral Anatomy*, 7th ed. C.V. Mosby, St. Louis, 1980

Eroschenko, V.P. *DiFiore's Atlas of Histology with Functional Correlations*, 11th ed. Wolters Kluwer/Lippincott, Williams & Wilkins, Philadelphia, 2008

Foerster, O. *The Dermatomes in Man*. Brain *56*:1–39, 1933

Gazzaniga, M.S. (ed.-in-chief), *The Cognitive Neurosciences III.* MIT Press, Cambridge, MA, 2004

Gilroy, A.M., MacPherson, B.R., and Ross, L.M. (eds.). *Atlas of Anatomy,* Thieme, New York, 2009

Guyton, A.C., and Hall, J.E. *Textbook of Medical Physiology*, 10th ed. W.B. Saunders, Philadelphia, 2000

Haymaker, W.B., and Woodhall, B. *Peripheral Nerve Injuries: Principles of Diagnosis*, 2nd ed. W.B. Saunders, Philadelphia, 1953

Hoppenfeld, S. *Physical Examination of the Spine and Extremities.* Appleton-Century-Crofts, New York, 1976

Huettel, S.A., Song, A.W., and McCarthy, G. *Functional Magnetic Resonance Imaging.* Sinauer and Assocs., Sunderland, MA, 2004

Kandel, E.R., Schwartz, J.H., and Jessell, T.M. *Principles of Neural Science*, 4th ed. McGraw-Hill, New York, 2000

Kendall, F.P., McCreary, E.K., Provance, P.G., Rodgers, M.M., and Romani, W.A. *Muscles: Testing and Function with Posture and Pain*, 5th ed. Lippincott Williams & Williams, Baltimore, 2005

Lockhart, R.D., Hamilton, G.F., and Fyfe, F.W. *Anatomy of the Human Body,* 2nd ed. Faber & Faber, London, 1965

Lockhart, R.D., Hamilton, G.F., and Fyfe, F.W. *Anatomy of the Human Body.* J.B. Lippincott, Philadelphia, 1959

Marieb, E.N., and Hoehn, K. *Human Anatomy and Physiology*, 9th ed. Pearson, Boston, 2013

Marieb, E.N., Wilhelm, P.B., and Mallatt, J. *Human Anatomy*, 6th ed. Benjamin Cummings/Pearson, San Francisco, 2012

Mescher, A.L. *Junqueira's Basic Histology.* McGraw-Hill Medical, New York, 2010

Moore, K.L. *The Developing Human: Clinically Oriented Embryology*, 6th ed. W.B. Saunders, Philadelphia, 1998

Moore, K.L., and Dalley, A.F. *Clinically Oriented Anatomy*, 5th ed. Lippincott/ Williams & Wilkins, Philadelphia, 2006

Murphy, K, *Immunobiology*, 8th ed. Garland Science/Taylor & Francis Group, London, 2012

Netter, F. *Atlas of Human Anatomy*, 4th ed. Saunders/Elsevier, Philadelphia, 2006

Nomina Anatomica, 6th ed. Churchill Livingstone, New York, 1989

O'Rahilly, R. *Gardner-Gray-O'Rahilly Anatomy.* WB Saunders, Philadelphia, 1986

Purves, D., Augustine, G.J., Fitzpatrick, D., Hall, W.C., La Mantia, A.S., McNamara, J.O., and White, L. (eds.). *Neuroscience*, 4th ed. Sinauer Associates, Sunderland, MA, 2008

Roberts, M., and Hanaway, J. *Atlas of the Human Brain in Section*, 2nd ed. Lea & Febiger, Philadelphia, 1970

Rohen, J.W., Yokochi, C., and Lütjen-Drecoll, E. *Color Atlas of Anatomy: A Photographic Study of the Human Body*, 5th ed. Wolters Kluwer/Lippincott Williams & Wilkins, Philadelphia, 2002

Romanes, G.J. (ed.). *Cunningham's Textbook of Anatomy*, 12th ed. Oxford University Press, Oxford, UK, 1981

Ross, M.H., and Pawlina, W. *Histology: A Text and Atlas.* Wolters Kluwer/Lippincott Williams & Wilkins, Philadelphia, 2011

Rosse, C., and Gaddum-Rosse, P. *Hollinshead's Textbook of Anatomy*, 5th ed. Lippincott-Raven, Philadelphia, 1997

Skinner, H. *The Origin of Medical Terms*, 2nd ed. Williams & Wilkins, Baltimore, 1961

Terminologia Anatomica, 2nd ed. Georg Thieme, New York, 2011

Warfel, J. *The Head, Neck, and Trunk: Muscles and Motor Points*, 6th ed. Lea & Febiger, Philadelphia, 1993

Warfel, J. *The Extremities*, 6th ed. Lea & Febiger, Philadelphia, 1993

Williams, P.L. (ed. & chair). *Gray's Anatomy*, 38th ed. Churchill Livingstone, New York, 1995

APPENDIX A

ANSWER KEYS

PAGE 34

Upper Limb: Bones & Joints in Review

Bones of the upper limb

A Clavicle
B Scapula
C Humerus
D Ulna
E Radius
F Carpals
G Metacarpals
H Phalanges

Joints of the upper limb

1 Acromioclavicular joint
2 Glenohumeral joint
3 Sternoclavicular joint
4 Humeroulnar joint
5 Radiohumeral joint
6 Proximal radioulnar joint
7 Distal radioulnar joint
8 Radiocarpal joint
9 Intercarpal joint
10 Carpometacarpal joint
11 Intermetacarpal joint
12 Metacarpophalangeal joint
13 Interphalangeal joints

PAGE 41

Lower Limb: Bones & Joints in Review

Bones of the lower limb

A Hip
B Femur
C Patella
D Tibia
E Fibula
F Tarsal
G Metatarsals
H Phalanges

Bones of the upper limb

A^1 Scapula
B^1 Humerus
D^1 Ulna

E^1 Radius
F^1 Carpals
G^1 Metacarpals
H^1 Phalanges

Joints of the lower limb

1 Sacroiliac joint
2 Hip joint
3 Patellofemoral joint
4 Tibiofemoral joint
5 Proximal tibiofibular joint
6 Distal tibiofibular joint
7 Ankle joint
8 Intertarsal joint
9 Tarsometatarsal joint
10 Intermetatarsal joint
11 Metatarsophalangeal joint
12 Interphalangeal joints

PAGE 58

Upper Limb: Review of Muscles

MUSCLES ACTING PRIMARILY ON THE SCAPULA

A Trapezius
A^1 Rhomboids
A^2 Serratus anterior

MUSCLES MOVING THE SHOULDER JOINT

B Deltoid
B^1 Pectoralis major
B^2 Latissimus dorsi
B^3 Infraspinatus
B^4 Teres minor
B^5 Teres major
B^6 Coracobrachialis

MUSCLES MOVING ELBOW & RADIOULNAR JOINTS

C Biceps brachii
C^1 Brachialis
C^2 Triceps brachii
C^3 Anconeus
C^4 Brachioradialis
C^5 Pronator teres

MUSCLES MOVING WRIST & HAND JOINTS

D Flexor carpi radialis
D^1 Palmar longus

D^2 Flexor carpi ulnaris
D^3 Extensor carpi radialis longus
D^4 Extensor carpi radialis brevis
D^5 Extensor digitorum
D^6 Extensor digiti minimi
D^7 Extensor carpi ulnaris

FOREARM MUSCLES MOVING THE THUMB

E Abductor pollicis
E^1 Extensor pollicis longus
E^2 Extensor pollicis brevis

THENAR MUSCLES MOVING THE THUMB

F Opponens pollicis
F^1 Abductor pollicis brevis
F^2 Flexor pollicis brevis

HYPOTHENAR MUSCLES MOVING THE 5TH DIGIT

G Opponens digiti minimi
G^1 Abductor digiti minimi
G^2 Flexor digiti minimi brevis

OTHER MUSCLES ACTING ON THE THUMB & FINGERS

H Adductor pollicis
H^1 Lumbricals
H^2 Dorsal interosseous

PAGE 66

Lower Limb: Review of Muscles

MUSCLES ACTING PRIMARILY ON THE HIP JOINT

A Obturator internus
A^1 Iliopsoas
A^2 Gluteus medius
A^3 Tensor fasciae latae
A^4 Gluteus maximus
A^5 Pectineus
A^6 Adductor longus
A^7 Adductor magnus

MUSCLES ACTING PRIMARILY ON THE KNEE JOINT

B Rectus femoris
B^1 Vastus lateralis
B^2 Vastus medialis
B^3 Sartorius
B^4 Gracilis

B⁵ Biceps femoris
B⁶ Semitendinosus
B⁷ Semimembranosus

MUSCLES ACTING PRIMARILY
ON THE ANKLE JOINT
C Gastrocnemius
C¹ Plantaris
C² Soleus
C³ Flexor digitorum longus
C⁴ Flexor hallucis longus
C⁵ Tibialis anterior
C⁶ Extensor digitorum longus
C⁷ Extensor hallucis longus
C⁸ Fibularis tertius

MUSCLES ACTING PRIMARILY
ON THE SUBTALAR JOINT
D Fibularis longus
D¹ Fibularis brevis

MUSCLES ACTING ON THE DIGITS
OF THE FOOT
E Abductor hallucis
E¹ Abductor digiti minimi
E² Extensor digitorum brevis

PAGE 114

Review of Principal Arteries
A Aortic Arch

ARTERIES OF THE UPPER LIMB
B Brachiocephalic
C Subclavian
D Axillary
E Brachial
F Radial
G Ulnar
H Deep palmar arch
I Superficial palmar arch
J Palmar digital

ARTERIES OF THE HEAD AND NECK
K Common carotid
L Internal carotid
M External carotid

ARTERIES OF THE CHEST
A Aortic arch
A¹ Thoracic aorta

N Intercostal
O Internal thoracic
P Musculophrenic
Q Superior epigastric
R Pulmonary trunk
S Pulmonary

ARTERIES OF THE ABDOMEN
AND PELVIS
A² Abdominal aorta
T Celiac
U Superior mesenteric
V Inferior mesenteric
W Renal
X Testicular/Ovarian
Y Common iliac
Z Internal iliac
1 External iliac
2 Inferior epigastric

ARTERIES OF THE LOWER LIMB
3 Femoral
4 Popliteal
5 Anterior tibial
6 Dorsalis pedis
7 Arcuate
8 Dorsal metatarsal
9 Dorsal digital
10 Posterior tibial
11 Fibular
12 Medial plantar
13 Lateral plantar
14 Plantar arch

PAGE 119

Review of Principal Veins
VEINS OF THE UPPER LIMB
A Dorsal digital
B Dorsal digital network
C Basilic
D Cephalic
E Brachial
F Axillary
G Subclavian
H Brachiocephalic
I Superior vena cava

J Digital
K Superficial palmar arch
L Deep palmar arch
M Radial
N Ulnar

VEINS OF THE HEAD AND NECK
O Internal jugular
P External jugular

VEINS OF THE CHEST
Q Pulmonary
R Intercostal
S Azygos
T Thoracoepigastric

VEINS OF THE LOWER LIMB
U Dorsal digital
V Dorsal metatarsal
W Dorsal venous arch
X Great saphenous
Y Lesser saphenous
Z Plantar digital
1 Plantar metatarsal
2 Deep plantar venous arch
3 Medial plantar
4 Lateral plantar
5 Posterior tibial
6 Dorsal
7 Anterior tibial
8 Popliteal
9 Femoral

VEINS OF THE PELVIS
AND ABDOMEN
10 External iliac
11 Internal iliac
12 Common iliac
13 Testicular/Ovarian
14 Renal
15 Inferior mesenteric
16 Splenic
17 Superior mesenteric
18 Gastric
19 Hepatic portal
20 Hepatic
21 Inferior vena cava

APPENDIX B
SPINAL INNERVATION OF SKELETAL MUSCLES

The spinal cord segments and spinal nerve roots give origin to spinal nerves whose axons are distributed among the peripheral nerves throughout the body (most of the head excepted; Vth cranial nerve; V¹, V², V³). On leaving the spinal cord, the newly formed spinal nerves divide into anterior and posterior rami (page 84). The posterior rami supply the posterior skin and posterior muscles of the neck and trunk (i.e., erector spinae muscles, multifidus, etc). The anterior rami provide the nerves for the skin and muscles of the upper and lower limbs, and the anteriolateral muscles of the trunk. This table lists the skeletal muscle of the body individually or in functionally related groups, the names of the nerves that innervate them, and the spinal cord segments or nerve roots from which the motor nerves are derived. All nerves are branches of anterior rami unless stated to the contrary, i.e., posterior rami. A nerve root number in parentheses (e.g., L2) indicates a small contribution to the nerve of the muscle cited.

The loss of a nerve supply threatens the life of a skeletal muscle. When a muscle is partially or completely denervated, its functional loss is characterized by sensory loss, reduction/loss of a related deep tendon reflex, and muscle atrophy/weakness. These signs/symptoms can be identified or recruited by a trained diagnostic examiner (e.g., physician, physical therapist, nurse practitioner, physician's assistant, etc.) and aid in the formation of an anatomical or clinical diagnosis of nerve or nerve root dysfunction, such as neuropathy or radiculopathy (*radix*, root).

Cranial nerve innervation patterns are not included here, but they can be reviewed on page 83, and a summary of their functional classification can be seen in the glossary.

Sources: W. B. Haymaker and B. Woodhall, *Peripheral Nerve Injuries, 2nd ed.* (Philadelphia: W.B. Saunders. 1953); R. D. Lockhart, G. F. Hamilton, and F. W. Fyfe, *Anatomy of the Human Body* (Philadelphia: J. B. Lippincott, 1959); P. L. Williams, ed., *Gray's Anatomy, 38th ed.* (New York: Churchill Livingstone, 1995); K.L. Moore, A.F, Dalley II, *Clinically Oriented Anatomy*, 5th ed. (Philadelphia, Lippincott, Williams & Wilkins, 2006).

Abbreviations: br./brs. = branch/-es; n./ns. = nerve/-s; spinal segment in bold face indicates primary source of innervation.

SPINAL INNERVATION OF SKELETAL MUSCLES

SKELETAL MUSCLE	NERVE SUPPLY	SPINAL CORD SEGMENT/ NERVE ROOT
NECK MUSCLES		
Sternocleidomastoid	Spinal accessory n.	C2–C5
Suboccipital muscles	Suboccipital n.	C1 dors. rt.
SUPRAHYOID M.		
Digastric	Inf. alveolar n.	V³ cr. n.
Mylohyoid	Inf. alveolar n.	V³ cr. n.
Stylohyoid	Facial n.	VII cr. n.
Geniohyoid	By way of hypoglossal n.	C1
INFRAHYOID M.		
Sternohyoid	Ansa cervicalis	C1–C3
Sternothyroid	Ansa cervicalis	C1–C3
Thyrohyoid	by way of hypoglossal n.	C1
Omohyoid	Ansa cervicalis	C1–C3

SPINAL INNERVATION OF SKELETAL MUSCLES

SKELETAL MUSCLE	NERVE SUPPLY	SPINAL CORD SEGMENT/ NERVE ROOT
ANTERIOR VERT. M.		
Rectus cap./ant./lat.	Ant. rami	C1-C2
Longus colli/capitis	Post. rami/muscular brs.	C2–C6
LATERAL VERT. M.		
Scalenus anterior	Ant. rami	C4–C6
Scalenus medius	Ant. rami	C3-C8
Scalenus posterior	Ant. rami	C6-C8
DEEP CERVICAL M.		
semispinalis capitis/cervicis	Posterior rami/	C6–C8
erector spinae/multifidus small, deep movers	muscular brs.	C2-C6
THORACIC WALL		
Thoracic diaphragm	Phrenic n.	C3–C5
Intercostal muscles	Intercostal ns.	T1-T12
Serratus posterior superior	Thoracic posterior rami	T1–T3
Serratus posterior inferior	Thoracic posterior rami	T9–T12
Subcostalis/transversus thoracis	Intercostal ns.	T12/T1–T11
ABDOMINAL WALL		
External/internal oblique	Thoracic/lumbar anterior rami	T6–T12, L1
Cremaster (from internal oblique)	Genito-femoral nerve/genital br.	L1–L2
Transversus abdominis	Thoracic/lumbar anterior rami	T6–T12, L1
Rectus abdominis	Thoracic anterior rami	T5–T12
Pyramidalis	Subcostal n.	T12
Quadratus lumborum	Thoracic/lumbar anterior rami	T12, L1–L3
DEEP BACK		
Splenius capitis/cervicis, Transversospinalis group: semispinalis capitis/cervicis, multifidus, rotatores (primarily thoracic), Erector spinae, Interspinalis, intertransversarii	Posterior rami of cervical spinal, thoracic spinal, lumbar spinal, and sacral spinal ns. (as applicable)	C1–C8, T1–T12, L1–5, S1–3
PELVIS/PERINEUM		
Levator ani	Pudendal n./sacral plexus	S2–S3
Coccygeus	Sacral plexus	S3–S4; (Co1)
Perineal muscles	Pudendal n./sacral plexus Pelvic splanchnic ns.	S2–S4
Urethral sphincter muscles	Pelvic splanchnic ns. Pudendal n. perineal/rectal br.	S2–S4 S2–S4 S4

SPINAL INNERVATION OF SKELETAL MUSCLES

SKELETAL MUSCLE	NERVE SUPPLY	SPINAL CORD SEGMENT/ NERVE ROOT
UPPER LIMB		
Trapezius	Spinal accessory n.	C1–C5
Rhomboids major/minor	Dorsal scapular n. (C5)	C4–C5
Levator scapulae	Dorsal scapular n. (C5)	C3–C5
Serratus anterior	Long thoracic n.	C5–C7
Pectoralis minor	Median/lateral pectoral ns.	C5–T1
Subclavius	Nerve to subclavius	C5–C6
Supraspinatus	Suprascapular n.	C5–C6
Infraspinatus	Suprascapular n.	C5–C6
Subscapularis	Upper/lower subscapular ns.	C5–C6
Teres minor	Axillary n.	C5–C6
Deltoid	Axillary n.	**C5**–C6
Pectoralis major	Median/lateral pectoral n.	C5–T1
Latissimus dorsi	Thoracodorsal n.	C6–C8
Teres major	Lower subscapular n.	C5–C7
Biceps brachii	Musculocutaneous n.	**C5**–C6
Brachialis	Musculocutaneous/radial ns.	C5–(C7)
Coracobrachialis	Musculocutaneous n.	C5–C7
Brachioradialis	Radial n.	C5–**C6**
Triceps brachii	Radial n.	C6, **C7**, C8
Anconeus	Radial n.	C6–C8
Supinator	Radial n.	**C6**–C7
Pronator teres	Median n.	C6–C7
Pronator quadratus	Median n.	C7–C8
Palmaris longus	Median n.	C7–T1
Palmaris brevis	Ulnar n.	C8–T1
Flexor carpi radialis	Median n.	C6–C7
Flexor carpi ulnaris	Ulnar n.	C7, **C8**, T1
Flexor digitorum superficialis	Median n.	C8, T1
Flexor digitorum profundus	Median n./ulnar n.	C8, T1
Flexor pollicis longus	Median n.	C7, C8
Thenar muscles	Median n.	**C6**, C7–T1
Hypothenar muscles	Ulnar n.	C8, T1
Hand intrinsic muscles	Ulnar n.	C8, T1
Interossei muscles	Ulnar n.	C8, T1
Lumbricals 1, 2	Median n.	C8, T1
Lumbricals 3, 4	Ulnar n.	C8, T1
Wrist extensors	Radial n.	C6–C8
Digit extensors	Radial n.	C7, C8

SPINAL INNERVATION OF SKELETAL MUSCLES

SKELETAL MUSCLE	NERVE SUPPLY	SPINAL CORD SEGMENT/ NERVE ROOT
LOWER LIMB		
Psoas major	Lumbar plexus	L1–L3
Psoas minor	Lumbar spinal n.	L1
Iliacus	Femoral n.	L2–L3
Adductors of the hip	Obturator n.	L2, L3, (L4)
Adductor magnus	Obturator n./sciatic n.	L2, L3, (L4)
Pectineus	Femoral n./obturator n.	L2, L3
Quadriceps femoris	Femoral n.	L2–L4
Sartorius	Femoral n.	L2–L3
Tensor fasciae latae	Superior gluteal n.	L4–S1
Gluteus maximus	Inferior gluteal n.	L5, S1, (S2)
Gluteus medius/minimus	Superior gluteal n.	**L4**–S1
Posterior thigh muscles (hamstrings)	Sciatic nerve	L5–S2
Lateral hip rotators	Sacral plexus	L5–S2
Piriformis	Nerve to piriformis	L5–S2
Obturator internus	Nerve to obturator internus	L5–S1
Obturator externus	Obturator n. (posterior branch)	L3–L4
Gemelli superior/inferior	N. to obturator internus/n. to quadratus femoris	L5–S1
Quadratus femoris	N. to quadratus femoris	L5–S1
Tibialis anterior	Deep fibular n.	**L4**–L5
Extensor hallucis longus	Deep fibular n.	L5
Extensor digitorum longus	Deep fibular n.	**L5**–S1
Fibularis tertius	Deep fibular n.	L5–S1
Fibularis longus/brevis	Superficial fibular n.	L5–S1
Gastrocnemius/soleus	Tibial n.	S1–S2
Plantaris	Tibial n.	S1–S2
Tibialis posterior	Tibial n.	L4–L5
Flexor hallucis longus	Tibial n.	L5, **S1, S2**
Flexor digitorum longus	Tibial n.	L5–S2
Foot intrinsic muscles	Tibial/plantar ns.	L5–S3

GLOSSARY

Anatomical terms as set forth and revised by the Federative Committee on Anatomical Terminology (FCAT) and the International Federation of Associations of Anatomists (IFAA), published in *Terminologia Anatomica*, 2nd edition (Thieme, New York, 2011) are included herein. For further inquiry, consult a standard medical dictionary. The terms here are consistent with those listed in *Dorland's Illustrated Medical Dictionary*, 30th edition. (2003). Pronunciation of terms is given phonetically (as they sound, not by standard dictionary symbols). The primary accent (emphasis) is indicated by capitalized letters, e.g., ah-NAT-uh-mee, included with the definitions. The plural form is in parentheses following the term defined, e.g., alveolus(i) or alveoli. Pl. = plural.

A

a-, an-, without.

ab-, away from the midline.

AB, antibody.

abdomen, the region between the thoracic diaphragm and the pelvis.

abscess (AB-sess), a cavity in disintegrating tissue, characterized by the presence of pus and infective agents.

Achilles, in Greek mythology, one of the sons of Peleus, a young king, and Thetis, one of the immortal goddesses of the sea. Not wanting Achilles to be mortal like his father, Thetis dipped him into the River Styx, holding him by the tendinous cord between the heel (calcaneus) and the combined muscles of gastrocnemius, soleus, and plantaris, making him invulnerable to harm except at that spot. Achilles later became a great Greek warrior. In the many wars between Greece and Troy, Achilles was invulnerable to harm. At last, a Trojan, aided by the god Apollo, slew Achilles with an arrow into the vulnerable tendocalcaneus. The term "Achilles heel" refers metaphorically to one's vulnerabilities.

acinar, pertaining to acinus or acini.

acinus(i) (ASS-ee-nus), a saclike gland or dilatation.

actin, a protein of muscle, associated with the contraction/relaxation of muscle cells.

ad-, toward the midline.

adeno- (ADD-eh-no), gland.

-ae (-EE), plural and genitive form of *a*.

afferent, leading to a center; in the nervous system, a neuron directed toward the brain or spinal cord.

Ag, antigen.

AIDS, acquired immunodeficiency syndrome.

AKA (A-K-A), an acronym for "also known as."

-algia, pain.

alimentary canal, the digestive tract from mouth to anus.

alimentation, the act of giving or receiving food or nutritive material.

alveolus(i) (al-VEE-oh-lus), grape-shaped cavity, rounded or oblong. Refers to the shape of exocrine glands, air spaces within the lungs, and the bony sockets for teeth.

amino acid (ah-MEEN-oh), a two-carbon molecule with a side chain that contains either nitrogen (in the form of NH_2) or a carboxyl group (-COOH).

amorphous (ay-MORF-us), without apparent structure at some given level of observation. What appears amorphous at 1000X magnification may be quite structured at 500,000X.

amphi-, double, about, around, both sides.

amphiarthrosis(es) (AM-fee-ar-THRO-sis), see joint classification, functional.

ampulla(e), dilation of a tubular structure.

anastomosis(es) (ah-NASS-toh-moh-sis), connection between two vessels.

anatomical snuff box, a depression on the posterior aspect of the hand between the tendons of abductor pollicis longus and extensor pollicis brevis on the radial side and extensor pollicis longus on the ulnar side (see page 57). The floor of the "snuff box" is the scaphoid bone. "Snuff" was tobacco and it fit well in the "box" for snuffing or snorting in earlier days.

anatomy (ah-NAT-uh-mee), *ana* = up, *tome* = to cut; the structural details of plants and animals, including humans.

anemia (ah-NEE-mee-ah), a condition of inadequate numbers of red blood corpuscles.

angina (an-JYNE-ah), pain, especially cardiac pain.

angio-, a vessel.

angle, the point of junction of two intersecting lines, as in the inferior angle of the scapula between the vertebral (medial) and axillary (lateral) borders of that bone.

angulus(i), an angle.

ankle, the tarsus. The region between the distal leg and the hind foot, including the ankle joint.

annulus(i) (AN-new-lus), a ringlike or circular structure.

ano-, anus.

anomaly (ah-NOM-ah-lee), an abnormality, especially in relation to congenital or developmental variations from the normal.

A.N.S. or ANS, autonomic nervous system.

ansa, loop.

anserine, like a goose. *Pes anserinus,* goose foot.

ante- (AN-tee), forward.

antebrachium, forearm.

antecubital, in front of the elbow (cubitus).

anti-, against.

antibody, a complex protein (immunoglobulin). A product of activated B lymphocytes and plasma cells, it is synthesized as part of an immune response to the presence of a specific antigen.

antigen, any substance that is capable of inciting an immune response and reacting with the products of that response. Antigens may be in solution (toxins) or may be solid structures (microorganisms, cell fragments, and so on). Particulate matter that is phagocytosed but does not incite an immune response does not constitute an antigen. Specific antibodies formed by cloning (monoclonal antibodies) may react with certain surface molecules on a cell membrane; those surface molecules constitute antigens.

antigenic determinant, the specific part of an antigen that reacts with the product of an immune response (antibody, complement).

aperture (AP-er-chur), an opening.

apical, an apex or pointed extremity.

aponeurosis(es), a flat tendon.

apophyseal (app-oh-FIZZ-ee-al), refers to apophysis.

apophysis(es) (ah-POFF-ee-sis), an outgrowth; a bony process, such as the ischial tuberosity.

arborization (ar-bor-eye-ZAY-shun), treelike branching, e.g. branching of terminal dendrites.

areolar (ah-REE-oh-lar), filled with spaces.

arm, that part of the upper limb between the shoulder and elbow joints.

arrhythmia(s) (a-RITH-mee-ah), a variation from the normal rhythm of the heartbeat; the absence of rhythm.

arterio-, artery.

arthr- (AR-thr), joint.

arthritis(ides) (ar-THRI-tiss), inflammation of a joint.

articular, joint.

articular process, an outgrowth of bone on which there is a cartilaginous surface for articulation with another similar surface.

articulation, a joint or connection of bones, movable or not; occlusion between teeth; enunciation of words.

aspera, rough.

aster, a ray, as in rays of light; in the cell, rays of microtubules projecting from centrioles.

atherosclerosis, a form of arteriosclerosis or hardening of the arteries; specifically, characterized by yellowish plaques of cholesterol and lipid in the tunica intima of medium and large arteries.

ATP, adenosine triphosphate, a nucleotide compound containing three high-energy phosphate bonds attached to a phosphate group; energy is released when the ATP is hydrolyzed to adenosine diphosphate and a phosphate group.

atrophy (AT-troh-fee), usually associated with decrease in size, as in muscle atrophy.

avascular (ay-VASS-kew-lur), without blood vessels or, in some cases, blood.

avulsion, tearing a part away from the whole, as in tearing a tendon from its attachment to bone.

axial, a line about which a body rotates, or would if it could; e.g., the long axis of the body runs head to toe.

B

back, the region making up the posteriormost wall of the thorax and abdomen, supported by the thoracic and lumbar vertebrae. Strictly defined, it excludes the neck and sacrum/coccyx (pelvis).

basal lamina(e), a thin layer of interwoven collagen fibrils interfacing epithelial cells (and certain other nonepithelial cells) and connective tissue. Seen only with an electron microscope.

basement membrane, basal lamina and a contiguous layer of collagenous tissue. Seen with a light microscope, it controls diffusion and transport into/out of the cell.

basal ganglia, a term used by neuroanatomists/neuroscientists for the *special* collection of neurons among nuclei at the base of the cerebral hemispheres that mediate signals from the motor cortex in voluntary movement. The term *ganglia* generally refers to cell bodies in the peripheral nervous system.

basilar, at the base or bottom.

benign, nonmalignant; often used to mean mild or of lesser significance.

bi-, two.

bicipital, two-headed.

bicuspid, a structure, e.g., a tooth or valve, with two cusps.

bifurcate (BY-fur-cate), to branch.

bilateral, both sides (left and right).

-blast, formative cell; immature form.

blephar-, eyelid.

bloodborne, refers to some structure carried by the blood.

blood–brain barrier, a state in the CNS in which substances toxic or harmful to the brain are physically prevented from getting to the brain; it is represented by tight endothelial junctions in capillaries of the brain, tight layers of pia mater around vessels, and the presence of neuroglial endfeet surrounding vessels.

bolus, a mass of food; any discrete mass.

bone, immature, see bone, woven.

bone, lamellar, mature bone characterized by organized layers or lamellae of bone.

bone, mature, see bone, lamellar.

bone, primary, see bone, woven.

bone, secondary, see bone, lamellar.

bone, woven, immature bone characterized by random arrangements of collagen tissue and without the typical lamellar organization seen in more mature bone.

brachi-, arm.

bronch-, referring to bronchi or bronchioles of the respiratory tract.

buccal, pertaining to or directed to the cheek. In dentistry, refers to the cheek-side of a tooth.

bursa(e), synovial-lined sac between tendons and bone or muscle and muscle, or any other site in which movement of structure tends to irritate or injure adjacent structure. It contains synovial fluid and is lined externally by fibrous connective tissue.

bursitis, inflammation of a bursa.

C

cadaver (ka-DA-ver), a dead body.

calvaria, the bones of the skullcap or cranium; consisting of parts of the frontal, temporal, parietal, and occipital bones. The calvaria is a single entity, i.e., there is no calvarium.

canaliculus(i), a small canal.

cancellous (KAN-sell-us), having a lattice-like or spongy structure with visible holes.

cancer, a condition in which certain cells undergo uncontrolled mitoses with invasiveness and metastasis (migrating from the point of origin to other sites, usually by way of the lymphatic and/or blood vascular systems). There are two broad divisions: *carcinoma*, cancer of epithelial cells; and *sarcoma*, cancer of the connective tissues.

capillary attraction, the force that attracts fluid to a surface, such as water flowing along the undersurface of a pouring tube.

capitulum, a rounded process of bone, usually covered with articular cartilage. Synonym: *capitellum*.

caput medusae, the head of the mythical Medusa, whose golden hair entranced Neptune. The jealous Minerva turned the hair of Medusa into a mass of snakes. The term *caput medusae* is used for the snake-like appearance of the dilated, interwoven mass of subcutaneous veins surrounding the umbilicus in the condition of portal vein obstruction.

cardio-, heart.

carpus, carpo-, wrist.

caud-, tail.

cauda equina (horse's tail), the vertically oriented bundle of nerve roots within the vertebral canal below the level of the first lumbar vertebra (L1). Includes nerve roots for spinal nerves L2 through the Co2, bilaterally.

cauda equina syndrome, irritation/compression of the cauda equina, resulting in bilateral symptoms and signs that may include bladder and bowel incontinence, weakness in the lower limb muscles, sensory impairment from the perineum to the toes, and reflex changes.

cauterization, destruction of tissue by heat, as with an electro-cauterizing instrument.

cavity, potential, a space between membranes that can enlarge with fluid accumulation, as in the peritoneal cavity (ascites) or pericardial cavity (cardiac tamponade).

CD4, CD, "clusters of differentiation." The abbreviation refers to a collection of cell surface molecules with specific structural characteristics (markers) reflecting a common lineage. The identification of these markers is made by purebred (monoclonal) antibodies, which react only with surface markers of cells of a common lineage. Cells exhibiting cell surface markers of a common lineage belong to a cluster (of differentiation), identified by number, e.g., 4. Most helper T lymphocytes have markers of three different clusters: CD3, CD4, and CD8. Cytotoxic T lymphocytes are CD3, CD4, and CD8.

cell body, the main, largest single mass of a neuron, containing the nucleus surrounded by organelles in the cytoplasm.

-centesis, puncture.

central, at or toward the center.

ceph-, head.

cerebro-, brain; specifically, cerebral hemisphere.

cerumen (sur-ROO-men), the wax secretion of the external ear.

cerv-, neck.

cheil- (KY-el), lip.

chest, the thorax.

chir- (kir), hand.

choana(e) (KOH-ah-nah), referring to a funnel, as in the nasal passageways or apertures.

chol- (koll), bile.

chondro- (KOND-row), cartilage.

chromatin, the most stainable part of the cell nucleus; the condensed, uncoiled, genetically active phase of genetic material as seen in the interphase of a chromosome; euchromatin.

chromosome (KRO-moh-sohm), "colored body." A structure in the nucleus of a cell that contains DNA and is visible during metaphase and anaphase periods of cell division.

circulare(s), shaped like a circle.

-clast (klast), disruption, breaking up.

clearing, the process of ridding a specimen of water or solvent in preparation for microscopic study.

cleavage, division into distinct parts.

clinical, the setting in which a person is examined for evidence of injury or disease.

clot, coagulated blood; a reticular framework of fibrin, platelets, and other blood cells. Associated fluid is serum.

cm, centimeter.

CNS or **C.N.S.,** central nervous system, consisting of the brain and spinal cord.

co-, con-, together.

coagulation, the clotting of the blood.

coelom (SE-lom), the embryonic body cavity.

collagen (KOLL-ah-jen), the protein of connective tissue fibers. Several different types are found in fasciae, tendons, ligaments, cartilage, bone, vessels, organs, scar tissue, and wherever support or binding is needed. Formed by fibroblasts, endothelia, muscle cells, and Schwann cells.

collateral circulation, alternate circulatory routes; vessels between two or more points that exist in addition to the primary vessels between those points. Such circulation exists by virtue of anastamoses among a number of vessels.

colli-, neck.

colo-, colon.

complement, a group of proteins in the blood whose activation causes their cleavage and fragmentation. The fragments have several biologic functions, one of which is combining with antibody/antigen complexes to enhance the destruction of antigen.

concentric contraction, a type of muscle contraction in which the internal contracting force of a muscle is greater than the external load imposed on it (positive work), so that the muscle shortens.

concha(ae) (kawng; kongee), a large spiral shell; conch shell. Relates primarily to the nasal conchae.

concretion, an inorganic or mineralized mass, usually in a cavity or tissue.

condylar, condyloid, referring to a rounded process, as in a joint surface.

condyle, a rounded projection of bone; usually a joint surface, covered with articular cartilage.

contiguous (kon-TIG-yu-us), adjoining and being in contact. The basement membrane is contiguous with the basal surfaces of certain epithelial cells.

contra-, against.

contraction, shortening.

cornu(a) (KOR-new), a horn-shaped process.

corona, crown.

corona radiata, radiating crown; refers to the appearance of the subcortical white matter and, specifically, the projection tracts.

coronoid (KOR-oh-noid), crownlike or beak-shaped; refers to a bony process.

corpus(ora), body.

corpuscle (KOR-pus-il), any small body, not necessarily a cell. Red blood corpuscles lack nuclei and are not considered cells.

costa, rib.

costochondritis, an inflammation surrounding the cartilage of a joint of a rib, usually involving the synovium and fibrous joint capsule and perhaps related ligaments.

coxa(e), hip; the hip (coxal) joint. Deformities of the upper femur often include the term (such as *coxa varus* or *coxa valgus*). Preceded by the term *os*, it refers to the coxal or hip bone.

crani-, cranium.

cranial nerves; functional classification (see page 83): Classification of cranial nerve neurons is based on the embryology of the brain stem. Each cranial nerve carries functionally different kinds of fibers. Some are sensory, some are from glands or the lining mucosae of visceral cavities, and some are really special and unusual (i.e., visual and auditory receptors). They each get their own classification. Among motor neurons, these fibers may innervate muscle cells that cause glands to secrete; or they may supply "visceral" muscles that come from embryonic pharyngeal arches; or they may supply classic skeletal muscles, like TMJ muscles or facial muscles. There are no spinal nerve equivalents. Cranial nerves are represented by roman numerals (I, II, III, etc.). A thirteenth cranial nerve (c.n. zero) is quite controversial and not generally accepted as such currently; check online sources.

Level 1 classification: GENERAL (**G**) and SPECIAL (**S**).

General refers to the organization that follows (levels 2 and 3).

Special classification includes:

(1) **special sensory afferent (SSA) neurons:** from visual (II), and hearing/balance (VIII) receptors;

(2) **special visceral afferent (SVA) neurons:** from olfaction (I), and taste (VII, IX, X) receptors;

(3) **special visceral efferent (SVE) neurons:** to muscles derived from embryonic pharyngeal (visceral) arches such as muscles of the jaw, face, mouth, larynx and pharynx: V, VII, IX, X, and XI.

Level 2 classification: SOMATIC (**S**) and VISCERAL (**V**). Somatic refers to the embryologic somites from which skin, muscles, and joints (body wall or soma) arise:

(1) **general somatic afferent (GSA) neurons:** face (V), external ear (VII, IX, X);

(2) **general somatic efferent (GSE) neurons:** muscles of the eye (III, IV, VI); muscles of the tongue (XII).

Visceral refers to derivatives of the pharyngeal arches; e.g., muscles of the face, oral cavity, and pharynx; also refers to neurons of the autonomic nervous system from head to perineum supplying "viscera" (organs with cavities, smooth muscle, and glands):

(1) **general visceral afferent (GVA) neurons:** from mechanoreceptors (VII), mechanoreceptors, baroreceptors, chemoreceptors (IX, X), sensory receptors in thoracic and abdominal viscera (X);

(2) **general visceral efferent (GVE) neurons:** to salivary glands (VII, IX); innervation of smooth muscle and glands of thoracic and abdominal viscera (X).

Level 3 classification: afferent (**A**) (sensory) and efferent (**E**) (motor).

cranium, that part of the skull containing the brain.

cribriform, perforated; like a sieve.

cricoid, ring-shaped, as in the shape of the cricoid cartilage. The cricoid cartilage has a signet-ring appearance in which one side of the ring has a flattened area on which is an identifying mark or impression.

-crine (krin), separate off; referring to glands that do not have ducts, as in "separated off from ducts." The concept of ductless (endocrine) glands made little sense to the early investigators.

cruciate, shaped like a cross.

crus (crura), leg.

crux, cross.

cu., cubic.

cubital, front (anterior aspect) of the elbow.

cusp, a triangular structure characterized by a tapering projection.

cutan-, cutaneous (kew-TANE-ee-us), referring to the skin.

cystitis, inflammation of the urinary bladder.

cysto-, bladder.

-cyte (site), cell.

cytokine, a product of a cell that influences cellular activity, e.g., facilitates destruction of antigen by inducing or enhancing an immune response.

cytolysis, the dissolution and destruction of a cell.

cytotoxin, a product of a cell that acts to destroy another cell or has a toxic effect on it.

D

dachry-, relating to tears.

dactyl, finger, toe.

decussation, crossing over.

defecation, elimination of waste material through the anal canal/anus from the rectum.

deglutition, swallowing.

deltoid, delta- or triangular-shaped, e.g., the deltoid muscle of the shoulder.

demi-, half.

dendritic cells, cells that are born in the bone marrow, pass into the circulation, become immunologically activated, and take up residence in one of various tissues. They are called dendritic cells because of the array of tree-branch-like dendrites around the cell periphery. Dendritic cells populate the epidermis (Langerhans cells), lymphoid follicles (follicular dendritic cells), and spleen. Dendritic cells are antigen-presenting cells (APCs) and present antigen to B lymphocytes for identification and destruction.

denervation (dee-nerv-AY-shun), a condition in which a muscle or area of the body is isolated from its nerve supply.

denticulate, tooth-shaped.

dentin (DEN-tin), the hard portion of a tooth. It is more dense (harder) than bone, less dense (softer) than enamel.

deoxyribonucleic acid, a nucleic acid in which the sugar is deoxyribose; the genetic material of all organisms (including viruses). Usually consists of intertwining double strands (double helix). DNA replicates by duplication. It serves as a template for the synthesis of ribonucleic acid (RNA).

depolarization, neutralization of a polarity; in biological systems, an electrical change in stimulated excitable tissues (nerves, specialized cardiac muscle cells) from a baseline polarity (about –90 millivolts) toward neutral (0 millivolts). Such an event induces the conduction of an electrochemical wave (impulse) to move along an excitable tissue (e.g., nerve).

derm-, skin.

-desis, fixation.

desiccation (dess-ee-KAY-shun), drying out; without water.

desmo-, fibrous.

dexterity, skill with the hands.

di-, twice.

diapedesis, the movement of cells within blood and lymph vessels (RBCs, white blood cells) through the endothelial wall of the vessels to the extracellular spaces.

diaphragm(ae) (DIE-ah-fram), a partition separating two cavities. There are three significant fibromuscular diaphragms in the body: thoracic (separating thorax and abdomen), pelvic (separating pelvis and perineum), and urogenital (separating the anterior recesses of the ischiorectal fossa from the superficial perineal space).

diarthrosis(es) (die-ar-THRO-sis), see joint classification, functional.

differentiation, to make something different from something else; in the development of a cell, the structural and functional changes within that cell that make it different from other cells. An increase in heterogeneity and diversification make it possible for one to differentiate one structure from another.

diffusion, spontaneous movement of molecules without the application of additional forces.

digit, finger or toe.

diploic, referring to the marrow layer between the inner and outer layers of compact bone in the flat bones of the skull.

dis-, apart.

disc, a wafer-shaped, rounded or oval fibrocartilaginous structure; if crescent-shaped, it is called a *meniscus*. It may interface the articular cartilage surface in a synovial joint (articular disc) or it may interface opposing cartilage endplates of vertebral bodies (intervertebral disc).

discharge, to set off or release, to fire, to let go.

dissect (dis-SECT), to cut up, to take apart. In gross anatomy laboratories, the human body is studied by using ordered dissection by regions.

dys- (DISS), abnormal, painful, or difficult.

dorsum, back. Refers to the posterior aspect of the hand and the "top" of the foot.

E

ec-, out.

eccentric contraction, a type of muscle contraction wherein contracted muscle is stretched and lengthened during the contraction, such as antigravity contractions by antagonists during movement directed toward gravity. Even though there is a load on the muscle, the muscle is stretched (negative work).

-ectasis(es), dilation.

-ectomy, removal.

efferent, leading away from a center (organ or structure).

elbow, the region between the arm and forearm.

electrochemical, referring to combined properties of electrical and chemical, such as the neuronal impulse.

ellipsoid, a closed curve more oval than a perfect circle. Ellipsoid joints are reduced forms of ball-and-socket joints; broadly speaking, they include condylar-shaped joints.

em-, in.

embalm (em-BAHM), to treat a dead body with preservative chemicals to prevent structural breakdown by microorganisms.

-emia, blood.

emissary vein, a vein that drains a dural venous sinus and passes through the skull bone by way of a foramen.

emission, an involuntary release of semen; also, the movement of sperm from the epididymis to the prostate during sexual stimulation in the male.

en-, in.

encapsulate, to surround with a capsule.

encephalo-, brain.

endo-, in.

endochondral (en-do-KON-dral), *endo* = in, *chondral* = cartilage.

endochondral ossification, see ossification, endochondral.

endocrine (EN-doh-krin), *endo* = in, *crine* = separate. Glands that secrete their products into the tissue fluids or vascular system.

endocytosis, the ingestion of matter into a cell by surrounding the material with the cell membrane and budding it off in the cytoplasm.

endometrium, the inner, vascular, glandular lining of the uterus subject to rapid growth (proliferative phase) and secretory activity (secretory phase), followed by glandular/tissue collapse and subsequent hemorrhage (menstruation).

endosteum(-a), the lining of the medullary canal of long bones, consisting of a thin sheet of collagen fibers and large numbers of osteoprogenitor cells.

endothelium(-a) (en-do-THEE-lee-um), the epithelial lining of blood and lymph vessels and the heart cavities. Endothelia are of mesenchymal origin, not ectodermal, and have properties different from classical epithelia.

entero-, referring to the intestines.

enteroendocrine, refers to cells of the epithelial layer/glands of the gastrointestinal mucosa, which secrete hormones that stimulate/inhibit (regulate) intestinal/pancreatic gland secretion and/or motility of smooth muscle.

enzyme, a protein molecule that facilitates a reaction without becoming involved (changed or destroyed) in the reaction. Enzymes are identified by the suffix *-ase.*

epi-, upon, at.

epicondyle, an elevation of bone above a condyle.

epidid-, epididymis.

epidural, outside the dura, between the dura and the skull.

cpithelium(a) (ep-ee-THEE-lee-um), *epi* = upon, *thelia* = nipple. To the early histologists, the epidermis appeared to be lying on a collection of nipple-shaped dermal papillae.

erg, a unit of work.

ergo-, a combining form meaning *work.*

eversion, and **inversion,** occur at joints between (1) the talus and the calcaneus (*talocalcaneal joint,* also called the *subtalar joint*), and (2) the *transverse tarsal joint.* The transverse talar joints are formed by the union of the talus with the navicular and the calcaneus with the cuboid. The plane of the latter joints is 90 degrees to that of the subtalar joint. **Eversion** is a

combination of pronation and forefoot abduction. External or lateral rotation of the foot moves the sole of the foot laterally; that movement is called eversion. **Inversion** is a combination of supination and forefoot adduction. When the sole of the foot is rotated medially and comes to face medially, that movement is called inversion. Inversion has much greater range of motion than eversion.

ex-, exo-, out.

excretion (ex-CREE-shun), the discharging of or elimination of materials, such as waste matter. If the material excreted has some useful in-body function or use outside the body (e.g., semen), it has probably been secreted, not excreted, although there is no universal agreement on this. See secretion.

exocrine (EX-oh-krin), *exo* = out, *crine* = separate off; referring to glands that separate from classical epithelial surfaces.

exocytosis, removal of matter from a cell.

extracellular, outside of the cell, such as the fibrous tissue supporting cells, and vascular spaces.

extrinsic, coming from the outside. With reference to a specific area (e.g., thumb, hand, foot), extrinsic muscles are those with origins outside of the specific area, but which insert in the area and have an effect on the specific area. See intrinsic.

F

facet (FASS-et), a small plane or slightly concave surface. The flat cartilaginous surfaces of a joint may be called facets, as on the articular processes of vertebrae.

facet joint, a joint between articular processes of adjacent vertebrae; also called *zygapophyseal joints.*

facilitation, enhancement of or assistance in an event.

falx -falces, (pl. FAL-seez), sickle; sickle-shaped.

falx inguinalis (conjoint tendon), a tendon composed of fibers from the transversus abdominis and internal oblique that arcs over the spermatic cord and attaches to the pectineal line of the pubic bone. See page 51.

fascia(e) (FASH-uh, pl. FASH-ee), a general term for a layer or layers of loose or dense, irregular, fibrous connective tissue. Superficial fascia, often infiltrated with adipose tissue, is just under the skin. Deep fascia envelops skeletal muscle and fills in spaces between superficial fascia and deeper structure, and between/among muscle bellies (myofascial structure). Extensions of deep fasciae form intermuscular septa, support viscera (e.g., endopelvic fascia), act as fibrous bands, and support neurovascular bundles. Smaller, microscopic layers of fibrous tissue (e.g., perimysium, endomysium, vascular tunics) do not constitute deep fascia, even though they may be distant extensions of it. These fibrous connective tissue investments, integrated with tendons, ligaments, periosteum, and bone, blend into a unibody construction, resistant to all but the most traumatic of forces.

fascia, thoracolumbar, strong layer enveloping the deep back or paravertebral muscles from the iliac crest and sacrum to the

ribs/sternum. Plays an important role in limiting and moving motion segments of the back.

fascicle(s) (FASS-ih-kul), a bundle.

feedback, a communication relationship between two structures, e.g., wherein the output (secretion) of one substance induces inhibition or facilitation of the secretion of another substance. Negative feedback reflects an inhibitory effect; positive feedback reflects a facilitating relationship.

fenestration, an opening (in a wall); fenestrations between pedicels of the podocytes overlying the glomerular capillaries provide a passageway for glomerular filtrate to pass from the capillary interior to the glomerular capsule.

fibers, elongated lengths of tissue, e.g., living muscle fibers (cells or their parts), connective tissue fibers (nonliving cell products), living nerve fibers (extensions of cell bodies).

fibril (FY-brill), en elongated structure smaller than and part of a fiber.

fibrous (FY-brus), referring to a fiber or fiberlike quality.

fibrosus (fy-BROHS-us), a fibrous stucture.

filament, a small delicate fiber; in biology, a structure of some length, often smaller than a fibril, which is smaller than a fiber.

filtration, movement of a fluid by the application of a force, such as pressure, vacuum, or gravity.

final common pathway, the lower motor neuron arising in the anterior horn of the spinal cord and terminating on a muscle or gland.

fissure, a narrow crack or deep groove.

fixation, a process in preparation of tissue for microscopic study. Treatment of fresh tissue with a fixative preserves structure, preventing autolysis and bacterial degradation.

flaccid (FLA-sid or FLAK-sid), without tone; denervated; lax or soft.

foot, the most distal part of the lower limb. The skeleton of the foot consists of the tarsus, metatarsal bones, and phalanges. It joins with the leg at the ankle (talo-tibiofibular joint).

foramen(ina) (foh-RAY-men), opening or hole in a structure, such as bone, for the passage of a blood vessel or nerve.

> **sciatic**
>
> > greater, the uppermost foramen created by the sacrotuberous and sacrospinous ligaments within the greater sciatic notch of the hip bone; the piriformis muscle is the central structure within the foramen; above it passes the superior gluteal artery and nerve; below it, the inferior gluteal artery and nerve, sciatic nerve, pudendal nerve and internal pudendal artery, posterior femoral cutaneous nerve, and the nerves to obturator internus and quadratus femoris.
> >
> > lesser, the lowermost foramen created by the sacrotuberous and sacrospinous ligaments within the lesser sciatic notch; the internal pudendal vessels, the pudendal nerve, and the tendon of obturator internus, and the nerve to obturator internus pass through it. The pudendal nerve and arteries continue through the foramen to enter the pudendal canal on the lateral wall of the ischiorectal fossa.

forearm, that part of the upper limb between the elbow and wrist (radiocarpal) joints.

forefoot, that part of the foot anterior to the transverse tarsal (talonavicular and calcaneocuboid) joints.

fossa(e), a depressed or hollow area; a cavity.

fusiform, spindle-shaped; shaped like a round rod tapered at the ends.

G

gait, a manner of walking, running, or moving.

gastro-, stomach.

gastrointestinal, stomach and intestines.

genia-, origin.

genital(s), Latin, belonging to birth. Refers to reproductive structures; loosely, the term refers to the external genitals of either sex.

genu, knee; any structure of the body that is bent like a knee, e.g., genu of the corpus callosum.

glabrous, hairless; smooth epidermal covering.

glia, see neuroglia.

glomerulus, a small cluster of vessels or nerve endings, as in the glomerulus of the kidney.

glosso-, tongue.

glyco-, sweet, pertaining to sugar or carbohydrate, e.g., glycogen (starch), glycoprotein (sugar-protein complex).

glycoprotein, an organic compound consisting of carbohydrate and protein.

glycosaminoglycan, a long chain of double sugars (disaccharides) connected with a nitrogen-containing group (amine); *glyco* = sugar, *glycan* = polysaccharide. Previously termed *mucopolysaccharide*. Proteins combined with glycans are temed *proteoglycans*.

gomphosis(es) (gom-FOH-sis), bolting together. See joint classification, structural.

gray matter, brain and spinal cord substance consisting largely of neuronal cell bodies, glia, and unmyelinated processes. Collections of gray matter are generally called nuclei or centers.

groove, a linear depression in bone.

H

hallucis, genitive form of hallux.

hallux, great (first) toe.

hand, the most distal part of the upper limb. The skeleton of the hand consists of the carpus, metacarpus, and phalanges. It joins with the forearm at the wrist (radiocarpal) joint.

haustra(e), sacculations of the large intestine held in tension by longitudinal bands of smooth muscle (taeniae).

Haversian system, a cylindrical arrangement of bone cells and their lacunae, named after C. Havers, a 17th-century anatomist; the central tubular cavity, the Haversian canal, contains vessels. Seen in compact bone.

head, the most superior part of a body, bone, muscle or part; as in head of the humerus or the head of the body.

hem-, blood.

hematocrit (he-MAT-oh-krit), the measurement of red blood cell volume in a tube of centrifuged blood; the tube itself is called a *hematocrit tube*.

hematoma (hee-mah-TOE-mah), *hemat* = blood, *oma* = tumor or swelling. A collection of blood under the skin, fascia, or other extracellular membrane.

hematopoiesis (hee-mah-toh-po-EE-sus), blood cell formation; occurs in the bone marrow and, in early life, in the liver and spleen; blood cells include red blood corpuscles and white blood cells.

hemi-, half.

hemopoiesis (hee-mo-po-EE-sus), see hematopoiesis.

hemorrhage (HEM-or-ij), bleeding; escaping of blood from blood vessels into the adjacent tissues or onto a surface.

hemorrhoid, a varicose dilation of a vein that is a part of the superior/inferior rectal (hemorrhoidal) plexus of veins.

hemosiderin (hee-mo-SID-er-in), storage form of iron.

heparin, a glycoprotein present in many tissues that has anticoagulation (blood-thinning) properties.

hepat-, liver.

herniation, a protrusion through a wall or wall-like structure.

heterogeneous, varied, as in a mixture of nonuniform elements.

Hg, mercury (chemical symbol).

hiatus, an opening.

hindfoot, that part of the foot posterior to the transverse tarsal (talonavicular and calcaneocuboid) joints.

hip, the coxal bone; the region of the hip (coxal) joint.

histamine, a nitrogenous molecule whose effects include contraction of smooth muscle and capillary dilation.

HIV, human immunodeficiency virus.

homeostasis, stability of the internal environment in which cells, tissues, and organs contribute and respond to chemical input that results in stabilizing influences on cellular activity under a broad set of conditions, and maintains a long-lasting normal environment.

homogeneous, of uniform quality.

hydroxyapatite, $(Ca_3(PO_4)_2)_3 \cdot Ca(OH)_2$, a mineral or inorganic compound that makes up the mineral substance of bone and teeth. A very similar structure is found in nature outside the body.

hyper, excessive.

hyperplasia, increased number of normal cells.

hypertonia, increased muscle tension; increased resistance to stretching of muscle.

hypertrophy, increase in size of muscle.

hypo, inadequate or reduced.

hypoesthesia, reduced sensation.

hyster-, uterus.

I

-iasis, condition, presence of.

ileo-, ileum of the small intestine.

ilio-, ilium of the coxal (hip) bone.

immuno-, refers to the immune system or to some activity or part of that system.

immunosuppression, suppression of immune (lymphoid) system activity; also called *immunodepression*.

impinge, to have an effect on something; contact, irritate, strike.

infarction (in-FARK-shun), an area of dead tissue caused by interruption of the blood supply to the tissue.

infection, the invasion of body cells, tissues, or fluids by microorganisms, usually resulting in cell or tissue injury, inflammation, and immune response.

inflammation, a vascular response to irritation, characterized by redness, heat, swelling, and pain; may be acute or subacute (lasting more than two weeks, or chronic).

infra-, under.

inhibition, restraint or restraining influence.

injury, anatomic disruption at some level of body organization in response to an external force (e.g., blunt, penetrating, electrical, radiation, thermal).

innate, inborn, congenital.

innervation (in-nerv-AY-shun), provision of one or more nerves to a part of the body.

innominate, unnamed. First applied to the coxa (hip bone) by Galen; first applied to the artery by Vesalius.

integument, the skin.

inter-, between; e.g., interscapular, between the scapulae.

intercalated, inserted between.

interface, surfaces facing one another; to face a surface.

interstitium, interstices, interstitial, in the middle of something; between two or among more definitive structures. In anatomy, the term is commonly employed for spaces between or among structures, usually fluid spaces between or among more definitive fluid spaces (e.g., the vascular, loose, extracellular connective tissue spaces among blood vessels and renal tubules, called *interstitial tissue*); space/tissue. The term may also be used for extracellular spaces.

intima, innermost part.

intra-, within; e.g., intracellular, within a cell.

intramembranous ossification, see ossification, intramembranous.

intravenous, within a vein.

intrinsic, part of a specific area and not extending beyond that area (e.g., thumb, hand, foot). Muscles that arise (originate) and insert within the hand region are known as intrinsic muscles (of the hand). See extrinsic.

inversion, see eversion.

investing, surrounding or enclosing.

isometric contraction, a contraction that involves muscle contraction without bone movement, so that the muscle maintains the same apparent length. Fibril shortening in such a contraction is offset by the inherent elasticity of the myofascial tissue.

-itis, inflammation. Term does not specify the cause of inflammation; therefore, it does not mean infection, but may refer to the inflammation induced by or associated with an infection.

J

jejuno-, jejunum of small intestine.

joint classification, functional; joints are classified according to the degree of movement (i.e., immovable, partly movable, and freely movable).

Immovable joints are called *synarthroses*, partly moveable joints are called *amphiarthroses*, and freely movable joints are called *diarthroses*. Immovable joints may be fibrous (sutures, gomphoses) or cartilaginous (synchondroses). Partly movable joints may be fibrous (syndesmoses) or cartilaginous (symphyses). Freely movable joints are always synovial. Synovial joints are limited in their motion by joint architecture and ligaments, but within those limitations, they are normally freely movable. See also syn-.

joint classification, structural; joints are classified according to the material that makes the joint (i.e., fibrous, cartilaginous, bony, synovial). Fibrous joints are further classified as *sutures* (thin fibrous tissue between flat bones of the skull), *syndesmoses* (ligamentous sheets between the bones of the forearm and leg), and *gomphoses* (fibrous tissue between tooth and bony socket). Cartilaginous joints are further classified as *synchondroses* (hyaline cartilage between the end and shaft of developing bone) and *symphyses* (fibrocartilaginous discs between bones, as between vertebral bones and between the pubic bones). Bony joints are fibrous or cartilaginous joints that have ossified over time (synostoses). Classification of synovial joints can be seen on page 20.

jugular (JUG-yoo-lar), referring to the neck or a necklike structure. Specifically refers to the vein(s) of the neck so named.

K

kary-, nuclear.

keratin, a scleroprotein that is insoluble and fibrous. It is the principal constituent of the outer layer of stratified squamous epithelia in skin (stratum corneum; see page 19), hair, and tooth enamel (page 138).

kerato-, outer skin.

-kine, movement.

kinin (KY-nin), a polypeptide (short protein) that influences reactions, such as antigen-antibody complexes.

knee, the region between the thigh and the leg.

kupffer cells, stellate-shaped cells lining the liver sinusoids; they are intensely phagocytic, clearing microorganisms and debris (toxic material) from the lumen of the sinusoid. They are not attached to the endothelial cells of the sinusoids. The presence of RBC parts and iron fragments (ferritin) in their cytoplasm give evidence of their phagocytic role in taking up RBC fragments from the spleen.

kyphosis (ky-PHO-sis), humpback. Anatomically, a curve of the vertebral column in which the convexity is directed posteriorly; in orthopaedics, it is an excessive curvature of the thoracic vertebrae.

L

labium(i), lip, or any fleshy border.

labyrinthine (labee-RINTH-een), interconnecting, winding, as in an interwoven series of passageways.

lacerum (lahss-AYR-um), an irregular aperture or opening.

lacrimal, referring to tears.

lacuna(e) (lah-KOON-ah; lah-KOON-ee, pl.), a cavity or lake-like pit.

lamella(e), a thin, plate-like structure; may be circular, as seen in the Haversian system of bone.

lamina(e), layer.

laryngo-, larynx.

latency, inactivity. Usually a period between moments of activity.

latent, see latency.

leg, that part of the lower limb between the knee joint and the ankle joint.

-lemma, covering or sheath.

lepto-, slender.

leptomeninges, pia mater and arachnoid combined.

leuko-, white.

levator, a lifter; an elevator.

lever, -s, one of six simple machines used to lift weights. A mechanical advantage in lifting an object can be gained by pivoting a rigid bar of metal or wood on a fixed point (fulcrum, joint), placing the end of the bar under the object to be lifted, and pushing down on the opposite end of the bar to lift the intended object (first-class lever). See page 42. The amount of force or muscular effort required to lift the object is dependent upon on the weight to be lifted (resistance) and the distance from the fulcrum to the site of muscular effort. The further away from the fulcrum to the force (person lifting/pushing), the more power will be generated at the fulcrum to do the job. Pulleys are another kind of simple machine that can be used to lift loads.

lieno-, spleen.

ligament, fibrous tissue connecting bone to bone; also, a peritoneal attachment between organs.

lip-, pertaining to lipids; fat; triglyceride (composed of glycerol and three fatty acids); may be combined with protein (*lipoprotein*).

-listhesis, slip.

lith-, stone.

lithotomy, removal of a stone.

lordosis, a curve of the back seen in the cervical and lumbar regions in which the convexity is directed anteriorly. Anatomically, it refers to any curve of the back so described; orthopaedically, it is an excessive curve as described.

lumen(ina) (LEWM-un), a cavity, space, or tunnel within an organ.

lunar, referring to the moon; *semi-lunar,* half-moon-shaped.

luteal, pertaining to the corpus luteum.

lutein, a yellow pigment (lipochrome) from fat and yolk of eggs, as well as the corpus luteum.

lymphatic, refers to the system of vessels concerned with drainage of body fluids (lymph).

lymphoid, refers to the tissue or system of organs (lymphoid or immune system) whose basic structure is lymphocytes and reticular tissue.

lymphokine (LIM-fo-kine), a product of activated lymphocytes that enters into solution and influences immune responses, generally by enhancing destruction of antigen.

-lysis(es) (LYE-sis), destruction or dissolution.

M

macro, large (e.g., macromolecule).

magnum, great.

major, larger, typically used in anatomy to differentiate among two sizes of structure. See also minor.

-malacia, softening, as in demineralization of bone; changes in matrix of a tissue resulting in a loss of turgor or fibrous quality.

mamm-, breast.

manual, referring to the hand.

manus, hand.

mastication (*masticate,* to chew), the act of chewing.

mastoid, breast-shaped.

mater, mother; see dura m., arachnoid m., and pia mater, on page 81.

matrix(ices) (MAY-tricks), fluid or viscous background or ground substance, often apparently amorphous and homogeneous, often colorless. A variety of organic compounds and minerals may be dispersed within.

meatus (mee-AYT-us), an opening or passageway.

media, middle.

mediastinum(a) (mee-dee-ahs-TY-num), middle partition; the partition or septum between the lungs in the thorax.

mediate, influence.

mediator, an influential substance; a substance that acts indirectly but influentially in a reaction or in inducing a reaction.

medulla, inner part.

medusa, the radiating, contorted, dilated venous network bulging out on the surface of the anterior abdominal wall of chronic sufferers of portal vein hypertension/obstruction has been given the name *caput medusae* (head of the Medusa). In Greek mythology, Medusa was one of the Gorgon sisters, characterized as winged monsters with heads of snakes in place of hair. When a person looked at one of them, he was turned to stone. Medusa was the only mortal Gorgon. In offering service to his tyrant king, Perseus pursued Medusa and cut off her head (which, though detached, still had the power to turn onlookers into stone). Perseus presented the head to the vile king and his men, who, upon casting their eyes on the snake-covered head, promptly turned to stone. Perseus then became king.

mega-, big, great (e.g., megakaryocyte).

-megaly, enlargement.

menin-, refers to meninges.

meninges, dura mater, arachnoid, and pia mater coverings of the spinal cord and brain, and the first part of cranial and spinal nerves.

meniscus, a crescent-shaped fibrocartilaginous structure associated with some synovial joints.

ment-, referring to the chin (e.g., mental foramen).

mesenchyme (mesenchymal), embryonic connective tissue, often with plenipotentiary cells.

mesothelium(a) (mee-zoh-THEE-lee-um), the epithelium lining the great (closed) body cavities (e.g., pleura, peritoneum, and pericardium). It is of mesenchymal origin, not ectodermal, and has properties different from those of classical epithelia.

meta-, change.

metr-, uterus.

micro, small (e.g., microtubule).

microorganism, one of a group of organisms including bacteria, viruses, fungi, protozoans, and other microscopic life forms.

micturition, urination; discharge of urine outside the body.

mineralization, the process of mineral (calcium complexes) deposition, especially in bone formation and remodeling as well as formation of teeth.

mm, millimeter.

mm Hg, millimeters of mercury. The unit of a pressure-measuring system in which the open end of an air-evacuated (vacuum) graduated cylinder (tube) is placed in a container of liquid mercury. The pressure of the atmosphere or fluid pressing on the mercury pushes the mercury up the cylinder. The distance the mercury moves up the tube is measured in mm Hg and reflects the pressure imposed.

minor, smaller. See also major.

mitigate, to diminish the impact of; take away something to improve the overall situation. To become less painful or harmful.

modulate, to induce a change.

modulator, a controlling element or agency.

mortise, a recess that receives a part, as the talus fits into the recesses of the tibia and fibula.

motor, referring to movement; with respect to the nervous system, refers to that part concerned with movement.

mucosa(e) (mew-KOS-ah), a lining tissue of internal cavities open to the outside. Epithelial/gland cells secrete a mucus onto

the free surface of the lining, which consists of epithelial lining cells, glands, and underlying connective tissue and nerves/vessels; it may have a thin layer of muscle.

mucous, referring to mucus.

mucus, a secretion of certain glandular cells, composed largely of glycoproteins in water, forming a slime-gel consistency, thicker than serous fluid.

multi-, many.

muscular, referring to muscle.

muscularis (muss-kyoo-LAHR-is), a layer of muscle.

musculoligamentous, consisting of muscle and ligament.

musculoskeletal, consisting of muscle, bones, ligaments, tendons, fasciae, and joints.

musculotendinous, consisting of muscle and tendon.

mutation, some change in form or quality, such as a mutation that occurs by chance in a chromosome and having a number of influences on body structure or function as a result.

myelin (MY-eh-lin), compressed cell membranes of Schwann cells in the PNS and oligodendrocytes in the CNS, arranged circumferentially, in layers, around axons. Composed of cholesterol, components of fatty acids, phospholipids, glycoproteins, and water.

myelo-, marrow; usually refers to spinal cord.

myelopathy, neurologic deficit resulting from spinal cord injury or disease.

myo-, referring to muscle.

myoepithelium(a), contractile epithelial cells. Usually located at the base of gland cells, with tentacle-like processes embracing secretory cells. Particularly prominent in sweat, mammary, lacrimal, and salivary glands.

myofascial, skeletal muscle ensheathed by vascular and sensitive fibrous connective tissue.

myoglobin, the oxygen-containing, pigment-containing protein molecule of muscle.

myosin, the principal protein of muscle associated with contraction and relaxation of muscle cells.

myriad, a great number.

myx-, mucus.

N

naso-, nose, nasal.

neck, cervix. A constricted part of an organ or bone, as in the surgical neck of the humerus or neck of the gallbladder. The neck is that part of the body inferior to the head and superior to the first thoracic vertebra (cervical region) and confluent with the shoulders, upper back, and upper chest.

necrosis (neh-KRO-sis), a state of cellular or tissue death.

nephro-, kidney. See also renal.

nervous, (anatomic meaning) referring to the nervous system.

neuro- (NOO-roh), nervous, referring to nervous structure or the nervous system.

neuroglia (noo-ROHG-lee-ah), nonconducting support cells of the nervous system, including the astrocytes, oligodendrocytes, ependyma, and microglia of the CNS, and Schwann cells and satellite cells of the PNS.

neurologic (neurology), concerned with disorders of the nervous system. Also refers to nerve/neuronal disorders seen in a clinical setting.

neuron (NOO-ron), nerve cell.

neurovascular, refers to nerve(s) and vessel(s), as in neurovascular bundle.

nociceptor (no-see-SEP-tur), a receptor for pain.

nucha- (NOO-kaw), posterior neck; nuchal region.

O

occult, hidden.

oculus (i), eye.

-oid, having similar form; -like.

-oma, tumor.

omni-, all, universally (e.g., omnidirectional, in all directions).

ooph-, ovary.

ophth-, eye.

optic, relating to the eye.

or-, mouth.

orb, sphere, round structure.

orbicular, rounded, circular.

orbit, the bony cavity containing the eyeball.

orchi-, testis.

organelle(s) (or-gan-ELL), small functional structure within the cell cytoplasm.

os-, bone.

oscilloscope, an instrument that permits visualization of baseline and waves of changes in electrical voltage.

-osis, condition or state of (e.g., arthrosis is a generic term for a condition of a joint).

osseous, relating to bone.

ossification, endochondral, formation of bone by replacement of cartilage/calcified cartilage.

ossification, intramembranous, formation of bone directly from osteoprogenitor cells in embryonic connective tissue (mesenchyme) or in fibrous tissue adjacent to fractured bone. There is no intermediate stage of cartilage formation or replacement.

ossification, primary center of, the principal center of bone formation in the diaphysis or center of developing bone.

ossification, secondary center of, a satellite center of ossification, as in the epiphysis.

osteo-, bone.

osteoblastic, referring to bone-forming cells (*osteoblasts*).

osteoclastic, referring to bone-destroying cells (*osteoclasts*).

osteoid (OSS-tee-oyd), bonelike; nonmineralized bone.

osteoprogenitor, a primitive cell that has the potential, when stimulated, to become a bone-forming cell (osteoblast).

-ostomy, operation that makes an artificial opening.

ovale, oval.

oxy-, oxygen.

P

pachy-, thick.

pachymeninx, dura mater.

palpable (PAL-pah-bul), touchable; by touch.

palpate, to touch or feel (a common clinical technique).

palsy, weakness.

papilla, -ae (pl.), a projection of tissue resembling a nipple.

para-, alongside.

parenchyma (pah-REN-keh-ma), the functional substance of an organ.

paresis, weakness caused by incomplete paralysis.

parietal (pah-RY-et-all), referring to a wall or outer part.

-pathy, disease.

ped-, foot.

pedal, foot.

pedicel, a very small process that sticks out from a cell; arguably resembles a small foot (e.g., the pedicels of podocytes wrapped around the glomerular capillaries in the renal capsule of the kidney).

pedicle, footlike process; narrow stalk.

pedo-, child.

peduncle, a narrow stalk, specifically masses of white matter in the CNS.

pelvic girdle, the two coxal (hip) bones.

pelvis(es), the ring of bone consisting of the two coxal (hip) bones and the sacrum and coccyx.

-penia, deficiency or decrease.

penicillar, resembling a painter's brush or pencil.

pennaté, feather-shaped.

peri-, around.

perichondrium (par-ee-KOND-ree-um), the fibrous envelope of cartilaginous structures (except articular), containing blood vessels, fibroblasts, and chondroblasts (immature cartilage cells). It is the life support system for cartilaginous structures.

perineal, referring to the region inferior to the pelvis.

perineal body, a fibromuscular mass in the perineum in the median plane between the anus and the vagina. It is a critical attachment point for the deep and superficial perineal muscles, thereby giving stability to the muscles and tissues of the region. The line bisecting the urogenital and anal triangles runs right through the perineal body from ischiopubic ramus to ischiopubic ramus.

periodontal, around a tooth.

periosteum (pair-ee-OS-tee-um), the fibrous envelope surrounding bone, containing osteoprogenitor cells, osteoblasts, fibroblasts, and blood vessels, serving as the life support system of bone.

peripheral, away from the center, near or toward the periphery.

peristalsis (pair-ee-STAHL-sis), waves of coordinated and rhythmic muscular contractions in the walls of a cavity or tube-like organ, induced by hormones or other secreted factors and by nerves of the autonomic nervous system.

peroneal, the lateral (fibular) side of the leg.

perpendicular, refers to a plane at right angles (90 degrees) to an adjoining plane.

pes, foot.

pes anserinus, goose foot. Refers to the tendons (sartorius, gracilis, and semitendinous) that collectively insert on the medial proximal tibia.

petrous (PEET-russ), rocky or like a rock.

-pexy, fixation or suspension.

phagocyte, a cell that takes up cell fragments or other particulate matter into its cytoplasm by endocytosis. Phagocytes with a segmented nucleus are called polymorphonuclear leukocytes (*neutrophils*); mononuclear phagocytes (of the monocyte-macrophage lineage) are known by several names, depending on their location—e.g., macrophages, monocytes of the blood, histiocytes of the connective tissues, Kupffer cells of the liver, alveolar (dust) cells of the lung, microglia of the central nervous system. Many cells that are phagocytic under certain circumstances are not called or considered phagocytes.

phagocytosis (fay-go-site-OH-sus), the taking of fragments or other particulate matter into a cell.

phlebo-, vein.

-physis(es), growing part.

-pial, referring to pia mater.

pinocytosis, cellular ingestion of fluid.

pituitary (archaic), referring to mucus.

-plasia, referring to development or growth.

plasm-, referring to the substance of some structure, e.g., cytoplasm (cell substance).

-plasty, surgical correction.

plenipotentiary, having the capacity to develop along a number of different cell lines. Undifferentiated mesenchymal cells, pericytes, and certain other cells have such capability.

pneumo-, air.

PNS or **P.N.S.,** peripheral nervous system, consisting of cranial and spinal nerves and the autonomic nervous system.

pod-, foot-like process that sticks out from the body of a cell; also a cell with foot-like processes.

pole (polar), either extremity of an axis, as in south and north poles of the Earth. Also refers to processes of a neuron (e.g., unipolar).

pollex, thumb. *Pollicis,* genitive form.

poly-, many or multi-.

polymodal, with many modalities; polymodal receptors are responsive to several different stimuli.

portal circulation, veins that drain a capillary bed and terminate in a second capillary or sinusoid network, as in the hepatic portal vein and the portal system of the hypophysis.

post-, back of, after, posterior to.

pre-, in front of, anterior to.

precursor, a forerunner, whose existence precedes something that is formed from it.

pro-, in front of.

procerus (pro-SEH-russ), long, slender muscle.

process, bony, a projection sticking out from a surface.

process, neuronal, an extension of a neuron, containing cytoplasm/organelles and limited by a cell membrane. A neuronal process (dendrite or axon) is part of a living cell.

procto-, rectum. See also recto-.

progenitor cell, a stem cell for a lineage of cells, such as T lymphocytes. Progenitor cells are seeded throughout the body, where they can be utilized when their progeny are needed.

prolapse, the sinking down or displacement of a structure, such as the sinking of the uterus into the vagina.

propria (PROH-pree-ah), common.

protein, a chain of amino acids of varying length.

proteoglycan, a chain of disaccharides (carbohydrates) connected to a core of protein; a binding material.

proteolytic, causing digestion or breakdown of protein.

protuberance, a projection, or something sticking out from a surface.

proviral, refers to viral DNA that has been integrated into the DNA of the host cell.

pseudo (SOO-doh), false. In anatomy or medicine, having the appearance of one structure or phenomenon but not, in fact, being such a structure or phenomenon, e.g., pseudounipolar.

pterygoid (TAYR-ee-goyd), winglike.

-ptosis, falling, drooping.

pubescent, reaching sexual maturity.

pudendal, from *pudere,* to be ashamed. Referring to the external genitals, generally of the female sex.

pulp, a soft, spongy tissue, often vascular.

pyel-, pelvis.

pyo-, pus.

Q

quad-, four.

quadrant, one-quarter of a circle.

quadrate, four-sided; rectangular, usually square.

R

radi-, ray.

radiculitis, inflammation/irritation of a nerve root.

radiculopathy, nerve root deficit characterized by change in the deep tendon (stretch) reflex, sensory loss (objective numbness), and muscle weakness.

radix, root.

ramus (RAY-mus), a branch.

ratio, a fixed relationship or proportion between two things; e.g., 1:4 means that there is 1 unit for every 4 other units.

recto-, rectum. See also procto-.

reflux, backward flow.

renal, referring to the kidney. See also nephro-.

repolarization, an electrical change in excitable tissue away from neutral polarity (e.g., increasing polarity from 0 millivolts to –90 millivolts).

residue (REZ-ih-dyoo), the material left over after processing and extraction of other parts.

reticulum(a), a small network.

retro-, back, behind, posterior; opposite of antero-.

retroperitoneum, the area posterior to the posterior layer of parietal peritoneum. It lies anterior to the muscles of the posterior abdominal wall and includes the kidneys, ureters, abdominal aorta and immediate branches, inferior vena cava and immediate tributaries, pancreas, and ascending and descending colon.

retropharyngeal, refers to the space immediately anterior to the vertebral column and posterior to the pharynx. It contains blood vessels.

retropharyngeal plexus of veins, the site of the vertebral venous plexus that drains the cranial dural sinuses and connects them with pelvic veins by way of the azygos and caval systems. In the event of anterior neck trauma in conjunction with hyperextension of the cervical spine, a "silent" hemorrhage can occur from trauma to the venous plexus in the retropharyngeal space, which can result in exsanguination if not identified early on in the evolution of the hemorrhage.

rostral, beak; used as a term of direction toward the head end, and specifically when referring to a beak-like process in the anterior part of the brain.

rotundum, round.

S

salpingo-, referring to uterine tubes.

salpinx, uterine tube.

sarco-, flesh.

scavenger cell, see phagocyte.

Schwann cell, cell of the peripheral nervous system that provides myelin for some and a membranous covering for all axons. A line of Schwann cells forms a tube for axonal regeneration after axonal injury.

sciatica, pain in the buttock radiating to the foot via the posterior and/or lateral thigh and leg; it follows the distribution of the sciatic nerve, and therefore is assumed to be caused by irritation of that nerve or its roots (*radiculitis*).

scoliosis (sko-lee-OH-sis), any significant lateral curvature of the vertebral column. Some degree of lateral curvature is seen in most spines, probably related to use of the dominant hand.

-scopy, inspection or examination of.

sebum, the oil lying on the surface of skin, secreted by sebaceous glands (see page 19).

secondary sex characteristics, anatomic and physiologic changes occurring as a result of increased sex hormone secretion (testosterone in the male, estrogen in the female); these characteristics develop at puberty, generally at 11–14 years of age. In the male, they include growth of body hair, change in voice due to change in laryngeal structure, increased skeletal growth, increase in size of external genitals, functional changes in internal genitals, and changes in mental attitude. In females, they include enlargement of breasts, change in body shape due to skeletal growth and distribution of body fat, and maturation of internal and external genital structures.

secretion, elaboration of a product from a gland into a duct, vessel, or cavity. See excretion.

sella, saddle.

sella turcica, Turkish saddle. The concavity of the sphenoid bone which on its superior surface contains the pituitary gland underneath a dural diaphragm (diaphragma sellae). On each side of the sella is the cavernous sinus of the dural venous system.

sellar, saddle-shaped.

semi-, half or partly.

semi-lunar, half-moon-shaped.

sensitive, responsive to stimuli, eliciting an awareness of touch, pressure, temperature, and/or pain; innervated.

sensory, referring to sensation (e.g., touch, perception of temperature, vision).

septum(a), a wall or an extension of a wall; a structure that separates.

septum pellucidum, a vertical, double-wall (*bilaminar*) septum interfacing the lateral ventricles; occupies the midline within the anterior curvature (genu) of the corpus callosum to which the two laminae are attached. These thin sheets separate the two cavities of the lateral ventricles. Bulging into the ventricles on both sides of the septum are the heads of the caudate nuclei. The septum is attached posteriorly to the curved fornix. It is not related to the septal nuclei.

serosa (sir-OH-sa), lining tissue of cavities closed to the outside, consisting of a layer of squamous or cuboidal cells and underlying connective tissue.

serotonin, a nitrogenous molecule with many functions, including acting as a neurotransmitter, inhibitor of gastric secretion, and vasoconstrictor.

serous, watery; see serum.

serum, any clear fluid; also blood plasma without plasma (clotting) proteins.

sesamoid, pea-shaped. Generally refers to small bones of the hand and foot. The largest sesamoid bone is the patella. These bones are formed within the tendons or ligaments at points of stress.

Sharpey's fibers, fibrous bands of ligaments, tendons, and/or periosteum inserting directly into bone.

shoulder, the part of the body where the upper limb is joined to the trunk; specifically, the shoulder joint and surrounding area, including the upper lateral scapula and distal clavicle (acromioclavicular area).

-sial, referring to saliva.

sinus(es) (SY-nuss), a cavity or channel. A *venous sinus* is a large channel, larger than an ordinary vein, such as the dural venous sinuses in the cranial cavity, and the venous sinuses of the spleen; an *air sinus* is a cavity in bone lined with respiratory mucosa.

sinusoid, sinuslike; usually refers to thin-walled, porous vessels in glands. Generally slightly larger than capillaries, sinusoids vary in their structure depending on their location.

soft tissue, any tissue not containing mineral, e.g., not bone, teeth. Generally refers to myofascial tissues.

solute, a substance dissolved in a solvent, such as table salt and water. Water is the universal solvent; later rather than sooner, a large rock in a river will dissolve.

soma, somata (pl.), the body of some structure, e.g., corpus, cell body, and body wall.

somatic, referring to the body or body wall, e.g., the cell body of a neuron (soma); in organizational terms, contrasted with *viscus* or *viscera* (organs containing cavities).

spasm, rapid, violent, involuntary muscle contraction, usually resulting in some contortion of the body part experiencing the contraction.

spheno- (SFEE-no), shaped like a wedge; refers to a triangular-shaped structure that comes to a thin edge on one side.

sphincter, a concentric band of muscle surrounding a narrowed cavity or passage.

spindle, a structure that is round and tapered.

spinosum, spiny or spinelike.

splanchnic, pertaining to viscera or a viscus.

spleno-, spleen. See also lieno-.

spondyl-, vertebra.

squamous, platelike, thin. Generally refers to flat, thin epithelial cells.

stenosis (sten-OH-sis), narrowing.

stereocilia, a nonmotile (fixed) surface projection of a cell. Found on hair cells of the inner ear and pseudostratified columnar cells of the epididymis.

-stomy, hole or opening.

stratified, layered; having more than one layer.

stria, stripes or parallel markings.

stroma, the basic supporting or connective tissue of an organ.

styloid (STYL-oyd), having the form of a pointed spike or pillar.

sub-, under.

subchondral, under cartilage; specifically, the bone adjacent to articular cartilage.

subcutaneous (sub-kew-TANE-ee-us); under the skin.

subdural, under the dura; between the dura and the brain or spinal cord.

subscript, a small letter or number written below the primary term, as in ARM$_C$, and used for identification relating a structure shown to its descriptive term.

superscript, a small number or letter written above the subscript, as in ARM$_C$1. Used for identification of a term or structure related to the root descriptive term, e.g., three branches of an artery with subscript C might be identified by superscripts as C^1, C^2, and C^3.

supra-, above.

suprasegmental, above the segments of the spinal cord; that is, the brain. Tracts that predominately run through the cerebrum are known as *suprasegmental tracts*.

suture (SOO-chur), a type of fibrous or bony junction characterized by interlocking, V-shaped surfaces, as in the skull.

swallowing, deglutition.

sym-, see syn.

symphysis(es) (SIM-fih-sis); see joint classification, structural.

syn- (SIN), together, with, alongside.

synarthrosis(es) (sin-arth-RO-sis); see joint classification, functional.

synchondrosis (sin-kon-DRO-sis); see joint classification, structural.

syndesmosis(es) (syn-des-MO-sis); see joint classification, structural.

synostosis(es) (syn-os-TOH-sis); see joint classification, structural.

synovial (sih-NOH-vee-ul), refers to a viscous fluid similar in consistency to uncooked egg white. This fluid and the membrane that secretes it line freely movable joints (synovial joints), bursae, and tendon sheaths.

synthesis(es), formation of a structure from smaller parts; integration of parts.

T

taenia(e) coli, strips of longitudinal muscle in the muscularis externa of the large intestine (excluding the rectum and anal canal).

tarsal, tarso-, the ankle.

tectum, roof.

tegmentum, a region of gray matter on either side of the cerebral aqueduct in the midbrain.

tendinitis, inflammation of a tendon.

tendinous (TEN-dih-nuss), referring to tendon.

tendon, fibrous tissue connecting skeletal muscle to bone or other muscle. May be cord-like or sheet-like (aponeurosis).

thigh, that part of the lower limb between the hip joint and the knee joint.

thoracentesis, placement of a hollow needle through the thoracic wall into the pleural cavity for the purpose of withdrawing fluid.

thorax, the region between the neck and the abdomen.

thrombosis(es), a condition of clots or thrombi within a vessel or vessels.

thrombus(i), a clot within a blood vessel, obstructing flow.

-tome, suffix signifying a cut section; also an instrument for cutting, such as a microtome.

-tomy, to cut; e.g, appendectomy.

tone, normal tension in muscle, resistant to stretch.

torso, the part of the body less the limbs and head; the trunk.

trabecula(e), a beam of bone or a stout strand of connective tissue that is directed internally to support the interior structure, e.g., the spleen, developing bone.

tract, a collection of axons in the central nervous system, such as the reticulospinal, rubrospinal, tectospinal, vestibulospinal, corticospinal, spinothalamic, spinocerebellar tracts. Also a tubular system, such as the urinary and gastrointestinal tracts.

transcriptase, an enzyme (polymerase) directed by DNA to facilitate synthesis of a single strand of RNA that is structurally complementary to a strand of DNA.

transcriptase, reverse, a polymerase (enzyme) directed by RNA to facilitate synthesis of a single or double strand of DNA that is structurally complementary to a strand of RNA. In HIV infection of cells, RNA-directed reverse transcriptase makes possible the transcribing of viral RNA sequences into double-stranded DNA; this is then integrated into the host cell's DNA. The combined DNA is called proviral DNA.

trauma, an anatomic or psychic response to injury.

trochanter, a large process. Specifically, two processes of the upper femur.

trochlea (TROHK-lee-ah), a pulley-shaped structure.

-trophic, suffix referring to a nutritional state, e.g., hypertrophic (increased growth).

truss, a collection of members (beams) put together in such a way as to create a supporting framework.

tubercle (TOOB-er-kul), a rough, small bump on bone.

tuberosity (toob-eh-ROSS-eh-tee), a bump of bone, generally larger than a tubercle, smaller than a process.

tubulo-, referring to a tubular structure; when combined with "-alveolar," as in *tubuloalveolar*, refers to a gland that has a tubular duct.

tunica, referring to a coat or sheath; a layer.

turcica (TUR-sih-kah), Turkish, as in sella turcica (Turkish saddle).

U

undifferentiated, a structure that has not been dissected, physically or metaphorically, into component parts. Can also mean without structure. *Anaplasia* is a loss of differentiation or reverse differentiation.

uni-, one. A unicellular gland is a one-cell gland.

unibody, of one body; a structure with parts integrated into one unit.

unit, a single thing or quantity; the basic part of a complex of parts.

urogenital, referring to structures of both the urinary and genital (reproductive) systems.

urogenital diaphragm, a layer in the perineum consisting of the sphincter urethrae and deep transverse perineal muscles and their fasciae. Also called the *deep perineal space*.

V

vacuolation (vak-you-oh-LAY-shun), formation of small cavities or holes; part of a degenerative process in cartilage during bone development.

vacuum, a space devoid of air and thus lacking pressure. In the relative sense, decreased pressure in the thoracic cavity during inspiration represents a partial vacuum, drawing air from a space with air of higher pressure.

varicosity(ies), an enlarged and irregular-shaped, highly curved (tortuous) vein(s). Most often seen in superficial veins of the lower limbs and the testes/scrotum.

varix(ces), an enlarged, tortuous (twisted) vessel.

vas(a), vessel.

vasa vasorum, vessel that supplies a larger vessel.

vascular, referring to blood or lymph vessels or to blood supply.

vasoconstriction, constriction of a vessel, usually by circular smooth muscle in the wall of the vessel.

vasodilation, dilation of a vessel, usually by relaxation of a circular layer of smooth muscle in a vessel.

vasorum, of the vessels.

ventricle, a cavity.

vessel, a tubelike channel for carrying fluid, such as blood or lymph.

vestibule, an entranceway, cavity, or space.

villus(i), a fingerlike projection of tissue, as in the intestinal tract or placenta.

viral, relating to a virus.

virion, a single virus, also called a *virus particle*, consisting of genetic material (DNA or RNA) and a protein shell (*capsid*).

virus, one of a group of extremely small infectious agents, consisting of genetic material and a protein shell. A virus is not capable of metabolism, and thus requires a host to replicate. On attachment to a surface molecule on a cell membrane, a virus particle is enveloped by the cell membrane and brought into the cytoplasm, thus infecting the cell.

viscous, a fluid or semi-fluid state wherein molecules experience significant friction during movement.

viscus(era), referring to organs with cavities; viscera or visceral cavities.

vomer, a plowshare-shaped structure.

W

white matter, a substance of the brain and spinal cord consisting of largely myelinated axons arranged in the form of bundles or tracts. It appears white in the living or preserved brain.

wrist, the carpus, the region between the forearm and hand.

wrist drop, a condition in which the extensors of the wrist are weak or paralyzed. The wrist cannot be extended and therefore the wrist "drops" when one attempts to hold the hand horizontally or vertically upward. This condition is usually the result of radial nerve denervation.

X

xeno-, foreign.

xero-, dry.

Z

zygapophysis(es) (zi-gah-POFF-ee-sis), an articular process of a vertebra; also a joint between vertebrae (zygapophyseal articulation). Such synovial joints may be called *facet joints*. See also facet.

zygo- (ZY-go), referring to a yoke or union; joined.

INDEX

Words are indexed by generic terms (artery, bone, ligament, foramen, process, nerve, vein, and so on). For example, if you wish to locate a specific artery, look under "Arteries." Components of systems are indexed by "System." The principle reference among a number of cited page numbers is in bold type.

A

A band, of skeletal muscle, 12
Abduction, defined, 21
Acetabulum, 35, **37**
Acrosome, spermatozoan, 156
Actin, 12
Adam's apple, of larynx, 130
Adduction, defined, 21
Adductor hiatus, 61
Afferent, defined, 69
Agonist (prime mover), 43
Alveolus(i), 4
 glandular, 8
 respiratory, 131, **132**
Amphiarthroses, 20. *See also* Joint
 classification, G-8
Ampulla
 of inner ear, 98
 of uterine tube, 160
Amygdala, 73
Anal triangle, 51
Anaphase, of mitosis, 7
Anastomoses, 106, **107, 109–119**
Anatomic barriers, in immunity, 122
Annulus fibrosus, 25
ANS, **91–93**. *See also* Nervous system
Antagonist, 43
Antibodies, **121,** 122, 125, 126
Antigens, **121,** 122–123, 125
Aorta, 104, 107, **111**
Apertures, median/lateral, 82
Apparatus, juxtaglomerular, 148
Appendices epiploica, 141
Appendicitis, 126, 141
Aponeurosis
 bicipital, 55
 of external oblique, 49
 galea aponeurotica (scalp), 44
 iliotibial tract, 59
 palmar, 56
 plantar, 65
Arachnoid villi, 81, **82**
Arch
 of atlas
 anterior, 26
 posterior, 26
 of aorta, 103, **111**
 dorsal, digital, arterial, of foot, 110
 longitudinal, lateral, of foot, 40
 medial, of foot, 40

palatoglossal, 126, **135**
palatopharyngeal, **135**
palmar, deep/superficial, **109**
plantar, arterial, 110
tendinous (pelvis), 50
transverse, of foot, 40
zygomatic, **22, 45**
Area
 auditory area of cerebral cortex, 73
 Broca's speech area, **73**
 limbic, cerebral cortex, **73,** 74
 Wernicke's, of cerebral cortex,
 language interpretation, 73
 visual area, cerebral cortex, 73, 96
Areola, 162
Arteries. *See also* Cardiovascular system
 acromial rete, 109
 alveolar
 inferior, 107
 superior, 107
 aorta, 111, 112
 abdominal, 48, 91, 110, **111,** 112,
 113, 145, 155
 arch of, 104, 106, **111**
 ascending, 104, **107,** 111
 sinus(es), of the, 106
 thoracic, (descending), 48, 107, **111**
 arch, superficial, palmar, 109
 palmar, deep, 109
 arcuate, of the foot, 110
 auricular, posterior, 107
 axillary, 107, **109**
 basilar, 108
 brachiocephalic, 107,
 109, **111**
 brachial, 109
 profunda, 109
 bronchial, 111
 carotid
 common, 107, 109, **111**
 external, 107
 internal, **107, 108,** 115
 celiac, 111, **112,** 153, 154
 cerebellar
 anterior inferior, 108
 posterior inferior, 108
 superior, 108
 cerebral
 anterior, 108
 middle, 108
 posterior, 108

cervical
 ascending, 107
 deep, 107
 superficial, 107
colic
 left, 112
 middle, 112
 right, 112
collateral,
 middle, 109
communicating
 anterior, 108
 posterior, 108
coronary, **106,** 111
costocervical, trunk,
 107, **111**
cystic, 112
digital
 dorsal, of the foot, 110
 palmar, common, 109
dorsalis pedis, 110
epigastric
 inferior, **110,** 119
 superior, **111,** 119
esophageal, **111**
facial, 107
 transverse, 107
femoral, 61, 88, **110**
 circumflex
 lateral, 110
 medial, 110
 profundus, 110
 perforating, 110
fibular, 110
 circumflex, 110
gastric
 left, 111, **112,** 139
 right, 112, 139
gastroduodenal, 112, 139
gastroepiploic, **112**
 left, 112, 139
 right, 112
genicular anastomoses,
 knee, 110
 descending, 110
 lateral inferior, 110
 medial inferior, 110
 superior, 110
gluteal
 inferior, 110, **113**
 superior, 110, **113**

Perforators, defined, 117
Periarteriolar lymphoid sheaths
 (PALS), 124
Pericardium, 103
Perimysium, 42
Perineal floor, 51
Perineum, 51, 113
Periosteal bud, 18
Periosteum, **17, 18**
 of cranium, 81
Peripheral Nervous System (PNS).
 See Nervous system
Peripheral process, 69, 84
Peritoneum
 parietal layer, 5, **138**, 139, 141
 broad ligament, 158–160
 bursa, omental, 138
 fascia, internal spermatic, 49
 mesentery, 138
 mesocolon, sigmoid, 138
 mesometrium, 160
 mesosalpinx, 159, 160
 mesovarium, 159
 omentum
 greater, 138
 lesser, 138
 retroperitoneum, 145
 visceral layer, 5, 138–141
Pes anserinus, **60,** 61, 64
Peyer's patches, 126
Phagocytes
 and adaptive immunity, 121–126
 and innate immunity, 122
Phalanges, 40
Pharynx, 127, **130**, 134
Phlebitis, 117
Pial filum terminal, 77
Pimples, 115
Pineal gland, 75
Pisiform bone, 33
Pituita, 150
Placenta, and hormones, 149
Planes and sections, 1
Plantar flexion, defined, 21, 64,
Plaque, 106
Plasma, 100
 cell, **9,** 121
Plasmalemma, 11
Plates
 cribriform, 128
 epiphyseal, 18
 motor end, 69, 71
 nail, 15
 neural, 72
 perpendicular, of the ethmoid, 23, 129

Platysma, 44
Pleura, 5, 131
 parietal, 131
 visceral, 131
Pleural
 cavity, 131
 effusion, 131
 recess, 131
 costodiaphragmatic, 131
 costomediastinal, 131
Plexus
 brachial, 86, 87
 cervical, 86
 lumbar, 86, 88
 pterygoid, 115
 Purkinje, 105
 sacral, 86, 88
Plicae circulares, 140
Pneumothorax, 131
Podocytes, 147
Poles, of a neuron, defined, 13
Polysynaptic reflex, 85
Pons, of the brainstem, 76
Popliteus, 64
Porta hepatis, 142, **143**
Position, anatomical, 2, 21
Posterior, defined, 2
Posterior triangle, 46
P-Q interval, 105
Precentral gyrus, 73
Prepuce, 158
Pressoreceptors, 148. *See also*
 Interoceptors, 90
Procerus, 44
Process
 articular, 25, 26
 condylar (TMJ), **24,** 45
 coracoid, 52, **53**
 coronoid (TMJ), **24,** 45
 mastoid, 22, 23, 129
 styloid, 45, 46
 transverse, 26, 47
Progesterone, 151
Prolactin, 151
Promontory, sacral, 50
Pronation, 21
Pronator quadratus, 55
Pronator teres, 55
Prophase, of mitosis, 7
Proprioceptors, 90
Proximal, defined, 2
Pterygoid, lateral/medial, 45
Pubis, 35, 51
Pubococcygeus, 50

Puborectalis, 50
Pulmonary embolism, 117
Pulmonary trunk, 104
Pulmonary venules, 132
Pupil, 94
Putamen, 74
P wave, 105
Pyramidal tract, 79
Pyramids, 76, 79

Q

QRS complex, 105
Quadratus lumborum, 48
Quadratus plantae, 65

R

Radius, 31, 32
Ramus(i)
 anterior, **84**, 86
 ischiopubic, 51
 of the mandible, 22
 posterior, 84, **86**
 white, 91
Raphe, of bulbospongiosus, 51
Receptors
 classification of, 69, 90
 of integument, 16
 olfactory, 99
 glycogen, pancreatic islets, 154
 gustatory (taste), 99
 insulin, 154
 muscle stretch, 90
 pain, 78, 85
 pressure, 78
 temperature, 78
 touch, 78
Recess, anterior, of ischiorectal
 fossa, 51
Rectum, 134, 141
Red marrow, 17, 123
Red pulp, 124
Reflex, spinal, 85
Region
 ano-rectal, 141
 cervical, 26
 gluteal, 59
 inguinal, 49
 thoracic, 26
 lumbar, 27
 sacral, 27
 urogenital, 51, 157
 vertebral, 25

Target organs, hormone, 149, 151
Taste, 83, 99, 135
Taste bud, 99
Tears, lacrimal, 95
Teeth, 134, 135, **136**
Telencephalon, **72, 80**
Telophase, of mitosis, 7
Tendon, 30, 42
 central, of diaphragm, 48
 conjoint (falx inguinalis), 49
 pes anserinus, **60**, 61
 tendocalcaneus, 64
Tentorium cerebelli, 81
Testes, **156**, 157
 and fascial coverings, 49
Testosterone, 151, 156
Thalamocortical tract, 78
Thalamus, 75, 78
Thenar eminence, 57
Thigh, 60, 62
Thoracolumbar division. See ANS
Thrombi, 117
Thrombocytes, aka
 platelets, 100
Thrombophlebitis, 117
Thrombosis, 115, 117
 cavernous sinus, 115
Thymus, **123**, 149
 thymocytes, 123
Thyroid, 149, **152**
 thyroxin, 152
Tissues, 3, 6–14. See also Cells
 connective, 9, 14
 epithelial, **8**, 14
 fibrous connective, 9
 hematopoietic, 17, 18, **123**
 integration of, 14
 lymphatic, 120
 cells, 100, **120**, 123
 lymphoid, **121**–126
 mucosal associated lymphoid, 121,
 126, 135, 141
 muscle, 11
 nervous, 13
 supporting connective, 10
Tongue, 134, 135, 137
Tonsils, 126, 135
Torso, muscles
 of abdominal wall, **48, 49**
 of back, 47
 of inguinal region, 49
 of neck, 46, 47
 of pelvis, 50
 of perineum, 51
 of thorax, 48

Trabecula(e), of bone, **10**,
 17, 18
 of lymph node, 125
 of the spleen, 124
Trachea, **127**, 131, 132
Tract(s)
 of the CNS, **74**, 78, 79
 corticospinal
 anterior, 79
 lateral, 79
 digestive. See Digestive
 extrapyramidal
 reticulospinal, 79
 vestibulospinal, 79
 pyramidal. See Corticospinal
 tract
 reticulospinal, 79
 rubrospinal, 79
 hypothalamic-hypophyseal, 150
 iliotibial, 59, 60
Transverse plane, 1
Transverse tubule system, 12
Triad, of the liver, 142
Triangle, anal, 51
 anterior, 46, 51
 posterior, 46
 urogenital, 51
Triangular fibrocartilage complex
 (TFCC), of the wrist, 33
Trigone, of the bladder, 144
Trochanter, greater, **38**, 59
Trunk, brachiocephalic, **106**,
 107, 111
 celiac, 111
 pulmonary, 103, **104**,
Tube/tubule
 auditory, 97, **129**
 collecting, 147
 fallopian. See Uterine
 neural, 72
 oviduct. See Uterine
 pharyngotympanic, 129
 proximal convoluted, 147
 seminiferous, 156
 uterine, **158**, 159, 160
Tubercle
 greater, of the humerus,
 29, **53**
 infraglenoid, of humerus, 55
 lesser, of the humerus, 29, 53
 pubic, **35**, 51
 supraglenoid, of the
 humerus, 55
Tuberosity, ischial, 35, 36
 perineal boundary, 51

Ulna, 31, 32
Unit, functional of an organism, 6
 motor, 71
Ureter, 144, 146
Urinary system (tract)
 kidneys, 145, **146**, 147
 afferent arteriole, 147
 calyx
 major, 146
 minor, 146
 capsule, renal, 147
 cortex, 147
 efferent arteriole, 147
 glomerulus, 147
 introduction, 4, **144**
 medulla, 147, 153
 papilla, 147
 nephron, 147–148
 cortical, 147
 juxtamedullary, 147
 relations, of, 144, 145
 renal circulation, 147
 renal corpuscle, 147
 renal pelvis, 146
 renal tubule
 collecting tubule, 147
 duct, 147
 papillary duct, 147
 distal convoluted tubule, 147
 loop of Henle, 147
 proximal convoluted tubule, 147
 tubular function, 147–148
 ureter, 146
 mucosa, 146
 lamina propria, 146
 transitional epithelium(ia), 146
 muscularis, 146
 serosa, 146
 stones, location of, 144
 urethra, 144, 157
 membranous, in UGD, 51
 prostatic, cross section, 51
 spongy, cross section, 51
 urinary bladder, 144
 urine, 144, **146**, 148
Urogenital region, female, 51
 structures, 113, 158
Urogenital region, male, 51
 structures, 113, 155
Uterine tubes. See Tubes
Uterus, 158, **160**, 161
Utricle, 97
Uvula, 135

V

Vacuoles, 6
Vagina, **158,** 160–161
 prolapse of, 160
Valves, 102
 bicuspid, 104
 ileocecal, 141
 semilunar, 104
 tricuspid, 104
 venous, 102
Varicosities, 117
Vascular system. *See* Cardiovascular
 system, Arteries, Veins
Vastus intermedius, 62
Vastus medialis, 62
Veins
 angular, 115
 arch, dorsal, 117
 auricular, posterior, 115
 axillary, 109
 azygos and tributaries, 116
 basilic, 109
 brachial, 109
 brachiocephalic, 109,
 115, 116
 right, 115
 cephalic, 109
 cerebral, superior (bridging), 115
 cervical, deep, 115
 classification of, 102
 cubital, median, 109
 cystic, 118
 digital. *See also* plantar, 117
 dorsal, of the hand, 109
 dorsal, of the foot, 117
 diploic, 115
 emissary, 115
 esophageal, anastomotic with
 superior vena cava, 118
 facial, 115
 deep, 115
 femoral, 116, 117
 circumflex
 lateral, 117
 medial, 117
 profundus, 117
 gastric, left/right, 118
 gastroepiploic, left/right, 118
 gluteal
 inferior, 117
 superior, 117
 great cerebral, 115
 hemiazygos, 116
 accessory, 116

 hepatic, 116
 portal system, 118
 anastomoses of, 118
 and tributaries, 118
 hypophyseal portal system, 150–151
 iliac
 common, **116,** 117
 external, **116,** 117
 internal, **116,** 117
 intercostal
 anterior, 116
 posterior, 116
 1st superior, 116
 introduction to, 102
 jugular
 anterior, 115
 external, 109, **115,** 116
 internal, 109, **115,** 116
 lingual, 115
 of the liver, **118,** 142
 lumbar, 116
 ascending, 116
 marginal
 lateral (foot), 117
 medial, 117
 maxillary, 115
 median, of forearm, 109
 mesenteric
 inferior, 118
 superior, 118
 metatarsal, 117
 obturator, 117
 pancreatic, 118
 phrenic, 116
 portal, hepatic, 118
 hypophyseal, **150,** 151
 pterygoid plexus, 115
 plantar, arch
 deep, 117
 digital, 117
 lateral, 117
 medial, 117
 metatarsal, 117
 popliteal, 117
 pulmonary, 102, **103,** 104, 106, 132
 rectal
 inferior, 118
 middle, 118
 superior, 118
 renal, 116
 retromandibular, 115
 review of principal veins, 119
 sinuses, of the dura mater, 115
 cavernous, 115
 confluence of, 115

 intercavernous, 115
 occipital, 115
 petrosal
 inferior, 115
 superior, 115
 sagittal
 inferior, 115
 superior, 115
 sigmoid, 115
 straight, 115
 transverse, 115
 sinusoids
 liver, 142
 lymph, 125
 splenic, 124
 structure of, 102
 subclavian, 109
 left, 116
 right, **115,** 116
 subcostal, 116
 suprarenal, 116
 temporal, superficial, 115
 thoracic, internal, 116
 thyroid
 inferior, 116
 middle, 115, **116**
 superior, 115, **116**
 tibial, anterior, 117
 venae comitantes, **109,** 117
 vena cava
 inferior, 111, **116,** 117, **118**
 superior 111, **116**
 vertebral, 115
Ventral, definition of, 2
Ventricles, of the brain, 80–82
 development, 72
 flow pattern, 82
Ventricles, of the heart, 104
Vermiform appendix,
 126, 141
Vertebrae, column of, 25
 cervical, 26
 coccygeal, 27
 disorders, 25
 foramina of, 25
 lumbar, 27
 sacral, 27
 thoracic, 26,
Vertigo, 98
Vesicles, synaptic, 70
Vessels
 blood, 102
 lymph, 123, 125
Vestibular folds,
 larynx 130